AMERICA
A CELEBRATION!

AMERICA
A CELEBRATION!

MARTIN W. SANDLER
Foreword by Walter Cronkite

A Dorling Kindersley Book

Dorling [DK] Kindersley

London, New York, Sydney, Delhi, Paris, Munich and Johannesburg

Project Editor and Photo Research/Editor: Barbara M. Berger
Designer: Timothy Shaner, Night & Day Design

Publisher: Sean Moore
Editorial Director: LaVonne Carlson
Art Directors: Tina Vaughan, Dirk Kaufman
Production: David Proffitt

Assistant Picture Editor: Laarnie Ragaza

First American Edition, 2000
2 4 6 8 10 9 7 5 3 1

Published in the United States by
Dorling Kindersley Publishing, Inc.
95 Madison Avenue
New York, New York 10016

DK Publishing offers special discounts for bulk purchases for sales promotions or premiums.
Specific, large–quantity needs can be met with special editions, including personalized covers,
excerpts of existing guides, and corporate imprints. For more information, contact Special Markets
Department, DK Publishing, Inc., 95 Madison Avenue, New York, NY 10016 Fax: 800–600–9098.

Library of Congress Cataloging–in–Publication Data

Sandler, Martin W.
 America: a celebration! / Martin W. Sandler.– 1st American ed.
 p. cm.
 Includes index.
 ISBN 0–7894–6806–9
 1. Photography–United States–History. 2. United States–Social life
and customs–20th century–Pictorial works. 3. United States–Social
life and customs–19th century–Pictorial works. I. Title.
 TR23 .S32 2000
 779'.9793–dc21 00–031493

Reproduced by Colourscan Ltd, Singapore Printed and bound by Legatoria LEM s.r.l

See our complete catalog at
www. dk.com

contents

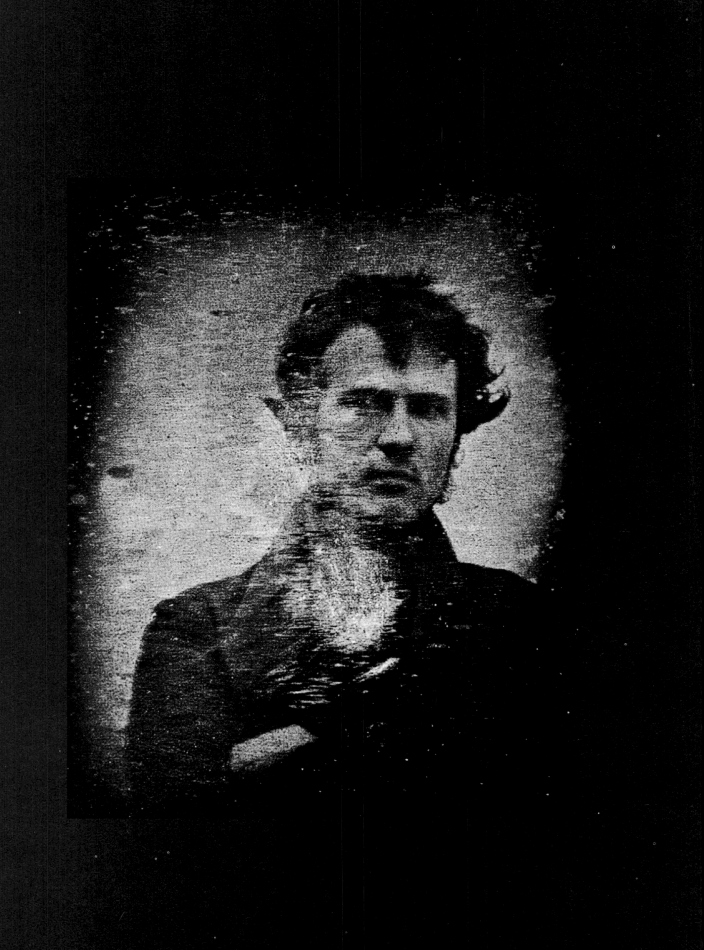

foreword

There is a lot wrong with America. Not enough people bother to vote and the democracy is therefore diminished. There is too much poverty in a land of plenty. There are too many of us who go without adequate medical care. Our educational system is scarcely the pride of the developed world. We have not led the world to perpetual peace but still endorse war as an adjunct of foreign policy.

Those are the dark sides of our nation, but none is unsolvable by a people whose optimism is a national characteristic and whose achievement is a time–honored value. As black as our clouds may be, they cannot cast in shadow the accomplishments of this country and its people. That side of our story is the feast of good news in *America: A Celebration!*

Here are magnificent presentations through the photographer's art of that glorious experience that has made America, despite our problems, a mecca of the ambitious and the downtrodden across the face of the earth.

Here is the evidence, in the pictures and accompanying narrative, of the spirit of the people from many lands who came together here to adorn its incredible natural wonders and find sustenance in its fields and forests.

In one of the book's captions, Walt Whitman is cited as having written that in America "the people are the poetry." That is what this book is all about; it is a book of poetry.

Walter Cronkite

1839 Only nine months after Louis-Jacques-Mandé Daguerre had startled the world by demonstrating the miracle of photography, Robert Cornelius captured this self-image (*left*). It is the earliest photograph of note taken in the United States.

introduction

In 1829 James Madison, the "father of the United States Constitution," reflected upon what he saw as the state of the Union some 50 years after the historic blueprint for government had been created. "The happy union of these states is a wonder" wrote Madison, "their constitution is a miracle: their example the hope of liberty throughout the world." Today, more than 170 years later, our states are more closely allied than ever; our Constitution remains a marvel; and people throughout the world continue to look to America as the model and hope of liberty.

America: A Celebration! chronicles this remarkable achievement. It is a panorama of how Americans have viewed themselves, presenting America's story through the eyes of its image-makers – a celebration of a 161–year love affair between a nation and a medium called photography that has both documented it and helped it grow.

Both the United States and photography are relatively young. Given America's place in the world, it is easy to lose sight of the fact that the nation is still an infant among the major countries of the globe. It is equally easy to forget that photography, despite its impact, has been in existence for far less than 200 years. For all but six of its decades as a republic, America has come under the

scrutiny of the camera, as photographers have presented us with an indelible record of the territory we have covered and provided us with the opportunity to better understand where we are now.

Photographs are everywhere, so many in fact that, as photohistorian Peter Turner has pointed out, more photographs exist than bricks. One wonders if there is anyone who has not seen a photograph. How many people can there be who have never been in one? But it is not the sheer number that is most important. It is the impact that photography has had on our lives.

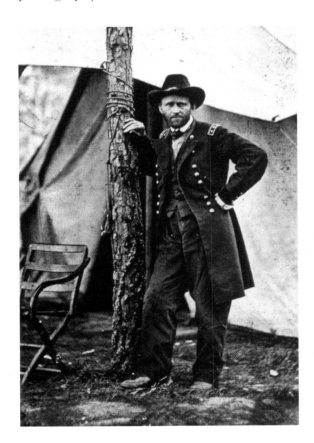

1986 The Statue of Liberty turns 100 (*left*).

1864 Union general and future President Ulysses S. Grant (*right*).

introduction

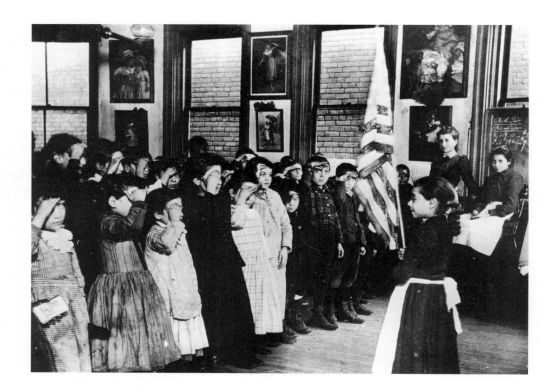

Photography is quite simply the universal folk art, the most democratic form of expression the world has ever known. It has also become a universal language understood by everyone, perhaps surpassing even reading and writing as a form of communication. And just as photography, from the beginning, has been shaped by the world around it, it in turn has shaped events and changed the way we see the world. As Dorothea Lange reminded us, "The camera is an instrument that teaches people how to see without a camera."

The photographs in *America: A Celebration!* were taken by photographers from all walks of life. Included are scores of images by some of the most highly acclaimed photographers in history, such as Walker Evans, Ernst Haas, Gordon Parks, Dorothea Lange, Jacob Riis, Weegee, Lewis Hine, Slim Aarons, Timothy O'Sullivan, Carleton Watkins, and Marion Post Walcott.

But this is a book that, along with presenting vivid portrayals of the celebrities and the movers and shakers of each decade, places emphasis on the joys and everyday affairs that are the heart of the story of every society. Thus, hundreds of the pictures included were taken by amateurs and less-recognized professionals. Their photographs remind us that every picture is a historical record of sorts, and that while some say a

1887 Immigrant children salute the flag (*above*).

1926 Flappers dance the Charleston (*right*).

little about a time and a place and others say a lot, each is a reminder of one of the oldest ideals of democracy, that of making "everyone a historian."

Looking back on his career, photographer Lewis Hine stated, "There were two things I wanted to do. I wanted to show the things that needed to be appreciated. I wanted to show the things that need to be changed." Through its pictures and narrative commentary, *America: A Celebration!* shows many of the things throughout the decades than needed to be changed and discloses how Americans worked to change them. Its primary purpose, however, is to reveal and celebrate those things worthy of appreciation.

In the pages of the book you will discover how the camera has been a

relentless eyewitness to the incredible beauty of a vast, untamed land and to the determination and courage of a people who settled the huge continent. You will encounter the inventive spirit that turned the nation into an industrial giant and gave its citizens the highest standard of living in the world. You will discover how Americans learned to play, and, once having learned, turned play and entertainment into an art form. And you will witness a nation's love affair with machines. You will see how, from steamboats to trolleys to trains to automobiles to the heavens and beyond, a restless people has kept itself on the move.

Many of the photographs in this book speak directly to the words penned by historian Oscar Handlin when he wrote,

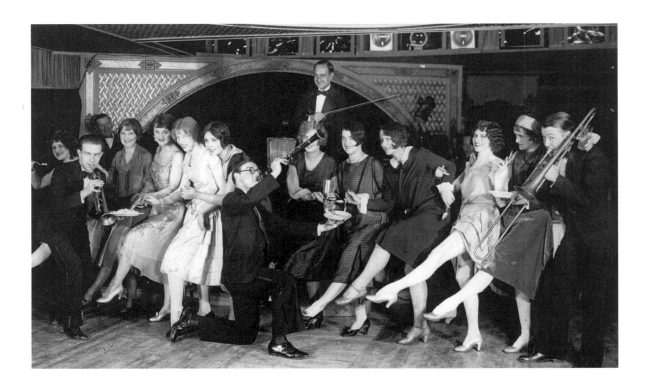

introduction

"Once I thought to write the story of America's immigrants. Then I discovered that the immigrants *were* America's story." Many of the photographs supply evidence of the way in which the United States has, throughout its history, been a magnet for dreams, attracting people throughout the world in search of a better life. Other pictures disclose how this infusion of new energy has been instrumental in the building of the nation. The photographs also reveal how, more than any other country, the story of America is the story of a rainbow of people of various colors, religions, and origins, each making their own contributions, enriching us in ways too numerous to recount.

Among the most striking images in this book are the photographs that reveal the diverse natural wonders of the vast American landscape. Here are the mountains, the rivers, the valleys, the deserts, the breadth and beauty of a land that has also defined us as a nation. Here also are images revealing the energy and vitality of American cities. Many of the earlier pictures were taken by such accomplished pioneer landscape photographers as Timothy O'Sullivan, Carleton Watkins, William Henry Jackson, and John Hillers. A large number of the modern scenes were captured by the latter-day master of color photography, Ernst Haas.

Perhaps if there is one thing above all others that the pictures in this book reveal, it is the indomitable spirit of the American people. The United States, of course, has had its share of economic hardships, injustices,

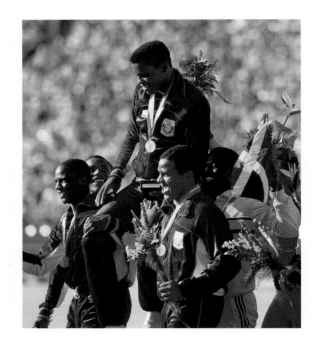

conflicts, and social ills. But time and again, among the images of people at work, at play, and on the go, we find pictures of Americans working to remedy these ills, to adjust to changing circumstances, and to move in new and better directions. Here in these pages are civil rights leaders and ordinary people, black and white, working to gain long overdue rights and opportunities for African-Americans and other minorities. Here are women campaigning for and finally winning the right to vote too long denied them. And here are Native Americans proudly demonstrating their age-old skills and traditions.

Most of the photographers who took these pictures were unabashedly taken with

1984 The victorious American Olympic relay team (*above*).

1995 A Native American powwow (*right*).

the spirit shown by their subjects. Dorothea Lange, who captured the quintessential images of those hardest hit by the Great Depression, expressed it best. "Their roots were all torn out," she wrote. "The only background they had was a background of utter poverty . . . I had to get my camera to register the things about those people that were more important than how poor they were – their pride, their strength, their spirit. "

The final images in this book depict the ways in which Americans across the nation bid farewell to the 20th century and welcomed in a brand new millennium, bound to bring with it even greater changes. Some things, however, are for certain. At this new century's end there will still be men and women who find in the camera their most sublime means of expression. There will be tens of millions of new photographs,

many of which will become emblazoned in the public's memory. And there will be political leaders, writers, sports heroes, performers, artists, and ordinary citizens creating that type of a tapestry of life captured in *America: A Celebration!*

In 1835 the inveterate French observer Alexis de Tocqueville wrote, "In America I have seen the . . . happiest [people] to be found in the world . . . One will . . . find people continually changing paths for fear of missing the shortest cut leading to happiness." Tocqueville was right. The pursuit of happiness is ingrained not only in the nation's most cherished document but in the national character as well. That despite their trials and challenges so many Americans have achieved it is a real reason for celebration.

MARTIN W. SANDLER

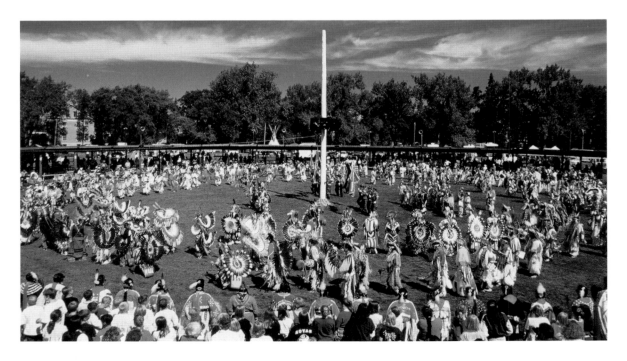

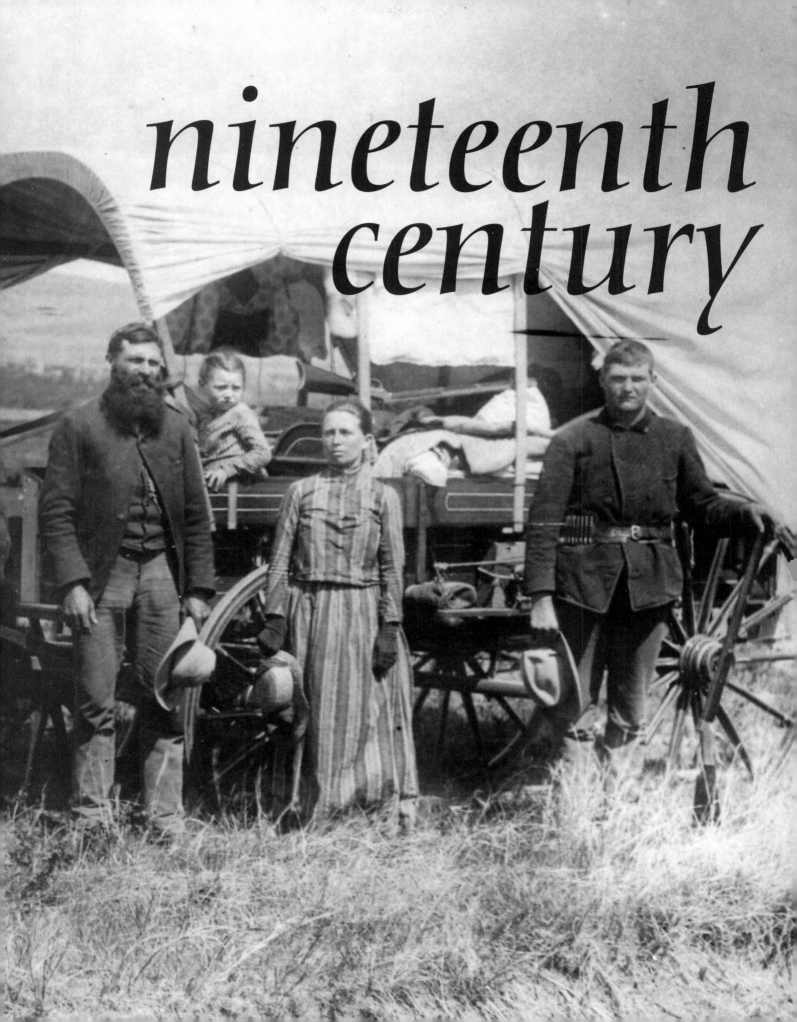

nineteenth century

nineteenth century

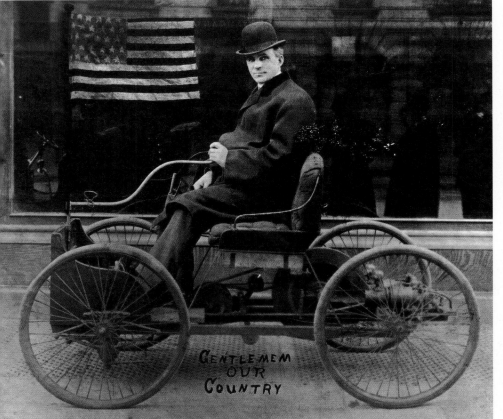

In the 1800s the new miracle of photography began to change the way people would see the world. Photographers, taking part in government surveys, introduced Americans to the splendors of the unsettled West. By the 1870s, millions were making the long, arduous journey to the virgin lands, seeking new opportunities and new lives.

At the same time, immigrants from around the world were pouring into the country, forever changing the face and character of the nation. They would encounter an unprecedented technological revolution in which new farm and office machines seemed to appear every day and a transcontinental railway system linked the nation with two bands of steel. And by the end of the century inventors and tinkerers were working on a new contraption called the automobile.

1896 Henry Ford (1863–1947) did not invent the automobile. But he successfully adapted the assembly line method of production to auto manufacturing and put the car in the hands of the millions. Over 15 million Ford automobiles, affectionately known as "Tin Lizzies," were eventually sold.

1886 The Homestead Act of 1862 provided that any citizen over the age of 21 could claim 160 acres of public western land for a nominal price and the promise to improve the new holdings and live on it for at least five years. Here (*previous pages*), a family of settlers poses proudly on the site of what will become their new home in Loup Valley, Nebraska.

1861 The dome of the Capitol building, Washington D.C., under construction at about the time that President Abraham Lincoln took office. The original dome of the building was destroyed by fire in the War of 1812. The later dome was designed by architect Charles Bullfinch.

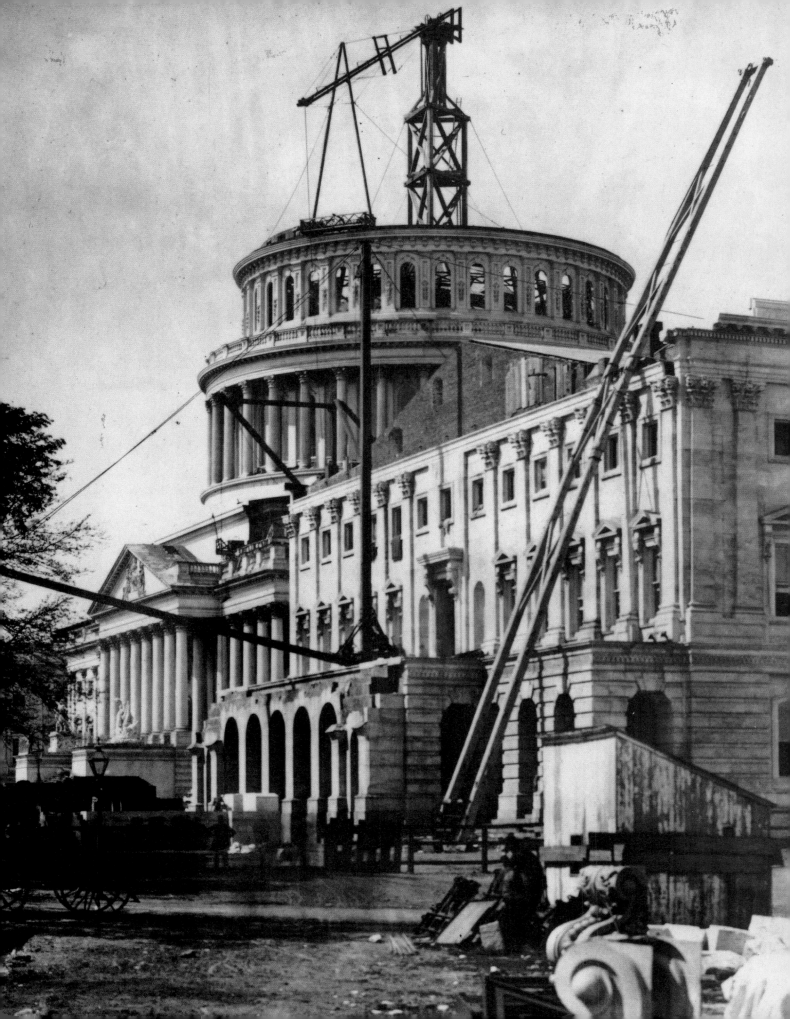

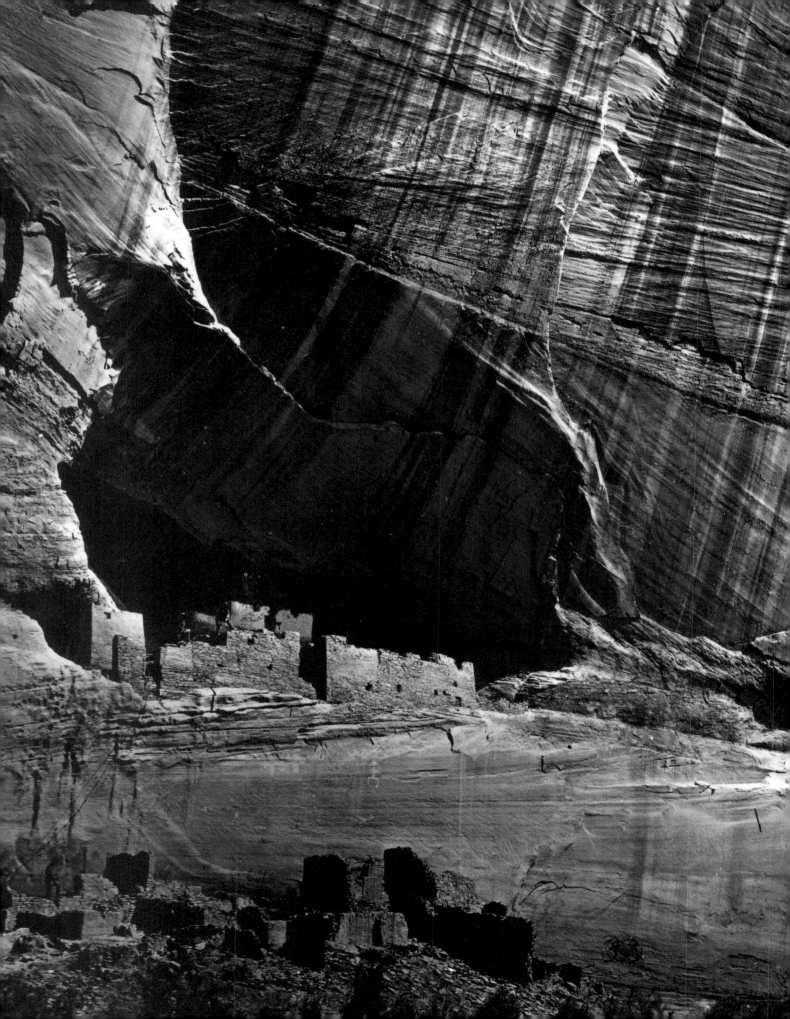

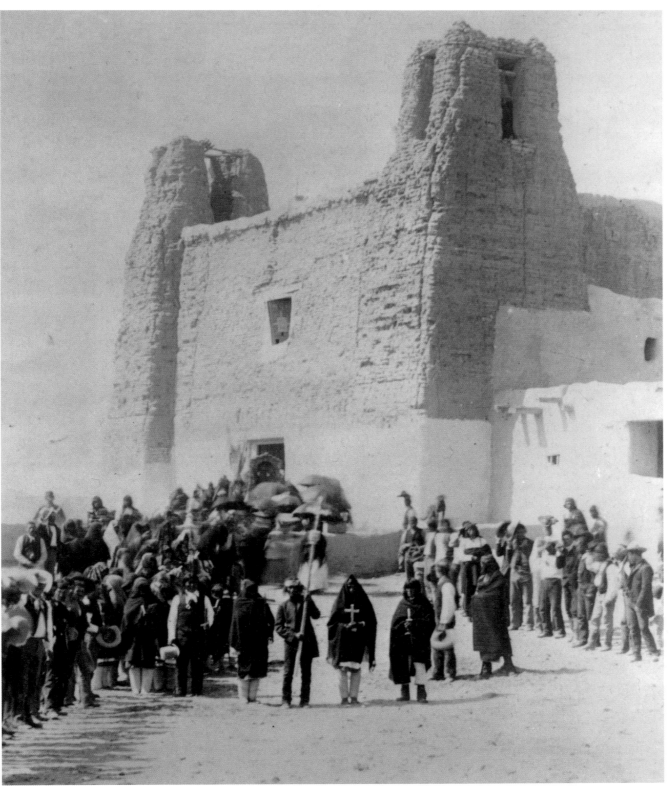

c. 1890 On one of the geological surveys into the American West, Timothy O'Sullivan captured this now-famous image of the remains of Anasazi cliff dwellings in Arizona's Canyon de Chelly (*left*). The site became a favorite subject of future photographers, including Gertrude Käsebier and Laura Gilpin.

1890 A group of Pueblo Indians from the Native American village of Acoma, New Mexico, gather at the Saint Esteban del Rey mission to observe a feast day.

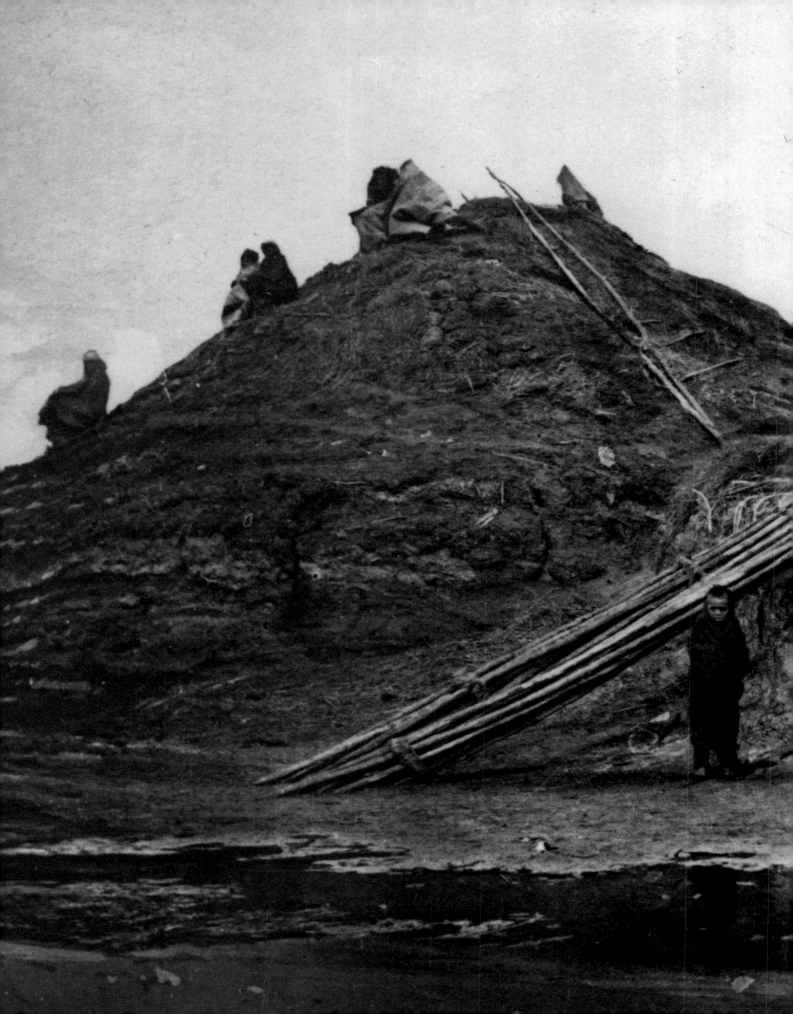

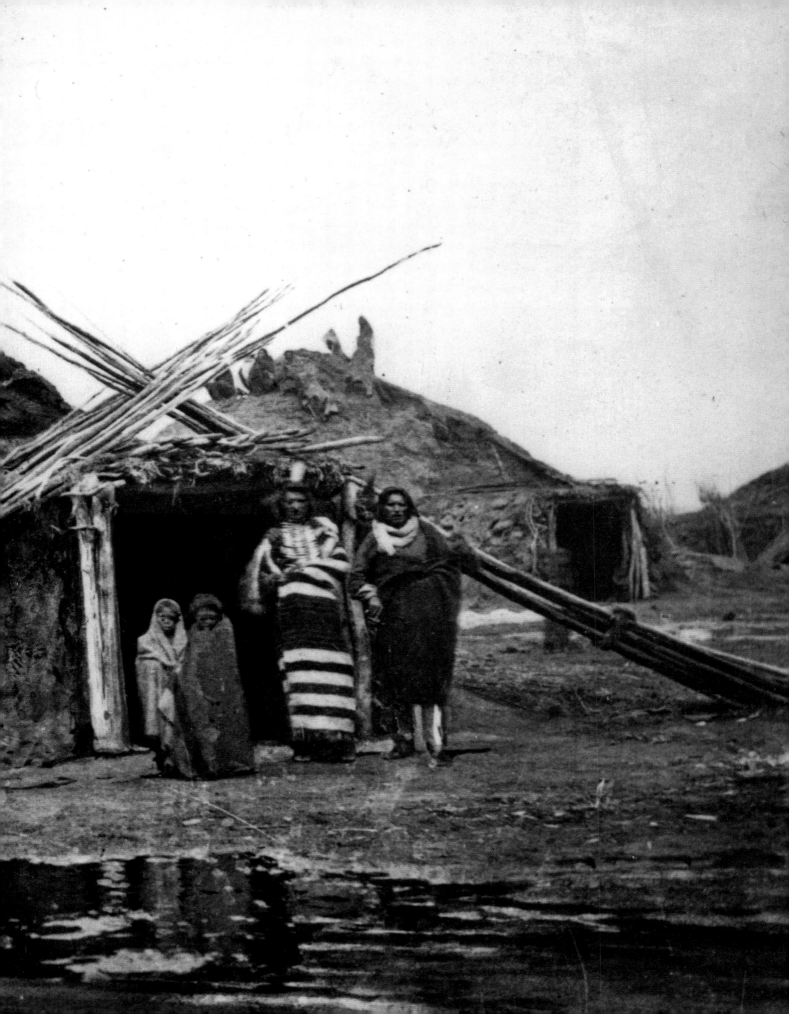

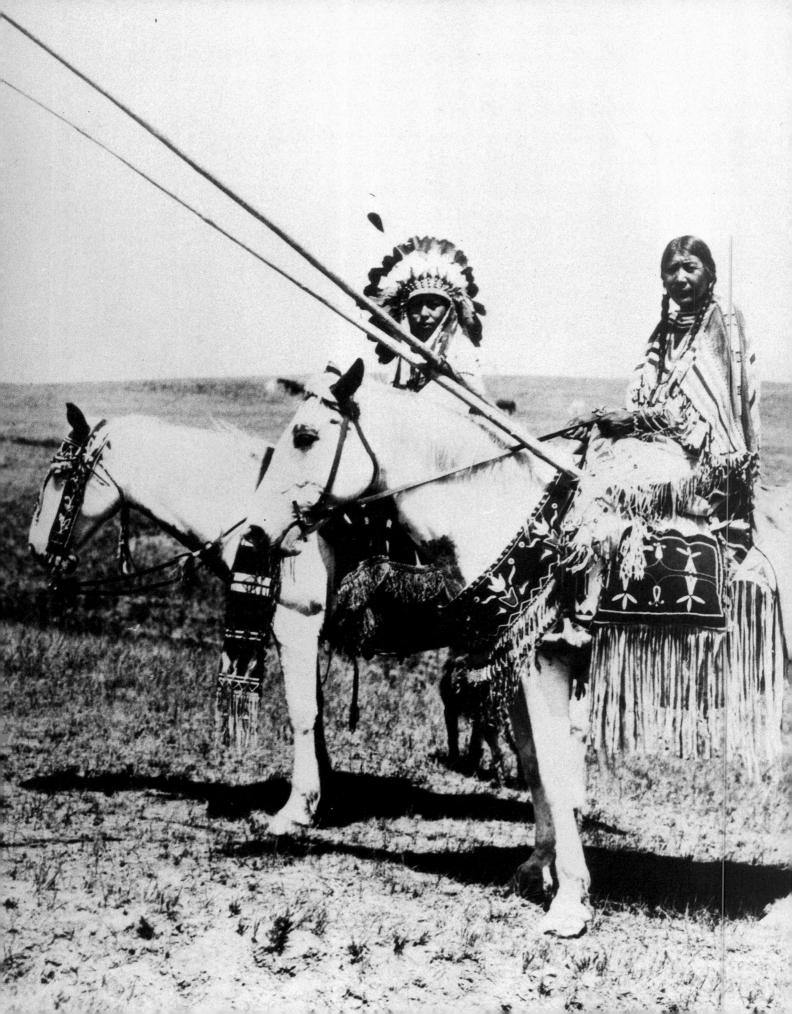

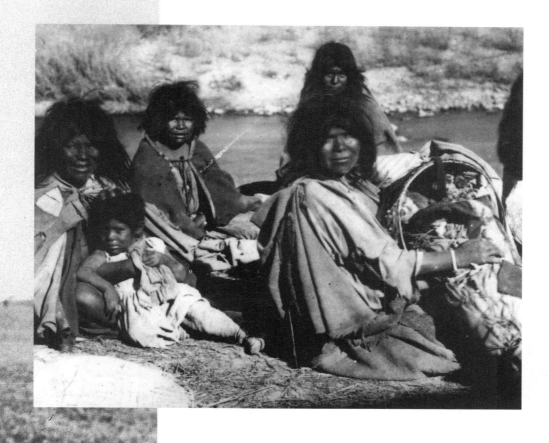

1860 Members of the Soshone tribe pose in this early photograph taken in Salt Lake City. As seen in the image, family ties were extremely important to most Native Americans.

c. 1890 A Blackfoot chief and his squaw traveling on horseback with their child. The long poles in the picture were part of that piece of Native American equipment called a "travois," upon which nomadic Indians like the Blackfoot transported their belongings.

1871 A Pawnee family (*previous pages*), poses outside their earth lodge at Loup, Nebraska. This family was actually untypical of their fellow tribe members since most Pawnees were nomadic and lived in teepees as they followed buffalo and other game across the American plains.

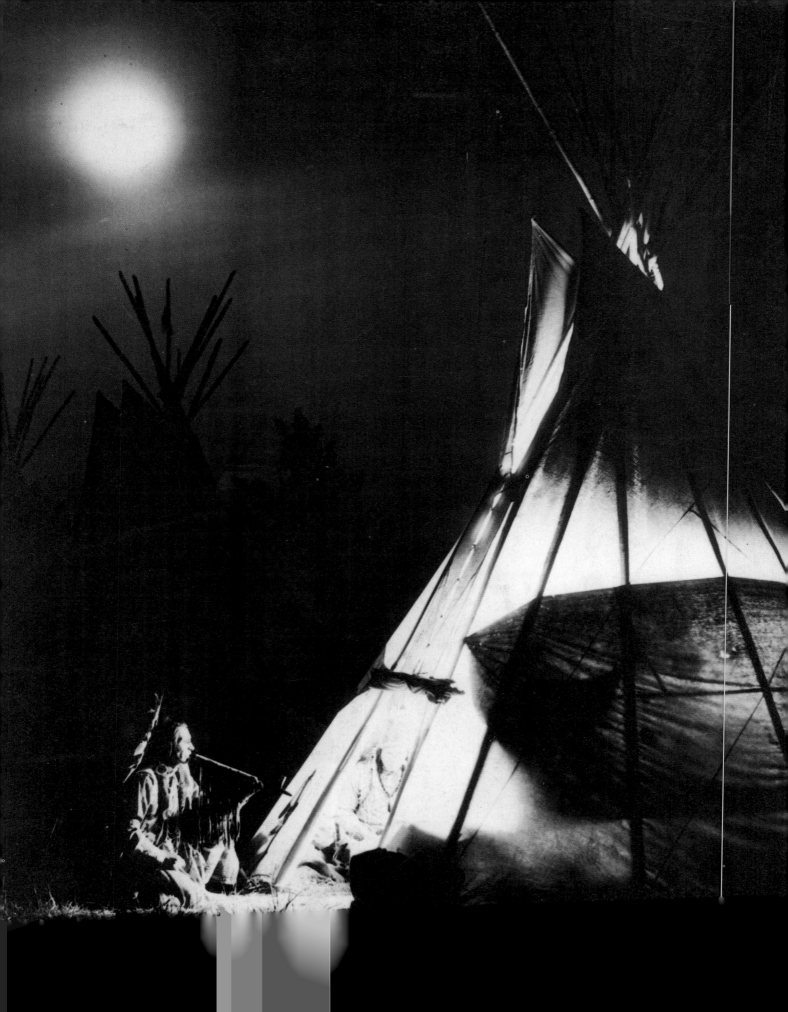

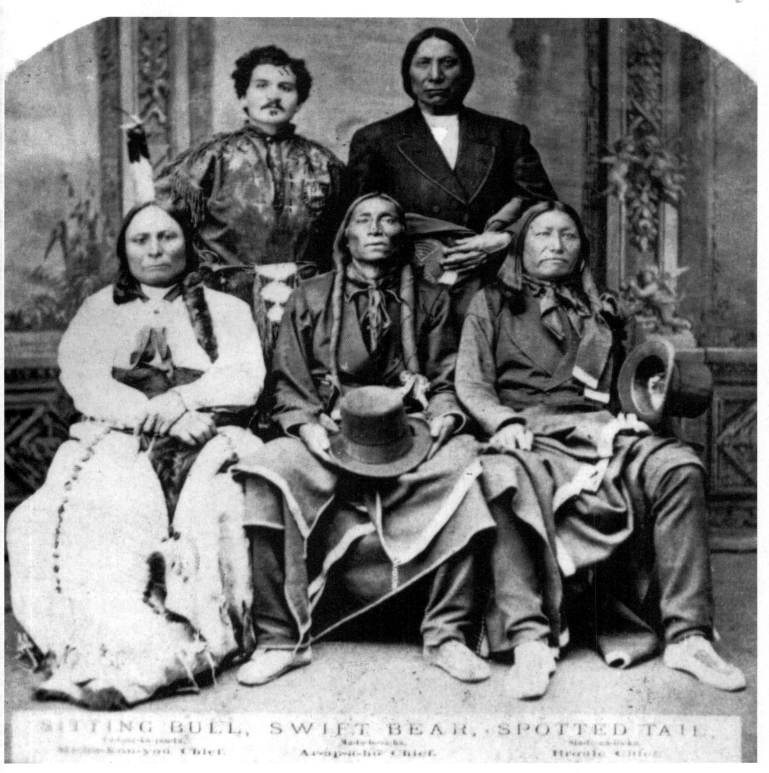

SITTING BULL, SWIFT BEAR, SPOTTED TAIL.
Minne-Kow-you Chief. Arapaho Chief. Brule Chief.

c. 1880 A Native American of the Blackfoot tribe smoking outside his tepee by moonlight (*left*), in the tribal camp on the Glacier National Park reservation in Montana.

c. 1885 A group portrait of four Native American leaders posed with their interpreter after their long, ill–fated struggle to hold on to their lands and ways of life had ended. The chief at the left of the front row is the fabled Sitting Bull (1834–1890) who, in 1876, led the Sioux against Lieutenant Colonel George Custer at the Battle of the Little Bighorn.

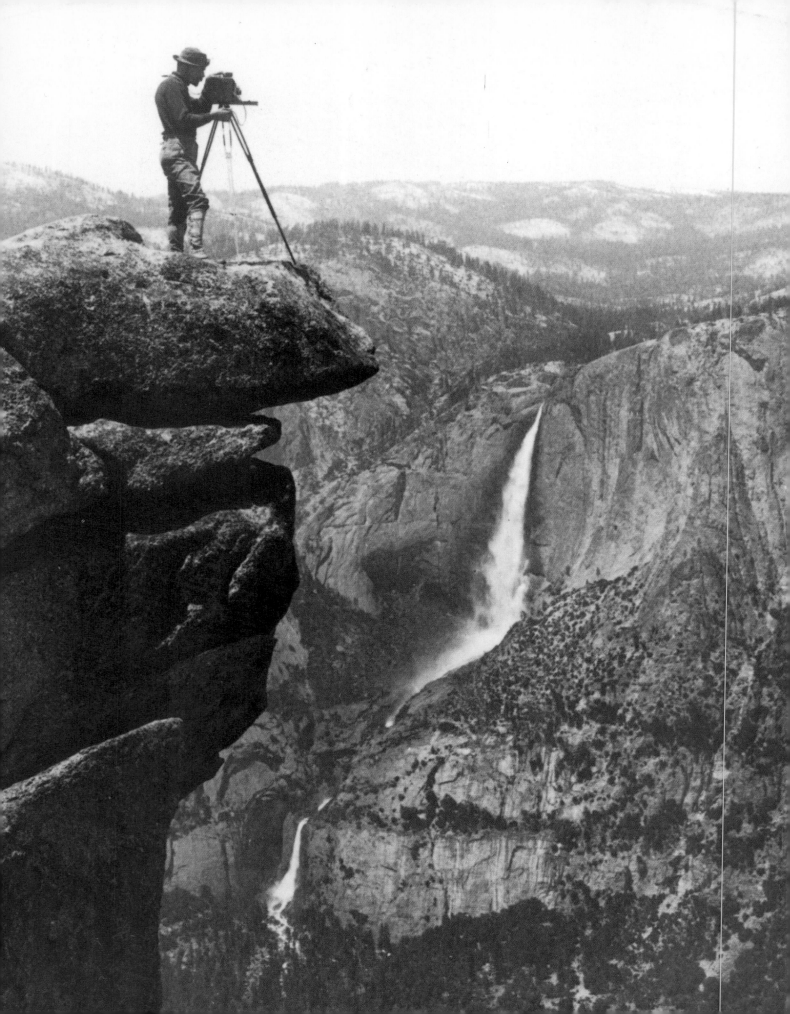

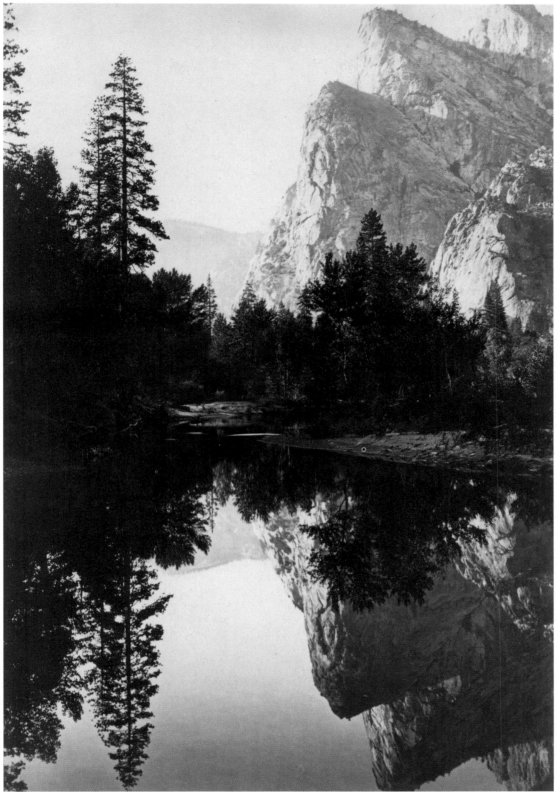

1880 William Henry Jackson was among the most accomplished photographers of the West. Here he is seen photographing Yosemite Falls from California's Glacier Point.

c. 1873 As they sought to produce the most striking images possible of the virgin western landscape, early photographers employed a number of techniques. One of their favorites was to capture the reflections of mountains in the many lakes that dotted the region.

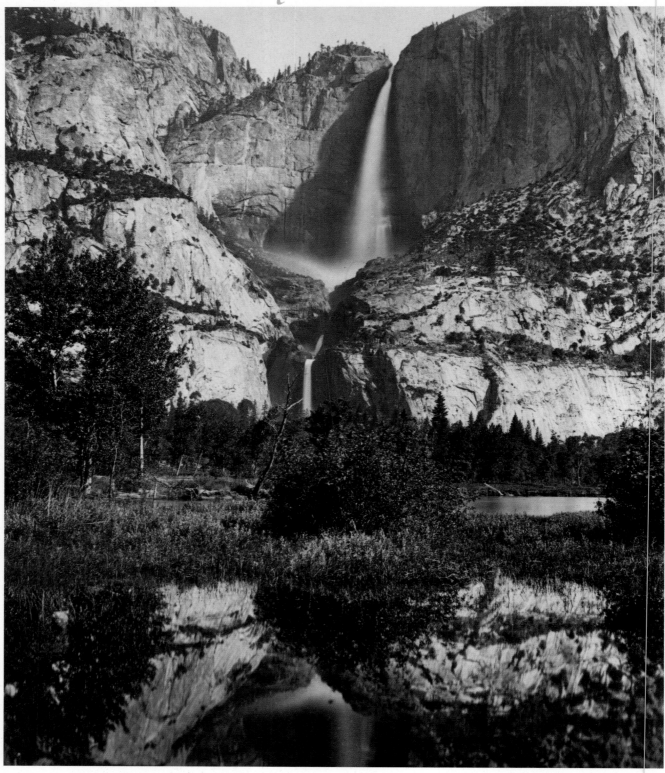

1873 Carleton Watkins, one of the earliest photographers of the Far West, worked with an enormous camera that held 20 x 24–inch glass plate negatives. Watkins photographed extensively in the Yosemite Valley, where he captured this image of the falls in Yosemite Park.

1870 Watkin's photographs of Yosemite Valley inspired many painters, including Albert Bierstadt and Thomas Moran. His images prompted Congress to pass a bill in 1864 requiring that the state of California prohibit private development forever in Yosemite. At the urging of naturalist John Muir, Yosemite was declared a National Park in 1890.

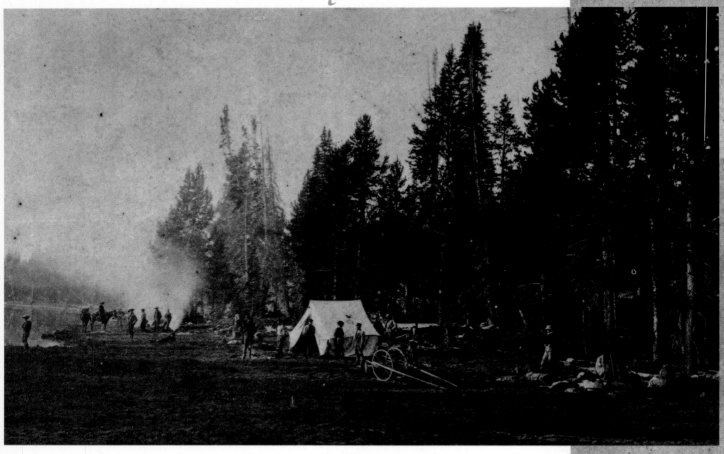

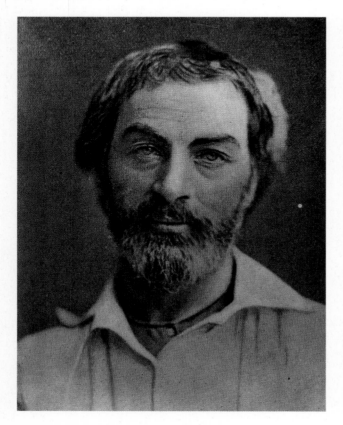

c. 1870 Ferdinand V. Hayden was the leader of one the most extensive geological surveys into the American West. Here is Hayden's survey camp near Pelican Creek, a site 15 miles east of Yellowstone Lake, Wyoming.

1868 Timothy O'Sullivan (right), official cameraman for the U.S. Geological Exploration of the 40th parallel (1867–1869), makes his way across the Carson Desert in Nevada. The survey photographers were forced to endure extremes of searing heat and bitter cold; but the images they captured established them as pioneers of landscape photography.

1855 Poet Walt Whitman (1819–1891) at the age of 36 (*left*). His collection of poems titled *Leaves of Grass* was, according to Ralph Waldo Emerson, "The most extraordinary piece of wit and wisdom that America has yet contributed." "The United States themselves," wrote Whitman, "are essentially the greatest poem."

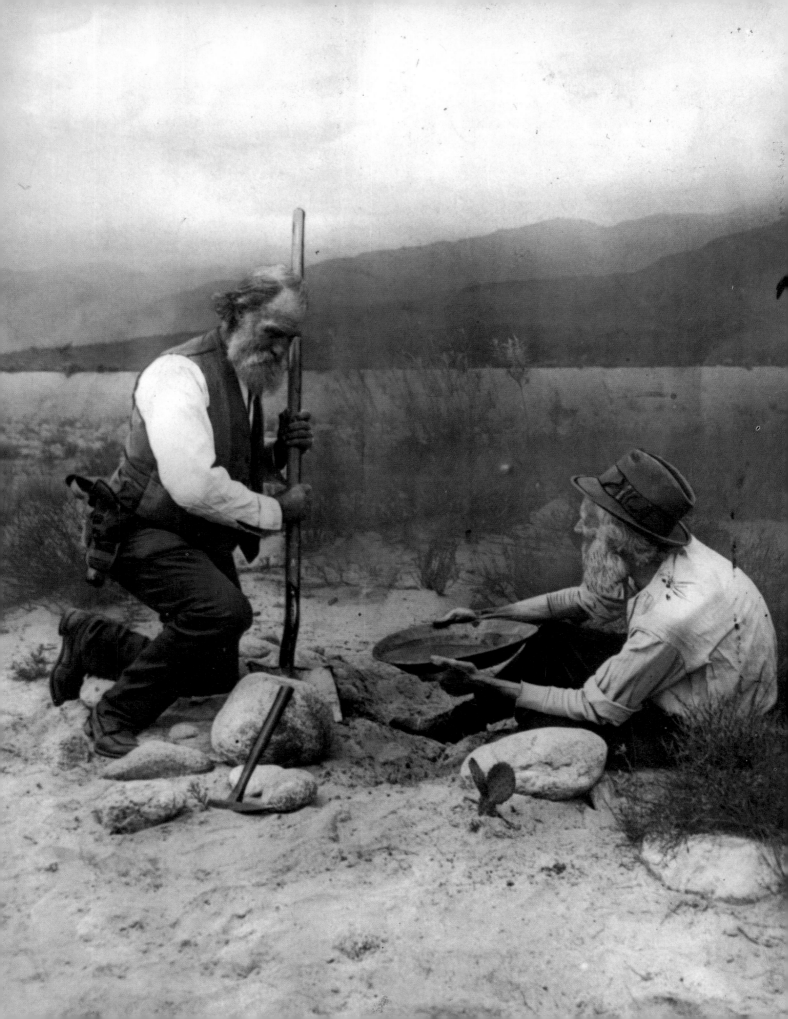

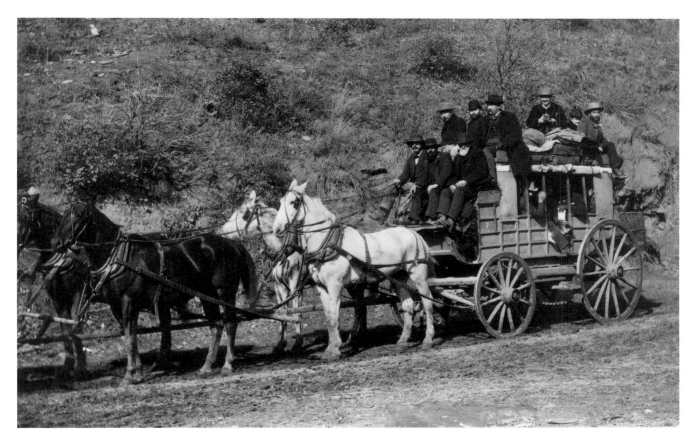

c. 1890 Photographer John C. H. Grabil of Deadwood, South Dakota produced one of the most extensive collections of western Americana, including images of railroads, cattle roundups, Indian life, and coaches and wagons. In this picture, Grabil photographed passengers aboard the Deadwood stage as it was about to make its the final run.

c. 1850 The search for gold in American can be dated as far back as the 1600s, when Spanish conquistadors came to the New World in search of treasure. Although relatively few ever struck it rich, there were enough gold strikes to keep the dream alive. These two prospectors (*left*) were photographed panning for the precious mineral in early California.

c. 1849 Most of the treasure-seekers who flocked to California in 1849 lived in tents and were far too busy digging or panning to be concerned about either their appearance or their living conditions. How then to explain this nattily attired gentleman (*right*)? And is that a treasure map that he holds in his hands?

1867 The gold that was discovered in California in 1849 lay in streams or shallow mines and was soon picked clean. Between 1859 and 1882 gold and silver worth hundreds of millions of dollars was harvested by mining companies in Nevada and California from deep within the earth. This (*previous pages*) is the Gold Hill mining camp in California.

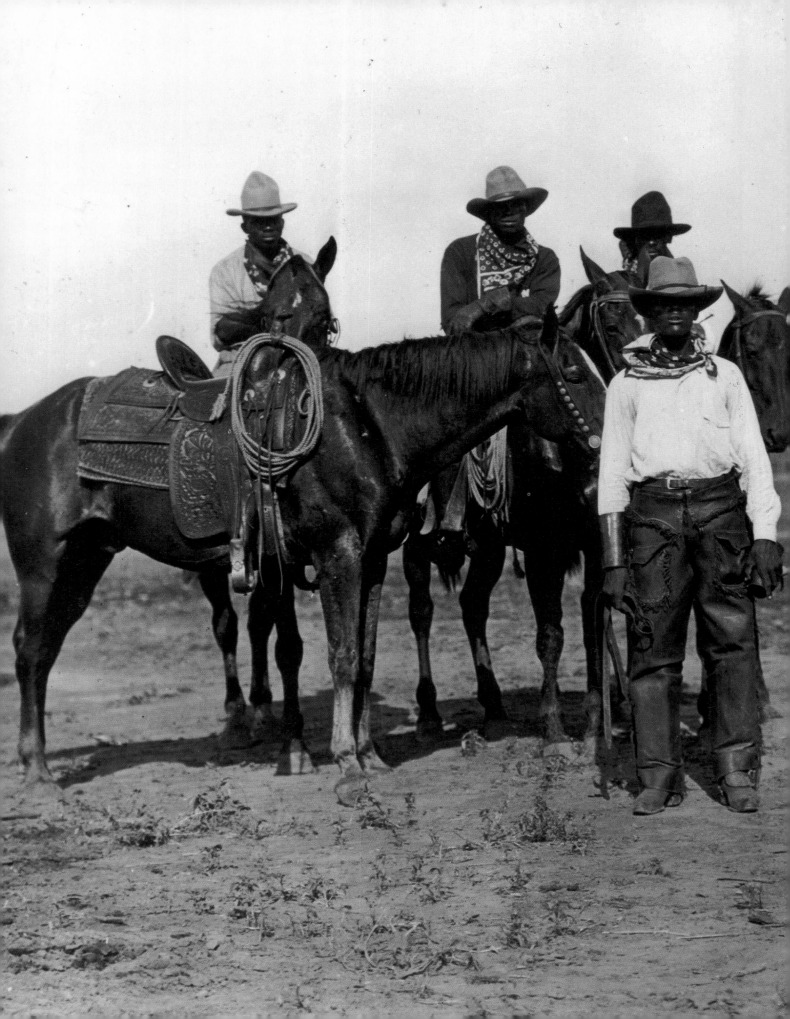

1855 More books, plays, and movie and television productions have been created about the American cowboy than any other figure. In most of these depictions the cowboys have always been white. In reality the ranks of cowpunchers were made up of thousand of vaqueros (Mexican cowhands) and well more than 5,000 African–American cowpunchers.

c. 1863 As early as the mid–1860s, towns and even budding cities had arisen on the once barren plains of the American West. In 1859, Denver was a tiny village. Within five years it had grown into a bustling town complete with a bank, a bakery, a drugstore, various specialty shops, and the hallmark of all new western towns – several saloons. Here (*following pages*), a convoy of covered wagons pauses before heading further west.

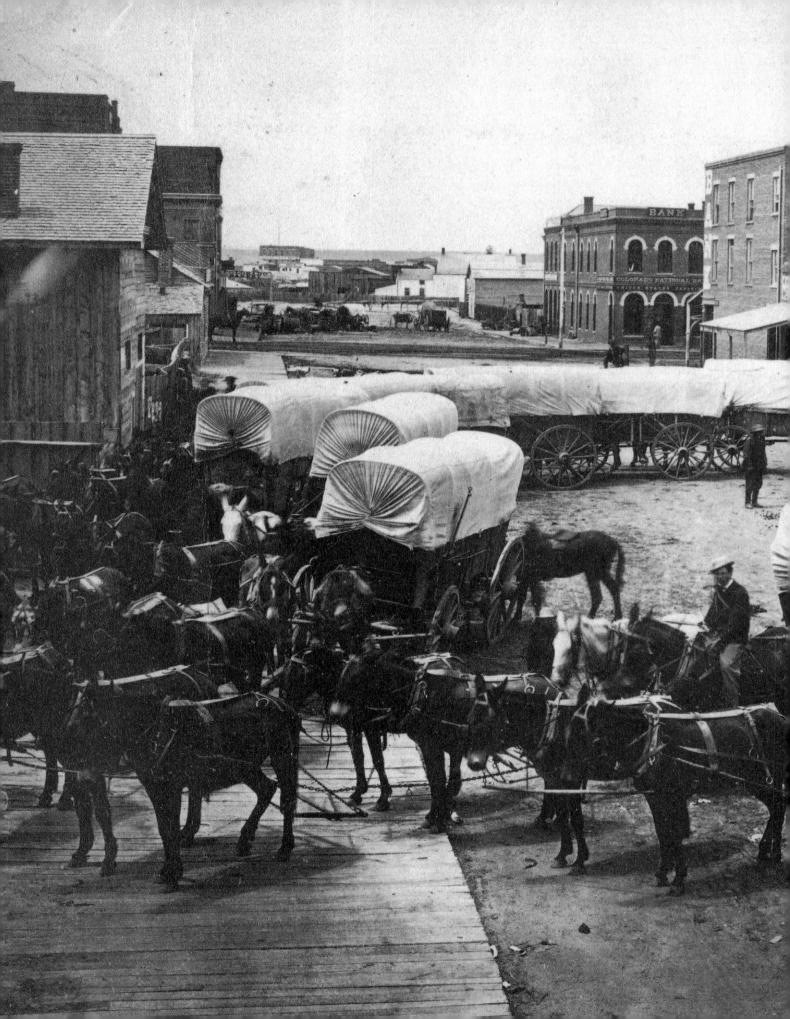

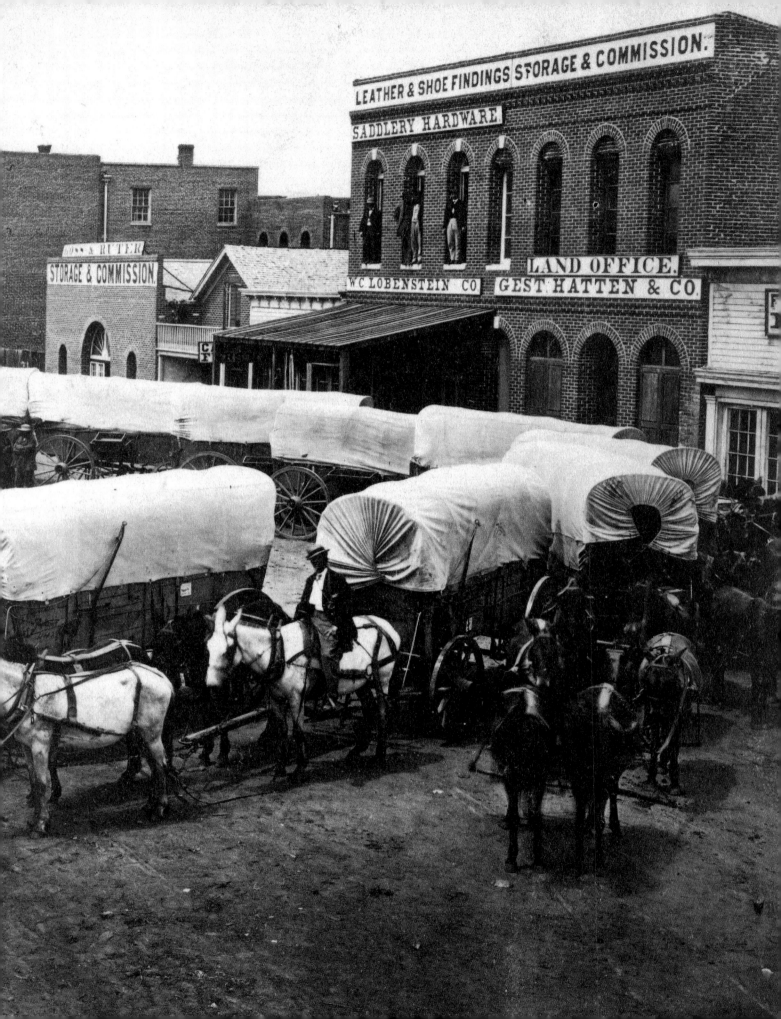

nineteenth century

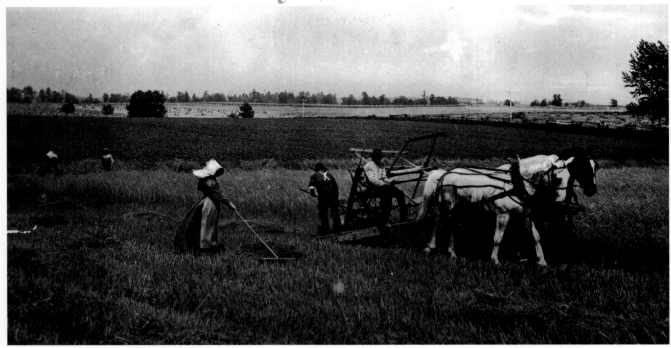

c. 1870 Pioneer farmers harvest their crops (*above*) with the use of a primitive reaping machine. Before the decade was over, newly introduced steam-driven reapers, threshers, harvesters, and other farm machinery would make western farmers more productive than ever imagined, and would help frontier families turn the prairie into the breadbasket of America.

1850 The former slave Frederick Douglas (1817–1895). Escaping from bondage, he issued a call to African-Americans to take up arms in the cause of freedom and helped organize two black regiments. After the Civil War he served in several government posts, including minister to Haiti. His inspiring autobiography has become a classic of American literature.

1888 Solomon Butcher was a native Nebraskan who was aware that by the 1880s, the sod houses that characterized early life on the Nebraska frontier were beginning to vanish. He devoted himself to photographing pioneer families in front of these unique dwellings (*right*). Here he preserved the image of an ex-slave family who, along with scores of other African-Americans, sought a new life in the West.

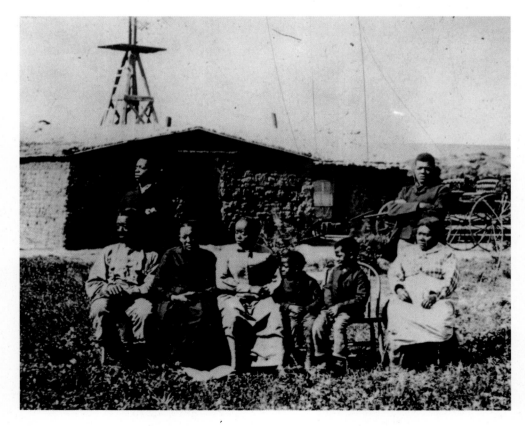

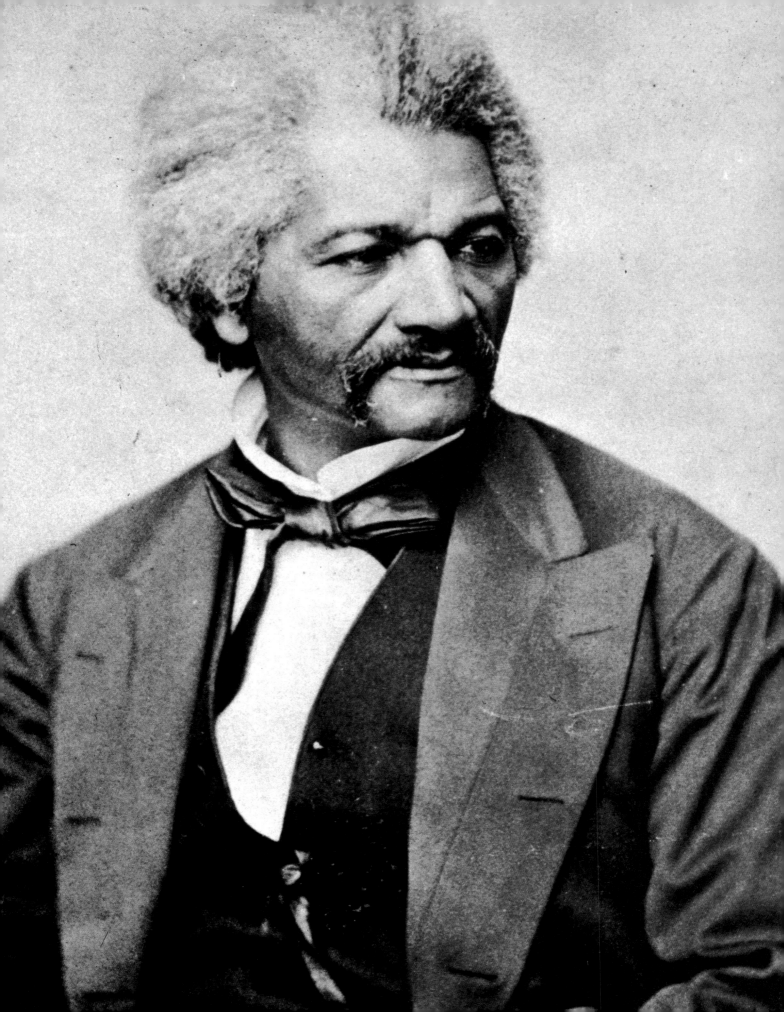

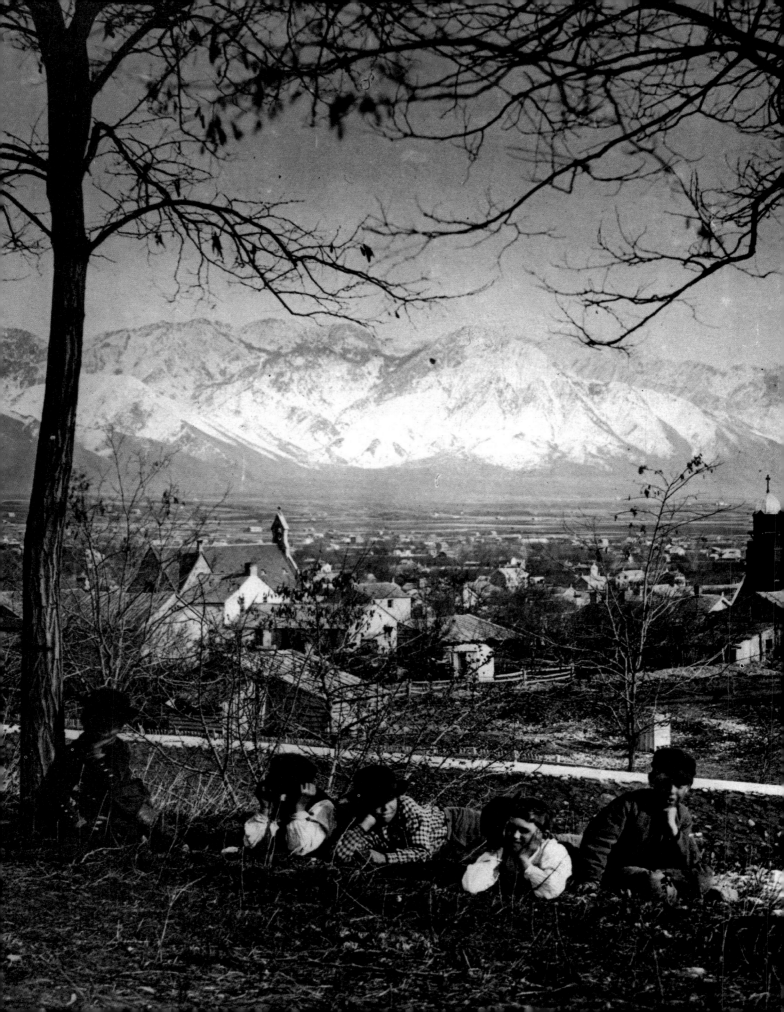

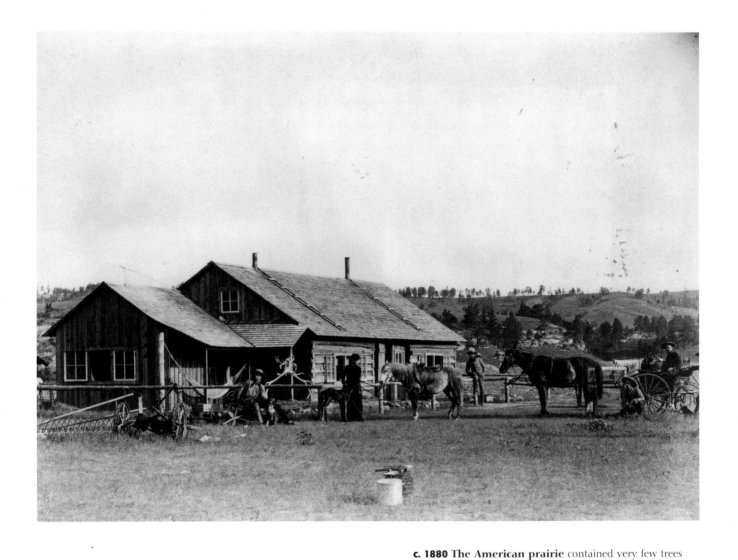

c. 1880 The American prairie contained very few trees and most early settlers built their first homes of sod. By 1880 some families had become "well-off" enough to import lumber and build themselves houses of wood. Signs of prosperity in this picture include the second story, the side porch, and the luxury of window glass.

1870 In the mid–1840s, thousands of followers of the Church of Jesus Christ of Latter–day Saints, better known as the Mormons, fled religious persecution in Nauvoo, Illinois, and headed to the West. Led by Brigham Young, they reached Utah in 1848 where they founded Salt Lake City. In this picture a group of Mormon children pose on a hilltop overlooking the rapidly growing city.

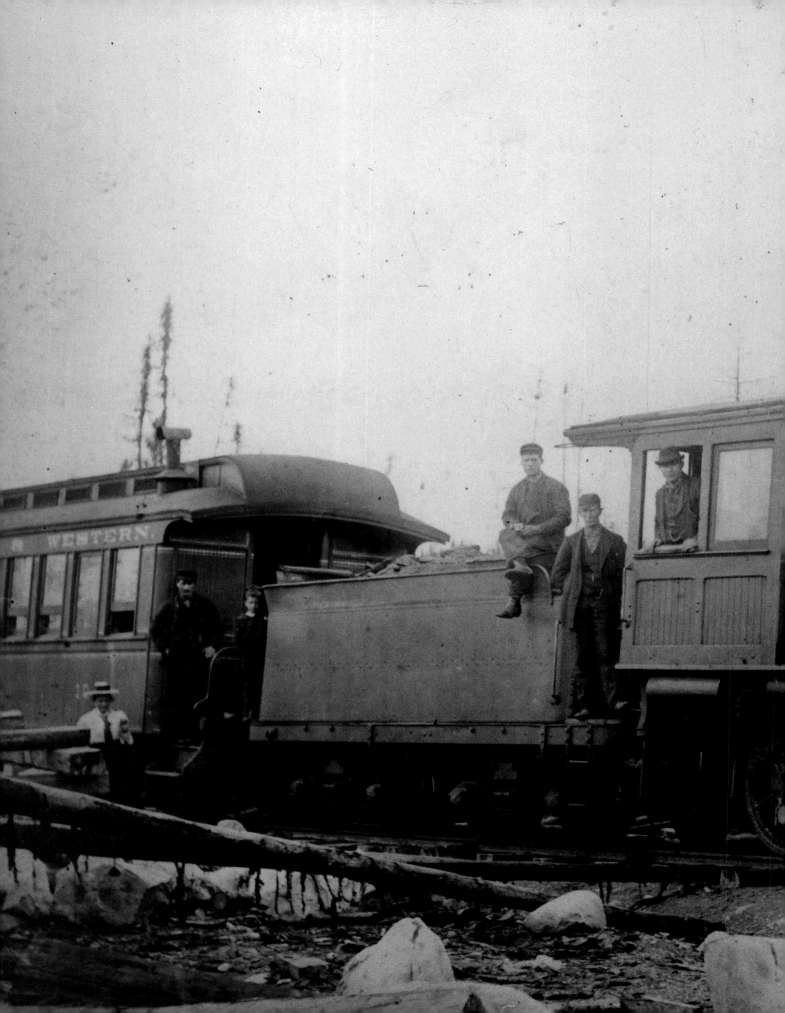

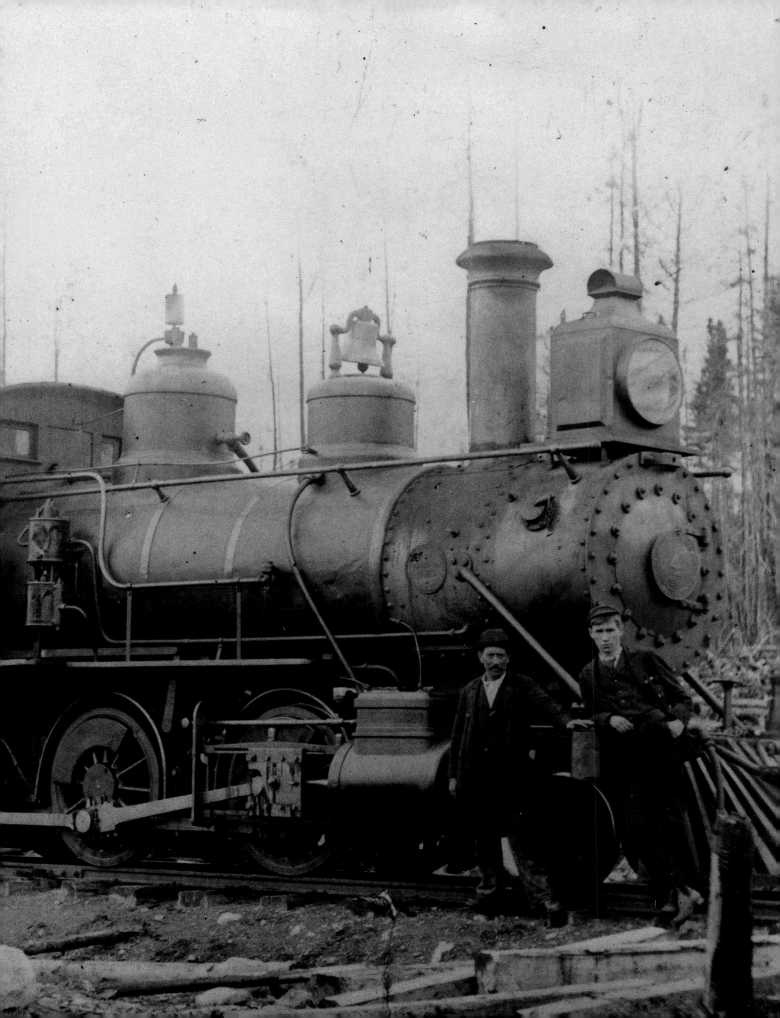

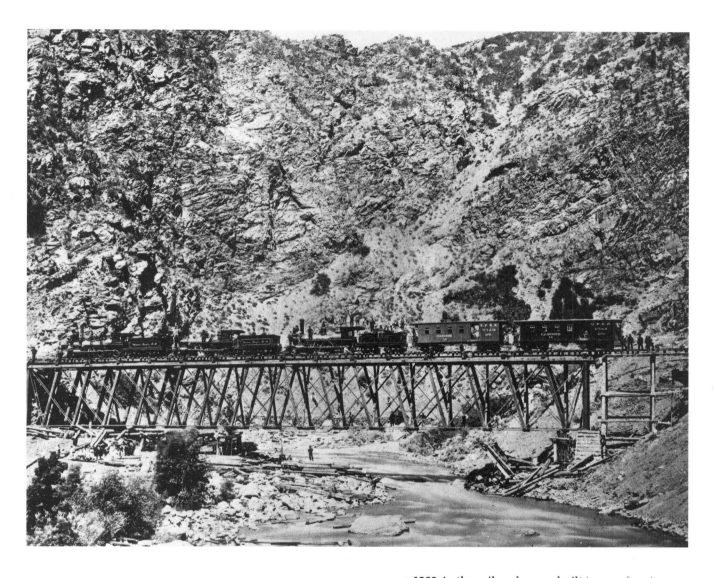

c. 1868 As the railroads were built in areas few city dwellers had ever seen, millions of Americans rode the trains simply to encounter the majestic landscape. These travelers were enjoying the view along the route of the California Western Railroad.

1894 As the railroad progressed it developed its own special lexicon. After several accidents were caused early on by cows wandering on the tracks a special iron grill, appropriately called a "cowcatcher," was attached to the front of locomotives. Its greatest value was in brushing aside rocks and timber that had fallen on the rails.

c. 1880 By the 1880s, (*previous pages*) the steam locomotive had become the symbol of American progress. To Walt Whitman the locomotive was nothing less than "type of the modern! emblem of motion! pulse of the continent!"

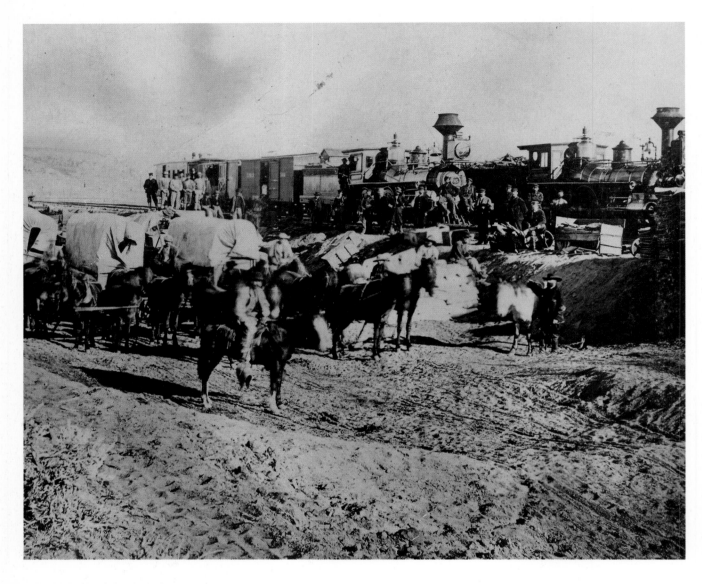

1867 The building of the transcontinental railroad involved thousands of track layers, graders, surveyors, blasters, bridge builders, and other workers. Equipment and supplies were needed in even greater numbers. In this photograph supply wagons have reached railroad crews working near Archer, Wyoming.

c. 1870 The transcontinental railroad, completed in 1869 with the joining of the rails at Promontory Point, Utah, was one of the greatest construction feats in all of America's history. In this scene, two trains test the strength of one of the many high trestle bridges that were built along the railway's route.

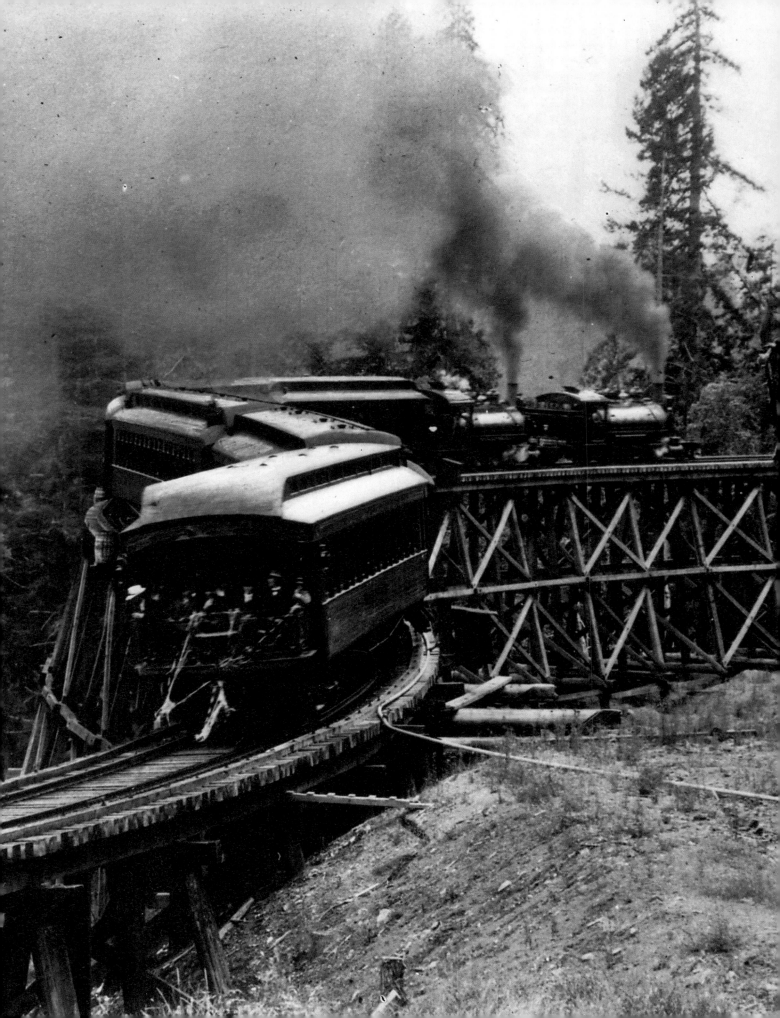

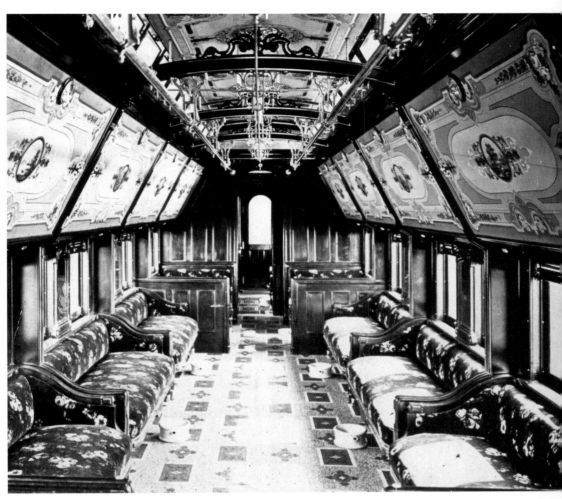

c. 1870 By the 1870s, sleeping and dining cars made going by train more comfortable than ever. If one was rich, train travel could be even more luxurious. This picture depicts the interior of a car that was part of the special "rolling palaces" built to meet the desires of those who could afford the highest fares.

1889 Throughout the late 1800s, the various American railroad companies continued to extend their lines in even the most remote parts of the nation. Here, railroad workers entertain visitors during a break in their work at a construction camp in South Dakota.

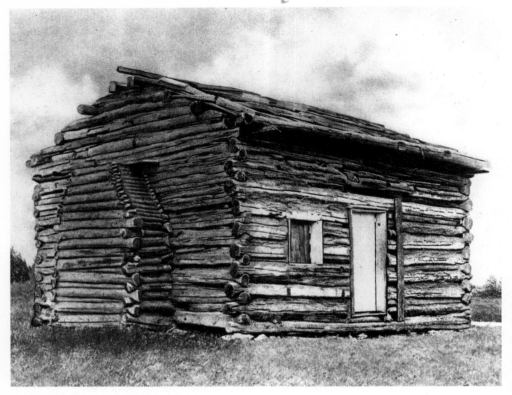

c. 1890 The log cabin in which United States President Abraham Lincoln was born in 1809 (*left*). During the late 1800s, the log cabin became an American symbol of simple honest virtue. Candidates throughout the nation claimed they had been born in log cabins whether it was true or not. The Lincoln cabin, now housed within a museum, still stands on the Kentucky farm that belonged to his father.

1863 During the Gettysburg Address, President Abraham Lincoln stated "The world will little note nor long remember what we say here." He was wrong. His brief address has become one of history's most famous speeches. Here (*below*) an unknown photographer captured Lincoln as he sat hatless in the midst of the throng on that November day in 1863.

c. 1865 Abraham Lincoln (1809–1865), the 16th President of the United States. This portrait (*right*), captured by America's premier early photographer Mathew B. Brady, was one of dozens of images of Lincoln that Brady photographed in his Washington studio.

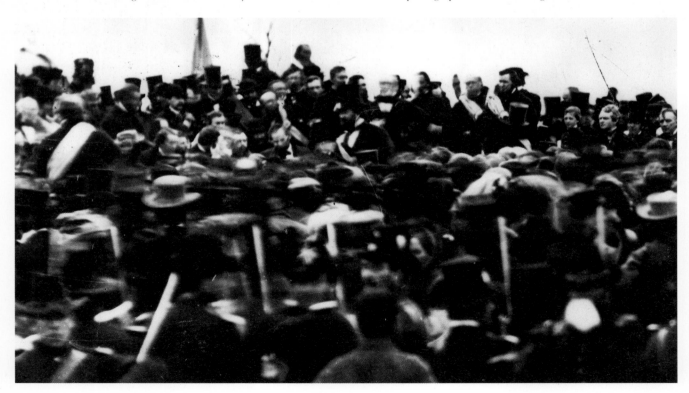

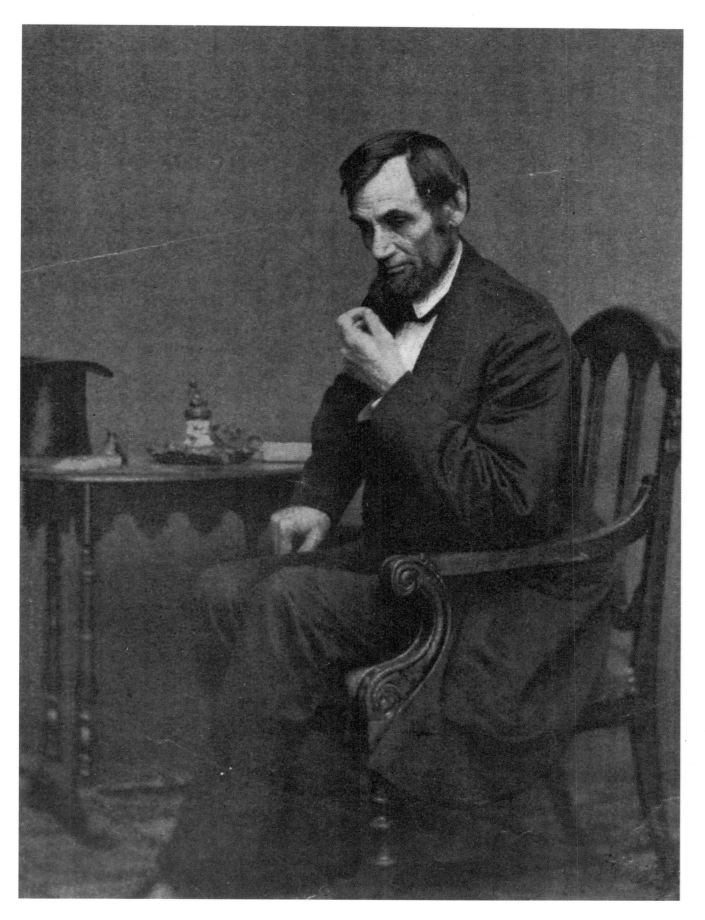

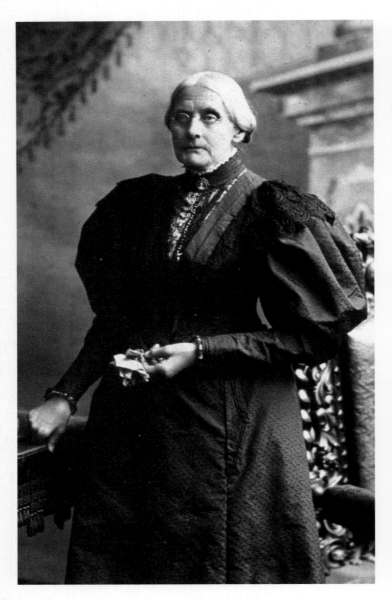

c. 1898 Susan B. Anthony (1820–1906) was one of the nineteenth century's most accomplished social reformers. In 1852 she organized the Women's State Temperance Society in New York. During the Civil War she petitioned for slave emancipation and black suffrage. When the war was over, she turned her attention to winning the ballot for women and, along with Elizabeth Cady Stanton, became the leading champion of women's right to vote.

c. 1860 Sojourner Truth (1797–1883), whose birth name was Isabella Van Wagener, was born a slave in New York. Under a law providing for the gradual abolition of slavery in that state she became free. When her master refused to let her go, she fled to freedom where she became a powerful speaker at abolitionist and women's rights meetings.

c. 1890 American abolitionist leader Harriet Tubman (*right*) (1820–1913). Born a slave, she escaped to Philadelphia where she set up a secret network of abolitionist sympathizers who helped slaves escape to the North and Canada. When the Civil War broke out Tubman became a spy for the Union army. After the War, she founded schools for ex-slaves and was an articulate champion for women's rights.

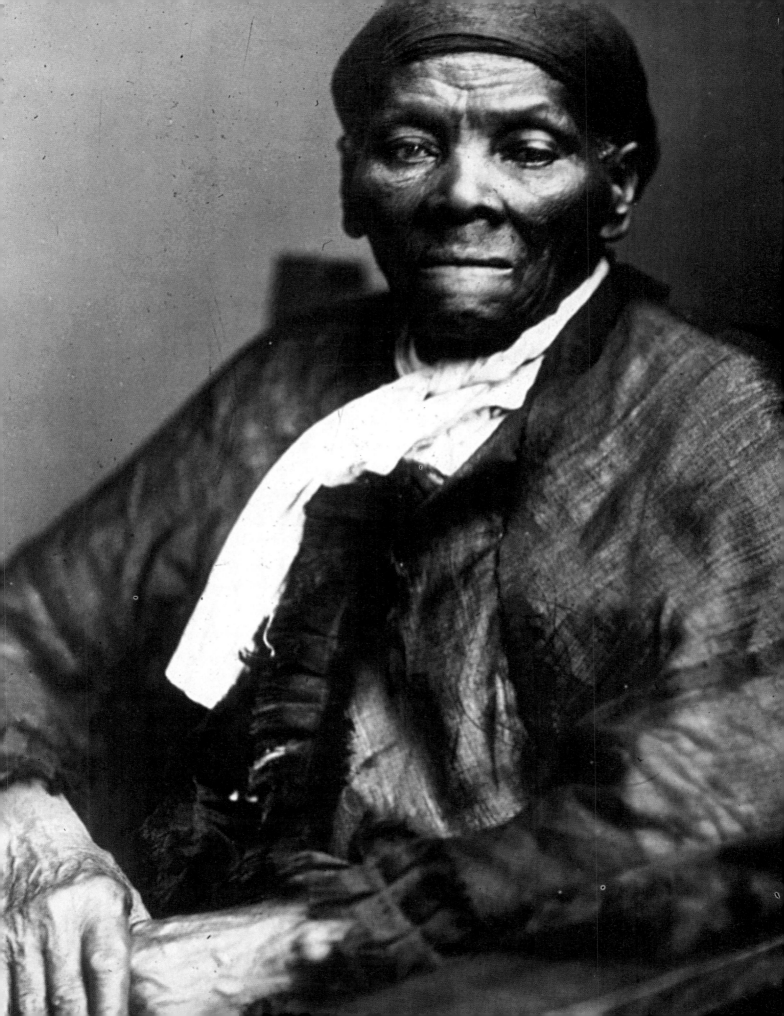

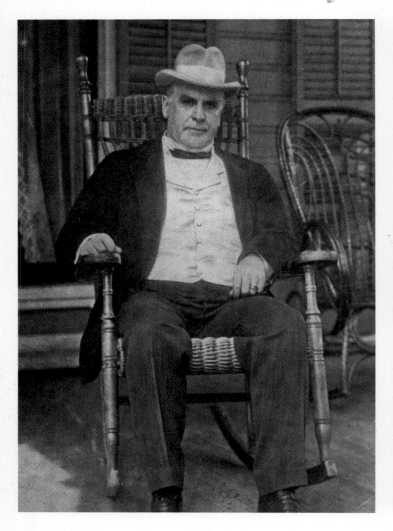

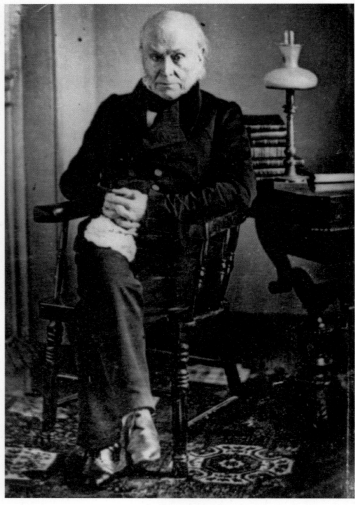

1896 William McKinley (1843–1901), the 25th President of the United States (*above*), on the porch of his home in Canton, Ohio. During the 1896 election, McKinley campaigned from his porch while his opponent William Jennings Bryan toured the country. McKinley won the elections of 1896 and 1900, but was assassinated in Buffalo, New York.

1845 John Quincy Adams (1767–1848) the sixth President of the United States (*above right*), was the son of the nation's second President, John Adams. From 1817 to 1825 he served as James Monroe's Secretary of State where he formulated the Monroe Doctrine. After being denied reelection, he became the first ex-President to be elected to the Congress.

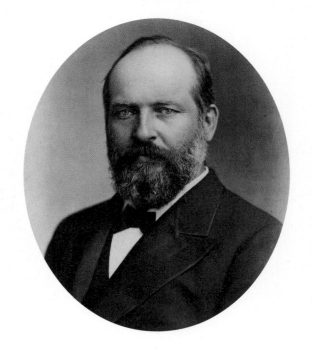

c. 1880 James Abram Garfield (1821–1881), the 20th President of the United States, was a teacher, a lay preacher, a lawyer, and a Republican leader in the U.S. Congress before becoming Chief Executive in 1881. Garfield (*right*) served in the White House for only 199 days before being struck down by an assassin's bullet.

c. 1850 With the outbreak of the War for Texan Independence in 1835, Sam Houston (1793–1863) became commander-in-chief of the Texan army (*far right*). His victory at San Jacinto on April 21, 1836, assured the establishment of the Republic of Texas, which was admitted to the Union in 1845. Houston became one of the state's first senators.

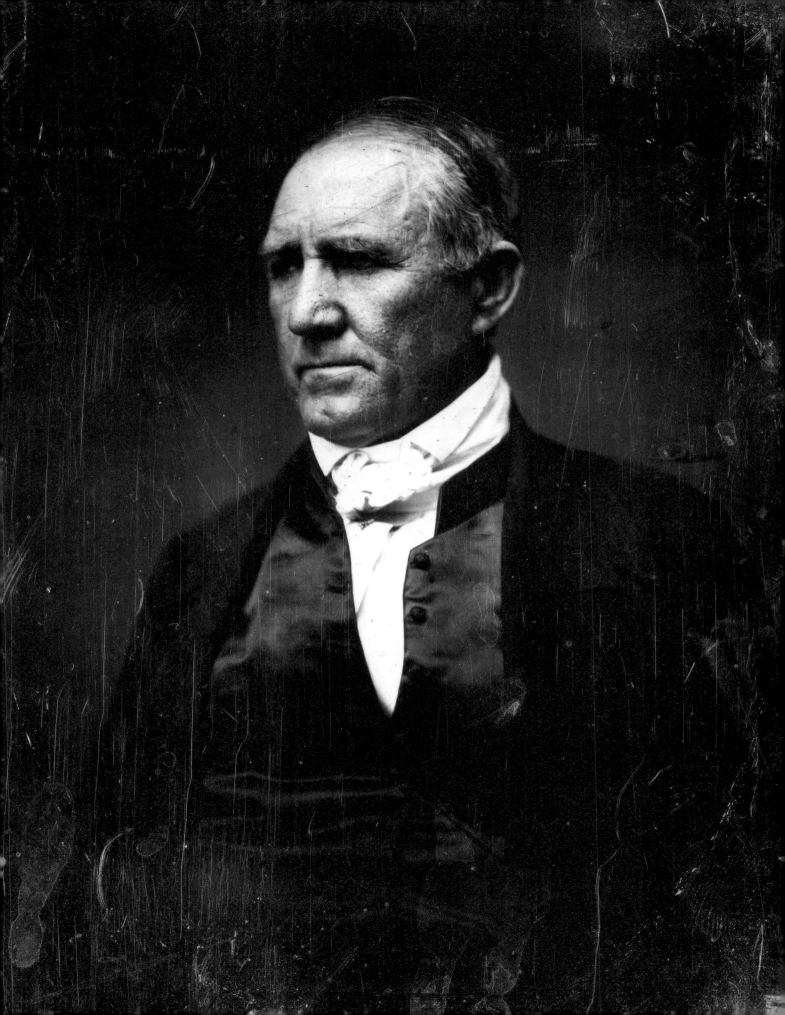

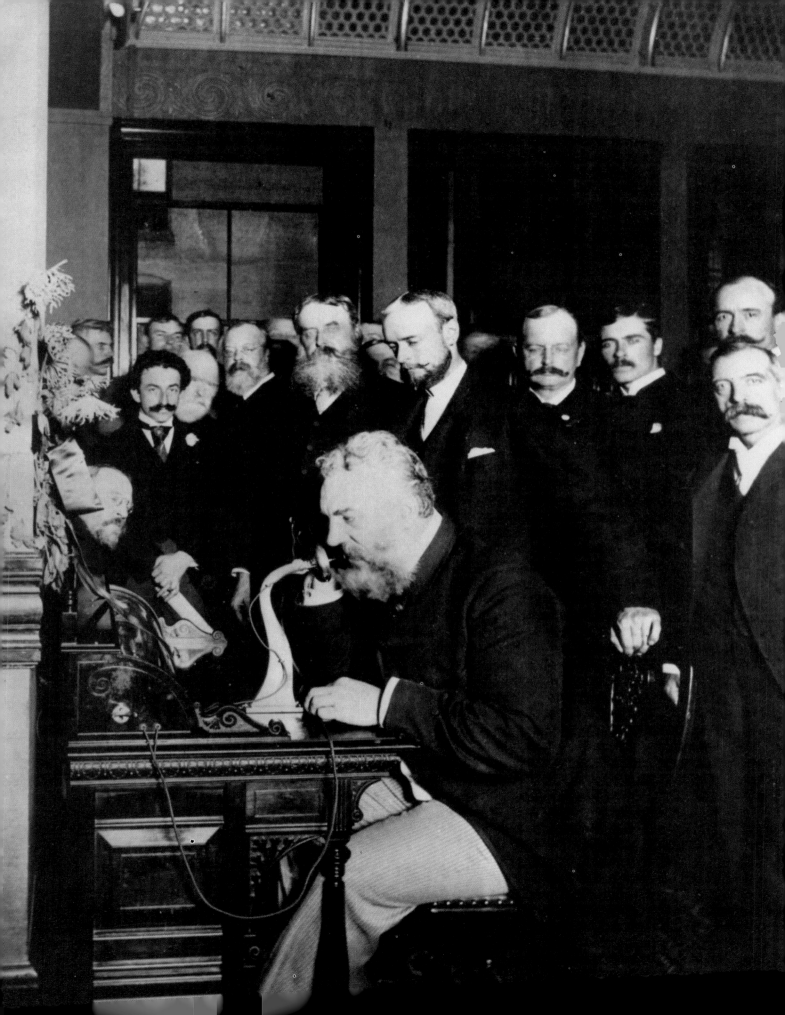

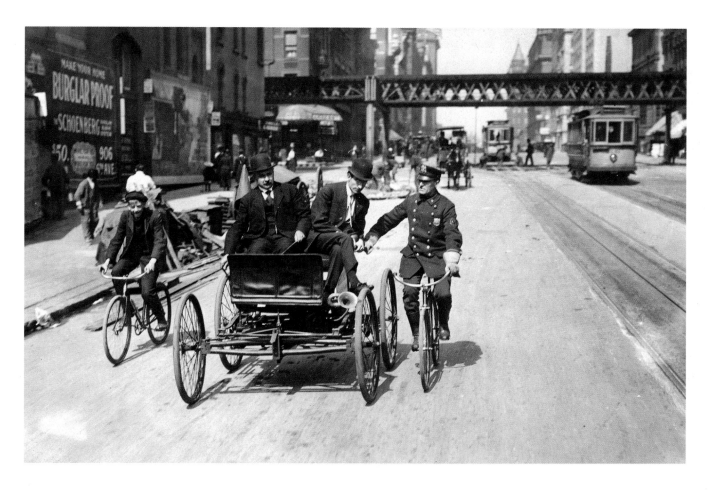

1893 The United States was launched headlong into the automotive age when, beginning in 1891, a number of electrically powered cars made their appearance and became popular with the wealthy. Within a decade, gasoline-powered vehicles were developed. Seen here is one of the earliest of these vehicles invented by Elwood G. Haynes.

1892 Alexander Graham Bell (1847–1922) making the first telephone call from New York to Chicago. Bell, born in Edinburgh, emigrated to America in 1871. In 1873 he became professor of vocal physiology at Boston University, experimenting with various devices for transmitting sound. In 1875, Bell sent the first acoustic message; he patented the telephone the next year and went on to invent the photophone and gramophone.

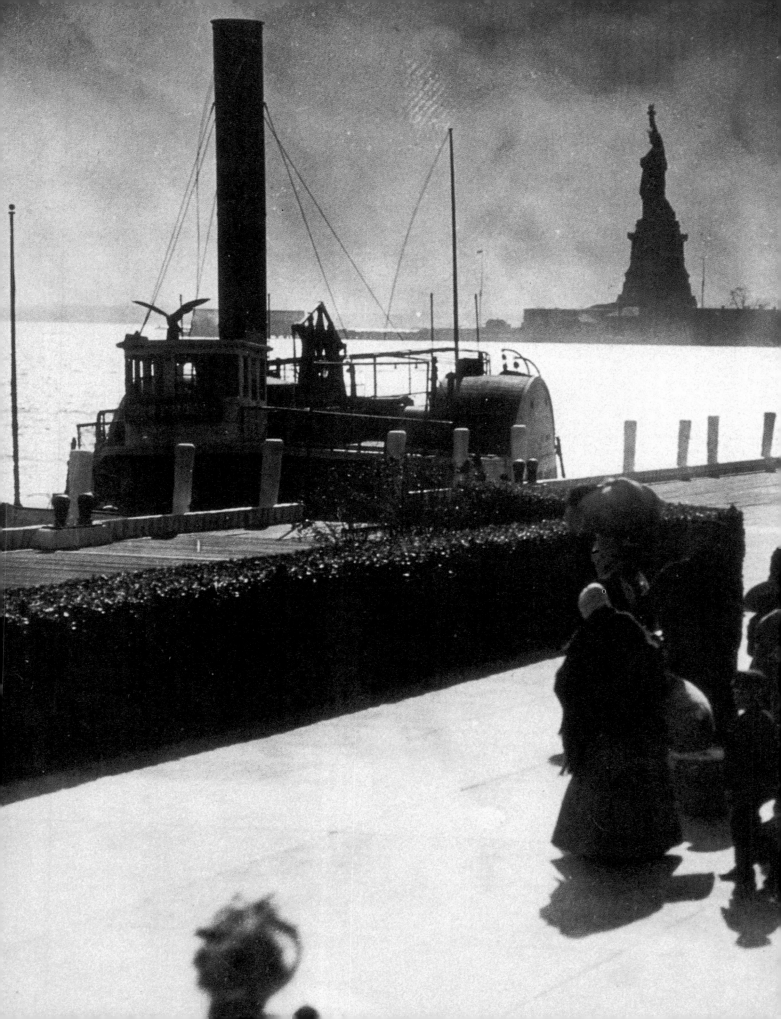

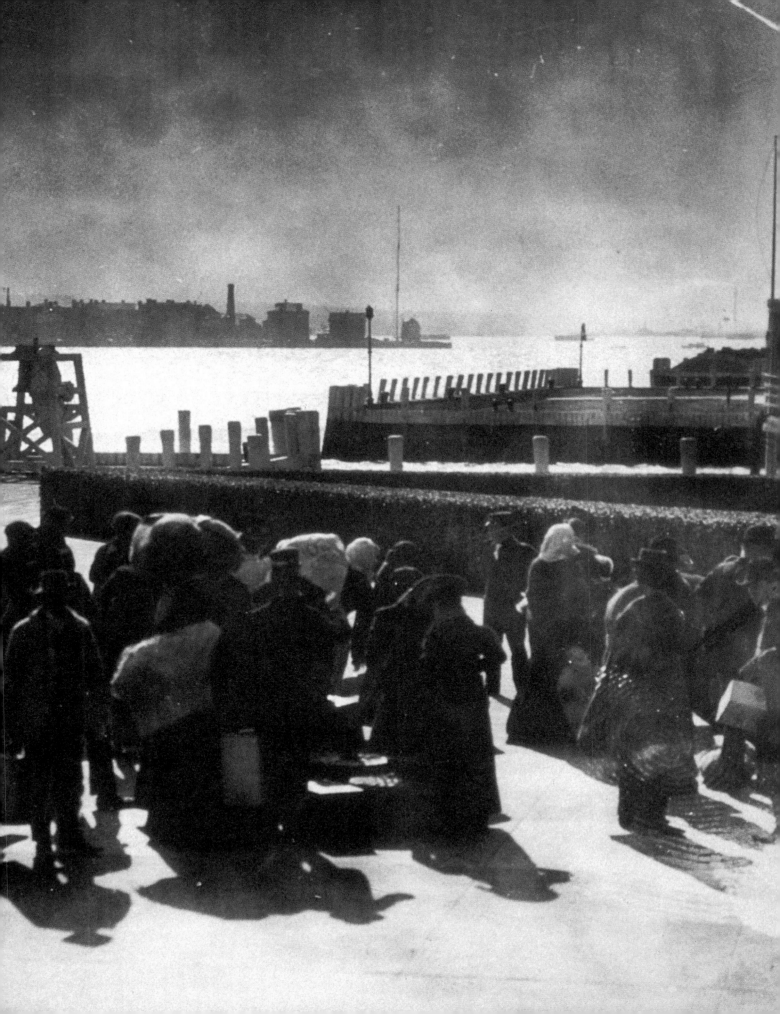

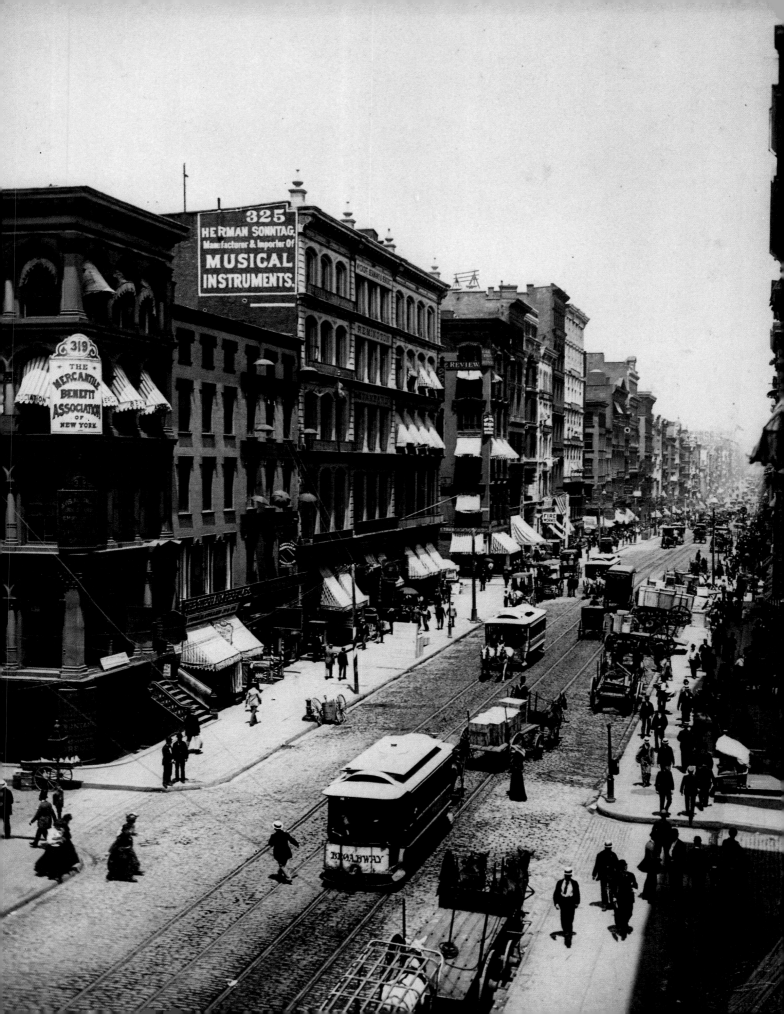

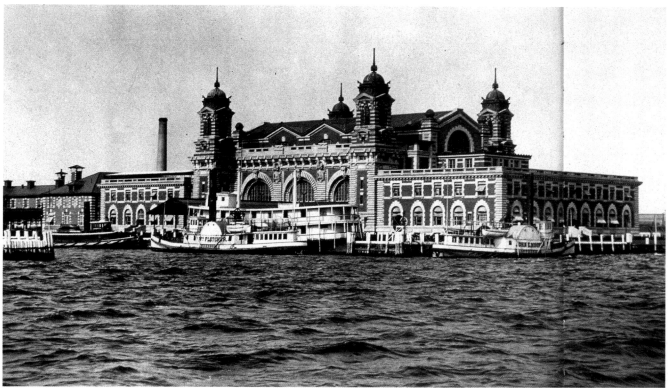

c. 1895 **A view of Ellis Island** in New York Harbor (*above*), run by the United States Immigration Service. Between 1892 and 1920, the busiest years of the facility, more than 20 million newcomers entered America through its doors. Even more than the Statue of Liberty, it became the symbol of immigrant experience.

c. 1890 **Hester Street** in New York's Lower East Side (*right*) was a center of Jewish immigrant life in the late nineteenth century. "They told us," said one immigrant, "that the streets were paved with gold. They weren't even paved, we paved them."

1893 **The electric trolley** (*left*), introduced in America by Frank Sprague in Richmond, Virginia, in 1888, revolutionized urban transportation. Yet when this picture was taken horsedrawn trolleys, known as omnibuses, still traveled the streets of American cities.

c. 1899 **Immigrants arriving** at New York's Ellis Island (*previous pages*); most will build new lives and many will help build America.

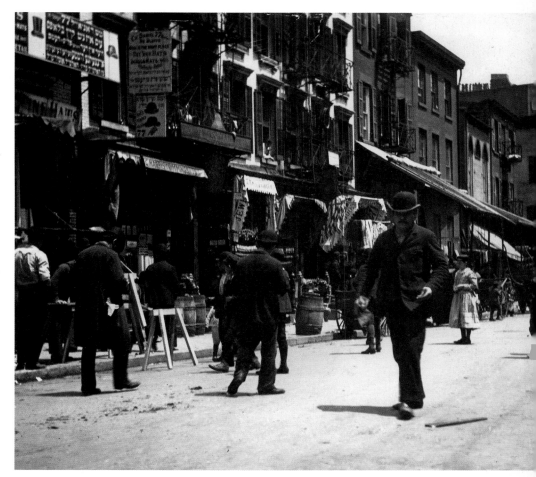

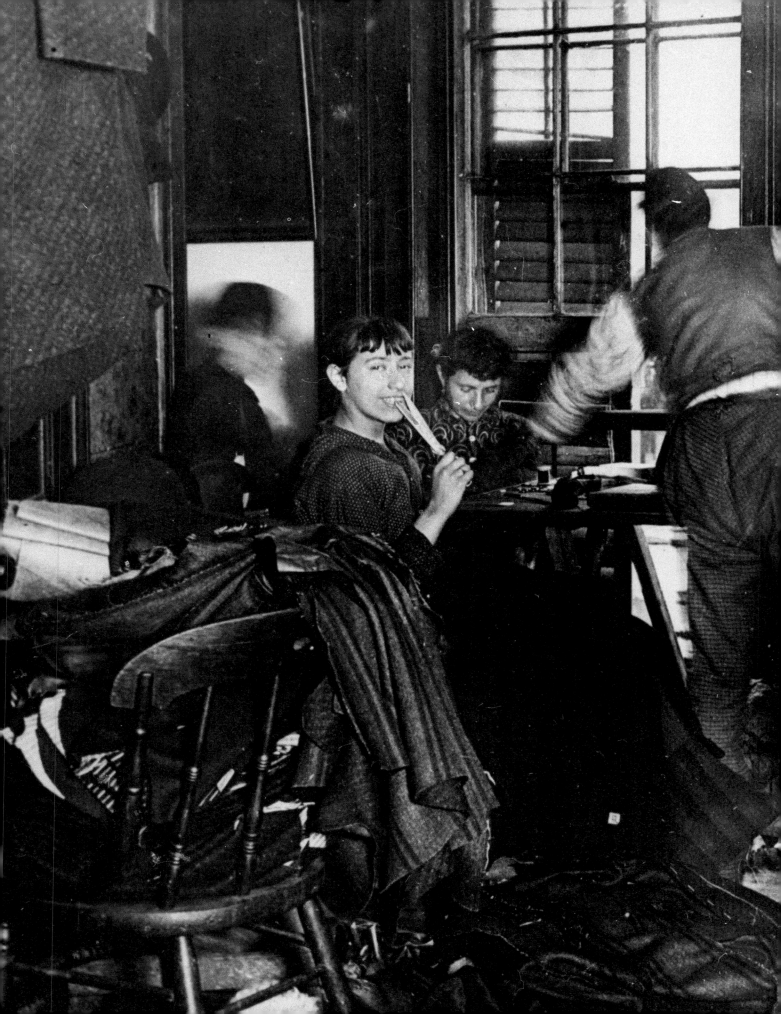

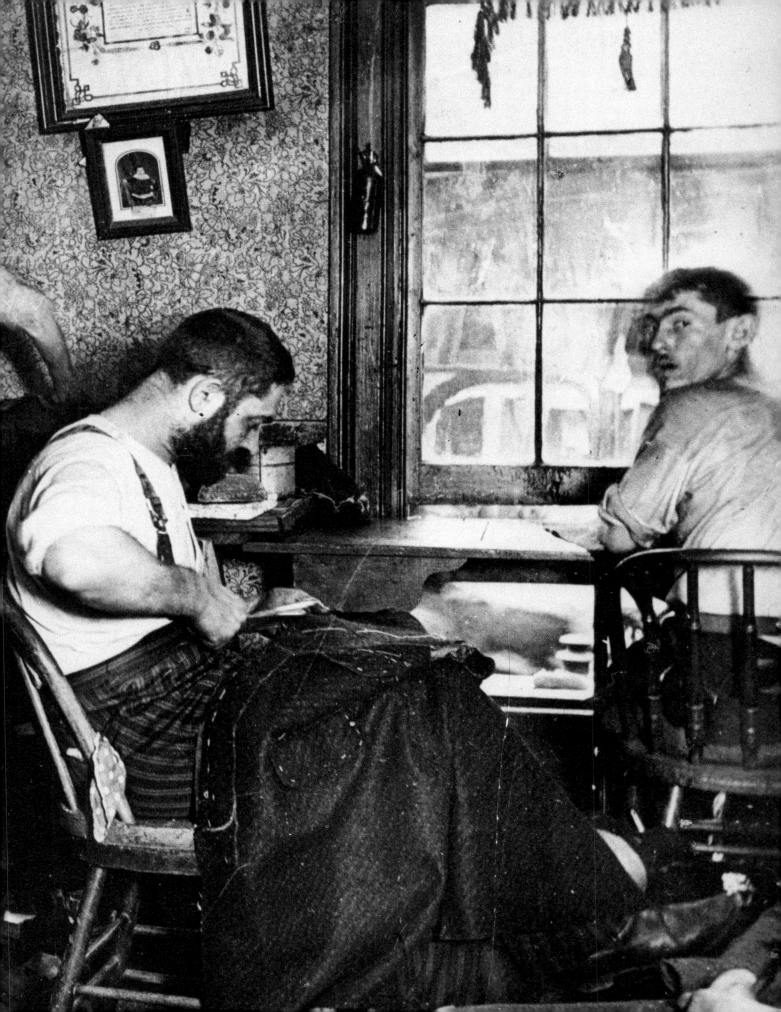

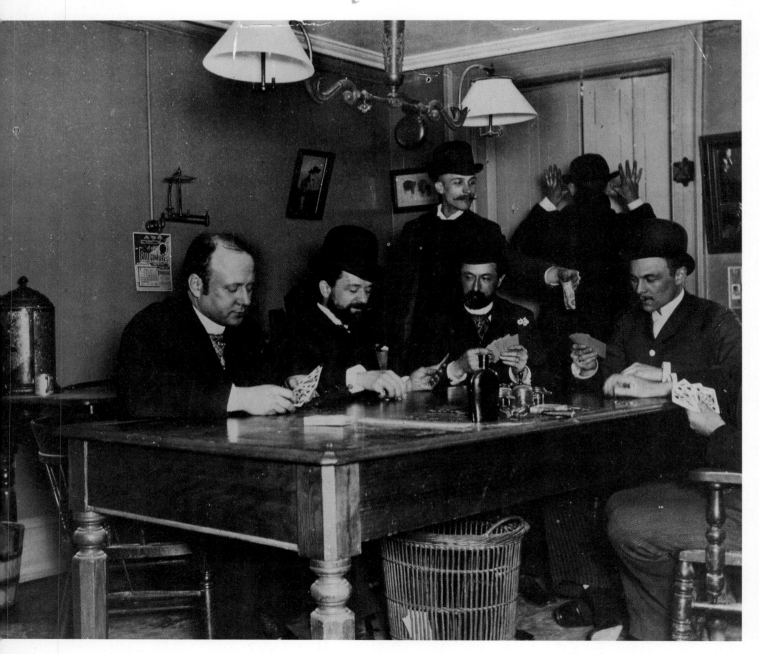

1890 Jacob Riis, an immigrant himself from Denmark, was the premier photographer of New York immigrant life. His most powerful images were those in which he depicted the squalid conditions endured by those who dwelled in the tenements. In a departure from this subject, Riis captured this picture of cardplayers in New York.

1887 Jacob Riis's books and lectures were instrumental in the passage of laws aimed at cleaning up the urban slums in which immigrants lived. This picture of garment workers (*previous pages*) was one of the images Riis used to illustrate his lecture "The Other Half; How It Lives and Dies In New York."

1890 Mulberry Bend on Manhattan's Lower East Side was the home of thousands of Italian immigrants. Scores of pushcarts and markets attracted people from throughout the city.

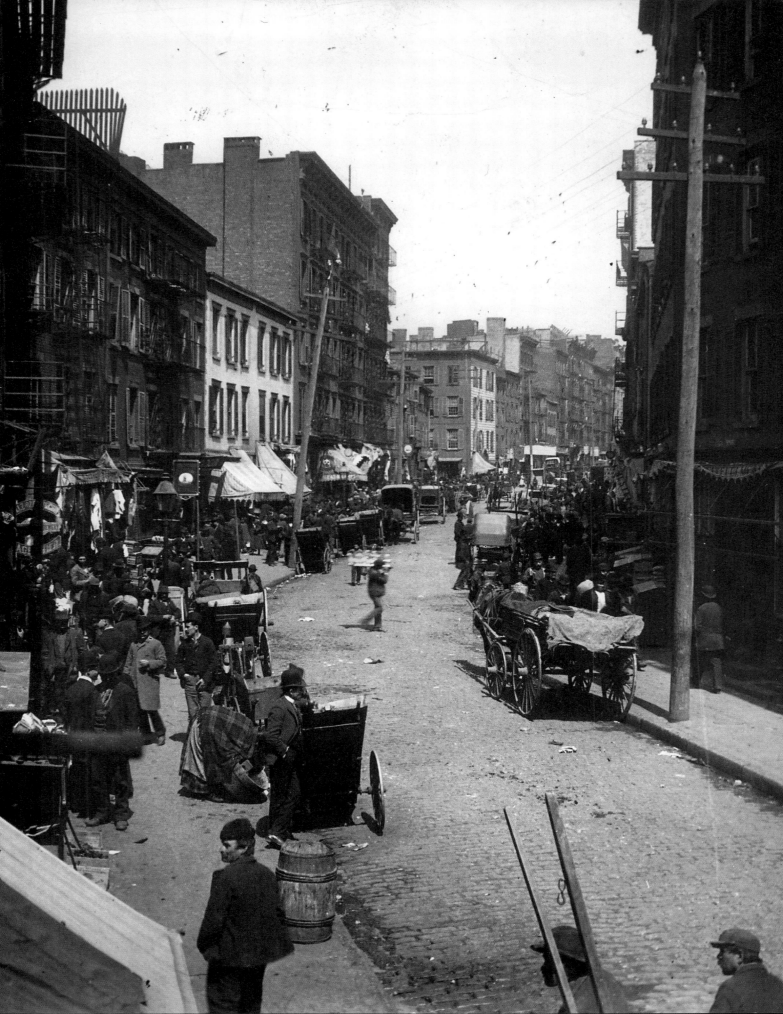

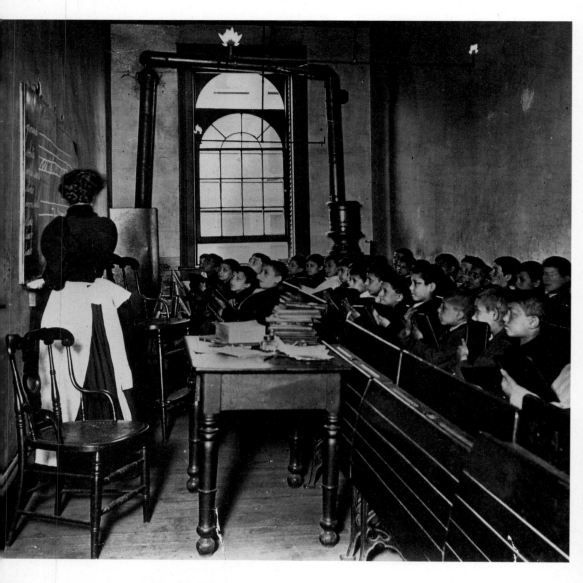

1887 In America, unlike in most countries from which the immigrants had migrated, schooling was free, open to almost everyone. This picture, taken by Jacob Riis in a New York public school, was made possible by Riis's use of the newly developed technique of flash photography.

1887 Life for most immigrants, especially in the teeming American cities, was terribly difficult. But for children in particular there was an avenue to better opportunities. It was through education. In this photograph immigrant children in New York's Mott Street Industrial School salute the flag and recite the Oath of Allegiance to their new country.

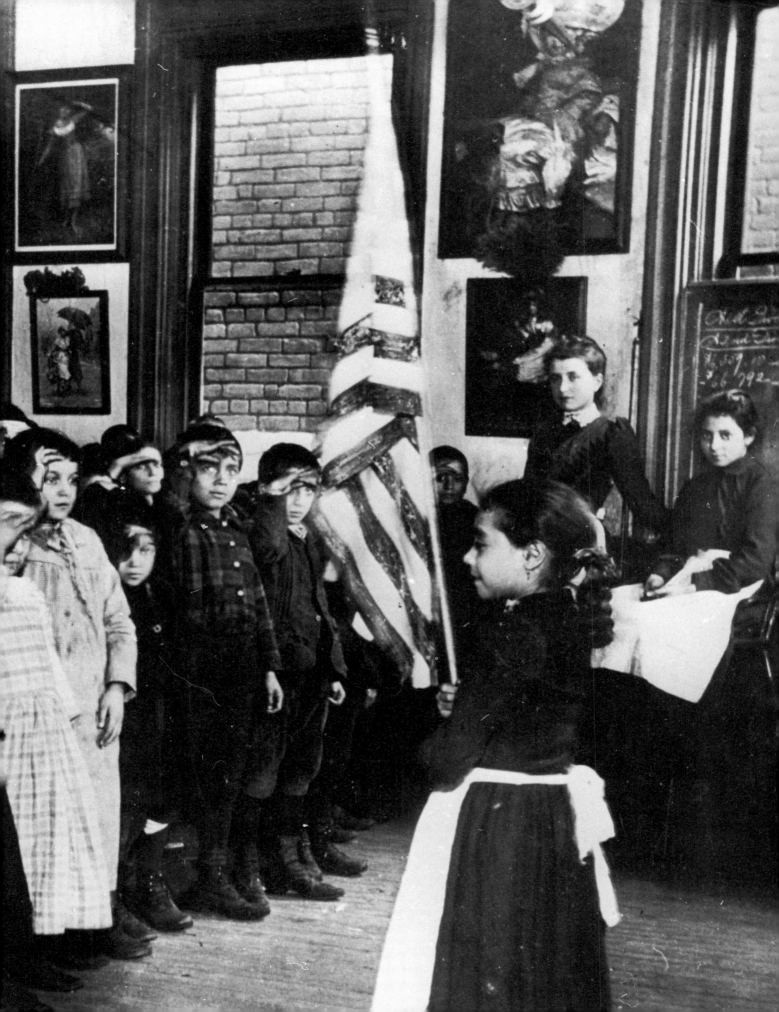

nineteenth century

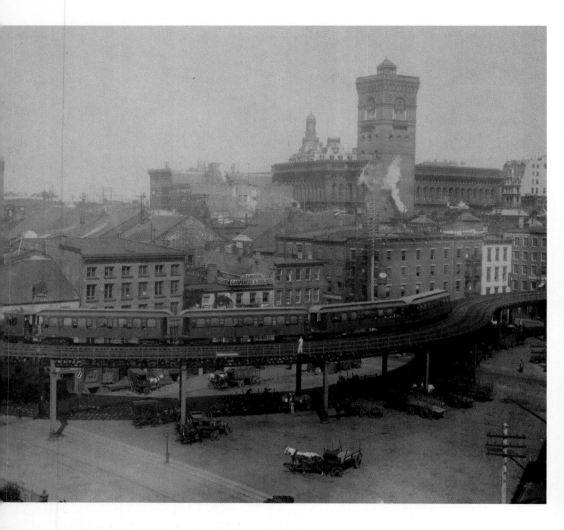

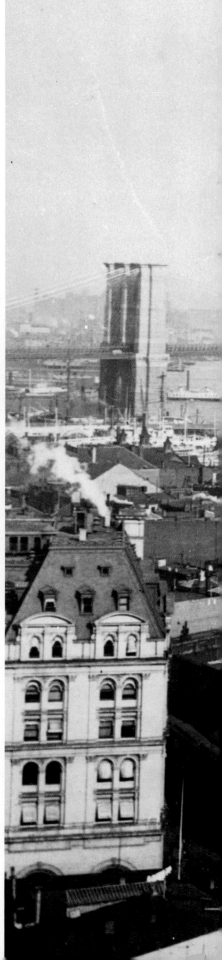

1893 The first elevated railway system in America was established in New York City by Charles Harvey in the late 1860s. By the mid-1880s, tens of thousands of passengers were riding the New York el every day. Motivated by this success, other cities, most notably Boston and Chicago, constructed their own elevated lines.

1893 A view over New York including the Great East River Bridge. The bridge that connected New York to Brooklyn, then the largest and third-largest cities in the United States, was erected between 1869 and 1883. Better known as the Brooklyn Bridge, it was built by John and Augustus Robling and it was the world's longest suspension bridge.

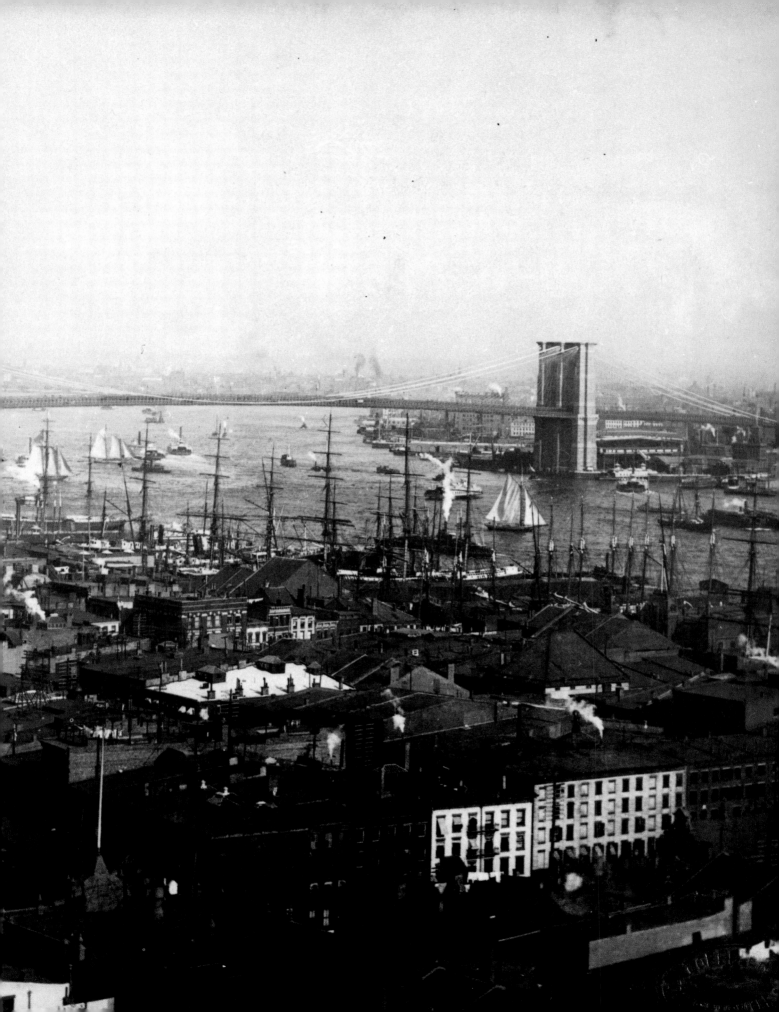

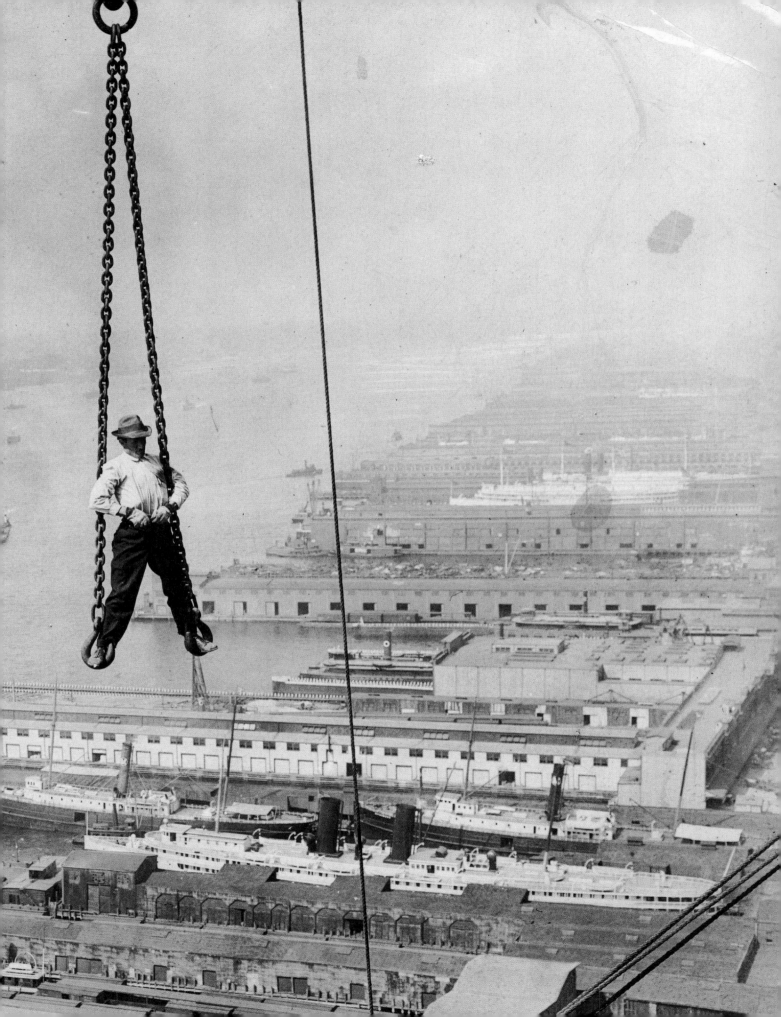

nineteenth century

1859 One of the most popular forms of early photography was the stereograph, which produced pictures in pairs. This image, taken in 1859 by British photographer William England, shows the High Bridge over New York's Harlem River. Designed by American engineer John B. Jervis, it was part of the Croton Aqueduct, which still carries water to New York City.

1859 William England sold thousands of his stereograph cards of American scenes through his London Stereoscopic Company. This is England's image of P. T. Barnum's famed American Museum in New York, which housed such curiosities as a bearded lady, the Quaker Giant, and a family of trained fleas.

c. 1890 As American cities grew in the second half of the 19th century, they expanded vertically as well as horizontally. Here (*previous pages*) a worker is hauled up to the top of a 30-story skyscraper under construction on New York's waterfront.

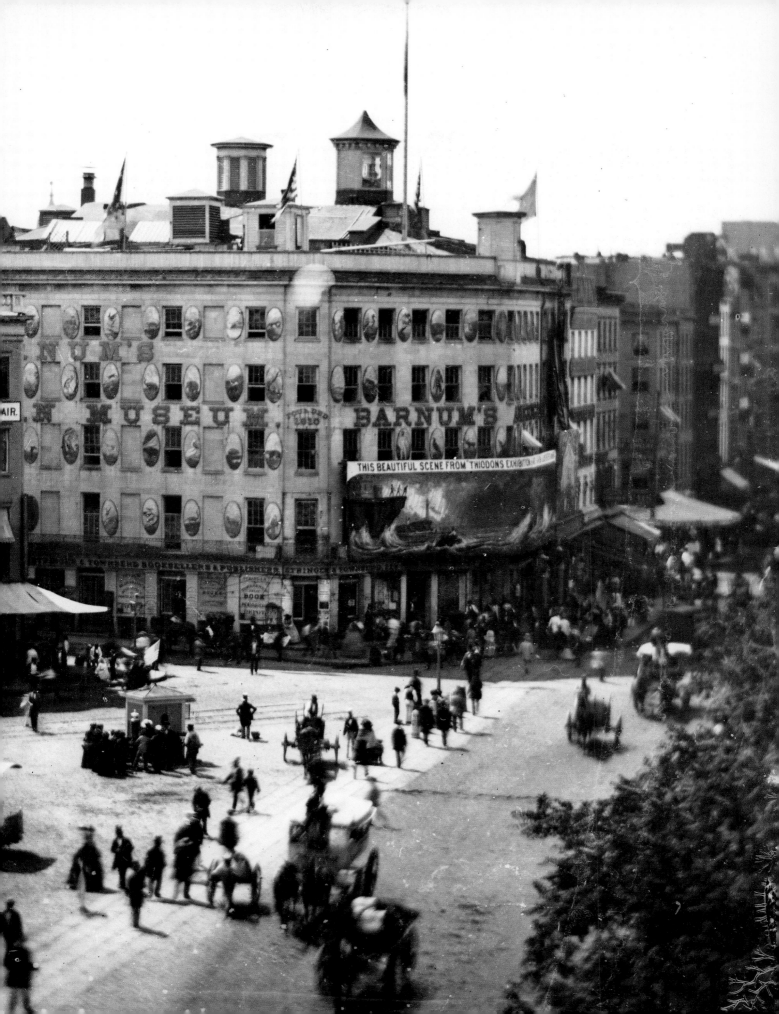

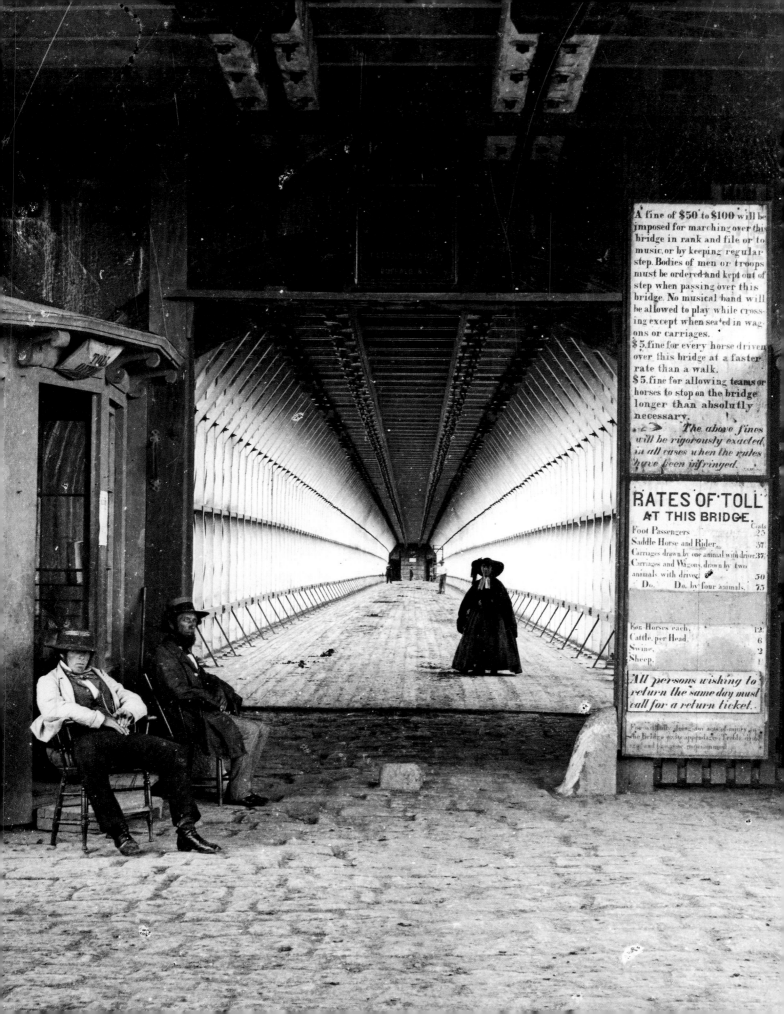

A fine of $50 to $100 will be
imposed for marching over this
bridge in rank and file or to
music, or by keeping regular
step. Bodies of men or troops
must be ordered and kept out of
step when passing over this
bridge. No musical band will
be allowed to play while cross-
ing except when seated in wag-
ons or carriages.
$5 fine for every horse driven
over this bridge at a faster
rate than a walk.
$5 fine for allowing teams or
horses to stop on the bridge
longer than absolutely
necessary.
→ The above fines
will be rigorously exacted
in all cases when the rules
have been infringed.

RATES OF TOLL
AT THIS BRIDGE.

	Cents
Foot Passengers	25
Saddle Horse and Rider	37
Carriages drawn by one animal with driver	37
Carriages and Wagons drawn by two animals with driver	50
Do. Do. by four animals	75
For Horses each,	12
Cattle per Head,	6
Swine,	2
Sheep,	1

All persons wishing to
return the same day must
call for a return ticket.

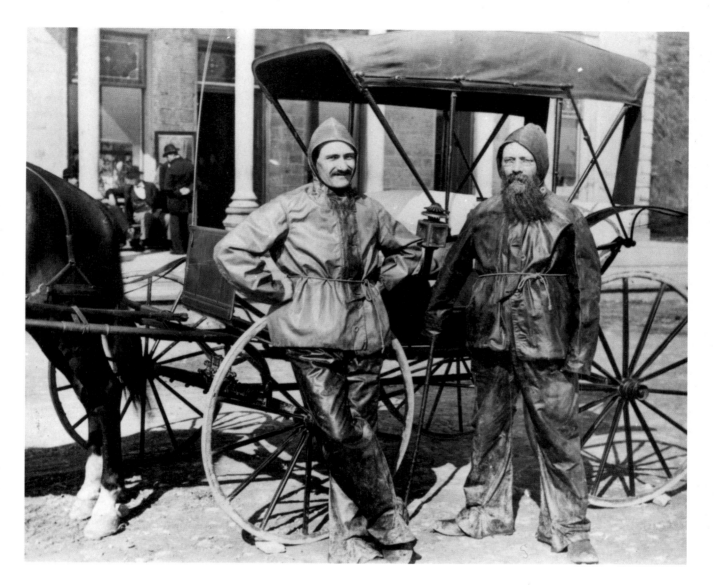

1894 When spectators visited Niagara Falls two things were certain. They would view spectacular scenes – and they would get wet. Here coach drivers who transported visitors to the falls are seen in their protective tarpaulin clothing.

1859 William England captured this striking image of the entrance for foot passengers and horse carriages on the Niagara Suspension Bridge. Above the toll bridge's pathway one can see the underside of the railway tracks that ran along the upper part of the bridge.

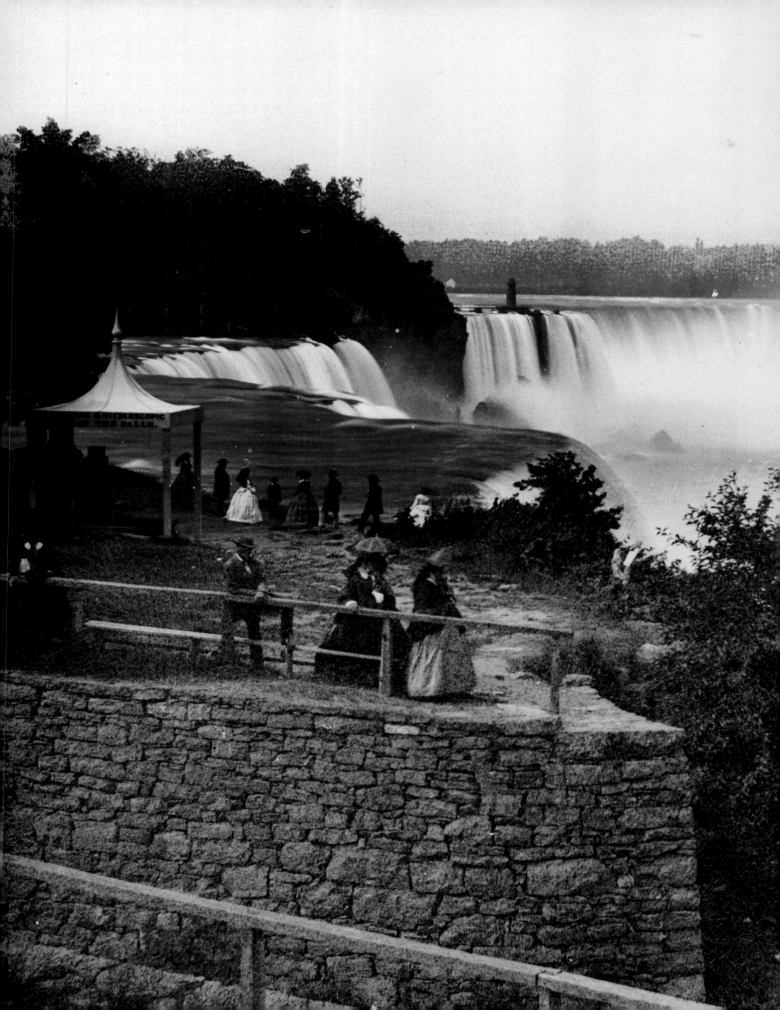

c.1885 Stephen Grover Cleveland (1837–1908) holds a distinct place in the annals of the United States presidency. Elected in 1884, defeated for reelection in 1888, and then reelected in 1892, he is the only president to have served two nonconsecutive terms.

1859 Visitors overlooking Niagara Falls from Prospect Point, on the American bank. The booth advertising "Photographic and Stereographic Views of the Falls" belonged to American photographer Platt D. Babbitt, who held the monopoly on views from this vantage point.

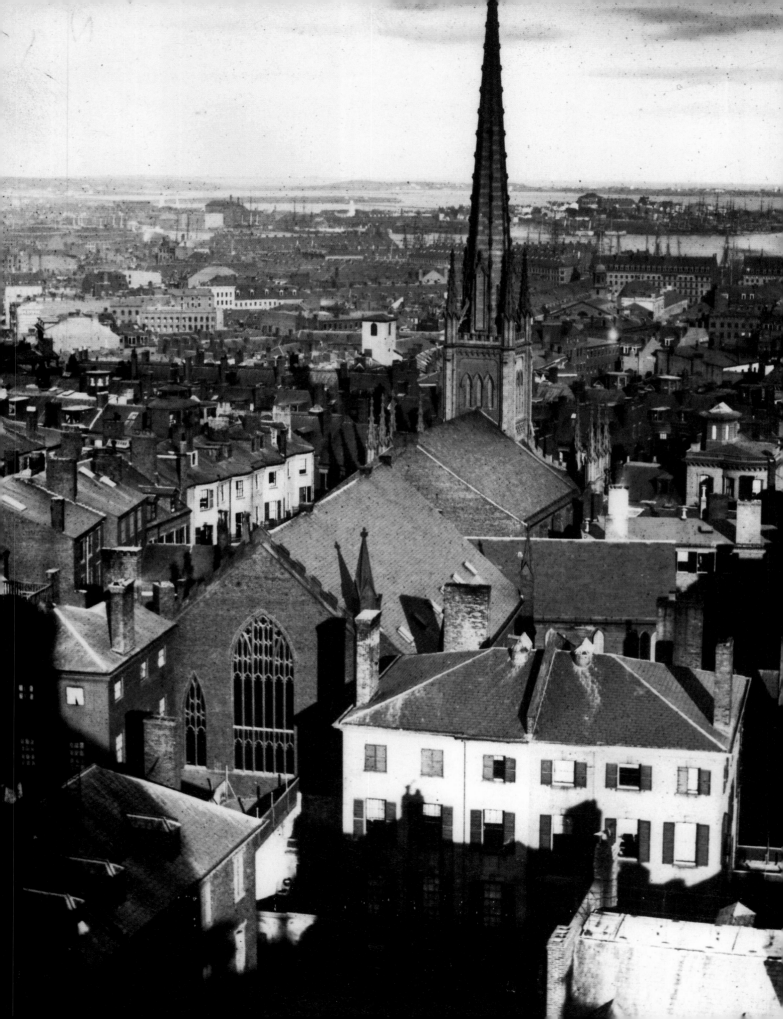

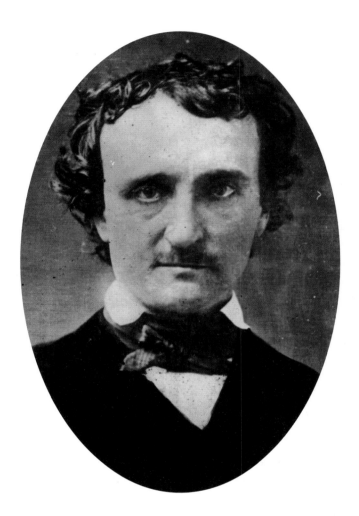

c. 1849 The daguerreotype, the world's first form of pho-
tography, made it possible for the first time people to view
images of the celebrities of their day. Such an image was this
daguerreotype of Edgar Allan Poe (1809–1849), who by the
time the picture was taken had become one of the nation's
most well-known poets and a master of the short story.

1859 One of the favorite tactics of those who captured
stereograph views was to take their pictures from as high up
as they could. This is an 1859 view of Boston as seen looking
east from that city's State House.

nineteenth century

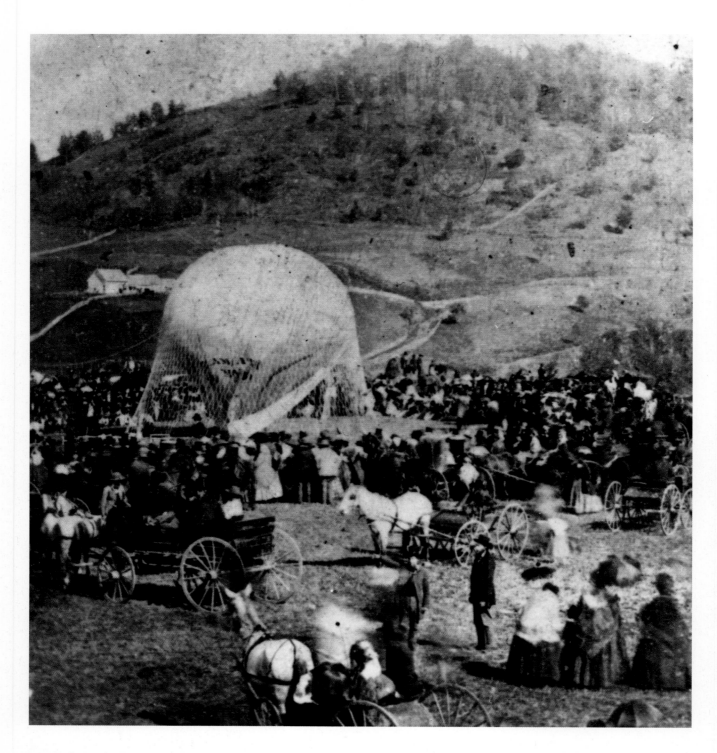

1890 The most famous aeronaut of the 19th century was Professor John Wise, who successfully accomplished countless balloon flights. On the first leg of a projected Trans-Atlantic voyage in 1859, Wise soared over 800 miles in less than 24 hours, an air-travel record that was not broken until 1910. Here Wise inflates his balloon before an admiring crowd at St. Johnsbury, Vermont.

1890 The growth of American cities in the last half of the 19th century was nothing short of phenomenal. In 1860 only about one American in four lived in a city. By 1890 one in three were urban dwellers, and by 1910 nearly half of all Americans lived in a city. This photograph shows Chestnut Street in Philadelphia.

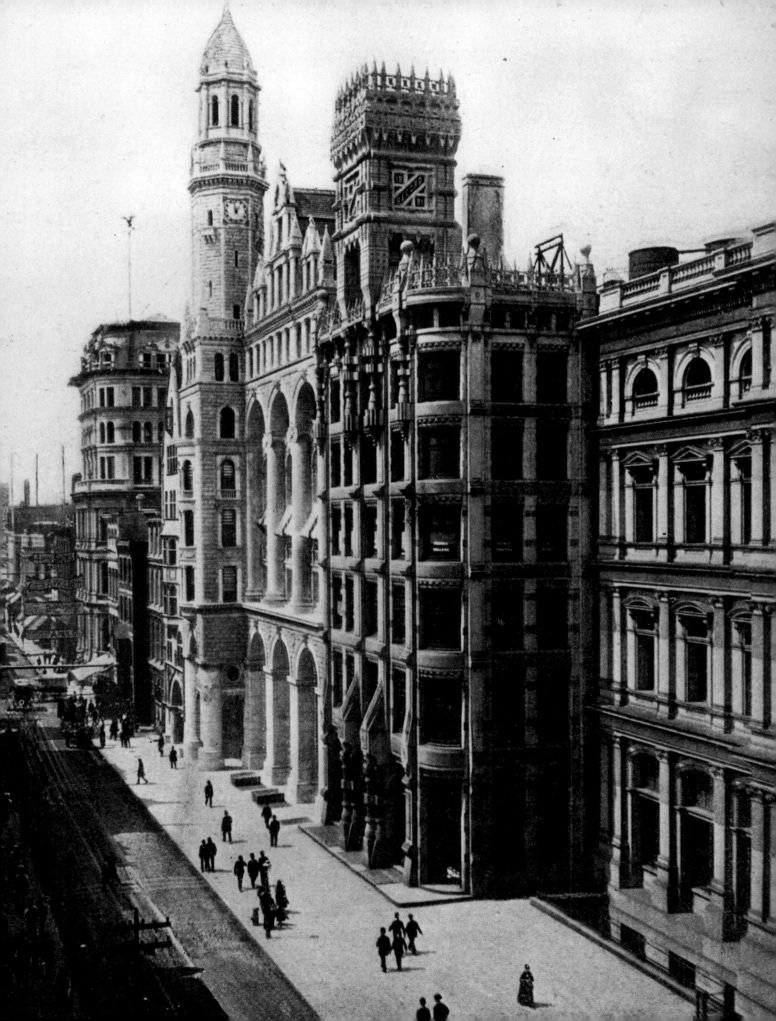

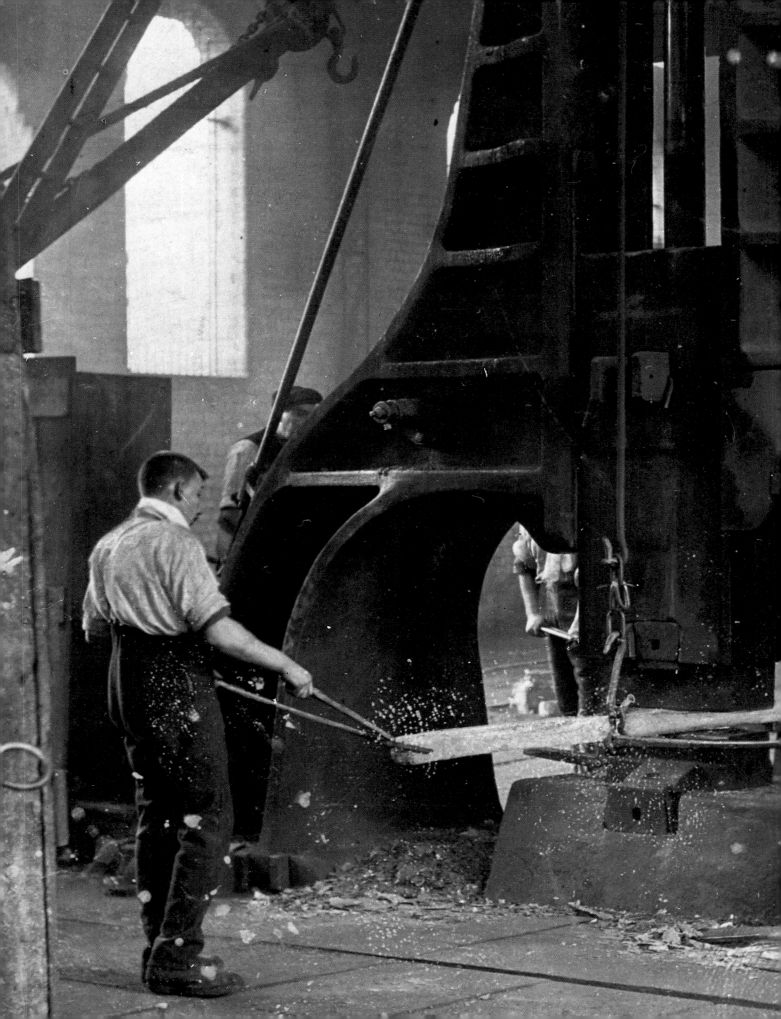

Also available from

WF Waldrip

Vincent R. Mayr

☆☆☆☆☆ **Lyman Henry at it Again**
Reviewed in the United States us on February 27, 2022
Verified Purchase

What a wonderful reappearance by Lyman Henry and his associates. Entertaining and exciting! W. F. Waldrip has once again expounded his literary wit to entertain and enrich our lives. Wonderful story by a wonderful author.

Find more at www.amazon.com

Made in the USA
Las Vegas, NV
23 January 2024

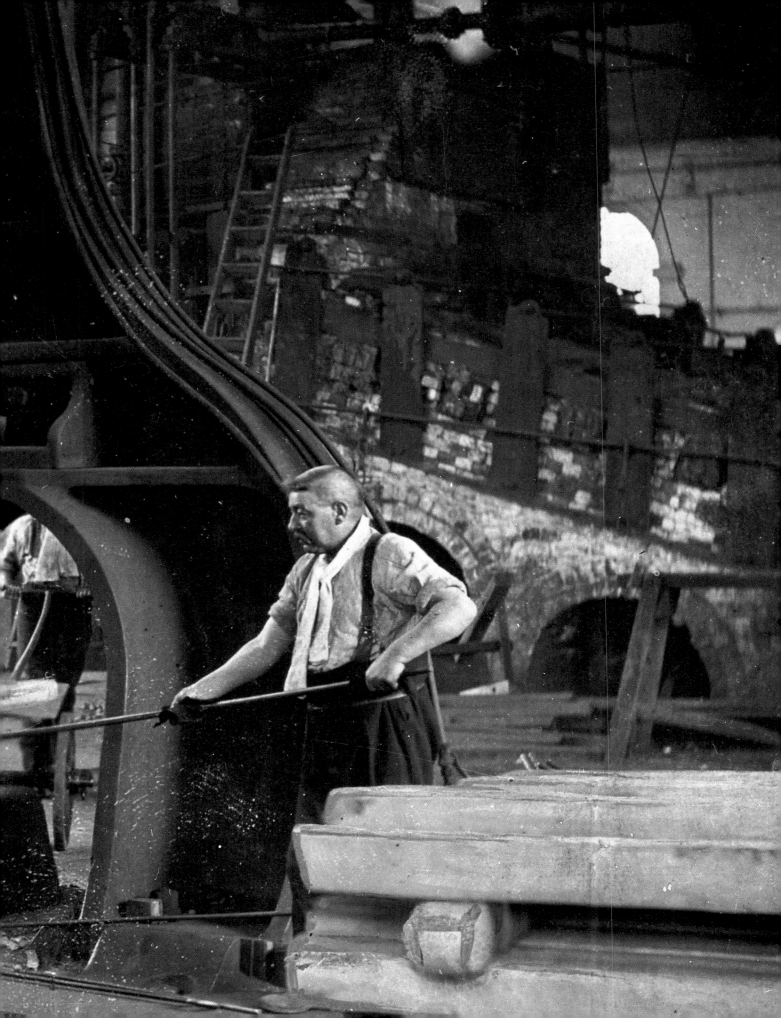

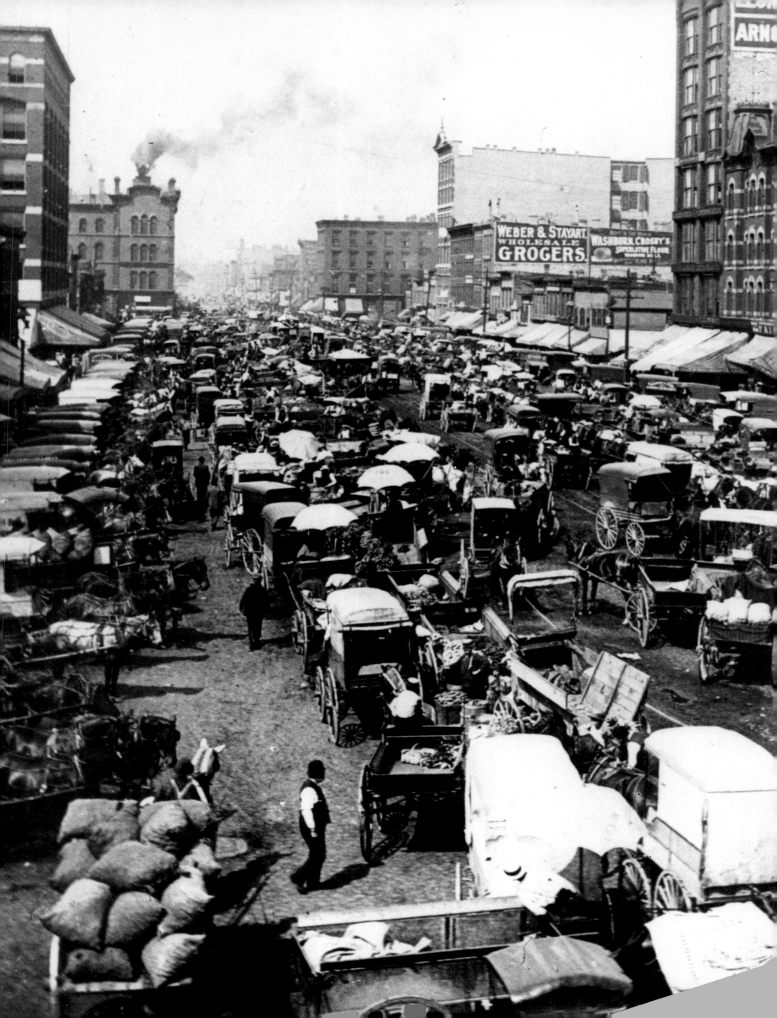

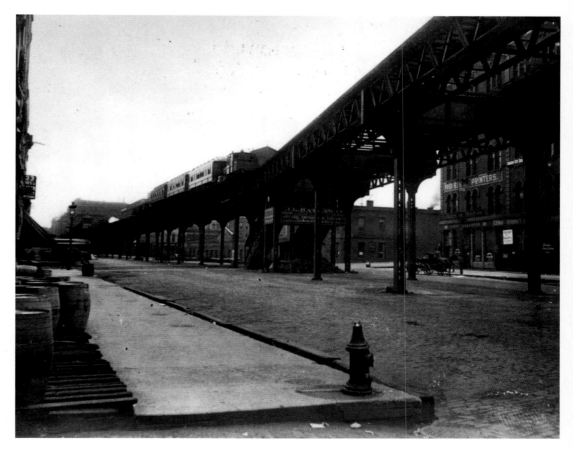

1895 Elevated railways, like this one running above Market Street in Chicago, were built to alleviate the noise and congestion of the streets beneath them. But the noise from the cars rattling across the overhead rails created an even greater racket and the structures themselves turned the streets below them into dark and foreboding areas. Yet it was not until fairly recent times that many cities began to remove their els.

1860 Despite continued advancements in transportation, America – until well into the 19th century – was still a nation in which people and goods moved primarily by horse. This is a scene in Chicago's Haymarket district.

1895 The manufacture of steel was at the heart of the revolution, which, in the 19th century, made the United States the industrial leader of the world. Here, steel workers in Pittsburgh (*previous pages*) are seen at a Bessemer converter that forced a blast of air through molten iron, removing most of the impurities from the metal.

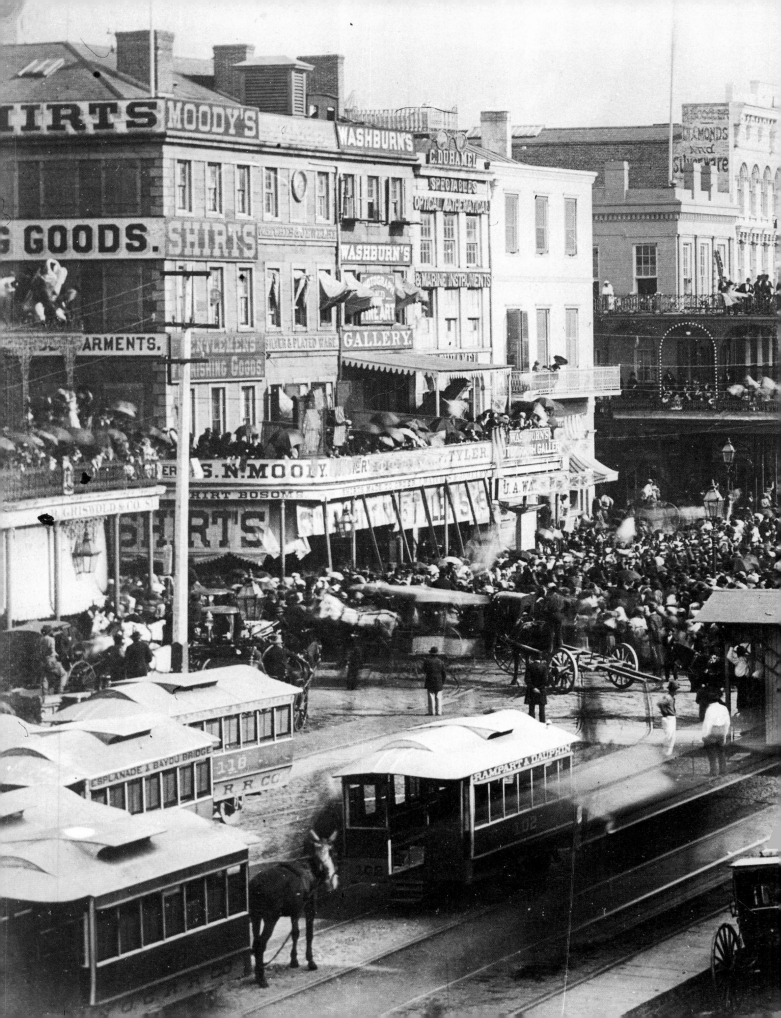

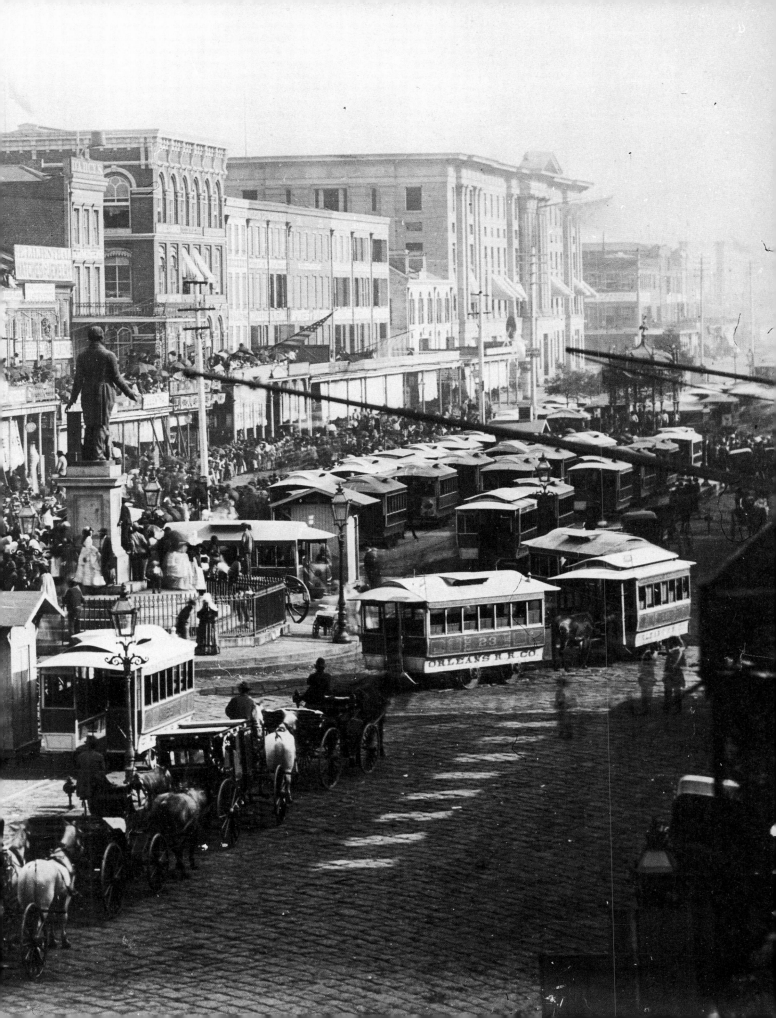

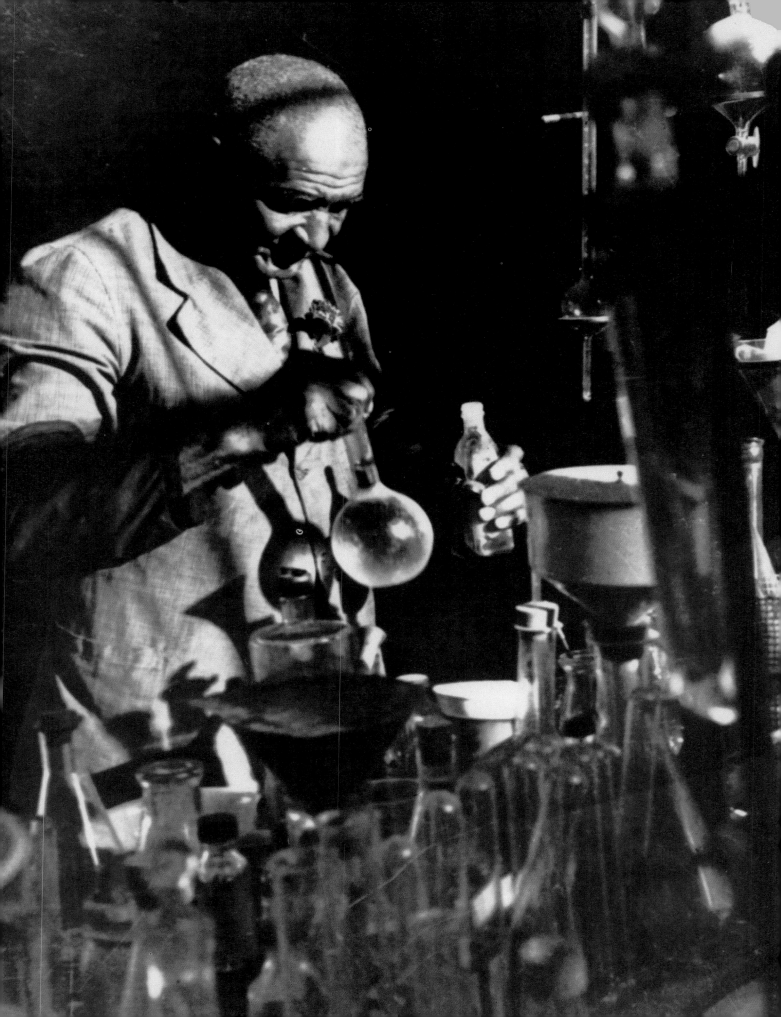

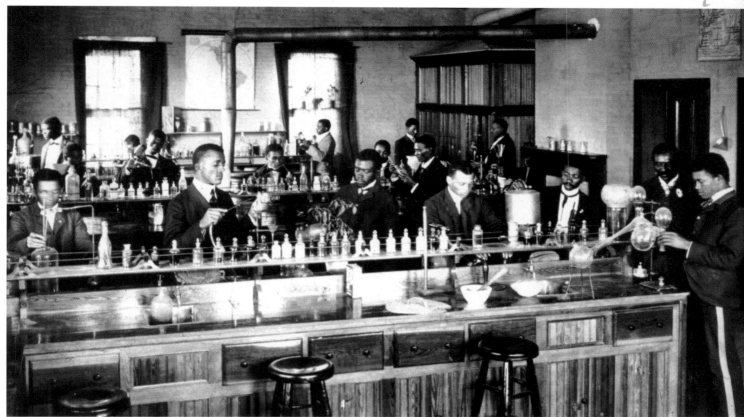

1884 Founded in 1881, Alabama's Tuskegee Institute (*above*) was established to train black students, many of whose parents and grandparents had been slaves. This photograph was taken by Frances Benjamin Johnston, who compiled a powerful visual record of young African-Americans seeking to better their lives.

1896 George Washington Carver (1861–1943) was born a slave in Missouri during the Civil War (*left*). He became a leading agricultural scientist of his day and won world renown for his discovery of hundreds of industrial and commercial uses of the peanut. As a member of the faculty at Tuskegee Institute, he trained scores of future black scientists.

c. 1870 During the Reconstruction Era following the Civil War, African-Americans, for the first time, were elected to Congress. Mississippian Hiram R. Revels (1822–1901) was the son of free blacks who sent him to college in the North (*right*). A former Union Army chaplain, he became the first African-American to serve in the United States Senate.

c. 1870 From almost the birth of the nation, New Orleans (*previous pages*) had been the terminus of the teeming traffic of both people and goods that flowed down the Mississippi River and its tributaries. By 1870 the city had become not only a major port, but was well on its way to becoming a thriving metropolis.

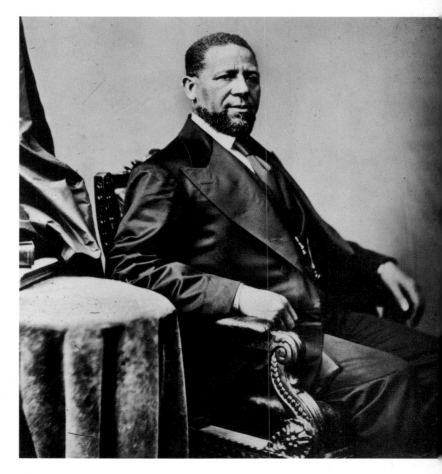

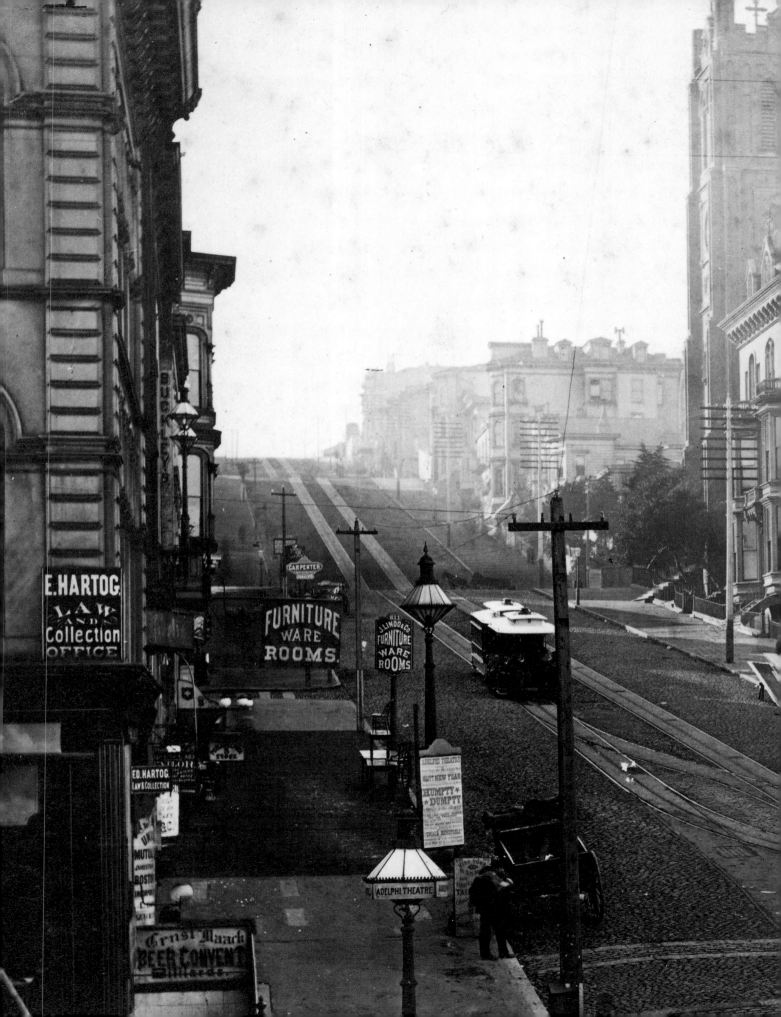

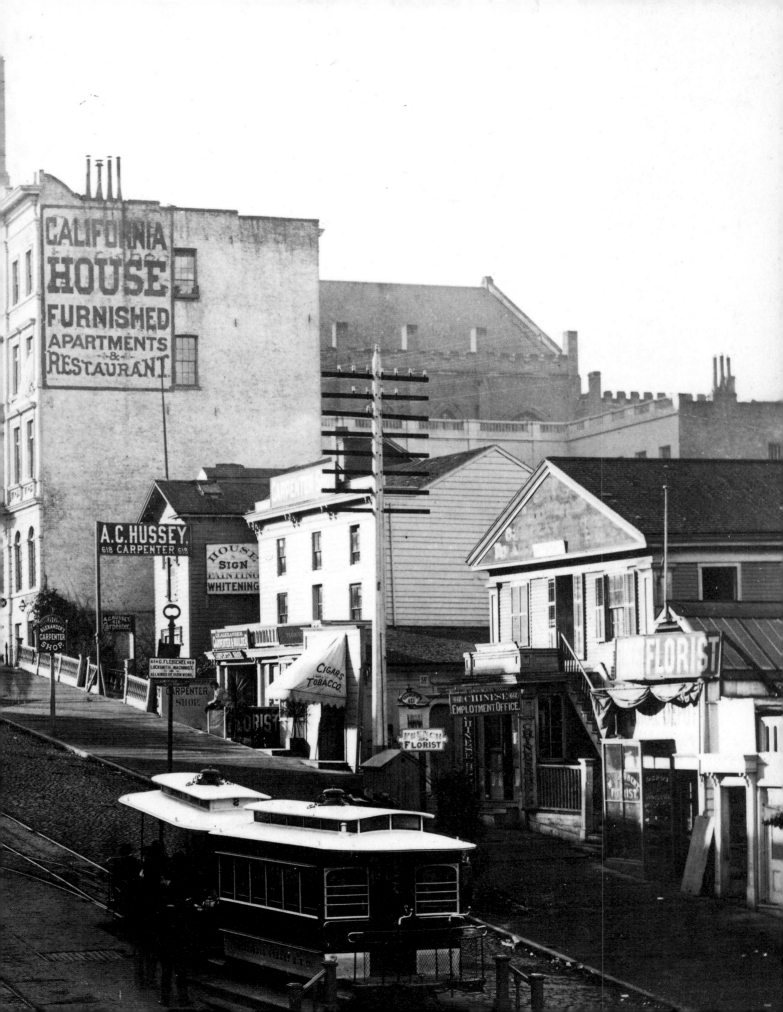

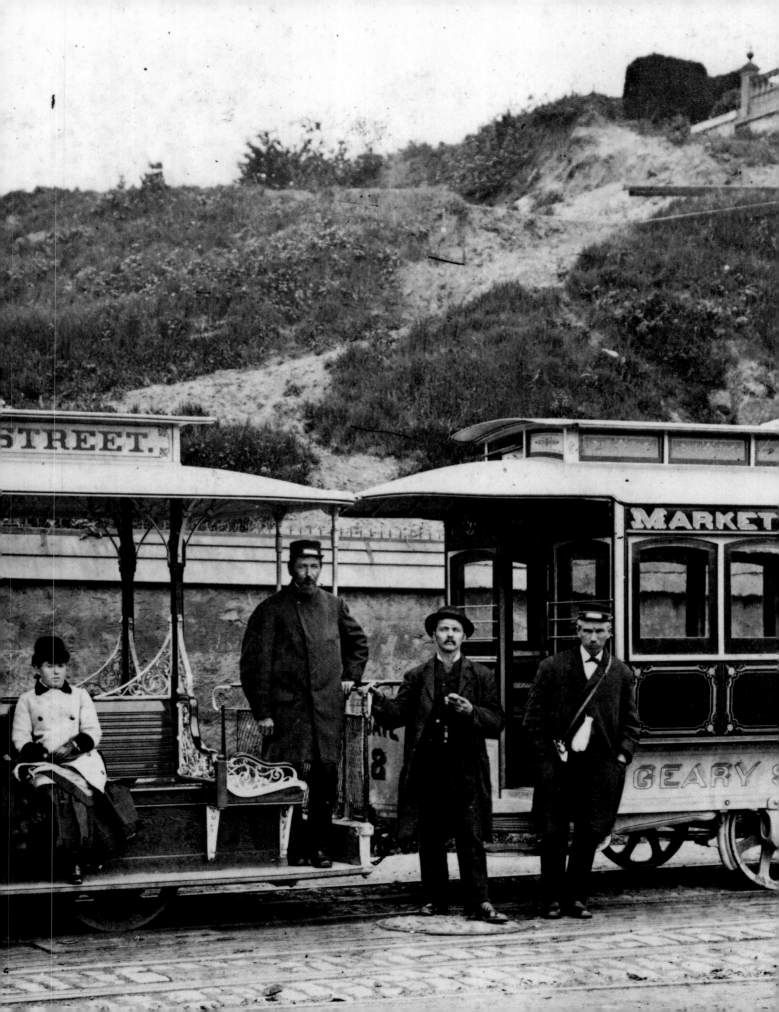

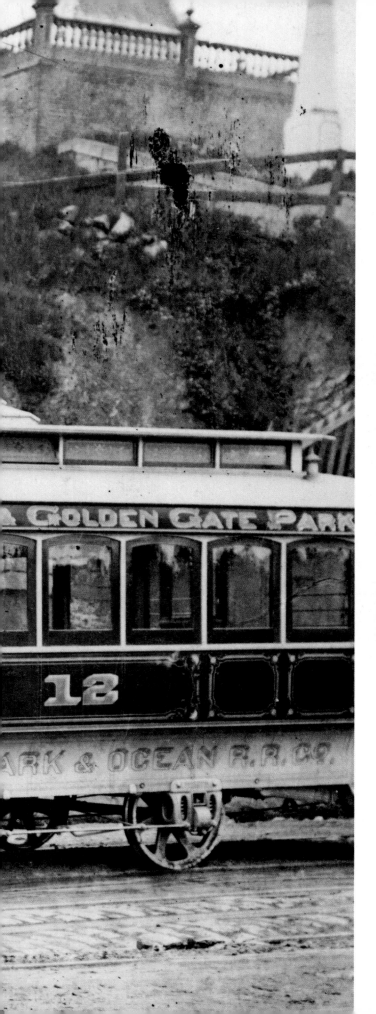

1890 The first Chinese came to California in great numbers during the 1850s, looking for gold. Legally banned from panning, many went to work laying tracks for the transcontinental railroad. By 1890 more than 25,000 Chinese lived in San Francisco's Chinatown.

c. 1890 In 1873, Andrew Hallidie, a manufacturer of steel cables, introduced his cable railway in San Francisco. The man standing at the rear of the first car in this picture was the "gripman" who snared or released the moving underground cable, allowing the cars to stop and start and to move along at a desired speed.

c. 1890 In 1776 a Spanish mission and fort were established on a peninsula on the south side of the Golden Gate Strait (*previous pages*). The tiny village that surrounded the mission was called Yerba Buena. In 1846 the name was changed to San Francisco. Two years later gold was discovered. By 1850, San Francisco's population had exploded from about 800 to more than 25,000!

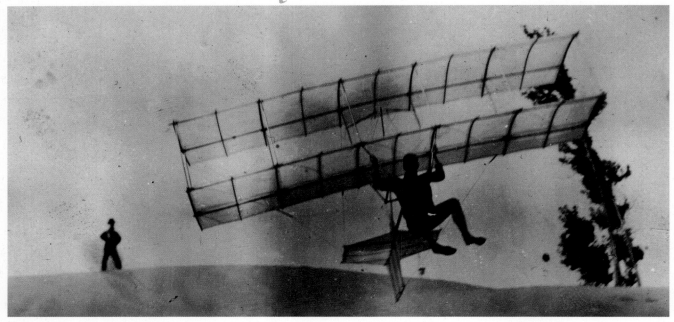

1896 Americans were not to be deterred in their quest for flight. Typical of those who were determined to conquer the air was Augustus Moore Herring, seen here conducting an 1896 glider experiment.

c. 1890 In early America indoor bathing was reguarded as a health hazard. By the 1890s, however, attitudes had changed and "taking the waters" became viewed as a healthy activity. This was the bathhouse at San Francisco's Hotel del Monte.

c. 1870 A horse–drawn cart passing through a section cut out of the base of a giant sequoia tree (*right*) in the Marposa groves of Yosemite Park, California.

c. 1895 Here, the American explorer and army officer General John Charles Fremont, his family, and their friends form a circle demonstrating the circumference of one of the trees in the Santa Cruz Grove of Big Trees (*following pages*).

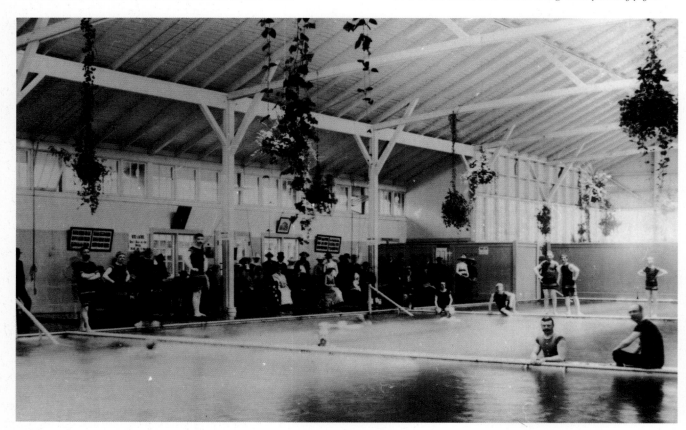

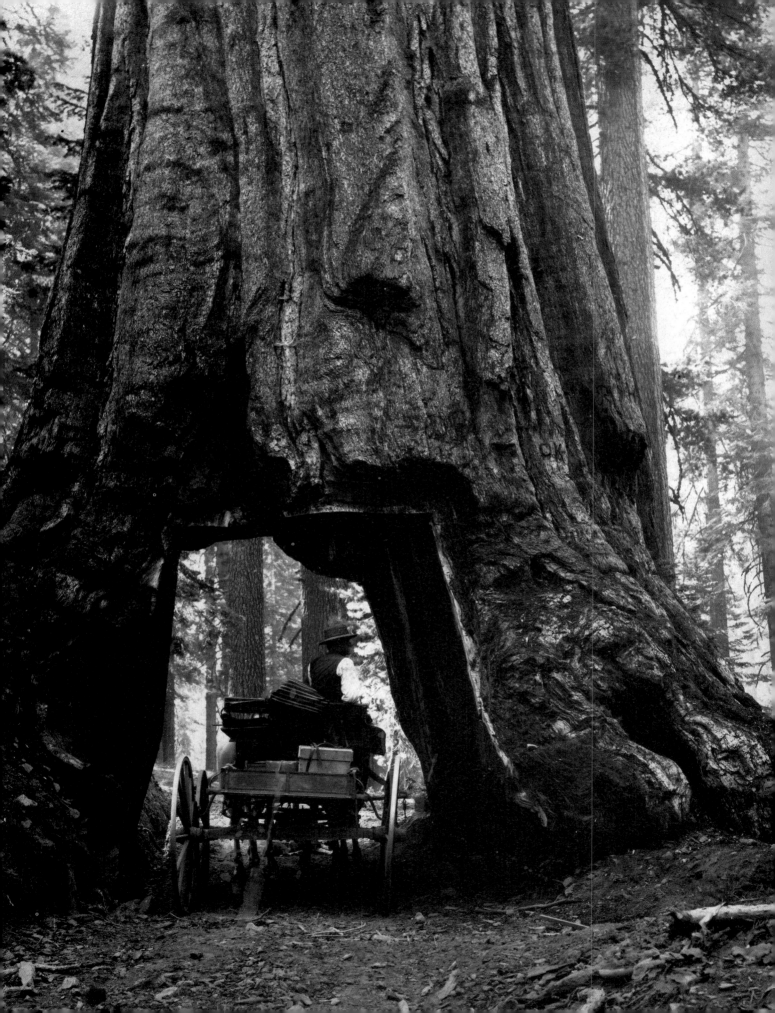

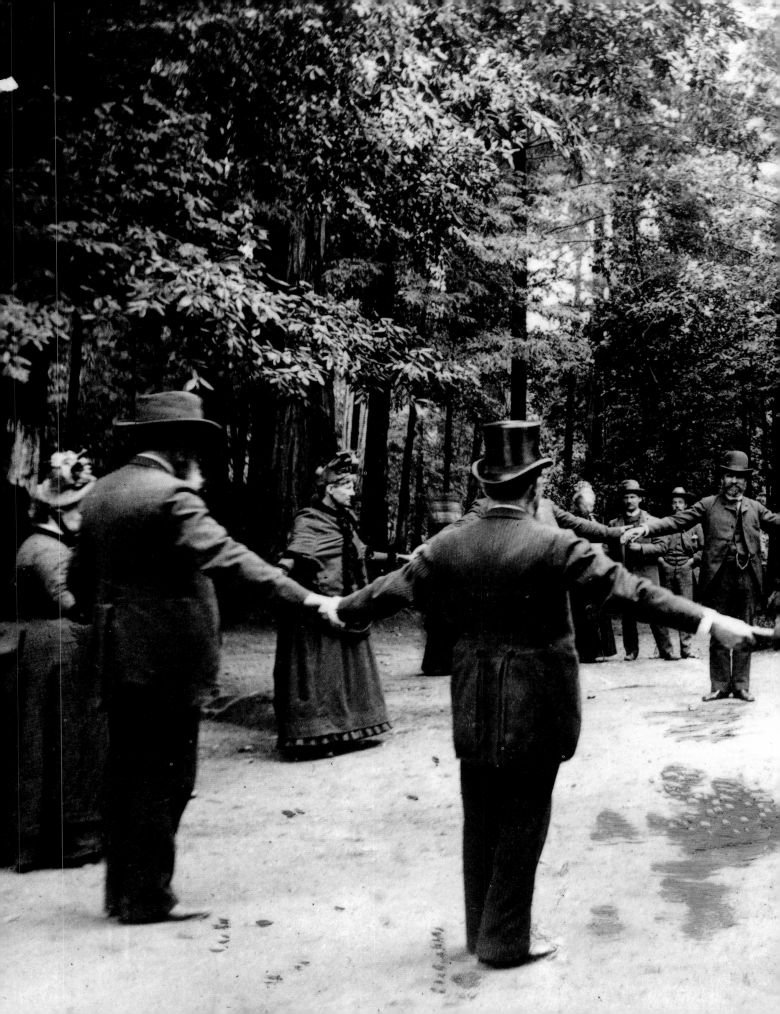

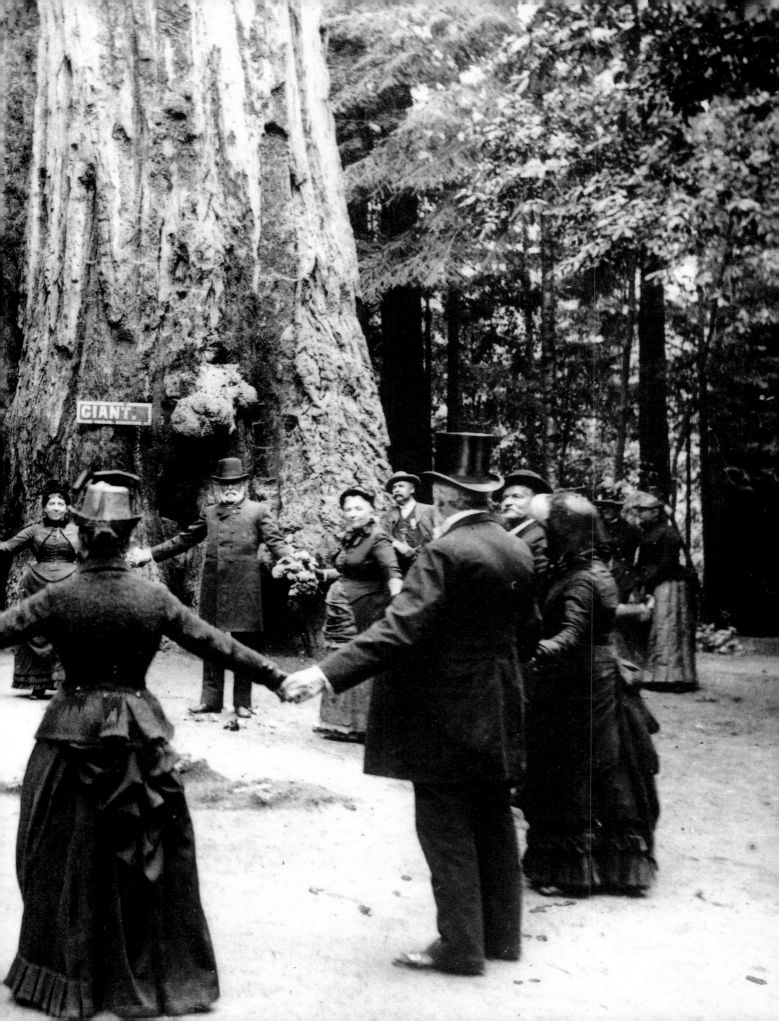

1900s

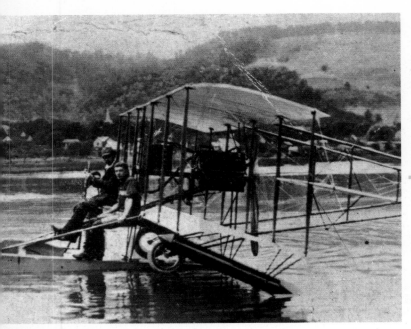

c. 1909 Glenn Curtiss was one of America's most important pioneer aviator and holder of several early airspeed records. In this photograph Curtiss is shown seated at the controls of a seaplane he invented and flew successfully.

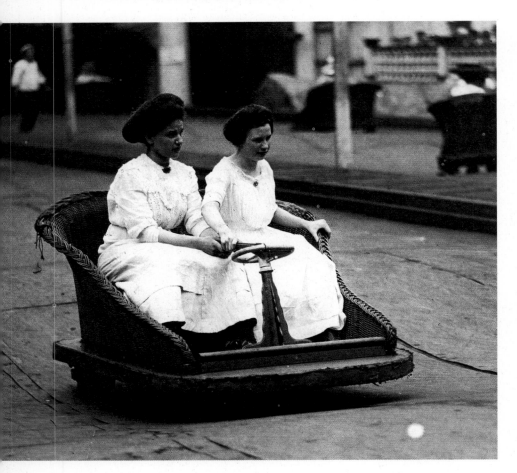

In the first decade of the brand new century immigration to America reached full flower. Many of the newcomers would go to work in factories, helping turn the nation into the industrial power of the world. It was a decade marked also by the continued transformation of what had long been a country of small towns and villages. By decade's end, almost half of all Americans lived in the city.

It was a period in which the rich got even wealthier and ordinary Americans, released from 12-hour working days, finally learned to play. Much of this play centered around the automobile, as Fords and dozens of other makes began to clog the nation's still unpaved roads. Perhaps the decade's defining moment took place in North Carolina, where the Wright brothers launched the world into the age of flight.

c. 1900 Most of the amusement parks in America were built by trolley companies who located them at the end of their lines in order to attract the greatest number of passengers possible. These women (*above*) are cautiously experiencing the thrill of the basket ride at New York's Coney Island.

1907 At the turn of the 20th century, the tide of immigration to the United States not only continued but accelerated. In this 1907 photograph (*previous pages*), newcomers stand expectantly on the desk of the S.S. *Amerika*, waiting for the ship to dock in New York.

c. 1900 Theodore Roosevelt (1858–1919), the 26th President of the United States, was one of the most energetic figures in the nation's history (*right*). Cowboy, big-game hunter, leader of the Rough Riders in the Spanish–American War, he viewed the presidency as a "bully pulpit."

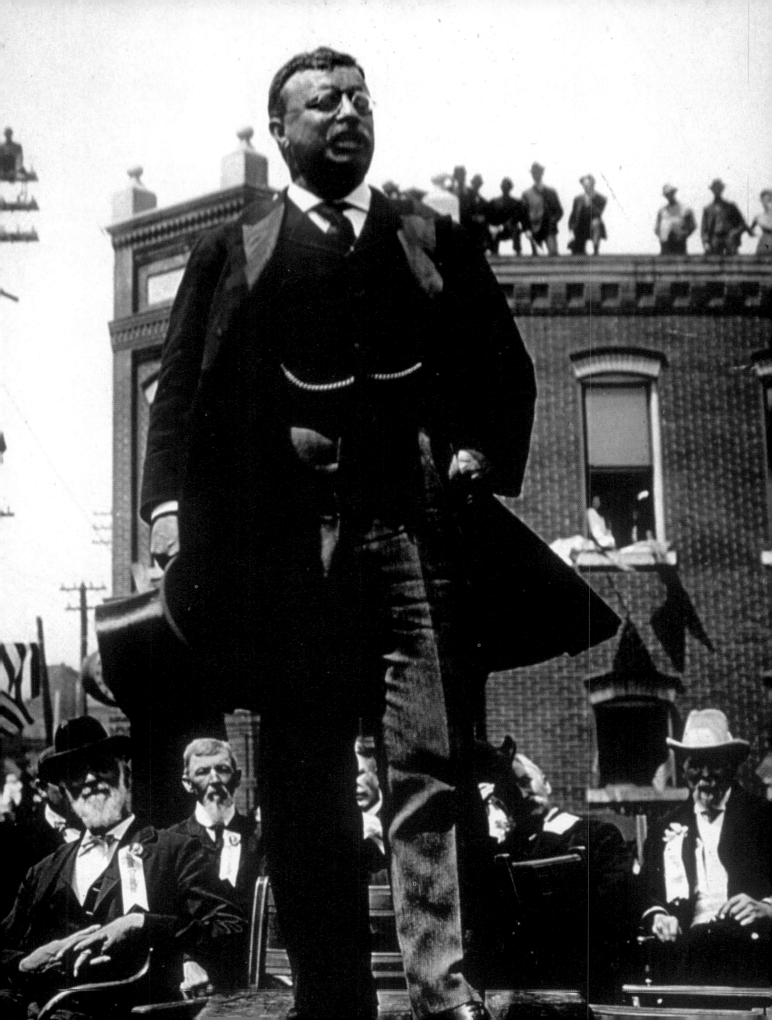

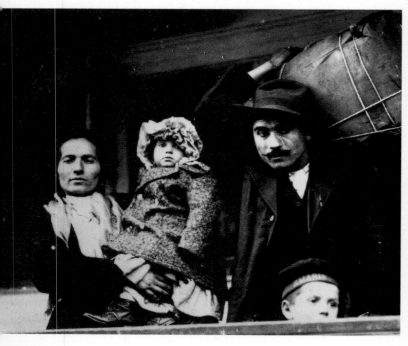

1905 Once immigrants landed in New York, ferries trans–ported them from the docks to Ellis Island. Here an Italian family awaits the beginning of their New World experience.

c. 1905 The Registry Hall at Ellis Island (*right*). "Just imagine," exclaimed a young Armenian immigrant, "you're fourteen years old and you're in a strange country and you don't know what's going to happen."

1905 A customs official attaches labels to the coats of a German immigrant family. For some, the sight of uniformed officials at Ellis Island was frightening.

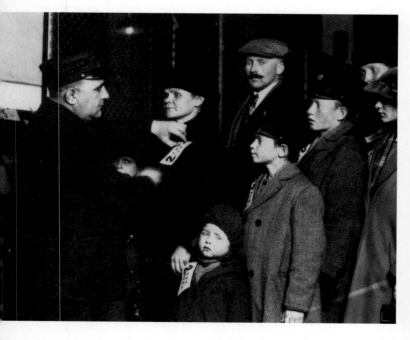

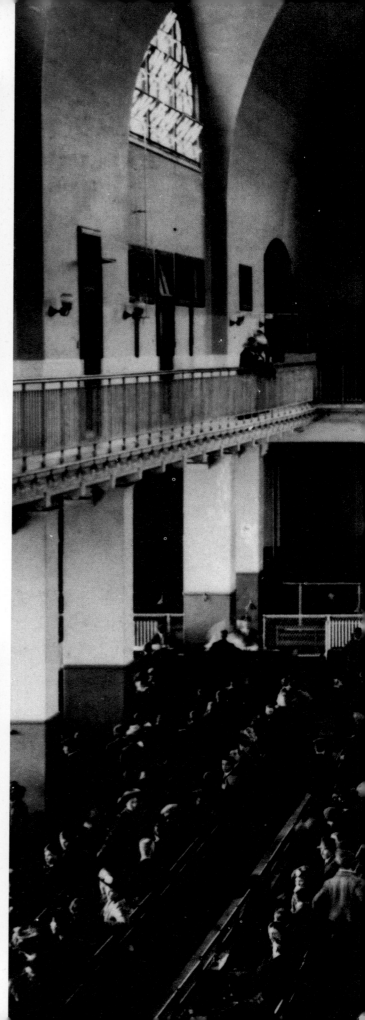

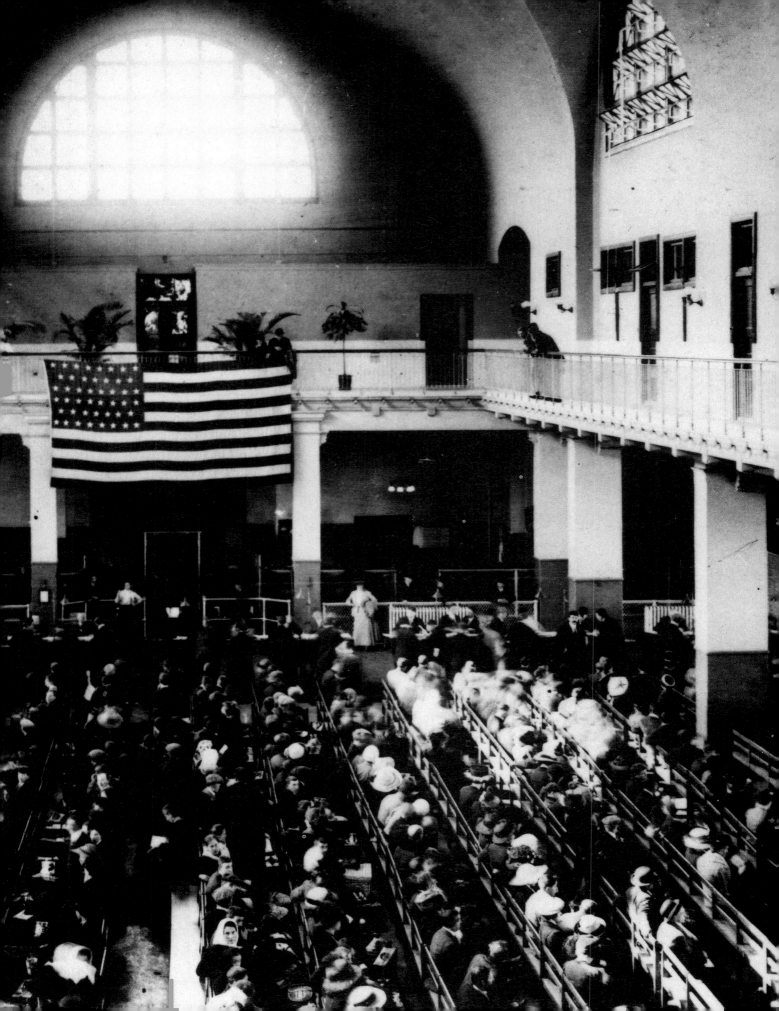

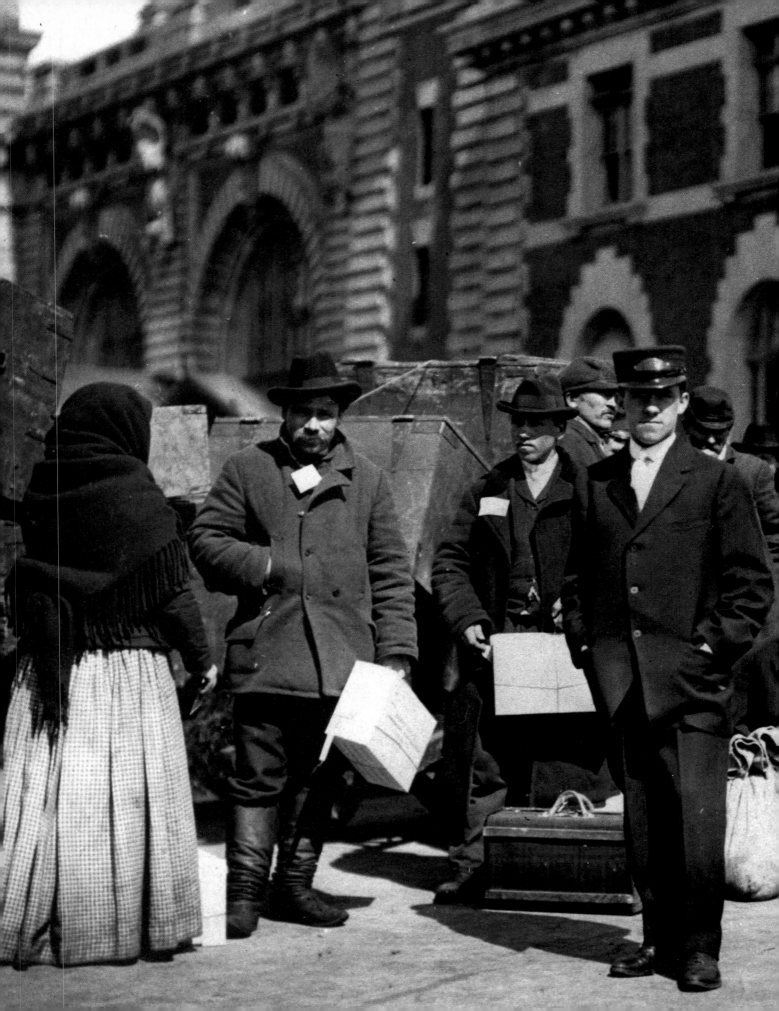

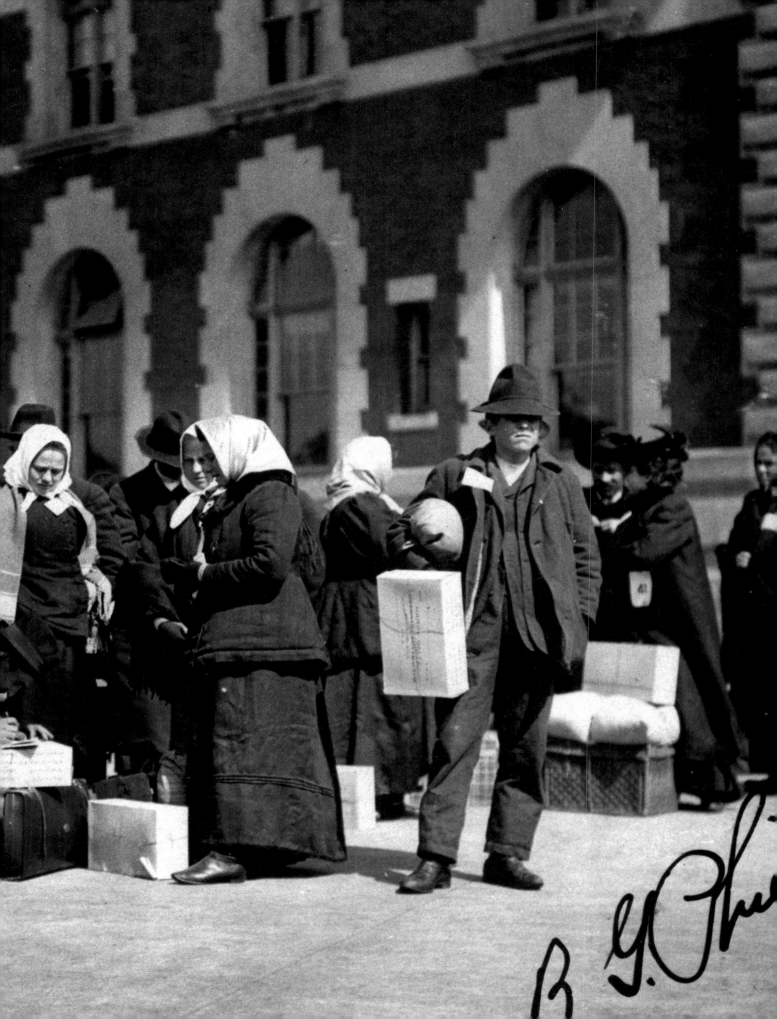

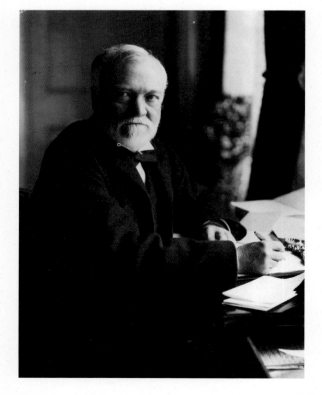

c. 1900 Jewish immigrants from England, dressed in their best clothing, await processing at Ellis Island. Behind them are the terrors of the long ocean voyage. Ahead lie the challenges of building a whole new life.

c. 1900 Andrew Carnegie (1835–1919) immigrated to America with his impoverished Scottish parents in 1848 (*left*). In 1868 he founded the Union Iron Mills; by 1879 the company produced 75 percent of all American steel and Carnegie was earning $25 million a year. He spent the last 20 years of his life giving his money away, particularly to the many libraries and foundations that he created.

1905 Lewis Hine became famous for the alarming photographs he took of American child laborers. Before taking these pictures, Hine spent considerable time photographing immigrants as they disembarked at Ellis Island. Here he has captured the arrival of this striking young woman (*right*).

1907 New arrivals at Ellis Island (*previous pages*) who will undergo a battery of physical and verbal tests before they are allowed entry into America.

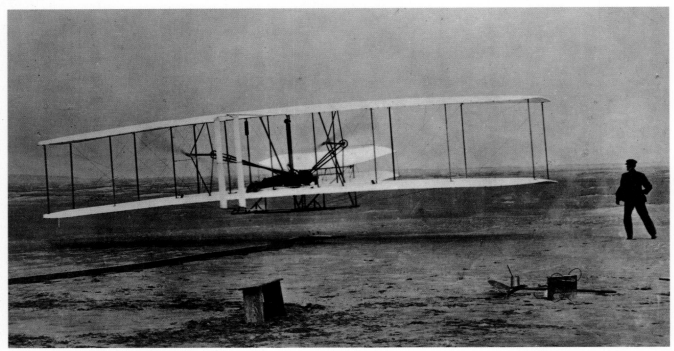

1903 The Wright Brothers launched the world into the Age of Flight on December 17, 1903. Here (*above*) Orville flies and Wilbur runs alongside a Wright glider fitted with a 12-horsepower engine at Kill Devil Hills near Kitty Hawk, North Carolina. The 12-second feat was the first official sustained flight by a heavier-than-air craft.

c. 1905 Early attempts at flight took many shapes and forms. Here (*below*) we see one young man's early ill-fated invention; a flying bicycle.

1902 Wilbur and Orville Wright, two bicycle makers from Dayton, Ohio, never finished high school; but by building and flying the world's first successful airplane they earned their place in history. Wilbur is shown (*right*) undertaking one of the many glider experiments carried out prior to their historic achievement.

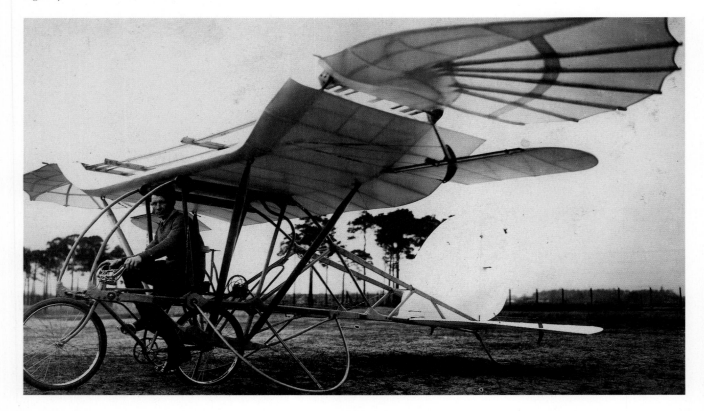

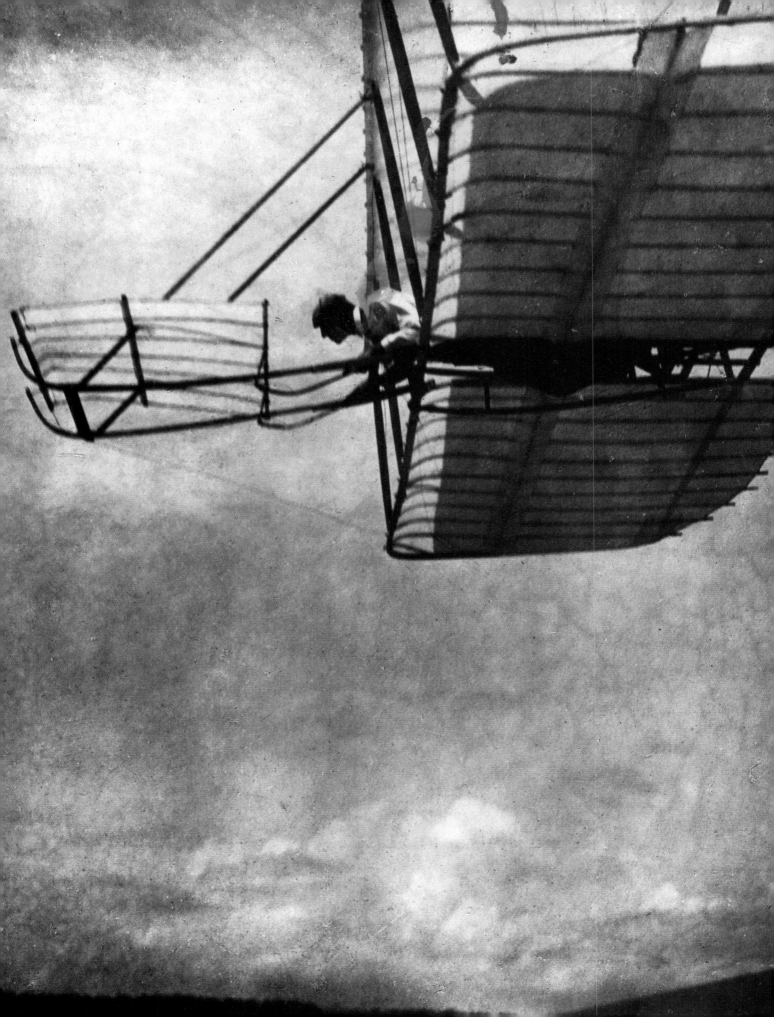

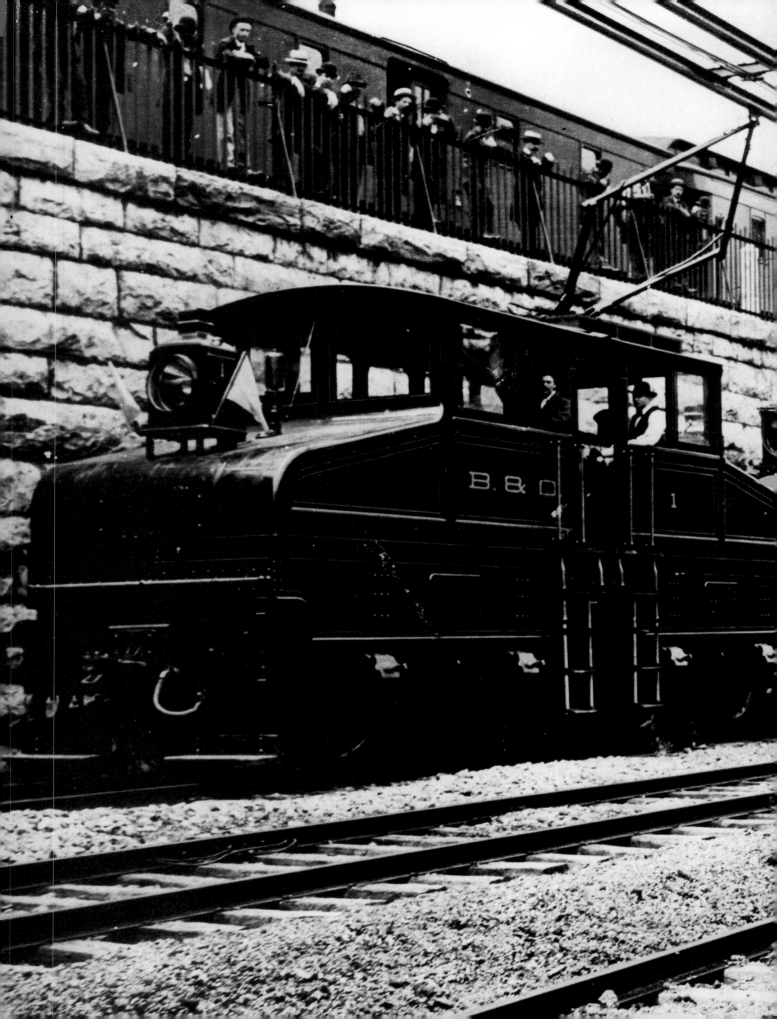

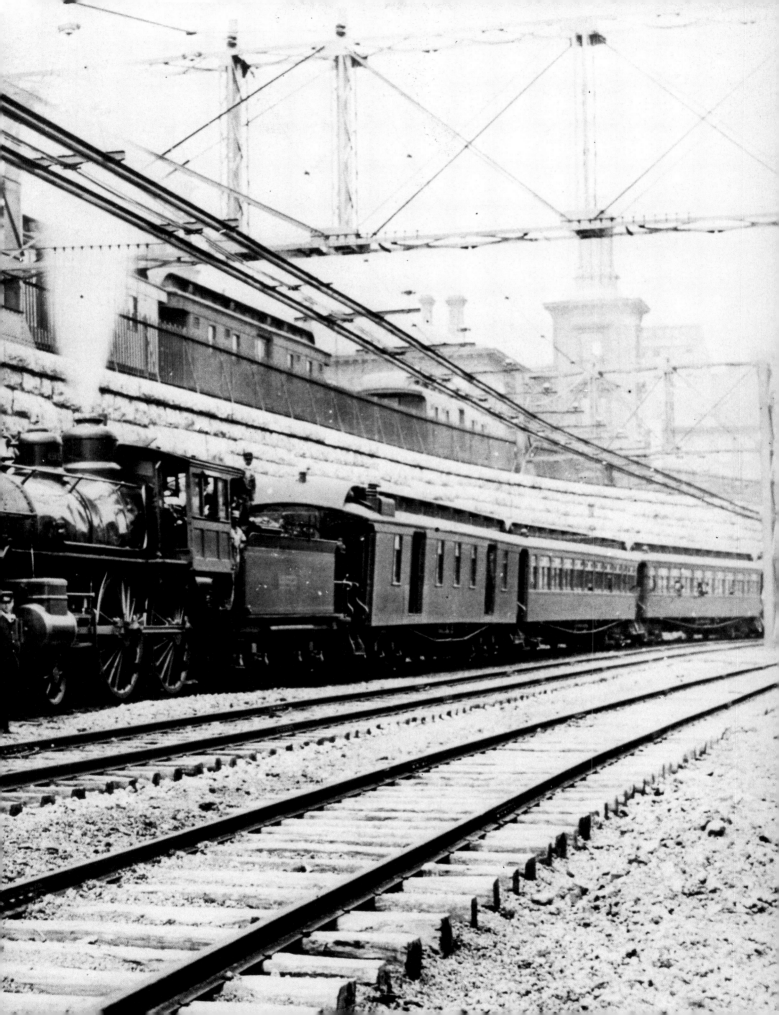

1900s

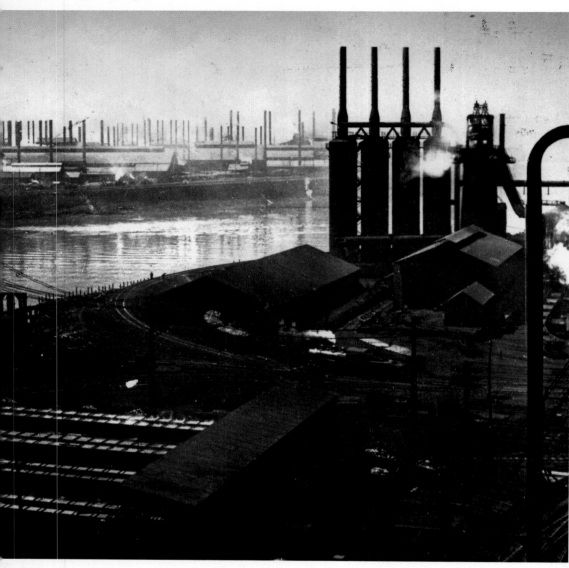

c. 1907 By the time this photograph of the Homestead
Steel plant was taken in 1907, Andrew Carnegie had sold the
complex to financier J. Pierpont Morgan, who used this
acquisition and others to form the United States Steel
Corporation, then the largest company in the world.

1903 The meteoric rise of American industry changed
the physical landscape of much of the nation. Towering
smokestacks came to dominate many cities. These boys
(*right*) are standing on a hill overlooking the Homestead
Steel plant in Pittsburgh.

c. 1900 Throughout most of the 19th century, trains
driven by steam–powered locomotives provided Americans
with their best and fastest means of overland transportation.
By the 1890s, however, electrically powered engines began
to make their appearance. The locomotive pictured here
(*previous pages*) is hauling a train along the Baltimore and Ohio
line, the first main line in the nation to use electric power.

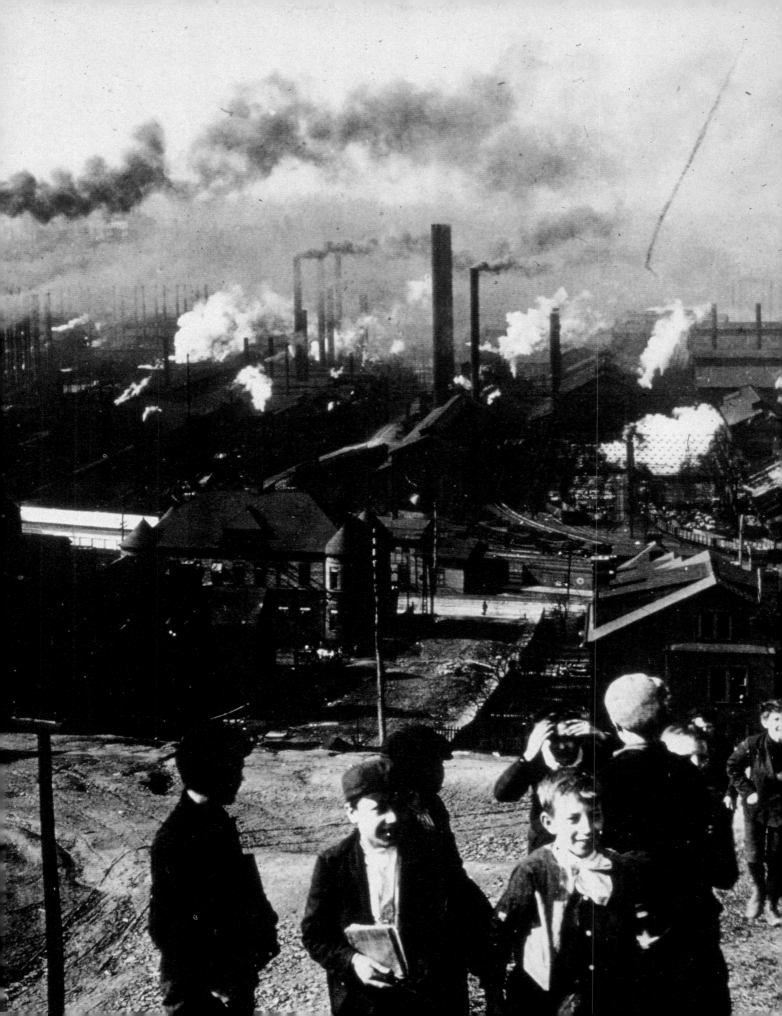

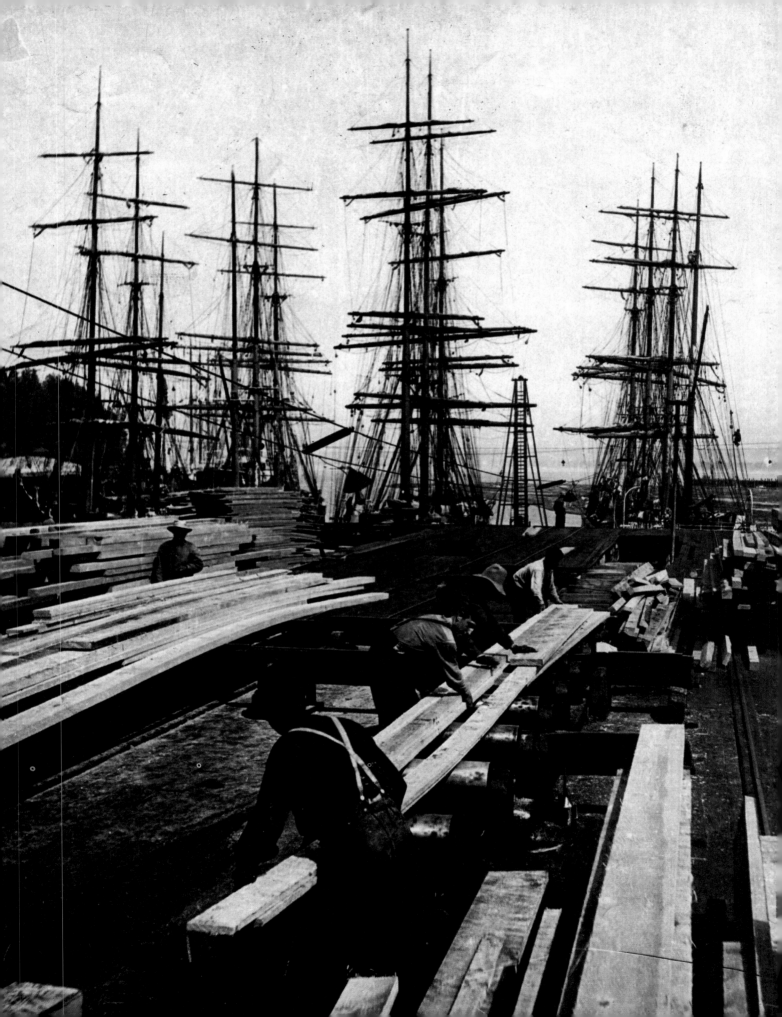

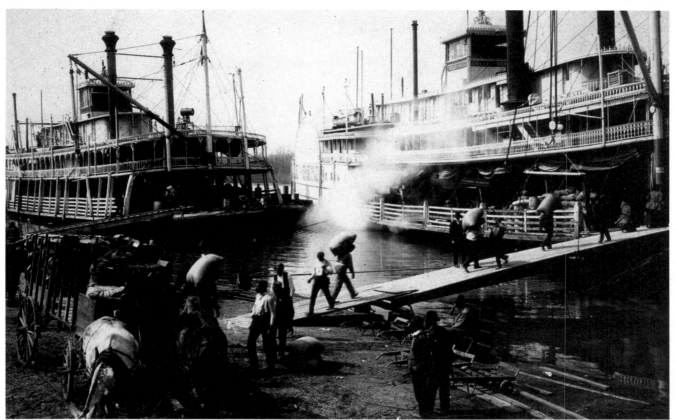

c. 1905 Despite the predominance of the American
railroad, there were still some regions of the country
where steamboats played a vital role. This picture, taken by
a Detroit Photographic Company photographer in 1905,
shows workers loading cargo on to a steamboat at a busy
landing on the Mississippi River.

c. 1900 Here lumber is being loaded on to ships in
a harbor in Washington State (*left*), where it will be taken to
pulp mills and turned into paper that was increasingly in
demand by the nation's growing offices and businesses. As
quickly as the nation's vast resources were harvested or
mined, they were turned into products.

c. 1900 In early America, bigger was commonly regarded
as better and progress was viewed as inevitable; hence,
the gigantic ladles used to pour molten steel (*right*) became
symbols of American strength and purpose.

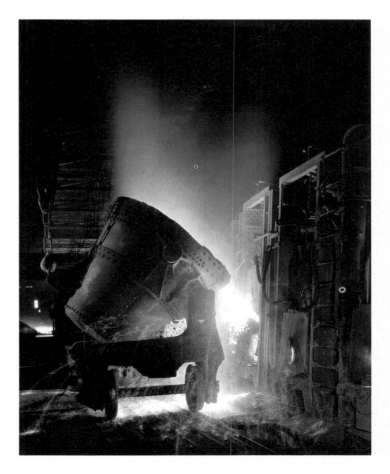

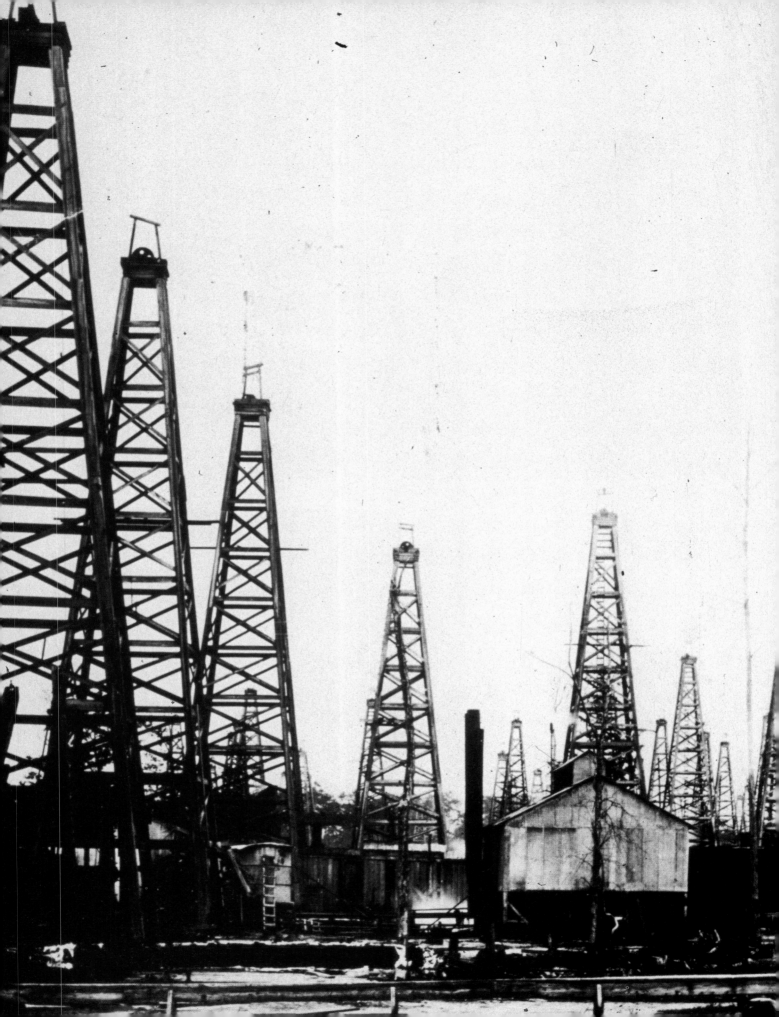

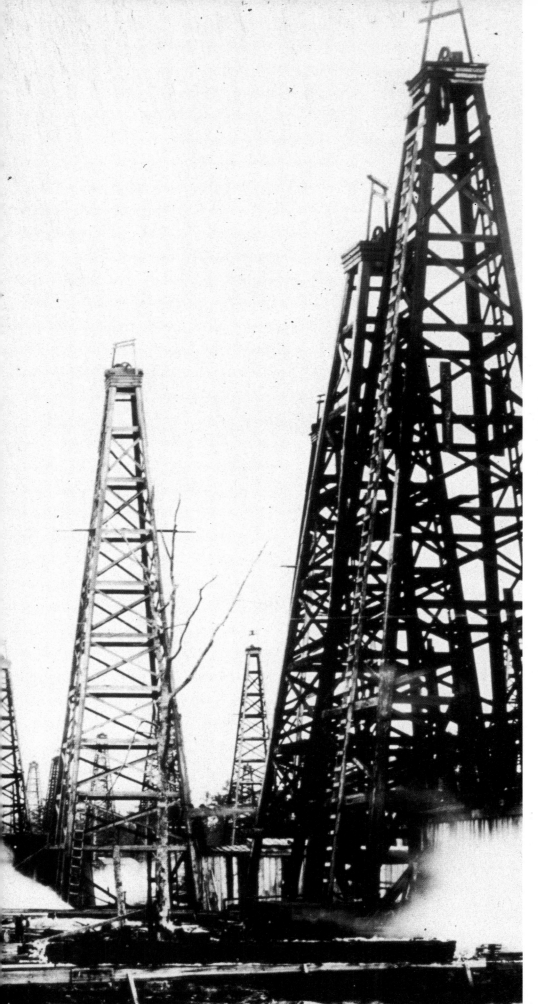

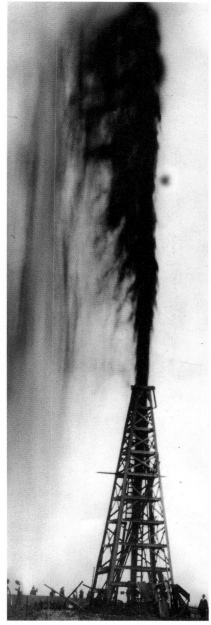

1901 This is the Spindletop oil gusher in Jefferson County, Texas. At the time of its discovery in 1901, it was the largest producing oil well in the world.

1908 The oil that was drilled in ever increasing quantities from American oil fields lubricated the machines that allowed the country to grow into a manufacturing colossus.

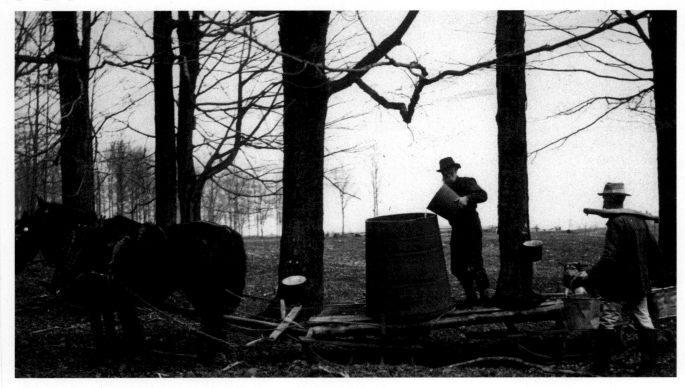

1903 Not all Americans were caught up in the accelerating pace of business, industry, and urban life. In many areas of the country, life went on as it had for generations. Here (*above*), New Englanders gather sap with a horse–drawn wooden sled and barrel, much as their fathers and grandfathers had done before them.

c. 1905 The original caption for this photograph (*below*) contained only the words "Clinch Valley Division." Just where was Clinch Valley? One thing is for certain, however. These are the faces of men (and boys) who in the early years of the 1900s helped make the United States the world's most productive nation.

1900 Some 30 years after the completion of the transcontinental railroad, railway crews were still at work cutting through mountains, crossing rivers and gorges, laying track everywhere. These workers (*right*), toiling in Fish Cut in Green River, Wyoming, were aided by the recently perfected steam shovel.

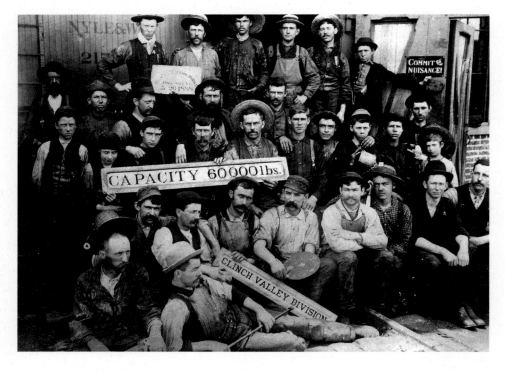

WEYLE AND BARBER PHOTO

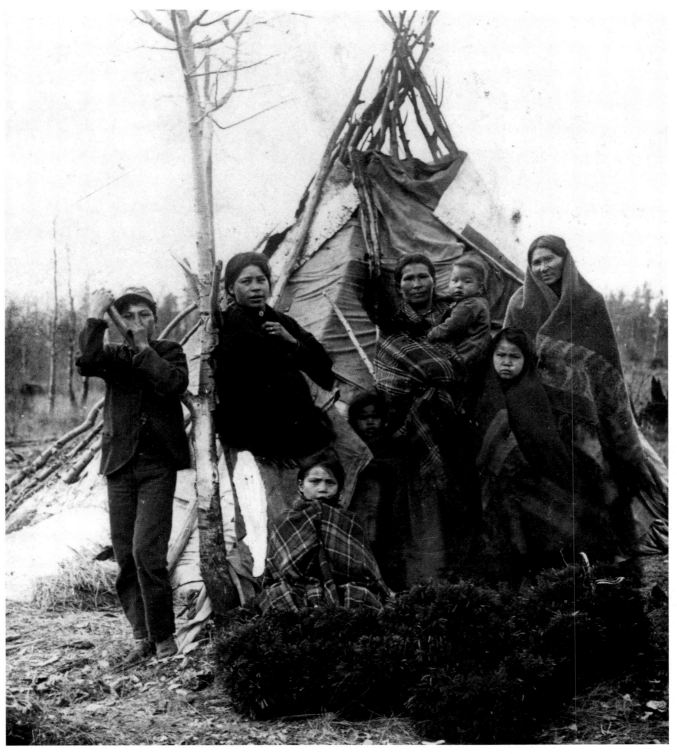

c. 1900 A family of Menominee Native Americans poses in front of their dwelling. The Menominee, one of the original tribes of Wisconsin and Upper Michigan, were part of the Algonquian language family. They supported themselves through farming and fur trade.

c. 1907 This photograph, titled *A Cheyenne Warrior of the Future*, was taken by Richard Throssel. Throssel, like other photographers such as Edward Curtis, Roland Reed, and Herman Heyn, was motivated by his desire to depict the Native Americans in as proud and dignified a manner as possible.

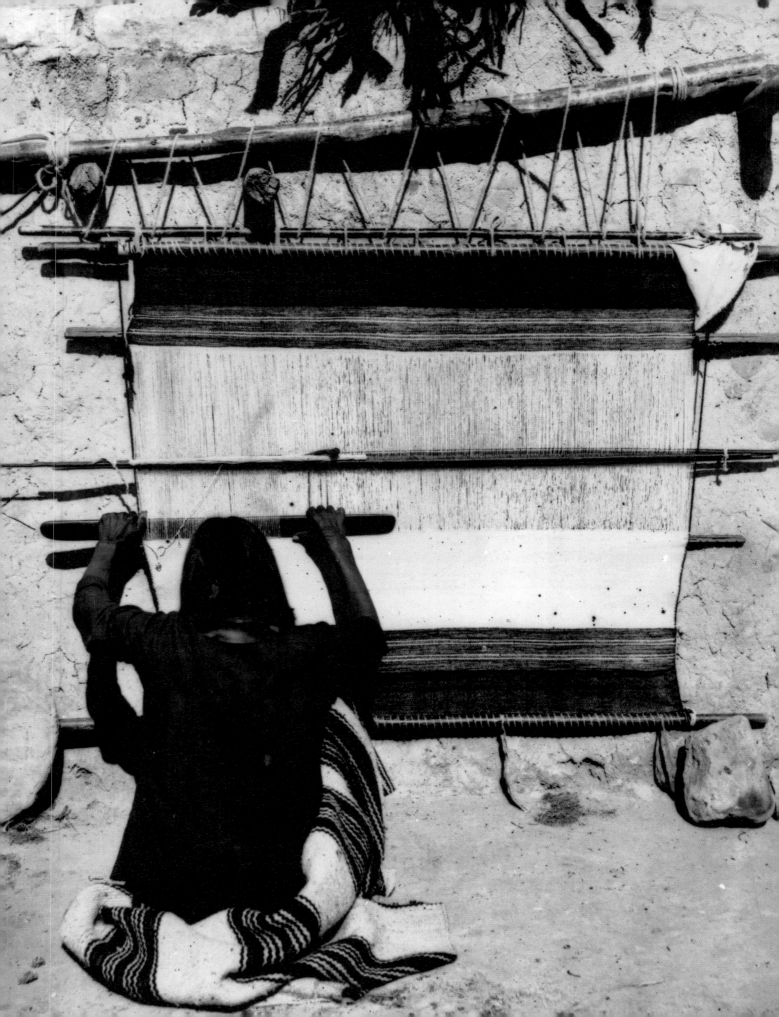

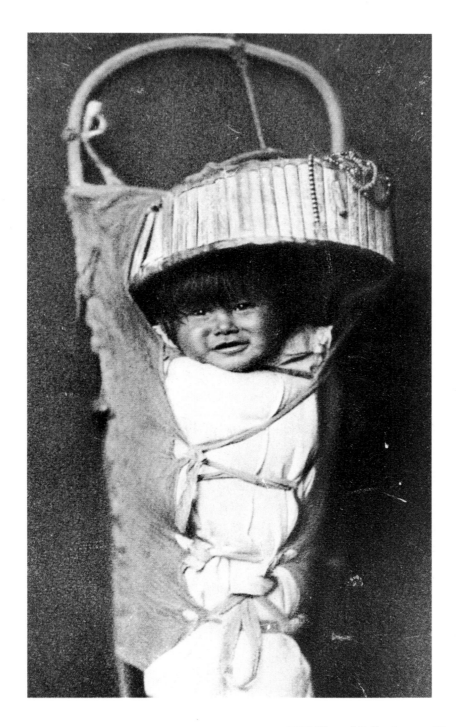

c. 1900 The Navajo Indians of the American Southwest were highly skilled in many crafts. This Navajo woman was weaving a blanket on a loom whose design dated back to the 1600s. Known as a "chief's blanket," the fabric was woven so tightly that water could not penetrate it.

c. 1900 Edward S. Curtis spent 30 years photographing every tribe of North American Indians he could reach. With his health all but broken by this endeavor, he published 20 volumes of his work beginning in 1907, entitled *The North American Indians*. A major New York newspaper called it "the most gigantic undertaking in the printing of books since the King James edition of the Bible." Curtis took this picture of an Apache baby in 1910.

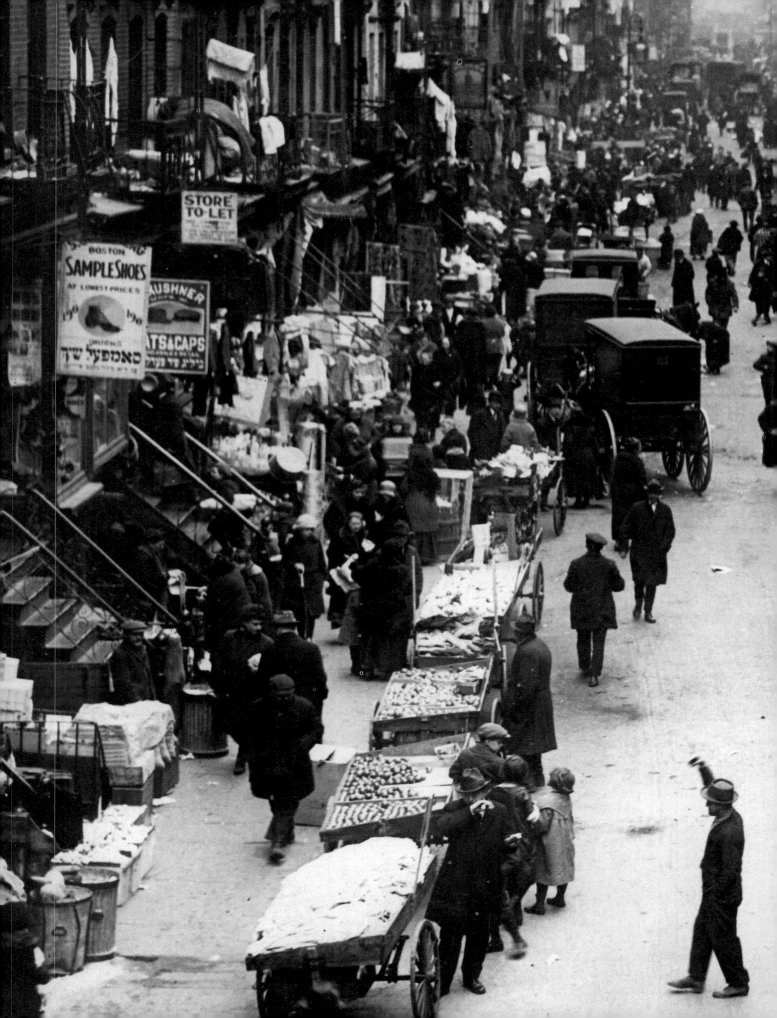

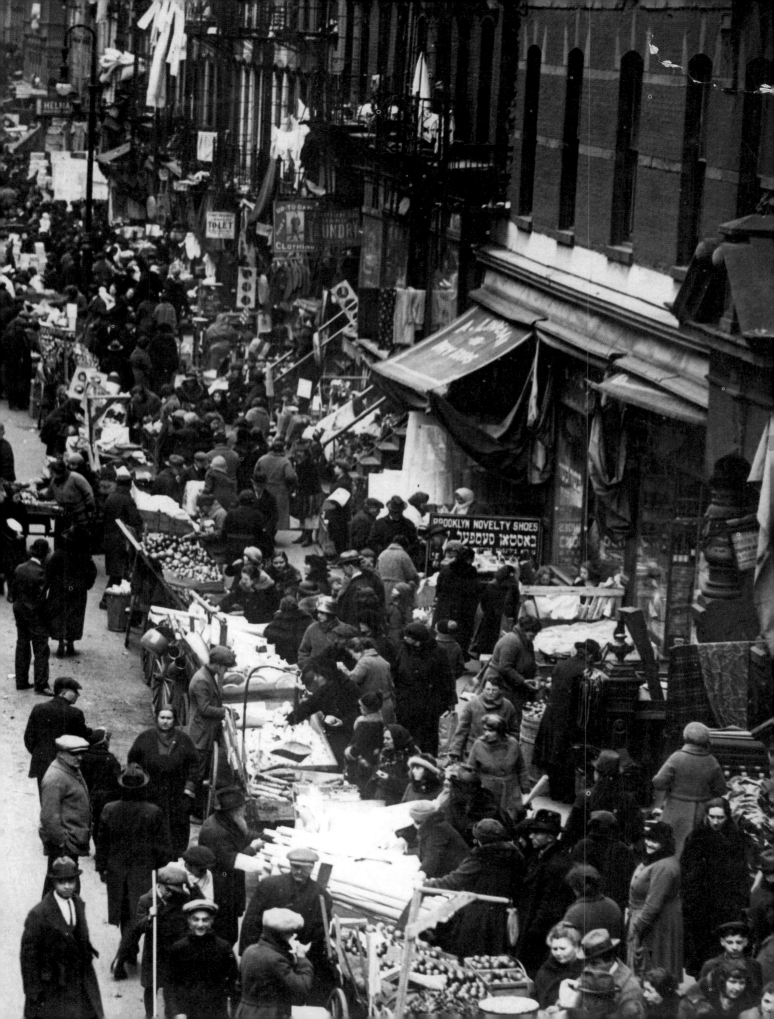

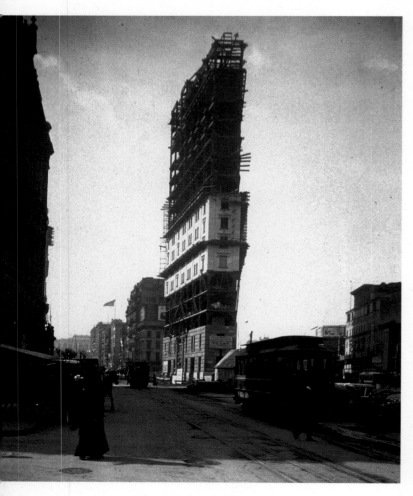

1904 A view of the Times Building, home to the *New York Times*, under construction in newly named Times Square. The *New York Times* was purchased by Adolph Ochs in 1896, and he turned it into one of the most influential newspapers in the world.

1900s By the turn of the 20th century, New York City had firmly established itself as the nation's mecca of theatrical performances. This is a view of Broadway and 42nd Street (*right*), the heart of the "Great White Way."

c. 1900 For American immigrants, the streets became the very arteries of life. The newcomers had little money to travel far from their homes but almost everything they could afford to buy could be found in their neighborhood streets. This (*previous pages*) is the pushcart market on New York's Lower East Side.

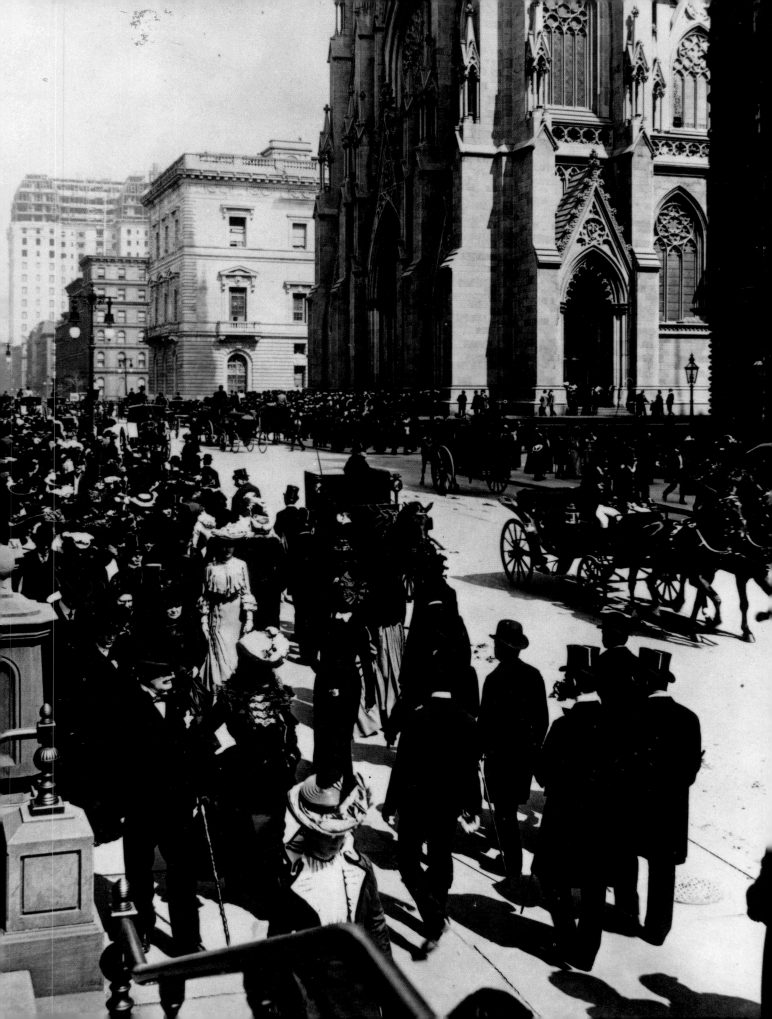

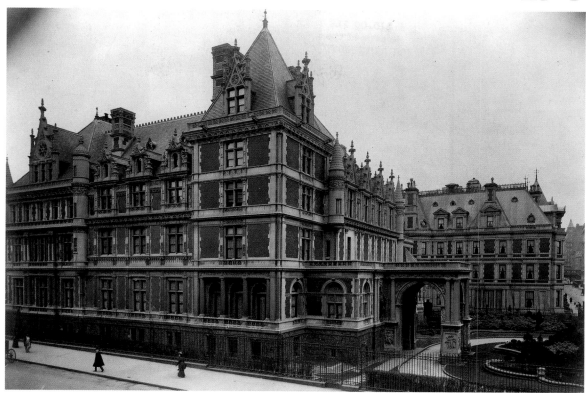

1902 William Henry Jackson, one of the premier Western photographers, formed the Detroit Photographic Company, which produced postcards of scenes taken around the nation. In this scene, strollers dressed in their finery parade past New York's St. Patrick's Cathedral on Easter Sunday (*left*).

c. 1905 The invention of the automobile spawned the development of vehicles that could be used for purposes other than personal or public transportation, such as this street sweeper (*below*) in New York.

1908 The enormous success of American business created a class of millionaires who delighted in flaunting lavish life-styles. This was the New York residence of steamship and railroad magnate Cornelius Vanderbilt, which required the full-time work of some 50 servants to keep things in order (*above*).

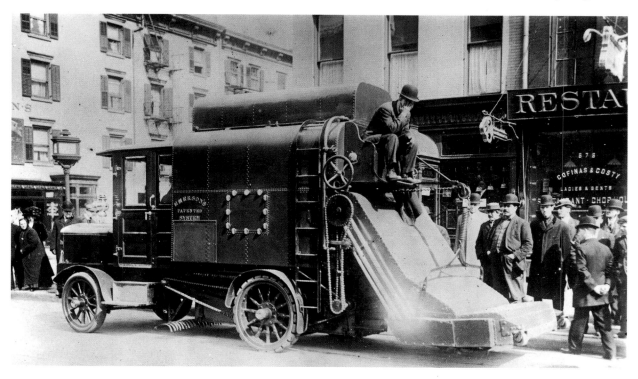

c. 1909 The nation's first stock market was the New York Stock Exchange, begun in 1792. With the various booms in canal, railroad, and insurance stocks in the 19th century, other stock exchanges were established throughout the country. New York's American Stock Exchange began as an outside curb market. Here we see traders making their transactions.

1909 The immigrants who poured into the cities of America brought with them their own rich and varied customs and traditions. This picture depicts one aspect of the 1909 Chinese New Year celebration in New York's Chinatown.

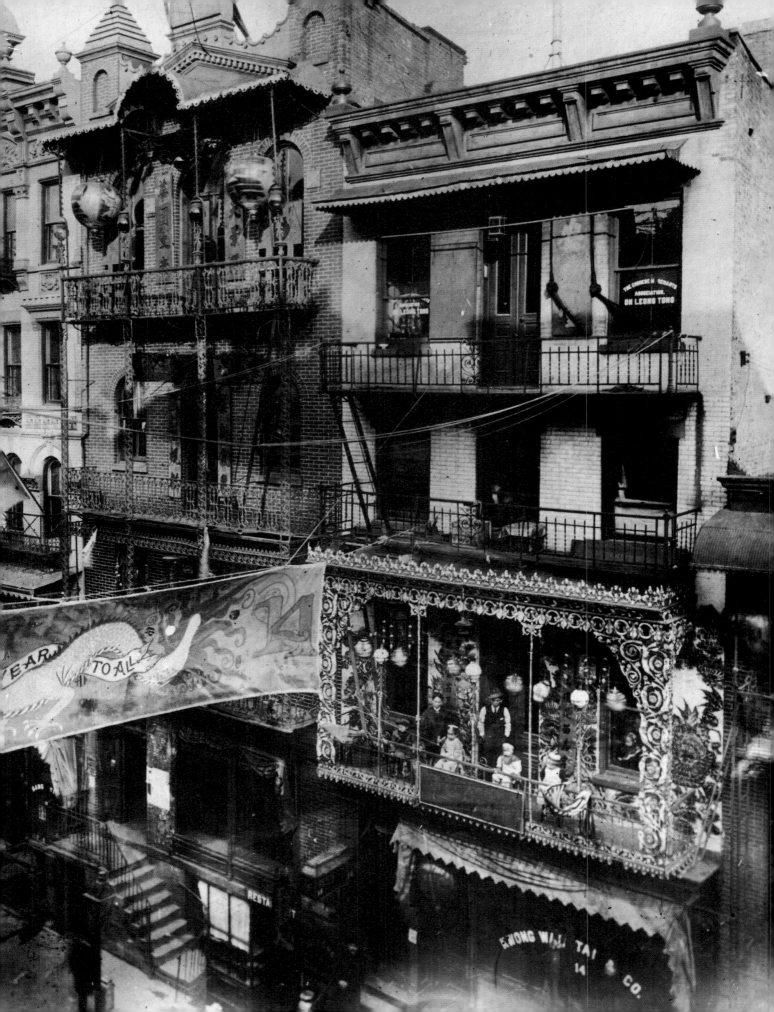

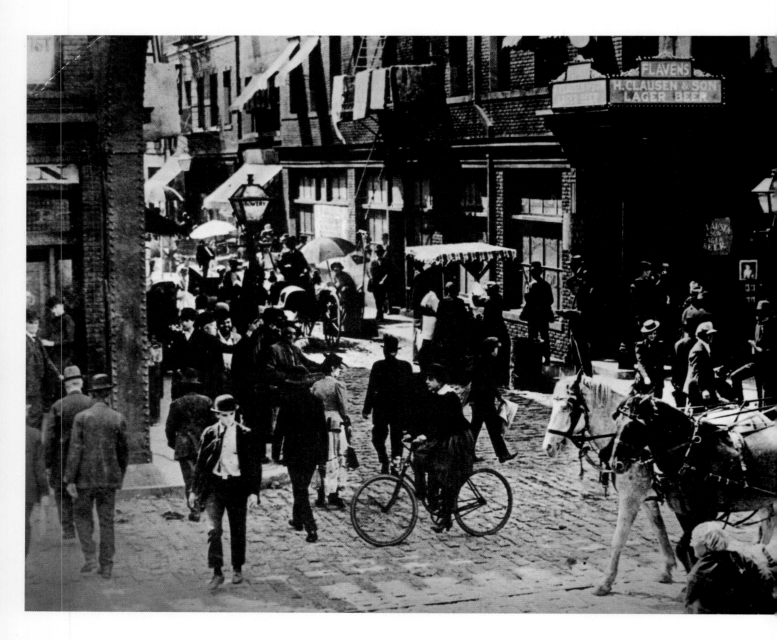

c. 1900 In the 1900s that East Side section of New York known as the Bowery was among the city's busiest thoroughfares. "Anyone attempting to conduct a simple act like crossing from one side of a street to another is seriously tempting the fates," proclaimed one startled tourist. He was right. Hundreds of people annually were injured in the crush of delivery wagons, streetcars, and pedestrians.

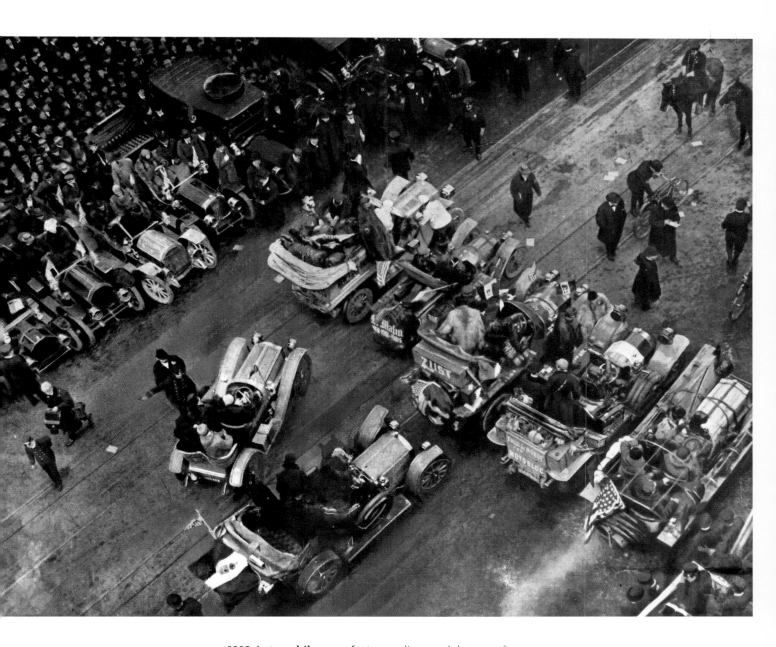

1908 Automobile manufacturers discovered that one of
the best ways to promote their cars was to enter them in
the many long-distance auto races that were becoming
extremely popular. These cars, lined up on New York's
Broadway, were awaiting the start of one of the longest
and most famous of these races – from New York to Paris.

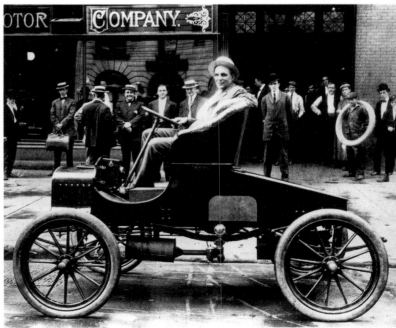

1906 Henry Ford poses in one of his cars outside his factory. By the time this picture was taken Ford would boast, "We are making 40,000 cylinders, 10,000 engines, 40,000 wheels, 20,000 axles, 10,000 bodies . . . all *exactly alike.*"

1904 Standing tophatted in the center of this photograph is New York City's mayor Seth Low at the opening of the New York subway. New York was not the first city in the nation to build a subway. That honor went to Boston. But within two decades, New York had the largest underground transportation system in the world.

1906 For decades after the American nation was born, the new country had not a single well–paved road. The coming of the automobile inspired the building of toll roads and turnpikes that at last gave Americans adequate avenues of overland transportation. Here, a driver pauses at a tollgate to pay his fare.

1904 In the first quarter of the 1900s, long–distance excursions as well as races were an integral part of the automotive scene. These proud drivers and passengers are parading on the grounds of the Louisiana Purchase Exposition in St. Louis having completed their run to that city from New York.

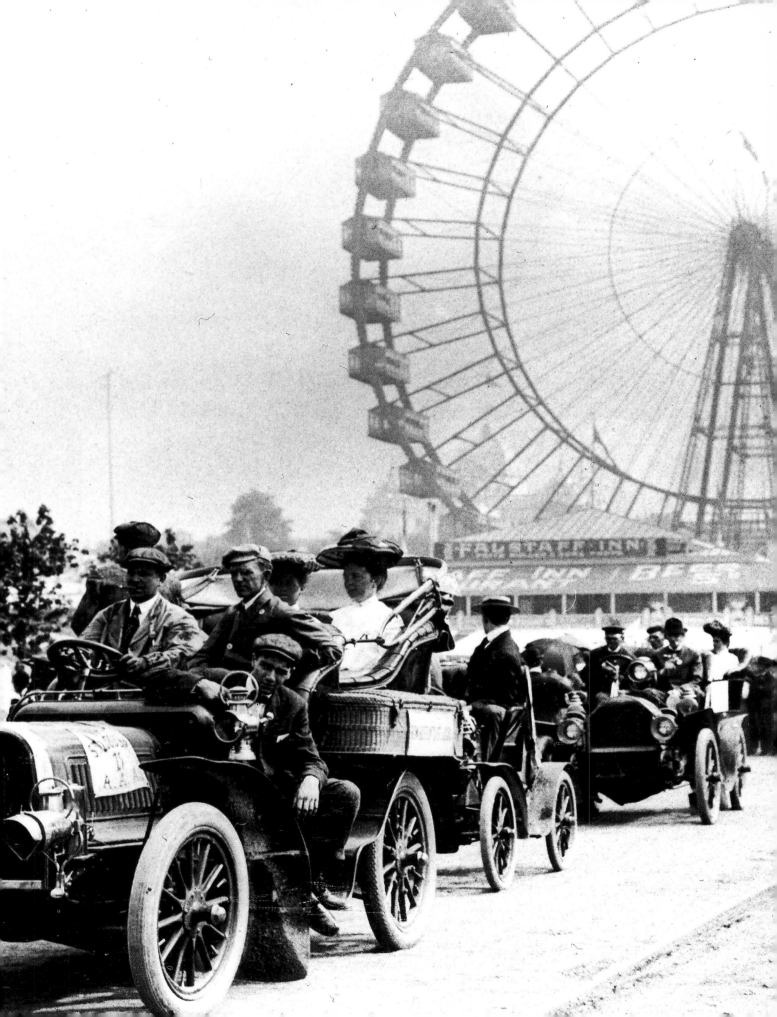

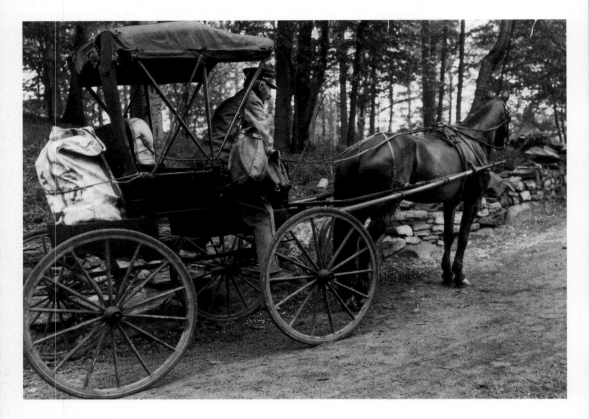

c. 1905 The delivery of mail in the United States is even older than the nation itself. In 1775, on recommendation of a committee headed by Benjamin Franklin, the Continental Congress established a postal system for the United Colonies with Franklin as postmaster general. In this photograph, a rural free–delivery postman goes about his "appointed rounds."

1909 United States mail couriers in horse-drawn vans pose proudly for their picture; although Ford is mass-producing automobiles in 1909, the horse is still "king of the road."

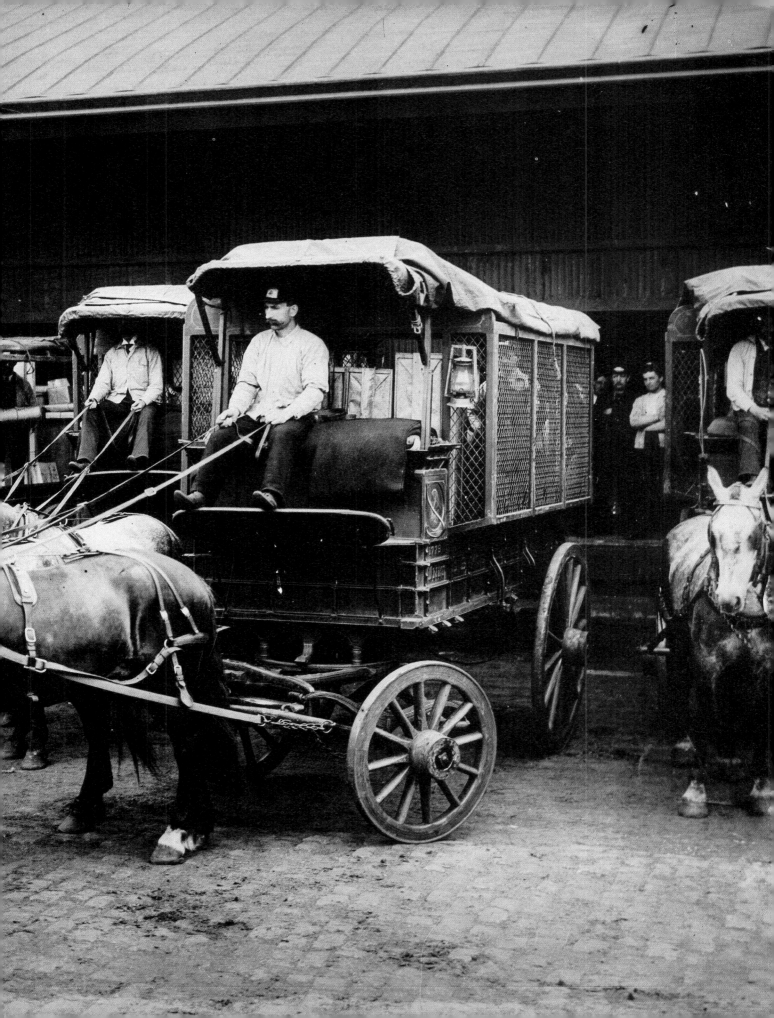

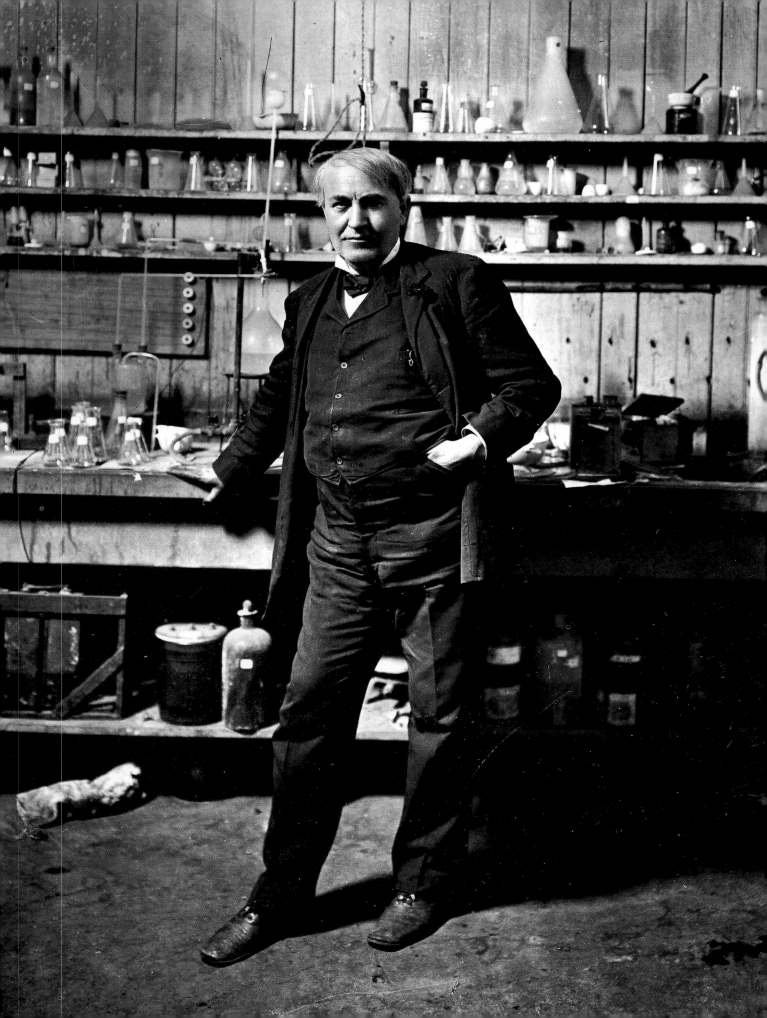

1906 In the course of his 60–year career as an inventor, Thomas Alva Edison (1847–1931) did perhaps more to transform the way people lived than any other individual in history (*left*). Holder of more than 1,000 patents, his greatest contribution was the incandescent electric light bulb.

1906 In the first decade of the 1900s, trade shows became increasingly popular. No major showing was complete without a display of Edison's latest accomplishments (*below*). A tireless worker, the "Wizard of Menlo Park" explained his success by stating, "Genius is two percent inspiration and 98 percent perspiration."

c. 1901 Thomas Edison's laboratory at Menlo Park, New Jersey (*above*), was the first independent research and development facility in America. With the aid of his laboratory assistants, Edison produced an average of one patentable device every two weeks of his adult life.

1900s

c. 1900 The American business explosion and the need for "white–collar" workers brought more American women into the labor force than ever before. These telephone operators were working at the Magneto Exchange switchboard at the National Telephone Company.

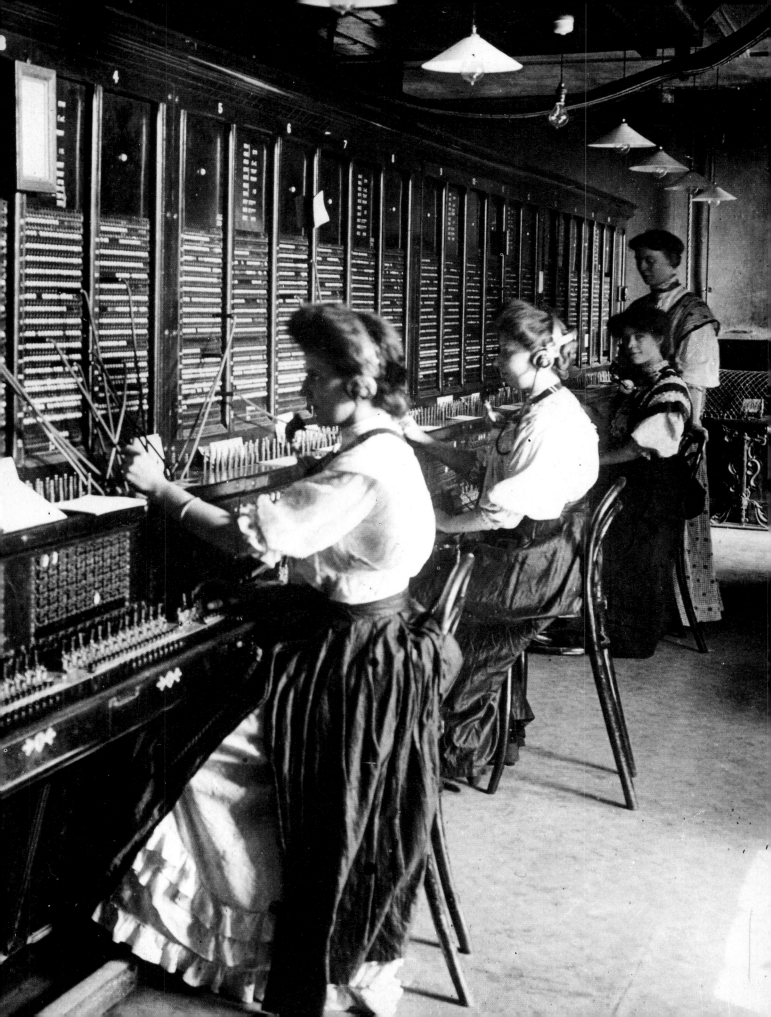

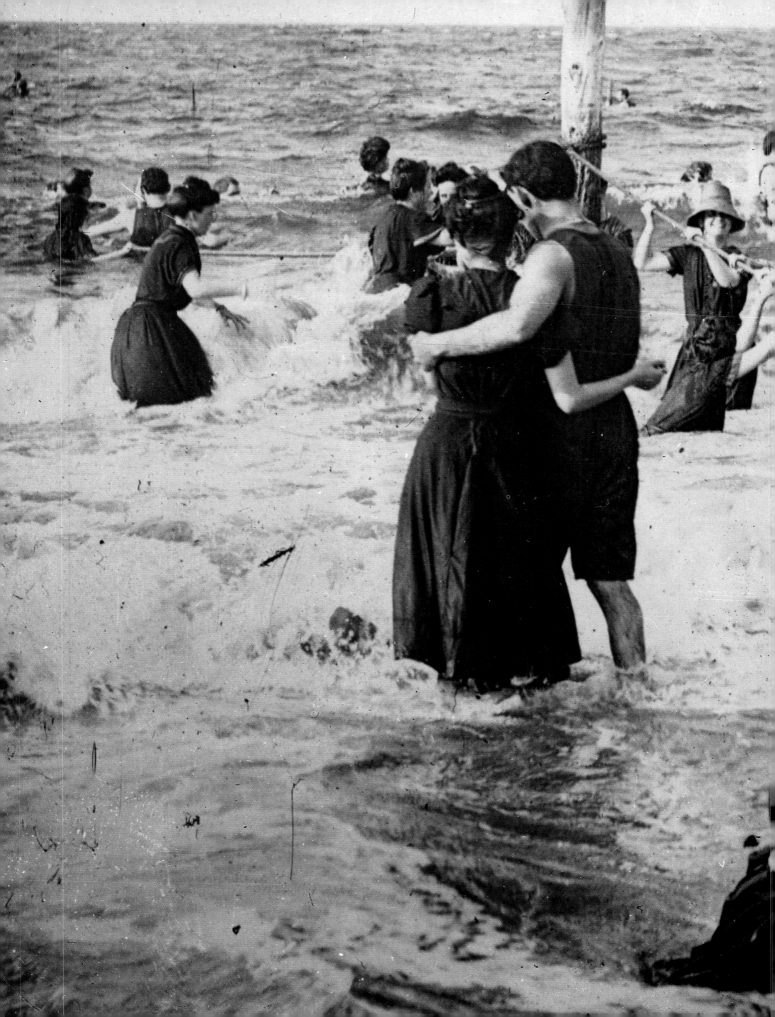

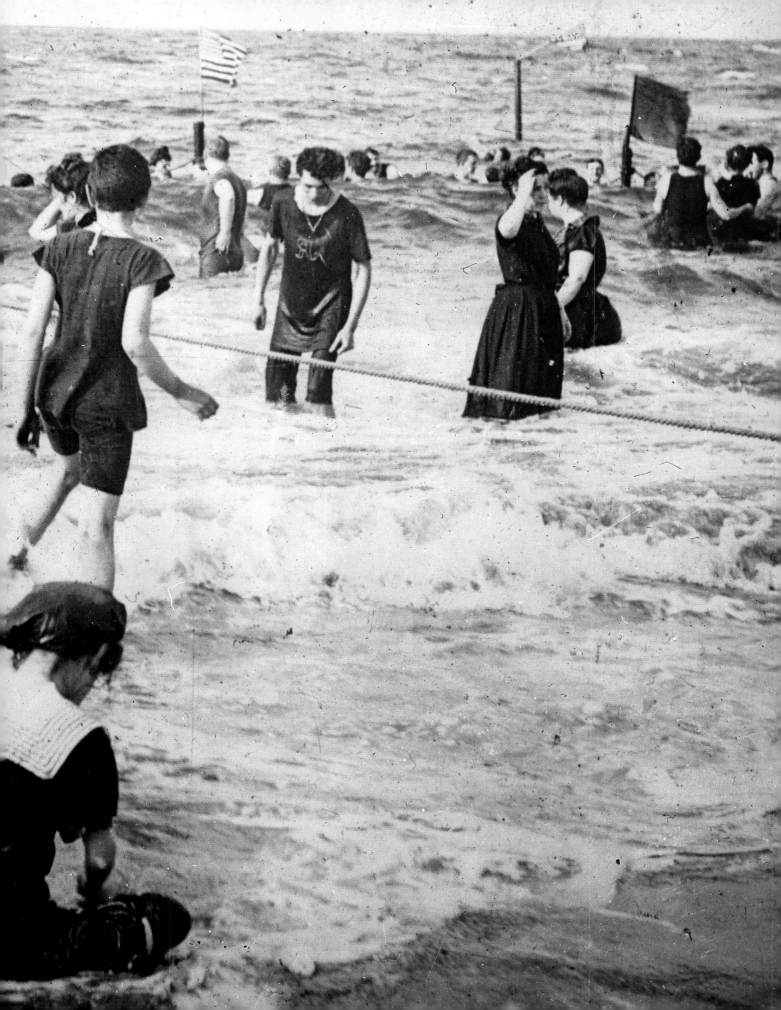

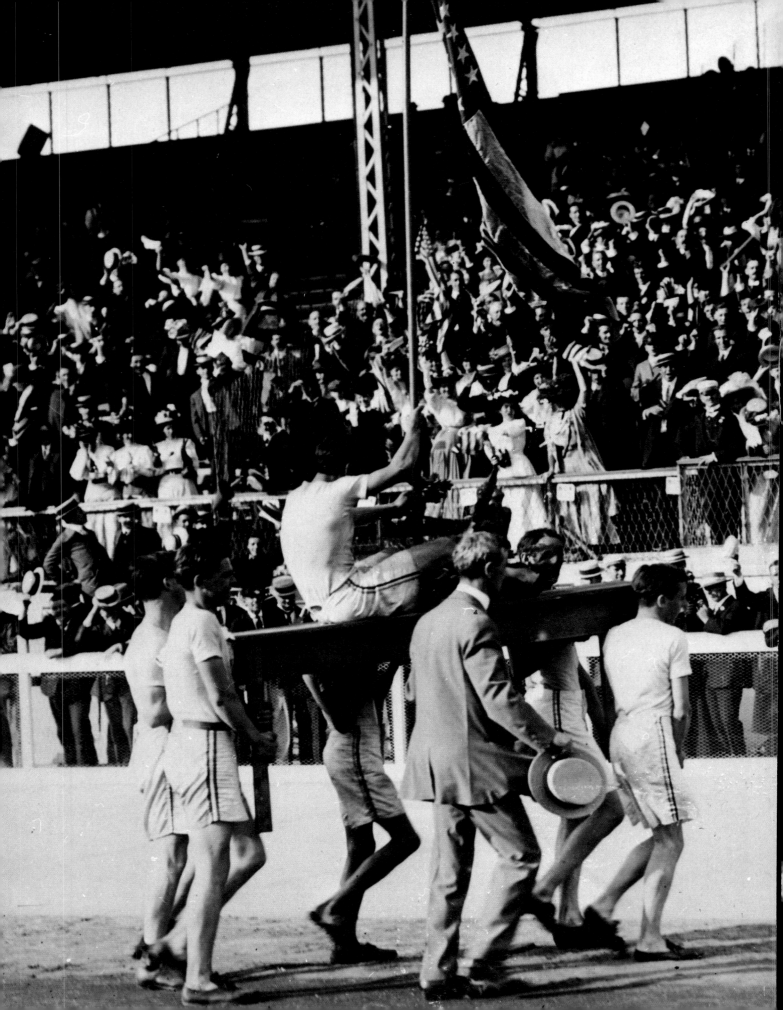

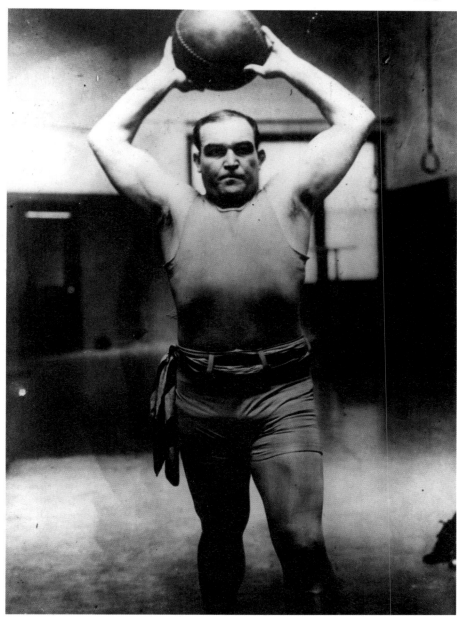

c. 1909 The man working out with a medicine ball is boxer Jim Jeffries, whose nickname was "the Boilermaker." Ten years earlier, Jeffries had beaten Bob Fitzsimmons to win the Heavyweight Championship of the world.

1908 Both the Olympics and the marathon date back to the glory days of Greece. In this picture the American John Hayes, winner of the marathon at the 1908 Olympic Games in London, is carried off in triumph on a table which also holds his coveted trophy.

1903 Despite the fact that a number of ministers continued to rail against the moral dangers inherent in men and women swimming together in the same ocean (*previous pages*), going to the beach became an increasingly popular way of spending a Sunday afternoon.

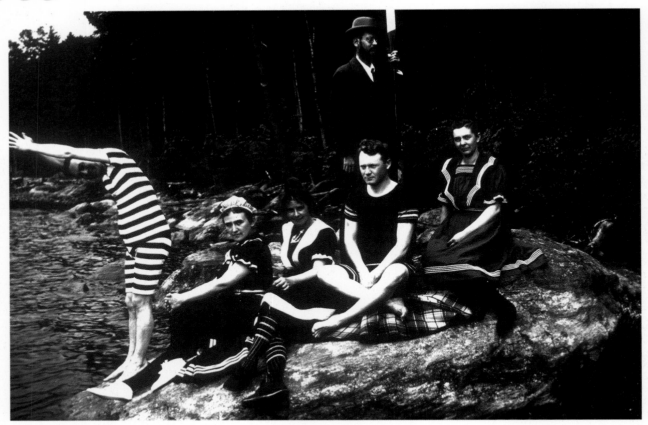

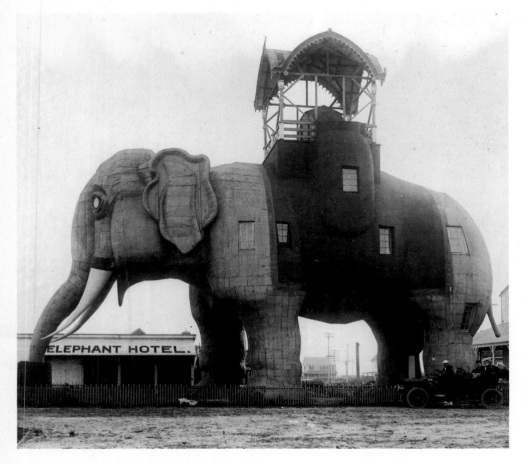

1901 In the 1900s, both modesty and aversion to suntans dictated the manner of bathing apparel. These revelers were photographed on a summer's day outing at Lake Pleasant, New York.

1907 One of the phenomena attached to the automotive mania was the emergence of roadside stands, restaurants, motels, and hotels constructed in what their builders felt were eye-catching shapes – all designed to attract the motoring public. This is the Elephant Hotel in Atlantic City, New Jersey.

1903 Amusement parks were the Newports of the working class in the early 1900s. Millions were attracted by such rides as the Whip, the Super Bump, and the Helter Skelter. Seen here is one of the most popular of all the rides in Luna Park at Coney Island, called Shoot-the-Chute.

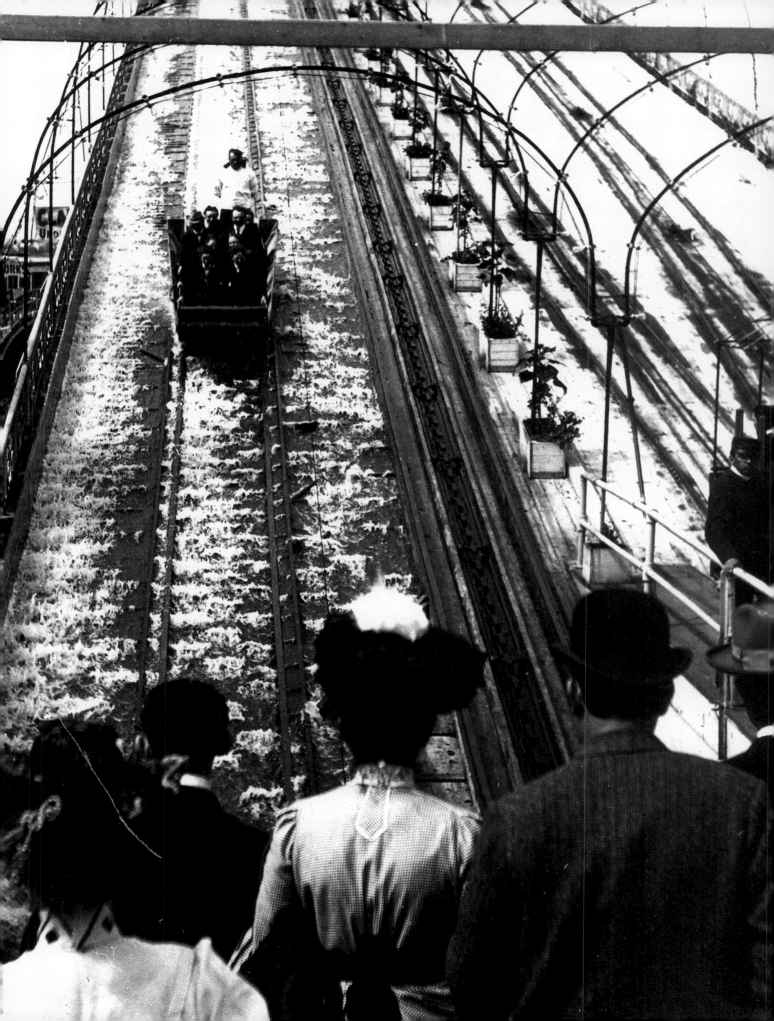

c. 1900 Early movie houses charged an admission price of five cents and were appropri‐ately called nickelodeons. By 1910, there were some 10,000 nickelodeons operating in the United States.

ING SUCCESS

THE

HAUNTED HOUSE

OR EVERYBODY

going on all the time 5¢

as long as you like

THE
RUNAWAY
HORSE
THE
UNTED
USE

HEATRE

5¢

THIS IS

THE

SHO

YOU HAV

BEEN

WAITIN

FOR

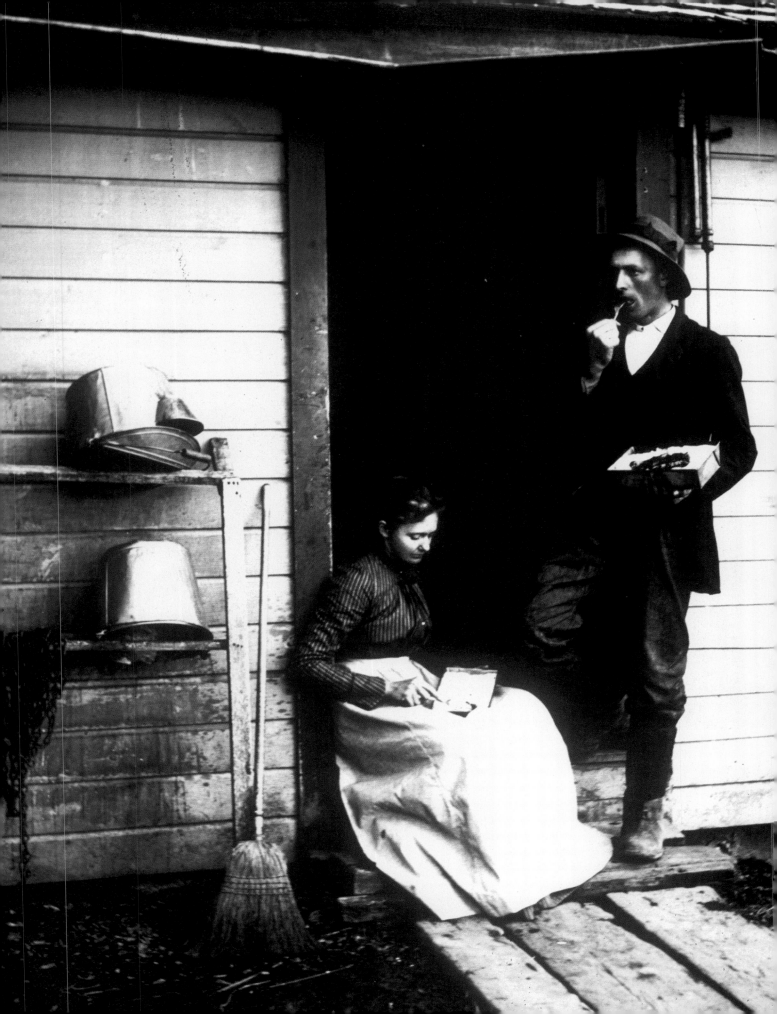

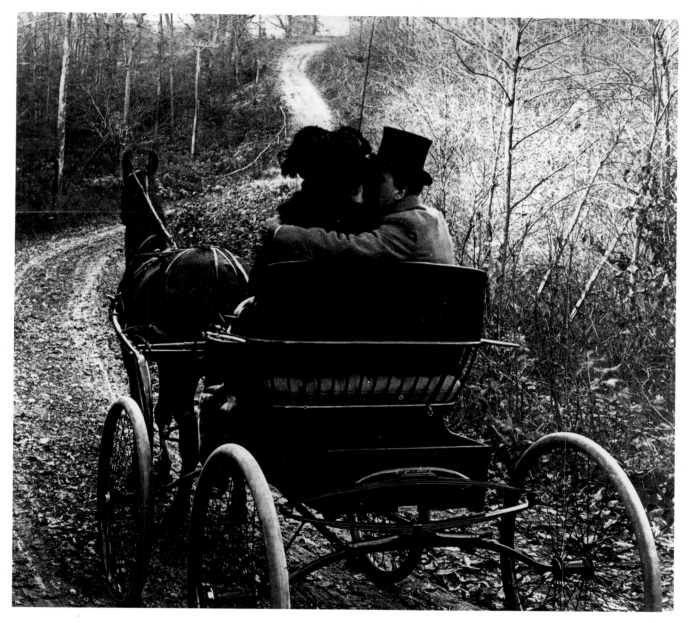

c. 1900 The automobile provided couples with whole new opportunities to escape prying eyes and be off by themselves. There were still many, however, who preferred older methods of courtship.

c. 1900 Many new foods were introduced in the early 1900s, including Hershey's bars, ice cream cones, hamburgers, and tuna in a can. Home–cooking, though was still a main-stay of most American families. This rural couple is taking a break with a home–baked treat.

1900s

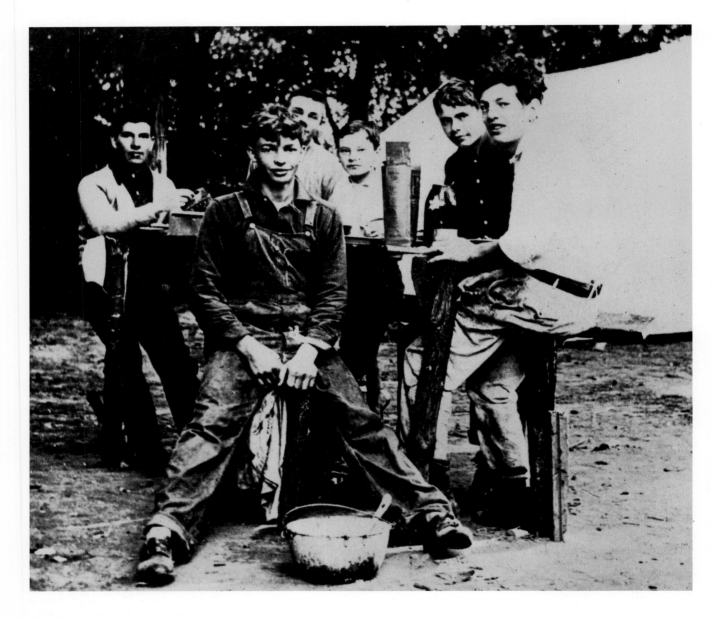

1907 One never knows what the camera will reveal. In 1907 a group of teenagers, off on a camping trip, posed happily for one of their companions. The young man in the front of the picture is Dwight David Eisenhower who would become a five–star general, command the Allied forces in the Normandy invasion, and become the 34th President of the United States.

1906 Theodore Roosevelt was the youngest man ever to ascend to the presidency. He was also the first Chief Executive to ride in a car, fly in an airplane, and win a Nobel Prize (for his contributions to the Russo–Japanese peace treaty in 1906). He is shown here with American conservationist John Muir.

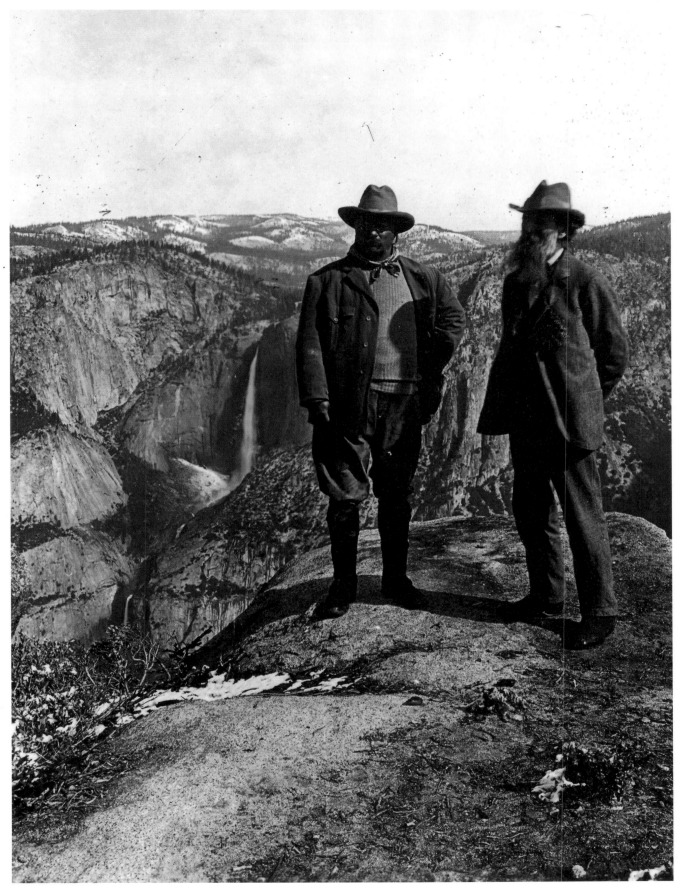

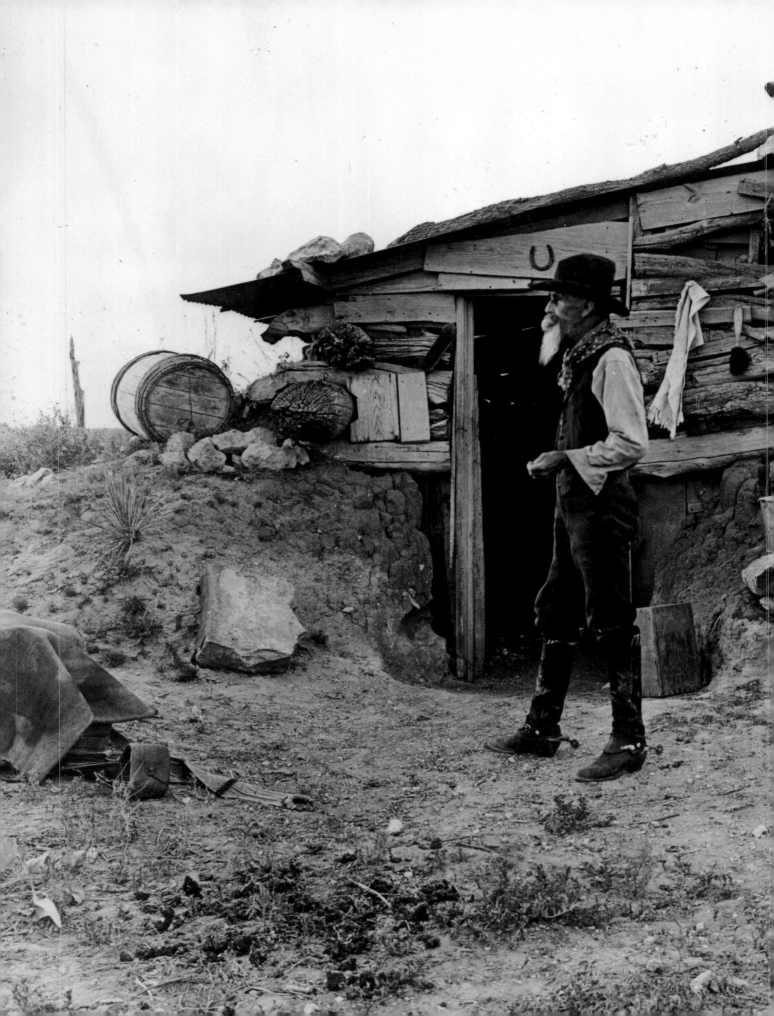

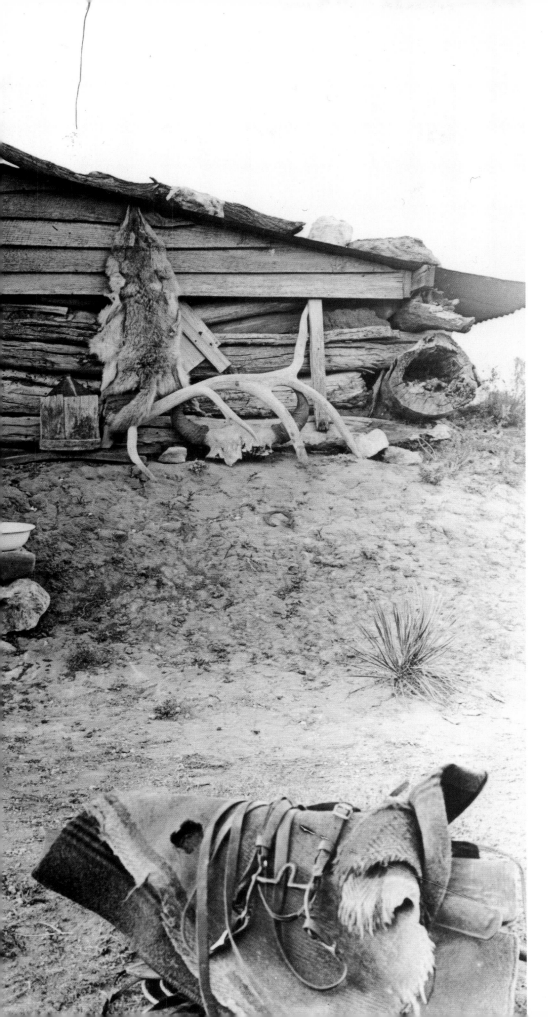

1908 Frontier justice was commonly quick and often informal. The man standing outside this Texas cabin is Judge Henry H. Campbell.

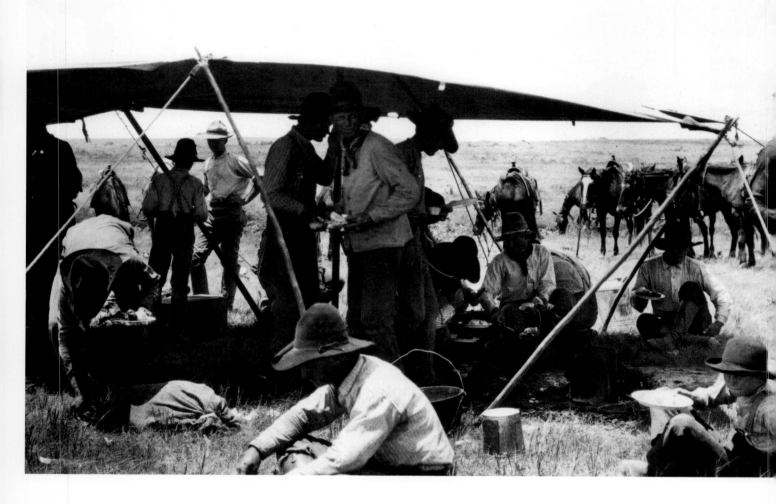

c. 1905 Mealtime provided one of the few opportunities for cowboys to dismount and catch a few moments away from the work of tending the cattle. These cowhands are partaking of a noonday meal during a spring roundup.

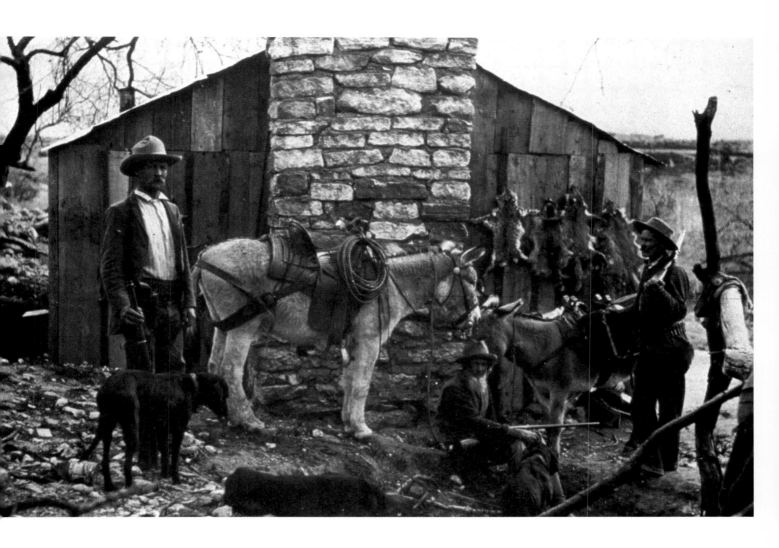

1908 Fur trappers were among the first non–Native
Americans to enter into vast unsettled regions of America.
Even after most of the areas began to be filled with pioneer
families, there were still enough fur–bearing animals for
trappers to ply their trade. This picture was taken at
Brown's Basin in Arizona.

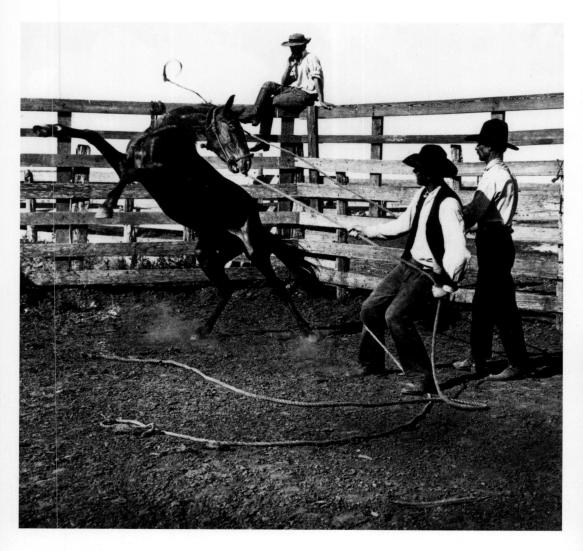

1908 The glory days of the American cowboy
lasted little more than two decades. Yet the cowmen
became the most celebrated of all American figures.
Here, two cowboys at the Matador Ranch in Bonham,
Texas, are engaged in one of the most hazardous of
cowboy tasks – breaking in a wild horse.

1905 This study of an American cowboy was
taken by Erwin Smith. A young cowpuncher himself,
Smith fastened a Kodak camera to his saddle and
produced the most comprehensive photographic
record of cowboy life ever compiled.

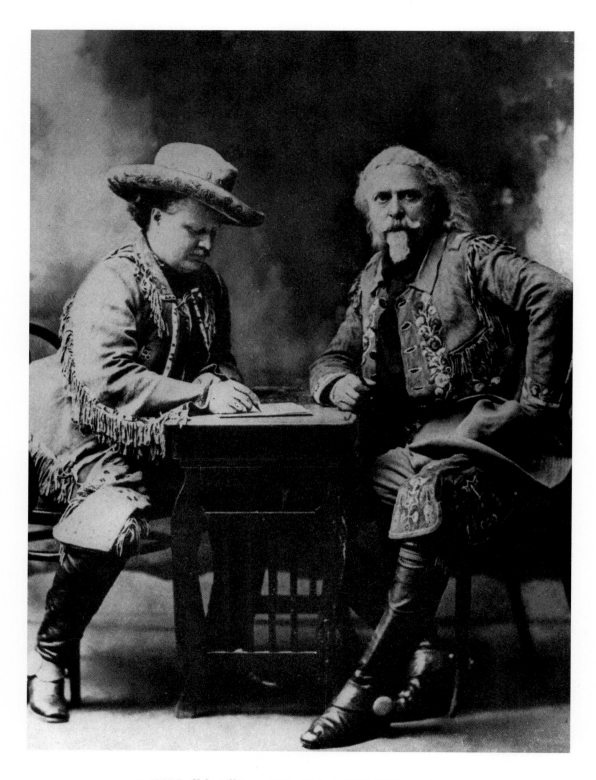

c. 1900 Buffalo Bill, born William F. Cody (1846–1917), was the consummate showman. After gaining fame as a frontier scout, he organized Buffalo Bill's Wild West Show, which drew enormous audiences around the world. The man wearing the hat in this picture is Pawnee Bill, the founder of one of the many other Wild West Shows inspired by Buffalo Bill's success.

c. 1900 The actress Evelyn Nesbit was one of the greatest
American beauties of her day. In 1906, she became a principal in
one of the era's greatest scandals: Nesbit's husband, the railroad
heir Harry K. Thaw, murdered her former lover, the famed architect
Stanford White, during a musical in Madison Square Garden.

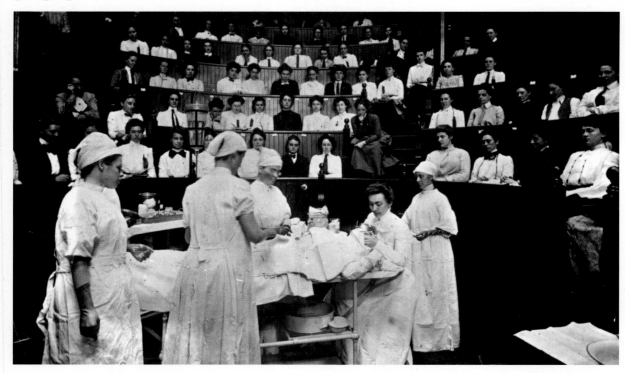

1907 In 1849, Elizabeth Blackwell (1821–1910) became the first American woman to receive a medical degree. Women continued to face many obstacles to receiving medical training, yet by 1907, the ranks of female doctors had increased and some even became surgeons (*above*).

c. 1902 Frances Benjamin Johnston traveled the South photographing young black men and women who were learning trades that would hopefully enable them to improve their way of life. She took this picture (*below*) of a sewing class in Snow Hill, Alabama.

c. 1900 By the early 1900s, Carnegie Hall in New York, a gift of Andrew Carnegie, had become the showplace of America's serious music talent. The young girl in this picture (*right*) was Florence Stern, at that time the youngest violinist ever to perform at Carnegie Hall.

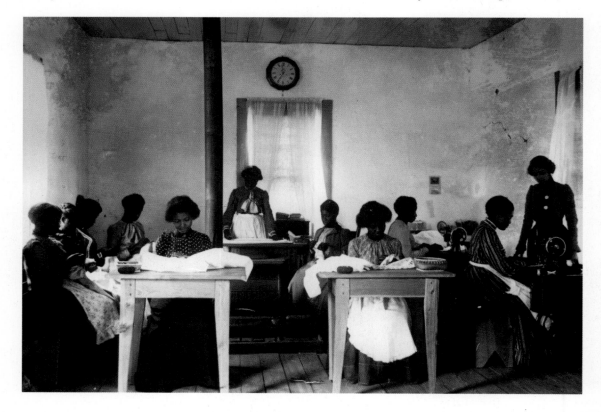

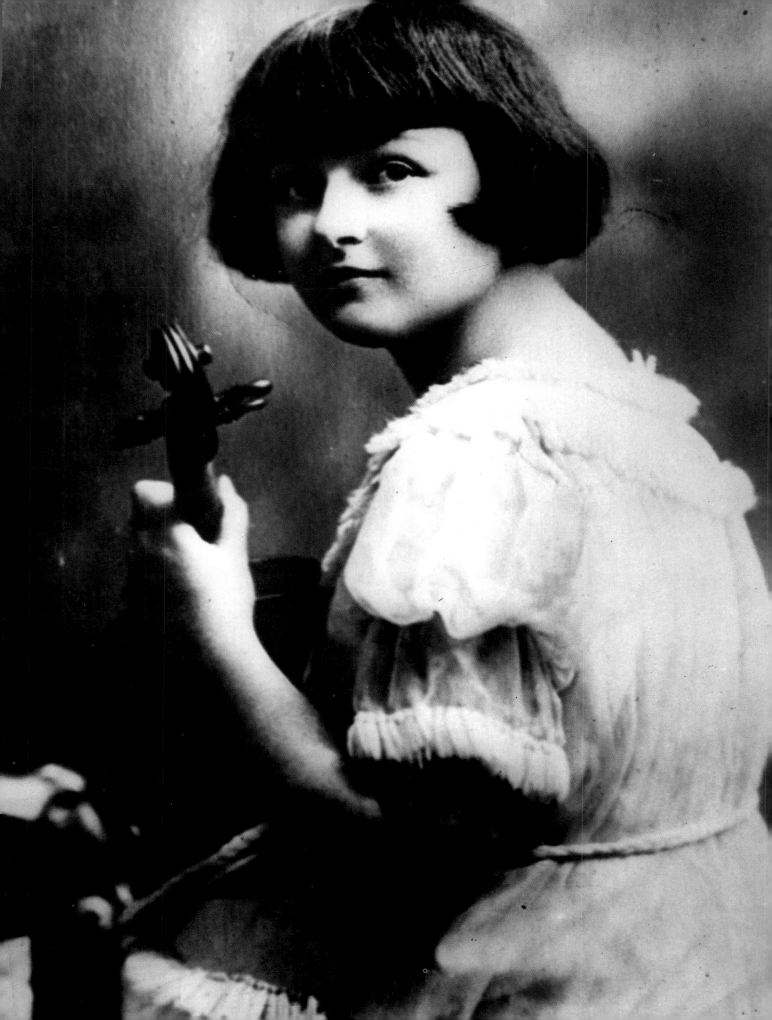

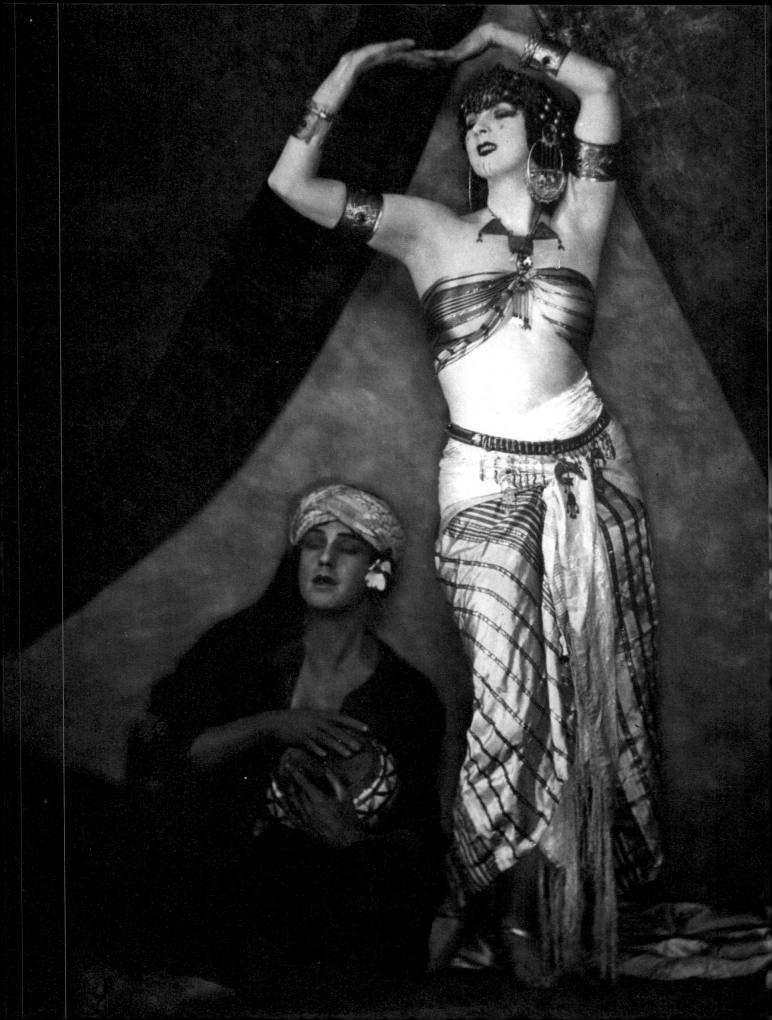

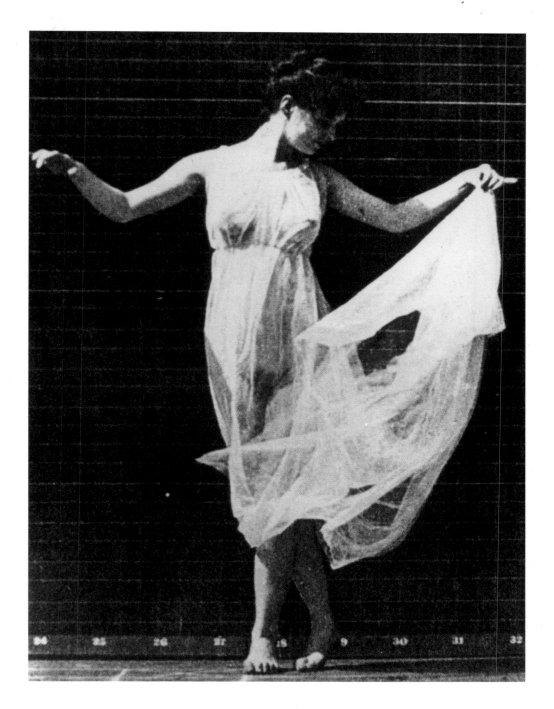

c. 1900 Isadora Duncan (1847–1927), shown here wearing the loose flowing tunic that was her trademark, was America's premier dancer of the early 20th century. An influential teacher, she was a pioneer of Modern dance.

c. 1904 In a time when interpretive and Modern dance were rapidly emerging, Ruth St. Denis (1878–1968) was widely regarded as America's most beautiful dancer. She is shown here with fellow dancer Ted Shawn.

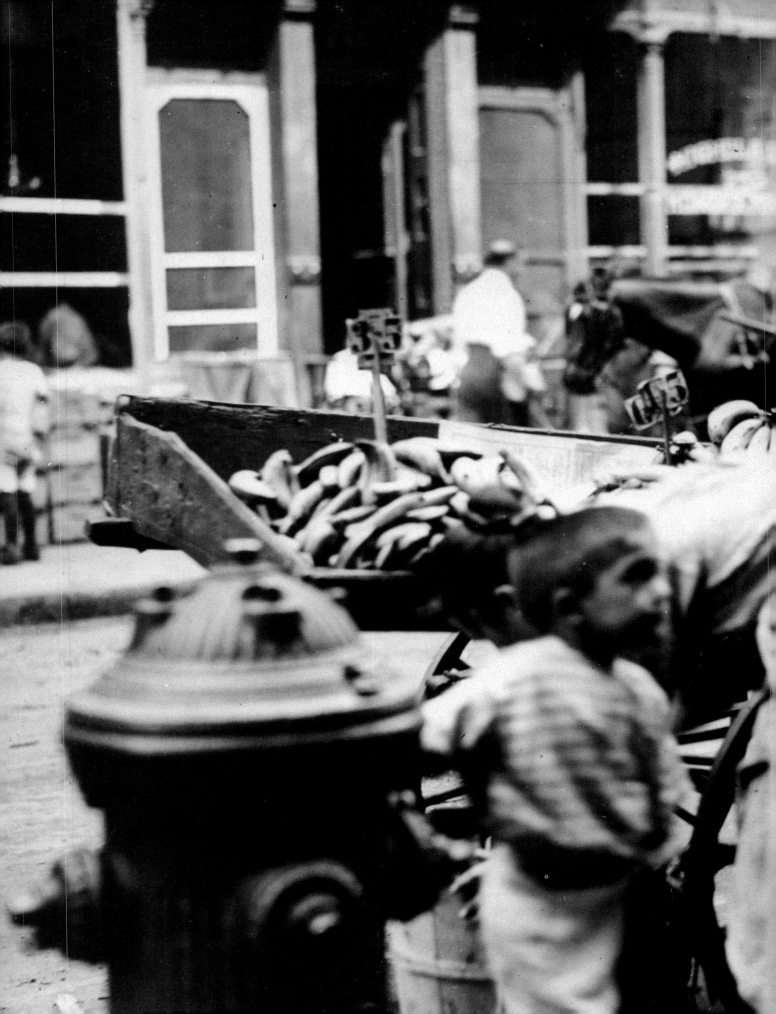

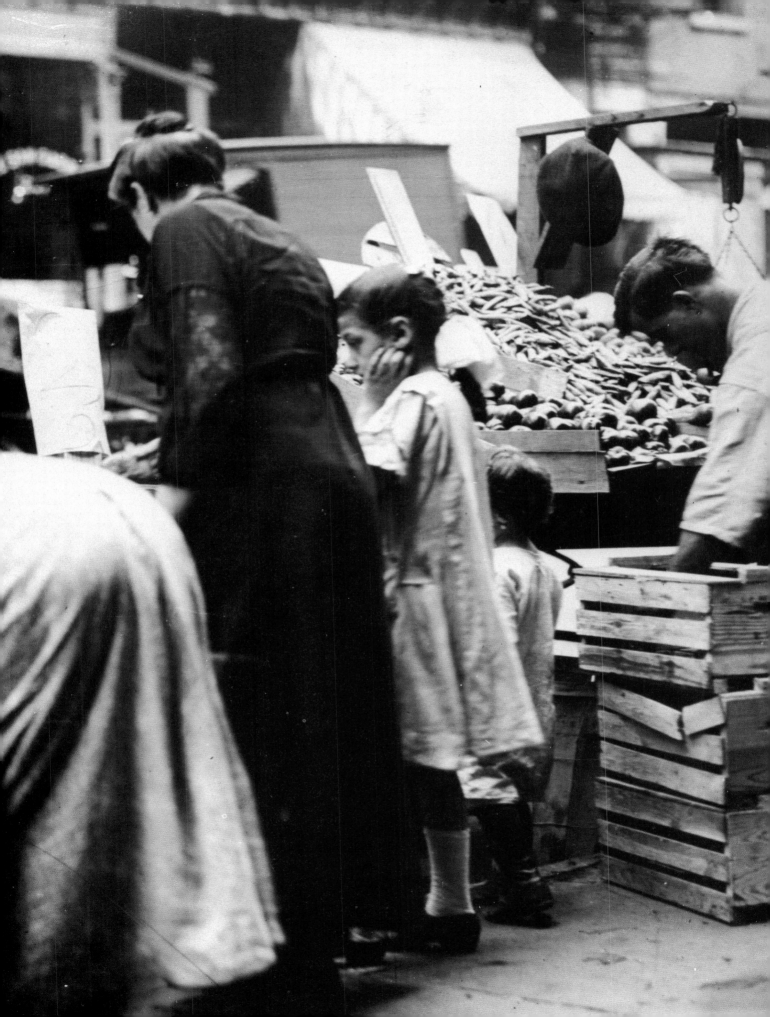

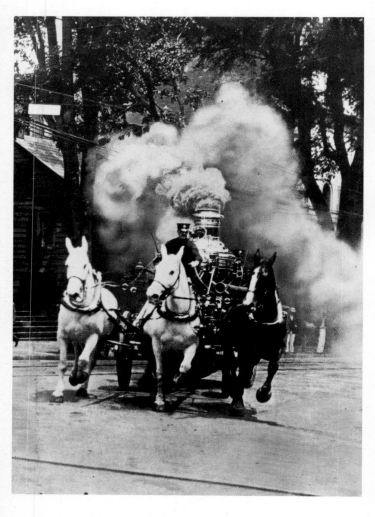

c. 1900 In the early 1900s, most houses and buildings were still built of wood, and fire was a common occurrence. One of the period's most dramatic sights was a horse-drawn fire wagon, its steam-powered pumper billowing smoke.

c. 1900 Supplying essential services to the ever-growing cities was a major challenge. Here, a group of New York's "finest" (*right*) line up for morning roll call.

c. 1900 The first American supermarket did not open until the 1930s; until then, urban families shopped at general stores, specialty shops, or outdoor markets (*previous pages*), such as these mothers with children in tow.

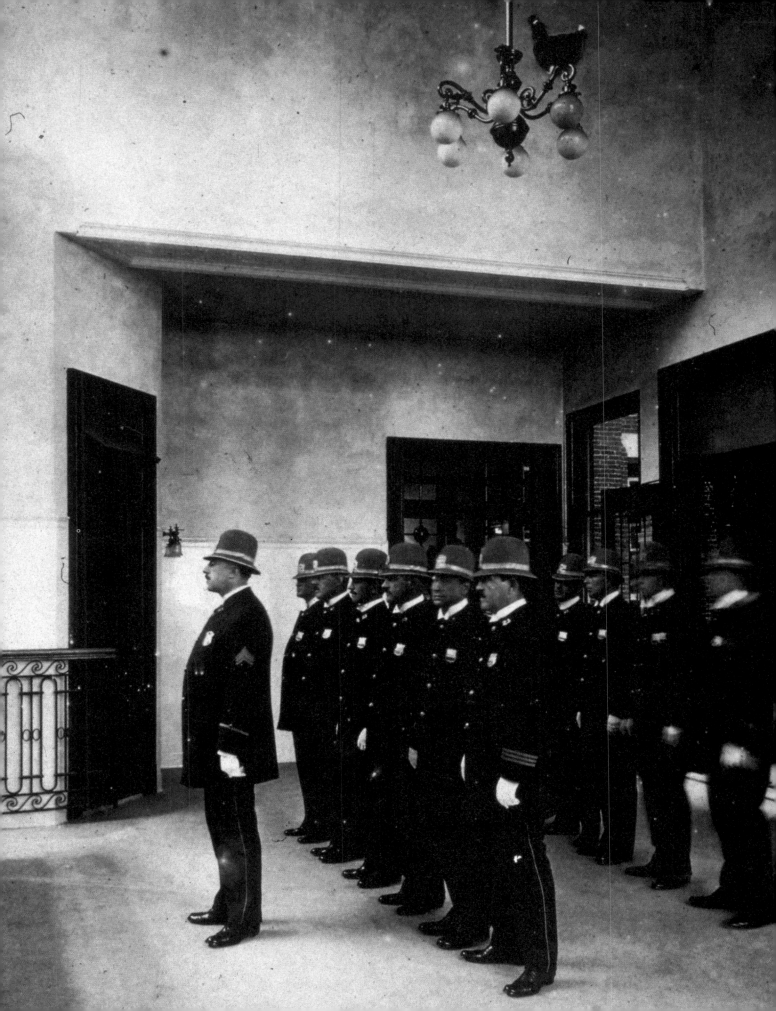

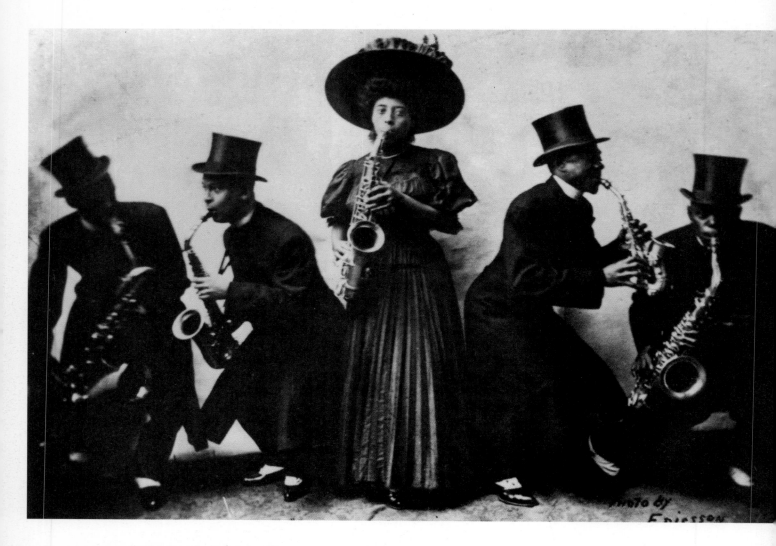

c. 1900 One of the many African–American contributions to American life was jazz, which originated in the early 1900s in New Orleans. Characterized by syncopation and individual improvisation, jazz had its roots in African–American plantation work songs and chants. As jazz grew in popularity, various distinct forms such as Dixieland emerged. This picture depicts an early jazz band posing for the camera.

c. 1900 From 1895 to 1905, Booker T. Washington (1856–1915) was regarded by most Americans, white and black, as the leading spokesman of his race. Born a slave, he was also a highly controversial figure. His willingness to accept social segregation and disenfranchisement for blacks in exchange for educational and economic opportunities put him in disfavor with many of his fellow African–Americans. Tuskeegee Institute, which Washington founded and built into a successful black industrial, vocational, and agricultural college, was a major achievement.

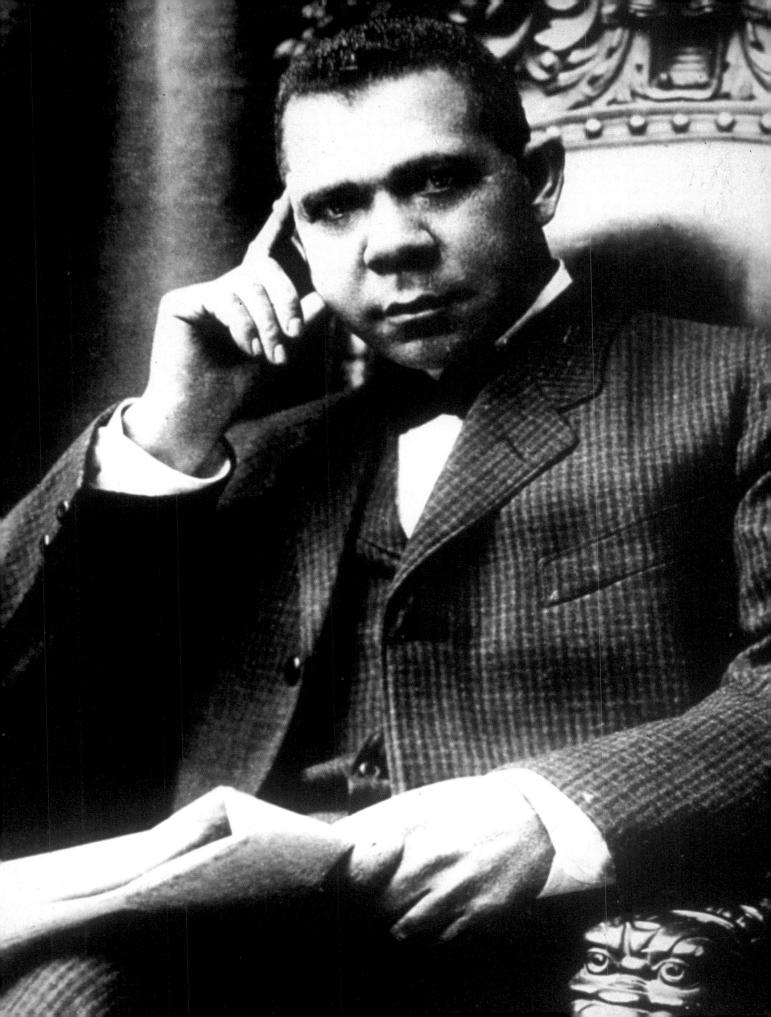

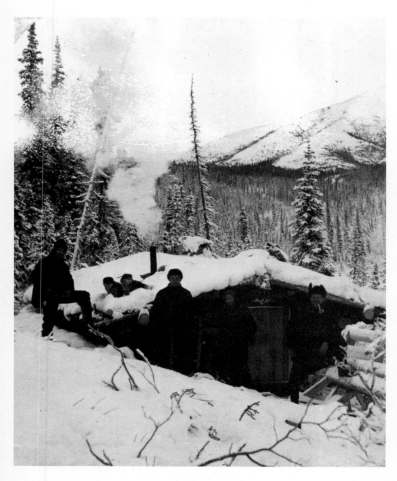

1900 In the early 1900s several gold strikes in Alaska attracted thousands of fortune seekers. Judging by the log cabin they had erected, these prospectors in Alaska's Dilman Creek were determined to remain in the frigid territory until they had struck it rich.

1909 On April 6, 1909, United States explorer Robert Edwin Peary (1856–1920), after several unsuccessful attempts, announced that he had become the first person to reach the North Pole. Eighty years later, however, controversy arose when a noted astronomer claimed that Peary's measurements were incorrect and that he had not, in fact, accomplished the feat.

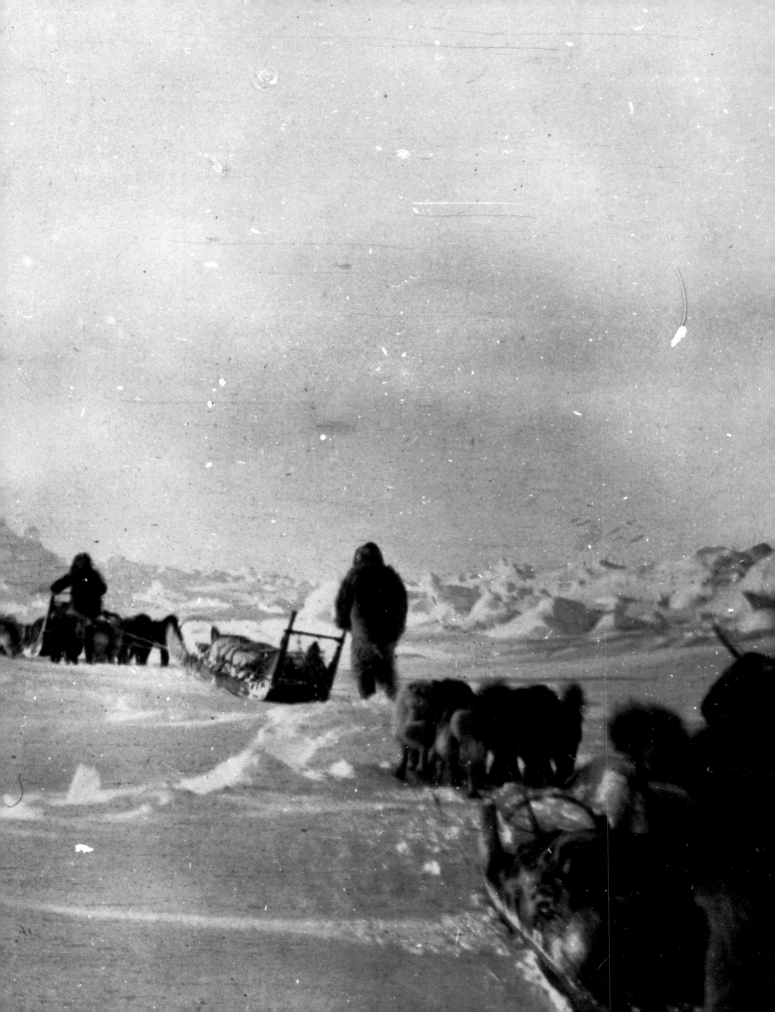

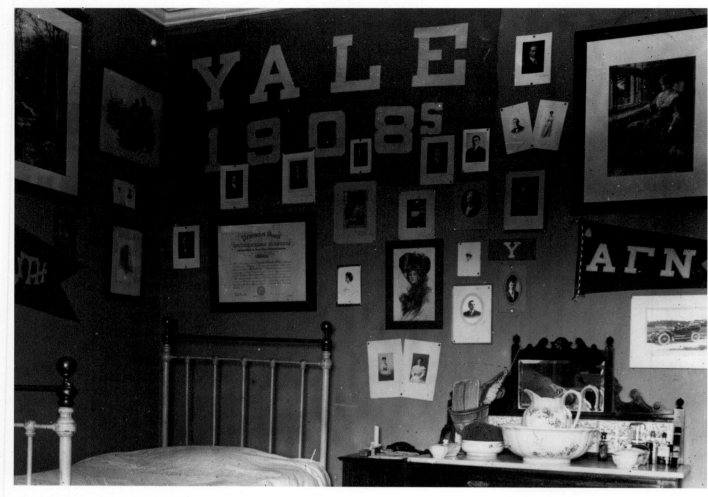

c. 1908 Business and industry increasingly created the demand for new types of knowledge and skills. This is a student's room at Yale University in New Haven.

c. 1900 The prolific novelist Henry James (1843–1916), established himself as among the nation's most accomplished authors (*left*). His books included *Daisy Miller*, *The Portrait of a Lady*, *The Bostonians*, and *The Wings of the Dove*. His *Art of the Novel* was the first major defense of fiction as a serious art form.

c. 1900 Mark Twain (1835–1910), whose birth name was Samuel Langhorne Clemens (*right*), was one of America's most beloved humorists, short story writers, and novelists. His best-known works include *Innocents Abroad*, *The Adventures of Tom Sawyer*, and *Life on the Mississippi*. Ernest Hemingway regarded Twain's *The Adventures of Huckleberry Finn* as the best book in American literature.

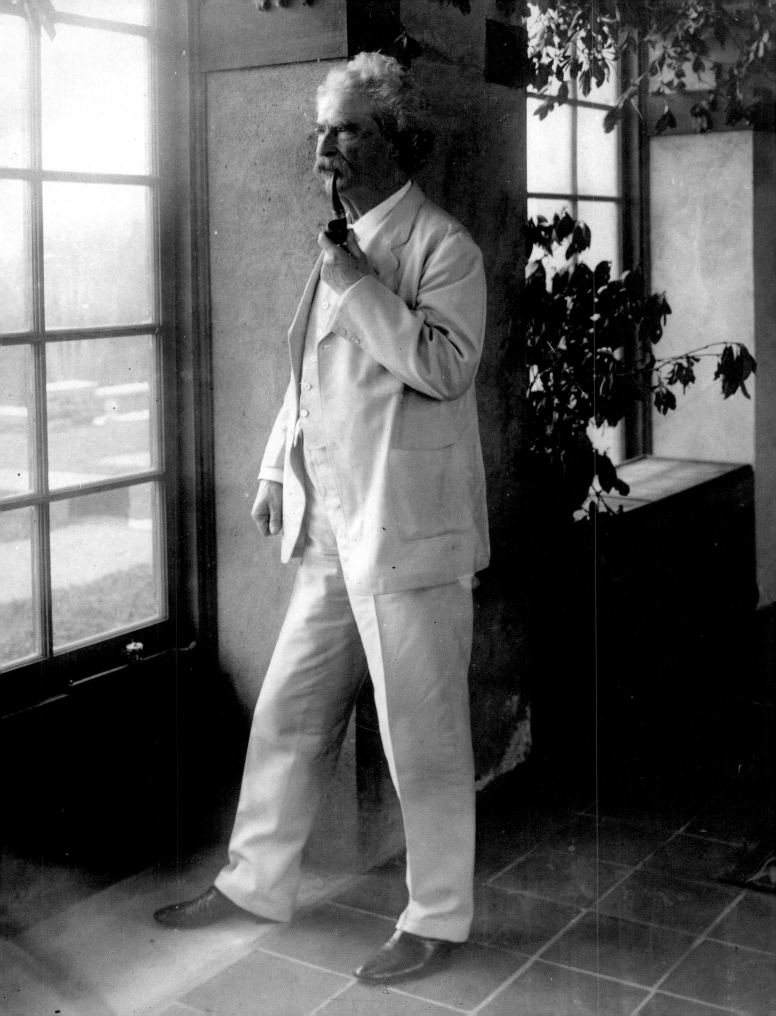

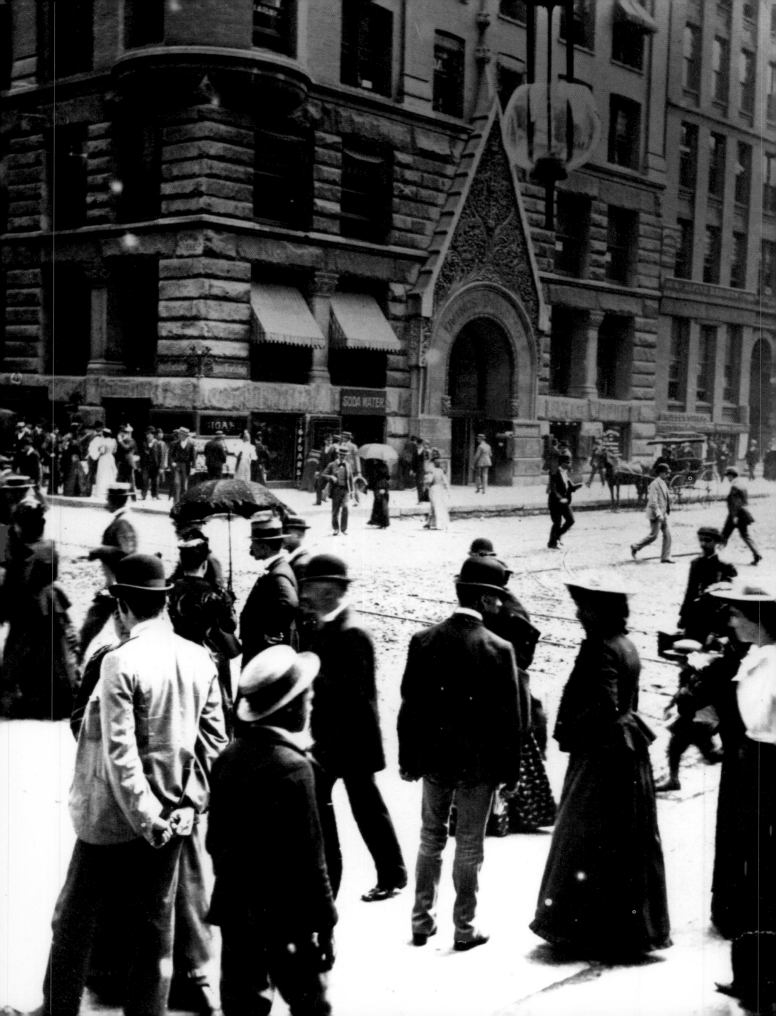

c. 1900 In this Chicago street scene we see two common aspects of turn-of-the-20th-century America. The building in the picture (*left*) is characterized by its ornate detail and everyone in the scene is wearing a hat, including the youngster at the bottom right of the image.

c. 1900 The immigration explosion brought with it changes in the physical face of America. This is the exterior of a Chinese temple, called a joss house, in San Francisco's Chinatown (*below*).

c. 1900 The main street in Salt Lake City, like most other American city streets in the early 1900s, is unpaved and has no sidewalks for pedestrians (*above*).

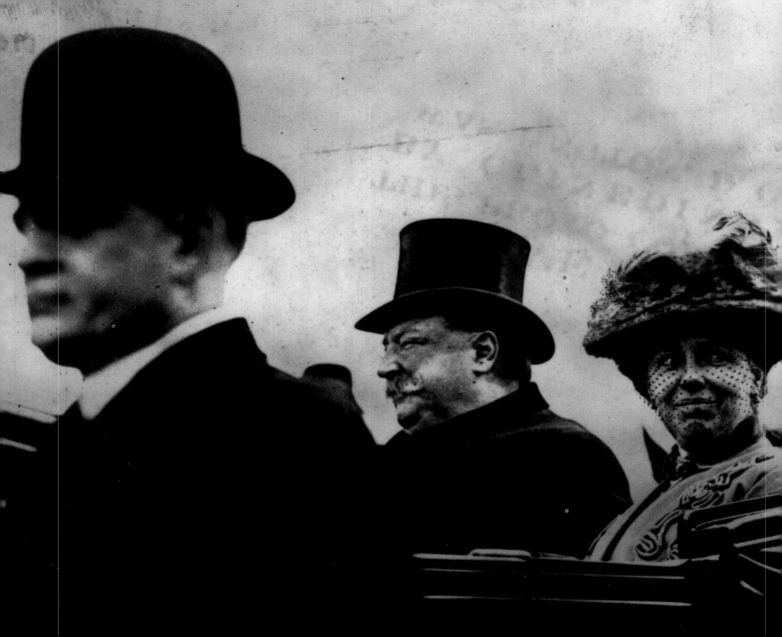

1909 William Howard Taft (1857–1930)
and his wife Helen Herron Taft (1861–
1943) are seen taking the carriage ride
from Taft's inauguration as the 27th
President of the United States. Helen
Taft was the first First Lady to write a
commercially published book (*Recollections
of Full Years*) and the first to accompany
her husband on the ride back from his
inauguration to the White House.

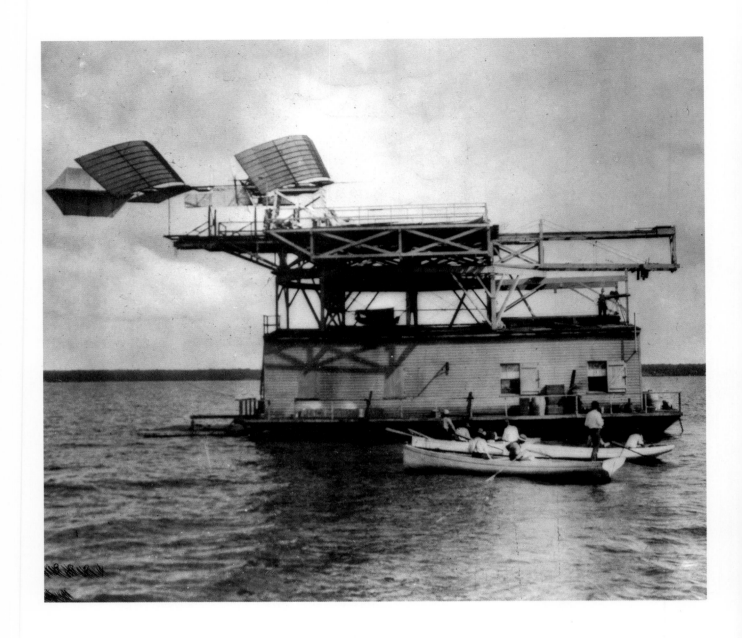

1903 Just a month before the momentous events at
Kitty Hawk, Samuel Langley, an aviation pioneer whose
experiments had inspired the Wright Brothers, attempted his
first flight in a heavier-than-air craft. Here we see Langley's
Aerodrome ready to be catapulted from a houseboat on the
Potomac River. To Langley's chagrin and to the delight of
those who believed man would never fly, Langley's plane
nose-dived into the river upon take-off.

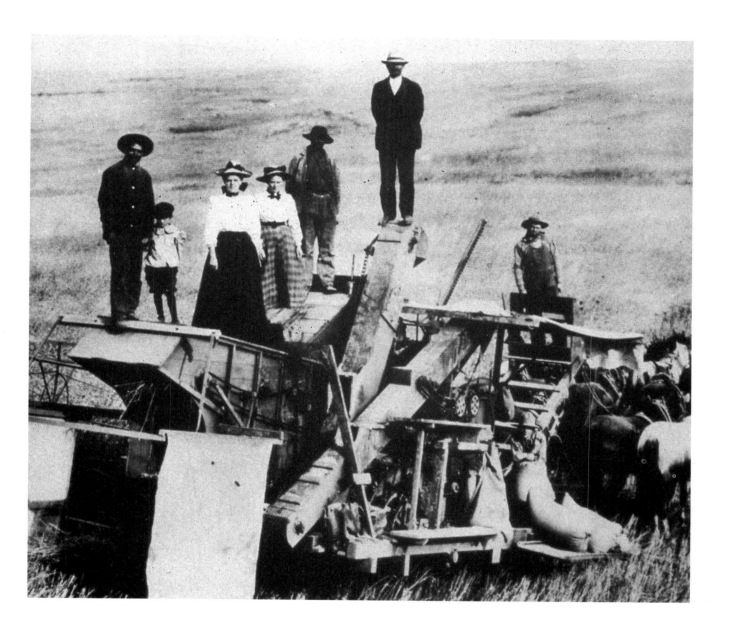

1900 "The saucy machine," proclaimed a midwestern
newspaper, "has driven the scythe from the field . . . and the
principal work of the harvest, now is to drive the horses
about the field a few times and lo! the harvest is gathered."

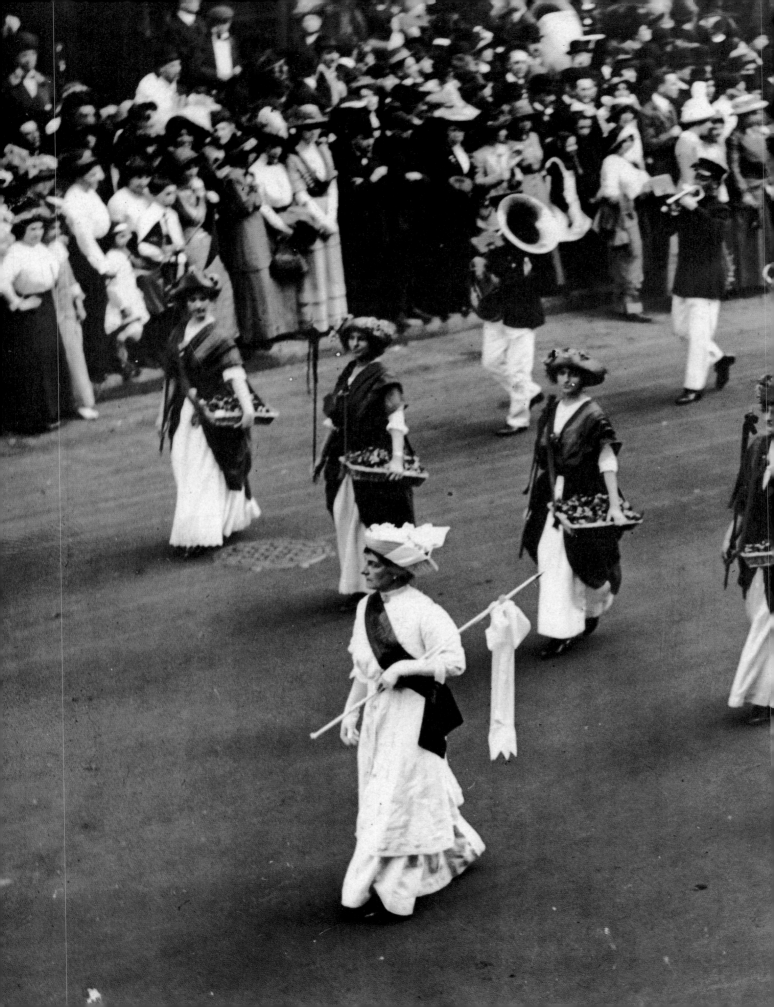

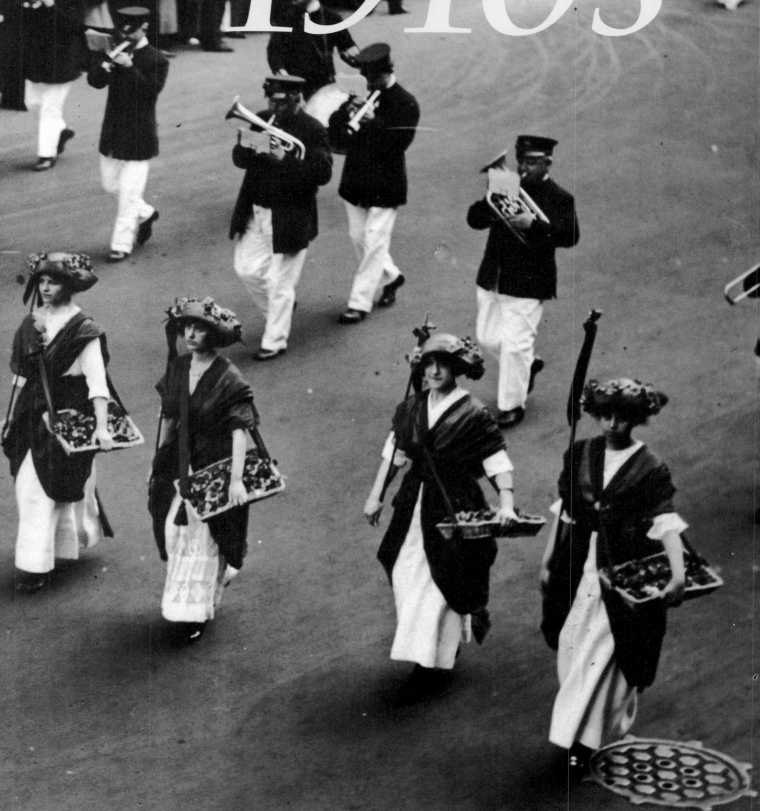

1910s

c. 1910 Americans' veneration of their automobiles came in many forms. This is the winner of the first prize for the best decorated car driven by a woman in a motor parade in Detroit, Michigan. The car is a Chalmers 30.

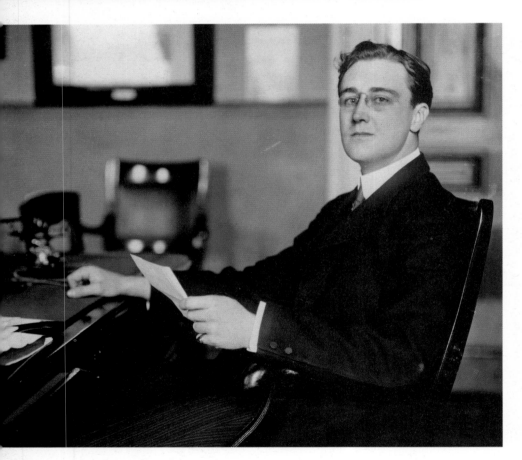

The early 1910s were marked by a President's unsuccessful attempts to keep the nation out of a world war. On the home front it was a time when Americans began to embrace spectator sports, and athletes like Jim Thorpe and Jack Dempsey became national heroes.

Thanks to improved steel and the invention of the elevator, the growing cities began to expand vertically as well as horizontally. The nation's love affair with the automobile reached new heights as the Ford Motor Company alone produced almost a quarter of a million cars in a single year. American women made their presence felt as never before by campaigning actively for their long overdue right to vote. And by mid-decade, Americans everywhere had discovered a new form of entertainment: the movies.

1913 Before he became the 32nd President of the United States in 1933, Franklin D. Roosevelt (1882–1945) was a New York State senator, and Assistant Secretary of the U.S. Navy in Woodrow Wilson's administration. Roosevelt was 31 years old when he posed for this picture in his Navy department office.

1918 The struggle for women's suffrage began with the Seneca Falls Convention for women's rights in 1848 and lasted for more than 70 years. Here (*previous pages*) we see a group of suffragettes marching in a New York City parade.

1917 By the 1910s, billboards were in evidence throughout cities and towns throughout America and were a visible symbol of the growth of American business in general and the advertising industry in particular. Here artist Lucille Patterson applies her talent to a billboard high above the streets of New York.

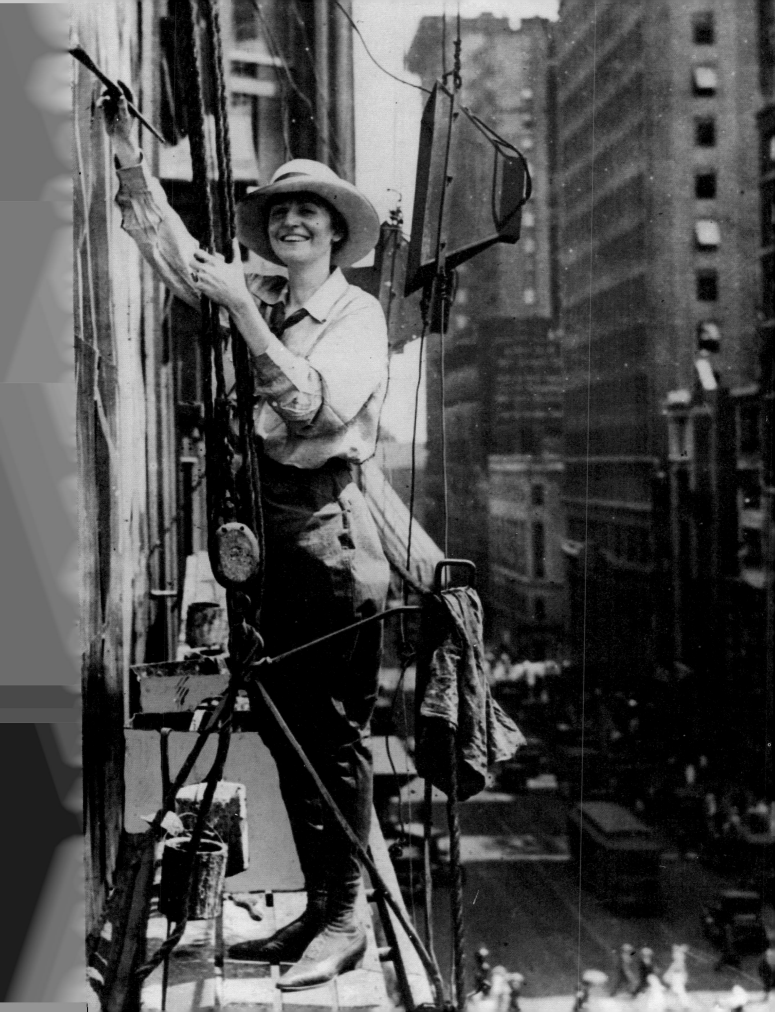

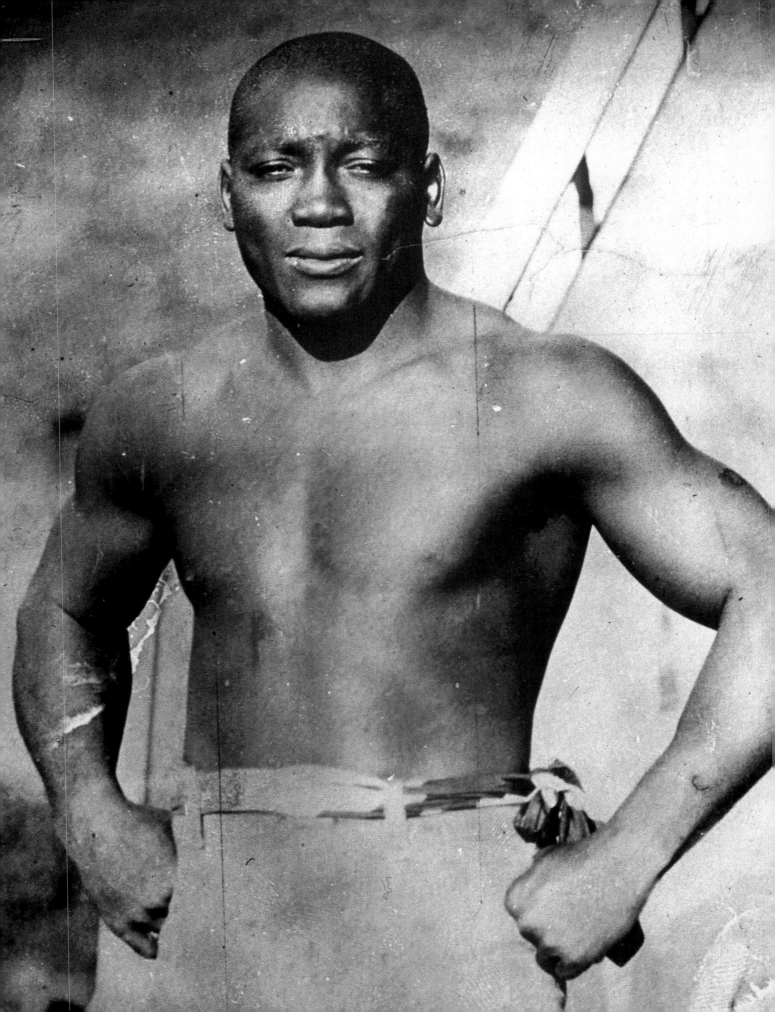

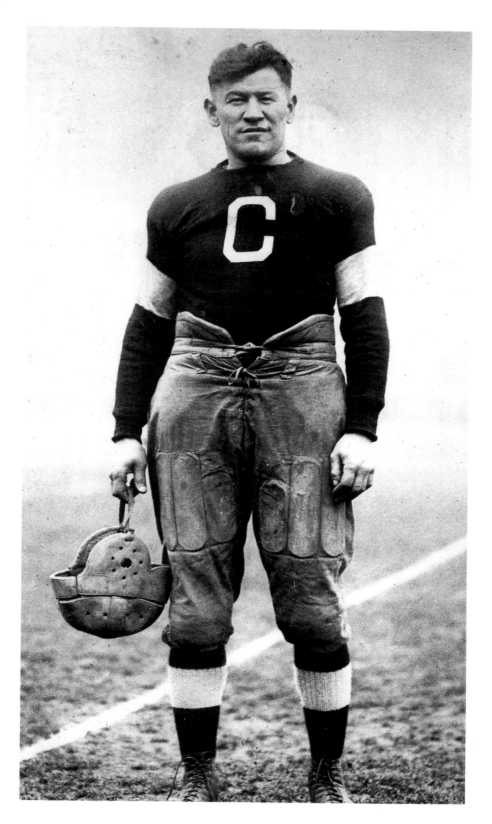

1910 Jack Johnson (1878–1968) overcame severe racial prejudice to become the first African-American to win the Heavyweight Championship of the World. He won his title in 1908 and held it until 1915 when he was ousted by Jess Willard, in what many believed was a biased decision.

c. 1915 Native American Jim Thorpe (1888–1953) was one of the nation's greatest and most versatile athletes. As a member of the 1912 U.S. Olympic Team in Stockholm he won both the decathalon and pentathalon, and was also an outstanding professional baseball and football player.

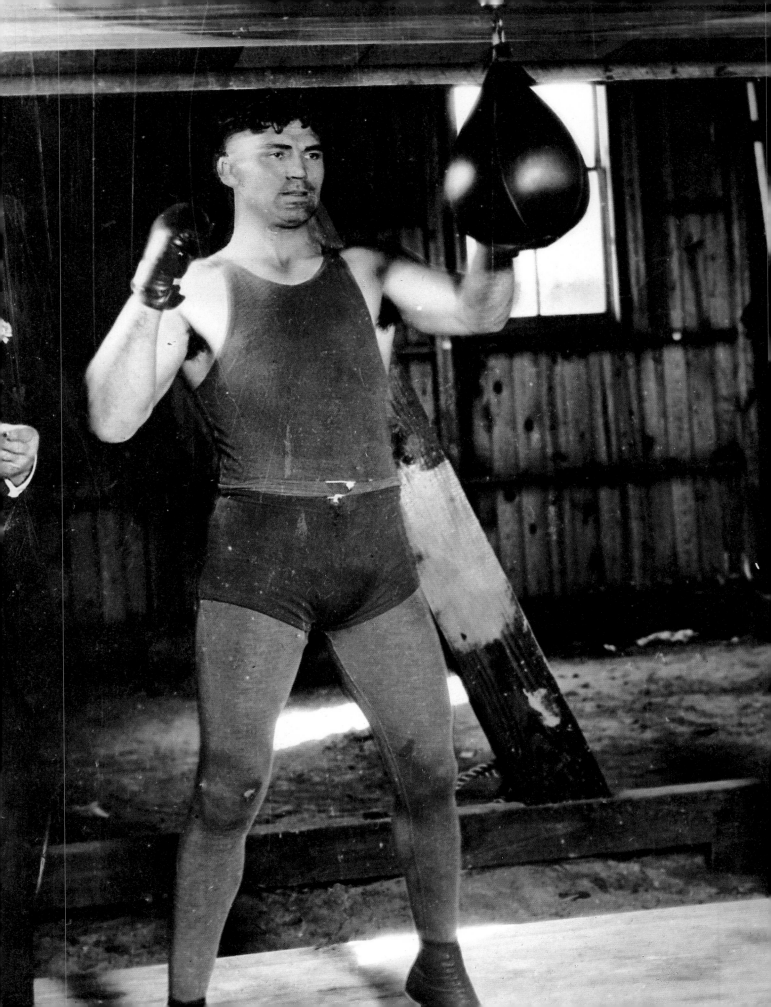

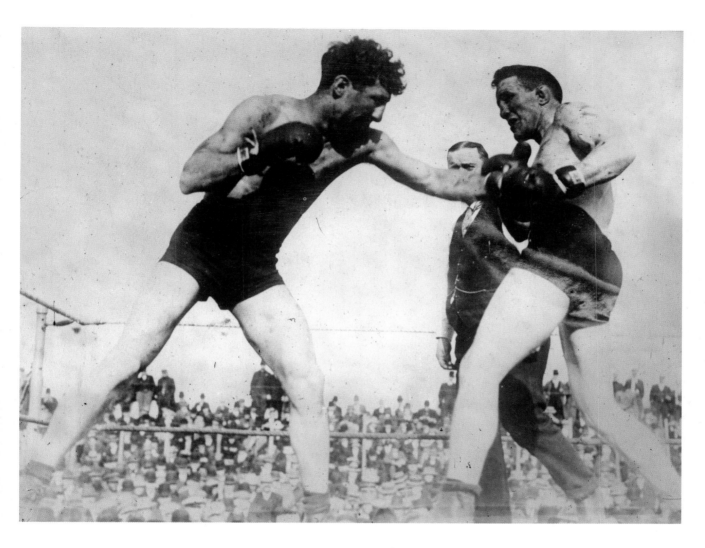

1913 Thanks to such popular fighters as Jess Willard, Jack Dempsey, and Gene Tunney, boxing matches in the first quarter of the 1900s drew hordes of spectators. In this picture, the Jewish–American boxer Abe Attel defends his featherweight crown.

c. 1915 Jack Dempsey (1895–1983), the legendary heavyweight champion, works the punching bag. Known as the "Manassa Mauler," Dempsey won his title from Jess Willard in 1919 and lost it to Gene Tunney in 1927.

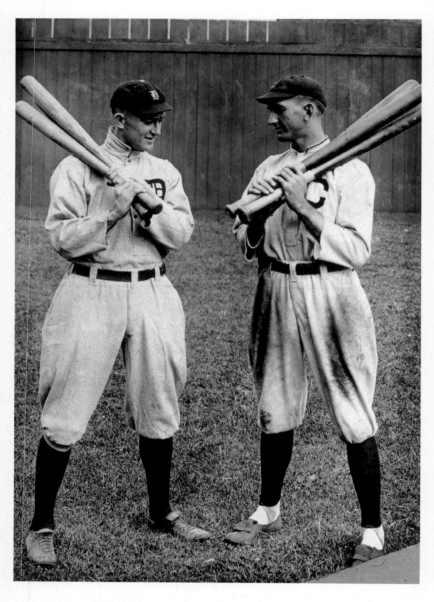

c. 1915 Ty Cobb (1886–1961) and "Shoeless Joe" Jackson (1867–1951) were two of the most accomplished early major leaguers. Cobb still holds the record for his lifetime batting average of .367. Jackson, an outstanding hitter and fielder, was banned from baseball for his part in the infamous "Black Sox" scandal.

1910 "Baseball," wrote Mark Twain, "is the very symbol, the outward visible expression of the drive and pride and rush and struggle of the raging, booming . . . century."

c. 1910 Of all the many automobile races that captured the attention of the American public in the 1910s, the greatest attraction was the annual race held at the Indianapolis Motor Speedway *(following pages)*. Today, the Indianapolis 500 remains America's premier automotive racing event.

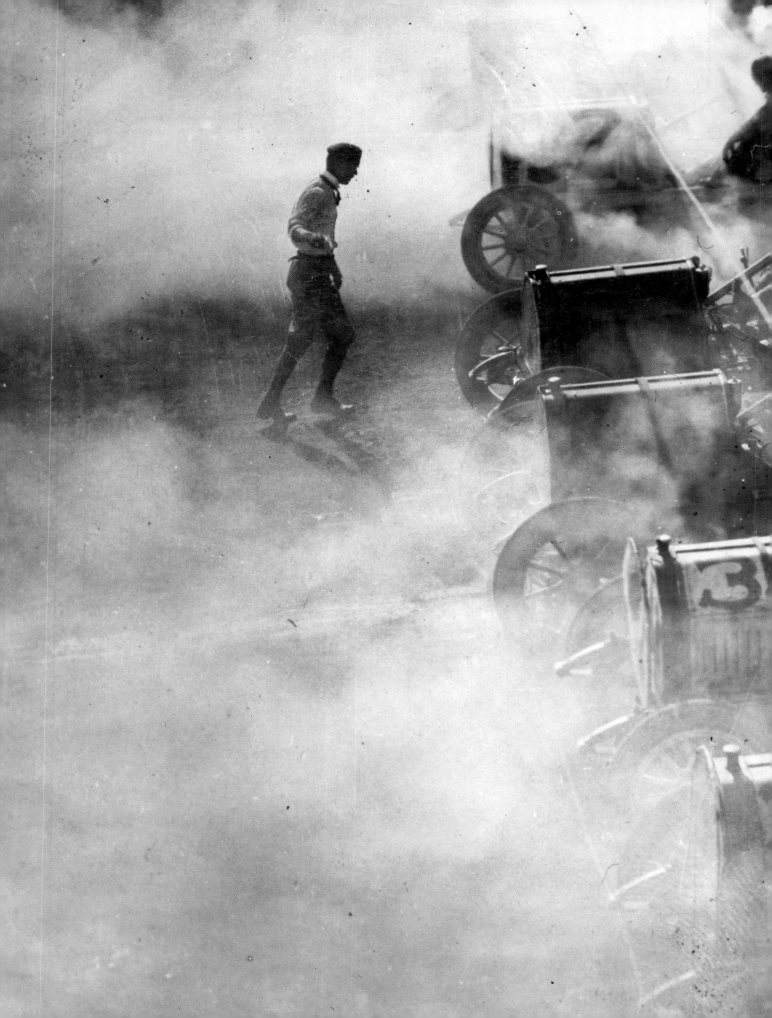

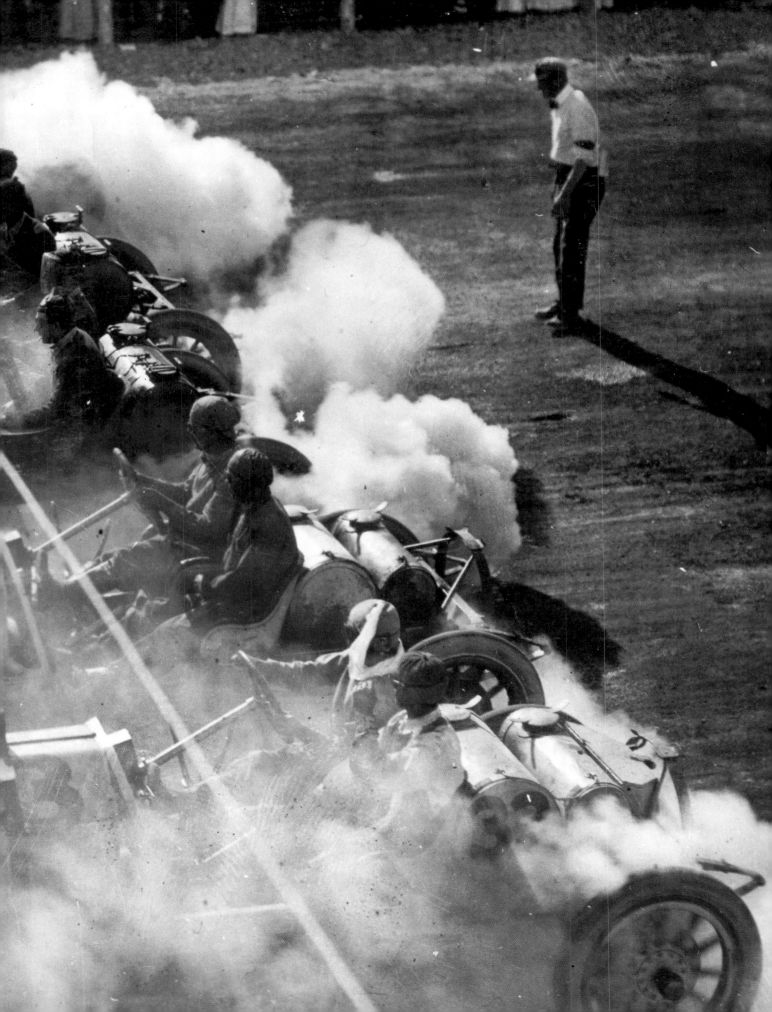

c. 1910 One early automobile manufacturer advertised his cars with the slogan "No hill too steep. No sand too deep." It was a gross exaggeration. In 1910 the lack of paved roads still presented a major obstacle to travel by car.

1914 Along with the race at the Indianapolis Speedway, the Vanderbilt Cup Motor Race was one of the nation's most popular and highly attended automobile contests. Early auto racing introduced the rear–view mirror, modern spark plugs, and streamlined designs.

c. 1910 A New York to Paris automobile contestant arrives at the typical American mining town of Cherry Creek in Nevada.

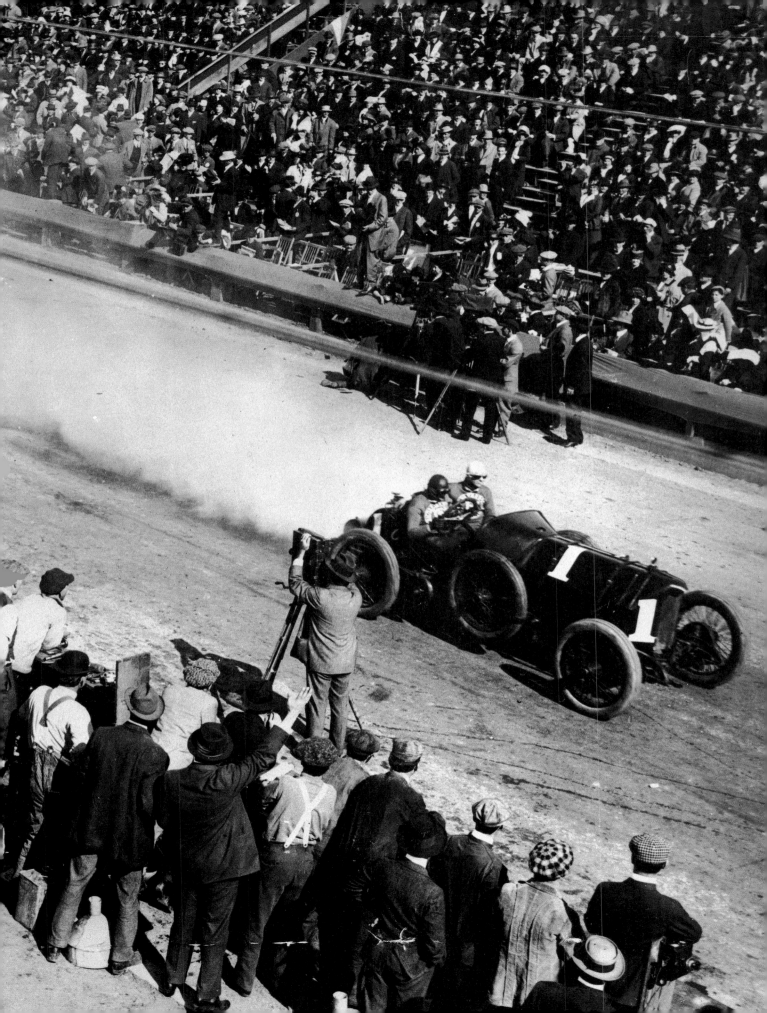

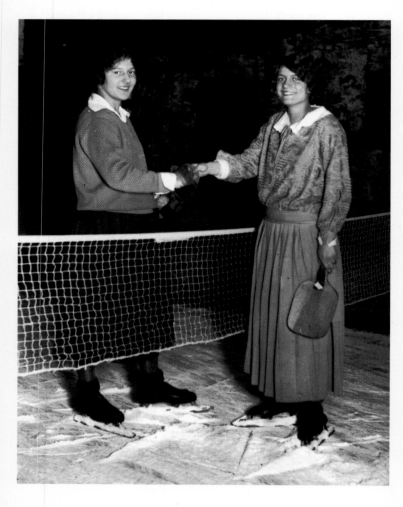

c. 1919 Two young women shake hands after completing their tennis match played on ice. Sports–hungry Americans seemed willing to embrace almost any new sport that was introduced. Not surprisingly, ice tennis suffered an almost immediate demise.

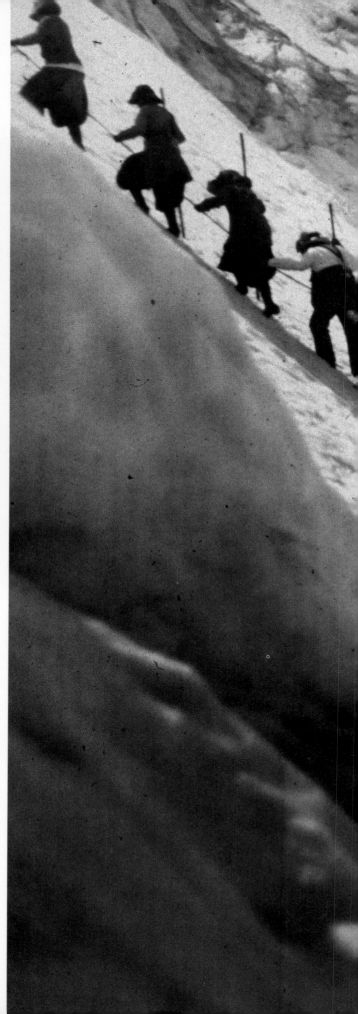

1913 By the time this picture was taken, millions of Americans had become participants as well as spectators in all types of outdoor recreation and sports. This is a group of climbers making their way to the summit of Oregon's Mount Hood.

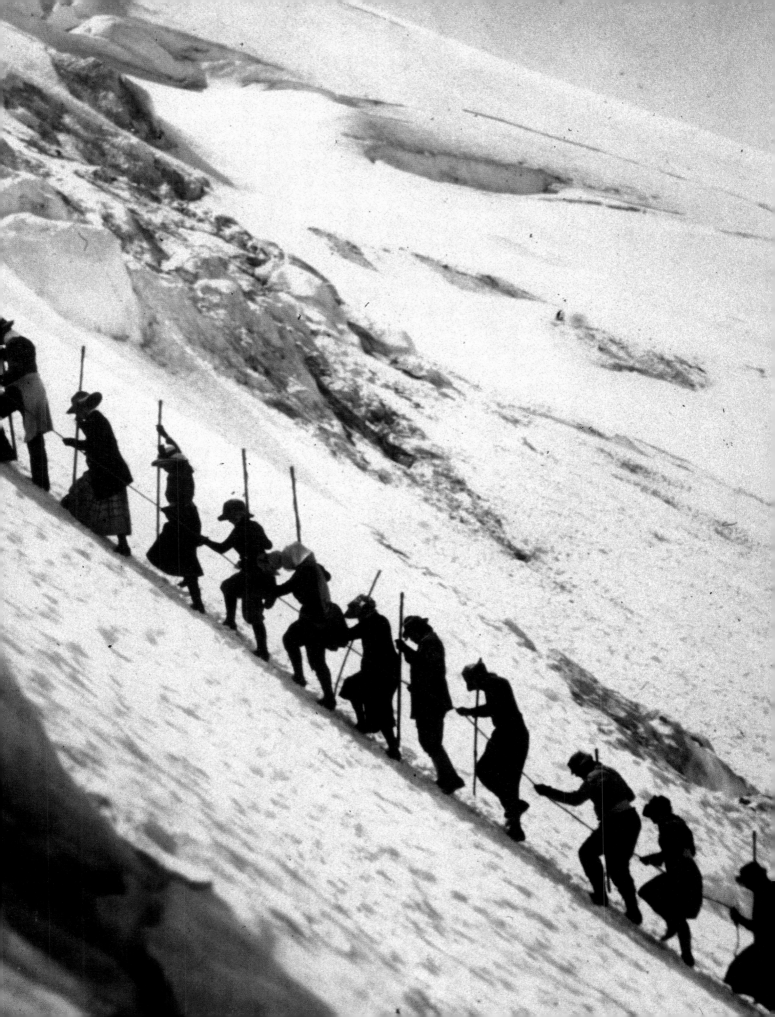

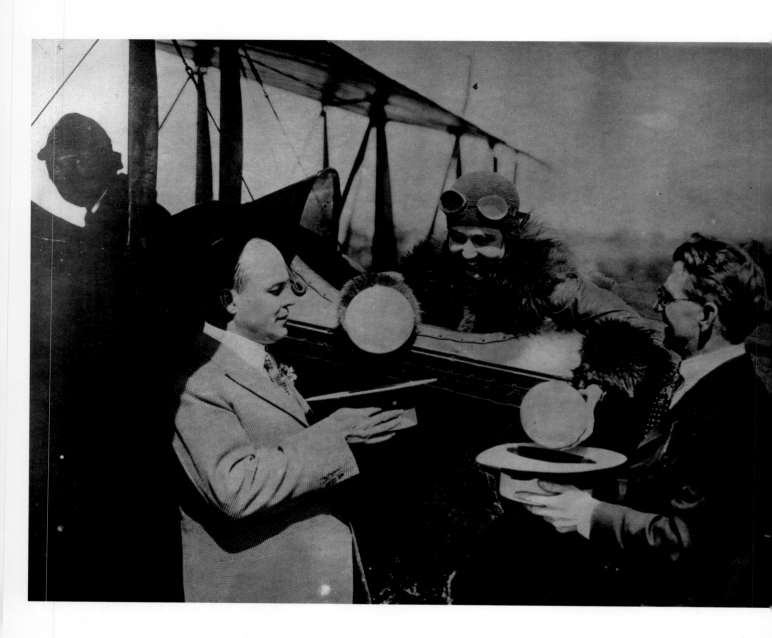

c. 1915 Although it is difficult to imagine there was a huge demand for the product, the pilot and woman in this photograph made daily deliveries of ostrich eggs from California to eastern cities. The men in the picture are using their hats to protect the fragile items.

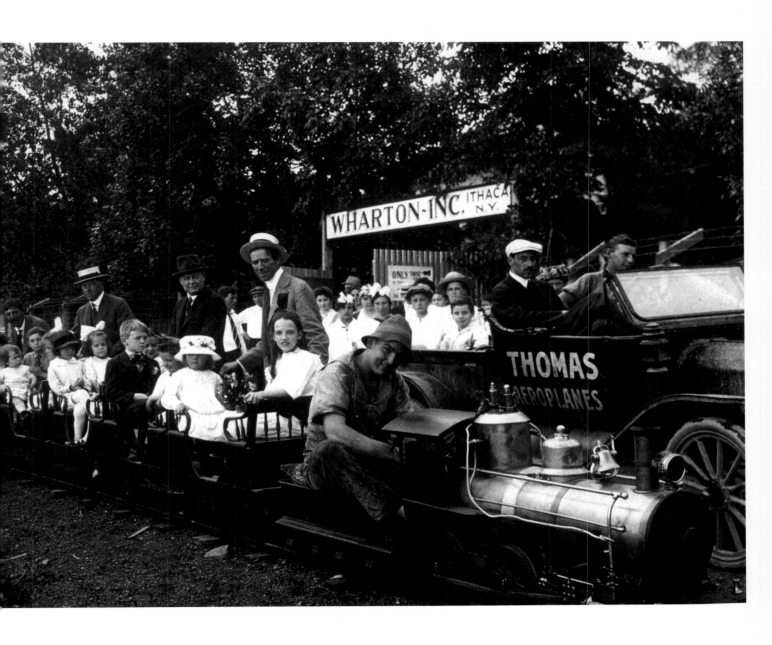

c. 1915 One of the most popular attractions at early
American amusement parks was the miniature train ride.
Here we see children dressed in their Sunday best ready to
begin their ride at a park in Ithaca, New York.

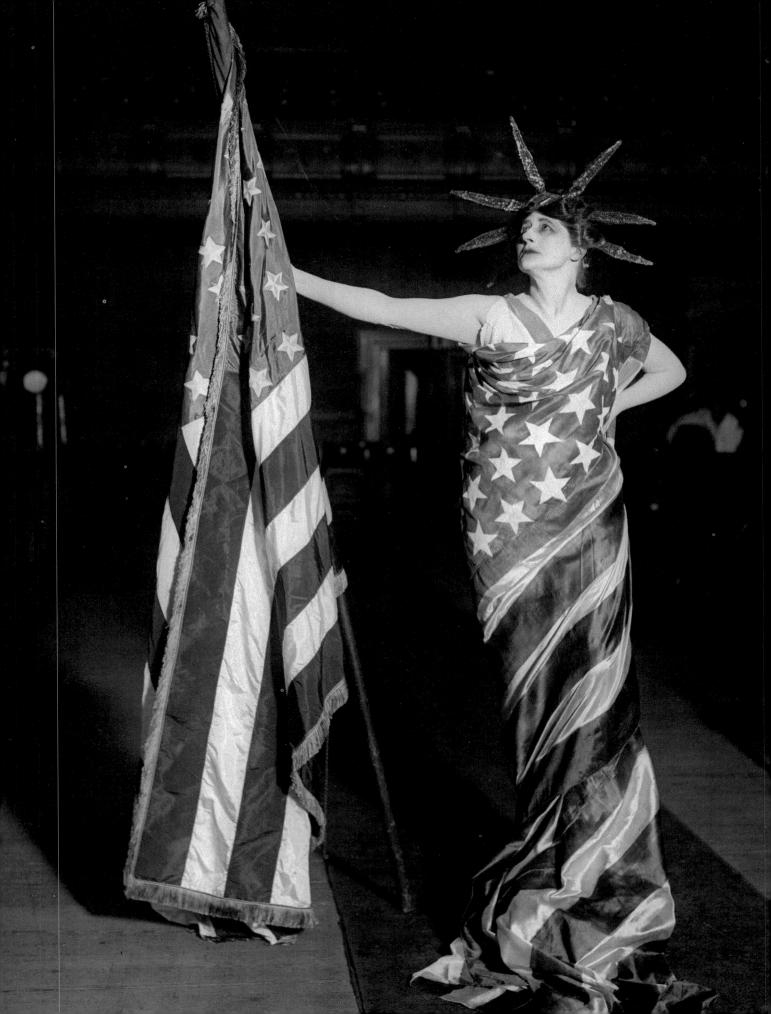

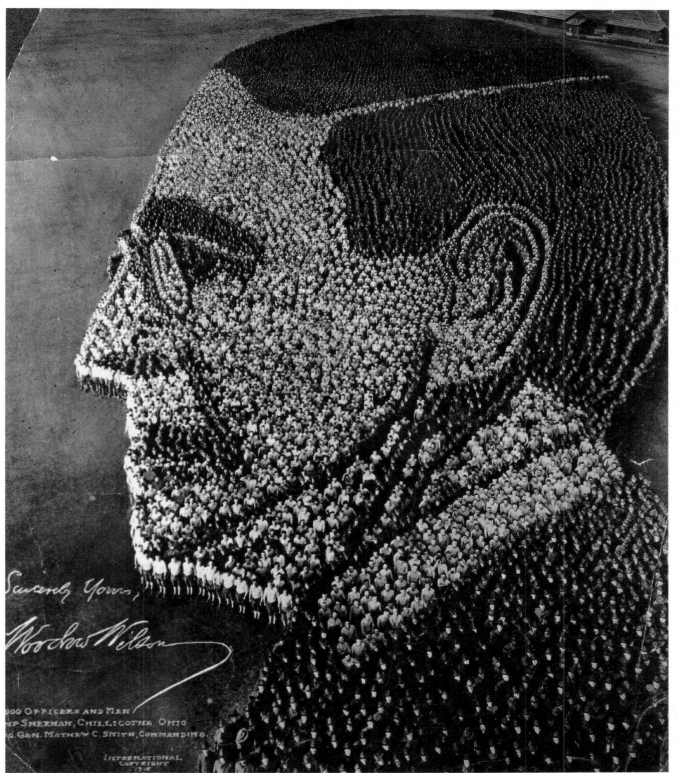

1918 America's participation in World War I occasioned an enormous burst of patriotism. This woman, wrapped in stars and stripes and proudly displaying the American flag, was taking part in a "Pageant of Freedom," one of many similar types of events held throughout the nation.

1918 As the nation's commander–in–chief in World War I, President Woodrow Wilson (1856–1924) was a symbol of America's determination in what was then regarded as "the war to end all wars." Here 21,000 soldiers at Camp Sherman, Ohio, create a living portrait of the President.

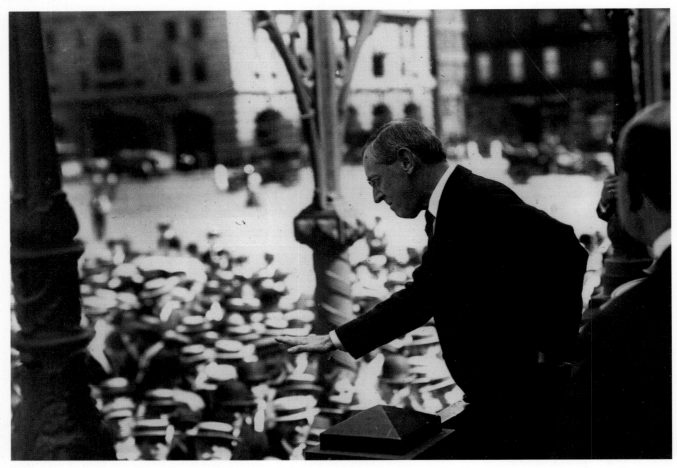

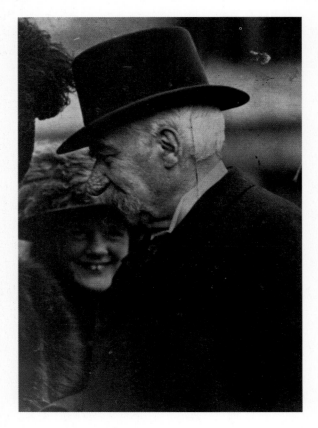

c. 1917 Woodrow Wilson speaking at a World War I rally (*above*). The 28th President of the United States, Wilson was the first chief executive who had been president of a major university: Princeton.

c. 1910 Out of the rise of American business emerged men of enormous wealth and influence (*left*) such as the financier John Pierpont Morgan (1837–1913). No event better illustrated his power than the financial crisis of 1895, when the U. S. government was forced to borrow $62 million in gold from Morgan's banking firm in order to replenish the Treasury Department's revenues.

c. 1910 Founder of the Standard Oil Company, John D. Rockefeller (1839–1937) (*right*) achieved his enormous wealth by gaining 90 percent control of all American refineries. Rockefeller (*in top hat*) retired in the 1890s and devoted himself to philanthropy, giving away more than $550 million before his death.

1919 Woodrow Wilson (*following pages*) is on his way to sign the Treaty of Versailles following World War I. One of the architects of the Treaty, Wilson's greatest political disappointment came when his impassioned plea for the establishment of a League of Nations was rejected by the United States Congress.

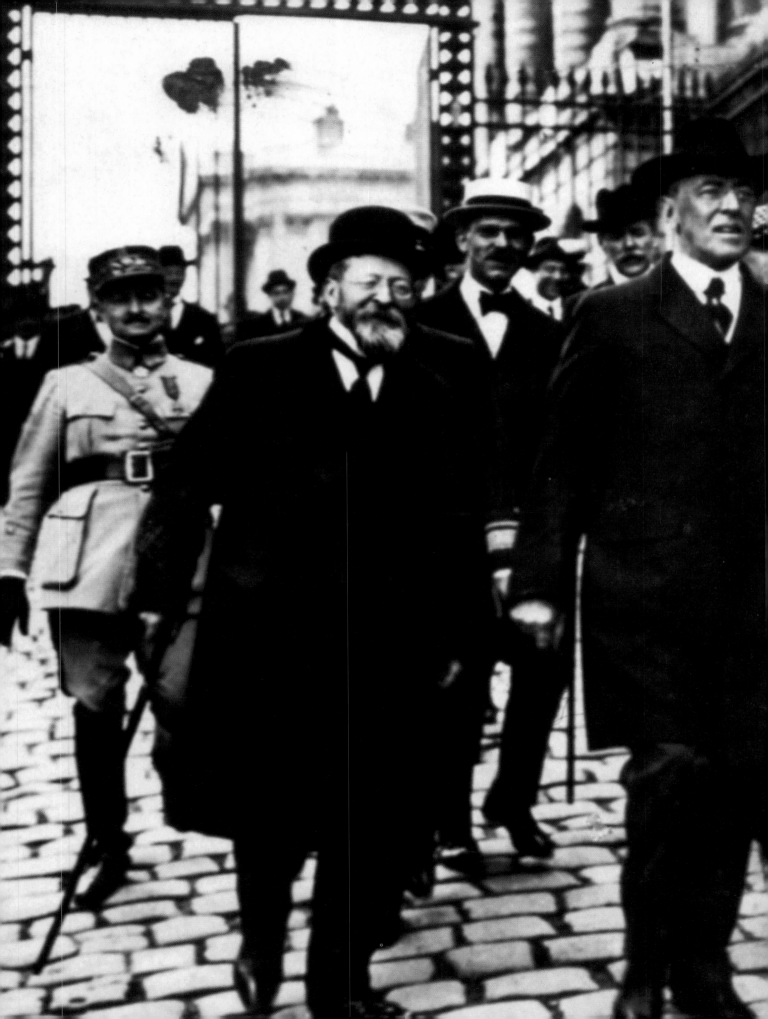

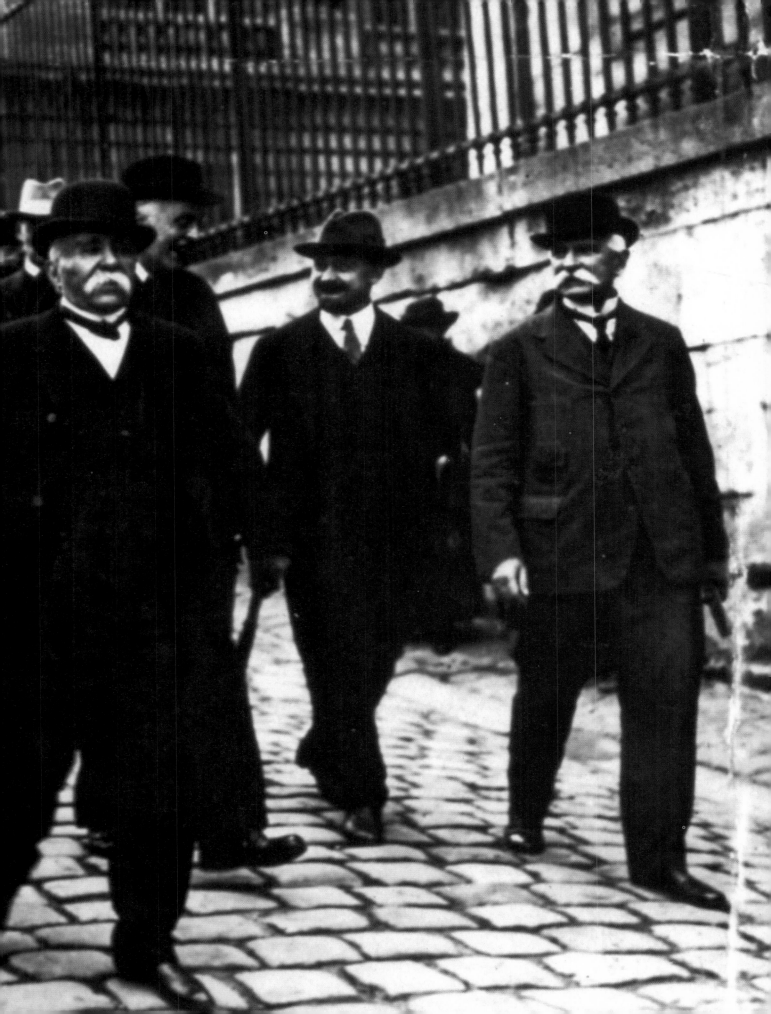

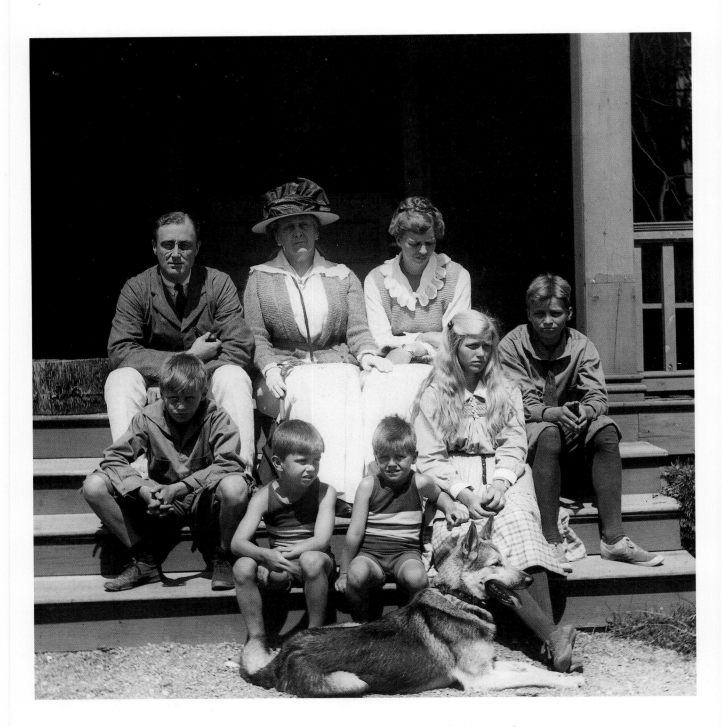

1919 Franklin Delano Roosevelt, his mother, wife Eleanor, and the Roosevelt children in front of their home at Hyde Park, New York. Fourteen years after this picture was taken Roosevelt would be elected President and would served longer (12 years and 39 days) than any other Chief Executive.

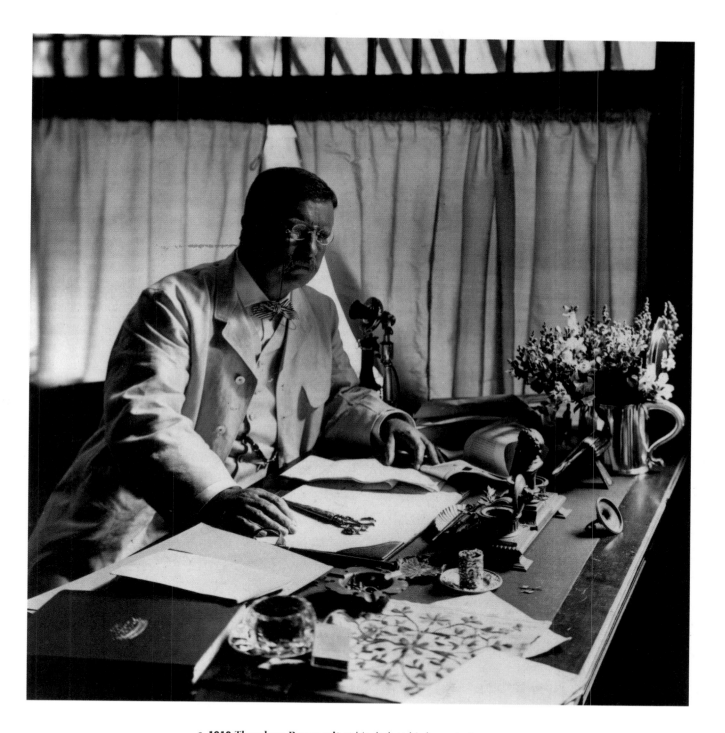

c. 1910 Theodore Roosevelt at his desk at his home in Sagamore Hill, New York, a year after his presidency ended. In 1912, Roosevelt was an unsuccessful candidate for the Republican nomination. He then organized the Progressive ("Bull Moose") Party, but was defeated in the election by Woodrow Wilson.

c. 1919 American socialite

c. 1919 American socialite
Mrs. Wallace Spencer (1896–
1986). At the time of this picture
(*left*) she was married to naval
officer Earl Spencer. In 1927
they divorced. During the
1930s she dominated world
headlines when she married
England's Edward VIII, who
gave up his throne for her.

c. 1919 As business magnates
continued to accumulate wealth,
the term "high society" became
part of the American lexicon.
Here (*right*) Mrs. Arthur Iselin,
wife of a successful society
photographer, and a friend,
share a laugh at the fashionable
New York Bulldog Show.

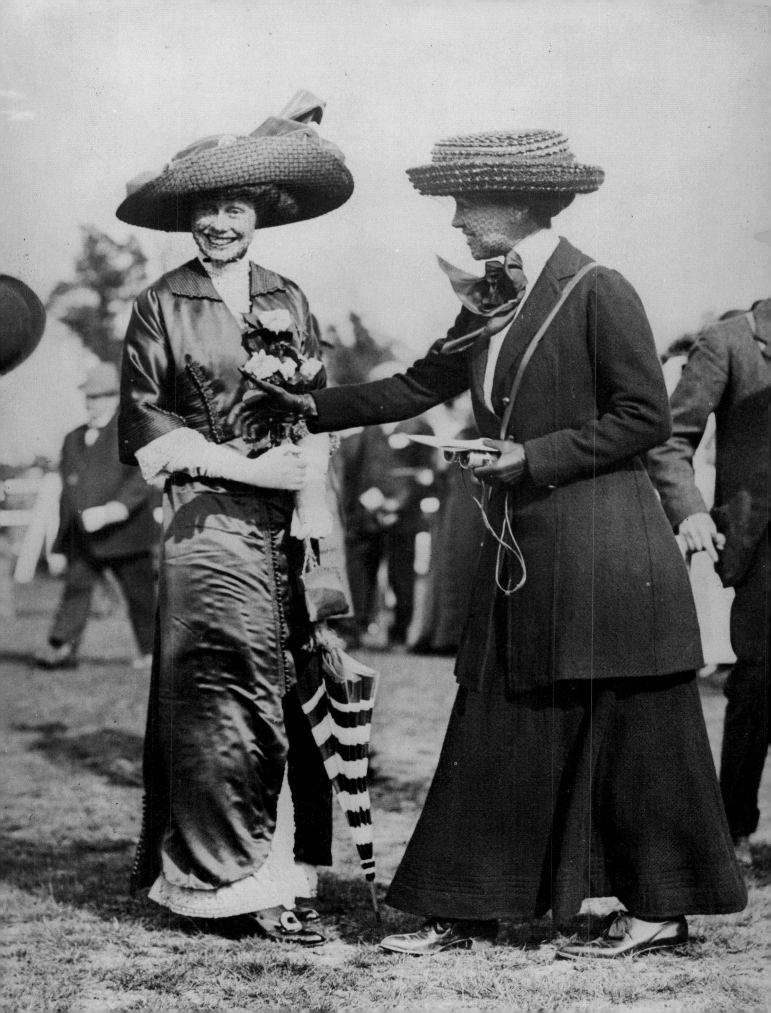

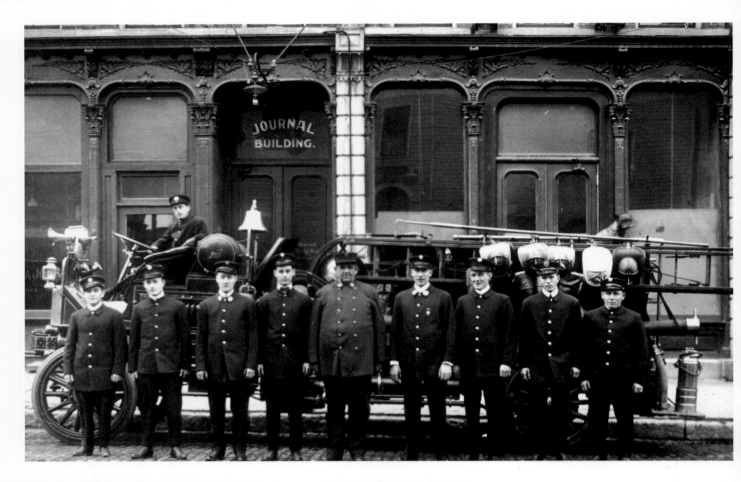

c. 1910 As the automobile steadily replaced the horse, fire engines increasingly made horse–drawn firefighting vehicles obsolete. Here, members of the Ithaca, New York, fire department (*above*) pose proudly with their new ladder truck.

1918 American pioneer labor leader Samuel Gompers (1850–1924) founded the Federation of Organized Trade and Labor Unions in 1881 (*left*), which in 1886 was reorganized as the American Federation of Labor (AFL). He was elected the first president of the AFL, and, with the exception of one year, served as its head until his death.

c. 1912 By the second decade of the 1900s, having one's picture taken had long ceased to be a novelty, but people were still anxious to have their likenesses preserved. These workmen (*right*) were clinging to a chain attached to a crane perched at the top of a skyscraper.

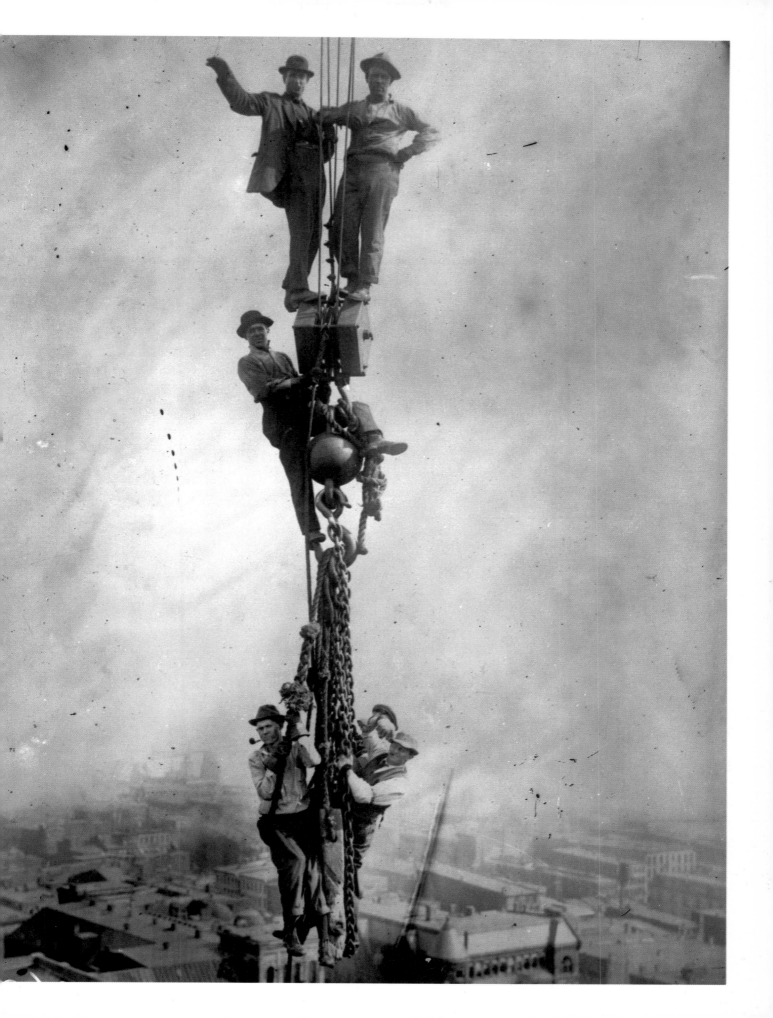

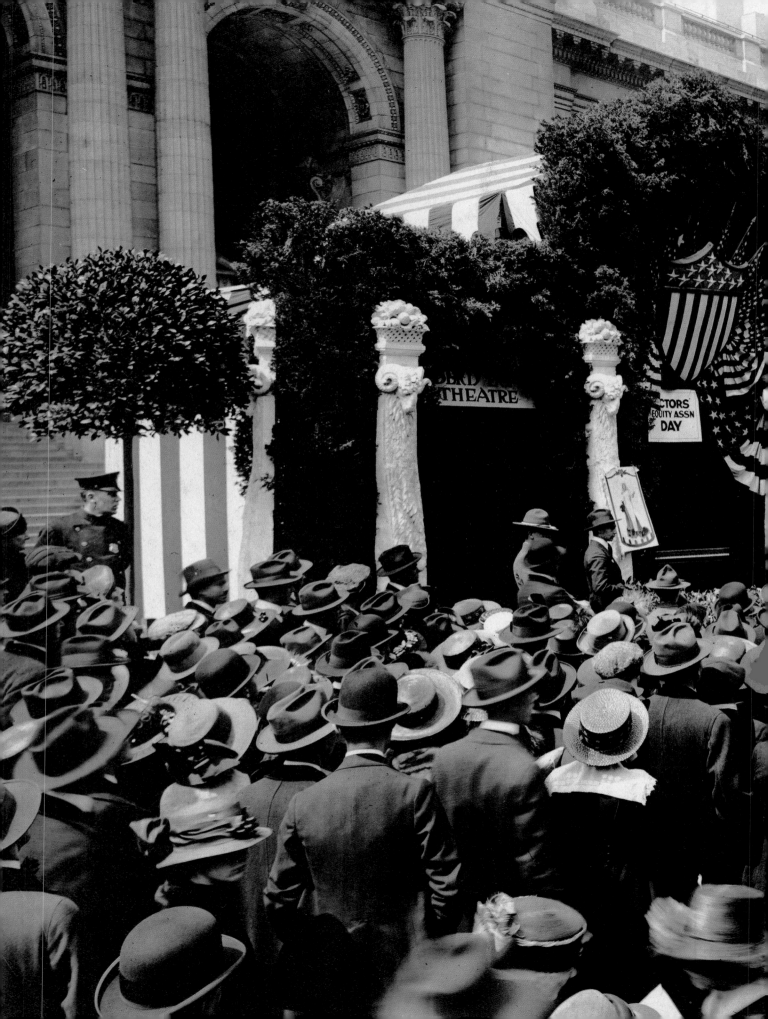

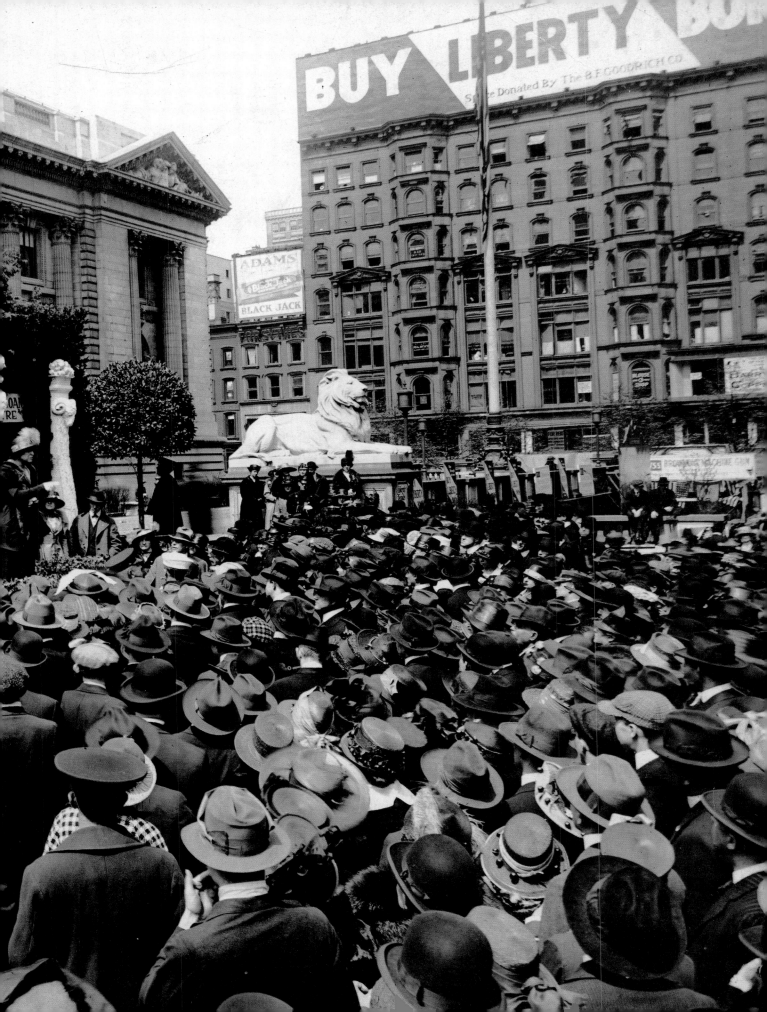

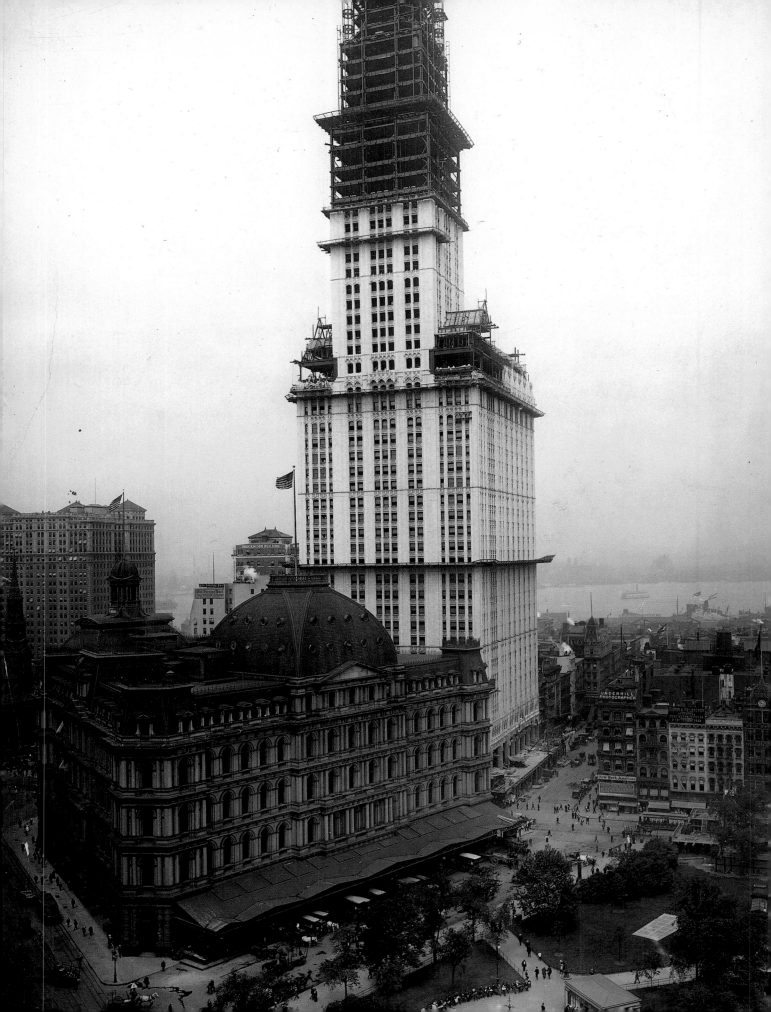

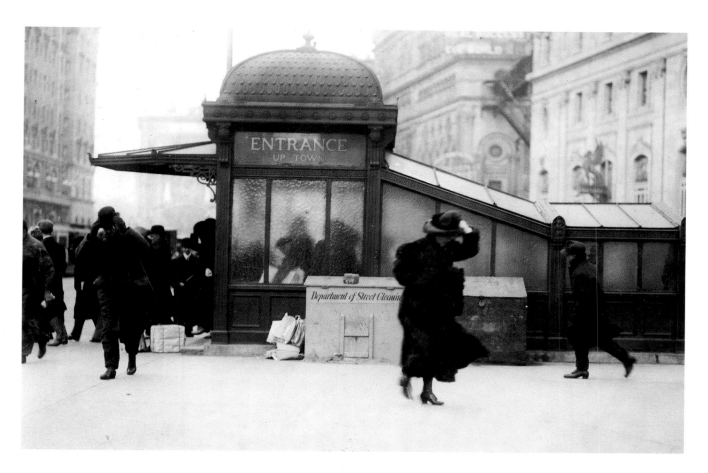

c. 1910 By 1910 the New York subway system was carrying millions of riders. This windy scene was shot in front of one of the many subway entrances (*above*).

c. 1912 As American cities increasingly attracted hordes of businessmen and tourists, magnificent hotels were built. This is the Hotel Astor in New York (*right*), at the time the world's largest establishment of its kind.

1911 In 1879, Frank W. Woolworth (1852–1919) opened his first "five-and-ten-cent" store in Lancaster, Pennsylvania. Along with his brother C. S. Woolworth (1856–1947) he then built a chain of stores throughout the nation that made the "Woolworths" a household name. This is a view (*left*) of the giant Woolworth Building under construction in New York.

c. 1917 In order to help finance the World War I military effort the United States government sold Liberty Bonds. Movie stars, sport figures, and other celebrities exhorted huge rallies, like this one (*previous pages*), urging Americans to dig deep to help the boys at the front. Before the war was over some $21 billion in Liberty Bonds had been sold.

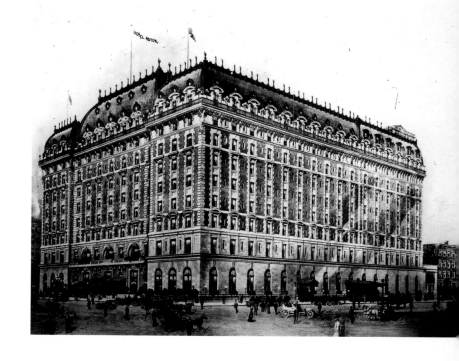

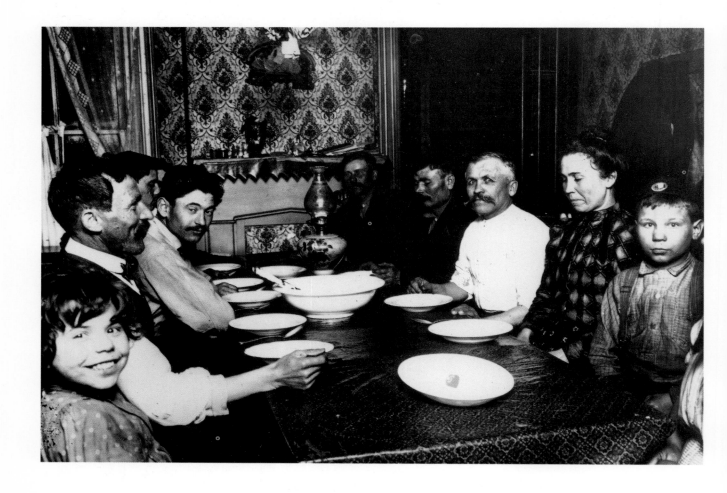

1912 Along with his child labor photographs, Lewis Hine, like Jacob Riis, captured dramatic scenes of immigrants living in New York City tenements. These Slavic newcomers were boarding with an immigrant family that had preceded them to America.

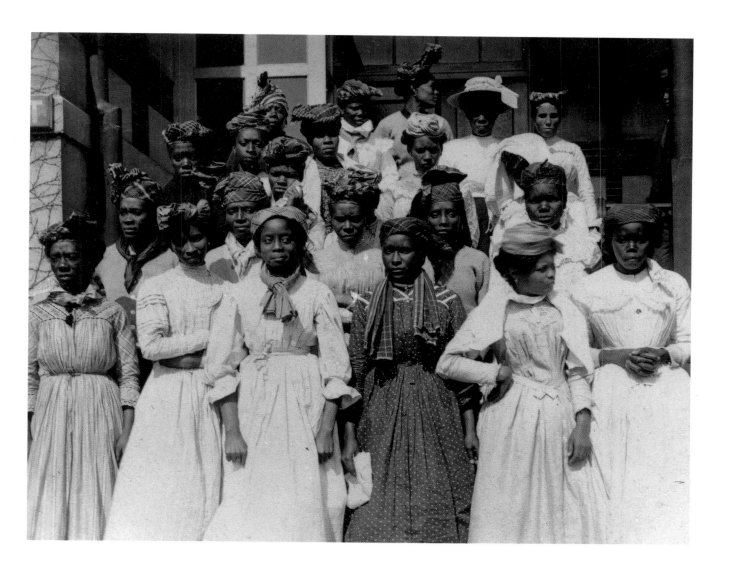

1911 Although the vast majority of immigrants to
America came from Europe, tens of thousands of others
came from other parts of the world. This group of women
posed at Ellis Island upon their arrival from the West Indian
Island of Guadeloupe.

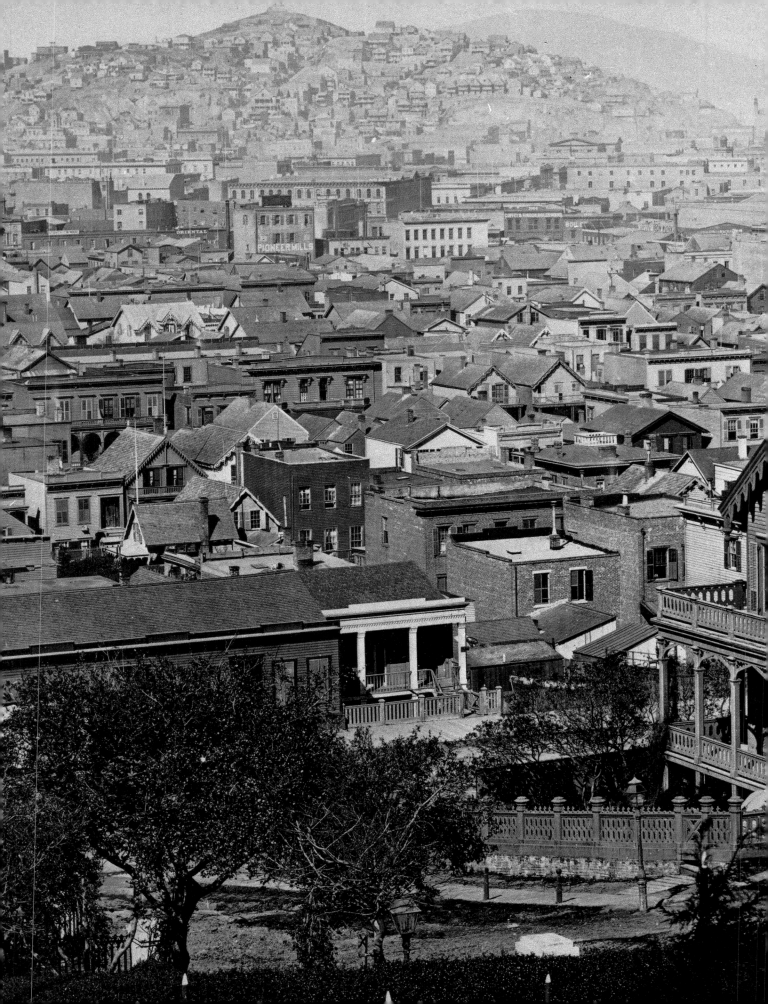

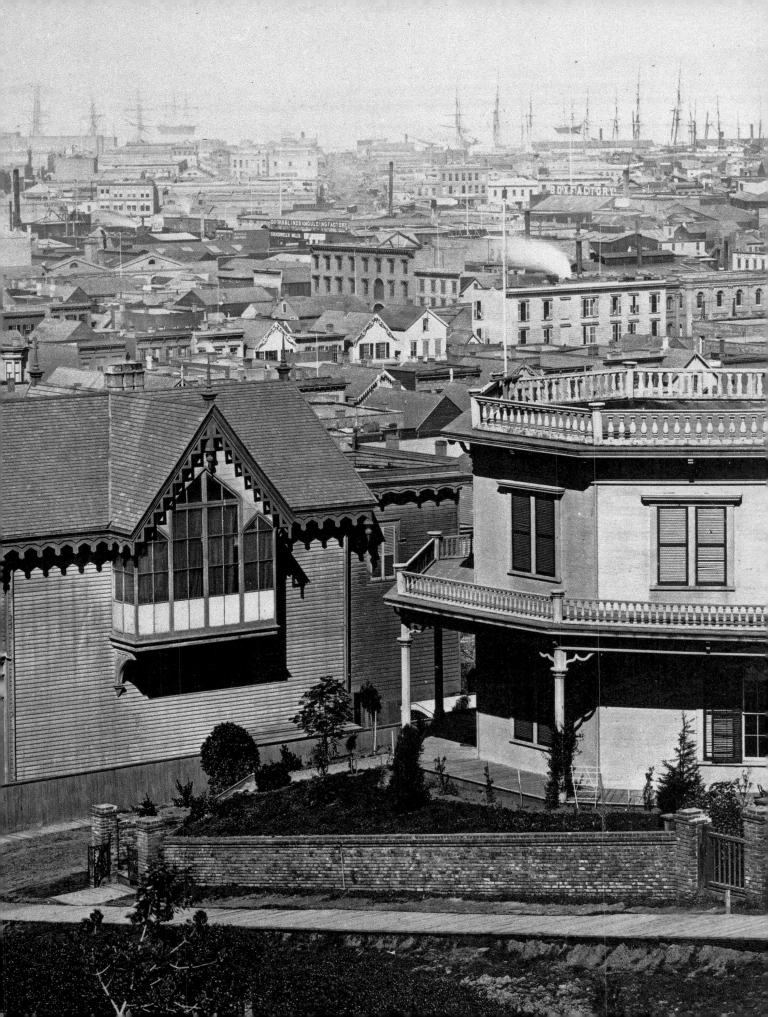

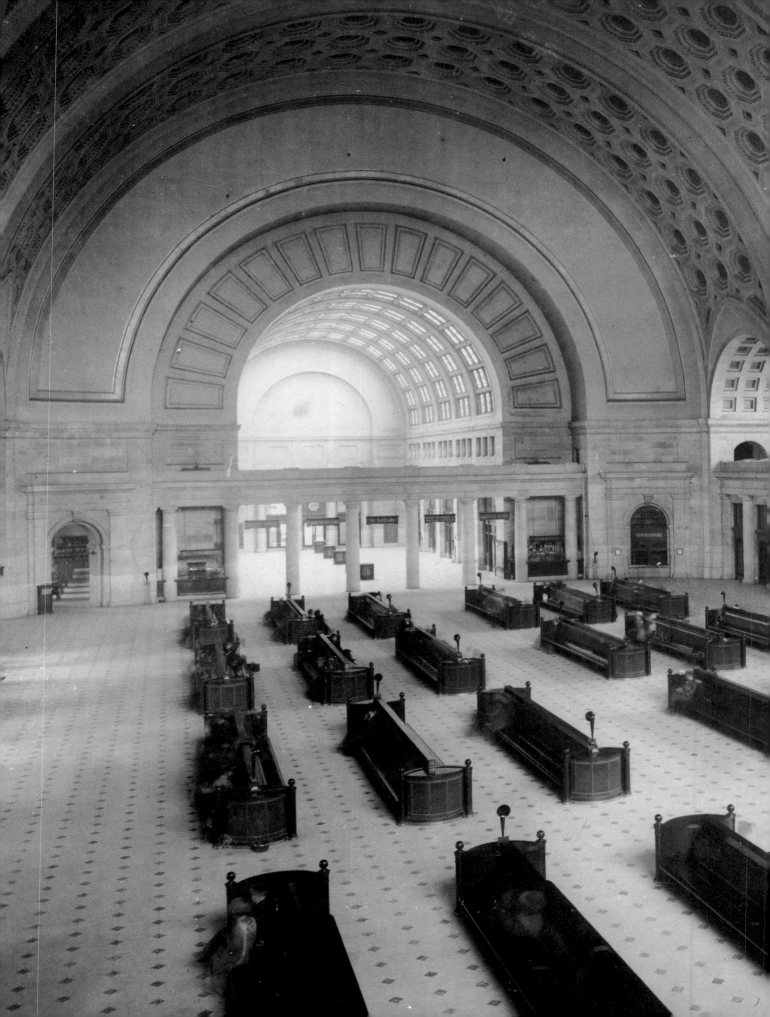

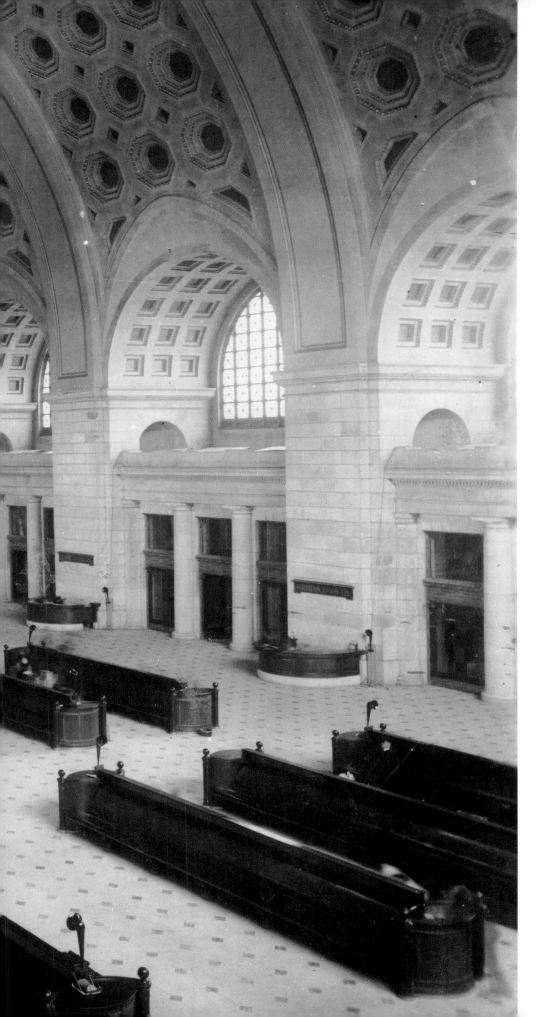

1913 Many of the railroad depots that were erected in the early 1900s were true architectural triumphs. This is a view of the waiting room at Union Station in Washington, D.C.

1910 In 1906, San Francisco was rocked by a devastating earthquake and fire that left it in ruins. As the picture shows (*previous pages*), it took less than four years for the budding city to rise out of the ashes.

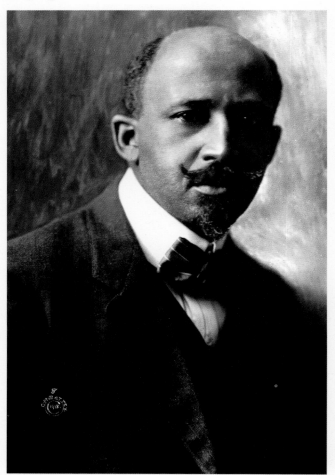

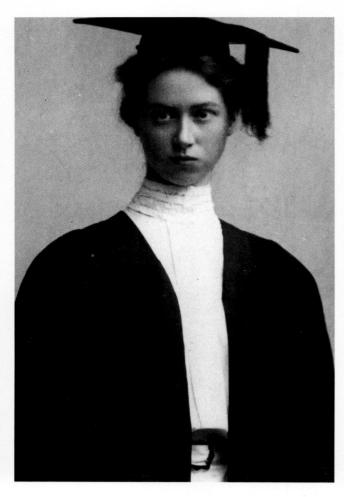

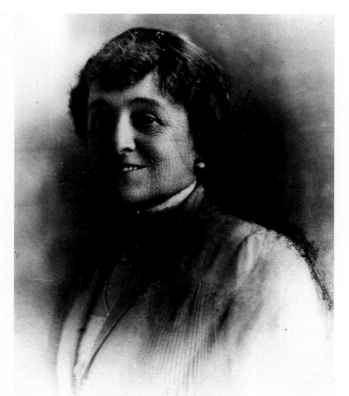

c. 1915 Author, educator, and social critic W. E. B. Du Bois (1868–1963) was an outspoken activist against racism (*above left*). In 1905 Du Bois helped organize the Niagara movement, a black group that demanded an end to racial discrimination in voting, public accommodations, education, and employment. He was one of the founders of the National Association for the Advancement of Colored People (NAACP).

c. 1910 Despite the obstacles that women faced in gaining meaningful work throughout the 18th, 19th, and early 20th century, the ranks of American authors and poets have always been filled with women. This is poet Marianne Moore (*above right*) on the day of her college graduation.

c. 1910 Pulitzer Prize winner Edith Wharton (1862–1937) was a social realist whose novels dramatically depicted life in the Victorian era (*left*). Her best known work is *Ethan Frome*.

c. 1910 A young Robert Frost (1874–1963). Farmer, teacher, lecturer, poet – Frost earned a place among the most acclaimed of all creative artists (*right*). Winner of four Pulitzer Prizes, he was honored by the United States Senate on both his 75th and 80th birthdays. Among his best known poems are: "Mending Wall," "The Road Not Taken," and "Stopping by Woods on a Snowy Evening."

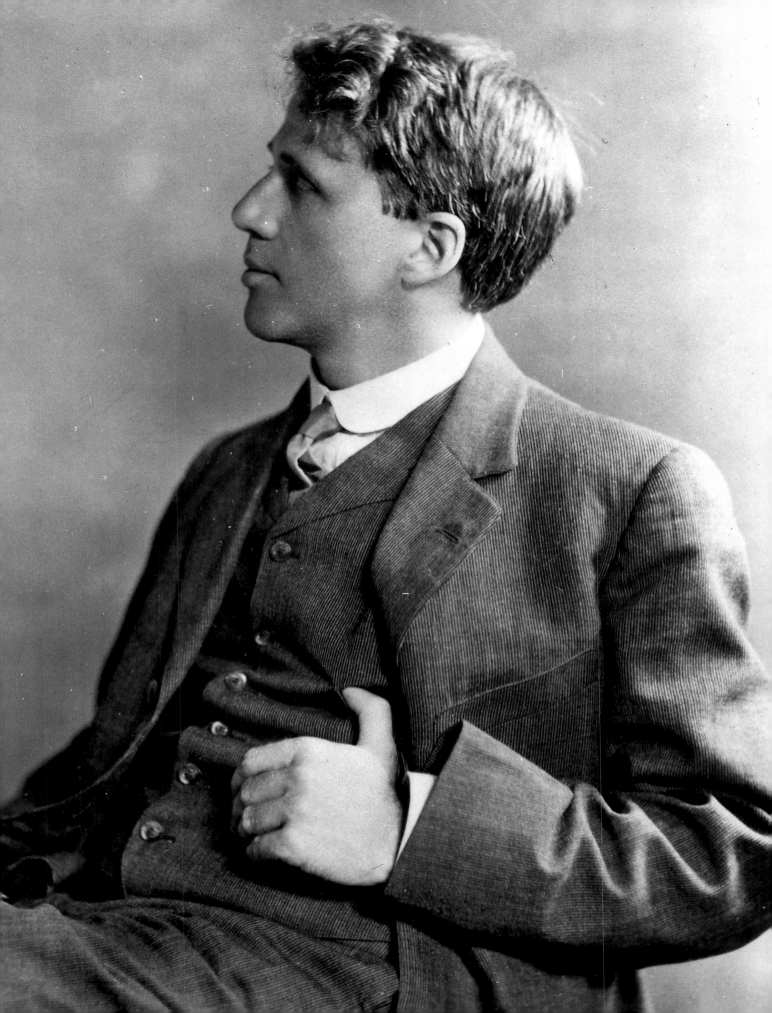

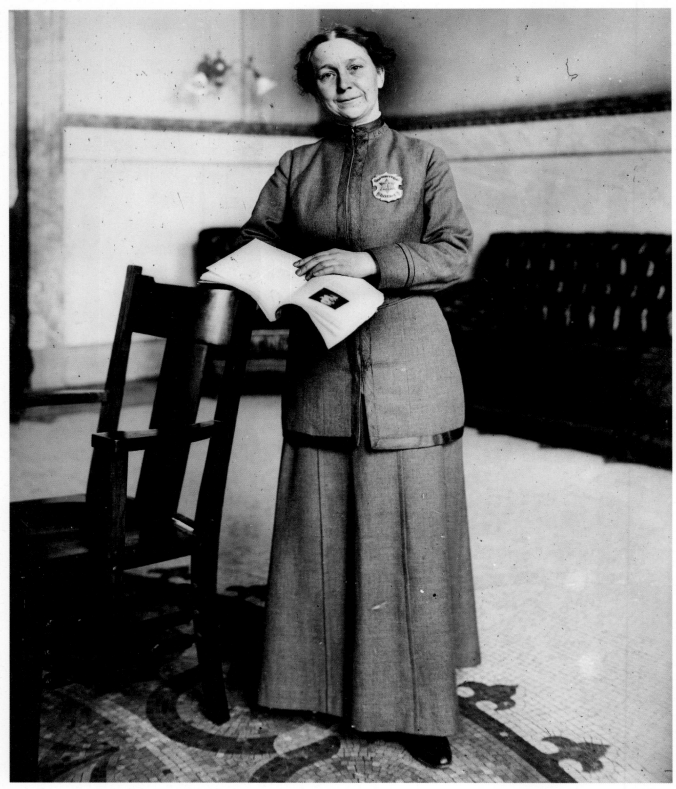

c. 1912 In the second decade of the 1900s, women continued to make inroads into professions that were once exclusively male. This is Mrs. Alice Stebbins of the Los Angeles police department. Stebbins was one of the world's first policewomen.

c. 1910 Frances Benjamin Johnston (1864–1952) was the most successful of all early American women photographers. She gained fame through her pictures of Washington, D.C. school children, black students at Tuskeegee and Hampton Institutes, women factory workers, and the U.S. Navy.

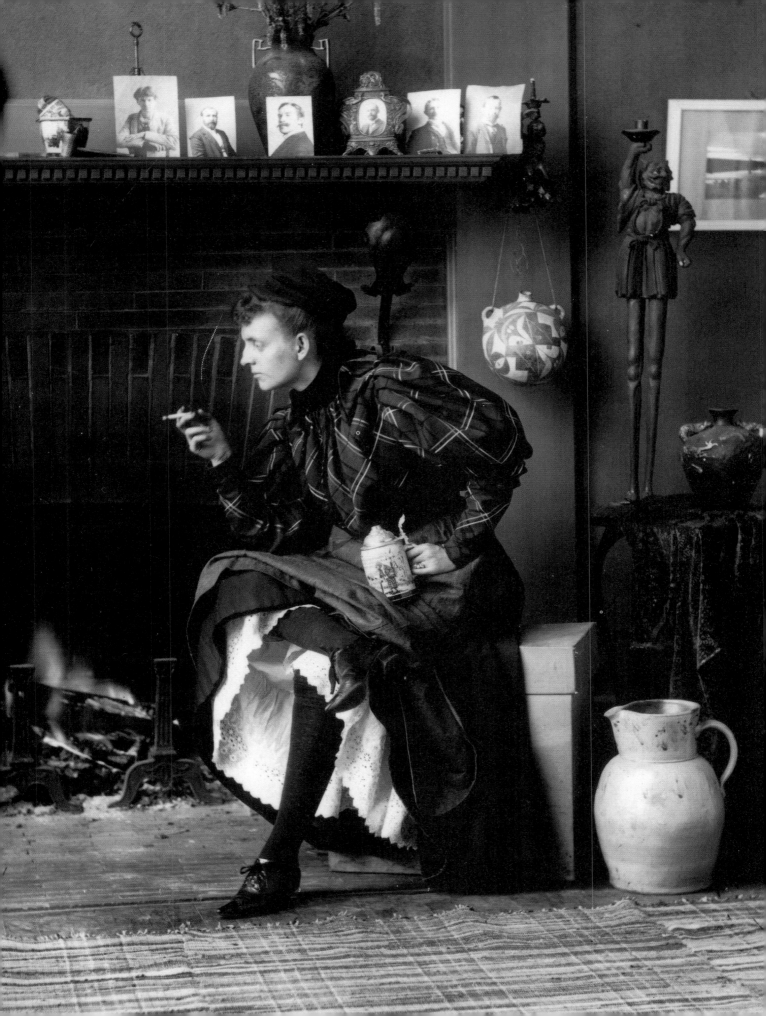

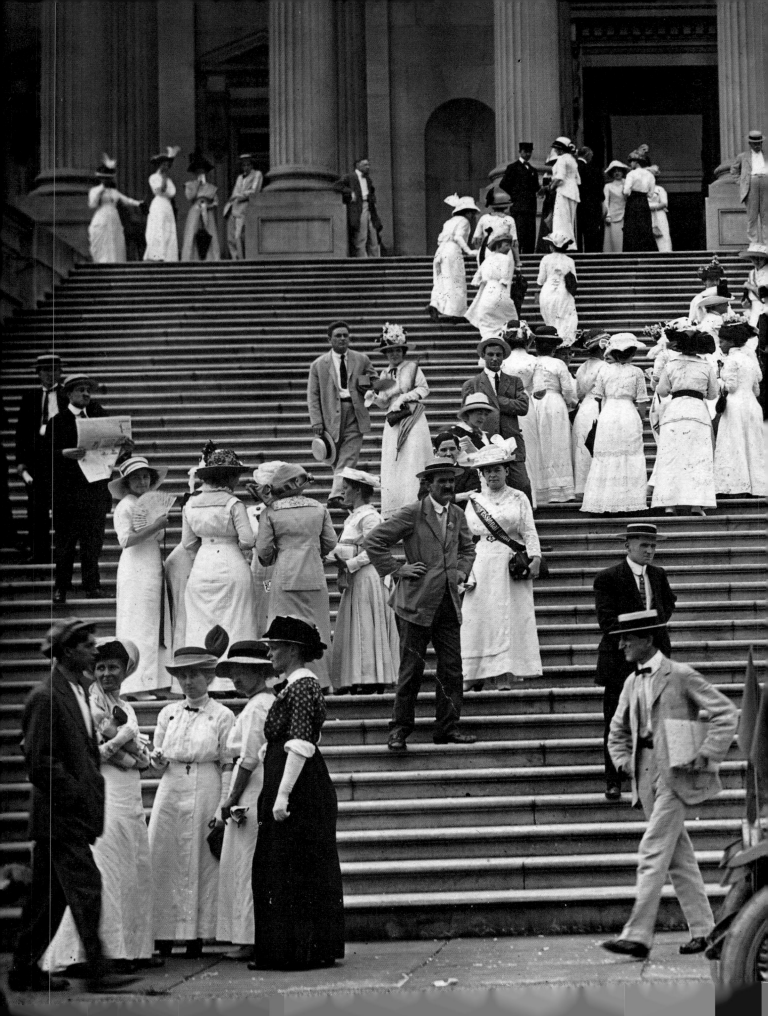

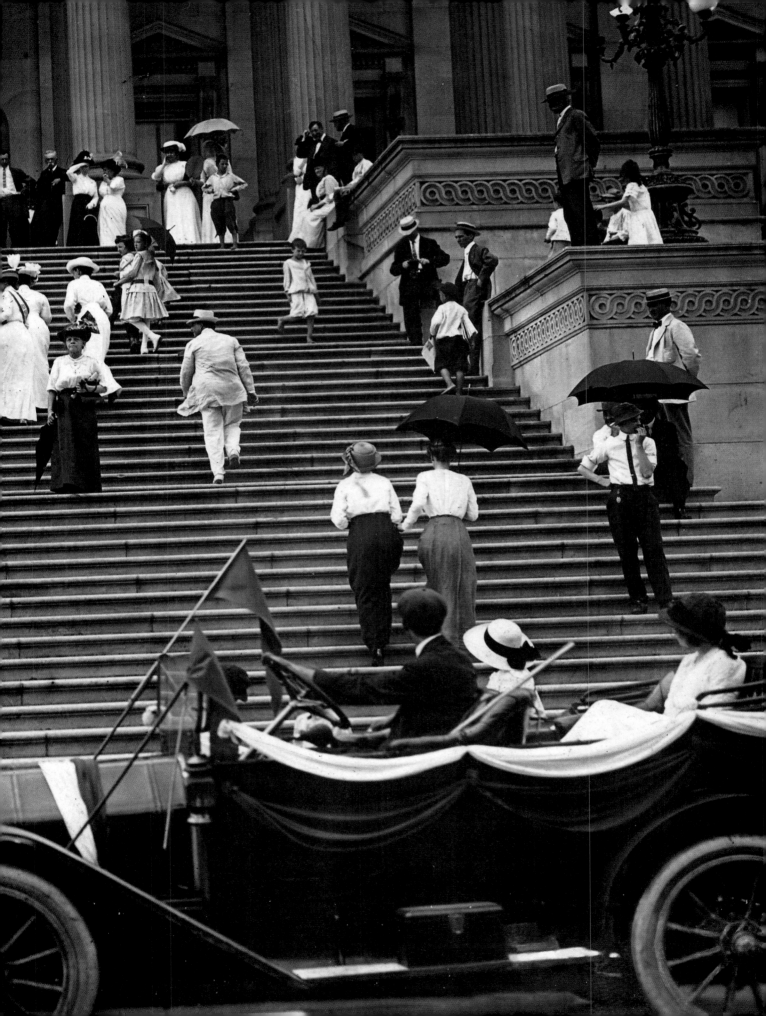

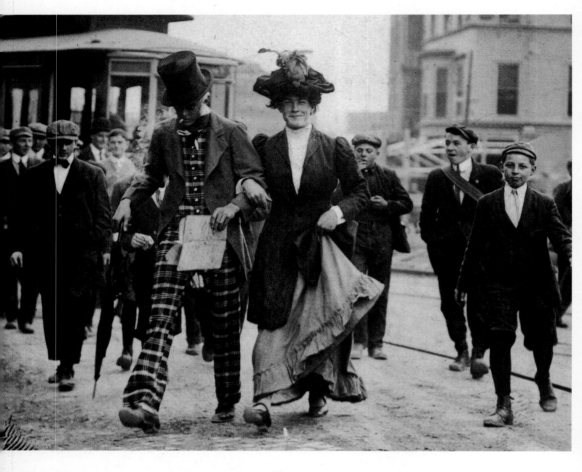

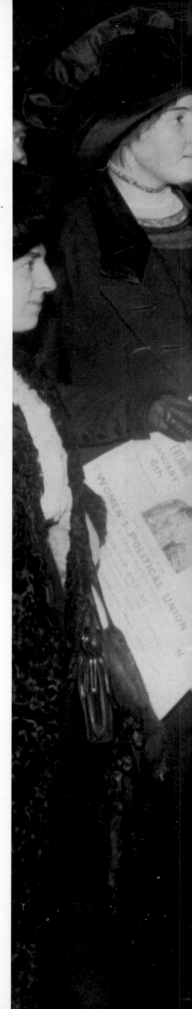

c. 1915 A young suffragette walking arm in arm with her boyfriend at Harvard University. The flamboyantly dressed young man, garbed to call attention to the suffragette cause, was one of the many males who joined in the crusade for women's right to vote.

c. 1913 Harriot Blatch (1856–1940) was one of the nation's leading champions of the women's right to vote movement. She is shown here (*right*) along with fellow suffragettes putting up a poster announcing a forthcoming lecture by noted British suffragette and feminist Sylvia Pankhurst.

c. 1910 In their unrelenting efforts to win the vote for women, suffragettes continually petitioned Congress. Here we see suffragettes from states throughout the nation (*previous pages*) about to enter the Senate to present a petition not only for the franchise, but for equal rights for women in general.

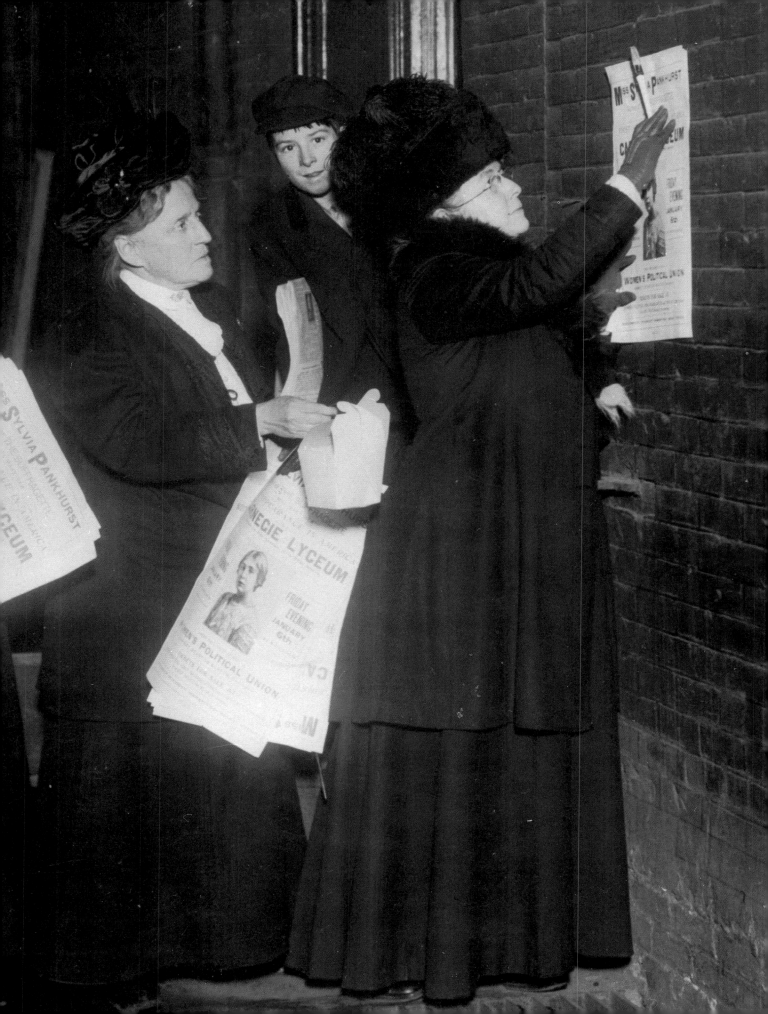

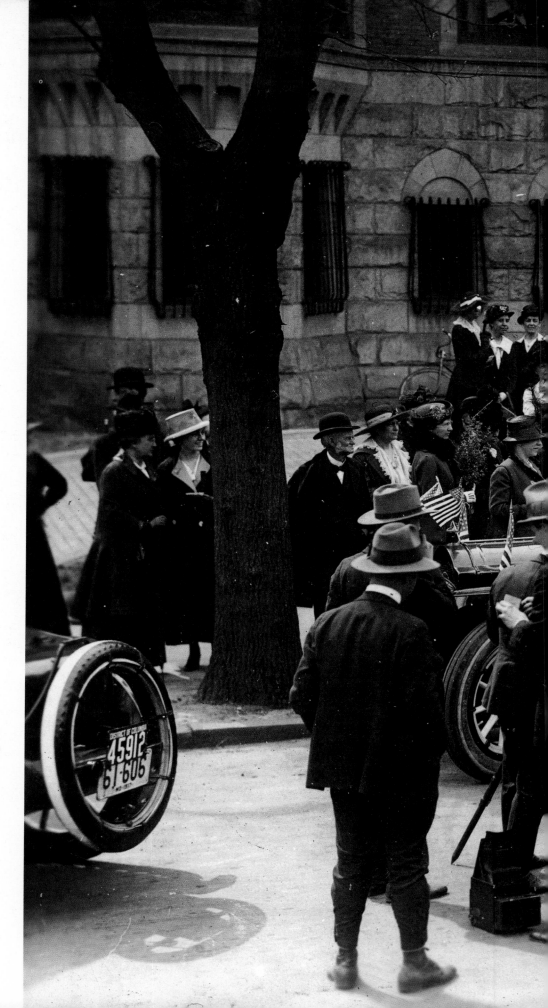

1917 Jeanette Rankin (1880–1973) seen here about to ride to her swearing-in, was a pacifist and suffragist who became the first woman ever elected to the United States Congress. Elected in 1916, she opposed American entry into World War I, a position that cost her reelection. Elected again in 1940, she was the only member of Congress to vote against America's entry into World War II.

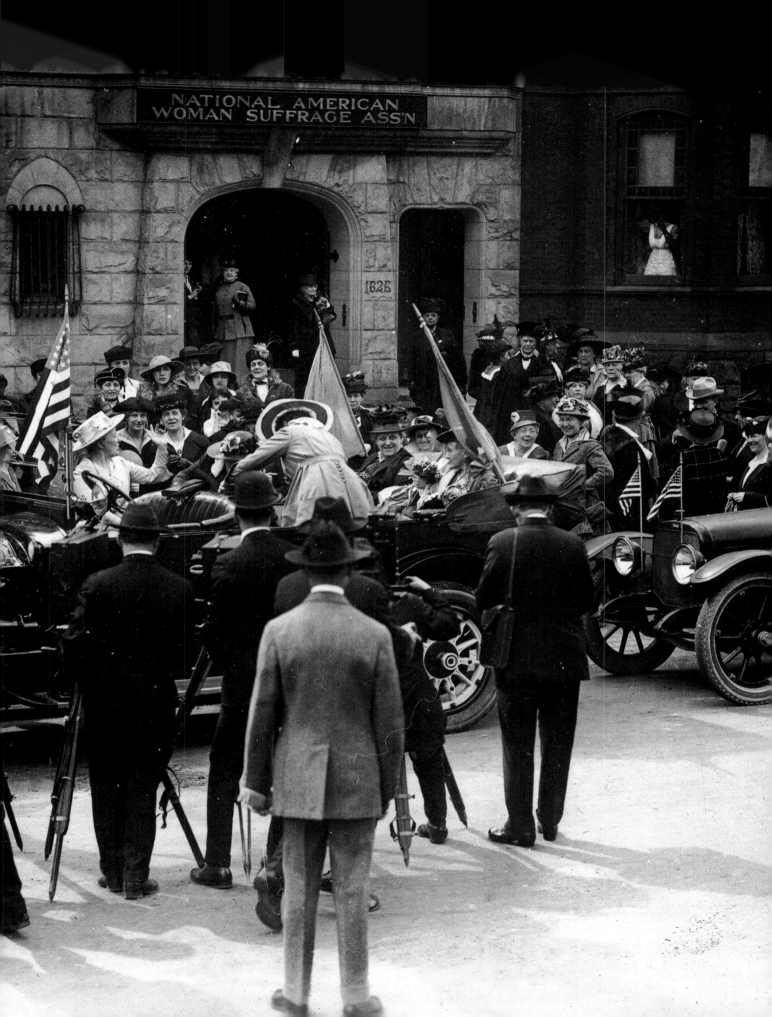

c. 1918 The advent of the automobile brought with it a
boon in the fortunes of dozens of related businesses such as
the petroleum, rubber, steel, glass, and chemical industries.
Here a woman checks under the hood of her car at an early
gas station.

1914 A couple with their proudest possession, a Model
T Ford. Five years earlier, Henry Ford had announced that
Model Ts would be available in any color the customer
wanted – "so long as it is black."

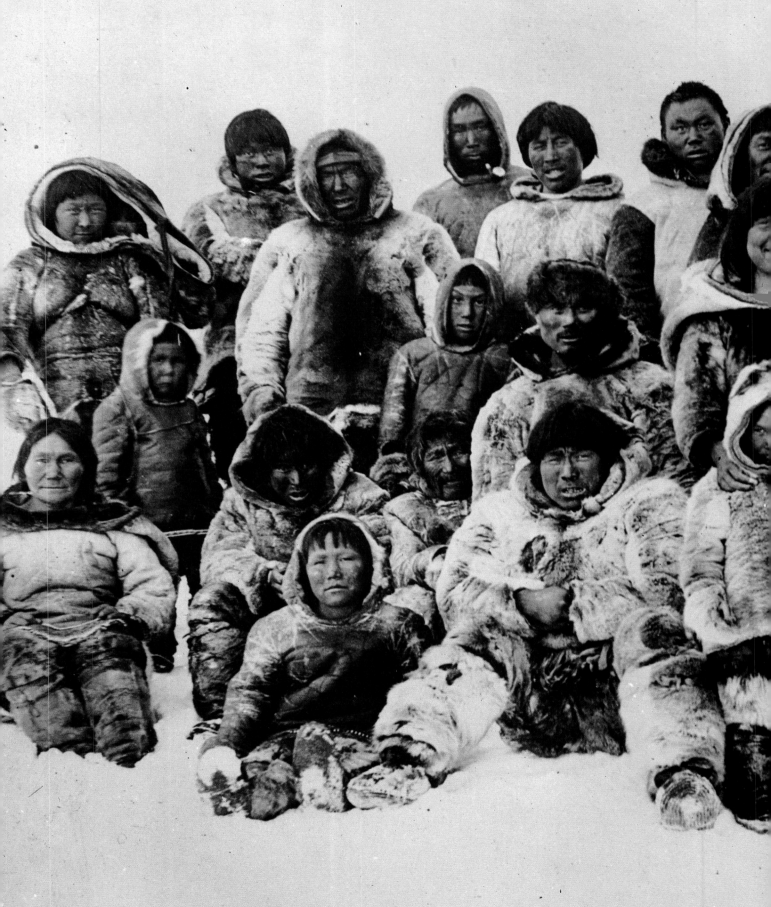

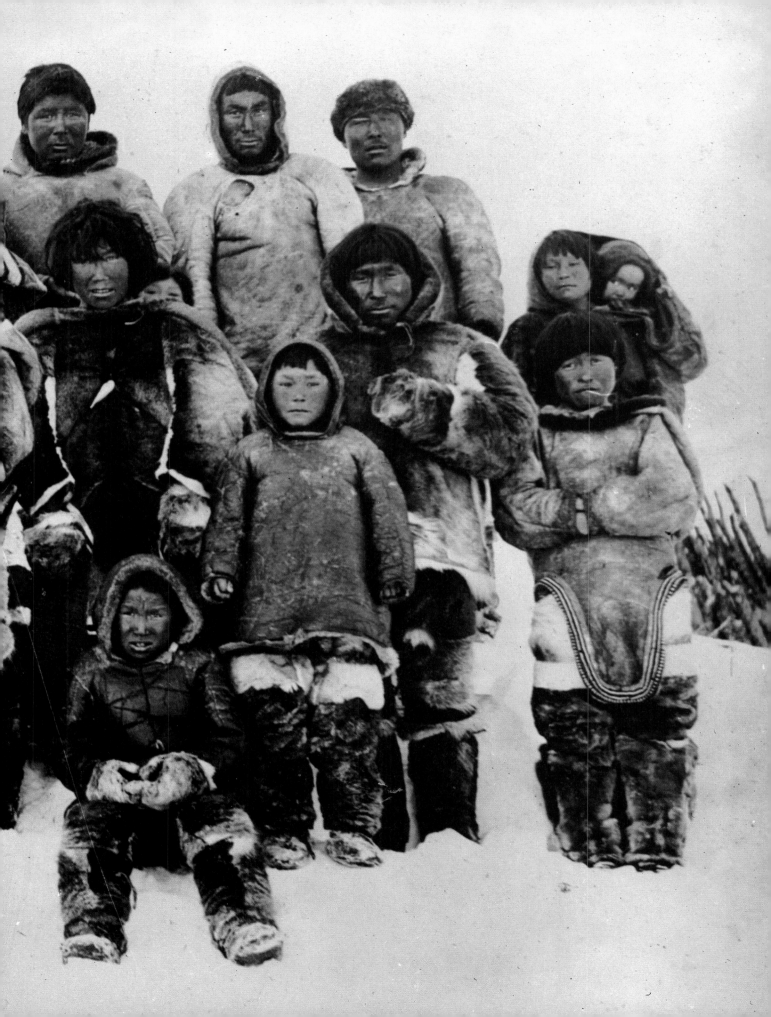

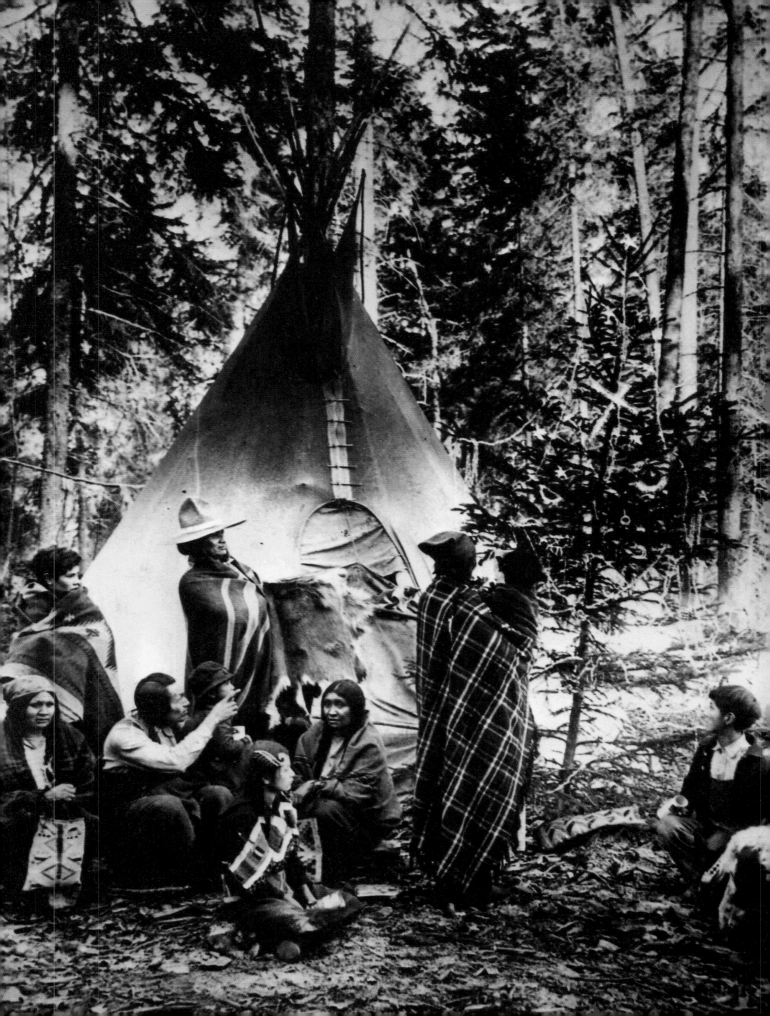

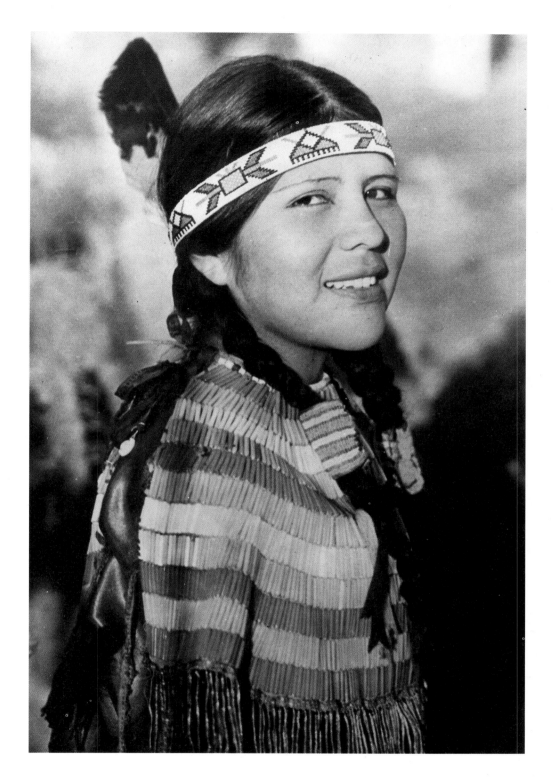

1914 Until well into the 20th century there were still remote areas of the American continent relatively unexplored. Here we see a group of Inuits (*previous pages*) of America's Arctic coastline at a camp of Canadian explorer Vilhjamer Stefanson near Point Barrow.

c. 1910 These are members of the Flathead nation, also known as the Salish (*left*), who lived on the west side of Glacier National Park in the Rocky Mountains.

c. 1910 Pioneer photographic companies discovered early on that portraits of Native Americans were among their best-selling images. This portrait of a Native American girl was taken by the General Photographic Agency.

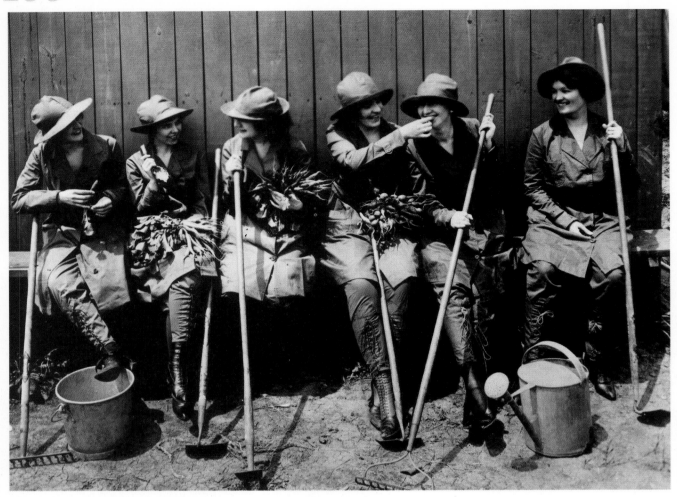

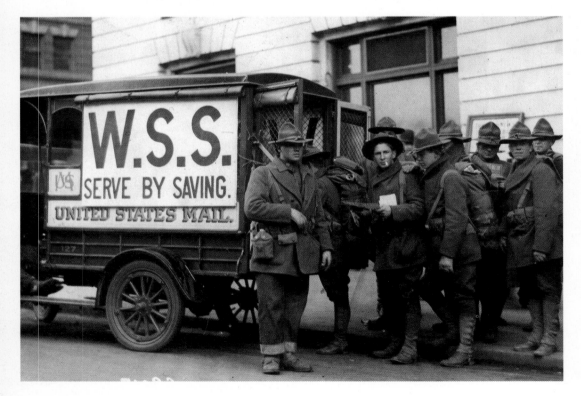

1918 World War I was the first conflict in which women played an active role. This is the Newton Square Unit of the Women's Land Army (*above*), which planted gardens and performed tasks designed to keep America clean.

c. 1918 By the time that America entered World War I, the truck was rapidly replacing the horse-drawn van as a means of mail delivery. These doughboys (*left*) were collecting mail from an early postal van.

1921 In support of the war effort many women went to work on farms where they replaced men who had gone off to fight. This mud-splattered young woman (*right*) divided her time between her farming contributions and her studies at Vassar College.

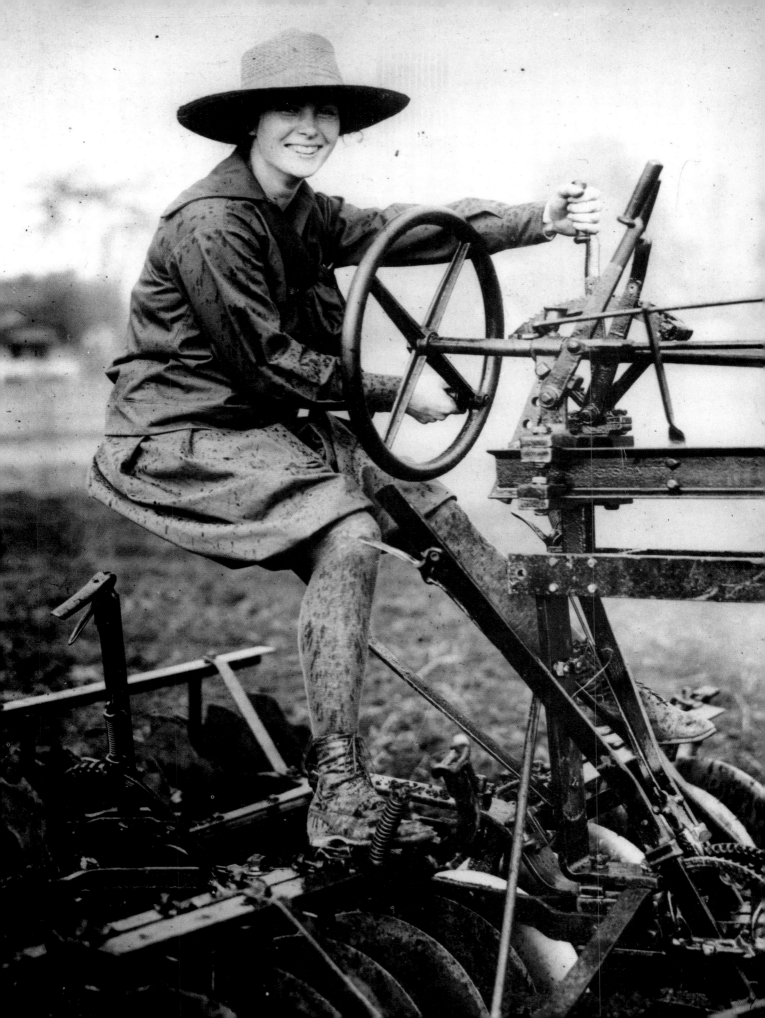

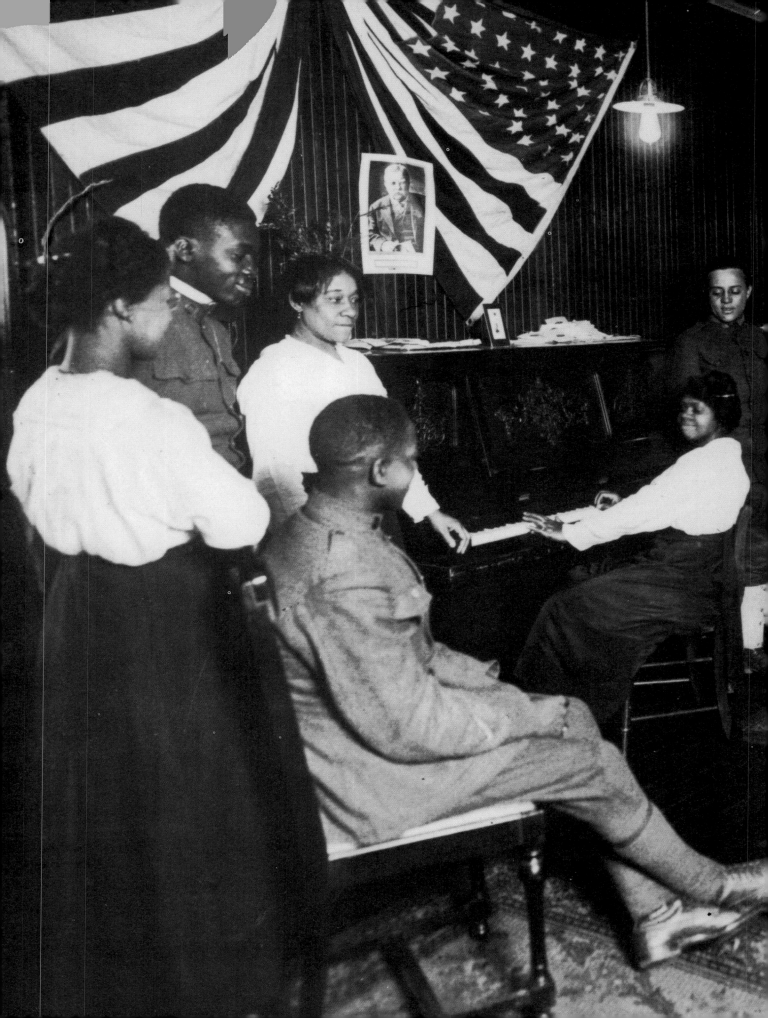

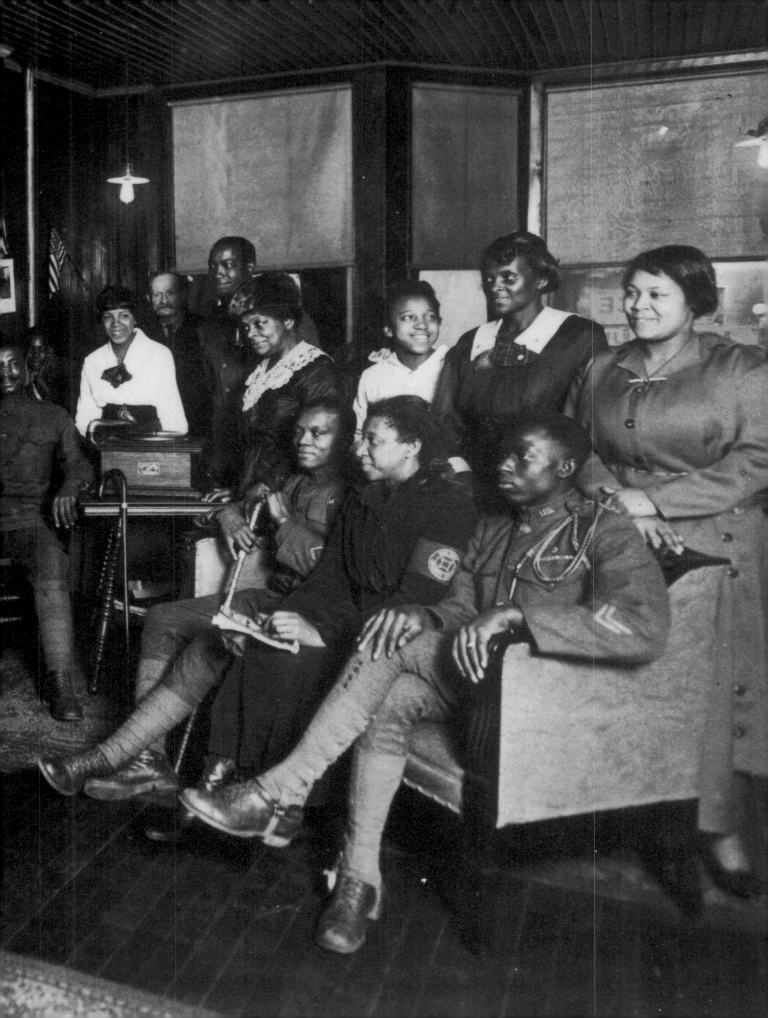

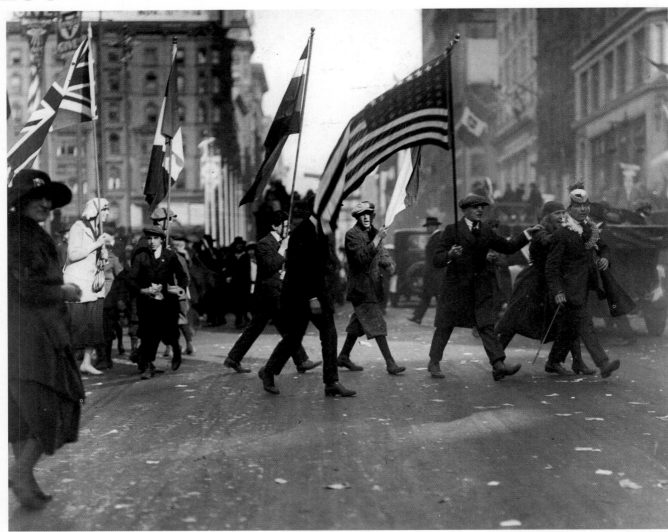

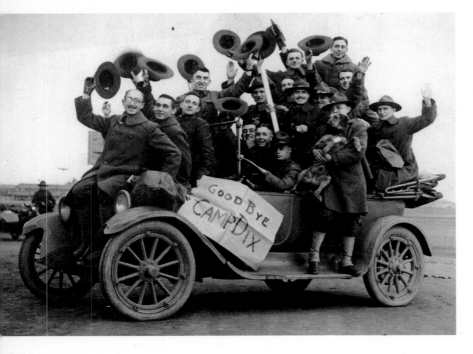

1918 The signing of the armistice on November 11, signaling the end of World War I, was the occasion for victory parades throughout the nation. This was the scene on New York's Fifth Avenue (*above*).

1918 The end of the "blood bath" that was World War I was the cause of genuine jubilation. In this picture (*left*), taken by Underwood and Underwood, one of the leading photographic agencies of the day, soldiers stationed at Camp Dix, New Jersey, celebrate their release from duty.

1918 Peace at last. These men and women rejoicing on Armistice Day (*right*) could hardly imagine that only 23 years later the United States would once again be plunged into another global conflict.

1918 Women played a major role in the war effort by entertaining soldiers on leave. Here (*previous pages*) soldiers listen to a pianist in a Newark, New Jersey club operated by African-American women. The picture was taken by James Van Der Zee, America's premier African-American photographer of his day.

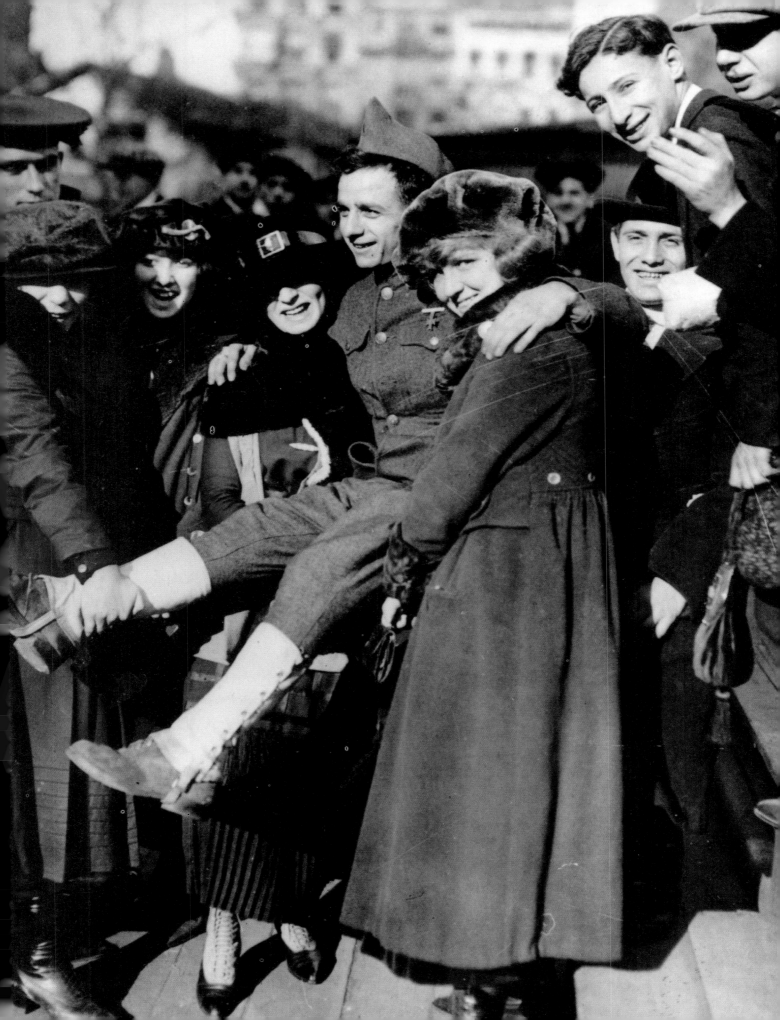

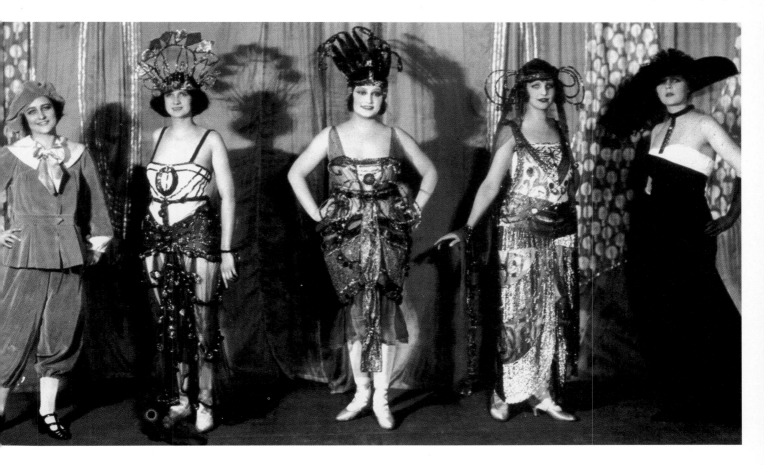

c. 1918 The early master of the musical extravaganza was theatrical producer Florenz Ziegfeld, who turned the chorus line into an art form. Here we see members of the chorus line in Ziegfeld's *Midnight Frolic* posing on stage at New York's New Amsterdam Theatre (*above*).

c. 1915 Born out of vaudeville, the American musical extravaganza captured the imagination and the attendance of millions of theatre goers. To audiences, no costume was too elaborate; no dance number was too overdone. Here (*left*) we see performer Nancy Wallace dressed to represent a Christmas ornament.

c. 1915 Titans of entertainment (*right*). Along with his brother Charles and master showman P. T. Barnum, John Ringling, seen at the left of the picture, was responsible for turning the American circus into what was billed as the "Greatest Show on Earth." The man at the right is famed theatrical producer Florenz Ziegfeld.

c. 1915 Like television that would someday follow, movies created instant celebrities. This is Theda Bara (1890–1955), whose seductive performances shocked many early moviegoers and earned her the nickname "the Vamp."

c. 1915 The movies not only spawned famed actors and actresses but gave birth to famous movie directors as well. The man (*right*) seated at the center of this picture is D. W. Griffith (1875–1948), who introduced such filmmaking techniques as the close-up, the fade-out, and the flashback. His 1915 movie *The Birth of a Nation*, a film about the years following the Civil War, was an early box office hit but is now regarded as being degrading to African-Americans.

c. 1915 "The magic empire of the 20th century, the Mecca of the World." That is how the movie industry billed itself as it became the largest form of mass entertainment the nation had ever encountered. Movies were still in the silent stage when this picture of two early cameramen (*previous pages*) was taken.

1919 In this picture a photographer for the Tropical Press Picture Agency captured four of the giants of early American movies. Left to right are: actress Mary Pickford (1892–1979), director D. W. Griffith, actor/director Charles Chaplin (1889–1977), and actor Douglas Fairbanks (1883–1939).

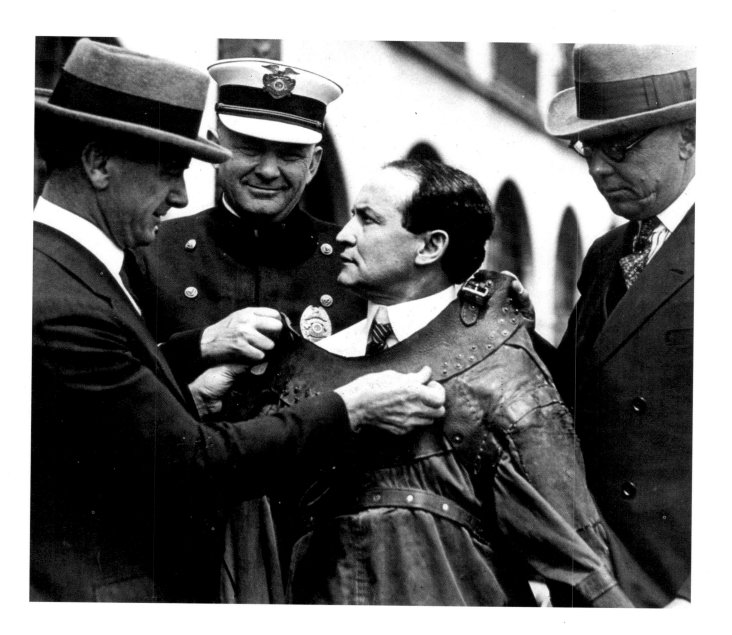

1915 The man in the center of this photograph is the
world–famous escapologist and magician Harry Houdini
(1874–1926). For more than 20 years, Houdini both shocked
and thrilled audiences with his escapes from strait jackets,
locked and chained trunks, ropes, and handcuffs. Here he is
being placed in an escape–proof suit before being dropped
into the sea. As usual, he quickly set himself free.

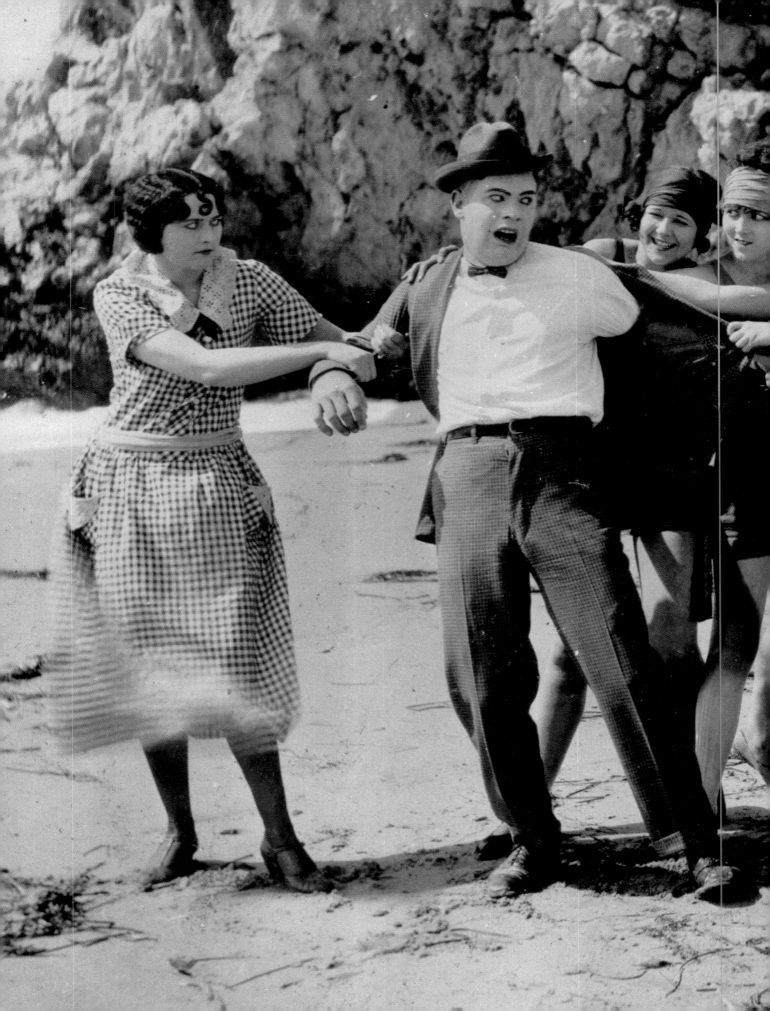

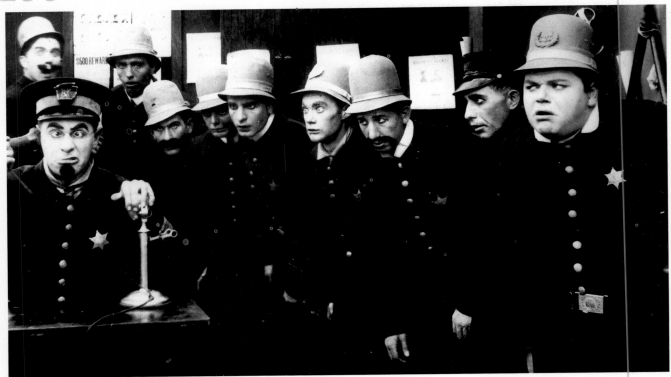

1918 Mack Sennett, born Michael Sinnot (1880–1960), was the pioneer of slapstick comedy; his antic Keystone Kops quickly became one of the nation's favorite attractions (*above*). The most popular of all the Keystone Kops characters was that played by the actor known as Fatty Arbuckle, shown to the far right. Arbuckle's career came to an abrupt halt when he was convicted of child molestation.

c. 1917 The youngster at the left of this photograph is Marion Morrison (1907–1979), who would gain worldwide fame as the actor John Wayne (*left*). Known affectionately as "Duke," Wayne would later become one of Hollywood's greatest stars – he is still well-loved for his portrayal of brave, straight-speaking and -shooting western heroes. In 1969 he won an Academy Award for his role in *True Grit*.

1915 Actress Billie Burke (*right*) began her movie career playing roles in which her striking beauty was featured. In 1939 she became known to audiences throughout the world for her portrayal of the Good Witch in the film classic *The Wizard of Oz*.

c. 1915 A scene from one of the many movies produced and directed by Mack Sennett (*previous pages*). His Keystone Photographic Company produced hundreds of films, and many featured his playful "bathing beauties." A number of Hollywood's earliest stars, including Gloria Swanson and Charlie Chaplin, got their start in Sennett films.

c. 1910 Jelly Roll Morton (1885–1941), born Ferdinand Joseph
La Menthe, was one of the pioneers of various forms of jazz from
ragtime to swing. A master of improvisation, he was the leader of
the innovative jazz band known as "The Red Hot Peppers."

c. 1911 Scott Joplin (1868–1917), known as the "father of ragtime," was both a pianist and composer. In 1899, his song "Maple Leaf Rag" became the first piece of instrumental sheet music to sell more than a million copies. In the 1970s Joplin's popularity was reborn when his song "The Entertainer" was used as the theme for the hit movie *The Sting*.

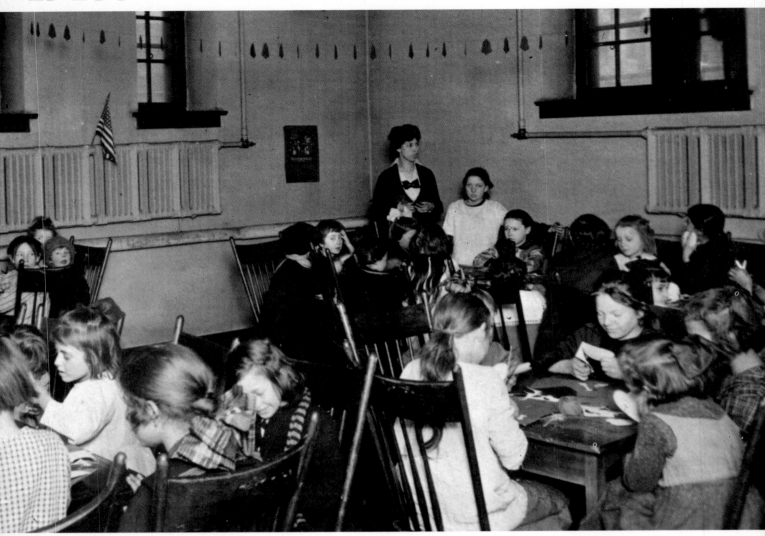

c. 1910 In the first two decades of the 1900s, the free American school system still served as a model for nations around the world. These youngsters were hard at work in a handicraft class.

c. 1912 Aviatrix Harriet Quimby (1875–1912) became America's first licensed female pilot in 1911, and the first woman to fly across the English Channel in 1912.

c. 1910 Born blind, deaf, and dumb, Helen Keller (1890–1968) became an inspiration to millions of people. Through the aid of constant companion and teacher Anne Sullivan, Keller graduated with honors from Radcliffe College, published several books, and devoted much of her life to raising money for the blind.

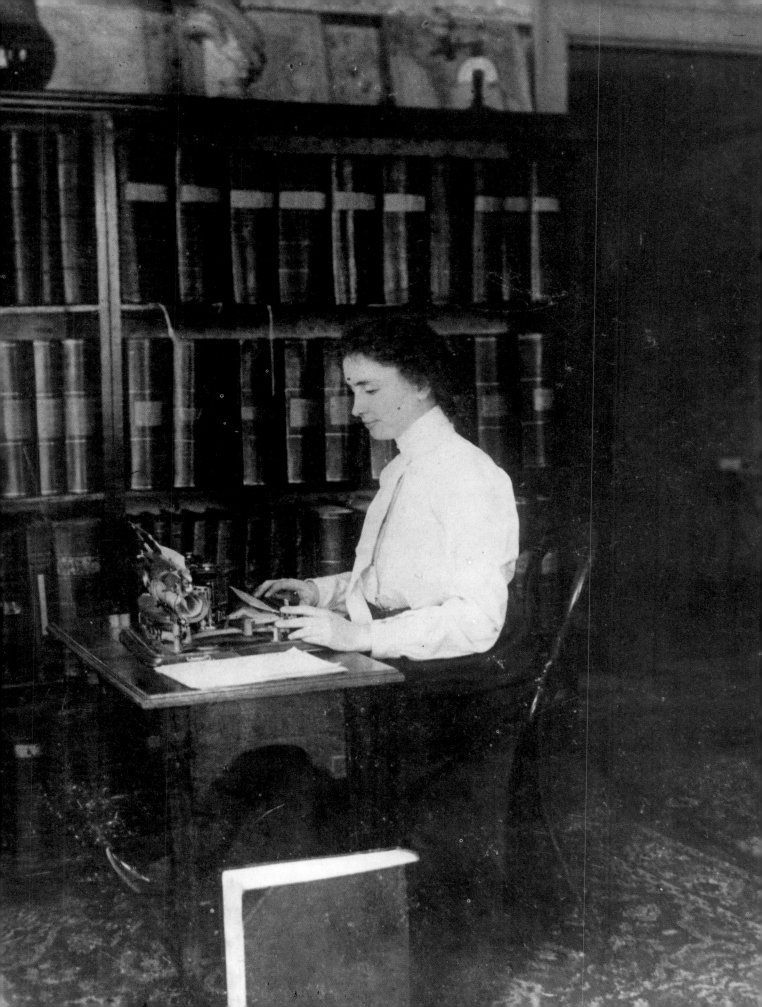

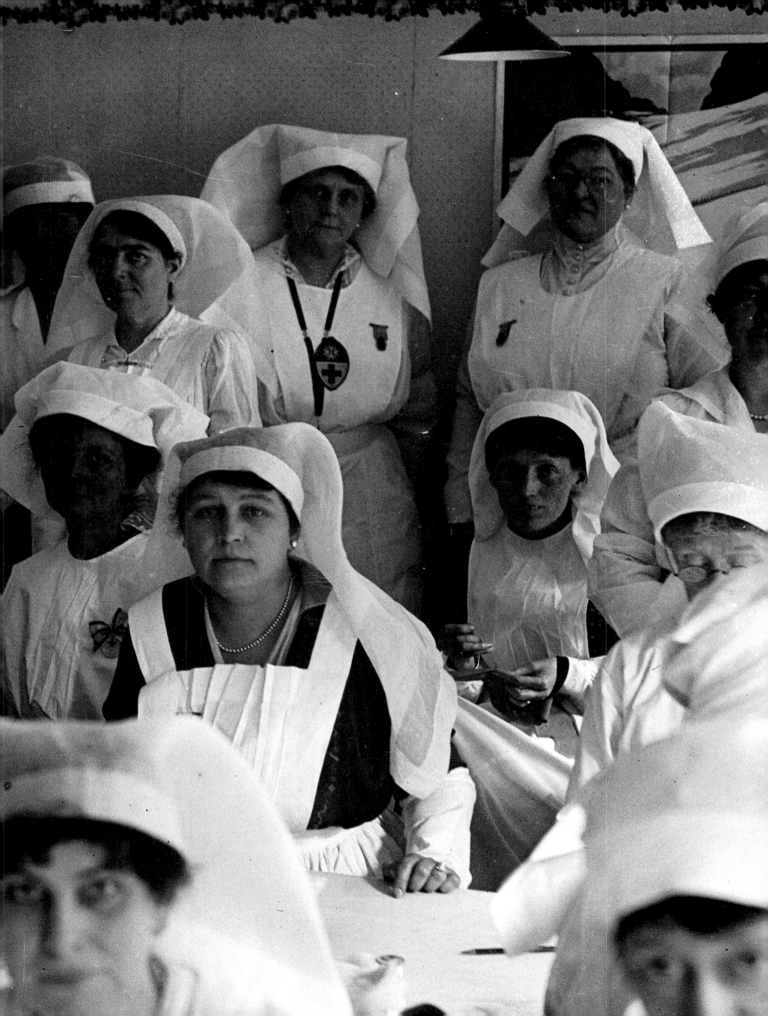

1910s

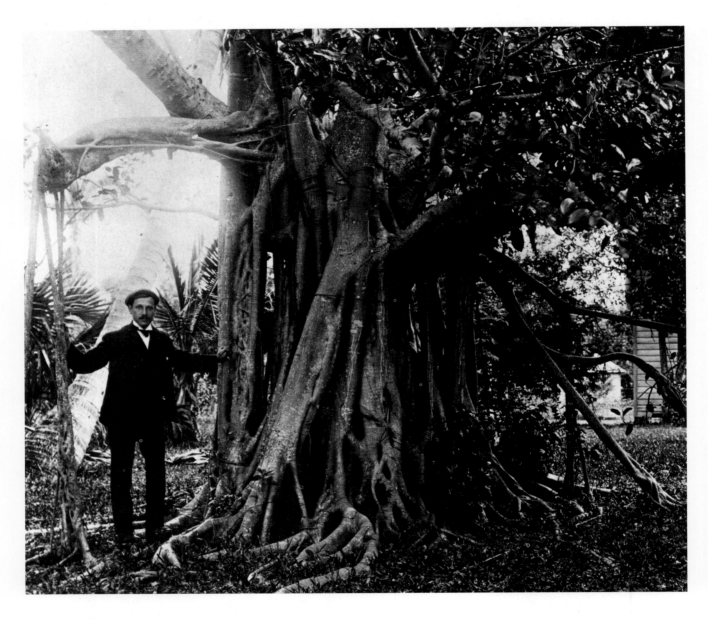

1915 The unusual banyan tree grows in profusion in tropical India and the East Indies, and has many roots that grow into additional trunks. Early settlers in the deep American South successfully imported and planted banyans, which made possible this picture taken in Palm Beach, Florida.

c. 1915 Dr. Robert H. Goddard (1882–1945) literally launched America into the age of rocketry. In 1935, one of Goddard's rockets achieved the world altitude record when it soared to a height of more than 1.9 miles. He is pictured here (*right*) with one of his earliest launching contraptions.

1917 American nurses played a major role during World War I. Hundreds aided doctors behind front lines in Europe. Many others, like the women pictured here (*previous pages*), were trained to care for the wounded once they were transported back to America.

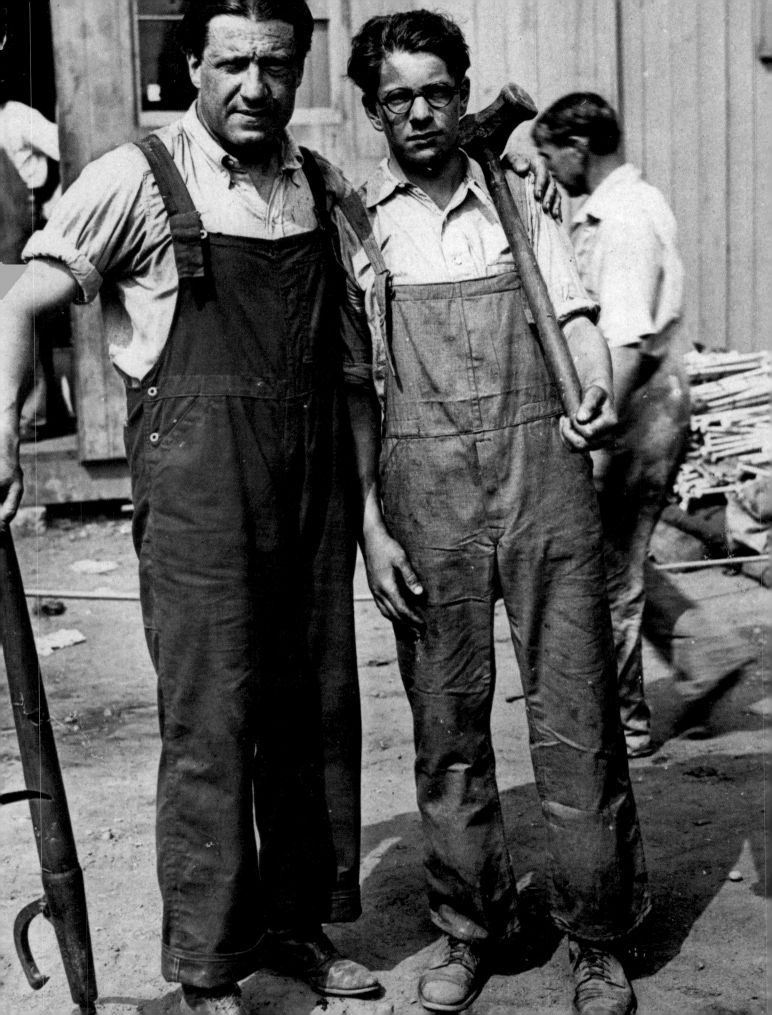

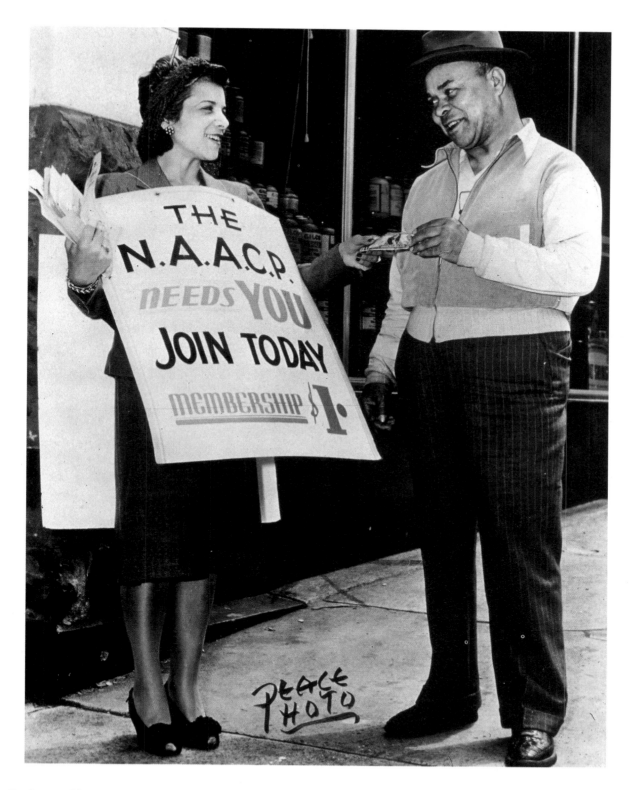

1918 During World War I, people from every walk of life contributed to the war effort. The man on the left is leading Zionist Rabbi Stephen S. Wise, who founded the Free Synagogue in New York City in 1907, and cofounded the American Jewish Congress in 1918.

c. 1910 The National Association for the Advancement of Colored People (NAACP) was founded in 1910 by African–American educator and writer W. E. B. Du Bois (1868–1963) and seven white Americans; the organization has been a powerful advocate for black rights and opportunities.

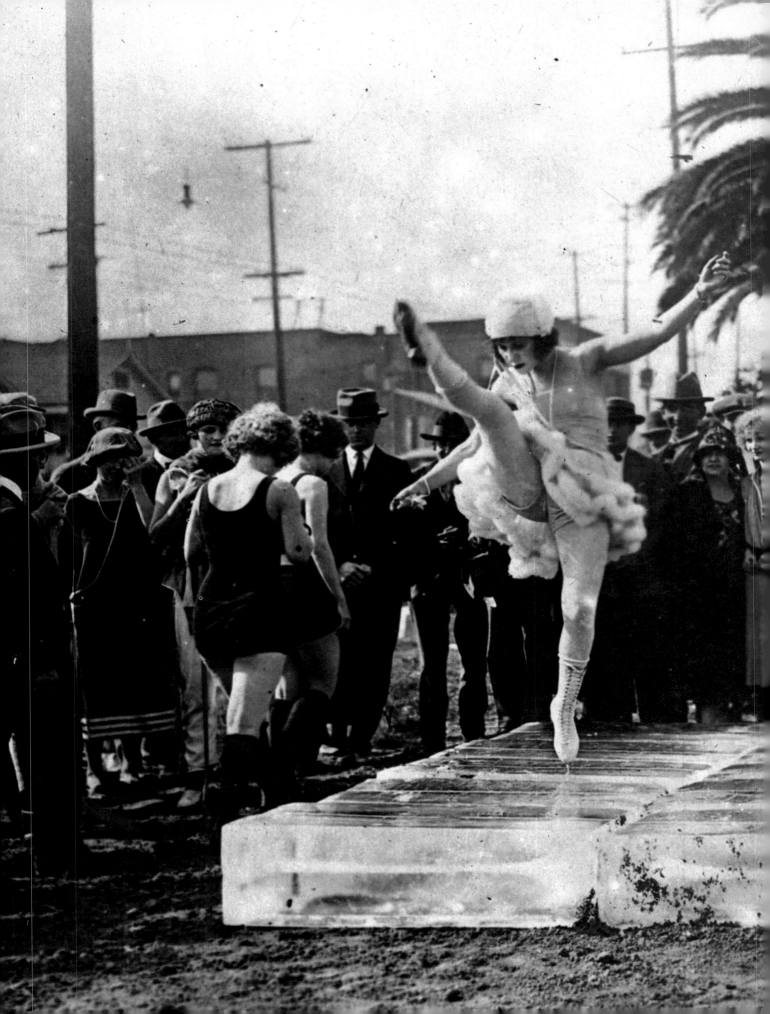

c. 1919 The "ice rink"
may have been tiny but
this woman's ambition was
large. She was French skater
Mademoiselle Marge and
she was in America urging
Californians to take up the
winter sport.

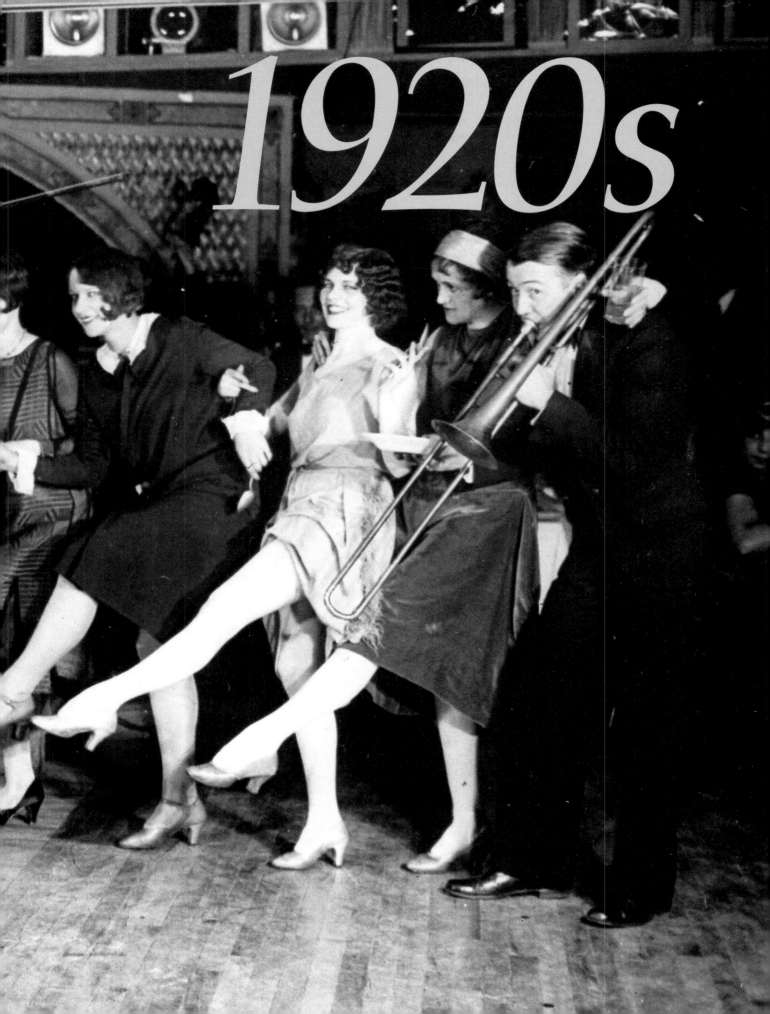

1920s

c. 1927 In the 1920s women achieved a greater sense of independence than ever before. After the town fathers of Reedy, West Virginia, banned the wearing of knickers by females, women there appealed to the state's attorney general and had the ordinance overturned.

The "Roaring Twenties" was unlike any decade in the nation's history. It was the decade of the Charleston, the flapper, Prohibition, and an amazing array of fads and wacky stunts.

It was an era of incredible personal accomplishments as well. Babe Ruth hit 60 home runs in a single season. Gertrude Ederle became the first woman to swim the English Channel. And Charles Lindbergh, the greatest hero of all, flew solo across the Atlantic.

Women finally got the right to vote, the movies began to talk, and writers like F. Scott Fitzgerald made their mark. American businesses continued to grow and the stock market reached all-time highs. It seemed it would never end. But when the market crashed, the Roaring Twenties became the decade of boom and bust.

c. 1929 The first Mickey Mouse cartoon (*Plane Crazy*) appeared in 1928 and the character, created by Walt Disney (1901–1966) was on his way to becoming a worldwide phenomenon. Here "Mickey" stands on top of a pile of fan letters.

1926 The exuberance of the "Roaring Twenties" was a direct outgrowth of the feeling of relief engendered by the end of World War I and an enormous, seemingly endless period of business prosperity. This was a dance contest (*previous pages*) at New York's Parody Club.

c. 1923 The unprecedented freedom that many women felt in the 1920s was due in no small measure to the automobile. This woman (*right*) was filling a tire with air with no member of the "stronger" sex in sight.

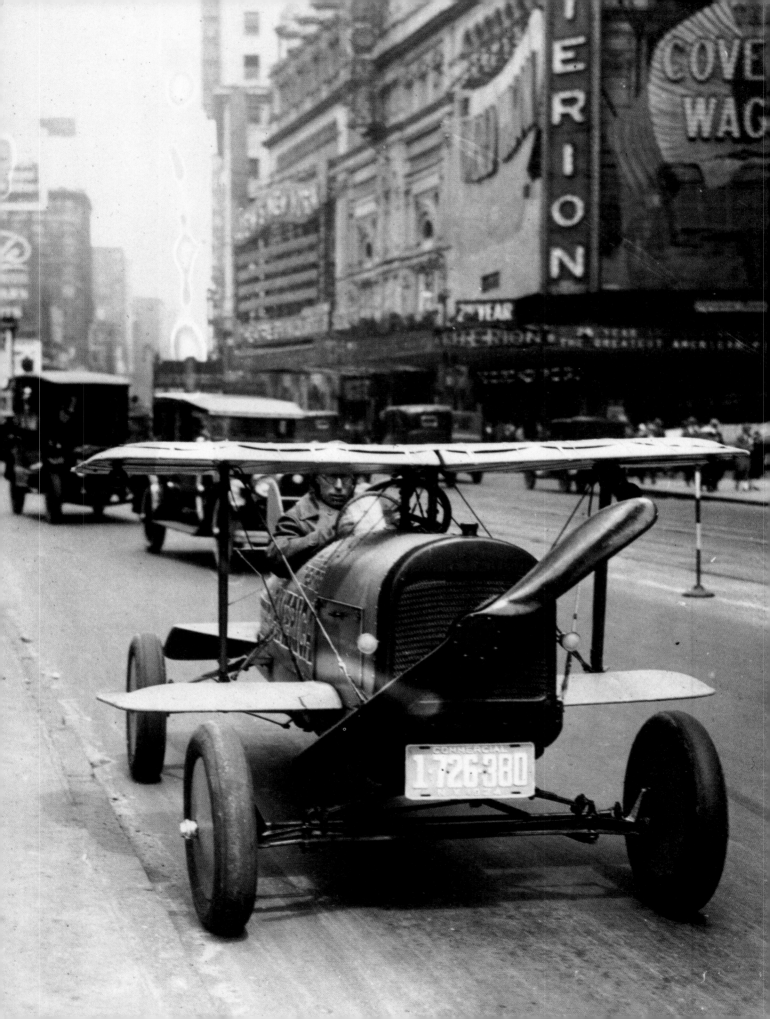

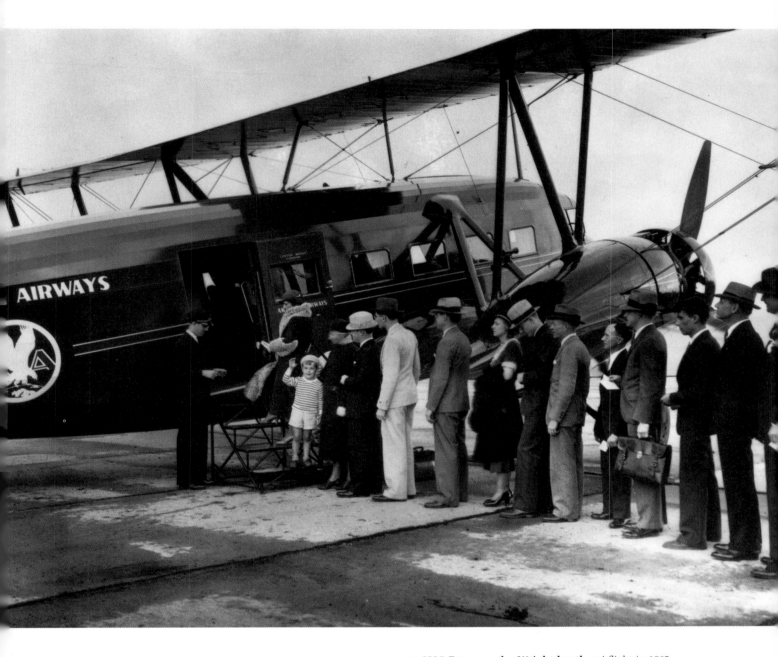

c. 1925 Between the Wright brothers' flight in 1903 and the end of World War I, few people saw commercial possibilities for the airplane. But after the war, rapid improvements in the capacity, speed, and endurance of aircraft led to the establishment of the first commercial airlines. These passengers were boarding an early American Airlines plane.

1924 Automobiles were the object of whimsy as well as adoration. This was one man's attempt to make his car both distinctive and aerodynamic.

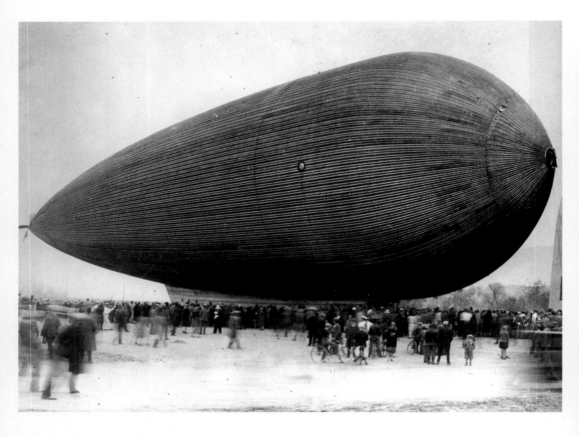

1929 From the earliest days of manned flight, dirigibles had provided a means of air transport and would continue to do so until the *Hindenburg* disaster in 1937. Here a crowd gathers to view the world's first all-metal dirigible.

1928 Aviatrix Amelia Earhart (1898–1937) poses upon her arrival in Southampton, New York, after her flight from Wales, making her the first woman to fly across the Atlantic. Before mysteriously disappearing on a round-the-world flight in 1937, Earhart set several other aviation records.

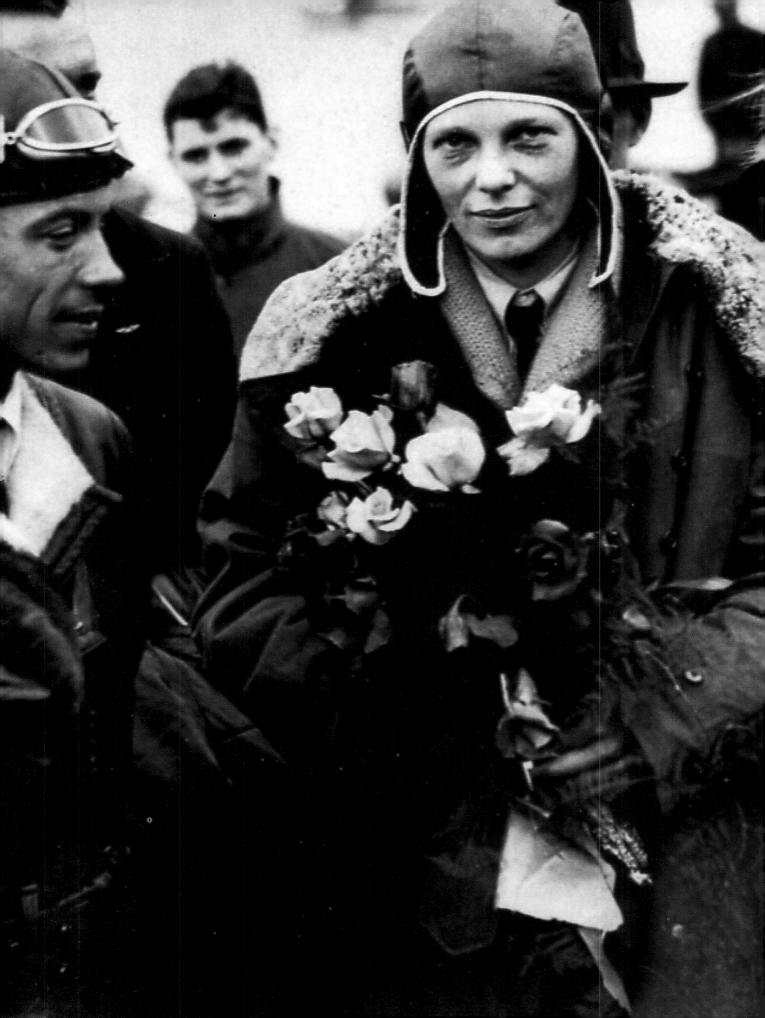

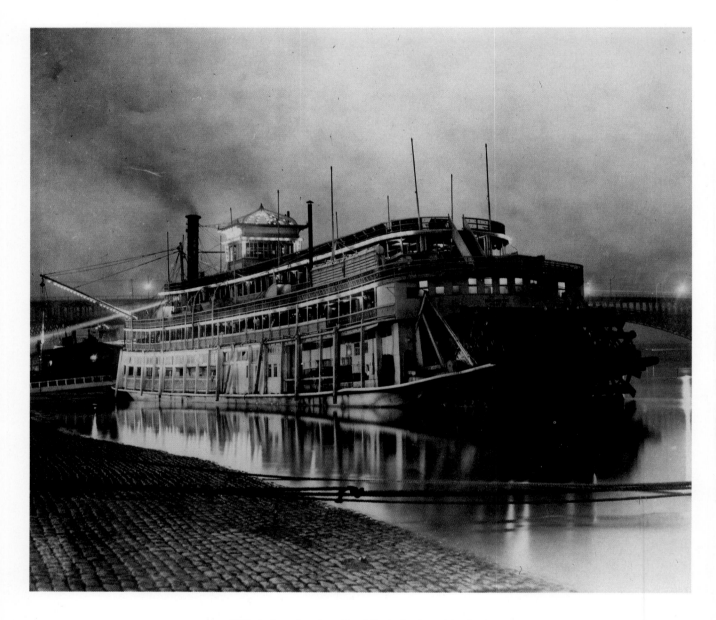

c. 1925 A steamboat on the Mississippi at night. By the 1920s, the glory days of these vessels had long passed, but excursion trips on the steamers remained popular.

c. 1925 The SS *Leviathan*, a former ship of the Hamburg–American Line, steams into New York Harbor. Originally named *Vaterland*, she was seized by the U.S. government in New York during World War I and renamed.

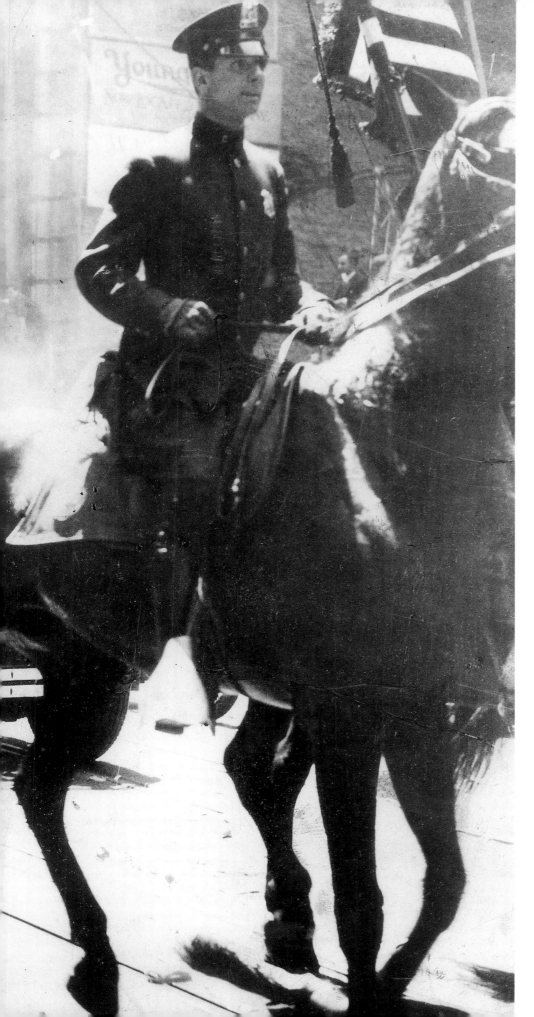

1927 In a great age of heroes, Charles Lindbergh (1902–1974) was the greatest hero of all. On May 20, 1927, Lindbergh, with the entire nation's hopes riding with him, took off from New York and 33 1/2 hours later landed in Paris – completing the world's first solo nonstop flight across the Atlantic. The ticker–tape parade that honored him in New York was unlike anything Americans had ever witnessed.

283

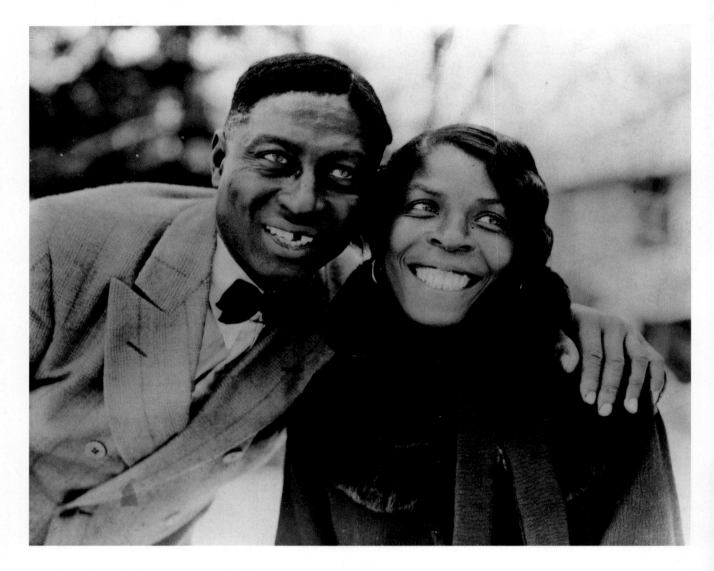

c. 1920 The man on the left is Huddie Ledbetter, known to the world as "Leadbelly" (1888–1949). A master of blues guitar playing, his most famous song was "Goodnight Irene."

c. 1925 Composer Irving Berlin at his piano. In the process of establishing himself as one of America's most beloved songwriters Berlin wrote more than 1,500 songs. Included among his hits were "Alexander's Ragtime Band," "God Bless America," "Always," and "White Christmas." His musicals included *Annie Get Your Gun* and *Call Me Madam*. He also wrote songs for such movies as *Blue Skies* and *Easter Parade*.

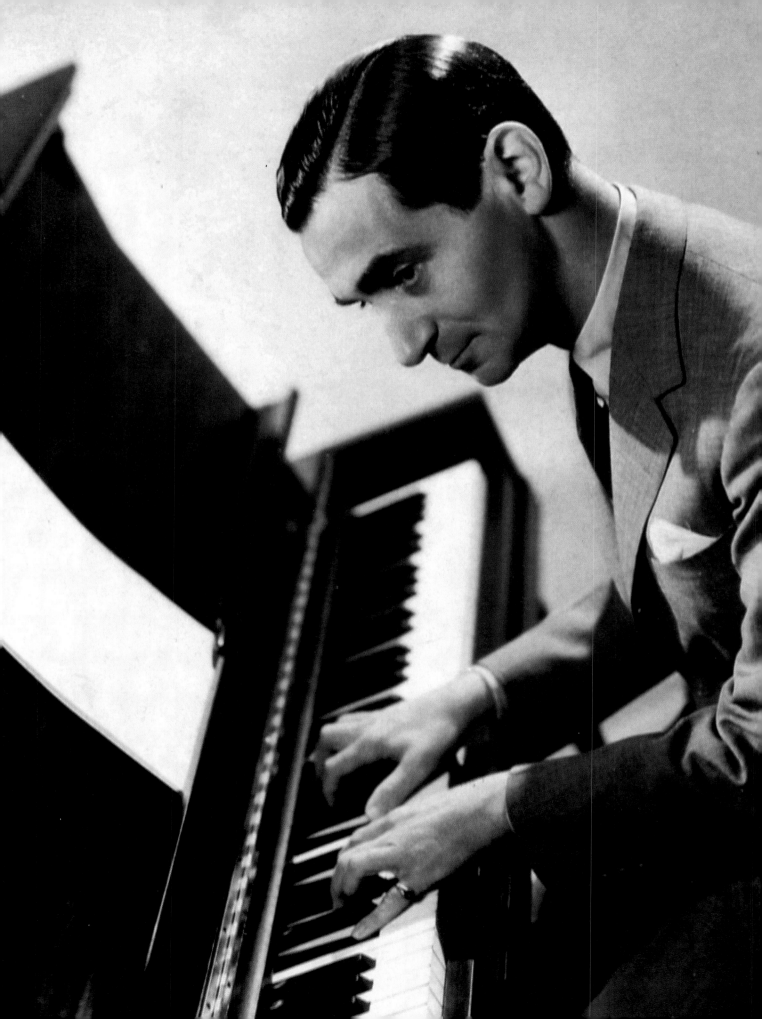

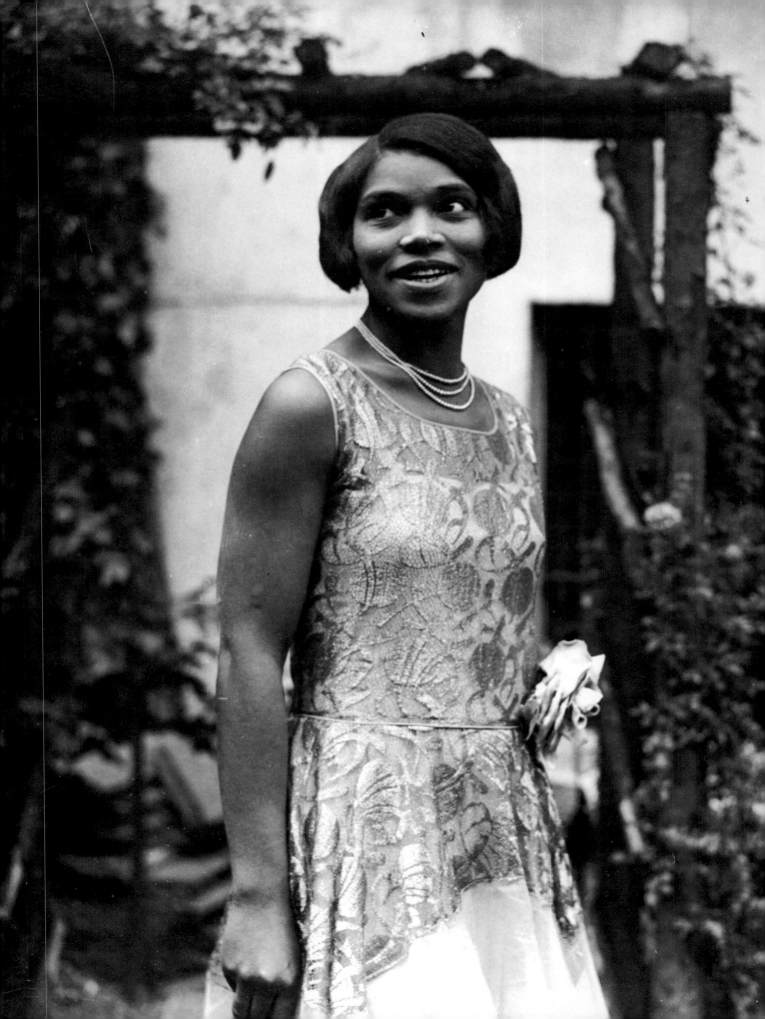

c. 1925 The Harlem section of New York was the center of African-American culture in the 1920s, attracting a large number of black writers, artists, and intellectuals. The Harlem Renaissance movement included such giant talents as Langston Hughes, Charles Johnson, and, seen here, the poet Countee Cullen (1903–1946).

1928 Contralto Marian Anderson (1897–1993) was possessed with a magnificent voice; nevertheless she was banned from singing at Washington, D.C.'s Constitution Hall because she was black. In 1955 Anderson became the first African-American singer to perform at the Metropolitan Opera.

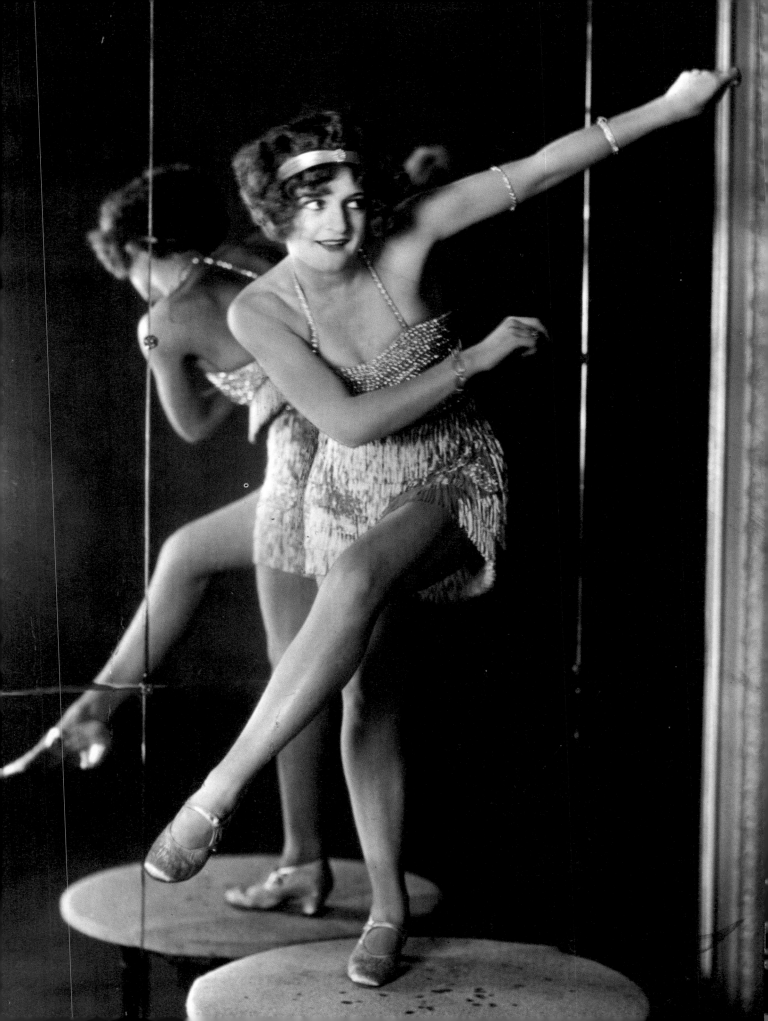

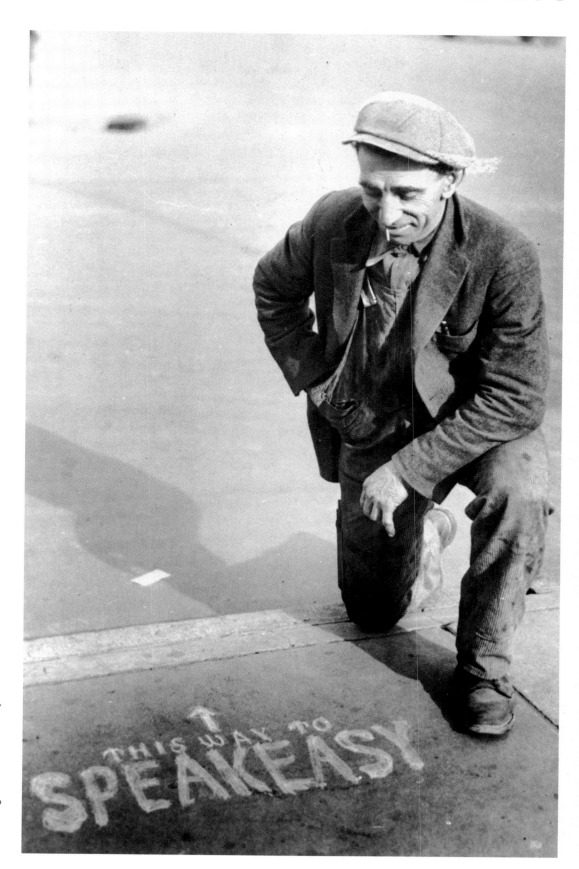

c. 1925 Developed in Charleston, South Carolina, the dance known as the Charleston became a vibrant symbol of the 1920s. Here world champion Bee Jackson practices her steps in front of the mirror.

c. 1925 Adopted in 1919 and commonly known as Prohibition, the 18th Amendment was probably the most disobeyed Constitutional Act in the nation's history. By 1924 New York city alone had some 100,00 establishments known as speakeasies selling "booze" to those anxious to flaunt the law.

1920s

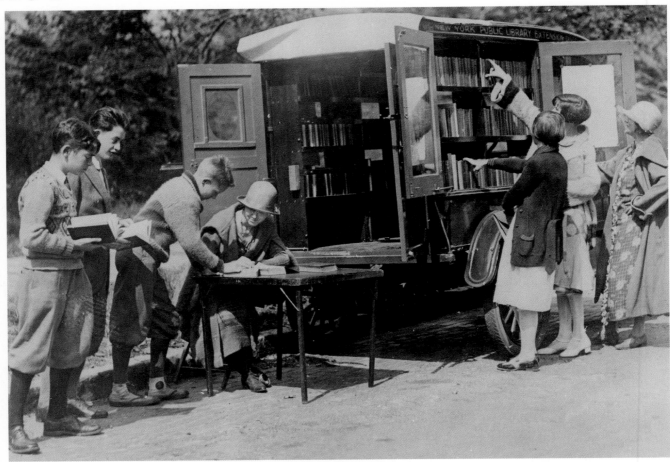

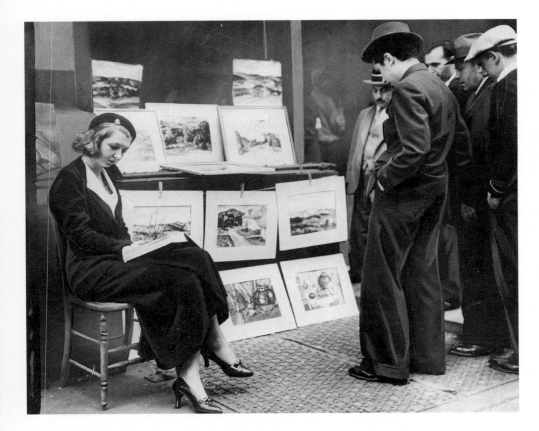

c. 1925 The automotive age made possible a brand new service probably never imagined by those who invented the first cars. Libraries in cities all over the country established mobile divisions that enabled those who had difficulty getting to the libraries to borrow books.

c. 1919 Sidewalk vendors are almost as old as the American city itself. Here a seemingly nonchalant artist reads while her work is examined.

1926 Building the huge bridges that were part of the landscape of many cities was one thing. Maintaining them was yet another. The four men seen here were climbing the upper span of New York's Brooklyn Bridge to prove than they had what it took to be hired as part of the bridge's painting crew.

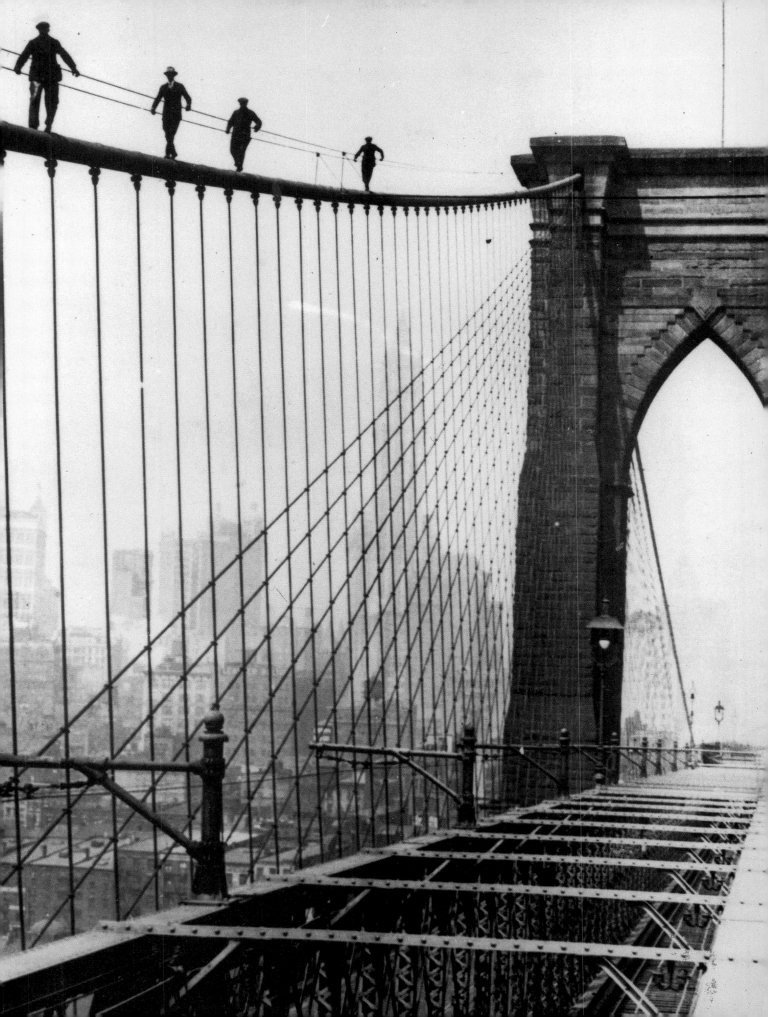

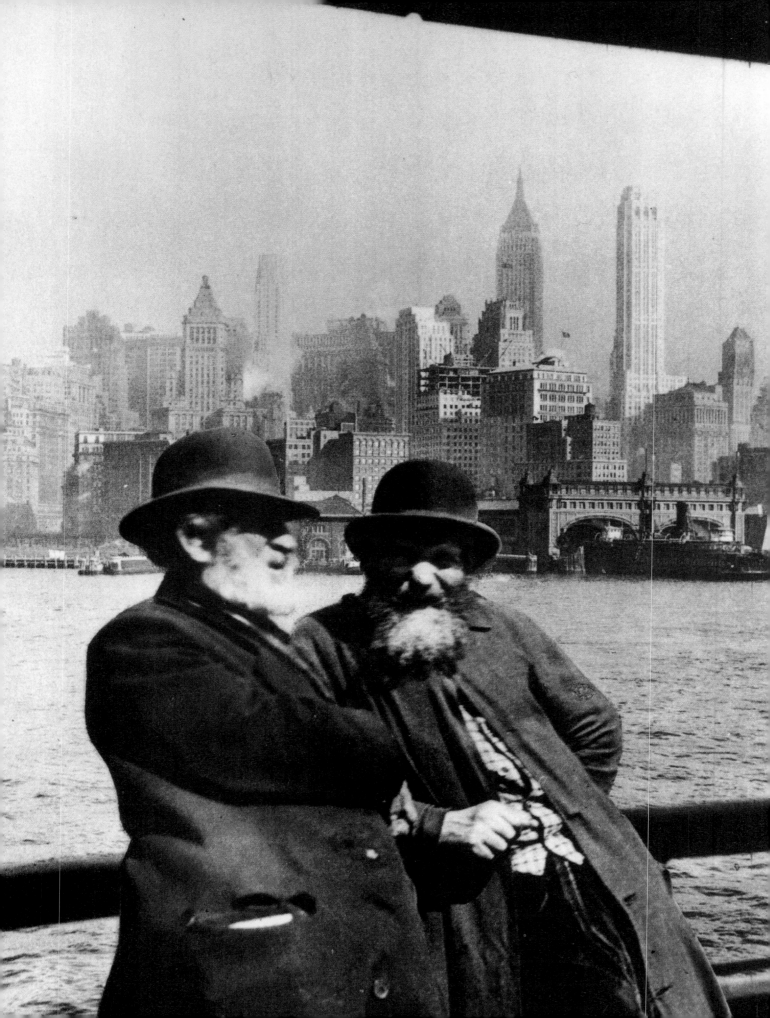

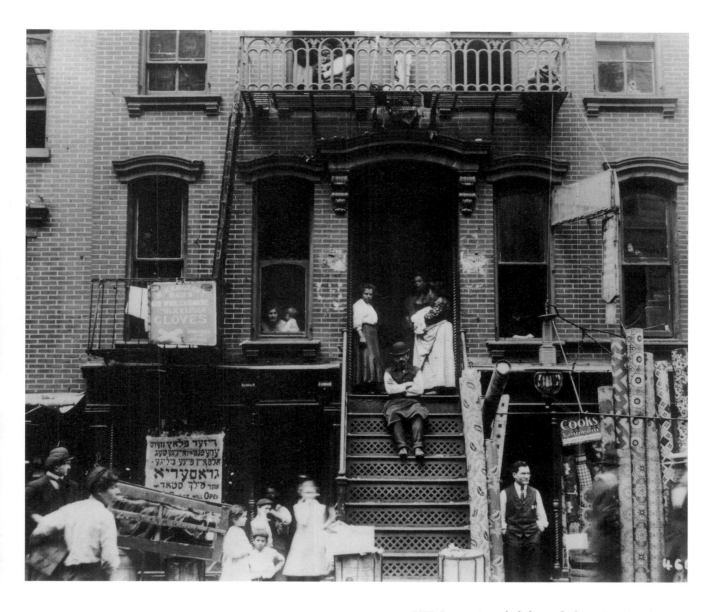

c. 1920 As one traveled through the various immigrant sections of New York it was often not that difficult to distinguish which group of immigrants had settled in a particular neighborhood. Signs such as the one in the left foreground of this picture told the story.

c. 1920 For those immigrants arriving in New York from small towns and villages in foreign lands, the sight of the towering buildings of New York was beyond anything they had imagined. These Jewish immigrants were awaiting the ferry that would take them from Ellis Island to Manhattan.

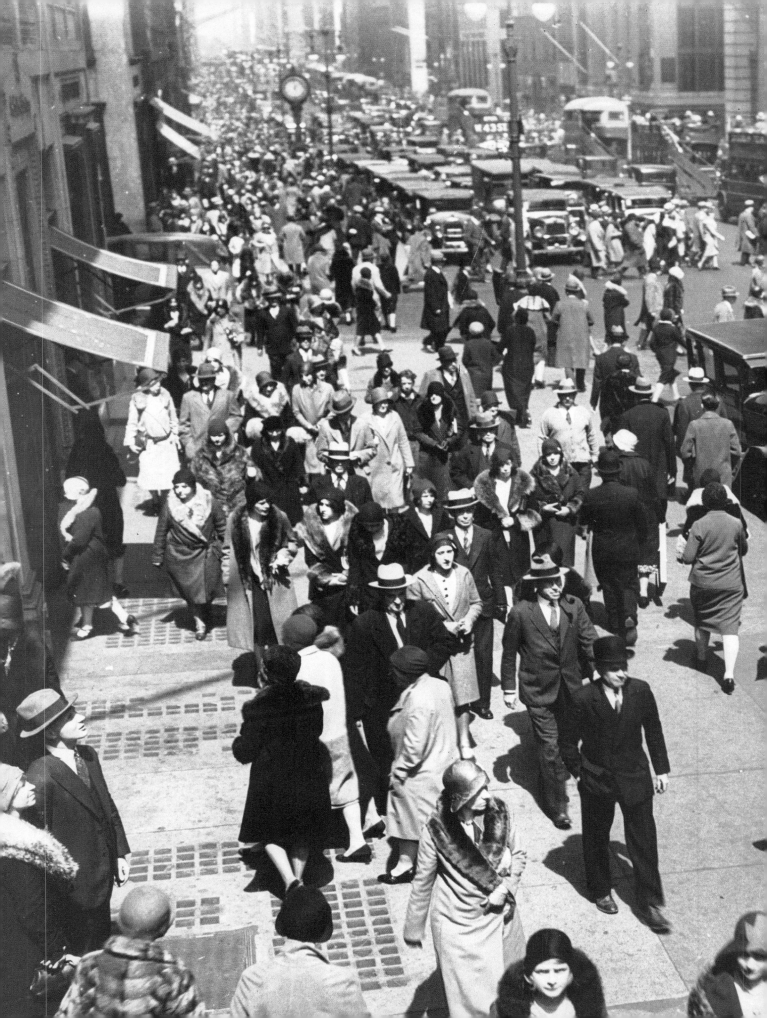

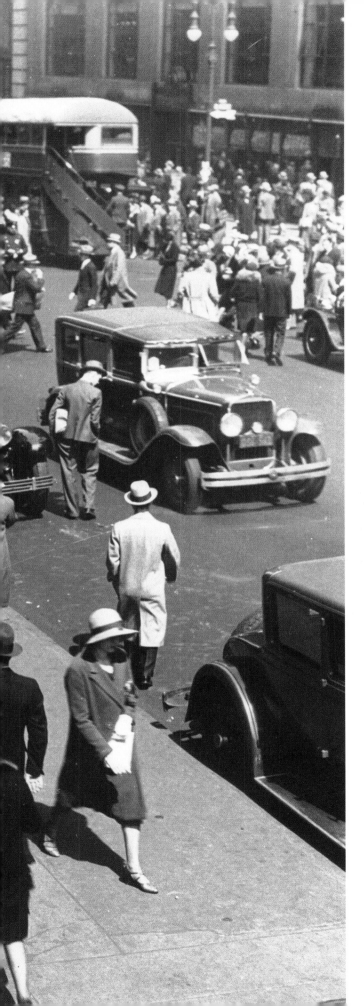

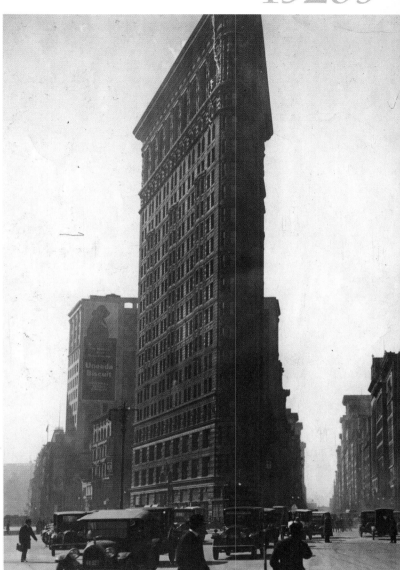

1921 The Flatiron Building in New York received its name from the fact that to many it resembled an inverted household iron. To many photographers and others, however, it most resembled the prow of a ship, a symbol of the spirit and energy that characterized the city.

c. 1926 "We cannot all live in cities," publisher and politician Horace Greeley had written, "yet all seem determined to do so." This was New York's Fifth Avenue.

1921 An English visitor to the United States described the American city as "a lady in ball costume, with diamonds in her ears and toes out at her boots." It was a particularly apt description of New York's Times Square (*previous pages*), which, aglow with lights, featured both the exciting and seamier side of urban life.

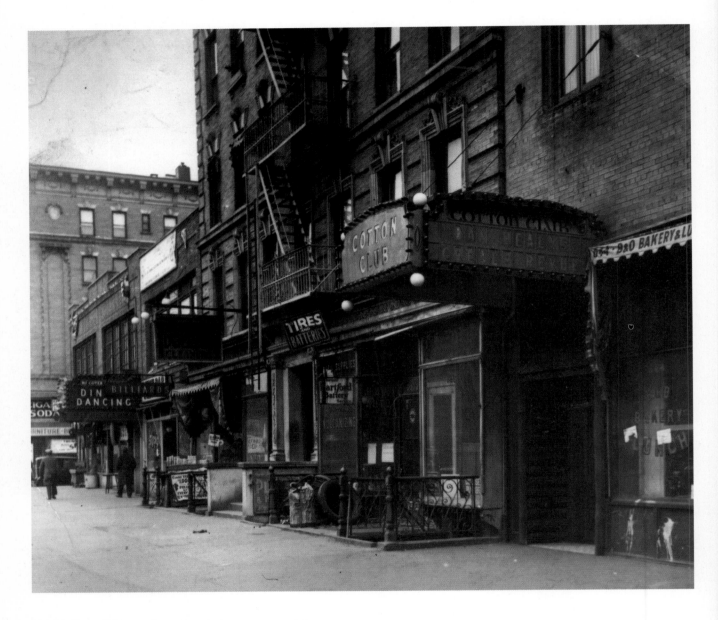

c. 1925 The modest and unassuming marquee on this building announced the location of one of the most exciting and influential nightclubs in the nation. Harlem's Cotton Club attracted tens of thousands of customers, white and black, who listened to the music of the best black jazz musicians and entertainers. Countless black performers credited the Cotton Club with giving them their start.

c. 1929 New York's George Washington Bridge, designed by the Swiss-American engineer Othmar Ammann, connected the states of New York and New Jersey. The wide tracks in the center accommodated subway cars.

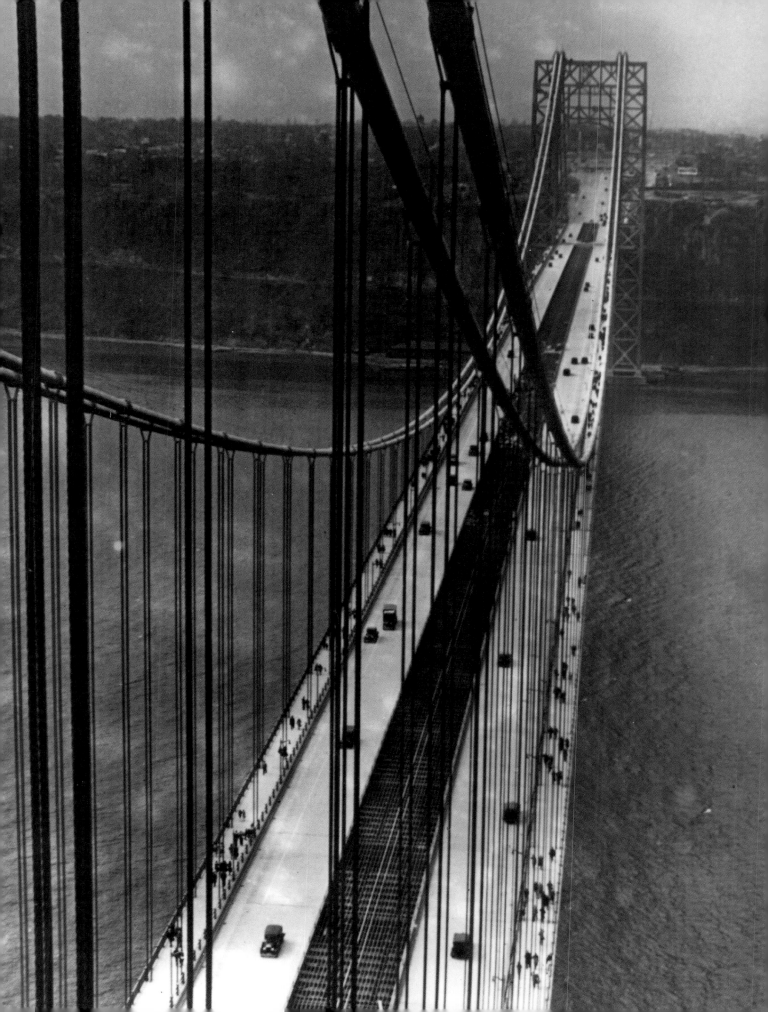

1920s

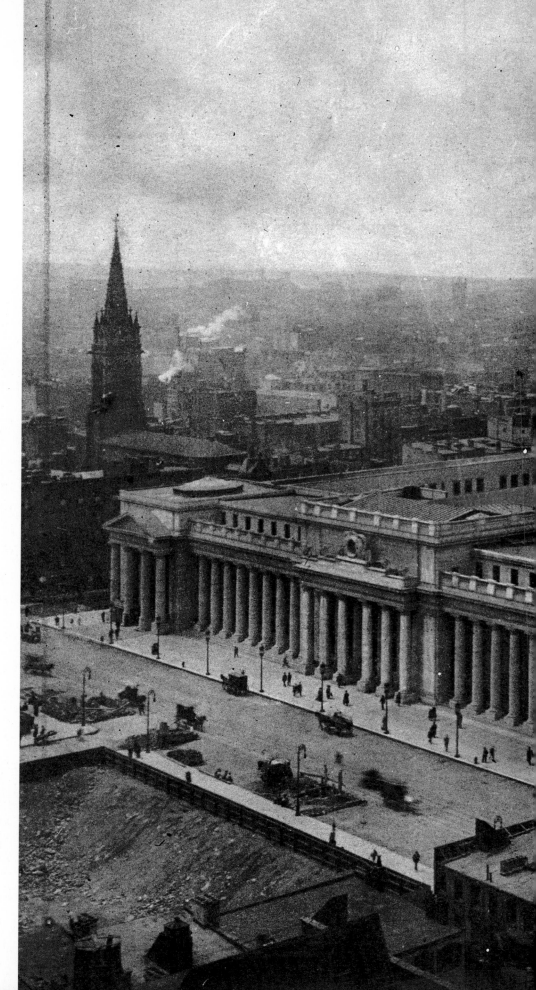

1924 In the early 1900s, many cities vied with each other for the honor of housing the nation's most spectacular railroad station. This was New York's Pennsylvania Station, modeled after the ancient Roman Baths of Caracalla. The structure was demolished in 1964.

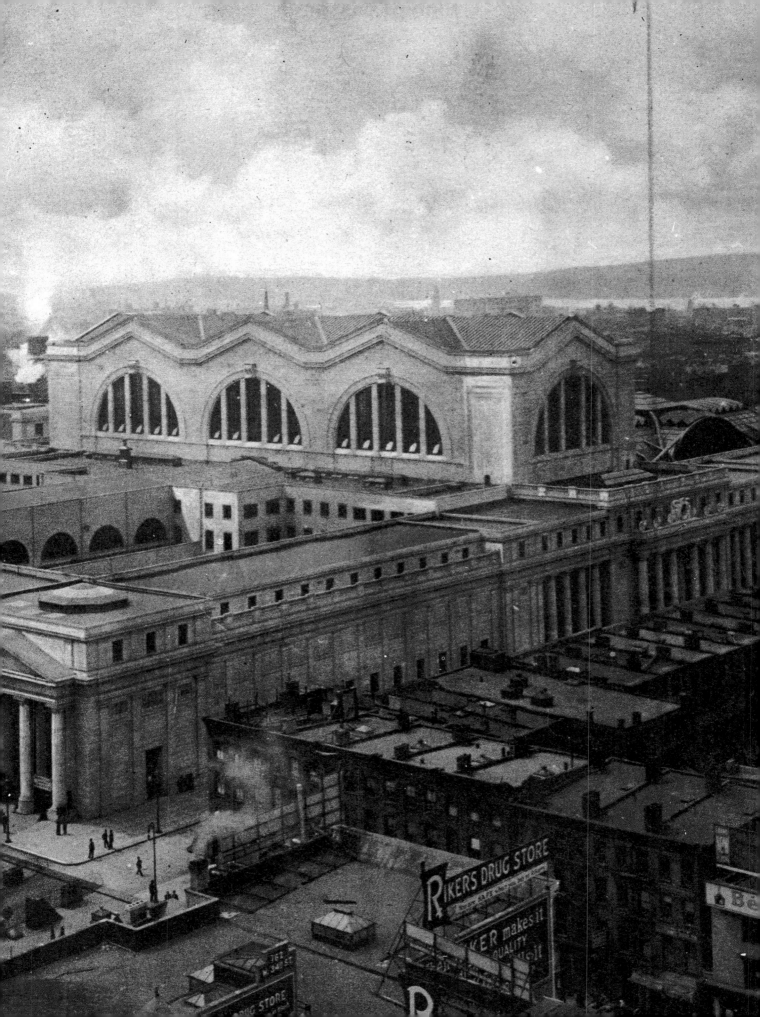

1923 At first a sport only for the wealthy, golf, by
the 1920s, was becoming a game increasingly embraced
by people of more modest means. These two golfers had
come up with a most unique caddie.

1922 Of all the daring articles of apparel worn by
women in the 1920s none seemed to shock people more
than the "scandalous" one-piece bathing suits introduced
not long before this picture was taken.

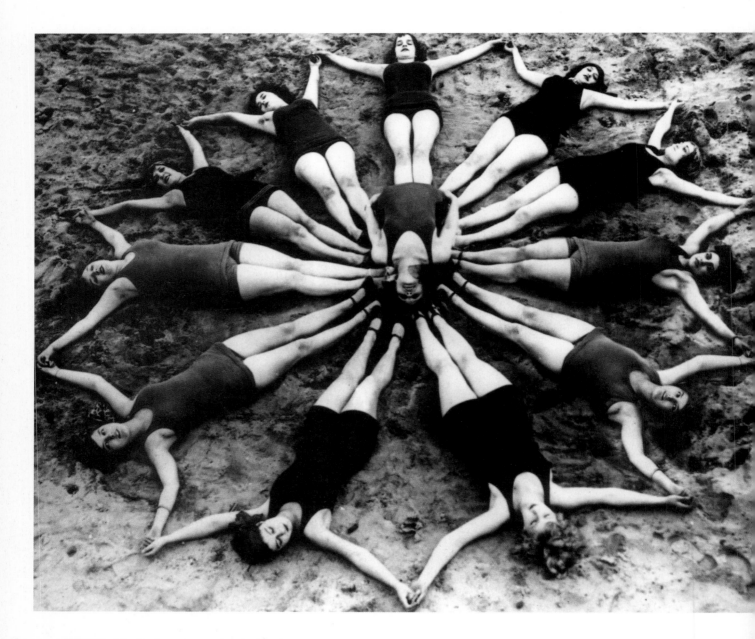

1925 The "daring" young women in this picture were members of a physical culture class. Known as the Daily Dozen Girls, they are shown forming a human starfish on New York's Brighton Beach.

1927 The person wearing this elaborate flapper's gown is not a woman. He is a female impersonator, winner of one of the top prizes in Philadelphia's Mummer Parade of 1927.

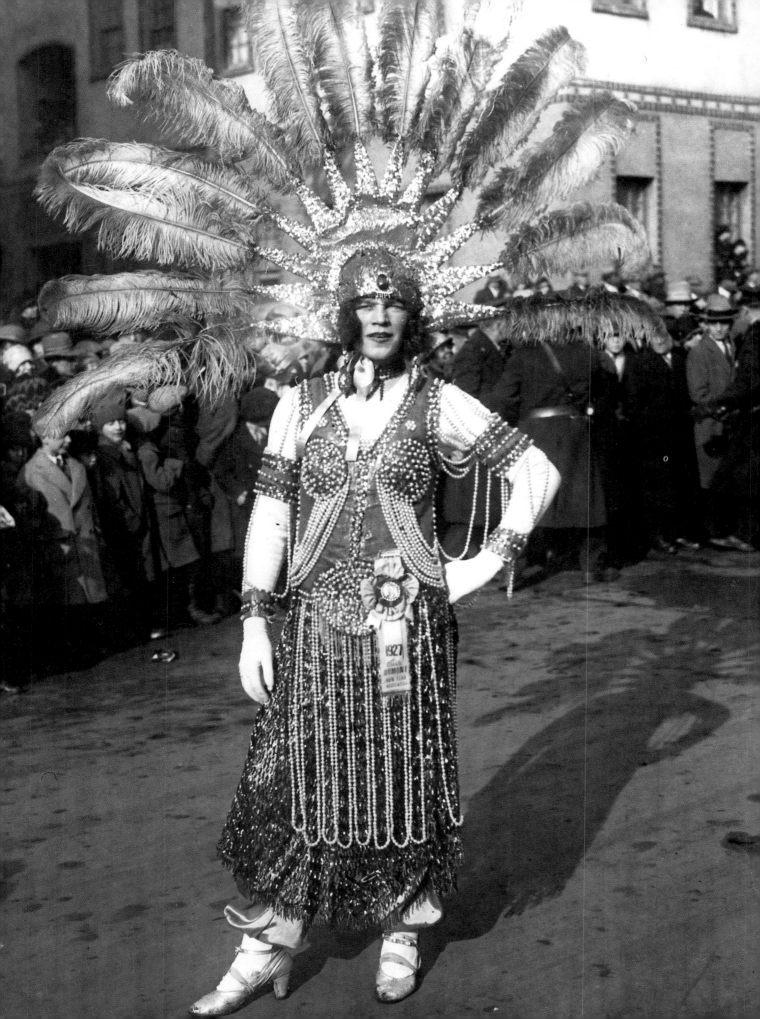

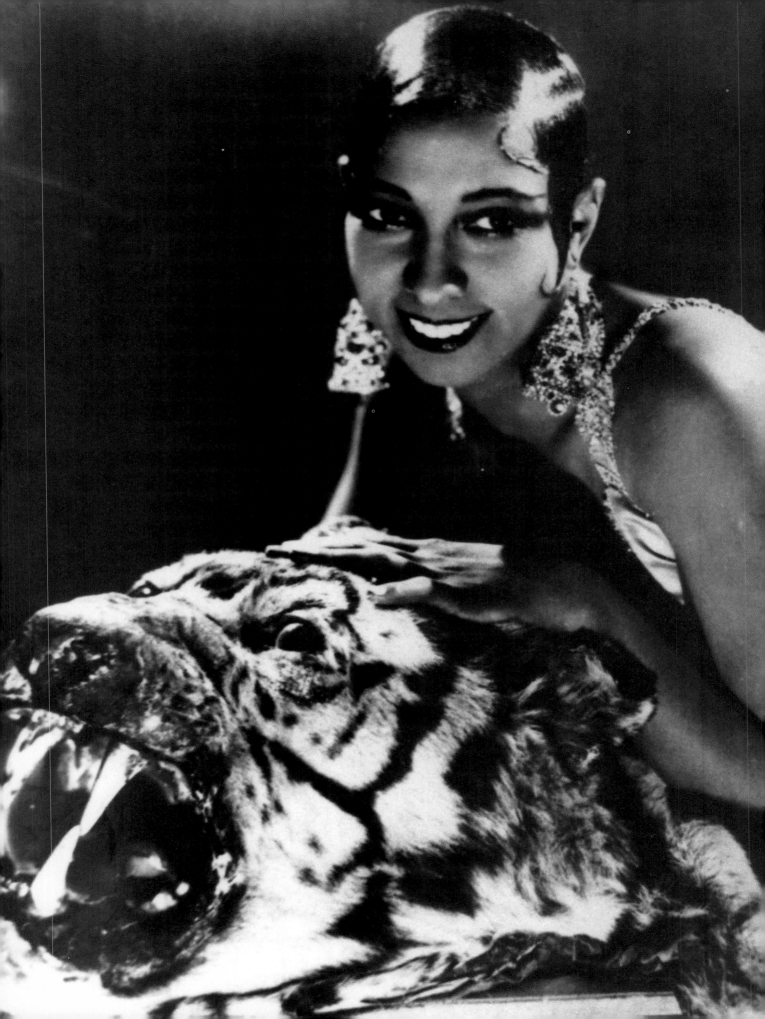

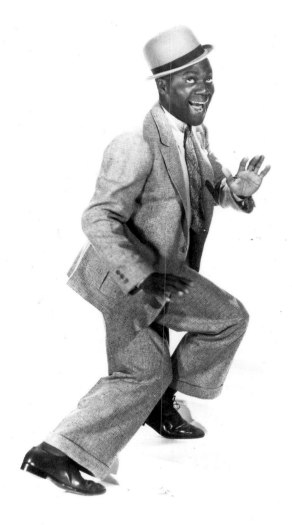

c. 1925 Dancer Bill Robinson (1878–1949) was one of the most popular of the African–American entertainers who drew audiences to the many nightclubs located in Harlem. A magnificent dancer, Robinson earned both the name Bojangles and the title of "king of tapology."

c. 1923 Renowned for her jazz singing, her sultry dancing, and her exotic costumes, Josephine Baker drew large audiences wherever she performed. Before her career was over she became as popular in France as she was in the United States.

1920s

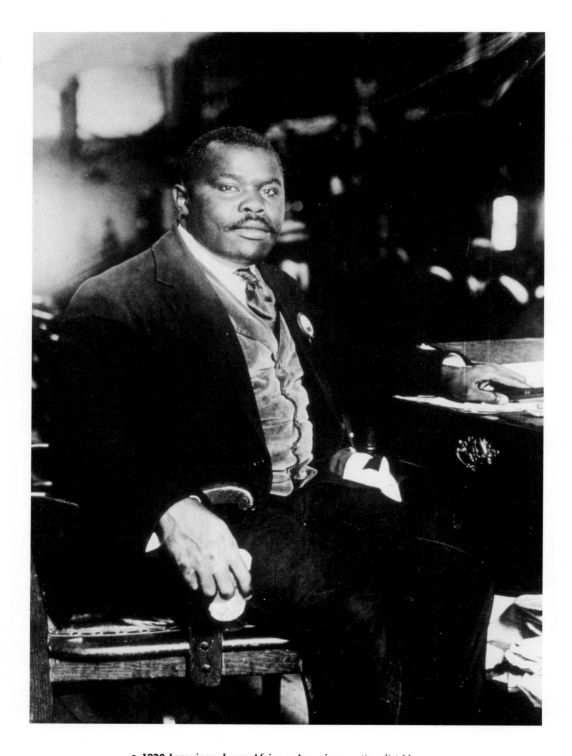

c. 1920 Jamaican–born African–American nationalist Marcus Garvey (1887–1940). Founder of the Universal Negro Improvement Association, Garvey raised millions of dollars to finance his plan to help African-Americans emigrate to Africa. In 1923 he was sentenced to prison for using the mails illegally but was pardoned two years later by President Calvin Coolidge.

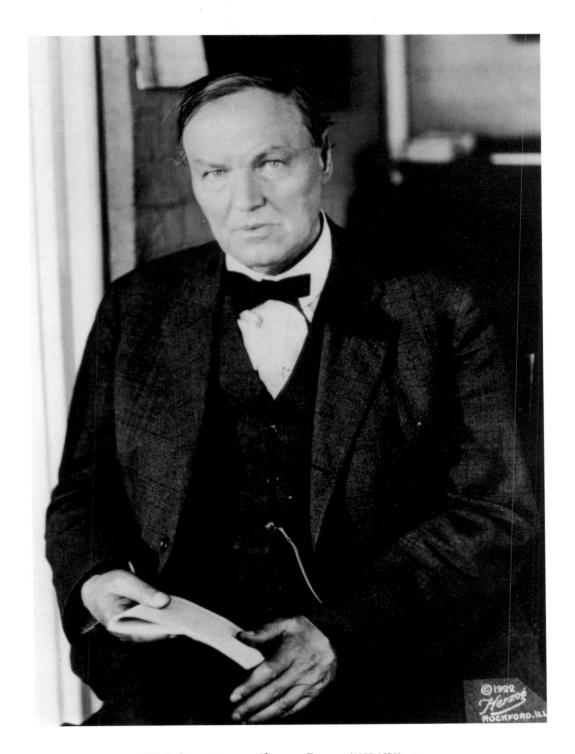

1925 Defense attorney Clarence Darrow (1857–1938) was
involved in some of the most famous trials of his era, including
the John Scopes case centering around the teaching of evolution,
and the Leopold and Loeb case in which two wealthy young men
were accused of a thrill murder. Most of his career was devoted
to fighting for the underprivileged.

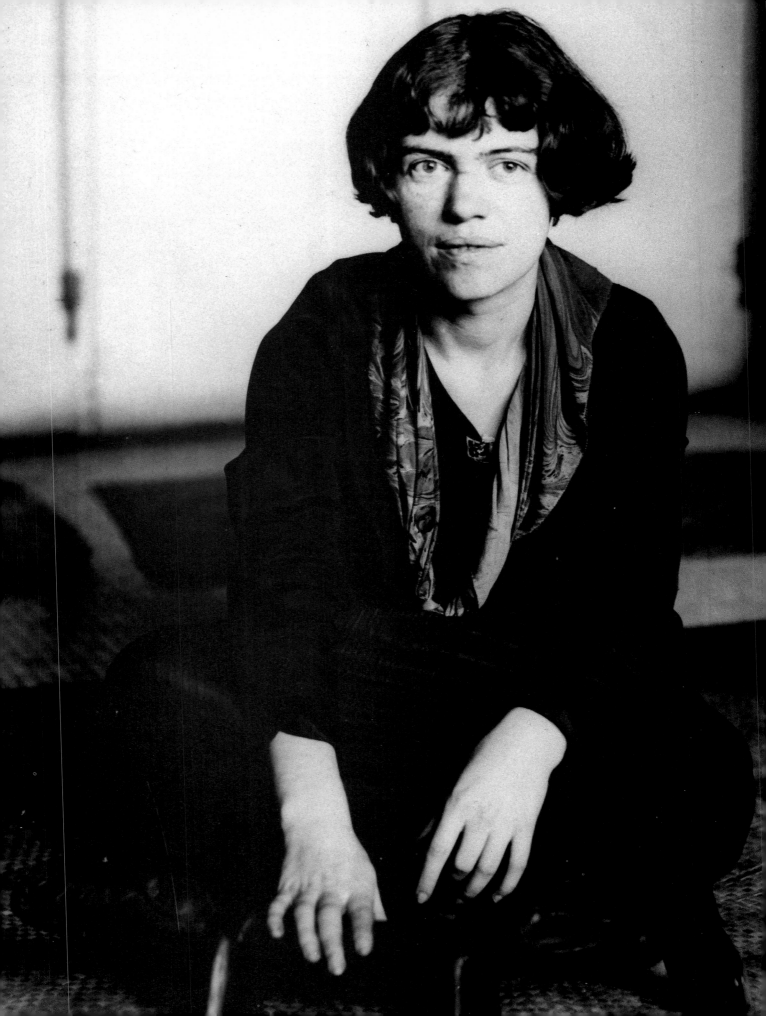

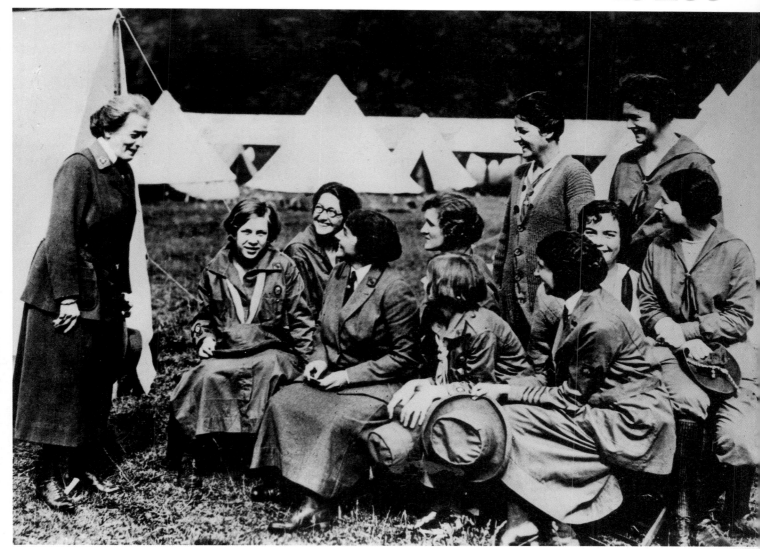

c. 1920 Standing on the left is Juliette Low (1869–1927), who founded the Girl Scouts of the United States of America in 1913 (*above*). Under Low's leadership, membership in the Girl Scouts rose rapidly. Over the years the organization has succeeded in adapting itself to meet changing times and the needs and diverse makeup of its members.

1926 Margaret Sanger (1883–1966) was a passionate social reformer and founder and president of the American Birth Control League, the organization that later became the Planned Parenthood Federation of America (*right*). In explaining her motivation Sanger said, "Mother bore eleven children; she died at 48. My father died at 80."

1928 American anthropologist Margaret Mead (1901–1978). Her anthropological expeditions, beginning in 1925, took her to Samoa, New Guinea, and Bali. A pioneer in stressing the relationship between culture and psychology, Mead (*left*) was also a curator of ethnology at the American Museum of Natural History. Her most well-known book is *Coming of Age in Samoa* (1928).

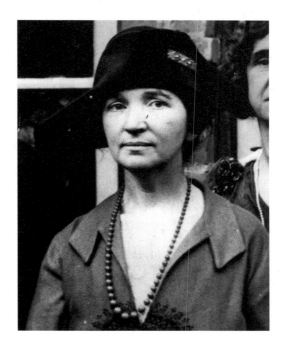

WOMEN !
USE
YOUR
VOTE

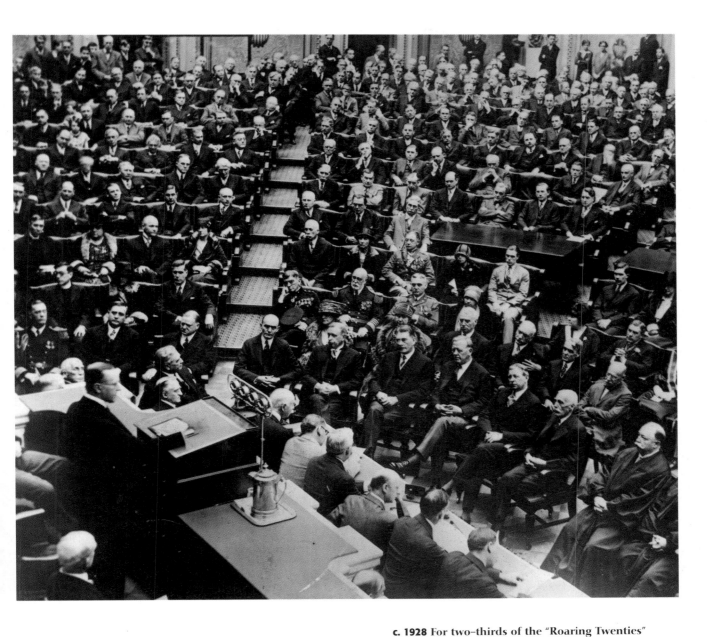

c. 1928 For two-thirds of the "Roaring Twenties"
Calvin Coolidge (1872–1933) served as the 30th President of the United States. It was ironic that in a wild-spirited decade marked by change, the nation was led by a conservative Chief Executive who had proclaimed that government's "greatest duty and responsibility is not to embark on any new ventures."

c. 1920 In 1920, through the 20ᵗʰ Amendment to the Constitution, women finally won the right to vote. For many suffragists, however, there was now another issue: that was the task of getting women in large numbers to exercise their hard-won right.

1920 Norman Rockwell (1894–1978) in 1920. Through the charming, often patriotic magazine paintings and covers he created, particularly for the *Saturday Evening Post*, Rockwell became one of the nation's most popular illustrators.

c. 1929 Eugene O'Neill (1888–1953), shown with his family, is regarded by many as America's greatest dramatist. His often tragic plays were far different from the types of drama previously encountered on the American stage. O'Neill's *Beyond the Horizon*, *Anna Christie*, and *Long Day's Journey into Night* all won the Pulitzer Prize. In 1936 he was awarded the Nobel Prize for Literature.

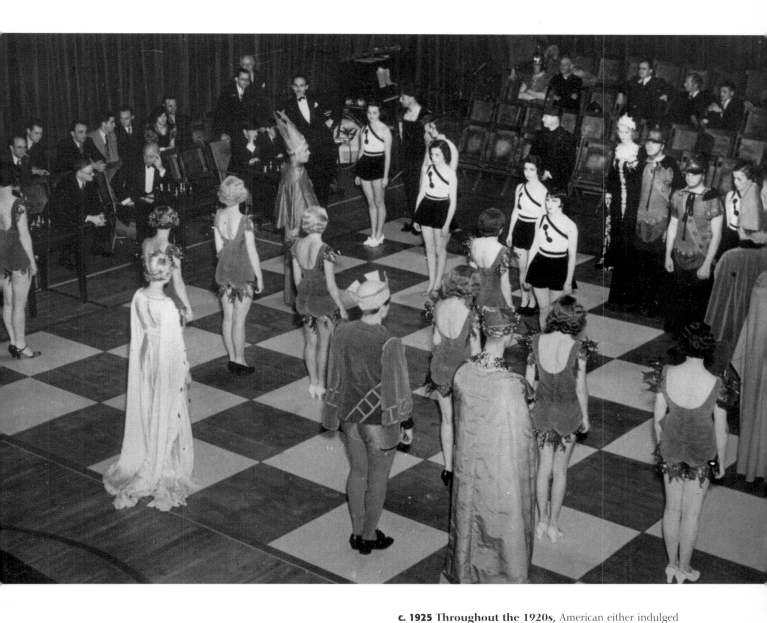

c. 1925 Throughout the 1920s, American either indulged in or became spectators to a host of crazes that consumed their interest. It was the era of the dance marathon, mah–jongg, the introduction of contract bridge, and the cross–word puzzle. These Californians were playing one of the more bizarre of the games – human chess.

c. 1922 In early 1922 there were four licensed radio stations in the United States. By the end of that year there were 576. At first, as this whimsical photograph illustrates, one had to use earphones to listen to a program. Soon, however, loudspeakers were built into radio sets and a roomful of people could listen together.

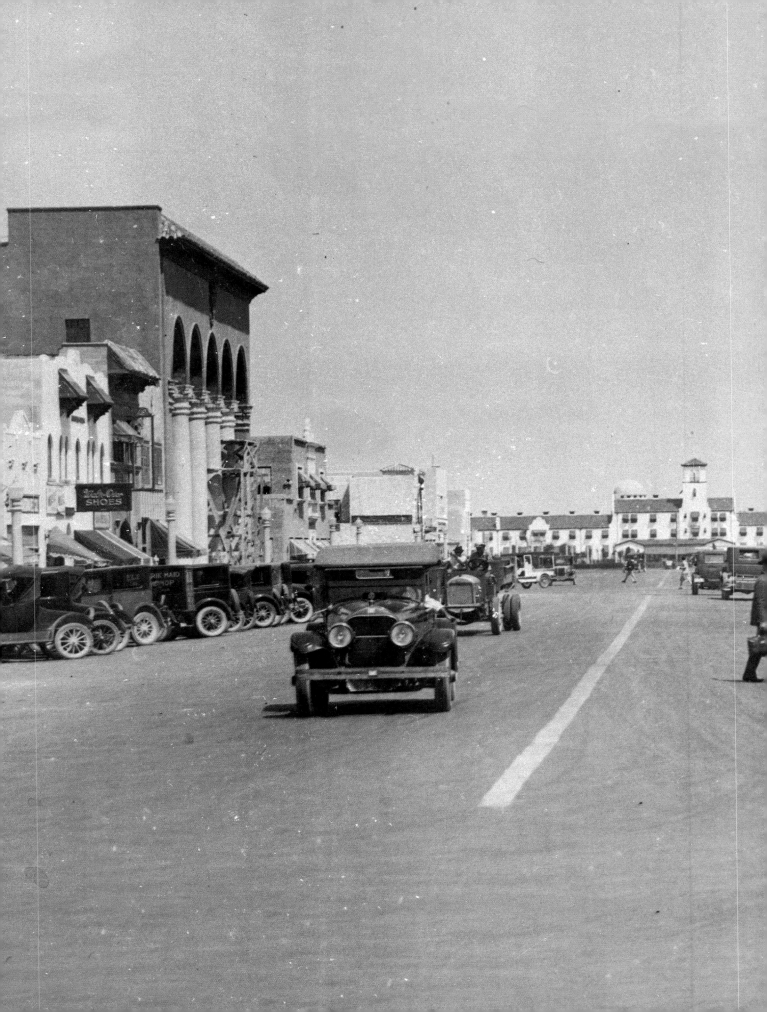

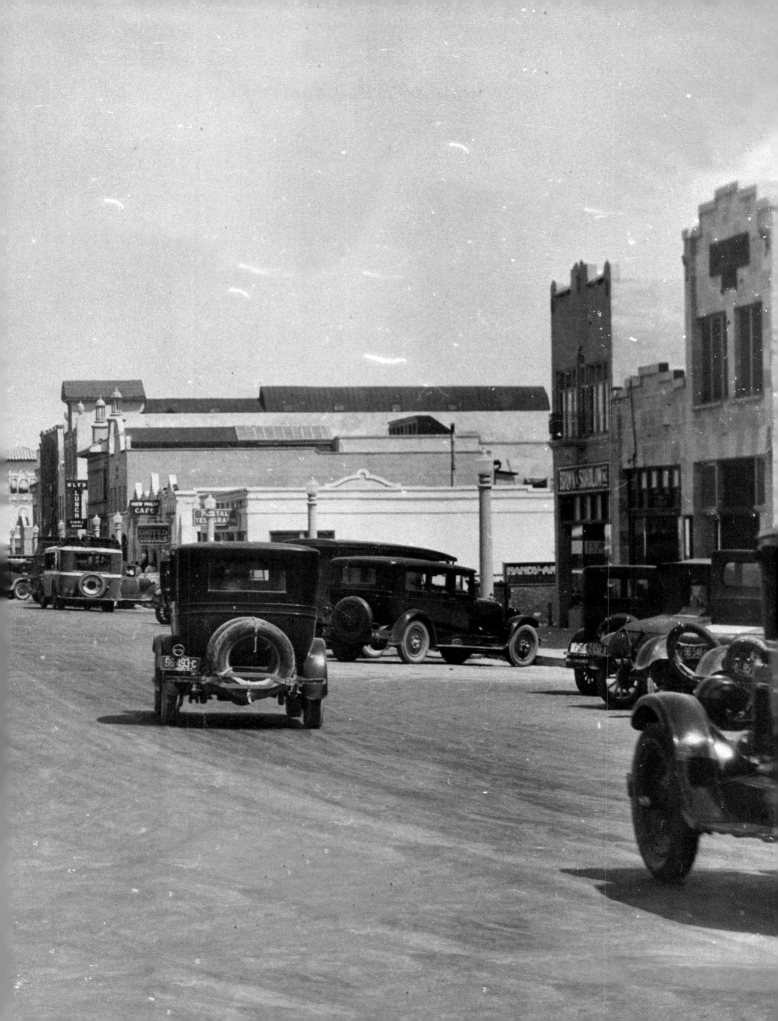

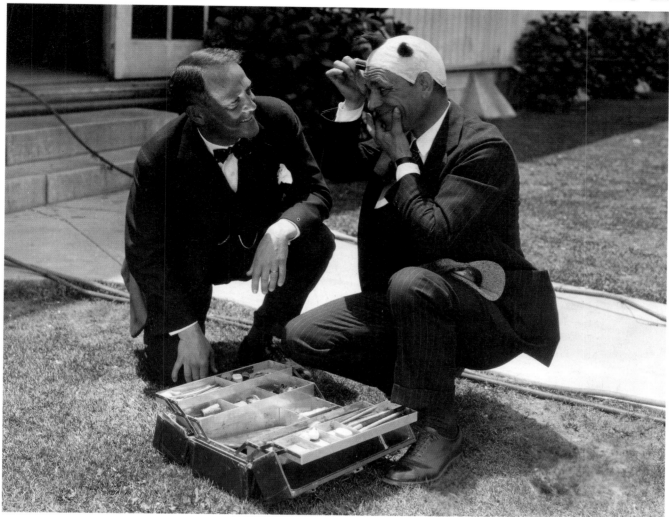

c. 1924 The man on the right is early film star Lon Chaney (1883–1920) seen testing out his makeup for a role as a circus clown (*above*). Chaney, known as the "Man of a Thousand Faces," would become best known for the parts he played in Hollywood horror classics, including *The Hunchback of Notre Dame* (1923) and *The Phantom of the Opera* (1925).

1929 Anna May Wong (1907–1961) was one of the stars of the silent silver screen (*right*). She made her first movie when she was only 16, starring opposite Douglas Fairbanks in *The Thief of Bagdad*.

c. 1925 During the days of silent movies most films were made in the East. But the warmer, sunnier climate and the film location possibilities of the Los Angeles area turned Hollywood (*left*) into the film capitol of the world.

c. 1927 In 1927 Warner Brothers ushered in the feature-length talking motion picture with its film *The Jazz Singer* starring Al Jolson. Movie mania was about to become bigger than ever and this quiet boulevard in the Hollywood section of Los Angeles (*previous pages*) was about to explode.

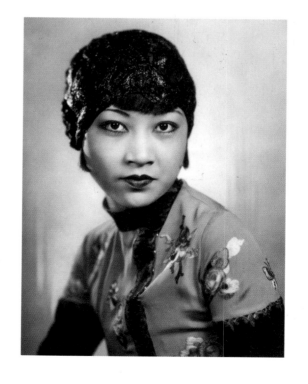

1920s

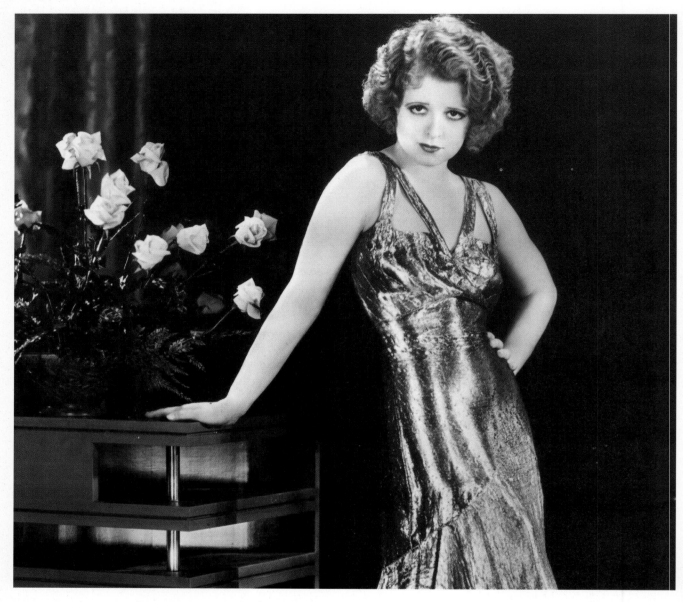

c. 1925 Silent screen star Clara Bow (1905–1965). When Bow was 16 she won first prize in a beauty contest and as a result won a bit part in a movie. Bow (*above*) eventually became a star and became known as the "It" girl through the sultry roles she played.

1928 The baby in this picture was destined to become one of the most famous of all movie stars (*left*). Born Norma Jean Baker, she was given the screen name Marilyn Monroe (1926–1962.) In the 1950s she became a sex symbol but displayed genuine acting ability in several of the screen comedies in which she appeared. She made further headlines through her marriages to baseball star Joe DiMaggio and playwright Arthur Miller.

c. 1928 With bobbed hair, no corset, and dress cut to the knees, actress Louise Brooks (*right*) presented the perfect picture of that woman of the 1920s known as the flapper.

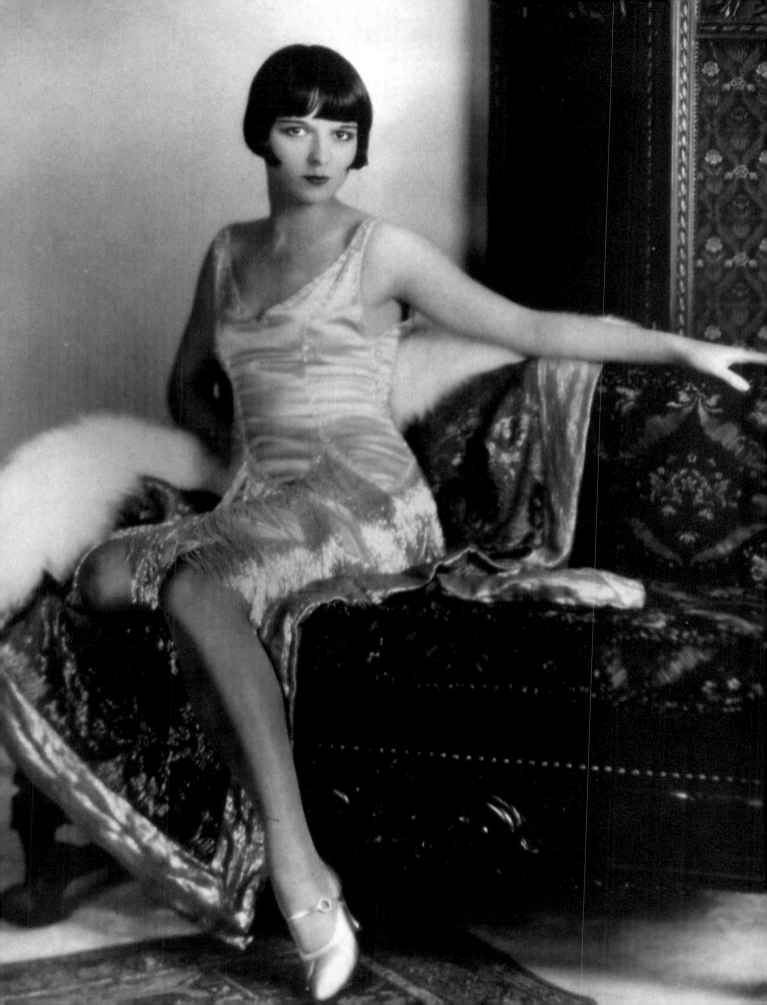

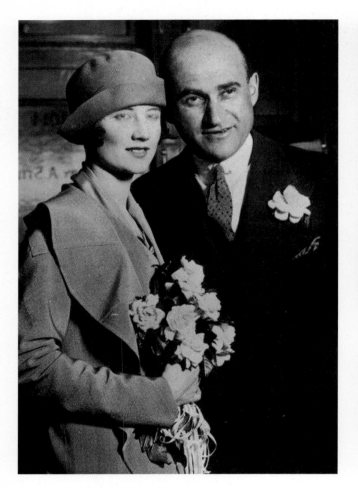

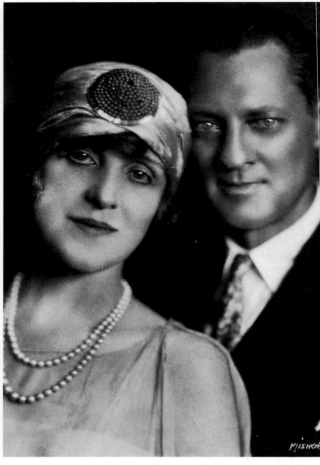

1925 Producer Samuel Goldwyn (1882–1974) with his wife, actress Frances Howard on their wedding day (*above left*). Among Goldwyn's movie hits were *Wuthering Heights, The Little Foxes, The Best Years of Our Lives,* and *Guys and Dolls.*

c. 1928 Lionel Barrymore (1878–1954), along with his sister Ethel and his brother John, helped turn the Barrymores into America's leading family of actors. All three played numerous roles on both the stage and the screen. Barrymore is shown here with his wife Irene Fenwick (*above*).

c. 1921 Beginning in 1921, Rudolph Valentino (*left*) established himself as the greatest male screen lover of his era. When he died at least two female fans committed suicide and more than 30,000 heartbroken mourners attended his funeral. He is shown here in a scene from his most famous movie, *The Sheik.*

c. 1923 Gloria Swanson (1897–1983) began her motion picture career as a Mack Sennett bathing beauty (*right*). That her influence extended beyond the screen was evidenced by the countless women who copied her hairstyles and latest way of dress. Her most famous role was Norma Desmond in *Sunset Boulevard.*

c. 1924 Walt Disney (1901–1966) changed the face of family entertainment through the animated characters he created and such movies as *Snow White and the Seven Dwarfs*, *Pinocchio*, *Dumbo*, *Bambi*, and *Fantasia*. He is shown here coaxing a penguin into performing for his innovative cartoon series titled *Silly Symphony*.

c. 1928 In this publicity photo, comedian and director Joseph "Buster" Keaton (1896–1966) arrives at a film studio armed with two bags filled with jokes. Because of his dead-pan expression, Keaton was known as the "Great Stone Face."

c. 1921 Charlie Chaplin (1899–1977) was the most famous comic actor in movie history. His face became so familiar that he was actually able to travel throughout Europe without a passport. He is shown here as the character known as "Little Tramp," one of his best-known screen roles.

1927 Actress Mary Pickford (1893–1979) clowns with two
fellow actors during a break in filming. The first star of silent
films, Pickford earned the moniker "America's Sweetheart."

c. 1927 Actor Douglas Fairbanks, Sr. (1883–1939) poses with a giant microphone. Fairbanks was known for his swashbuckling roles in such films as *The Mark of Zorro*, *The Three Musketeers*, and *Robin Hood*.

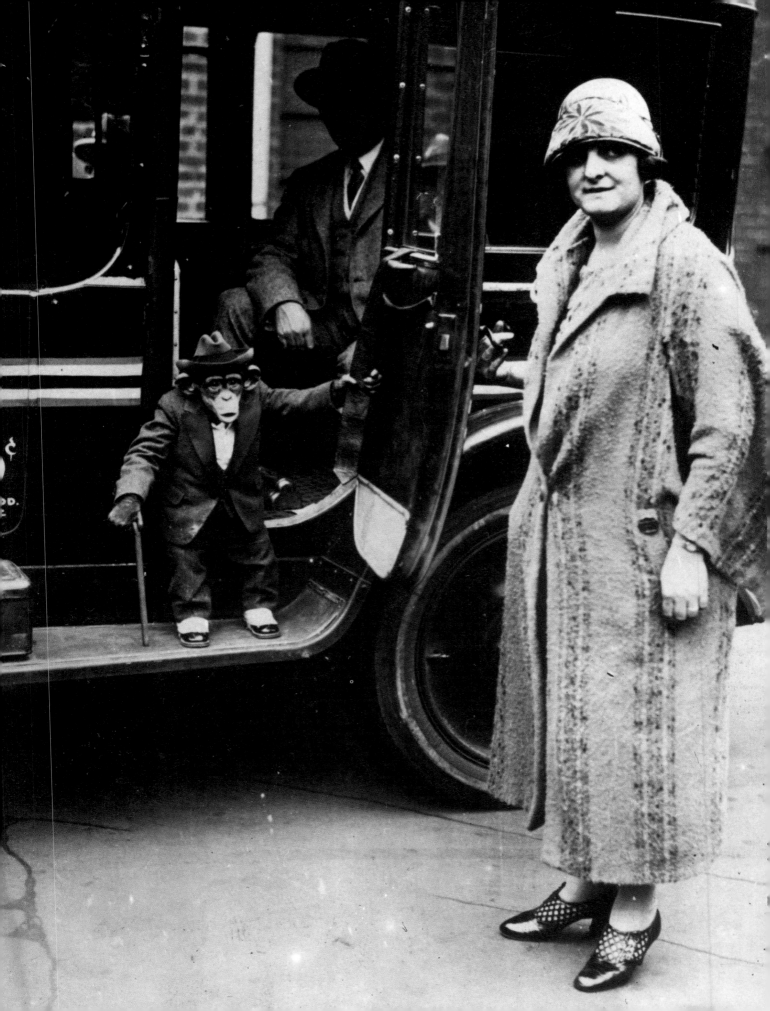

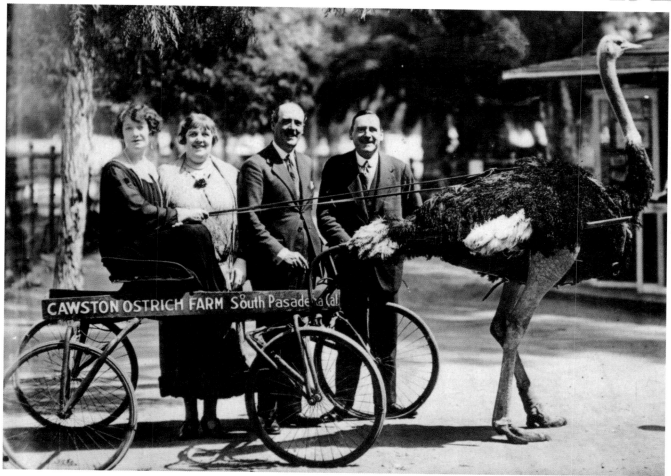

1926 In a decade dominated by pleasure seekers, having fun took many forms. This woman (*above*) is about to take a ride on an ostrich farm in Pasadena, California.

c. 1925 The proud fisherman in this picture holds a massive lobster caught in the waters off Provincetown, Massachusetts (*right*). It was 3$\frac{1}{2}$ feet long, weighed 27 pounds, and was estimated to be more than 50 years old.

1925 The chimp seen in this picture was billed as Joe Mendi, the gentleman chimpanzee (*left*). Here he is stepping out of a taxi, about to enter New York's Bellevue Hospital where he will entertain young patients.

1927 In the 1920s no stunt seemed too outrageous. These members of the Los Angeles Adventurers Club (*previous pages*) were eating their dinner while a most unusual guest joined them at the head of the table.

1921 The first U.S. Census was taken in 1790. When the 14ᵗʰ census was taken in 1920 it was found that the center of the population was on the farm of Mr. and Mrs. Joseph Herrin of Whitehall, Indiana. Here they proudly pose with a sign donated by a local pub.

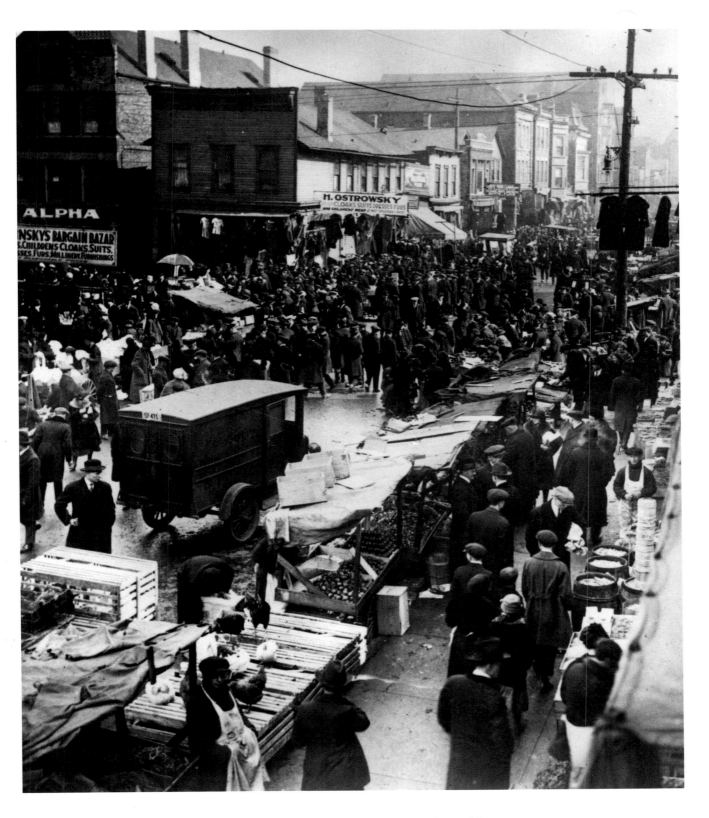

1925 In 1925, **Chicago's market district** was still one of the centers of activity in the city. There was, however, a major change. Automotive vans had replaced the horses that once dominated the area.

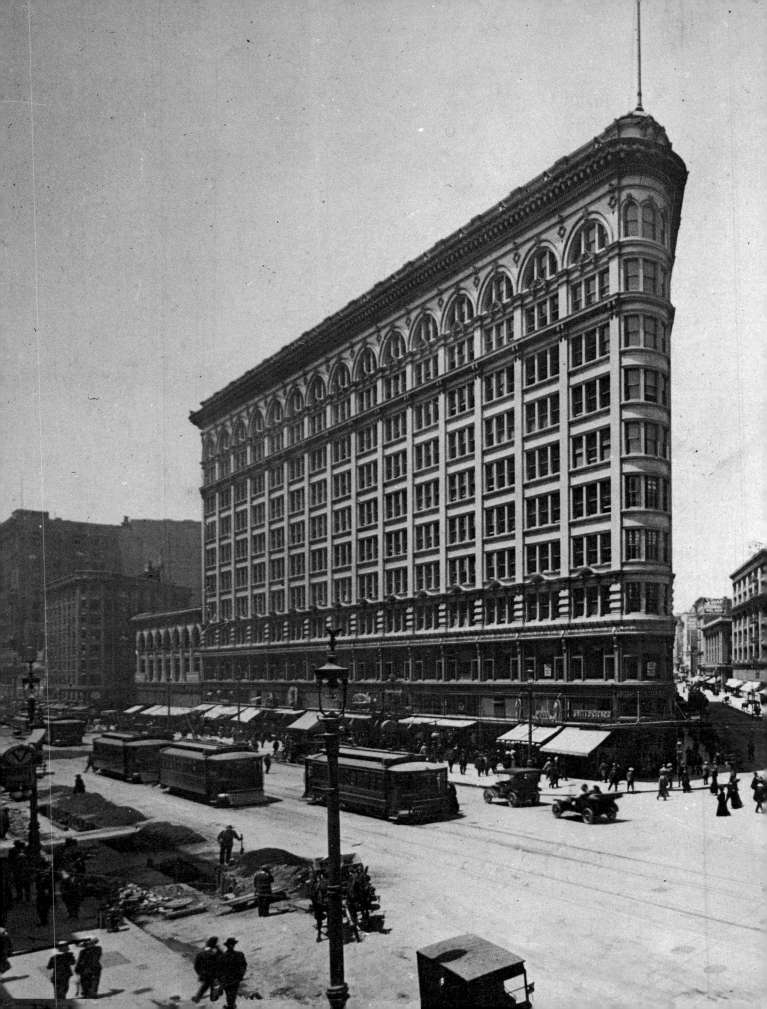

1925 This office building at the corner of San Francisco's Market Street, O'Farrell Street, and Great Avenue boasted a unique distinction. Ten feet wide at one end and broadening only to 20 feet wide at the other it claimed to be the thinnest building in the world.

337

1920s

1925 In the 1920s the flood of new automobiles brought not only pleasure and increased personal freedom but an alarming number of motoring accidents as well. This town found a dramatic way to emphasize the dire results of broken traffic laws.

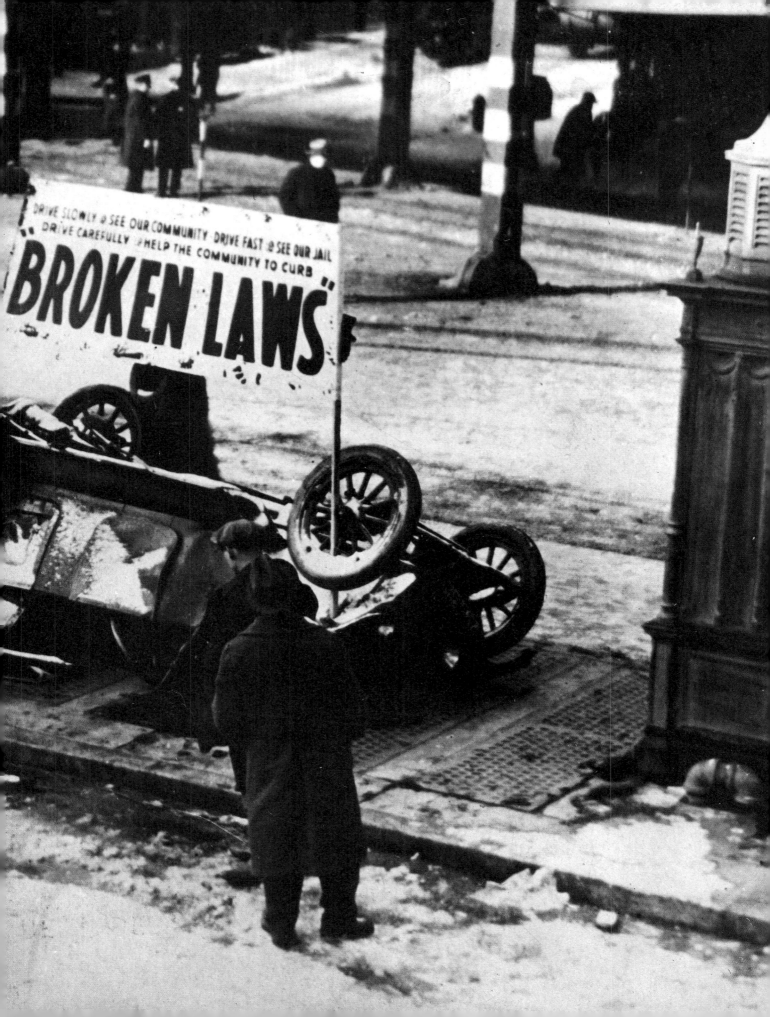

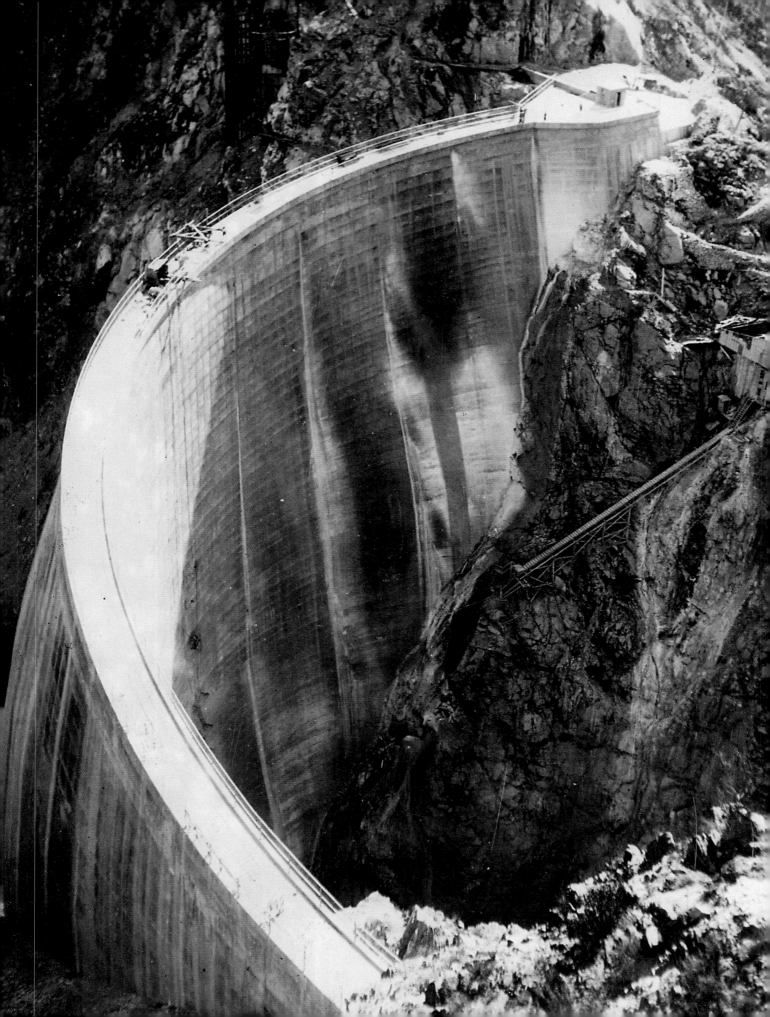

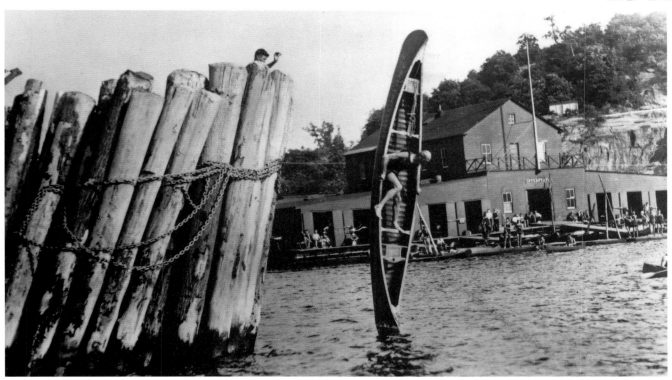

1929 The 1929s witnessed a host of construction marvels. This is the Pacoima Dam in California's San Fernando Valley, at the time the largest dam in the world.

1925 Stunts, stunts, and more stunts. From flagpole sitting to tightrope-walking between huge buildings, it seemed people would try anything to capture attention. Here Charles Clark (*above*) performs his favorite stunt – nose diving into the Hudson River in his canoe.

c. 1925 In 1925, electric trolleys were still highly visible but automobiles were becoming bigger and more luxurious. This is the scene (*below*) in Tampa, Florida at the height of the tourist season.

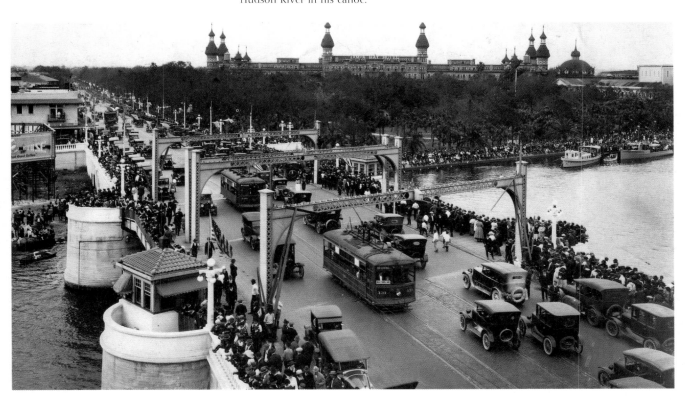

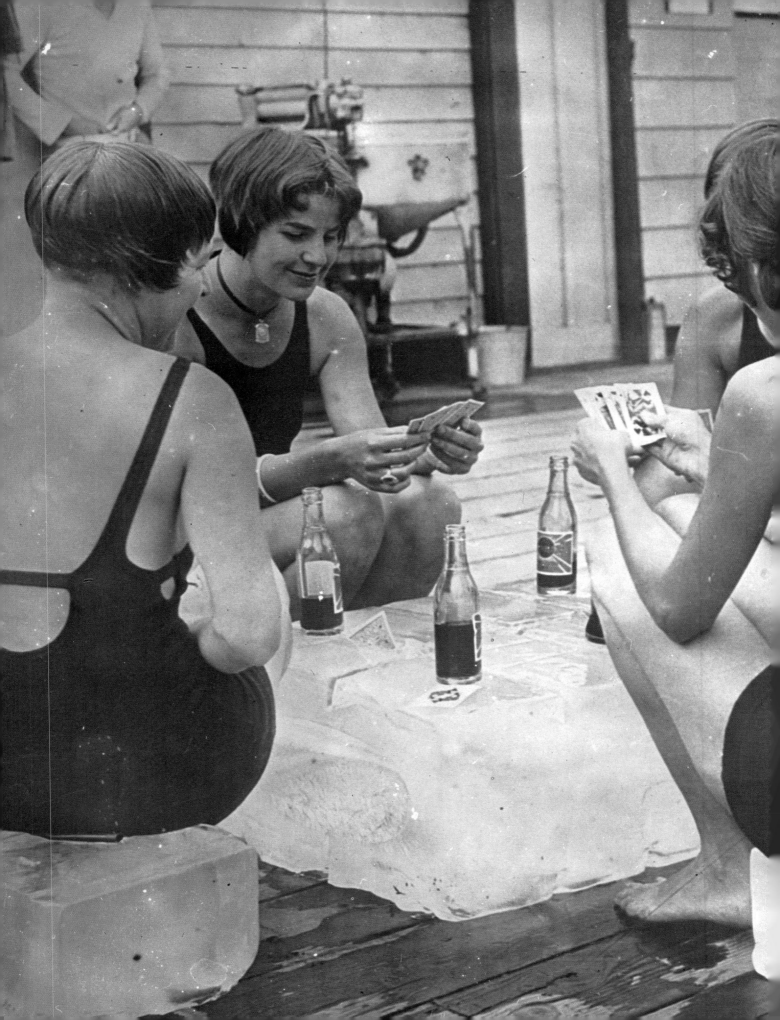

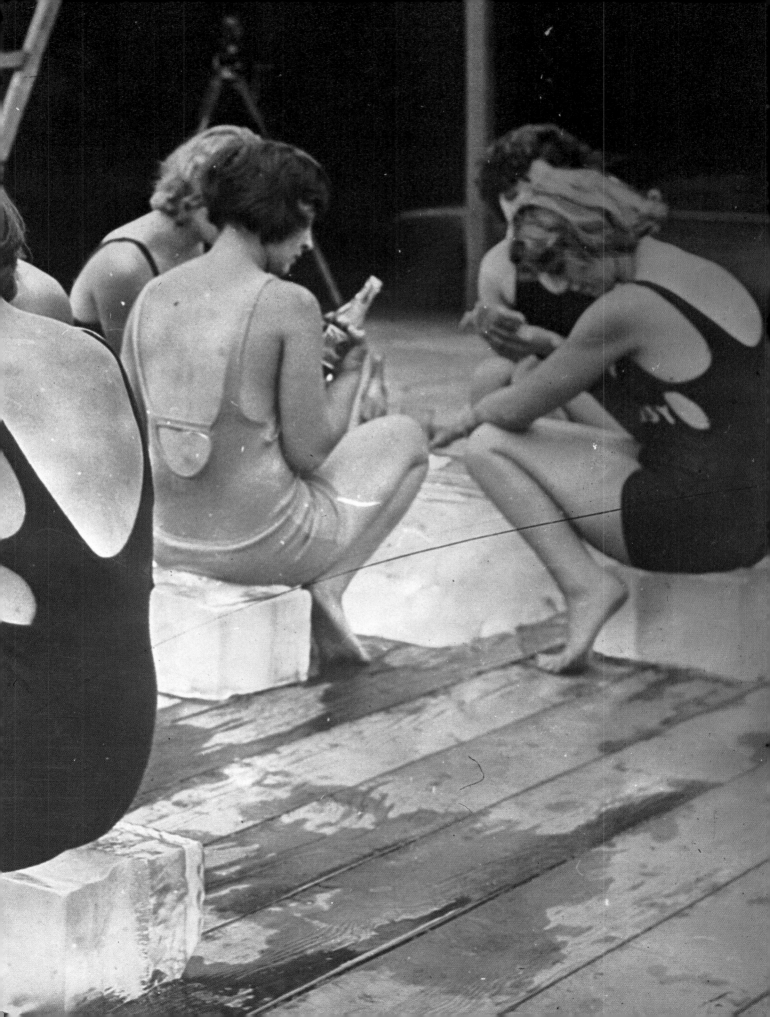

c. 1920 The subject of this stylized portrait was Edward Eslin Cummings (1894–1962) who always wrote his poetry completely in lower case and who signed himself as e.e. cummings. At first Cummings' poetry drew attention because of his unique way of presenting it, but gradually it became recognized for the insights it provided.

c. 1923 F. Scott Fitzgerald (1896–1940) (*above*) was one of the idols of the "Roaring Twenties." His book *The Great Gatsby* is regarded as the anthem of the era. Fitzgerald was only 24 years old when his first novel, *This Side of Paradise*, drew attention to the decade of boom and bust. In the 1930s, Fitzgerald went to Hollywood where he wrote several screenplays.

1929 In a time of great creative expression, not everyone could be an artiste or West Village Bohemian, but one could think up inventive ways to enliven leisure activities. These women (*previous pages*) are playing cards while sitting on blocks of ice.

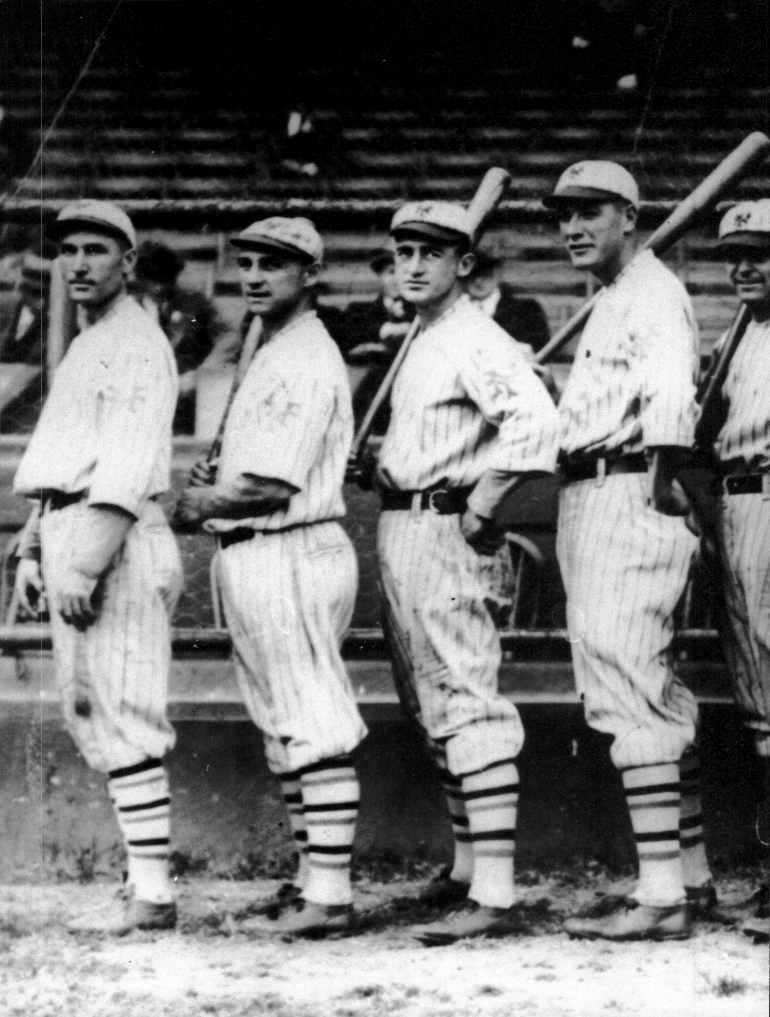

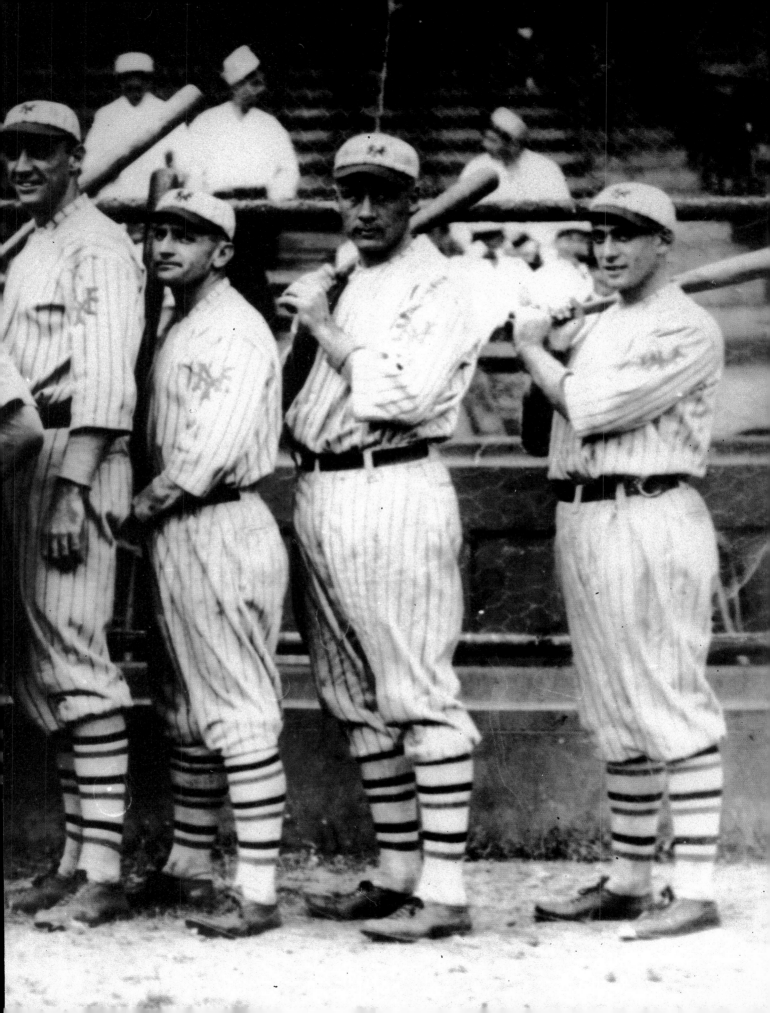

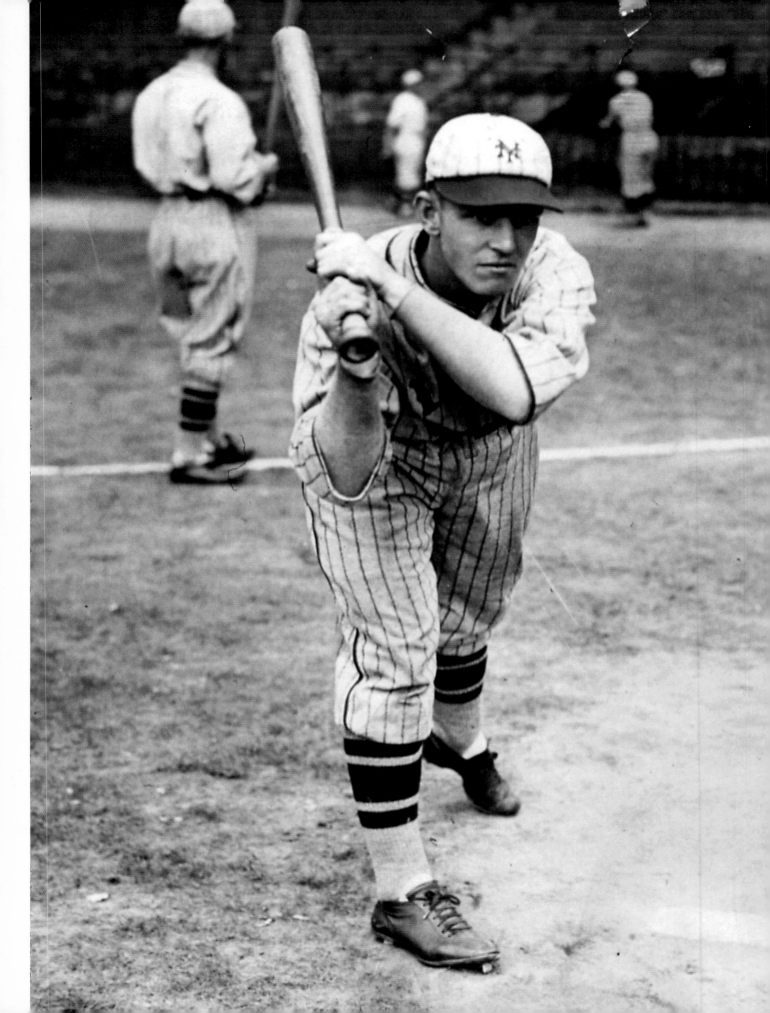

1922 In an age decades before the first Super Bowl, the World Series was the nation's premier sports event. Here members of the New York Giants raise the banner symbolizing their World Series victory in 1921.

c. 1929 In the 1920s, baseball stars ranked among the nation's most celebrated heroes. This is Mel Ott (*left*), star left-handed batter for the New York Giants.

c. 1925 Babe Ruth (1895–1948). George Herman "Babe" Ruth (*right*) was the most beloved baseball player of all time. A man of gargantuan appetites, Ruth, through his magnetic personality and the 714 home runs he hit, earned the name "the Sultan of Swat." Yankee Stadium is still known as "the house that Ruth built."

c. 1925 By the 1920s, baseball had become well established as the national pastime. Here members of the New York Giants (*previous pages*) pose for the camera.

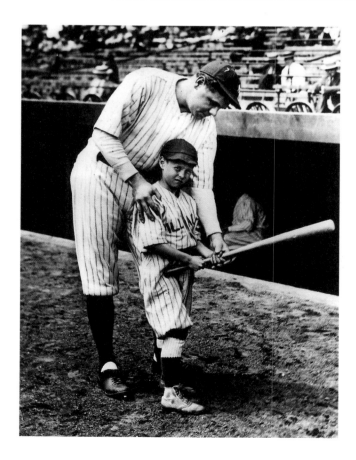

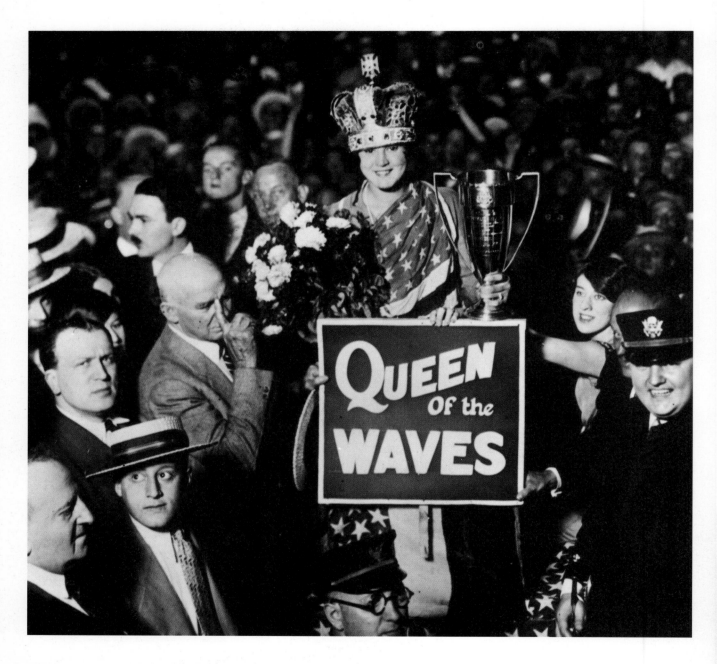

1926 In 1926, 19–year–old Gertrude Ederle not only became the first woman to swim the English Channel but completed her swim in a time almost two hours faster than any man had ever recorded. "It had to be done and I did it," proclaimed the young woman who came to be embraced by Americans as "Our Trudy."

1925 In the 1920s, through the participation of such football greats as Red Grange, professional football began to come of age. Here "Hinkey" Haines of the New York Football Giants shows off the latest in protective headgear.

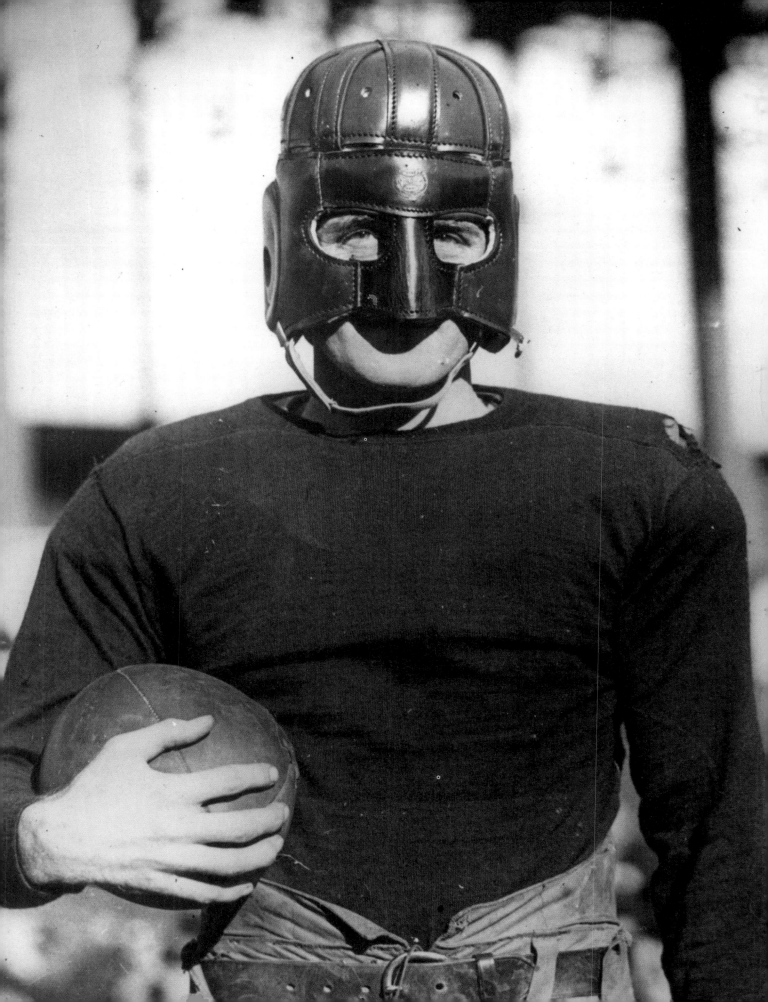

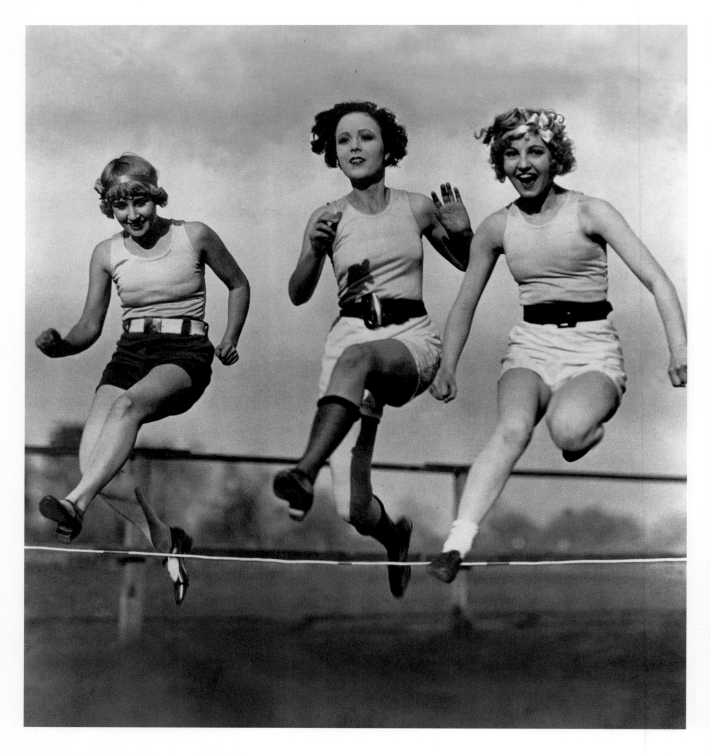

1926 A visible sign of the progress made by women in the 1920s was their increased participation in organized sports. These young ladies were competing in a low hurdles race in California.

1925 The 1920s was a decade of record-breaking events in areas great and small. Here champion dog jumper Rambling Gold sets the canine world record with a leap of 12 feet.

c. 1920 In their desire to gain their share in the booming times, Americans speculated in stocks of every kind. Here we see traders at work (*above*) in the New York Coffee Exchange.

c. 1920 Vincent Astor (1891–1989) was a scion of the family whose fabulous fortune began in the early 1890s when John Jacob Astor gained a monopoly in the lucrative fur trade. At the time this picture was taken (*left*), Vincent Astor was reputed to be the richest man in America.

1929 Like millions of Americans, this confident female broker (*right*) could little imagine that within a few months the stock market would collapse and that one of the nation's most extraordinary decades would come crashing to an end.

1920 In 1925 President Calvin Coolidge stated that "the business of America is business." That he was believed by millions of his countrymen was evidenced by the wild speculation in stocks that marked the first nine years of the 1920s. This (*previous pages*) is the New York Stock Exchange in action.

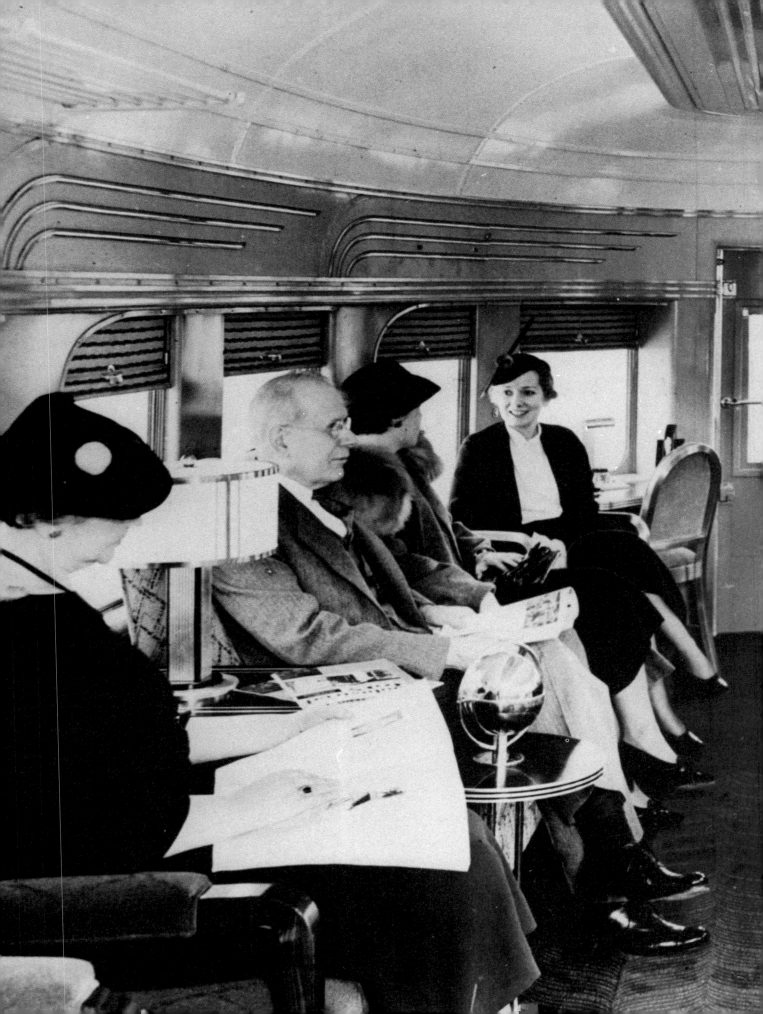

1930s

1930 This yacht is part of an incredible lineage of winners in sports history: from the America's Cup's inception in 1851 until the *Australia II* defeated the United States entry in 1983, American teams successfully defended the cup 25 consecutive times.

1930s

It was the decade of the Great Depression. In the White House, President Roosevelt launched his New Deal relief programs while Americans once again demonstrated their indomitable spirit in the face of adversity. Despite the hard times there was still much to marvel over – the Golden Gate Bridge, the dams built by the Tennessee Valley Authority, the Empire State Building, the New York World's Fair.

It was the last great decade of the ocean liners and the dawning of commercial air travel. And as millions sought release from their cares in the movies, the Hollywood studios established the star system. By decade's end, performers like Clark Gable, Fred Astaire, Jean Harlow, and Greta Garbo were household names.

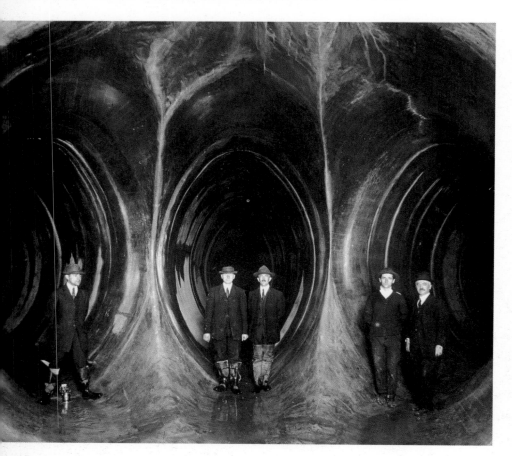

c. 1935 As American cities continued to expand, maintaining an adequate water supply became one of the most serious urban challenges. These men were standing at the point where the three underground passages of New York's aqueduct converged.

1936 By the 1930s, many of the diesel-powered trains that had replaced those driven by steam featured luxurious accommodations. These passengers were relaxing in the lounge car (*previous pages*) of the Illinois Central train known as "The Great Diamond."

1939 In a rare, untouched photo, actress Joan Crawford, freckles and all, is captured in her swimming pool. Crawford became an overnight sensation when she starred in the movie *Our Dancing Daughters*. In 1945 she won the Academy Award for her performance in *Mildred Pierce*.

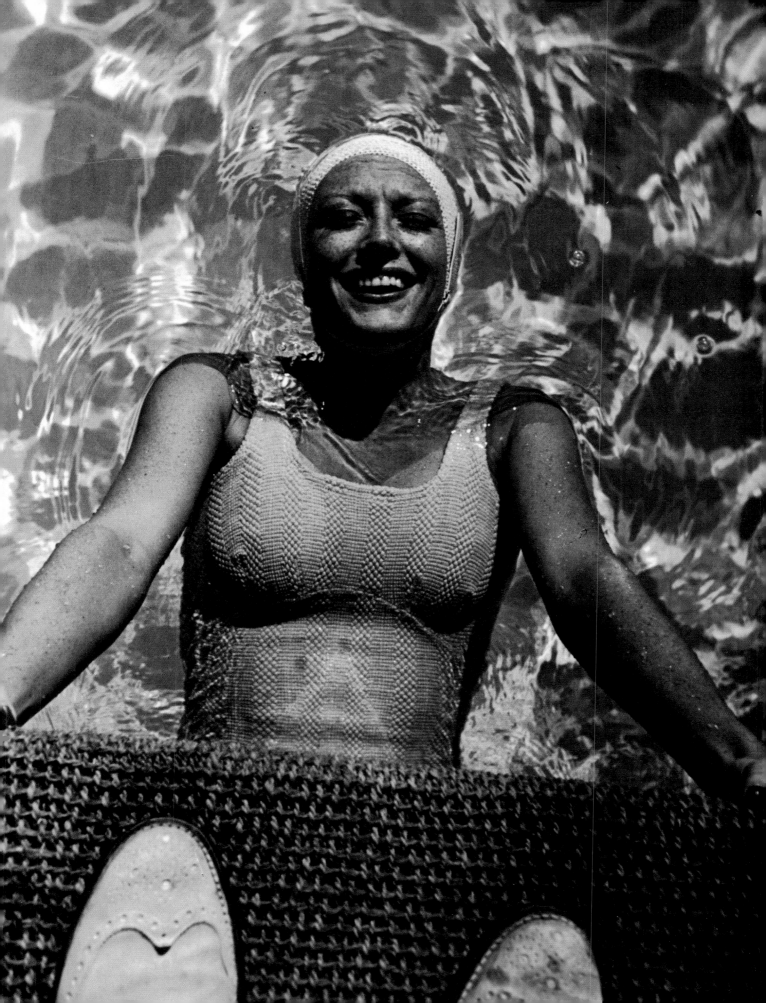

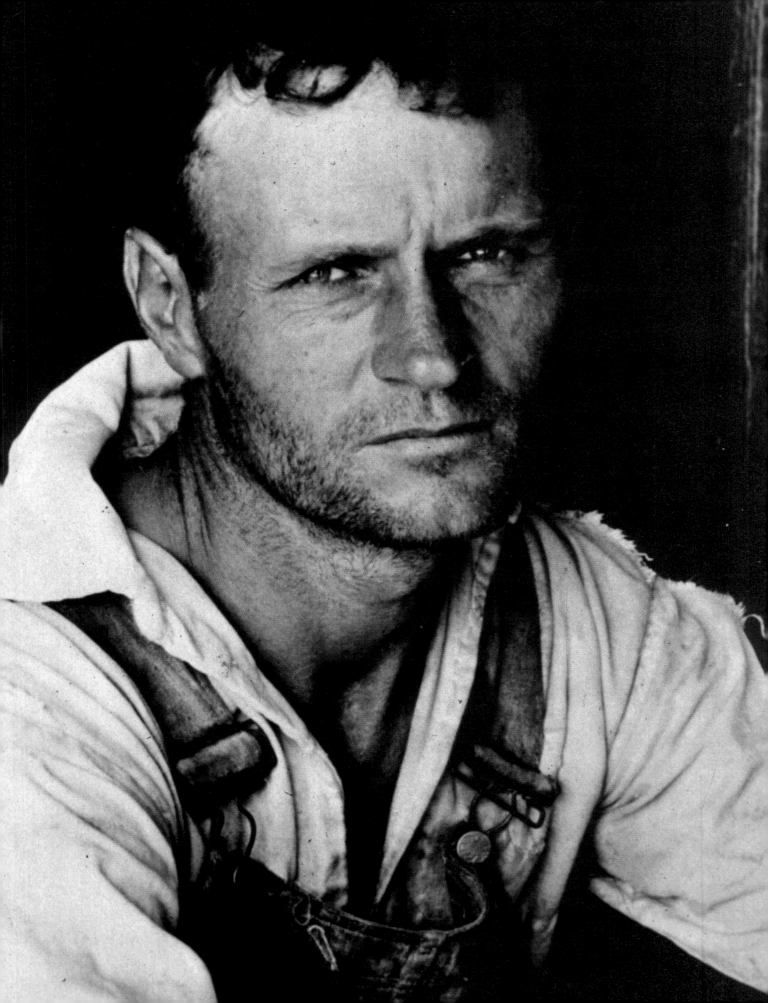

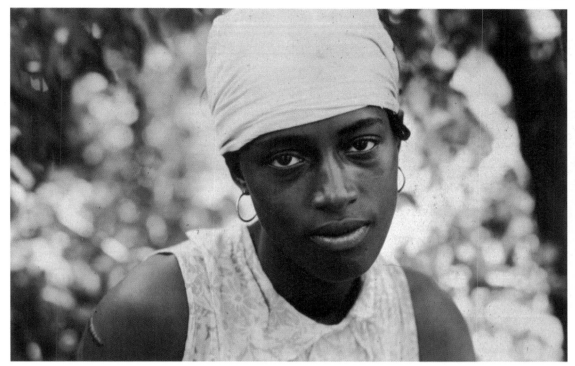

1936 More than any other event or development, the 1930s in America is remembered as the decade of the Great Depression. Hardest hit of all were the farmers of the American South and Southwest (*left*). This is Walker Evans's photograph of a cotton sharecropper in Hobe County, Alabama.

1936 On the faces of those caught up in the worst economic times in the nation's history could be seen both the anxiety occasioned by an unknown future and the hope for better times to come (*above*).

1936 Walker Evans was one of the scores of talented photographers hired by the government's Farm Security Administration (FSA) to chronicle the effects of the Great Depression. Although Evans became best known for his photographs without people, he was a master of portraiture as well.

1936 Roy Stryker, the head of the FSA project, directed his photographers to take pictures not only of people caught up in hard times but of normal everyday life as well. He saw the giant photographic project as an opportunity to "introduce America to Americans." This is Walker Evans's picture of a fish stand near Birmingham, Alabama.

1939 Dorothea Lange took many of the most memorable
of all the FSA photographs, such as this picture of a corner
store in Gordonton, North Carolina. "I had," she said, "to get
my camera to register the things about these people that
were more important than how poor they were – their
pride, their strength, their spirit."

1938 The desire to capture the indomitable spirit of hard-pressed people was apparent in the work of the FSA photographers. This is Walker Evans's image of a Cajun family on their farm near Crowley, Louisiana.

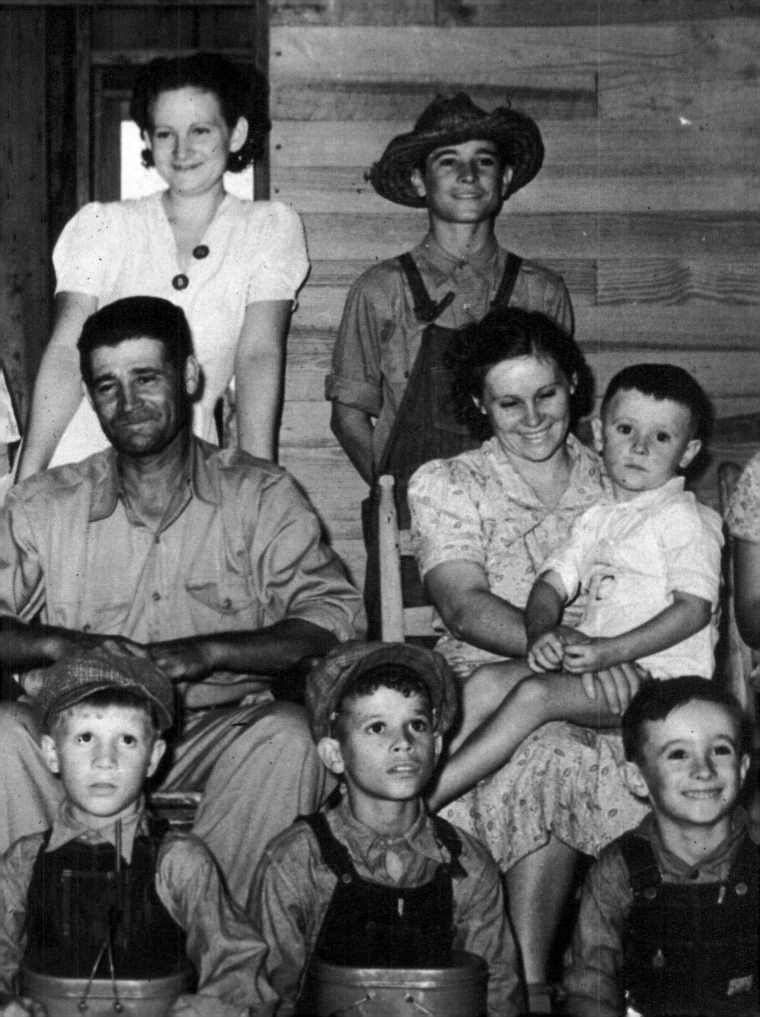

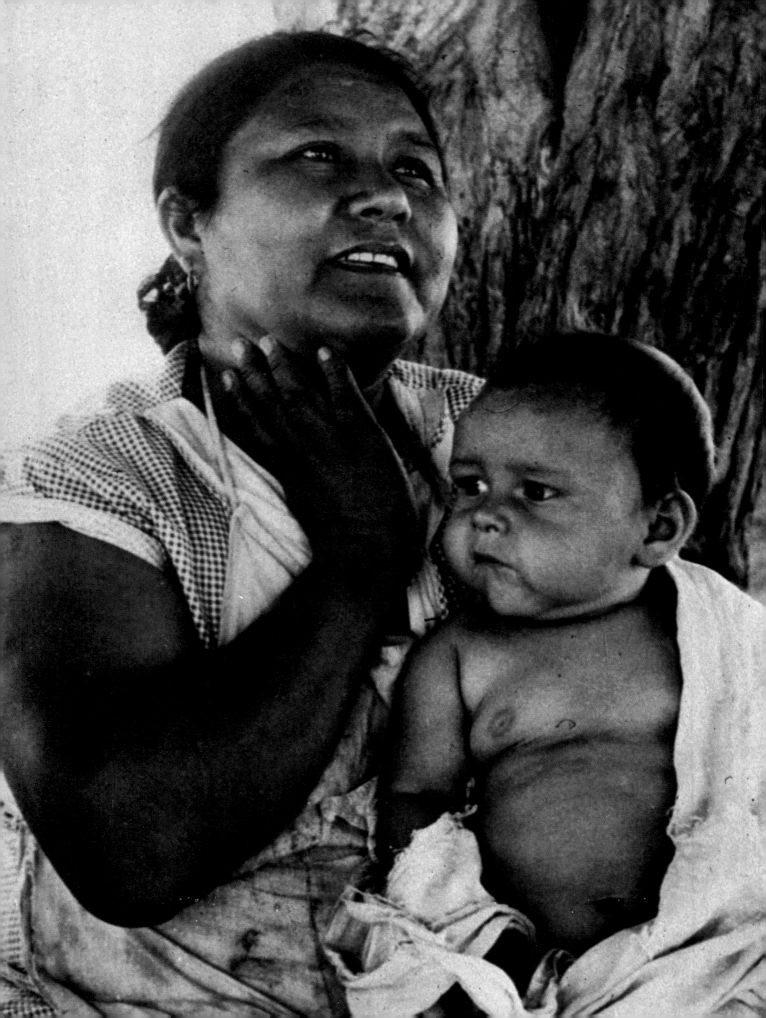

1935 This is Dorothea Lange's photograph of a Mexican mother (*left*) in California. In her caption to the picture Lange quoted the woman as saying: "Sometimes I tell my children that I would like to go to Mexico, but they tell me, 'We don't want to go, we belong here.'"

1939 Among the goals of the many relief agencies established during Franklin Roosevelt's administration was that of improving literacy throughout the nation. Here one of the students in an adult class reads aloud (*below*).

1938 Despite the Depression, the government continued to supply aid to public schools, particularly those in rural areas. Here we see a primary school classroom in La Forge Arms, Missouri (*above*).

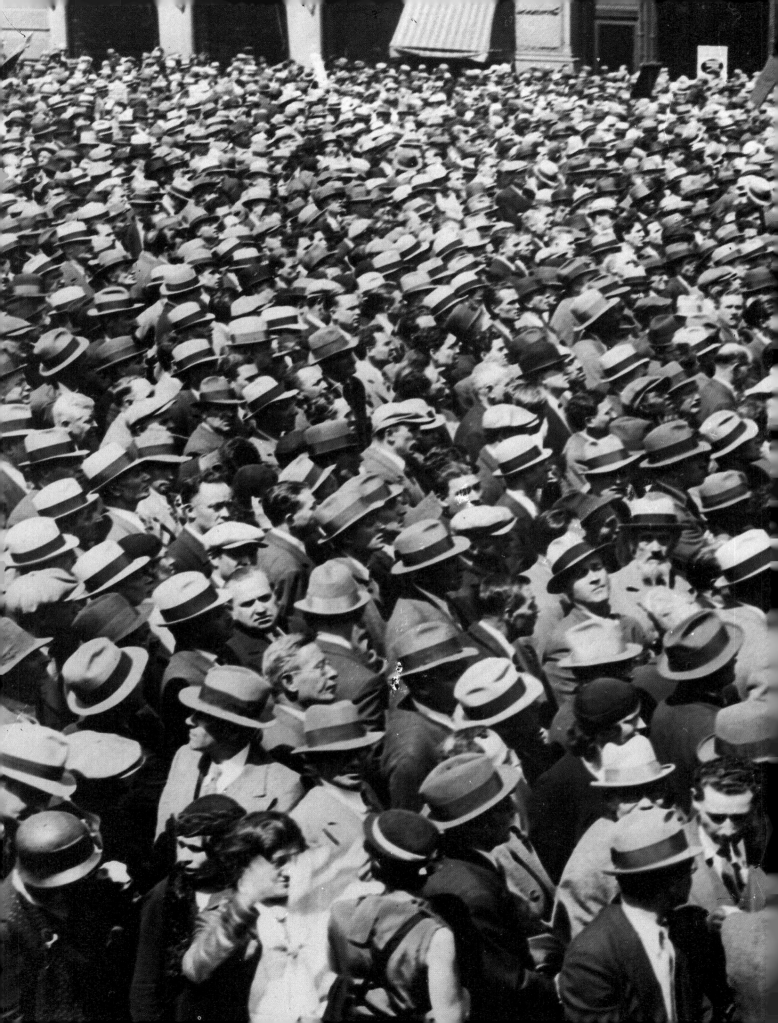

1939 "The camera," stated Dorothea Lange, "is an instrument that teaches people to see without a camera." This is Lange's image of a Salvation Army officer singing during a rally in San Francisco.

c. 1930 The effects of the stock market crash in 1929 had an enormous, adverse effect on millions of those who lived and worked in the cities. As businesses collapsed, countless white-collar workers found themselves unemployed. Here, a sea of people crowds together to listen to an official explain the details of one of the latest government relief measures.

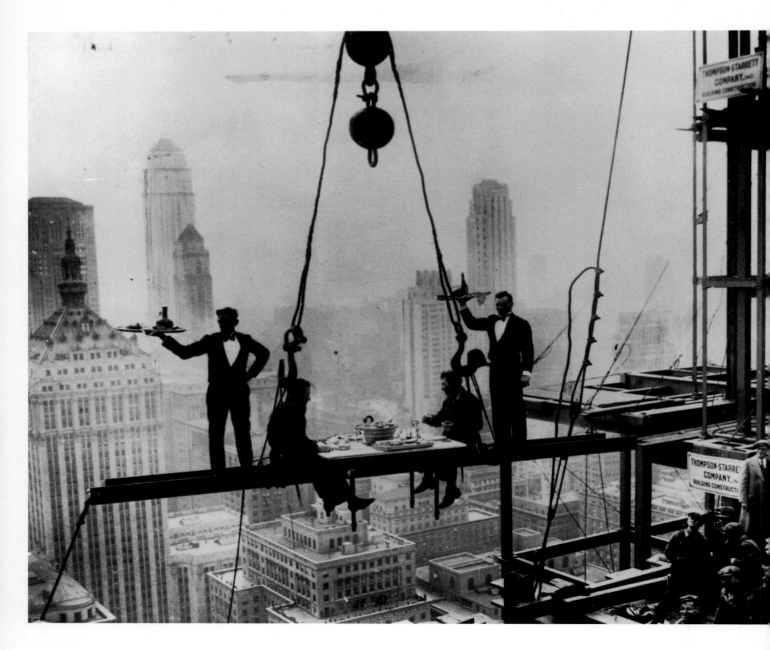

1930 This photograph gives new meaning to the term "high tea." Taken by a cameraman for the Keystone Photographic Company, it shows steelworkers being waited upon high above New York City.

c. 1933 Among the many aviation advances in the 1930s, was the introduction of the autogyro, forerunner to the helicopter. Here, the first cabin autogyro is seen flying across the front of New York's Rockefeller Center which, when the picture was taken, was nearing completion.

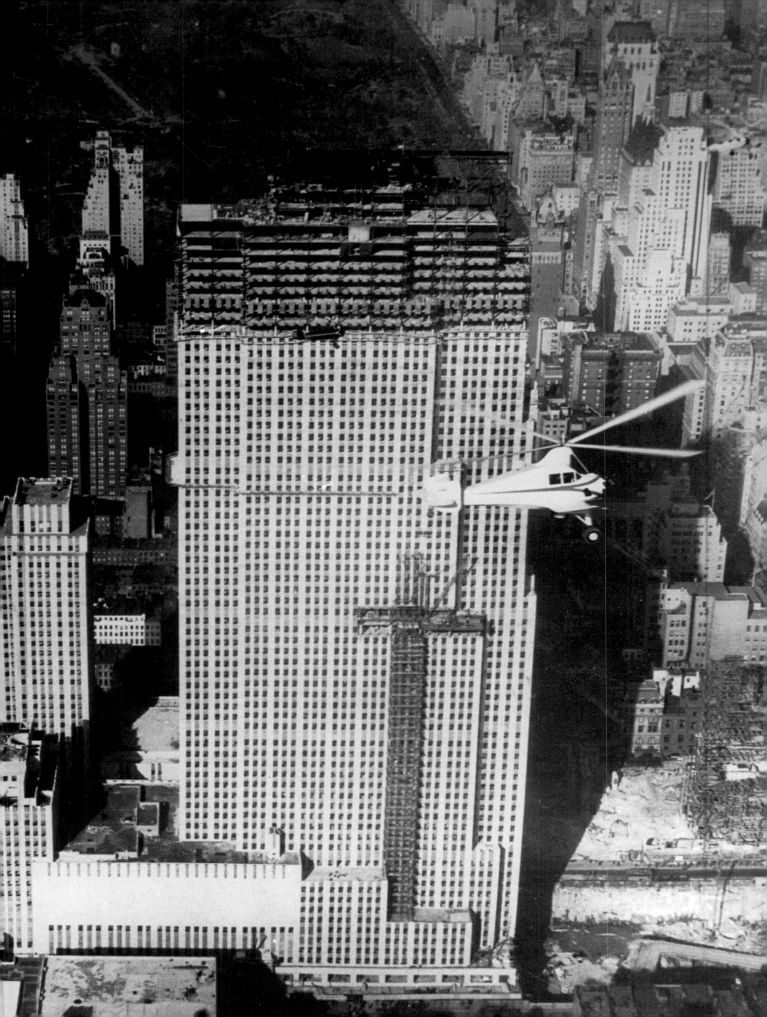

1939 Getting the news. In the 1930s, New York, like all major American cities, boasted several major daily newspapers. Here a fashionably clad gentleman buys the latest city edition from a young newsboy.

1938 In the hands of a master photographer, the camera can produce an image of great power and beauty, even when trained on a commonplace scene. This is Walker Evans's picture of the outside of New York City apartments.

c. 1937 The Austrian–born American photographer Arthur Fellig (who adopted the pseudonym Weegee) is internationally renowned for his photographs of the darker side of urban life, especially his raw and spontaneous documentation of crime and disaster scenes. Occasionally, though, his camera lens captured people enjoying simple pleasures, such as his candid image of these young residents of New York's Lower East Side (*following pages*), who were enjoying their own special way of "cooling off" during a hot summer afternoon.

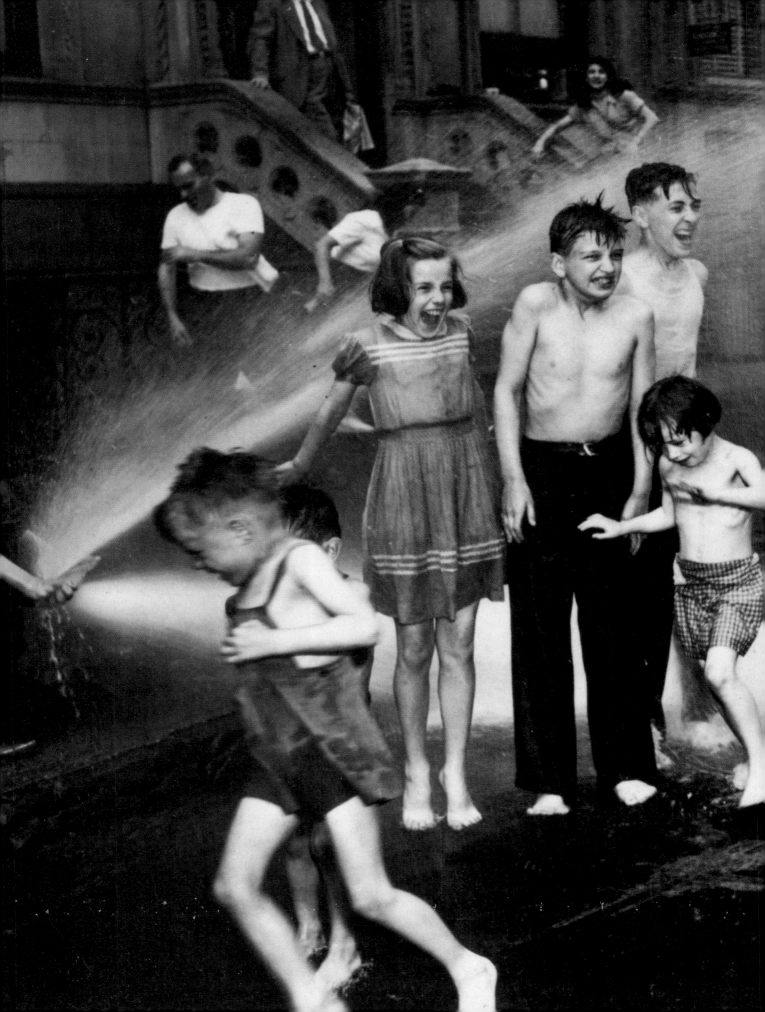

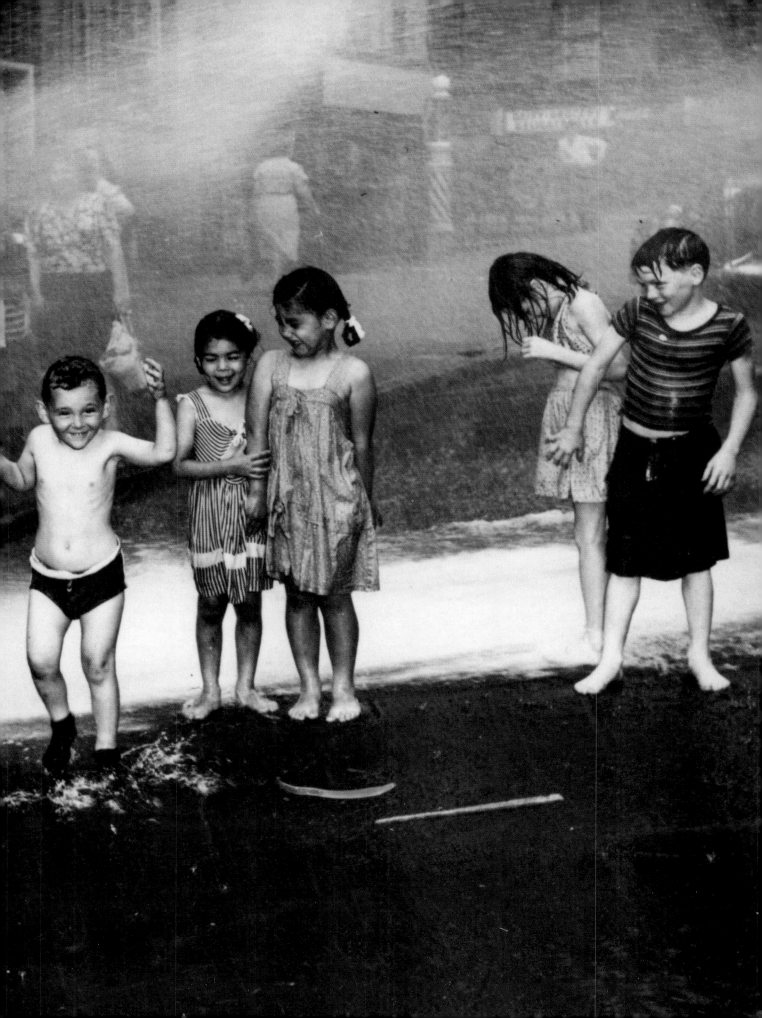

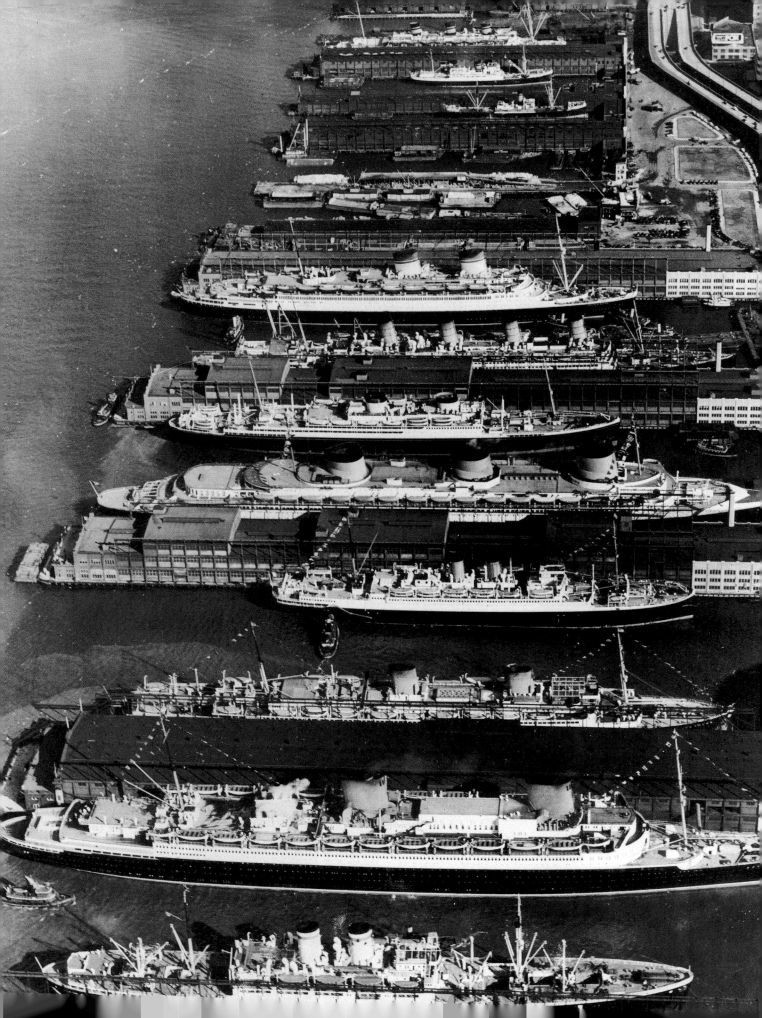

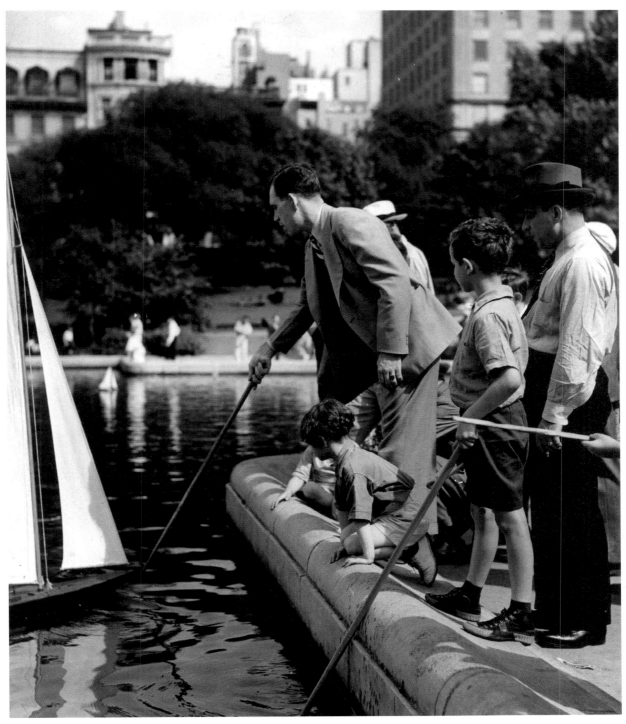

c. 1939 This dramatic photograph shows 358,274 tons of cargo ships and ocean liners docked in New York Harbor. From bottom to top they are: SS *Hamburg*, SS *Bremen*, SS *Columbus*, SS *De Grasse*, SS *Normandie*, SS *Britannic*, SS *Aquitania*, SS *Conte de Savoia*, SS *Fort Townsend*, and the SS *Monarch*.

c. 1930 By the 1930s, Sunday as a day of rest, relaxation, and family activities was a well-established notion. Here fathers and their sons sail miniature sailboats on a pond in New York's Central Park.

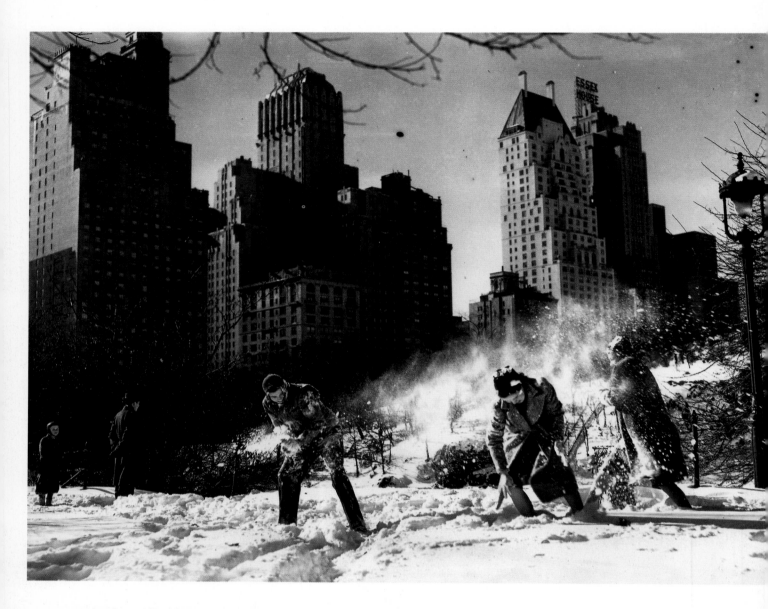

1938 The guiding force behind the design and construction of New York's Central Park was Frederick Law Olmstead (1822–1905). Built in the late 1850s, Central Park exceeded even Olmstead's dreams of a haven for city dwellers.

1938 Wild birds on a lake in Central Park. Frederick Law Olmstead's success in beautifying the nation's largest city led to his receiving similar commissions from cities throughout the nation.

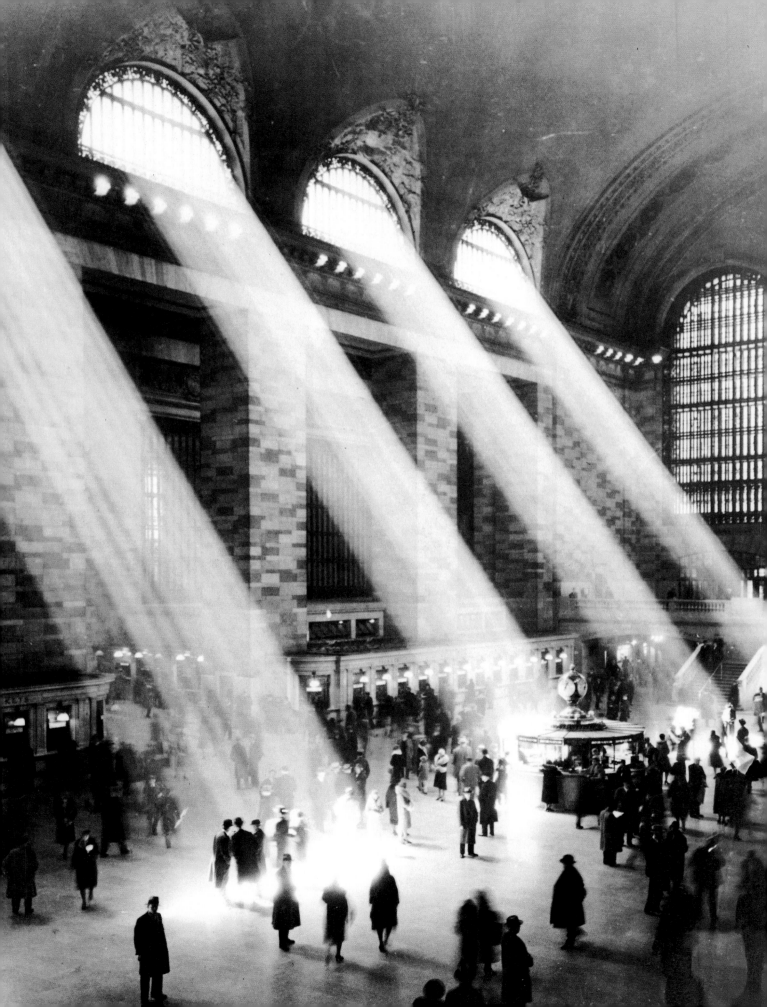

c. 1930 Sometimes a structure achieves an aspect beyond that planned by its architects. To the delight of both travelers and photographers, the play of light through the upper windows of New York's Grand Central Station added immensely to the beauty of the huge building.

c. 1936 The man leaning against the railing in this picture by Weegee is Fiorello H. La Guardia, three-time mayor of New York City. Affectionately known as the "Little Flower", La Guardia was a tireless reformer who battled racketeering, initiated unemployment relief, and instituted a host of social services.

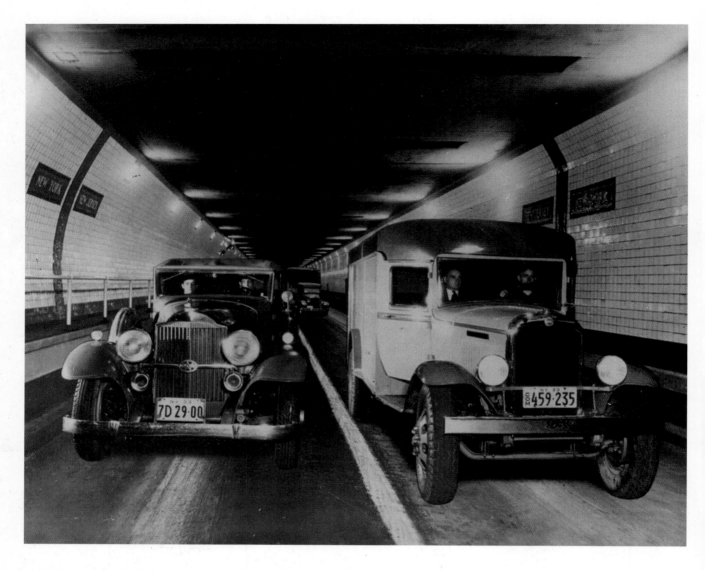

c. 1930 In their constant battle to relieve urban traffic congestion, city officials not only authorized the building of bridges but endorsed the construction of tunnels as well. This luxury car and early van were making their way through the 9,250-foot-long Holland Tunnel, connecting New York and New Jersey.

c. 1935 There was no question that tunnels such as the Holland made commuting into major cities easier than before they were built. But with so many cars on the road the tunnels far from solved the traffic problems. This is a scene at the entrance to the Holland Tunnel circa 1935 – except for the modern cars, not much different from a typical rush hour today!

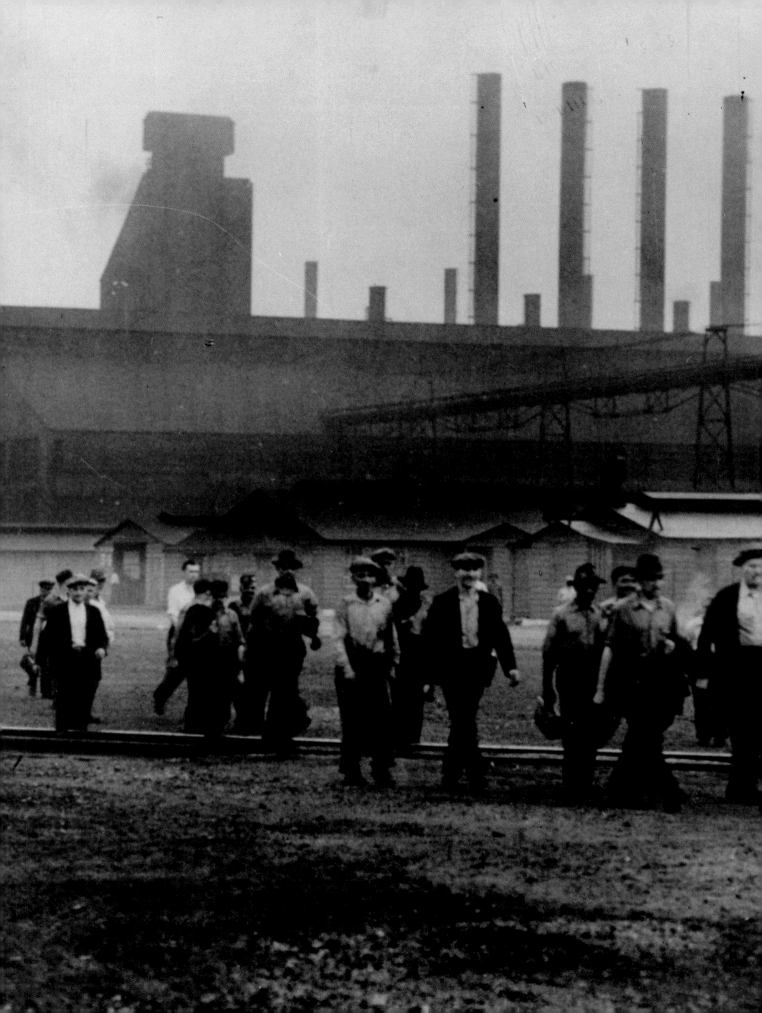

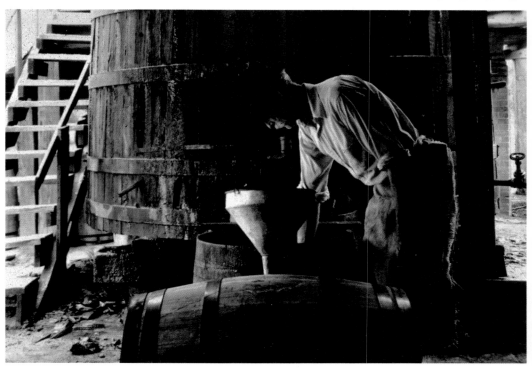

c. 1935 Thanks to increased government spending, much of America's heavy industry remained in operation during the Great Depression. These workers (*left*) had just finished their shift at Chicago's Inland Steel Company.

1937 In the 1930s, despite major advances in technology, some things were still done the old-fashioned way. This man was at work at a turpentine still (*above*) near Valdosta, Georgia.

c. 1938 In order to cope with a reduced workforce, companies sought ways to make their operations more efficient. This New York steel cable company saved time by placing their messengers on roller skates (*below*).

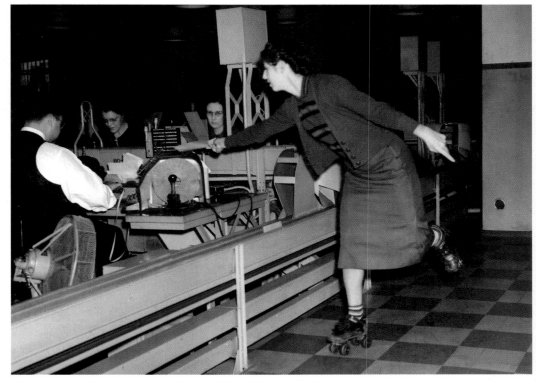

1930s

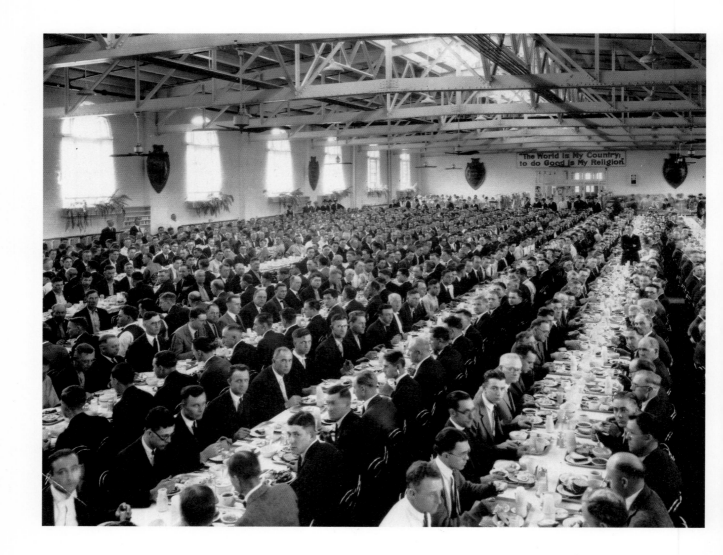

c. 1935 In the mid–1930s, the National Cash Register Company (now a multi–billion–dollar information technology company known as NCR) was one of the nation's largest employers. This is the company's employee dining room, where hundreds of workers took meals together at incredibly long tables.

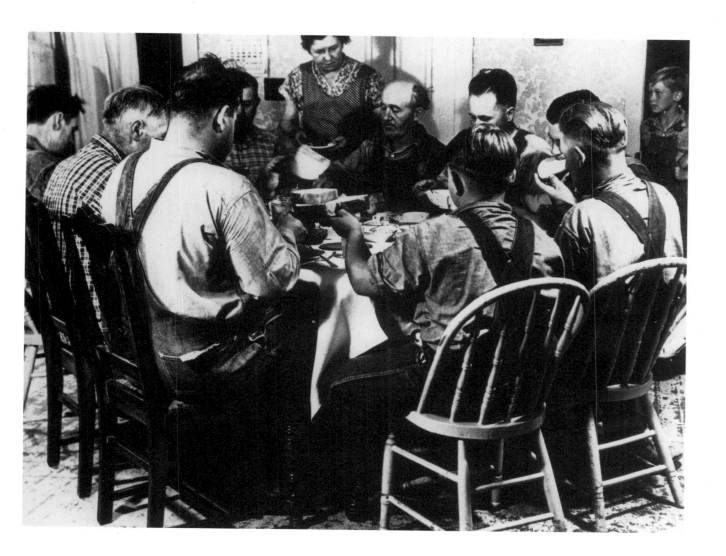

1939 Despite the migration to the cities and the fact that making a living out of the soil was increasingly difficult, millions of Americans still lived and worked on farms in the 1930s. These farmhands were gathered together for their noonday meal.

1939 Farming was always a difficult, back-breaking
occupation. In some areas of the country the topography
of the area made working the soil particularly challenging.
This Mennonite farmer in Boundary County, Idaho was
doing the best with what nature had presented him with.

1936 In taking his FSA photographs, Walker Evans
traveled throughout the South capturing images of
people working in ways similar to that of generations
before them. This scene was shot near Tupelo, Mississippi.

1933 The man fly–fishing
in California's Klamath River
is Herbert Hoover (1874–1964),
who had just ended his stint
as the 31st President of the
United States. Although
Hoover was widely blamed
for the coming of the Great
Depression, the various
humanitarian activities he
undertook after he left office
helped him regain a great
measure of his reputation.

1939 Although the glory days of cowboys had vanished some 50 years earlier, cattle raising was still a way of life for thousands of cowhands. These cowpokes were singing around an evening campfire on a ranch near Birney, Montana.

1937 Some types of American landmarks are almost as old as the nation itself. This covered bridge in Plainfield, Vermont, is one of dozens of such structures still in use in that state today.

1930 Travelers to the United States have always been amazed at the extraordinary diversity of the nation's topography. Here a lone motorist drives through Death Valley, California, one of the hottest regions on earth.

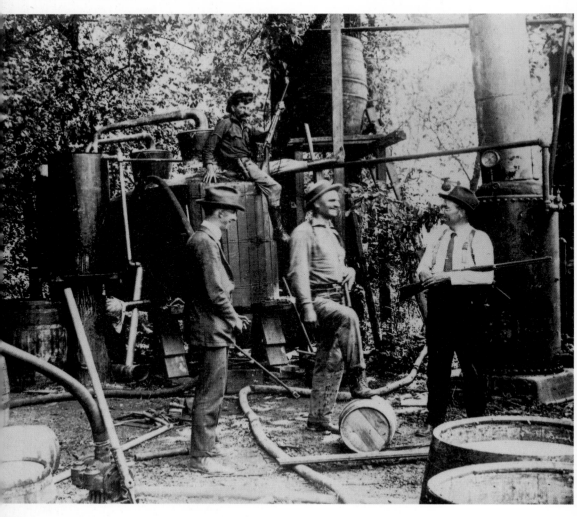

c. 1935 Although Prohibition was repealed in 1933 and
the sale of liquor in package stores, bars, and restaurants
once again became legal, countless private, hidden stills
were still in operation. These secret beer brewers were willing
to take the risk presented by being captured by the camera.

c. 1933 By the 1930s, California had become one of the
leading suppliers of agricultural products in the world. This
young woman happily posed while submerged in walnuts,
one of southern California's most valuable crops.

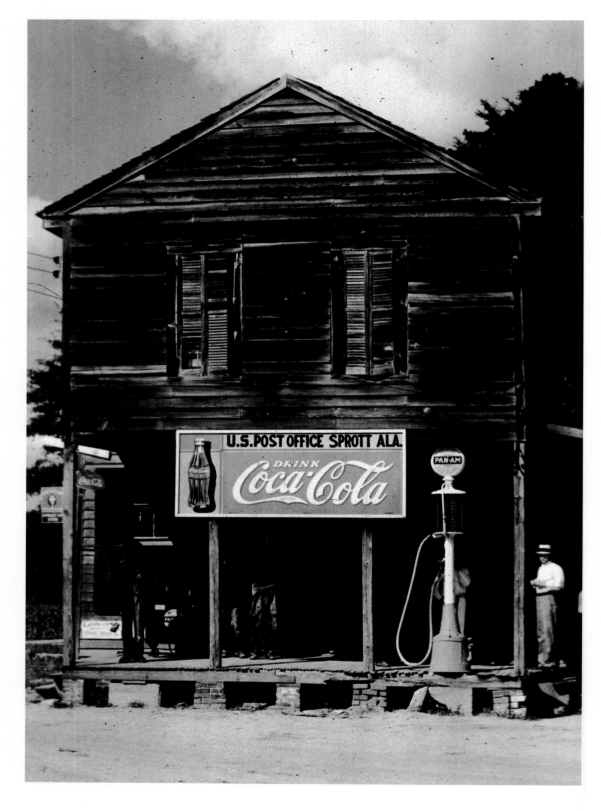

1936 Gleaming new post offices had been built in many
American cities during the 1930s. In rural areas, however,
many post offices were still located in country stores. The
U.S. post office in Sprott, Alabama, was photographed by
Walker Evans.

1936 "Walker Evans," one photohistorian has written,
"was an absolute genius in portraying humanity in pictures
showing no human beings." This is Evans's image of a share-
cropper's cabin in Hale County, Alabama.

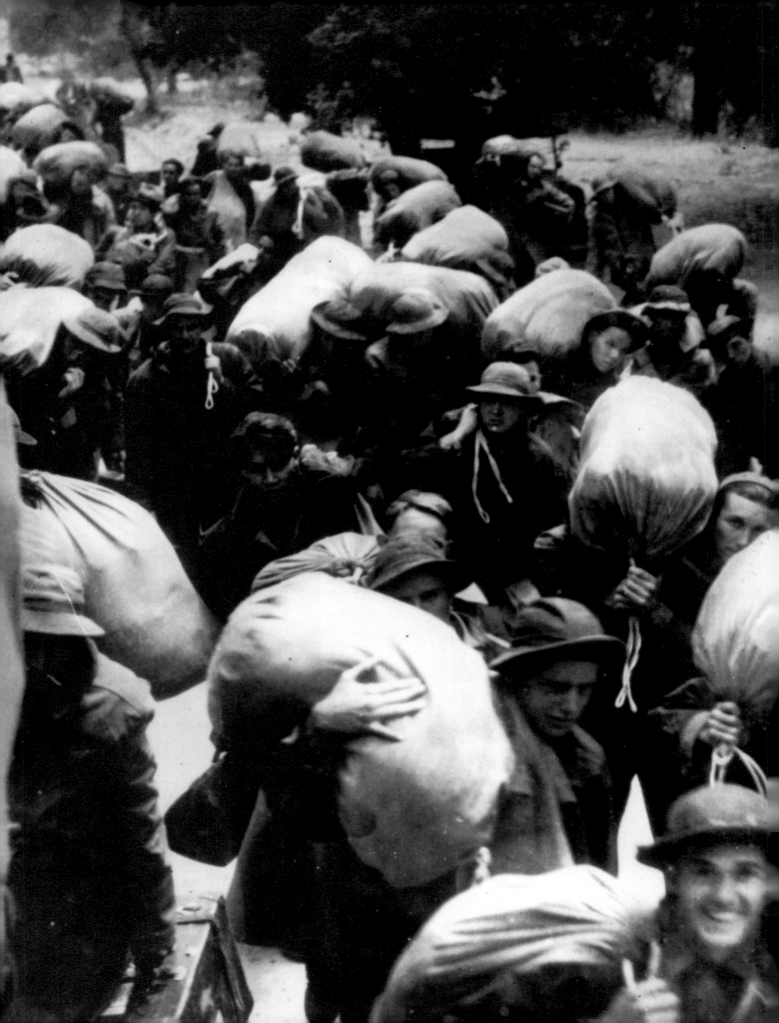

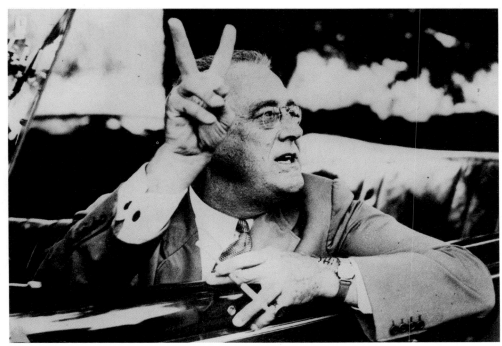

c. 1933 The Civilian Conservation Corps (CCC) was one of the most effective of the many agencies created by the Roosevelt administration to put people back to work. These young men (*left*) were leaving for California to work in projects jointly supervised by the Forest Service and the U.S. Army.

1939 It would take the coming of World War II, and the government military spending attendant to it, to kick-start the economy and finally end the Great Depression. But throughout the 1930s it was the relief programs instituted by Franklin Roosevelt (*above*) and his advisers that helped millions gain employment.

1933 Never had Americans experienced such a dynamic First Lady as Eleanor Roosevelt (1884–1962). An active advisor to FDR, she held press conferences, toured the nation (*below*), and wrote a syndicated column. After her husband's death she served for some eight years as a U.S. delegate to the United Nations General Assembly.

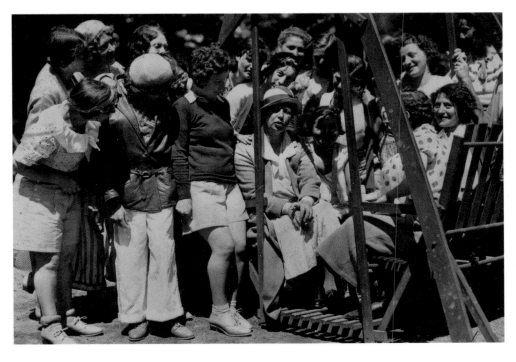

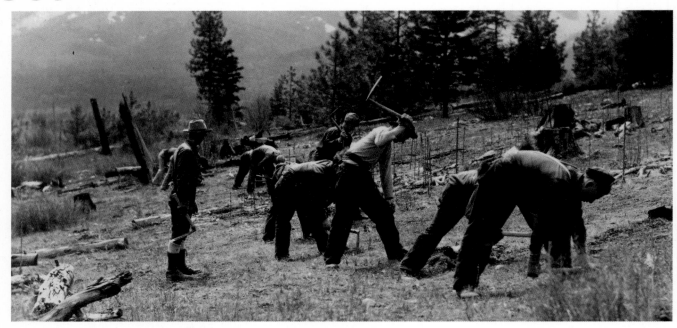

1933 Before its nine–year existence was over, the Civilian Conservation Corps gave work to more than 2.5 million young men. CCC workers planted over 200 million trees, dug countless drainage ditches and fish ponds, built reservoirs, and performed countless other tasks of benefit to the nation (*above*).

c. 1936 The Works Public Administration (WPA) was by far the most ambitious of the government's relief programs. WPA workers (*below*) built thousands of roads, schools, playgrounds, and other facilities. Under WPA auspices, writers, artists, actors, and playwrights were employed, and produced nothing short of a creative renaissance.

1933 One of the first reforms instituted by the Franklin Roosevelt administration was the establishment of the Tennessee Valley Administration (TVA), (*right*) a public corporation which provided electricity to darkened areas of the South. Here TVA construction workers begin work on the construction of a dam.

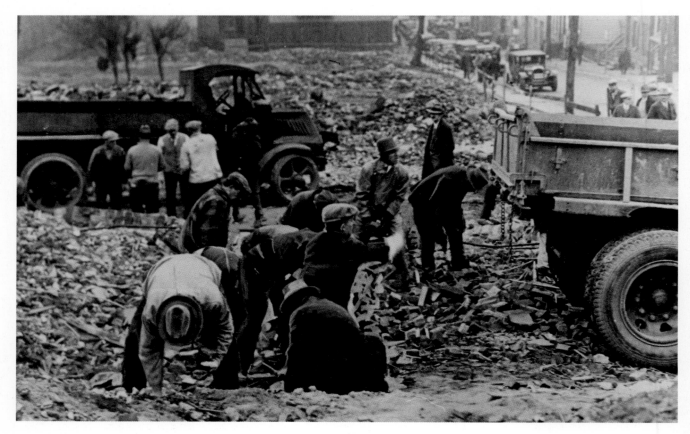

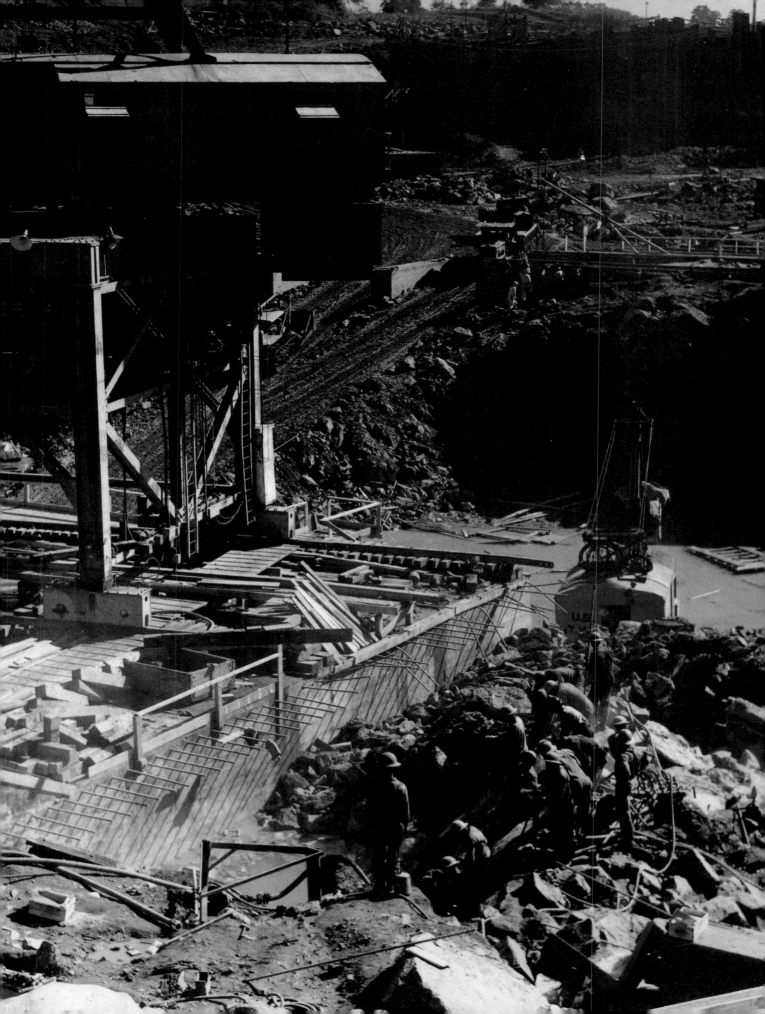

1936 As the signs in this picture reveal, the economic ills of the Great Depression brought with them drastically reduced prices in real estate and the most advantageous terms for those who could afford them. This was the Kennedy real estate office in Oakland, California.

1936 During the Great Depression, more Americans than ever before – most seeking respite from the reality of hard times – went to the movies. These billboards in Atlanta (*previous pages*) advertised current film attractions.

407

c. 1938 In the 1930s, Hollywood's leading screen stars ranked among the most recognizable individuals in the world. Here we see two of the most famous (*above*), James Stewart (1908–1997) and Henry Fonda (1905–1982).

1936 Actress Dorothy Lamour (1914–1996) is shown here in a scene from the movie *Swing High, Swing Low* (*right*). She won her fame, however, through the numerous "Road" films she made with Bob Hope and Bing Crosby.

1932 Swedish–born Greta Garbo (1905–1990) was one of the most intriguing of all movie stars (*left*). While most of her fellow film actors craved public attention, she sought seclusion. Her films included *Grand Hotel*, *Mata Hari*, *Anna Karenina*, *Camille*, and *Ninotchka*.

c. 1935 Shirley Temple (1928–) was a true phenomenon (*following pages*). At the age of five, she captivated the nation with her singing and dancing in the film *Stand Up and Cheer*. During the next three years she was Hollywood's top box-office draw. Shirley Temple clothing, books, ribbons, and other items filled the nation's stores, with the sale of more than six million Shirley Temple dolls topping the list.

1946 Bette Davis (1908–1989) was arguably the most accomplished movie star of the 1930s. A versatile actress, she played roles ranging from sultry vixens to British monarchs. She continued to perform on both the silver and small screen until she was in her 80s. Davis won Academy Awards for her performances in *Dangerous* (1935) and *Jezebel* (1938).

1933 Jean Harlow (1911–1937), known as the "Blonde Bombshell," was the sexiest actress of the 1930s (*left*). Her career was cut drastically short when, at the age of 26, she died during the filming of *Saratoga*.

1933 Singer and actor Paul Robeson (1898–1976), seen here with his wife (*right*), made headlines both on and off the stage. His most famous roles were in *The Emperor Jones*, *Showboat*, and *Othello*. Trained as a lawyer, Robeson was a passionate advocate of black rights. In the 1950s, because of his association with left-wing organizations, Robeson's passport was withdrawn and he moved to England.

1930 The youngsters who posed for this picture ranked among the most popular of all the Hollywood personalities of the 1930s. They were the stars of the "Our Gang" movies (*left*).

1935 The 1930s was the great age of the movie comedy. Seen here are four of the most beloved comic actors, the Marx Brothers (*above*). From left to right are Harpo (1893–1961), Zeppo (1901–1979), Groucho (1895–1977), and Chico (1891–1961).

c. 1930 The comic duo of Stan Laurel (1890–1965) and Oliver Hardy (1892–1957) rivaled the Marx Brothers with their comic genius. They are shown here (*below*) taking a break from playing two sections of a pantomime horse.

1938 The glamorous young woman on the left is Lucille Ball (1911–1989), destined to become television's greatest star of her time. Before helping make "I Love Lucy" TV's top program of the 1950s, Ball starred in dozens of movies (*above*).

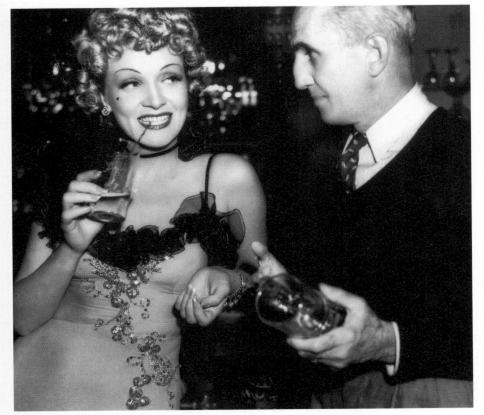

1939 Marlene Dietrich (1901–1992) talks with director George Marshall (1891–1975) on the set of the film *Destry Rides Again* (left). Known for her gorgeous legs and her sultry voice, Dietrich's most famous role was in the film *Blue Angel* (1930).

c. 1933 Mae West (1892–1980) began her career as a star of vaudeville (*right*). In an age of strict censorship, she was a master of the double entendre, which she used throughout the popular films she made with W. C. Fields.

1938 In this picture we see some of the most notable performers of the 1930s (*above*). From left to right are comedian Jack Benny (1902–1988), singer and actor Dick Powell (1904–1963), comedian Ken Murray (1903–1988), singer and actor Bing Crosby (1904–1977), bandleader Tommy Dorsey, and actress Shirley Ross (1813–1975).

c. 1933 Johnny Weissmuller (1904–1984) parlayed his popularity as an Olympic swim star into his movie role as Tarzan (*left*). The youngster with Weissmuller is Jackie Cooper, one of the 1930s' most accomplished child actors.

c. 1935 In the 1930s, some 35 million Americans tuned in to their radios every evening. The man with his arms raised in this photograph is Orson Welles (*right*), who along with his radio successes, became one of the greatest of all actors and stage and film directors.

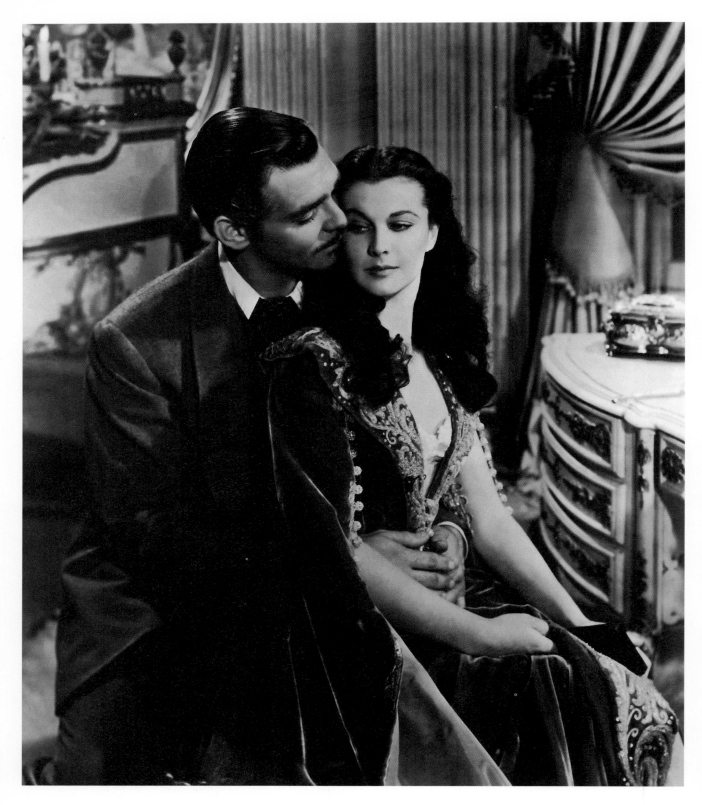

1939 Moviegoers had never seen a motion picture on the scale
of *Gone With the Wind*. Adapted from Margaret Mitchell's epic Civil
War novel, the movie established Clark Gable (1901–1950) as one
of Hollywood's leading stars. In this scene Gable embraces Vivien
Leigh (1913–1967), who won an Oscar for her role as Scarlett O'Hara.

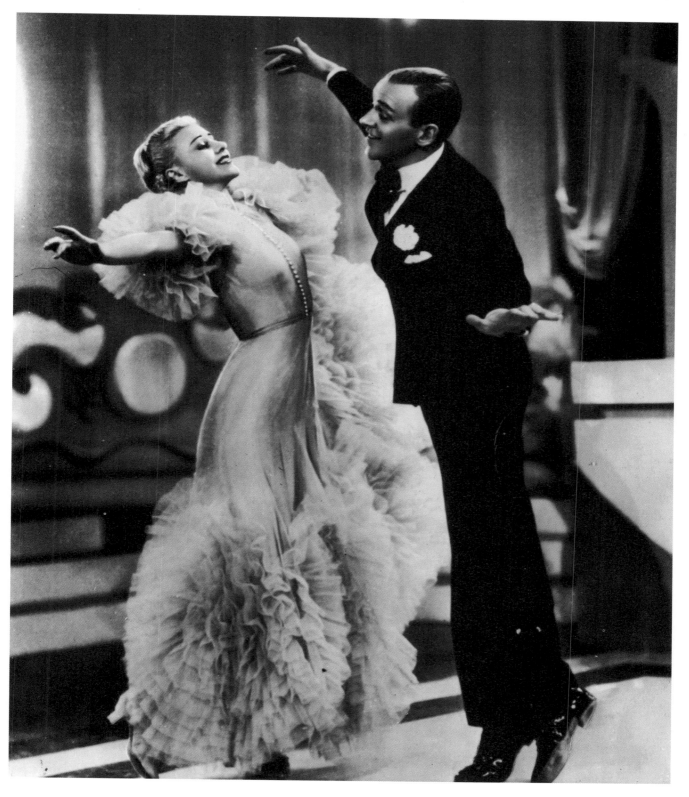

1936 The first film in which Fred Astaire (1899–1987) starred was such a box-office smash that his studio immediately insured his legs for a million dollars. Astaire danced with a number of film partners, but his most successful collaboration was with Ginger Rogers (1911–1995). They are shown here in a scene from the movie *Swing Time*.

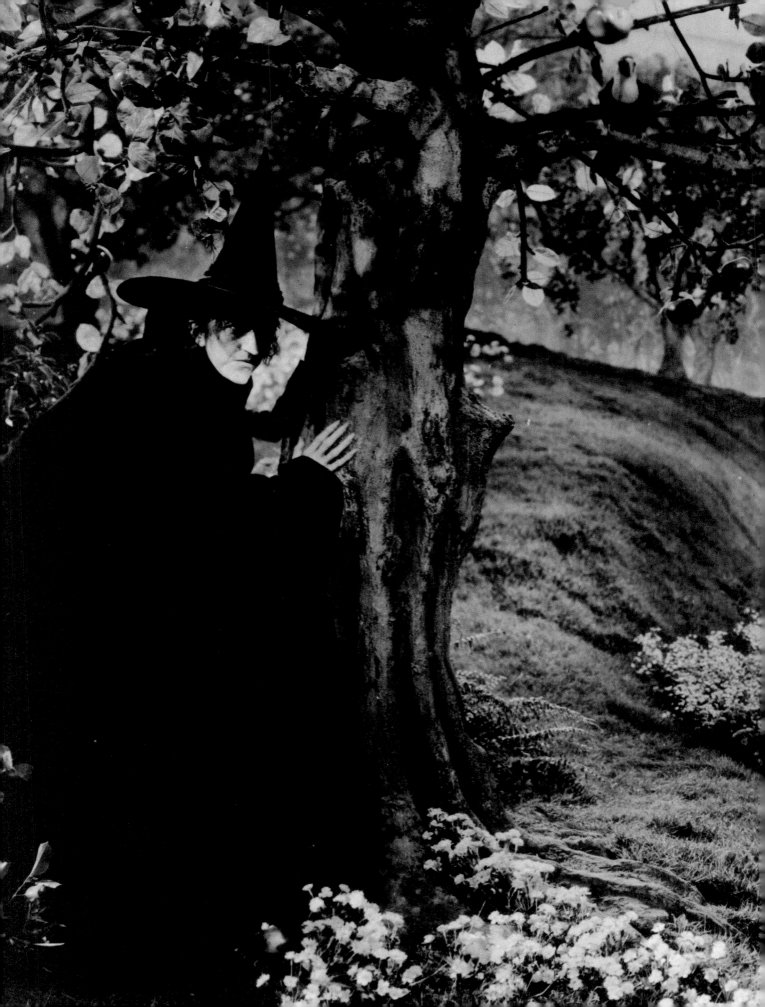

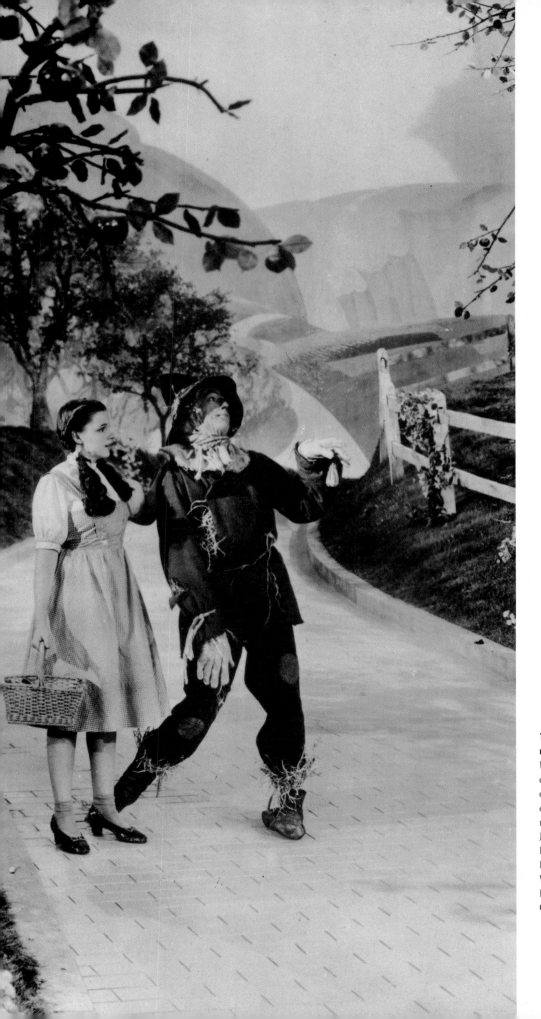

1939 The most beloved movie of the 1930s was *The Wizard of Oz*. Now a screen classic still enjoyed by millions of Americans when it is shown on television each year, the movie starred Judy Garland, Jack Haley, Burt Lahr, Ray Bolger, and Margaret Hamilton. Here we see Hamilton as the Wicked Witch of the West, Bolger as the scarecrow, and Garland (1922–1969) as Dorothy.

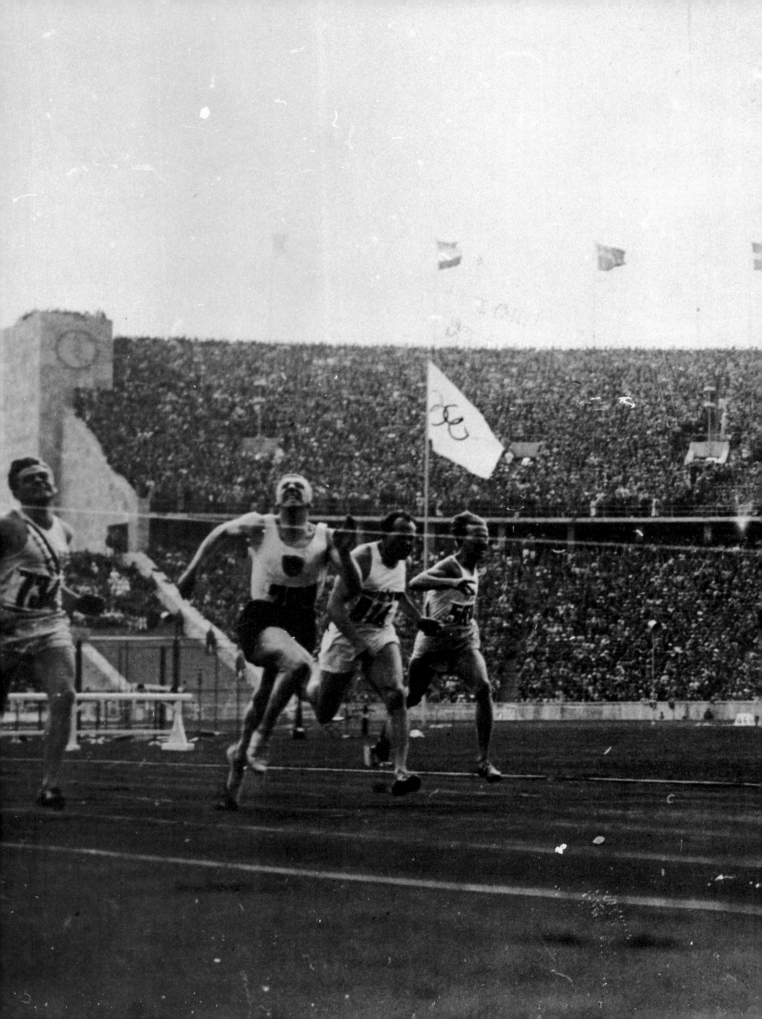

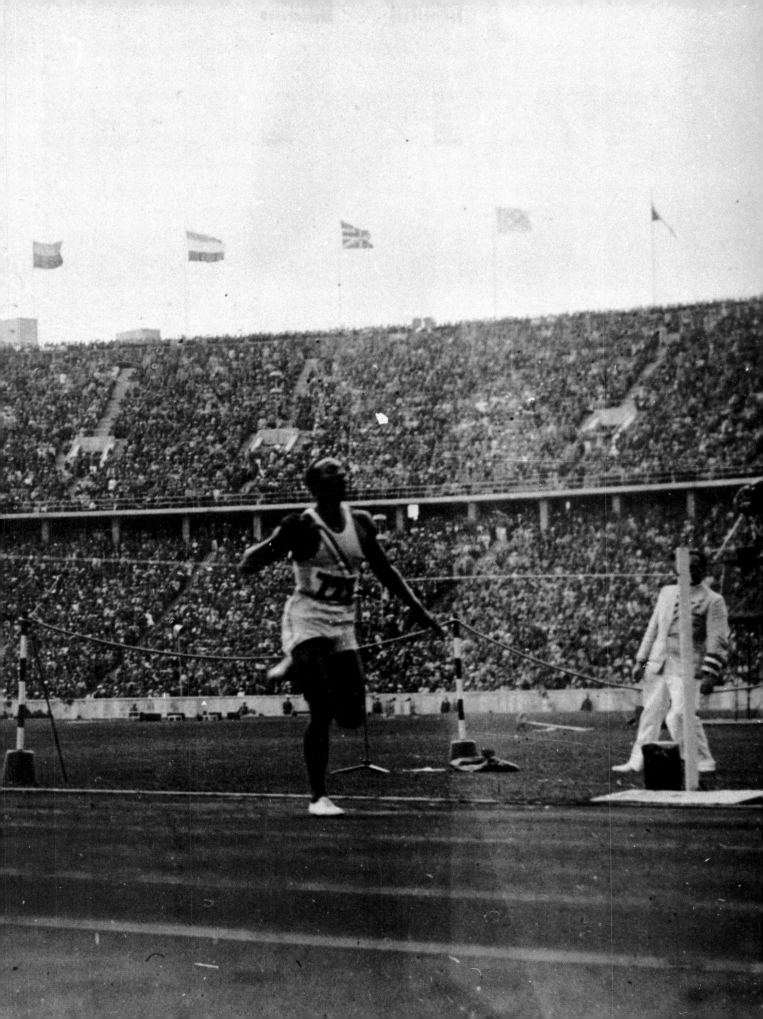

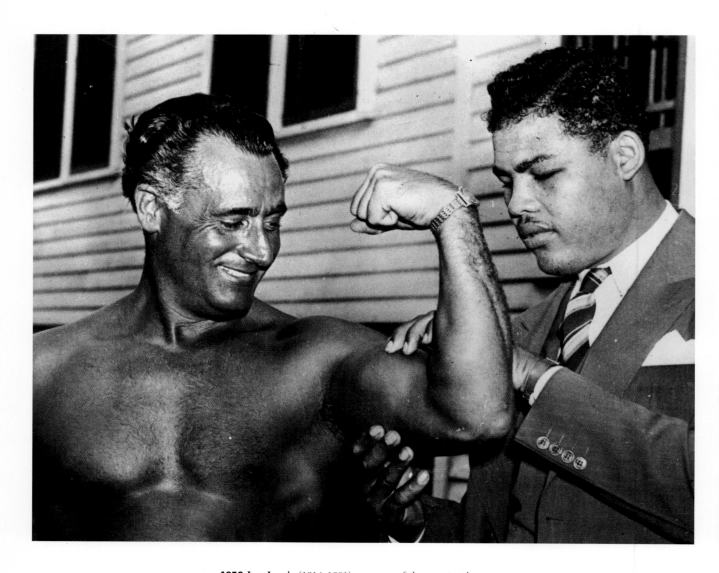

1938 Joe Louis (1914–1981) was one of the greatest heavy-weight champions of all time. Louis, nicknamed the "Brown Bomber," held his title from 1937 to 1949 and defended it successfully a record 25 times. He is shown here admiring the flexed bicep of Charles Atlas, who advertised himself as the world's most perfectly developed man.

1936 Track star Jesse Owens (*previous pages*) is shown crossing the finish line as he wins the 100 meters race at the 1936 Olympics in Berlin, one of four gold medals he would win at the event. The sight of an African-American outperforming his German athletes did not please Adolph Hitler.

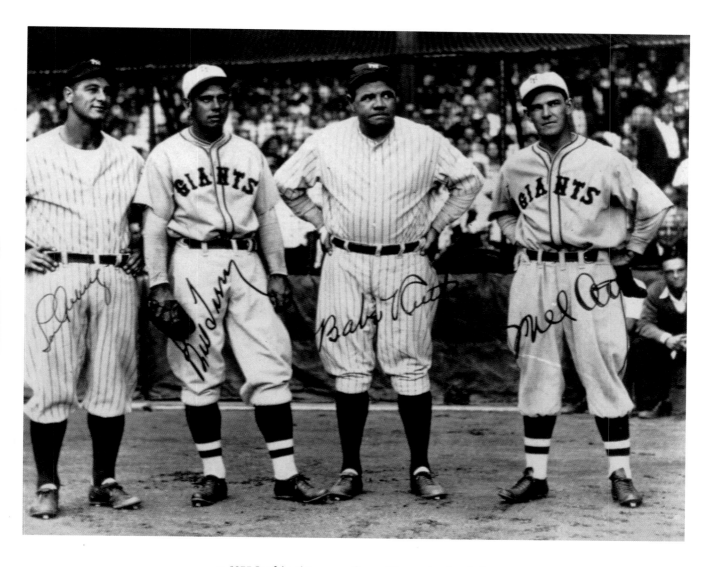

c. 1935 In this picture are four of the greatest baseball stars of the 1930s. From left to right are: the Yankee's Lou Gehrig, the Giant's Bill Terry, the Yankee's Babe Ruth, and the Giant's Mel Ott.

1936 Howard Hughes (1905–1976) was one of the most fascinating individuals of his time. Founder of the Hughes Aircraft Company, in 1935 he broke the existing air speed record by traveling more than 352 miles per hour. An inveterate entrepreneur, he was also an aircraft designer and a film producer. One of the world's richest men, he became equally famous for his reclusive life style.

c. 1939 By the 1930s, historic structures throughout the nation were becoming preserved through their designation as National Monuments. This building in Yorktown, New York, was the oldest customs house in the United States.

c. 1933 Designed by Henry Dreyfus and built by the American Locomotive Company, this steam "Hudson" locomotive on the New York Central System was a shining symbol of the age of railroad "streamliners."

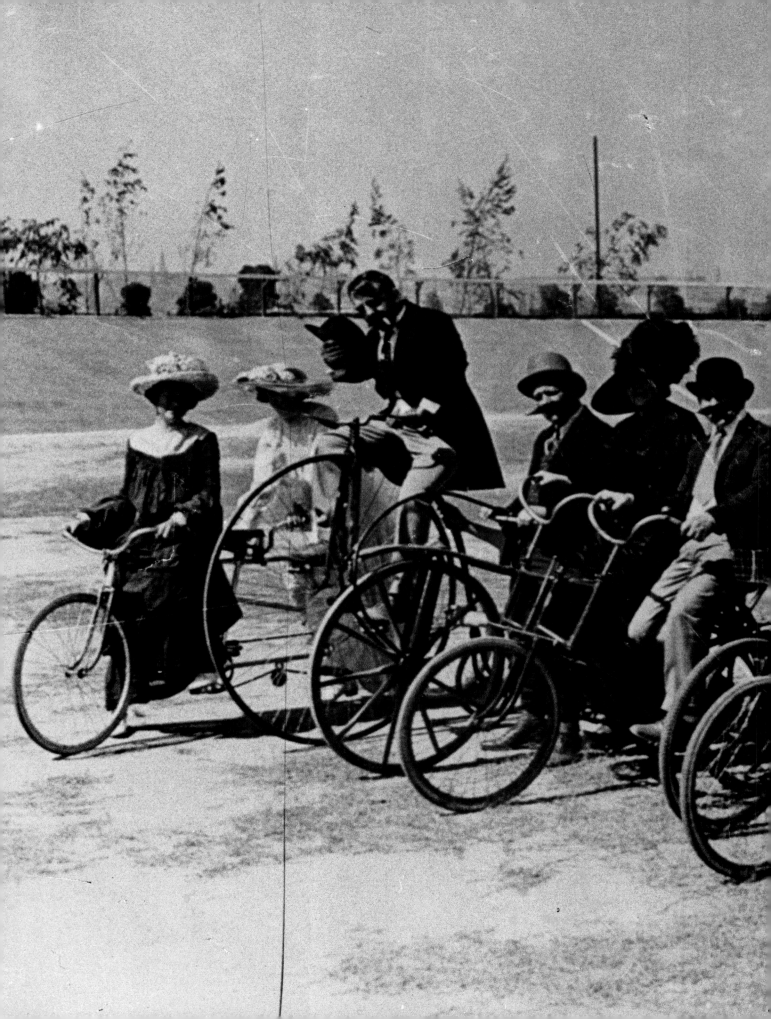

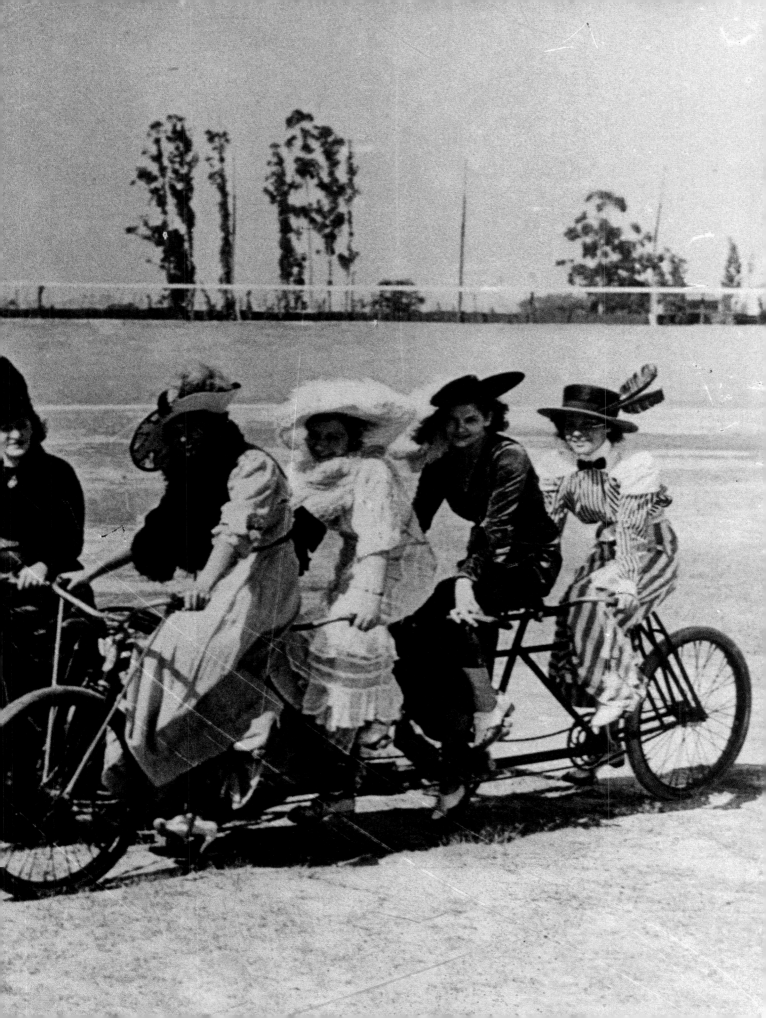

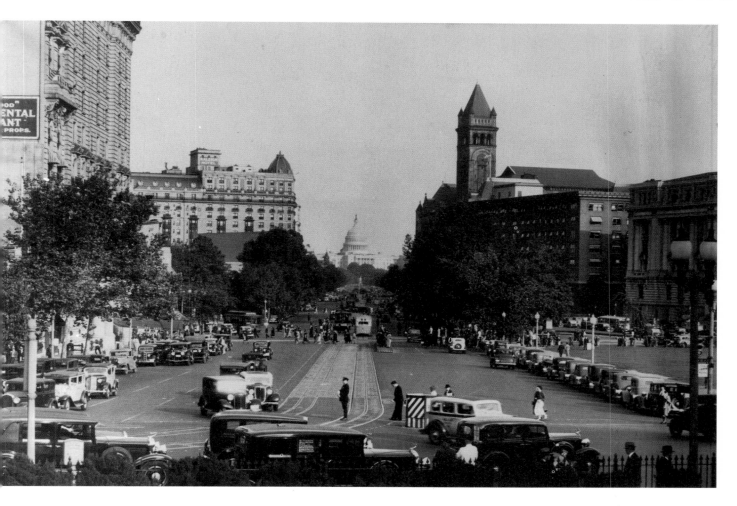

c. 1933 By 1930, more than 4.8 million automobiles were being produced each year – that was one car for every six Americans. Cars line Washington, D.C.'s Pennsylvania Avenue (*above*) looking toward the nation's Capitol.

1939 The dashing young man on the right is John F. Kennedy (1917–1963) at the age of 22 (*right*). Elected as the 35th President of the United States in 1960, Kennedy was the youngest man ever to win the presidency.

1938 Politics and America, they go hand-in-hand. This was the McLennon County Courthouse in Waco, Texas during a primary election (*left*).

c. 1930 Americans have always had a deep affinity for past ways of life. In this picture (*previous pages*) we see some of the more than 100 entries in a vintage bicycle race held in Montebello, California. Some of the entries dated as far back as 1816.

433

1931 Will Rogers stated, "We are the first nation in the history of the world to go to the poorhouse in an automobile." Here an official of the Los Angeles Signal Department counts cars at a busy intersection.

1938 Many American bridges were objects of great beauty as well as function. Structures such as San Francisco's Golden Gate Bridge, completed in 1937, were favorites of both amateur and professional photographers.

1930s

1930 Despite the economic
hard times, many of the "wacky"
antics of the 1920s carried over
to the 1930's. These California
women were gaining their
"15 minutes of fame" by riding
blocks of ice.

436

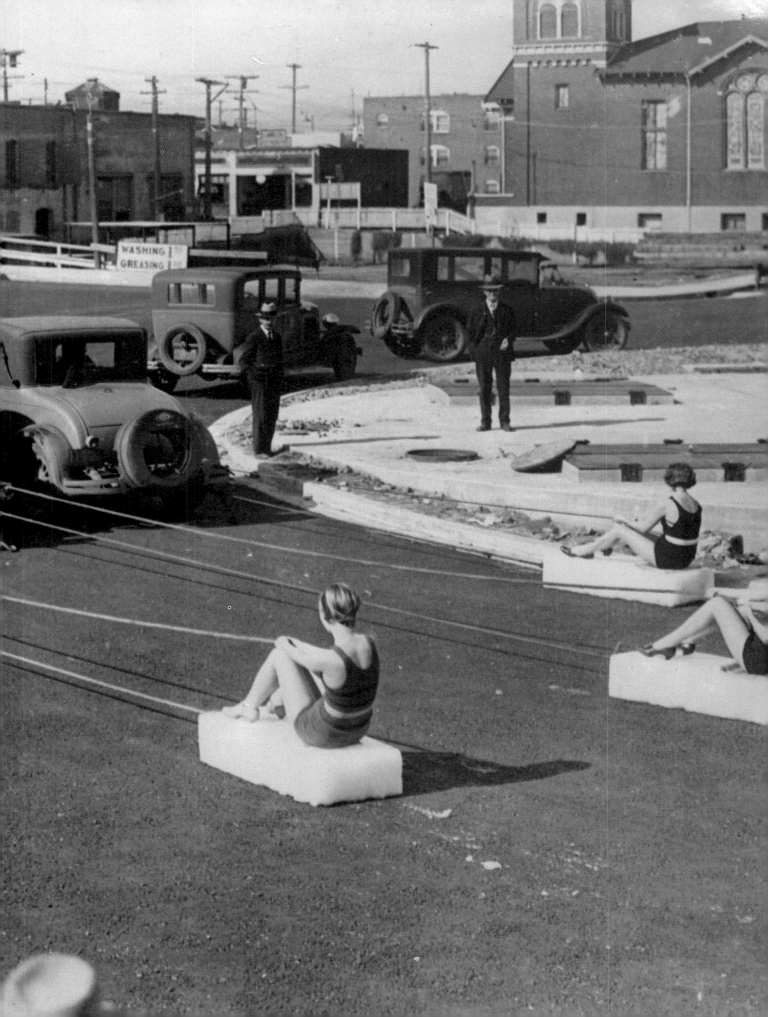

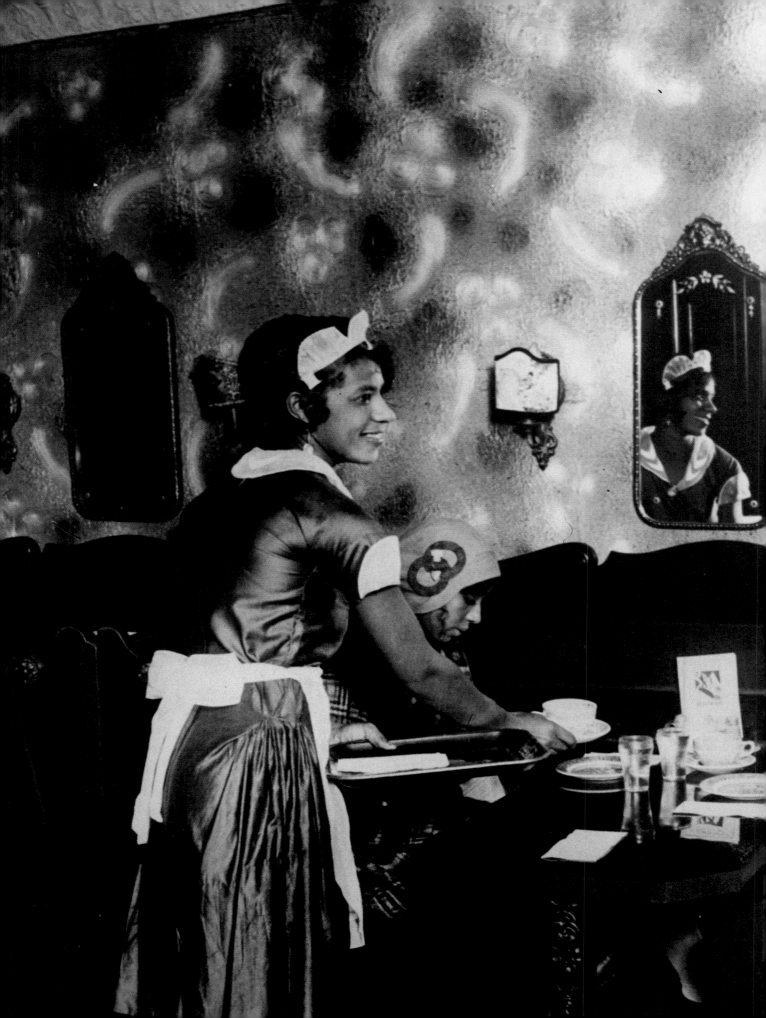

1938 America may have been caught up in the Great Depression, but for many of the very rich the high life continued. In this picture, socialite, heiress, and fashion designer Gloria Vanderbilt (*on the right*) attends a party with her aunt, Gertrude Payne Whitney.

c. 1930 In the 1930s, the Harlem section of New York continued to be the center of black society and cultural life. This is a scene in a Harlem tearoom.

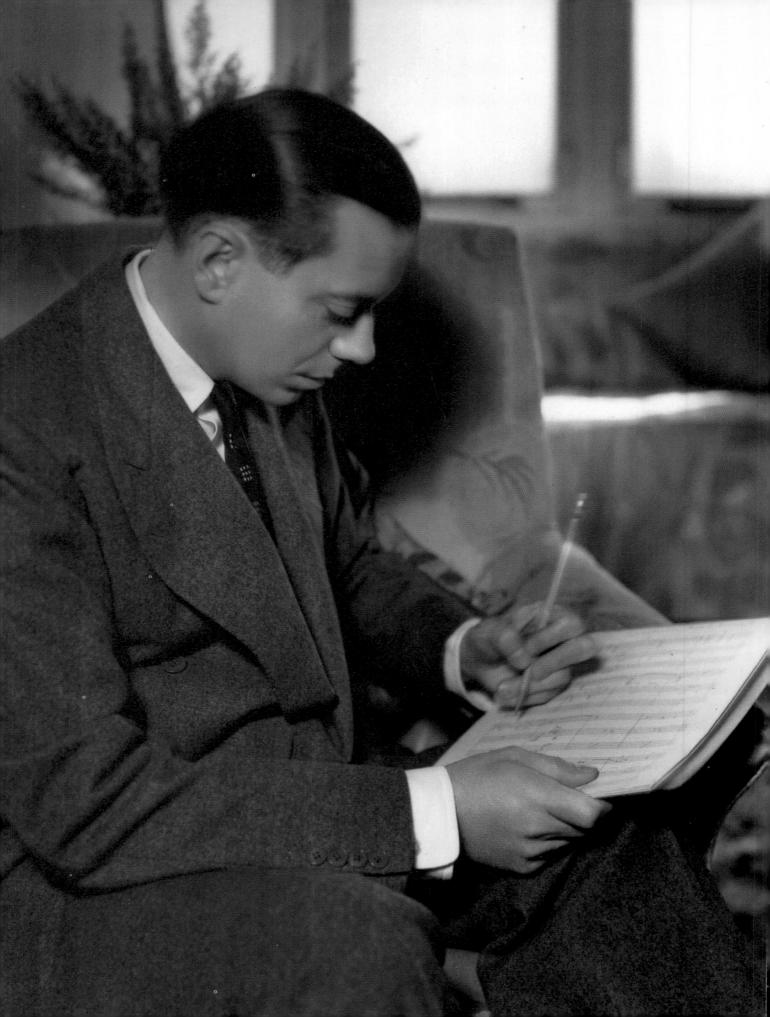

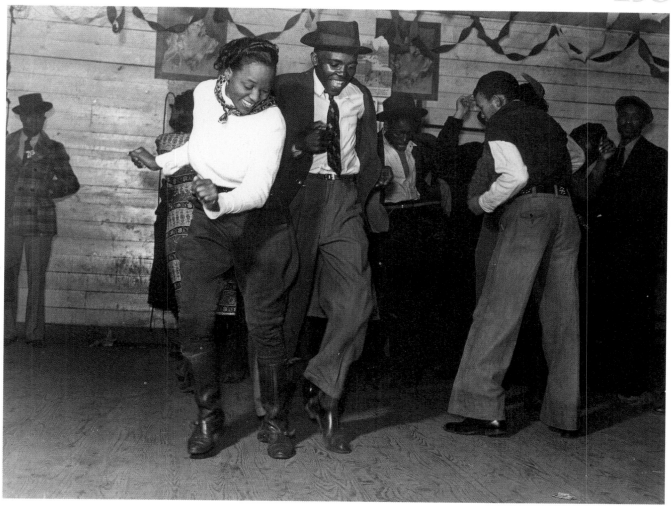

1939 Marion Post Wolcott was one of the most accomplished of all the Farm Security Administration (FSA) photographers who chronicled life in America during the era of the Great Depression. She captured this photograph of a jitterbugging couple in a "juke joint" in Clarksdale, Mississippi.

1933 Cole Porter (1891–1964) was one of the most ingenious of all American composers and lyricists. Among his movie musicals were *Born To Dance* (1936) and *High Society* (1956), while his hit stage shows included *Anything Goes* (1934), *Kiss Me Kate* (1948), and *Silk Stockings* 1955.

c. 1935 American jazz musician and bandleader Cab Calloway (1907–1997). In a decade that saw the rise of the big bands, Calloway became one of the most popular performers of all.

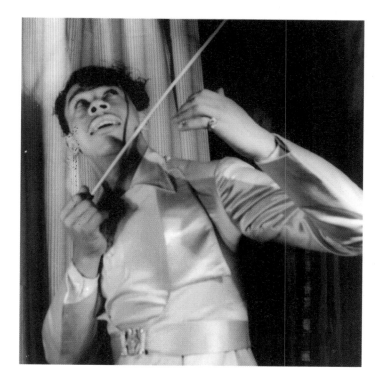

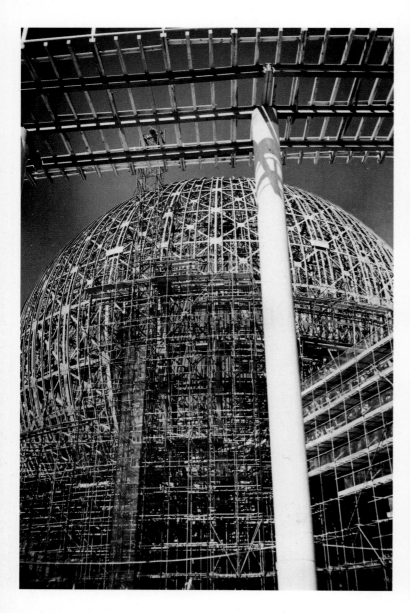

1938 The 1930s ended with the decade's greatest attraction – the largest, costliest, and gaudiest international exhibition ever staged. It was the New York World's Fair, which, along with 1,500 exhibitions, featured Billy Rose's Aquacade and General Motor's Futurama. Here we see the construction of the Fair's most spectacular landmark: the Perisphere. Inside the 190-foot-tall hollow globe, visitors rode on conveyor belts around the interior, peering down on Democracity, a diorama of urban and suburban life in the future.

1939 The Fair, wrote *Harper's* magazine "was good, it was bad; it was the acme of all vulgarity, it was the pinnacle of all inspiration."

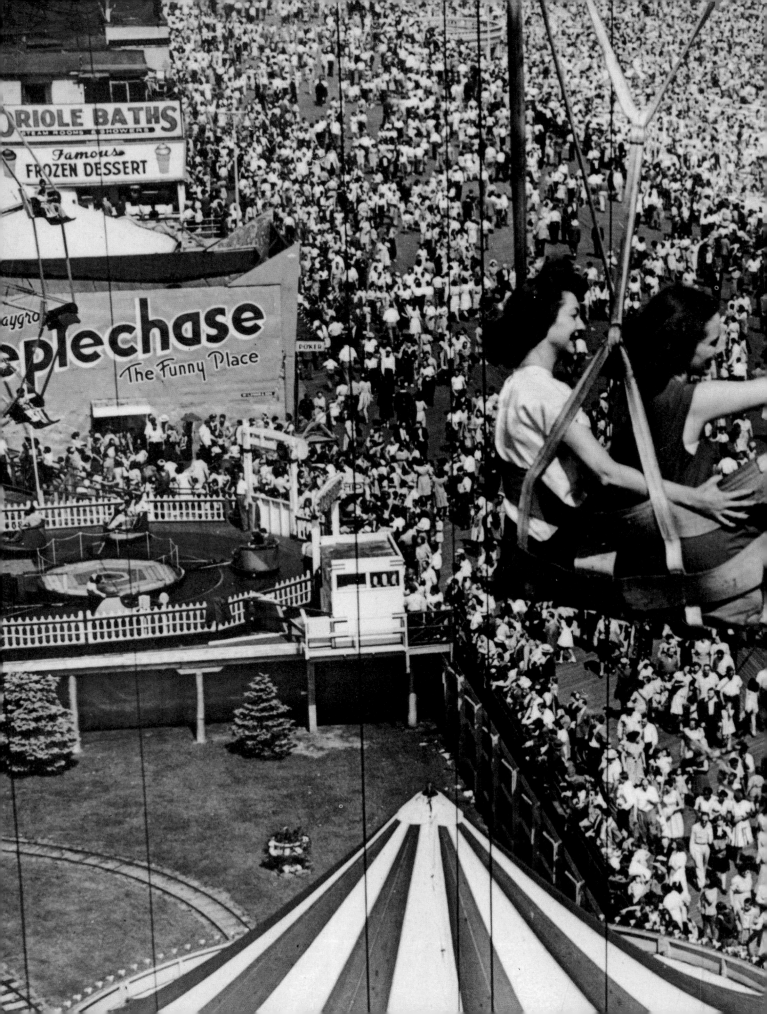

1940s'

c. 1943 World War II produced countless American heroes, the majority of whom returned to normal, everyday lives once the conflict was over. This young man, honored for his exploits as the commander of a PT boat, went on to new heights. He was John F. Kennedy, destined to become the 35th President of the United States.

As the nation became involved in the world's first truly global conflict, Americans at home pitched in to support the troops. They bought war bonds, endured rationing, and turned the country into an arsenal of democracy by supplying the armed forces with the largest number of ships, planes, tanks, and other weapons ever produced.

It was a decade in which Joe DiMaggio hit safely in 56 straight games and Babe Ruth bid a sad farewell to his fans. Jackie Robinson broke baseball's color barrier and Chuck Yeager broke the sound barrier high above the earth. Following the war, millions of returning servicemen took advantage of the G.I. Bill and the first 19 million of those who would become known as "baby boomers" made their appearance.

1940 When Adolph Hitler came to power, Albert Einstein left Germany and took a position at Princeton University. Here the brilliant physicist, his secretary (on his left), and his daughter take the oath of United States citizenship (*above*).

1946 With the long, traumatic years of World War II behind them, these Labor Day weekend pleasure-seekers enjoy the attractions at Steeplechase Park in New York's Coney Island (*previous pages*).

c. 1945 African–American singer Dorothy Dandridge (*right*) was also an accomplished actress. Like Lena Horne and other black film stars, she was denied leading roles because of her race.

1949 Established in 1945 as a successor to the League of Nations, the United Nations has been of great service in helping refugees and in providing disaster relief and development assistance. In this photograph taken on October 27, 1949, crowds gather at the cornerstone–laying ceremony for the UN building in New York.

1942 A view of buildings along the Avenue of the Americas (*right*) in midtown New York. Because of the war, the street contained far less activity than in normal times.

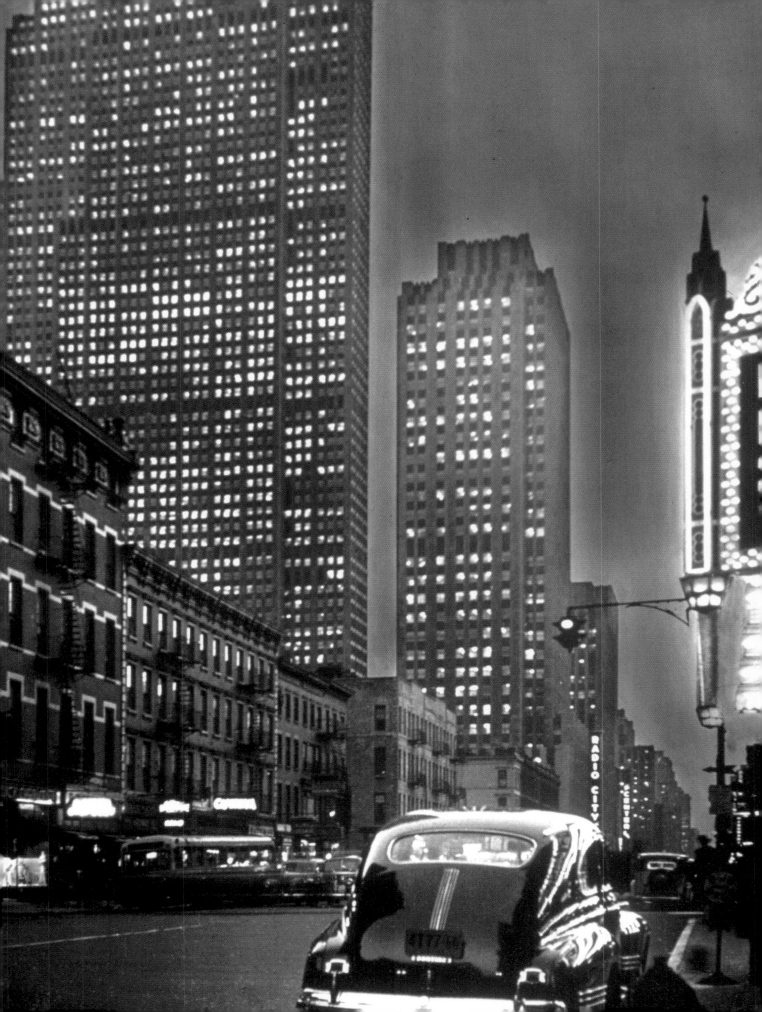

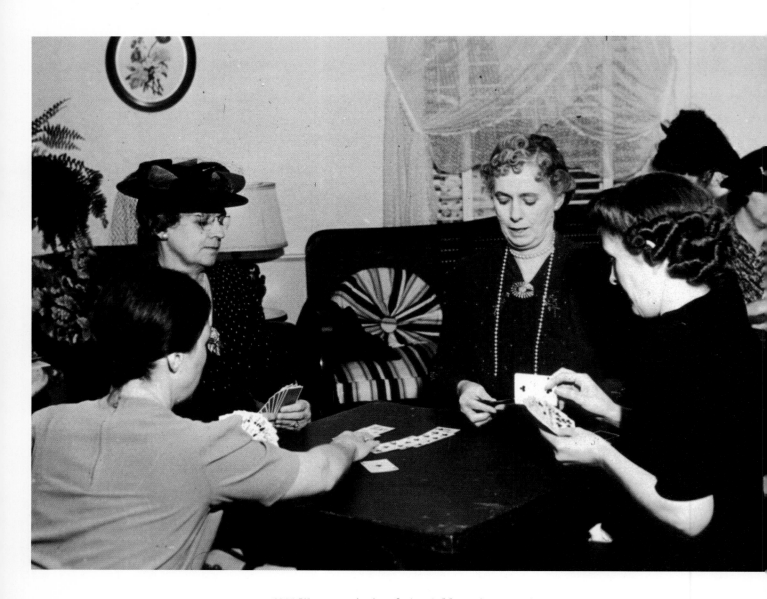

1941 Women enjoying their weekly card game at the
White Plains (Georgia) Bridge Club. America's entry into
World War II was less than two months away when this
picture was taken.

1940 This photograph of a family that had fled the
Dust Bowl of the 1930s is another of the pictures taken by
FSA photographer Russell Lee in Pie Town, New Mexico, a
community formed by migrant farmers.

GEO L WAINWRIGHT
LAW OFFICE

GEO L WAINWRIGHT
LAW OFFICE

GEO L WAINWRIGHT
LAW OFFICE

LUNCHEON · DINNER
FOUNTAIN SERVICE

FULL COU

30¢

60¢

1940s

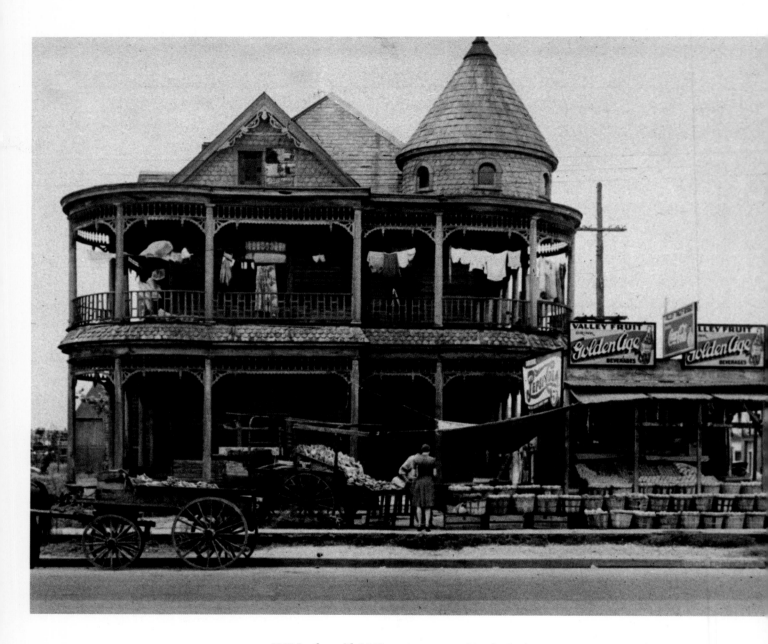

1943 In the mid–1940s, many communities destined to become major American cities were still far away from that status. This is the front of a fruit stand attached to a home in Houston, Texas.

c. 1940 The FSA photographers traveled every section of the nation compiling their visual portrait of America. This picture (*previous pages*) was taken on a street corner in Lowell, Massachusetts.

454

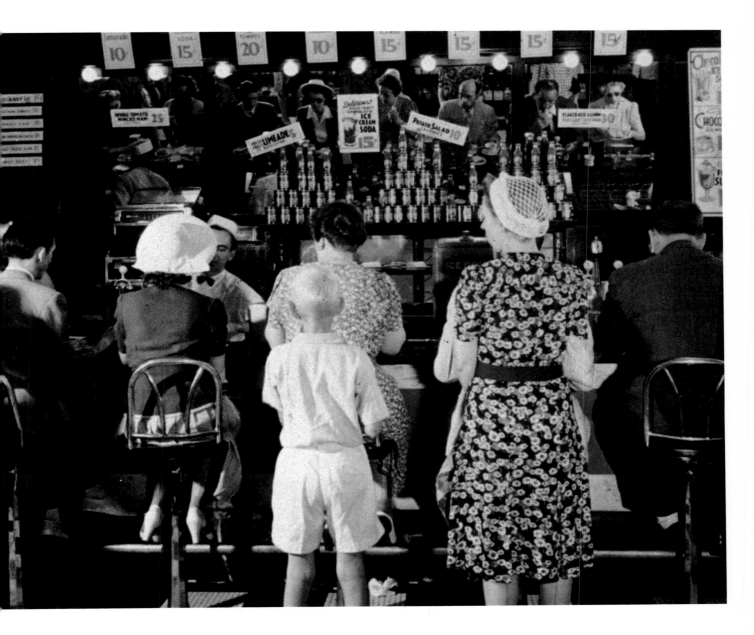

1942 Most American drugstores in the 1940s still had soda fountains. This one was in Washington, D.C.

1941 Artistically, some of the most effective photographs have been those in which vertical shapes are contrasted with horizontal forms. This was a grain elevator in Caldwell, Idaho photographed by Russell Lee.

1941 As late as the 1940s, Main Street in towns throughout the American Midwest looked much the same as they had some two decades before. This was Main Street in Hibbing, Minnesota.

1943 This old fishermen's net house was a noted landmark of Rockport, Massachusetts. Known by artists as "Motif #1," it is still a favorite subject of painters and photographers, as evidenced in this image by famed photograph Gordon Parks.

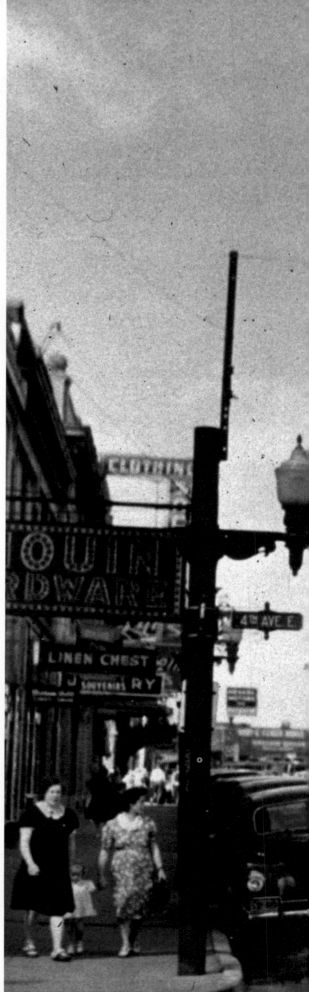

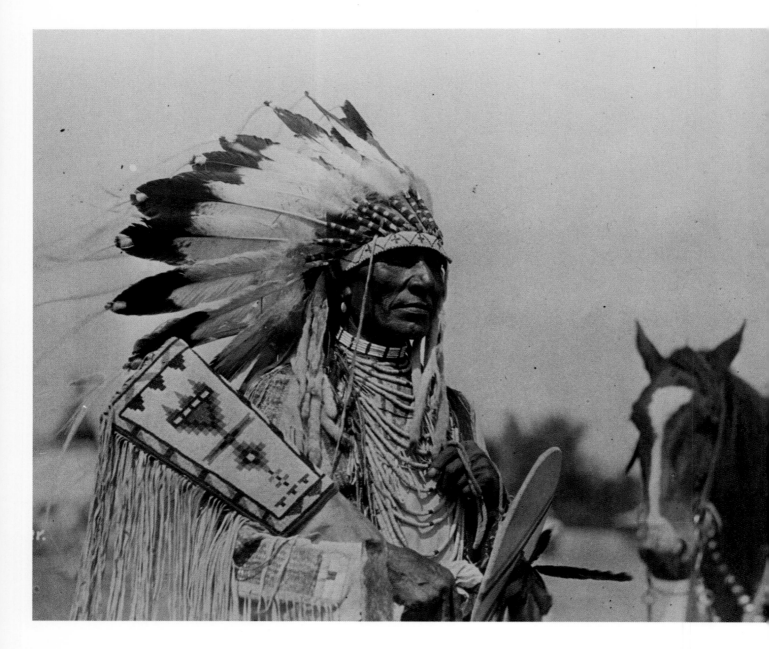

1945 The proud features of those who were first in America have always been a favorite subject of photographers. This Native American man is garbed in the traditional finery of his ancestors.

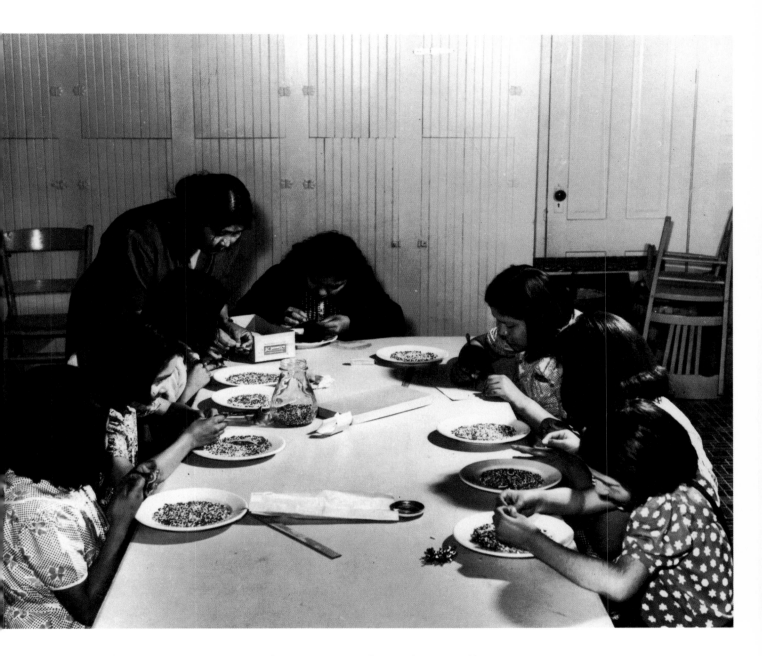

1940 The earliest American crafts were those created by
the Native Americans. Here young members of the Paiute
nation hone their beadwork skills.

c. 1940 Novelist Richard Wright (1908–1960) was born on a plantation in Natchez, Mississippi. Under the auspices of the WPA's Federal Writer's Project he burst upon the literary scene with a collection of short stories called *Uncle Tom's Children* (1938) and his novel *Native Son* (1940). In 1945 his reputation was enhanced with the publication of his largely autobiographical *Black Boy*. Through his success Wright became an inspiration to such other black writers as Ralph Waldo Ellison and James Baldwin.

1943 Marcus Garvey's influence on a host of followers continued well after his death in 1940. This black activist was photographed outside the New York offices of the United Negro Improvement Association, founded by Garvey in 1914.

1945 The date is January 22, 1945. As he takes the
oath of office, Franklin Delano Roosevelt becomes the first
American President to enter a fourth term. The man next
to the President is his son, Colonel James Roosevelt.

1947 Members of the freshman class of the Congress
of 1947 gather together. Thirteen years later the two young
men standing next to each other at the right rear (John F.
Kennedy and Richard Nixon) would face each other in a
hotly contested presidential election.

1940s

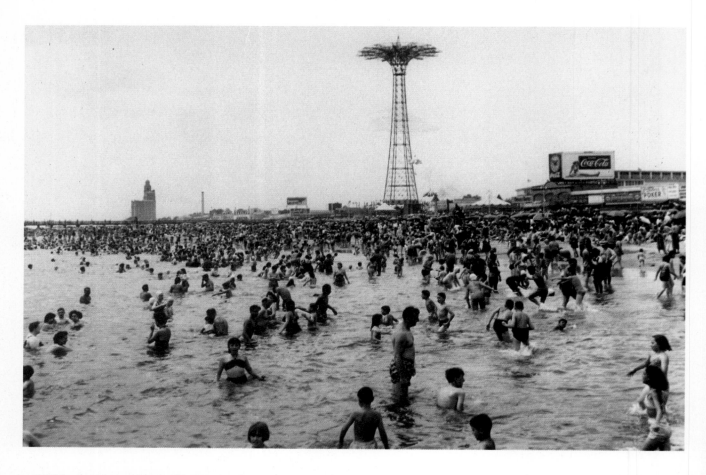

c. 1945 In the 1940s, New York's Coney Island featured not only countless amusements but one of the nation's most popular (and crowded) bathing beaches.

1943 A sailor home on leave enjoys an evening out at O'Reilly's, a New York Irish–American restaurant. The starred banner hanging from the ceiling indicates that three of the restaurant's employees were part of the armed forces.

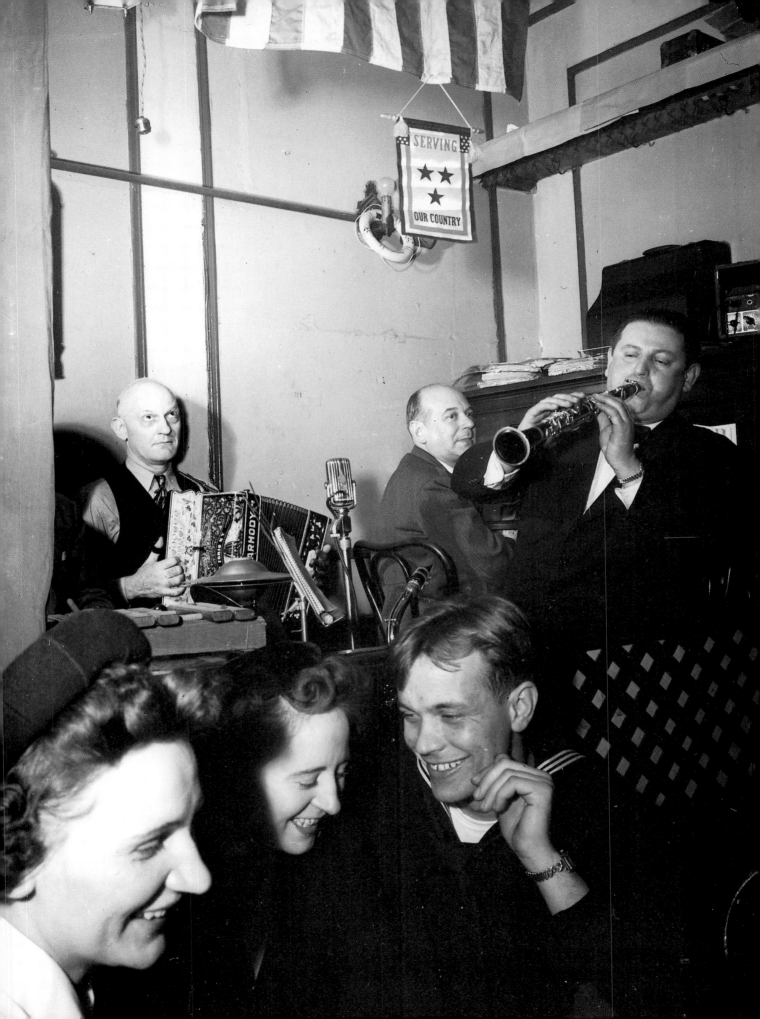

SERVING
★ ★
★
OUR COUNTRY

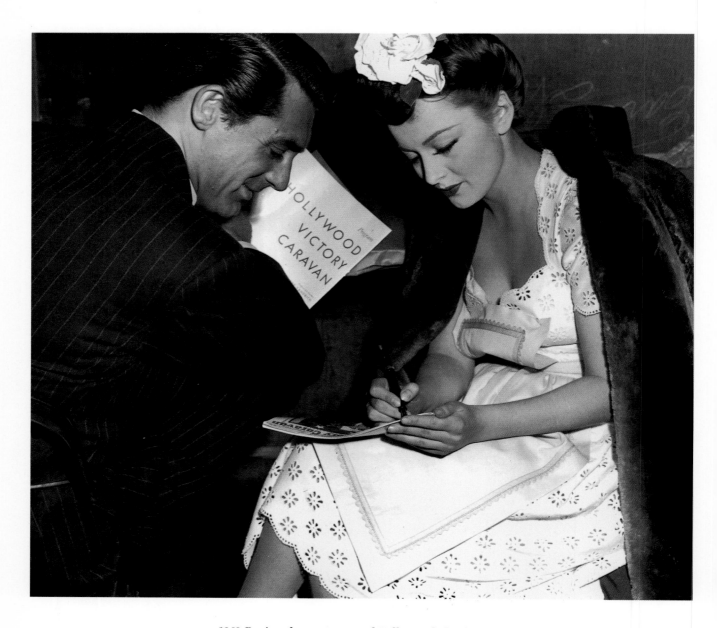

1942 During the war many of Hollywood's brightest stars contributed to the war effort by raising funds for Army and Navy relief. Here Cary Grant (1904–1986) and Olivia de Haviland (1916–) participate in a Hollywood Victory Caravan.

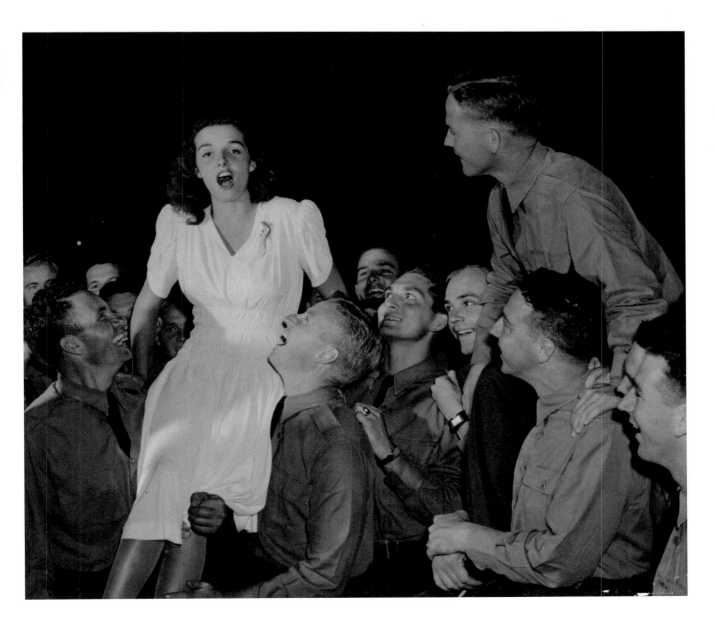

c. 1943 Jane Russell, one of the sexiest of Hollywood
actresses, burst upon the scene in the movie *The Outlaw*
(1943). She is shown here entertaining American troops.

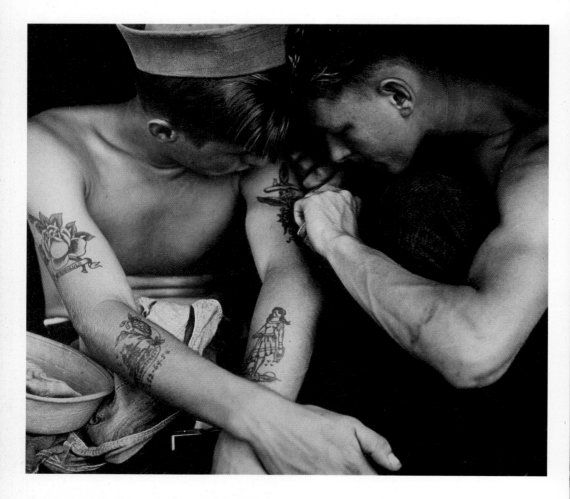

1944 Tattooing is a naval tradition practically as old as the United States Navy itself. These young sailors were members of the crew of the aircraft carrier SS *New Jersey*.

1944 Throughout World War II, service organizations throughout the nation provided needed rest and recreation for members of armed forces home on leave. Here a soldier and his partner demonstrate their jitterbugging skills.

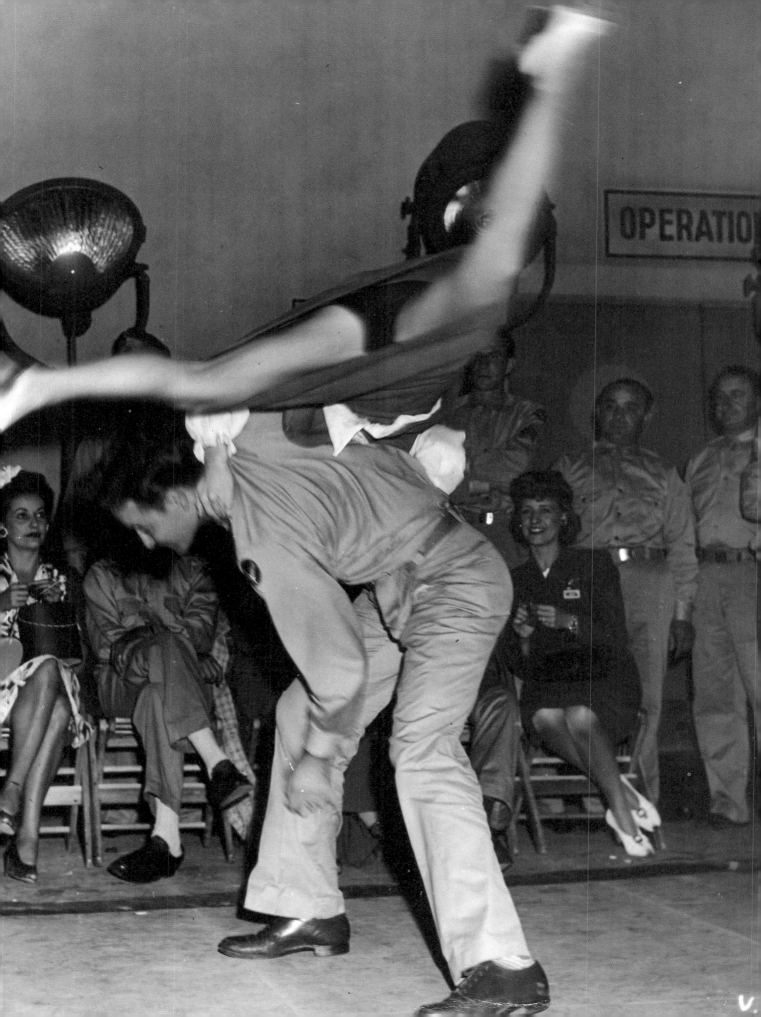

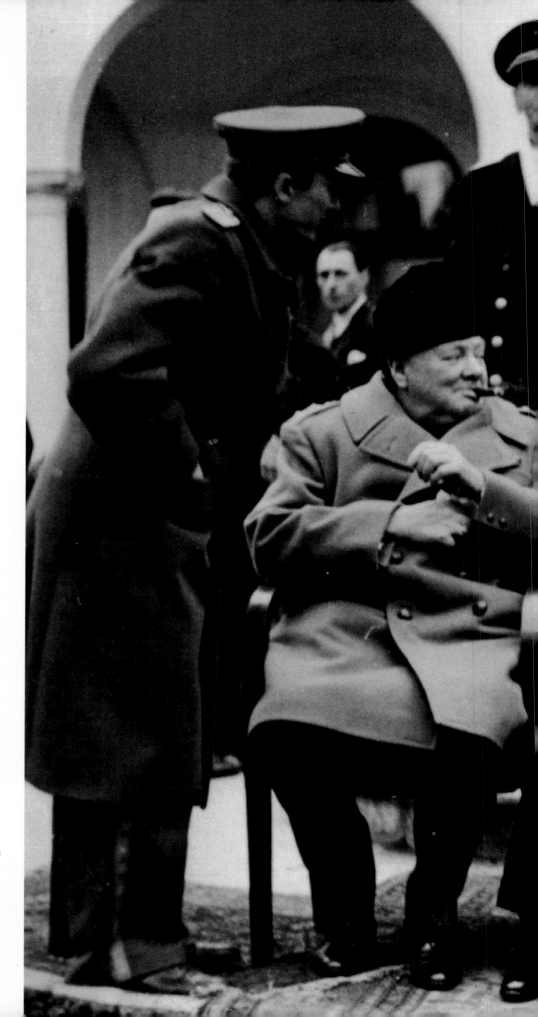

1945 In February, with the end of World War II in sight, the leaders of the three Allied Powers met in Yalta in the Crimea to discuss post–war plans. Seated left to right are: British prime minister Winston Churchill (1874–1965), American president Franklin Delano Roosevelt (1882–1945), and Soviet premier Joseph Stalin (1879–1953).

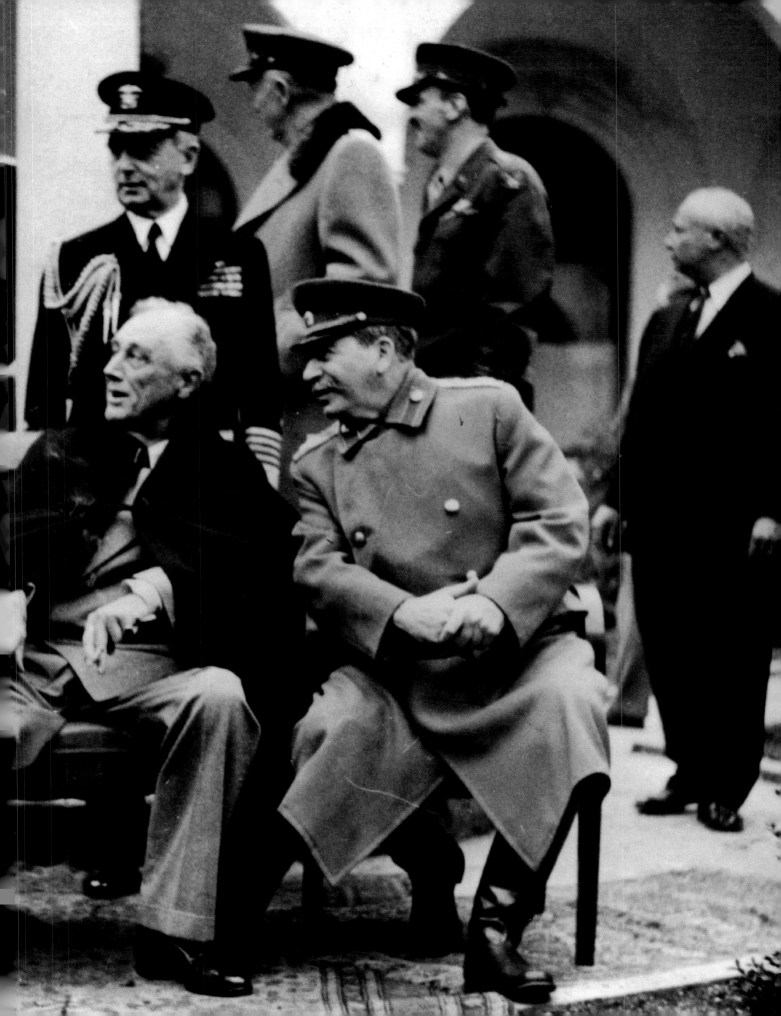

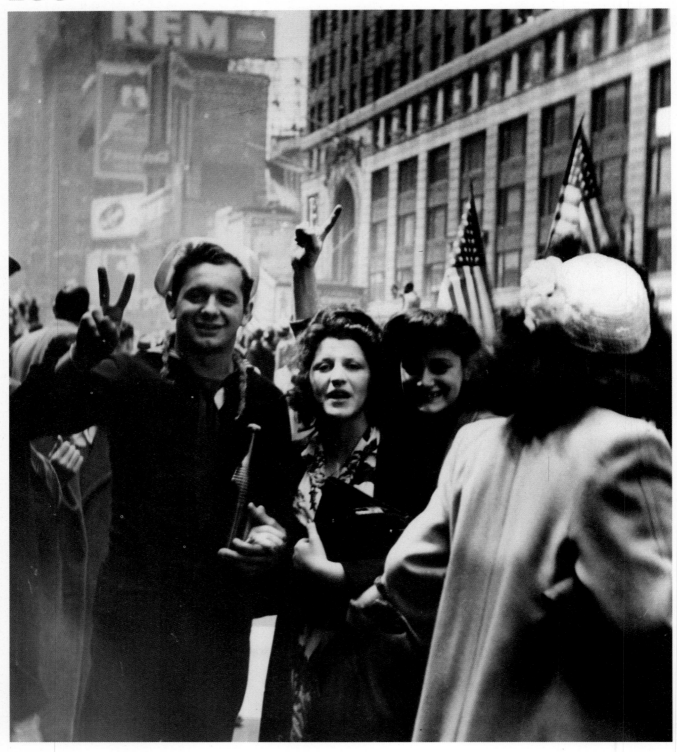

1945 The nation's greatest wartime celebration was
reserved for the capitulation of the Japanese, which
ended the war. There was, however, an earlier national
demonstration of joy when on May 8, 1945 when
Germany surrendered, ending the fighting in Europe.

1945 The newspaper headline and the soldier's
lipstick–smeared face tell the story. It is August
15, 1945 and the Japanese have just surrendered,
bringing World War II to an end.

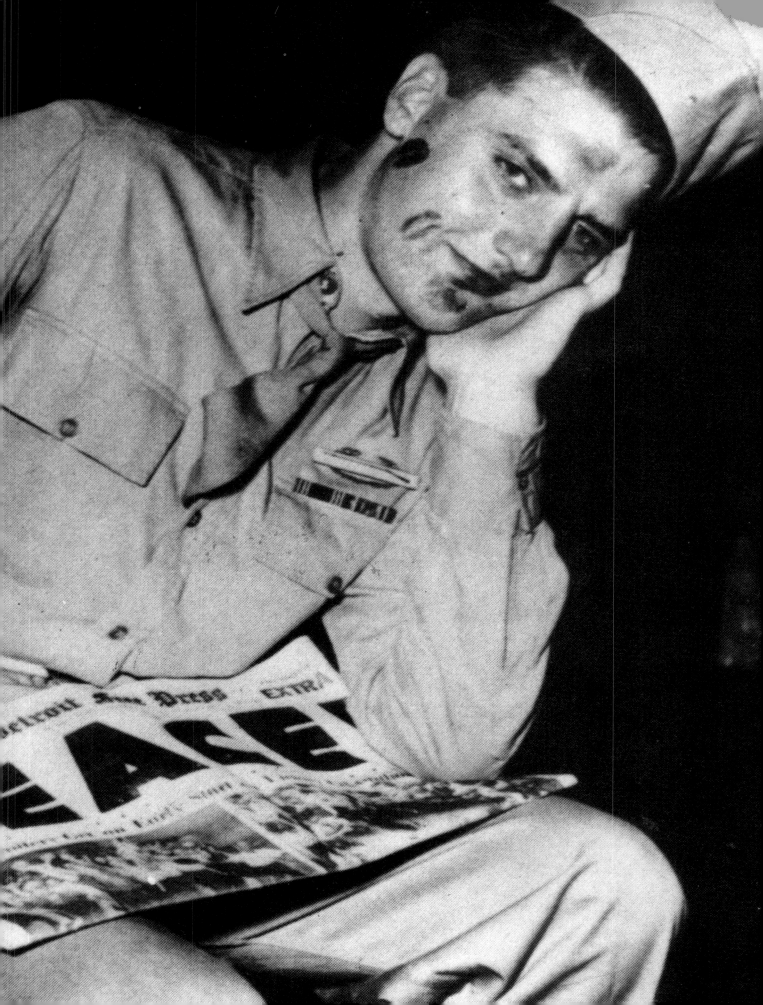

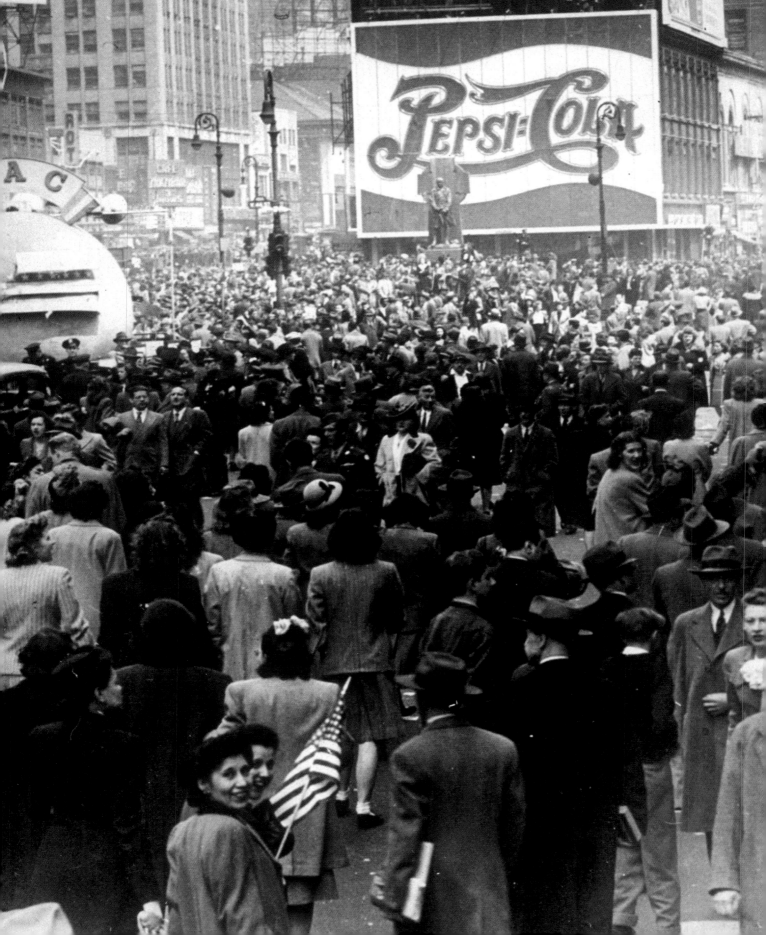

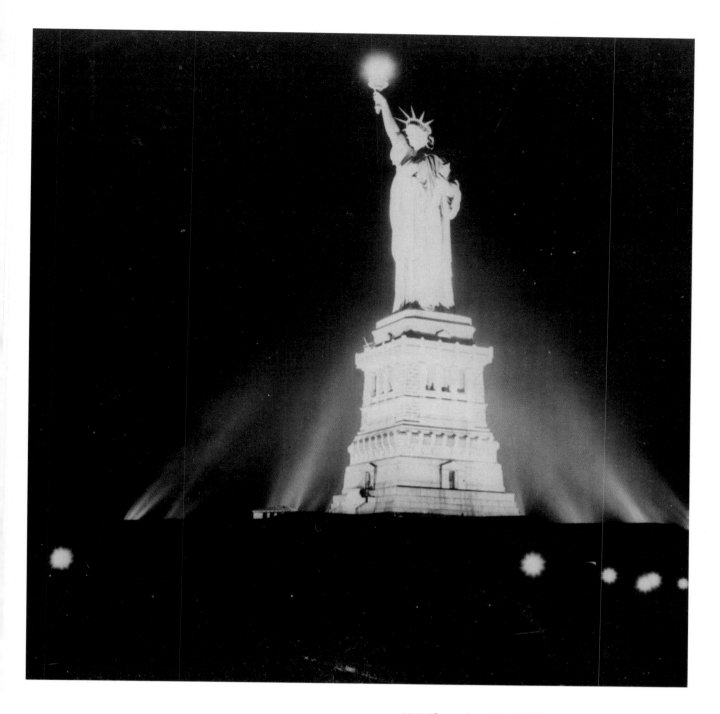

1945 Throughout World War II, as a defense measure, the Statue of Liberty was kept unlit. With victory assured, the policy was changed. This was the scene on May 19, 1945 when the statue was lit for the first time since the attack on Pearl Harbor.

1945 Times Square in New York has been the site of some of the nation's greatest celebrations. This was the scene after Germany's surrender in World War II had been announced.

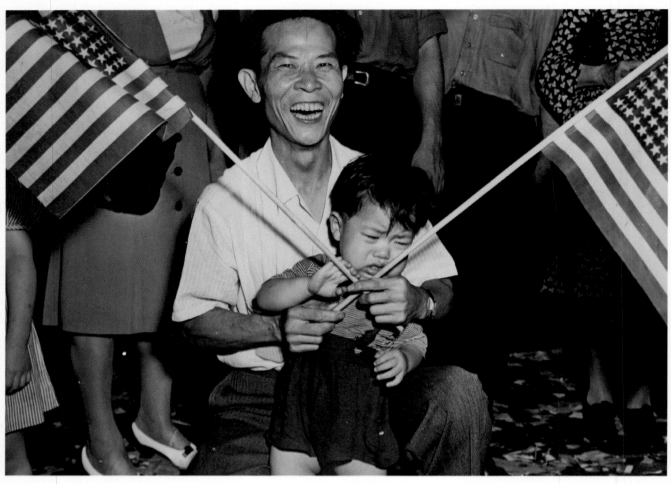

c. 1942 America's entry into World War II set off displays of patriotism reminiscent of that time, only 24 years earlier, when the nation became embroiled in the First World War. Here a father and son attend a "support the troops" parade in New York's Chinatown.

c. 1945 The woman in this picture is Barbara Pierce Bush, wife of future President George Herbert Walker Bush and mother of future Republican candidate for the presidency, George W. Bush, Jr. During her husband's term in the White House, Barbara Bush was a spirited champion of a more literate America.

1947 Harry S. Truman (1884–1972), the 33rd President of the United States. Thrust into the presidency on the death of Franklin Roosevelt, he surprised the experts with his adroit handling of the nation's highest office. He is shown here signing the Foreign Aid Assistance Act, which was part of what became known as the Truman Doctrine.

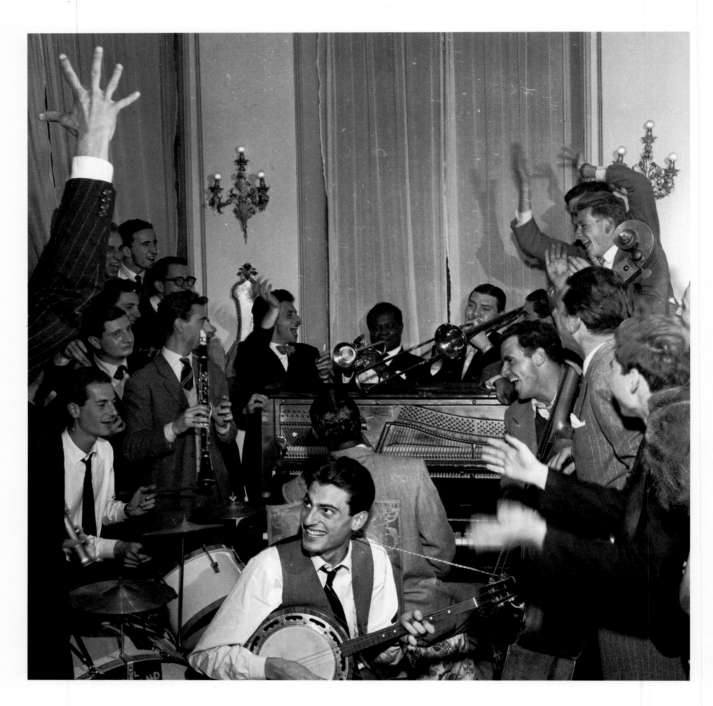

1948 This Dixieland band included some of the all-time giants of jazz. The trumpeter was Louis Armstrong (1900–1971), the pianist was Earl "Fatha" Hines (1905–1983), and the trombonist was the legendary Jack Teagarden (1905–1964).

c. 1940 Louis Armstrong (1901–1971) ranked among the most popular of all jazz musicians. A trumpeter, coronet player, and singer, "Satchmo," as he was affectionately called, began his career in New Orleans at the age of 13 when he played in clubs, bars, and on riverboats. His popularity earned him several movie roles.

c. 1949 The versatile Sammy Davis Jr. (1925–1996). A highly talented dancer, singer, mimic, and actor, he gained national attention for his many television appearances and for his roles in the "rat pack" movies starring Frank Sinatra.

1942 Duke Ellington was not only an outstanding jazz pianist but a brilliant composer and arranger as well. His hit compositions included "Mood Indigo," "Sophisticated Lady," and "Black and Tan Fantasy".

481

1944 The man at the left of this photograph is
saxophonist Charlie Parker (1920–1955). Before he died
at the age of 35, Parker, known as "Bird," helped turn
jazz improvisation into an art form, and along with
Dizzie Gillespie, developed that style of jazz known as
bebop. The other two performers in this photograph
are a very young Sarah Vaughn and singer/band
leader Billy Eckstine.

c. 1947 A young Harry Belafonte (1907–) at a
recording session. A dynamic performer, Belafonte
became best known for his interpretation of West
Indian Calypso music. He has also appeared in several
movies including *Carmen Jones* (1954), *Island in the Sun*
(1957), and *Buck and the Preacher* (1972).

c. 1945 The 1940s saw the rise of the Abstract Expressionist movement in art. Here, posed next to one of his works, we see the Dutch-born American artist Willem de Kooning (1904–1997) who, along with Jackson Pollock and Arshile Gorky, became a leader of the movement.

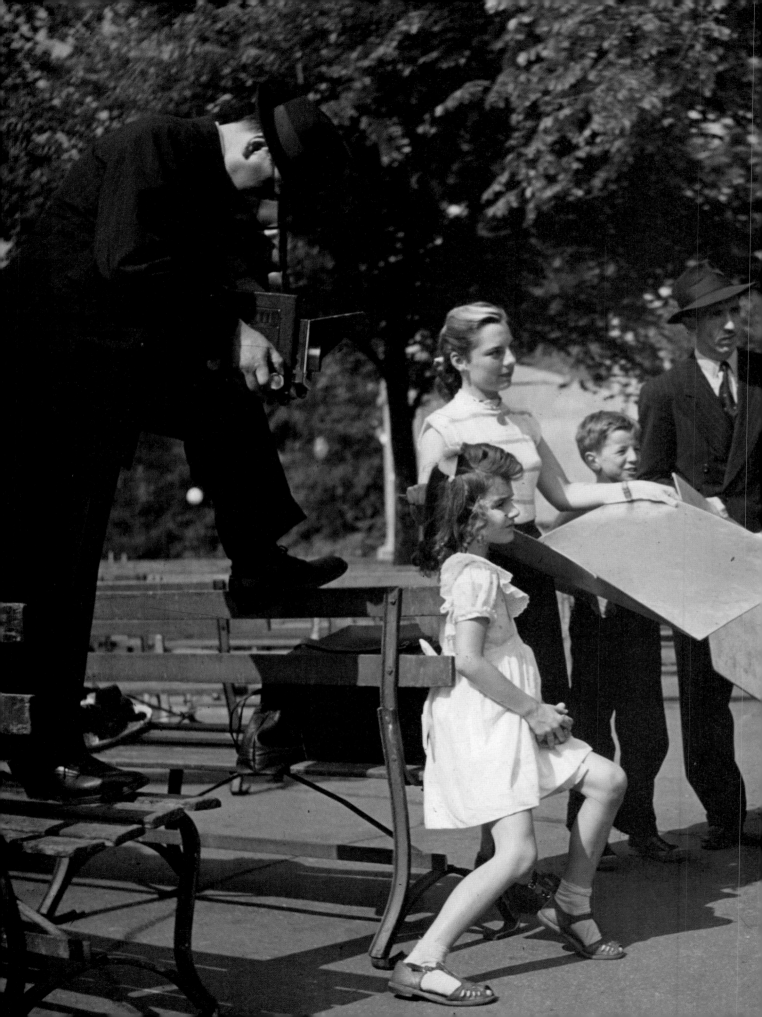

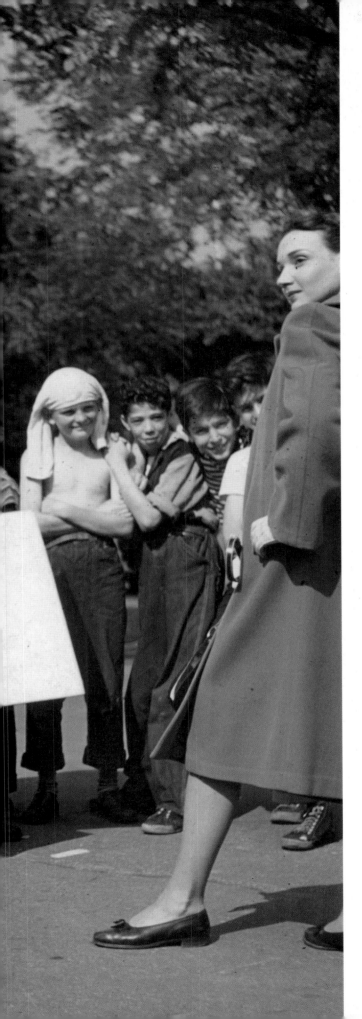

1940s

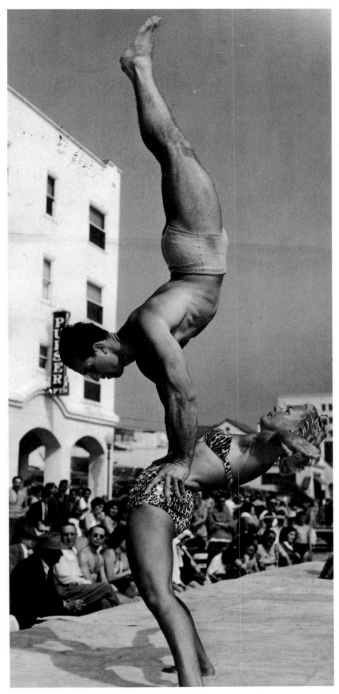

1946 An emphasis on physical fitness, inspired in great measure by rigorous training programs that servicemen had undergone, became more popular than ever after World War II. This couple was displaying their physiques and special skills at the appropriately named Muscle Beach, California.

1947 By the late 1940s, both the picture magazine and advertising photography had become well established. Here we see a fashion "shoot" in New York's Central Park.

487

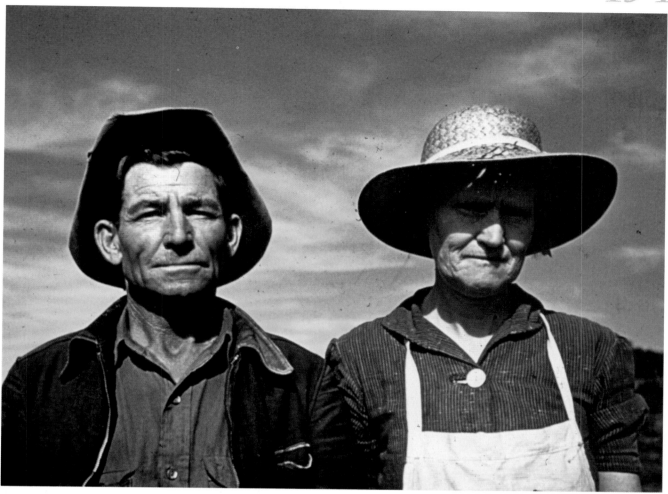

1940 This farm couple in Pie Town, New Mexico, was photographed by FSA photographer Russell Lee (*above*). Pie Town was a community formed by migrant farmers who had fled the ravages of drought-stricken Texas and Oklahoma.

1940 In the opinion of many literary critics, William Faulkner (1897–1962) was the greatest of all 20ᵗʰ-century American writers (*right*). Noted for his stream-of-consciousness writing style, Faulkner's novels of southern life included *The Sound and the Fury* (1929), *As I Lay Dying* (1930) and *The Town* (1940). In 1949 Faulkner was awarded the Nobel Prize for Literature.

1941 The rodeo was introduced by the first cowboys, the Mexican *vaqueros* who passed on their knowledge and skills to the Americans. This young woman waits her turn to participate in a rodeo in Ashland, Montana (*left*).

c. 1947 Americans have always grasped at any opportunity for pageantry and celebration. This was the Queen of the Apple Festival (*previous pages*) and her attendants at the Big Apple parade in Ohio.

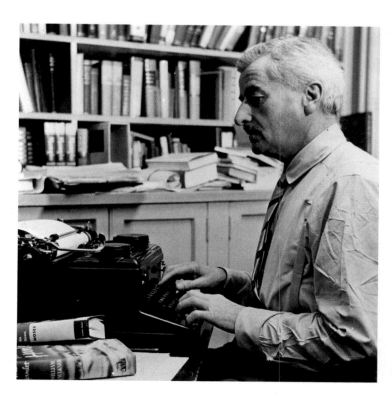

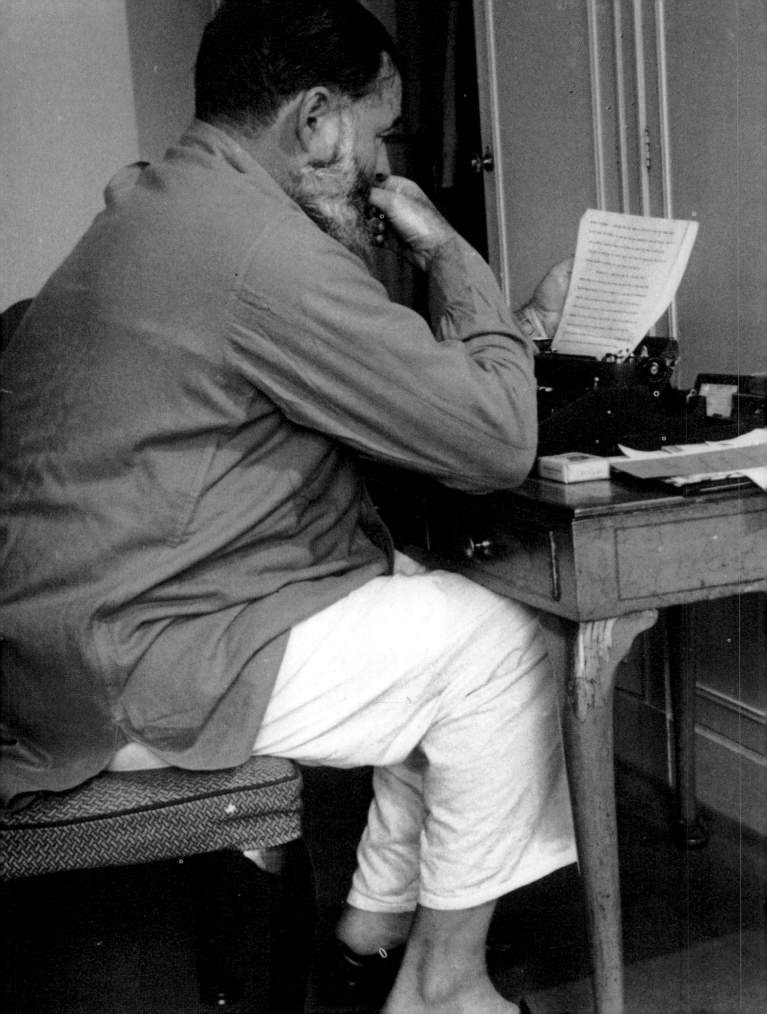

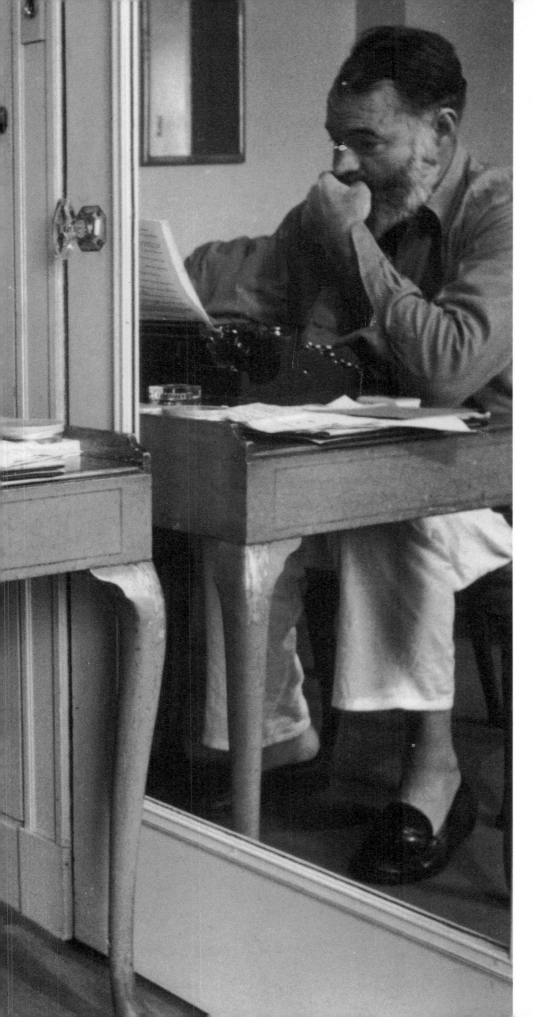

1944 Ernest Hemingway
(1899–1961), through his lean
writing style and his portrayal
of man's dignity in the face
of adversity, had a profound
influence on generations of
American writers. Some of his
short stories such as "The Snows
of Kilimanjaro" (1938) and
"The Killers" (1927) are among
the most highly acclaimed
of any stories written in the
English language.

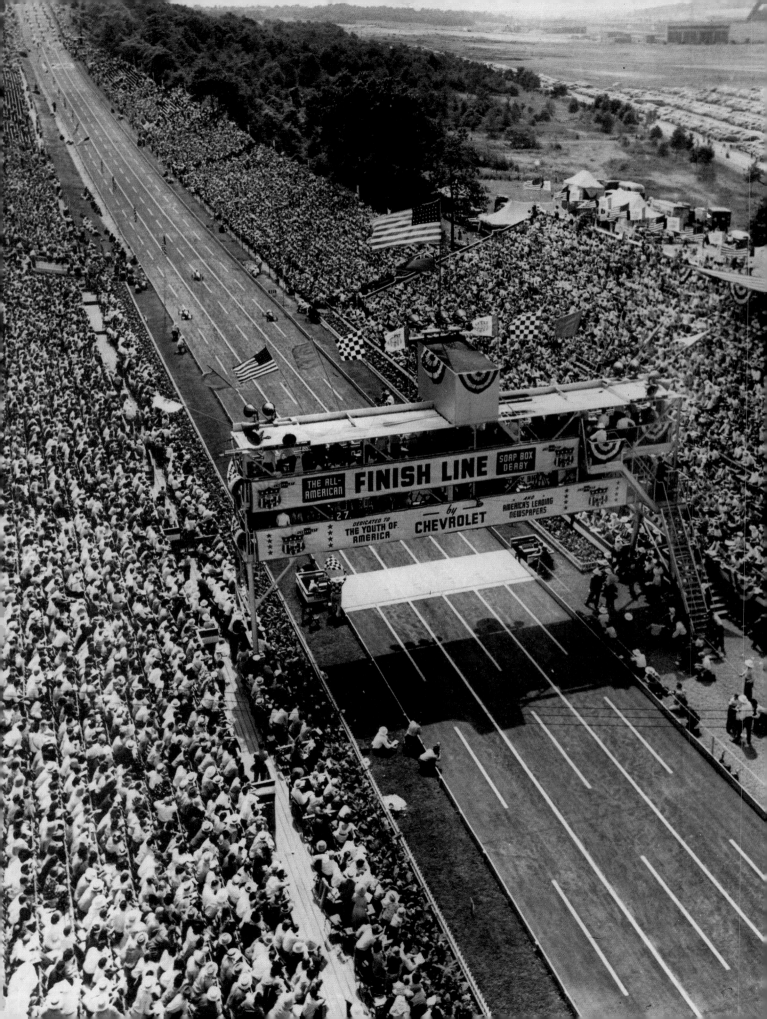

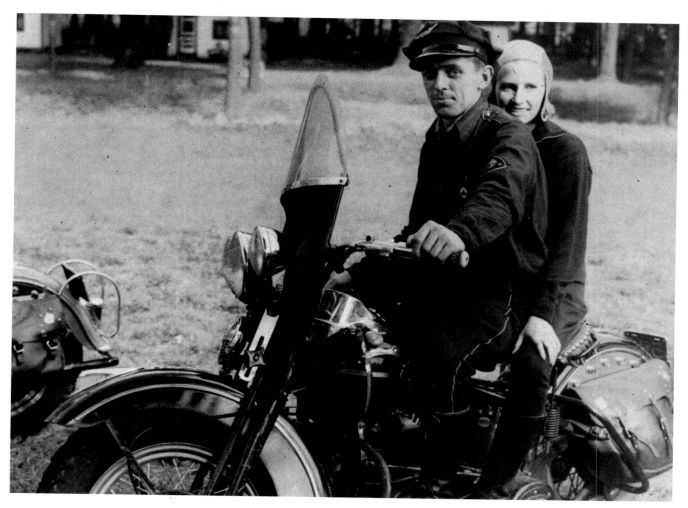

1941 On the road. Two members of a motorcycle club pose for their picture on the Mohawk Trail in the New England Berkshires (*above*).

1947 The man on the left is Captain Charles Yeager (1923–). On the day this photograph was taken (October 14, 1947) he became the first person to break the sound barrier (*right*). Six years later, Yeager set another record by flying 2½ times faster than the speed of sound.

1948 The Akron, Ohio, Soap Box Derby, in which young competitors race in homemade cars, has become a treasured annual event. Here (*left*) we have an overhead view of the 75,000 spectators who attended the 11th running of the race.

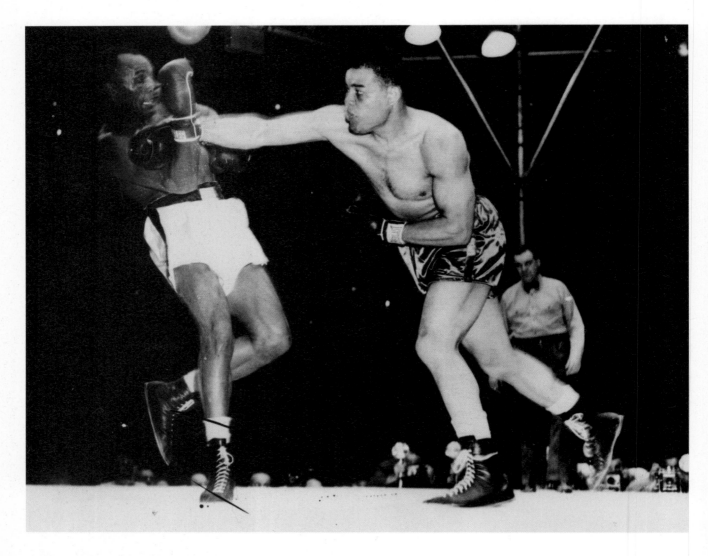

1948 Heavyweight champ Joe Louis rocks challenger
Jersey Joe Wolcott during their fight at New York's Yankee
Stadium. Louis would retire as champion in 1949, but a
year later would attempt an ill-advised comeback in
which he would be beaten handily by Ezzard Charles.

1948 "Boxing's simple," **Sugar Ray** Robinson explained.
"The other man can't hit you with but one hand at a time.
And got your right hand free to block that. And that leaves
your own left hand free to hit him anyway you want."
Robinson (1920–1989), who won both the world welter-
weight and middleweight championships, is regarded by
many as pound-for-pound the greatest boxer of all time.

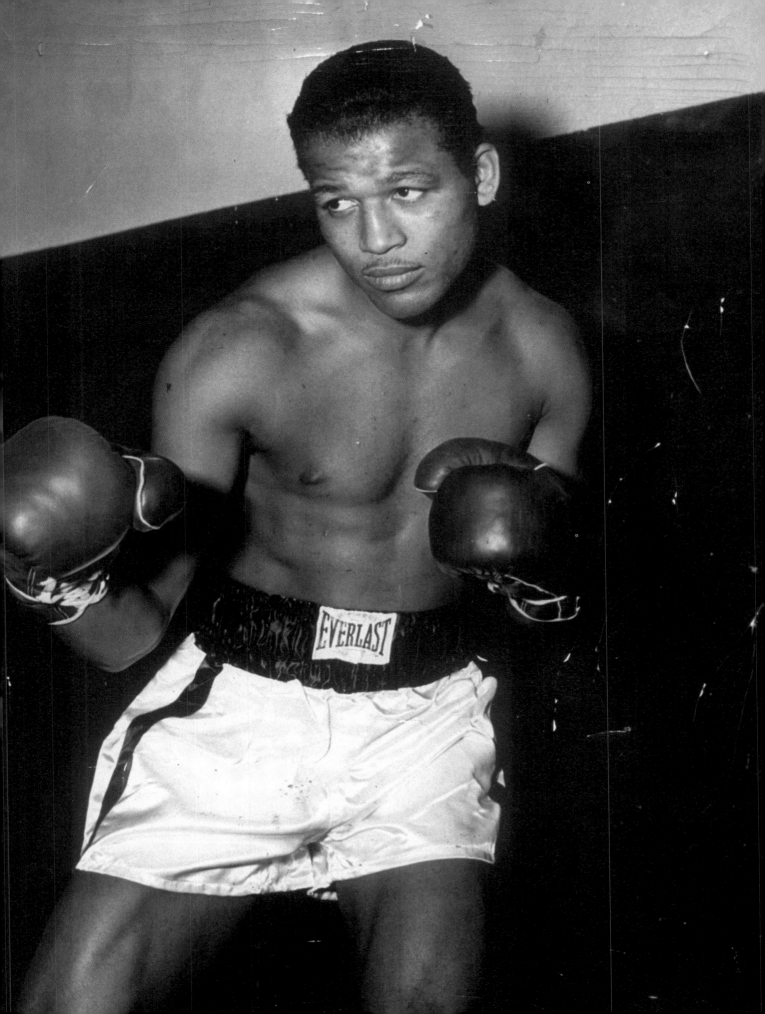

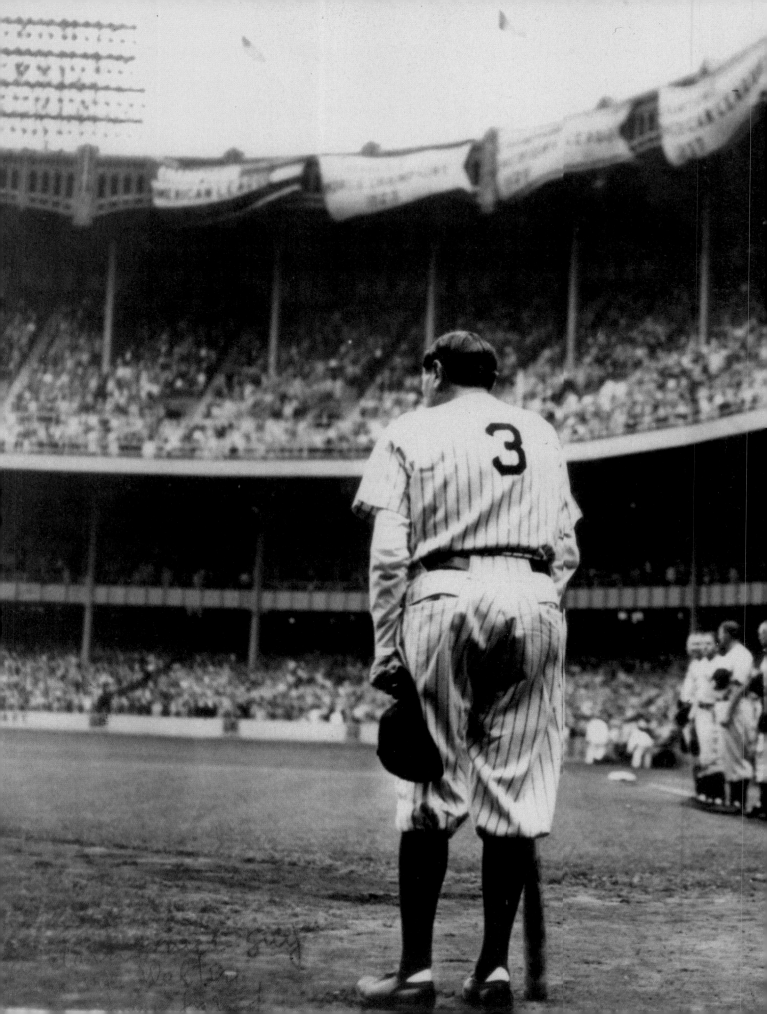

1948 In this Pulitzer Prize-winning photograph, Babe Ruth, his body wracked with illness, receives a standing ovation at Yankee Stadium as he bids farewell to the fans and his number is officially retired.

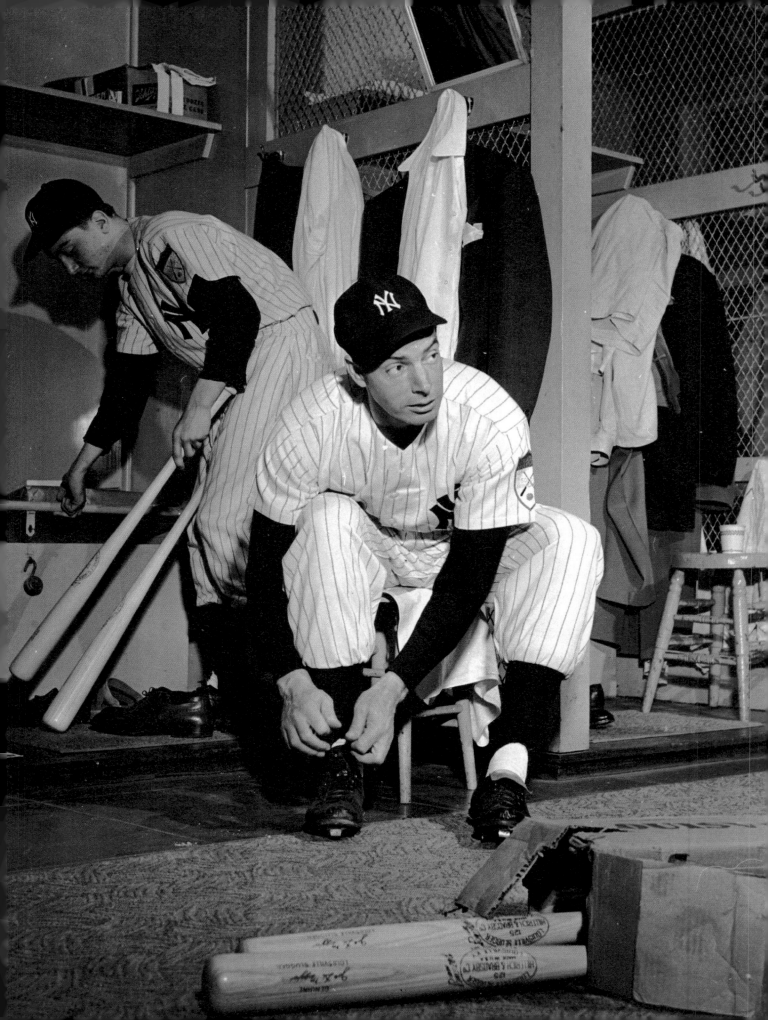

1949 The year famed photographer Ruth Orkin took this picture, Jackie Robinson (1919–1972) won the National League's batting championship and was voted the National League's most valuable player. He is shown here with his mother Mallie, wife Rachel, and son Jackie, Jr. (*above*).

c. 1947 Jackie Robinson was one of baseball's greatest stars. A magnificent fielder, he had a career batting average of .311. He will be best remembered, though, for the courage he demonstrated in becoming the first African-American to break the color barrier and play in the Major Leagues (*right*).

c. 1948 Known as "Joltin' Joe" and the "Yankee Clipper," Joe DiMaggio (1914–1999) was one of baseball's greatest hitters, fielders, and base runners (*left*). His feat of having hit safely in 56 consecutive games, established in 1941, is widely regarded as baseball's most unbreakable record.

1949 From the earliest daguerreotypes, children have ranked at the very top of many photographers' favorite subjects. This picture of Alaskan youngsters (*above*) was taken in their Atka village.

1940 The introduction of Kodachrome film in 1937 made color photography available to almost everyone. This bucolic scene near Terrebonne Bay in Louisiana (*below*), was captured by FSA photographer Marion Post Wolcott.

1949 "Shooting" marbles was a longtime favorite hobby of the young (*right*). This expert was showing off his skills to a group of youthful admirers.

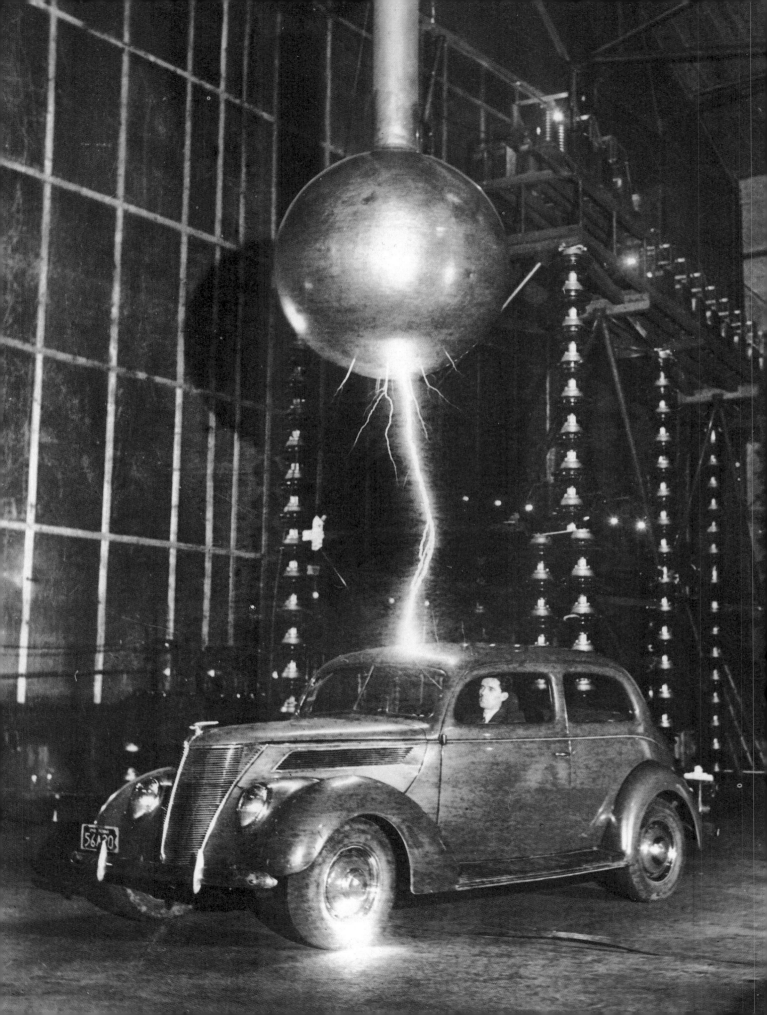

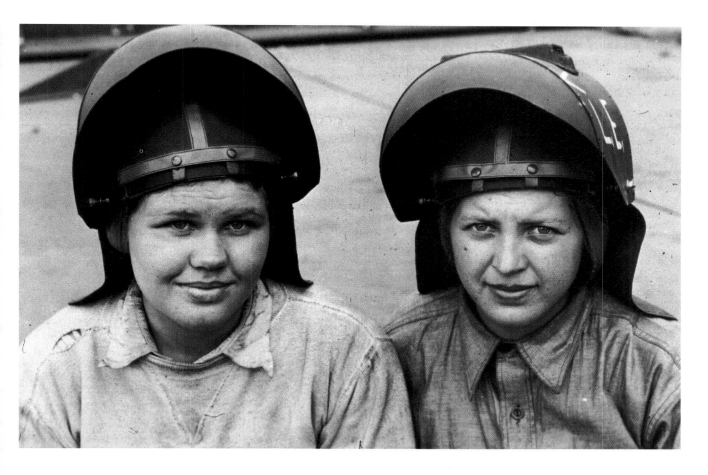

1943 During World War II, millions of American women went to work in defense factories, replacing men who had gone off to battle. These two welders were part of the workforce at Baltimore's Bethlehem–Fairfield Shipyards.

1947 The world of science. As scientists at Pittsburgh's Westinghouse Electric Corporation conduct a study of the effects of lightning, a worker remains unharmed as three million volts of laboratory-generated electricity strike the roof of the steel-topped car in which he sits.

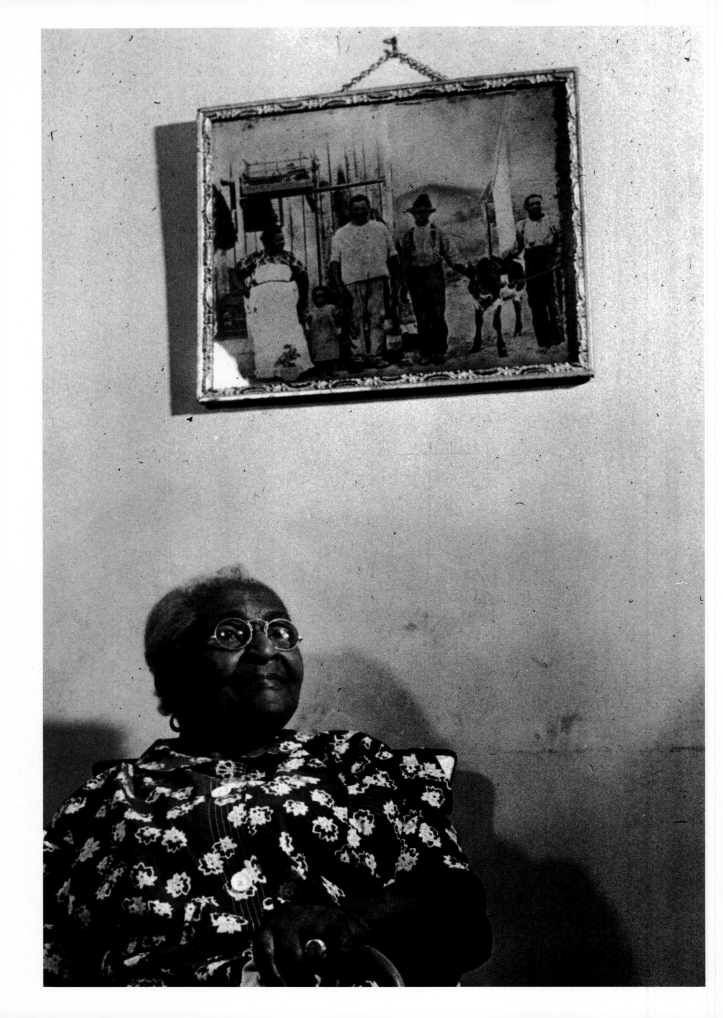

1940 Freedom of worship has always ranked among the most important of Americans' rights. This woman was praying in the Old Cathedral in St. Louis, Missouri.

1943 The beauty of this ancient church in Ranchos de Taos, New Mexico, captured the attention of several of America's most accomplished photographers. Both Laura Gilpin and Ansel Adams, among others, made the church famous through their depictions of the structure.

1942 The proud woman in this photograph is ex-slave Ella Patterson, the eldest resident of the Ida B. Wells Housing Project in Chicago. At the time this picture was taken she was 102 years old.

1940 Many of the earliest homes in the American Southwest were built of a mixture of sun–dried clay and straw called adobe. Here workers refurbish a house in Chamizal, New Mexico.

509

1940s

1942 Winters on the American plains have always presented many of the same challenges faced by the hardy pioneers who first settled the West. Here a young man checks his mailbox (*above*) in Morton County, North Dakota.

1941 The men standing on the platforms in this picture (*below*) were carrying on a way of life established by their ancestors hundreds of years before them. They were Native Americans fishing for salmon at the Celilo Falls on Oregon's Columbia River.

1943 During World War II, gasoline, an essential commodity in the war effort, was strictly rationed. This truck driver (*right*) found both his routes and his working hours shortened by the need to conserve gas.

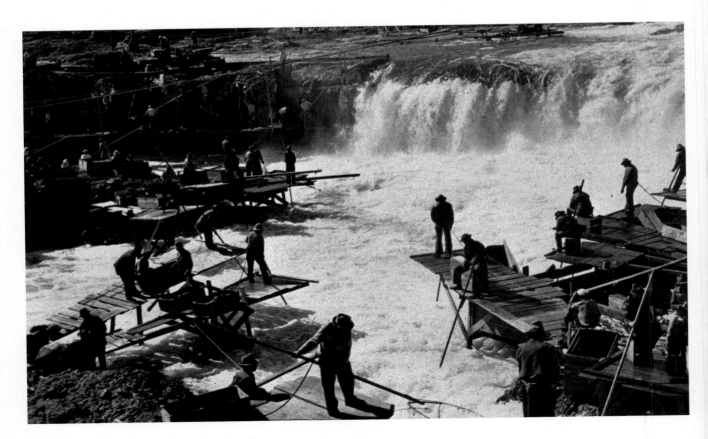

1940s

1949 In the 1940s, the movies entered a "golden age." Some 500 motion pictures were made every year and more than 80 million tickets were sold every week. Here (*above*) we see Harpo and Chico Marx, two of the Marx Brothers, relaxing between takes in *Love Happy*, the last movie all four brothers appeared in.

c. 1946 Milton Berle and Ethel Merman "ham it up" during a 1940s variety show (*left*). Berle would become the most popular of all the early television performers, while Merman would become the Broadway musical theatre's shining star.

1947 Bob Hope (1903) began his career as a star of both radio and stage (*right*). Among the many movies in which he appeared were the seven "Road" pictures in which he costarred with Bing Crosby and Dorothy Lamour. During World War II Hope traveled the world entertaining American troops.

1940 Celebrity Gathering (*above*). Actor Gary Cooper (1901–1962), second from left, author Dorothy Parker (1893–1967), third from left, and author Ernest Hemingway (1898–1961), sixth from left, party with friends at Cooper's Idaho retreat.

1941 The movie *Citizen Kane,* a thinly disguised portrayal of the life of William Randolph Hearst, has become a movie classic. Here we see Orson Welles (*left*), the star, producer, and director of the film.

1941 In the 1940s, radio became not only a chief source of entertainment but a prime conveyer of news and commentary as well. Among the most powerful of the radio personalities was Walter Winchell (1897–1972) (*right*), whose news reports and hard-hitting personal opinions were listened to by millions of Americans.

c. 1946 In the last decade before television made its appearance, radio attracted the greatest stars. Here, Frank Sinatra (1915–1998) and Jack Benny (*previous pages*) share a laugh as they read a script in a sound studio.

c. 1942 As the movie industry continued to grow, Hollywood publicity agents were kept busy satisfying the public's insatiable appetite for news and views of their favorite stars. Here John Wayne is "snapped" reading the comic strips to his children.

1941 James Cagney (1899–1986) was perhaps the most versatile of all major Hollywood stars. He began his career in vaudeville, moved on to the New York stage, and then became famous for his many gangster film roles. A talented singer and dancer, he thrilled audiences in the patriotic wartime film *Yankee Doodle Dandy*. In 1981, Cagney came out of a 20-year retirement to star in the movie *Ragtime*.

1942 Some movies have so
captured the imagination of
audiences that they have become
cult classics as popular now as
when they were first shown.
Arguably the greatest of them
all is *Casablanca* starring
Humphrey Bogart (1899–1957)
and Ingrid Bergman (1915–1982).

521

1948 In the 1940s, the married comic team of George Burns (1896–1996) and Gracie Allen (1902–1964) ranked at the top of the radio charts (*above*). Burns continued to perform until well into his 90s.

c. 1947 Frank Sinatra escorts fellow screen idol Ava Gardner (1922–1990) to a film premier, providing Hollywood film and gossip magazines "hot'" material for their next issues. The couple married in 1948, but were divorced in 1957.

1946 Rita Hayworth (1918–1987) was one of Hollywood's most vivacious stars (*left*). A favorite "pinup" of American servicemen during World War II, she is seen here in a scene from the movie *Gilda*.

1947 The actor Marlon Brando (1924–) is seen here embracing Kim Hunter in a Broadway performance of the Tennessee Williams play *A Streetcar Named Desire*. Brando would later win two Academy Awards for his performances in *On the Waterfront* (1954) and *The Godfather* (1972). The actress on the far right is Jessica Tandy, who along with her husband Hume Cronyn would enjoy a long and distinguished stage and film career.

1949 Beginning with her roles as a child actress in such films as *Lassie Come Home* (1942) and *National Velvet* (1944), Elizabeth Taylor (1932–), became known both for her great beauty and her acting ability. She won Academy Awards for her performances in *Butterfield 8* (1960) and *Who's Afraid of Virginia Woolf?* (1966).

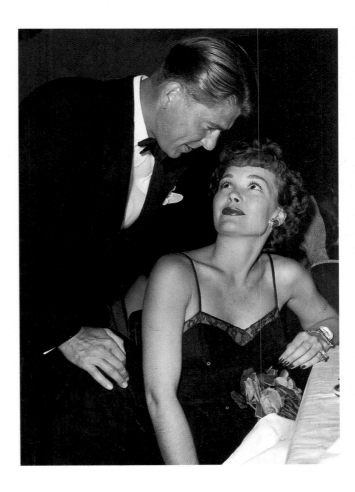

1946 The handsome man on the left is movie star
Ronald Reagan (1911–). From 1966 to 1974, Reagan
served as governor of California. In 1981 he took the
oath of office as the 40th President of the United States.
Seen with him is the accomplished film actress Jane
Wyman, who was Reagan's first wife.

c. 1942 The man on the right of this picture is actor
Roy Rogers, the "King of the Cowboys." One of several
stars of the westerns who were as apt to break into
song as pursue a villain, Rogers made scores of movies.
His wife, Dale Evans, shown with him, appeared in 20
of these films.

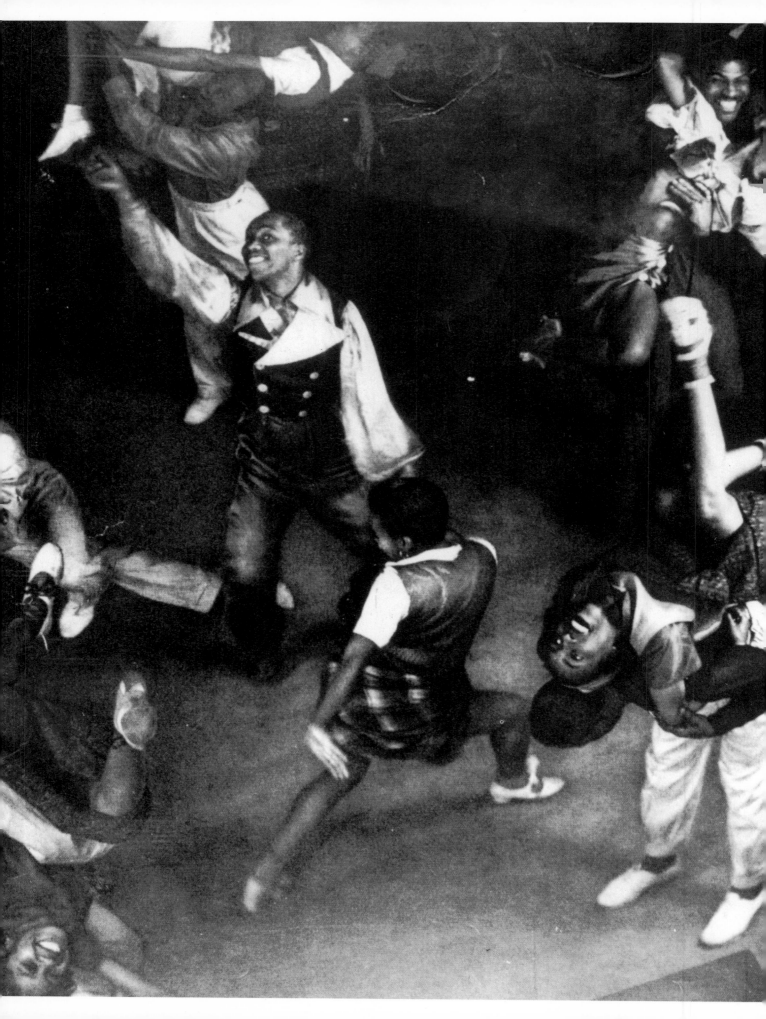

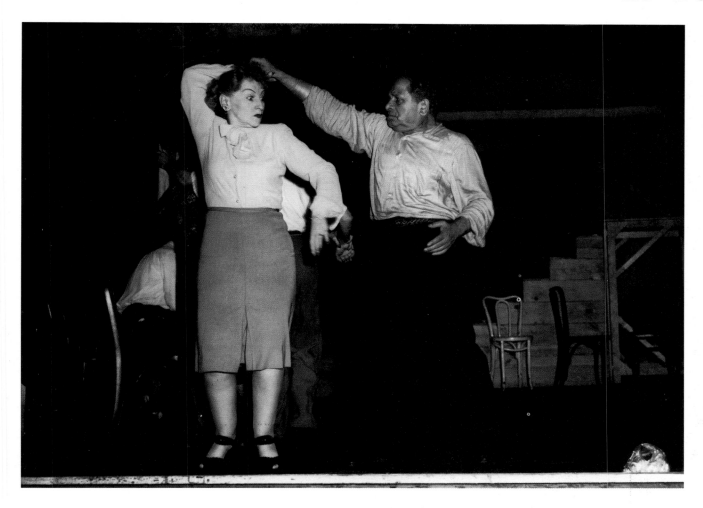

1945 Starting with the arrival of millions of Jewish immigrants to New York in the late 1800s, Yiddish Theatre grew into a major part of the theatrical scene. This couple was photographed during a rehearsal at New York's Yiddish Art Theatre (*above*).

c. 1940 As this photographer duly recorded, by the 1940s "public displays of affection" were no longer regarded by some people as being taboo (*right*).

c. 1949 In the 1940s, that type of spirited music known as "jive" became increasingly popular (*left*). It was music designed to set feet "a-tapping".

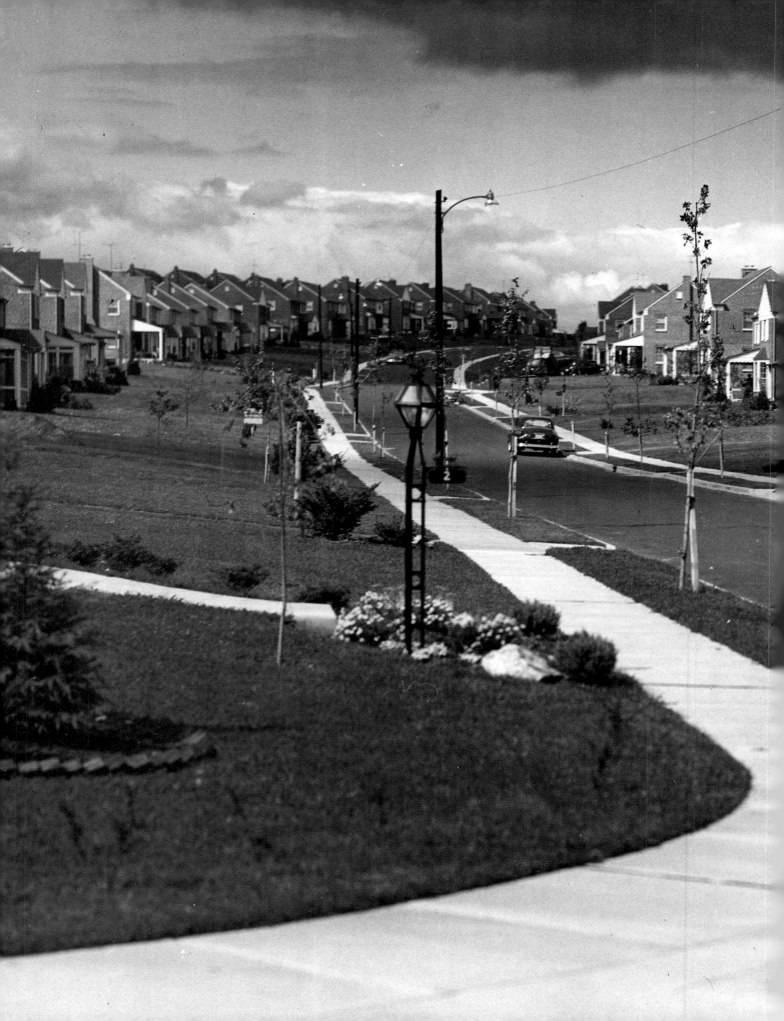

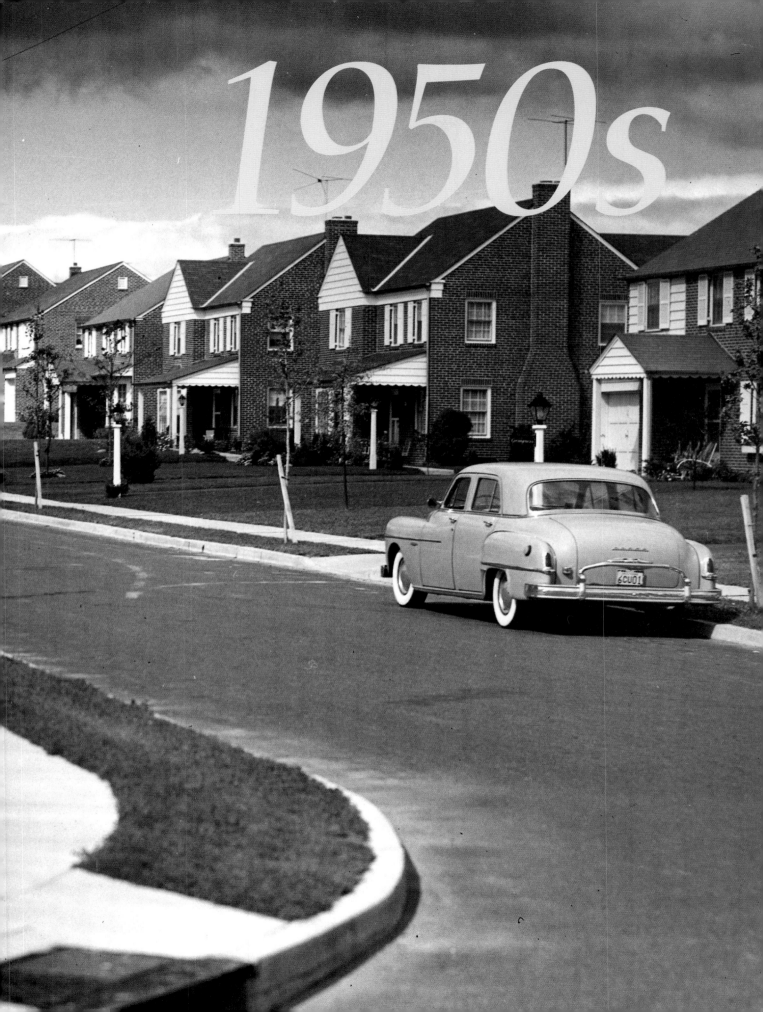

1950s

c. 1953 With more cars on the road than ever, high schools began to offer driving training programs. These California students were preparing for the highway by practicing on a device called a Drivotrainer.

I n the 1920s President Calvin Coolidge had stated that "the business of America is business." The same could have been said of the 1950s, except that many businesses were now corporations, and they kept getting bigger. It was the decade of the "man in the gray flannel suit" and of the daily suburban commuter.

Americans were introduced to compact cars, the high-speed computer, a life-saving polio vaccine, and music called rock-and-roll. The policy of "separate but equal" schools was abolished and a key Civil Rights Act was passed. Movie stars like James Dean and Marilyn Monroe became bigger than life. And the country was being held spellbound by a new form of mass entertainment called television.

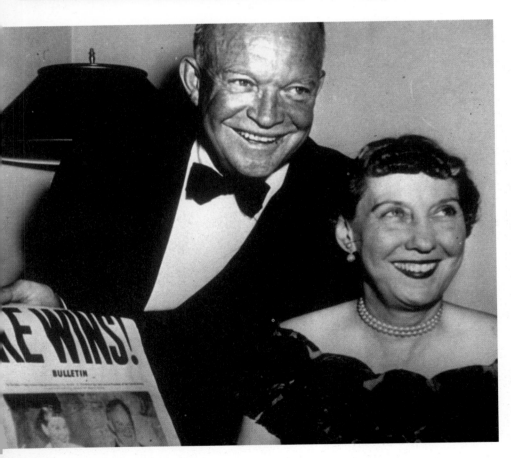

1952 Dwight David Eisenhower (1890–1969) and his wife Mamie celebrate "Ike's" election as the 24th President of the United States. Eisenhower was the first President to serve a constitutionally limited term.

c. 1950 With millions of GIs returning from World War II, the need for affordable housing was acute. In the late 1940s and early 1950s, real estate developer William Levitt and others redefined the suburb (*previous pages*) by building thousands of similar-looking houses.

c. 1955 James Dean (1931–1955) burst upon the scene like a meteor with his starring roles in *East of Eden* (1955) and *Rebel Without a Cause* (1955). A symbol of youthful rebellion for young people everywhere, Dean was kill was killed in an automobile accident. Like Monroe and Presley, his appeal has endured long after his death.

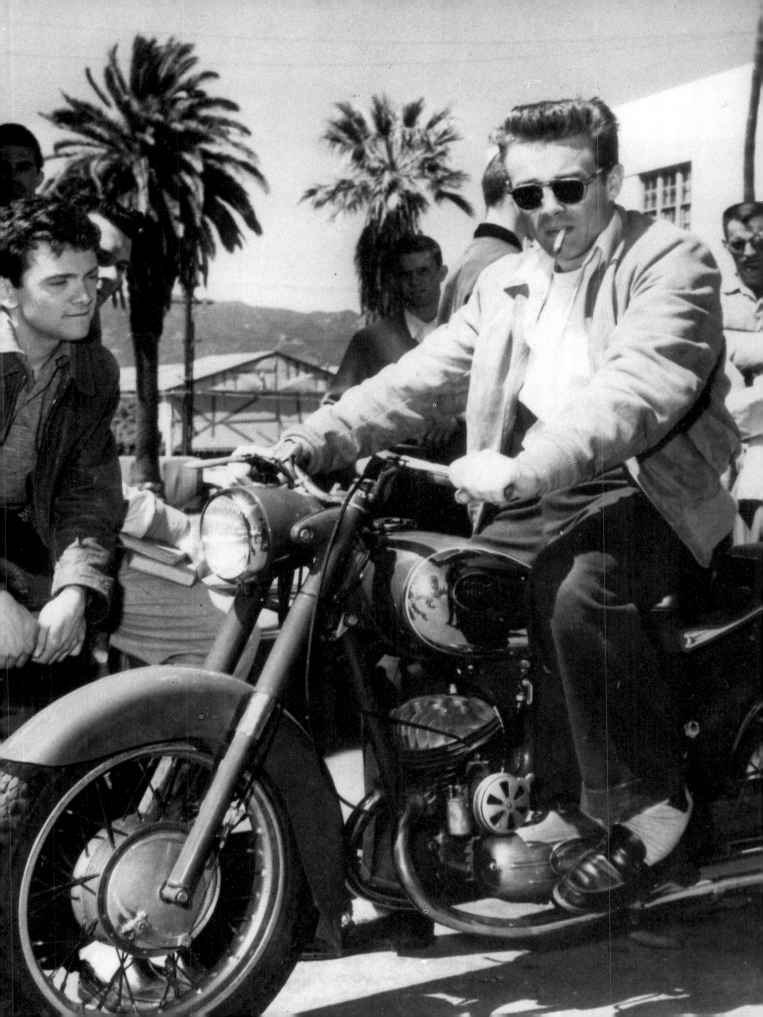

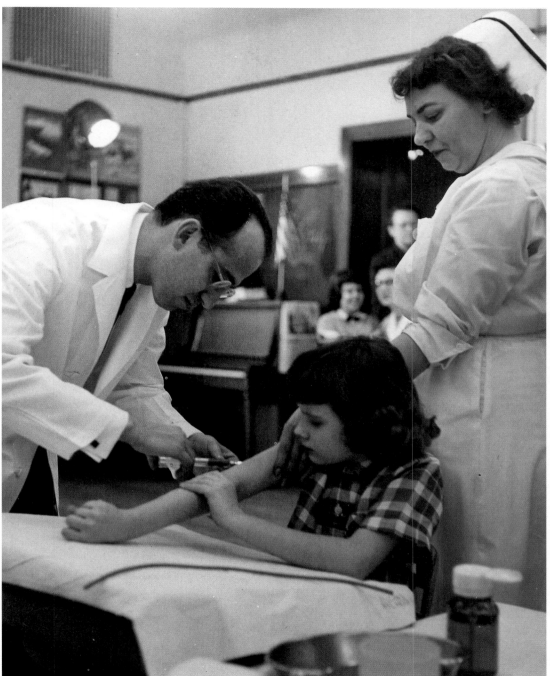

c. 1955 In the late 1940s and early 1950s, Americans lived in fear of infantile paralysis, commonly known as polio. By 1952, however, Dr. Jonas Salk (1914–1995) had created a preventative vaccine. Launched on a widespread basis in 1954, Salk's vaccine all but eradicated the deadly disease. Salk is shown here vaccinating a young girl.

c. 1952 These three men were ushering in an era. The room–sized machine they were operating was the Univac, the forerunner of today's computers.

c. 1955 It was the decade of the birth of television and the computer, but many American homes were still without refrigerators. Here an ice deliveryman makes his rounds.

1958 Color photography came into full flower in the 1950s, and Ernst Haas was among the most acclaimed of all color photographers This is Haas's portrait of a pretzel seller in New York's Greenwich Village.

1951 In the 1950s, Americans by the millions discovered the drive-in movie (*previous pages*). For adults it was a chance to enjoy the flicks in the comfort of their own cars. For teenagers the drive-in provided the opportunity for romance away from prying eyes.

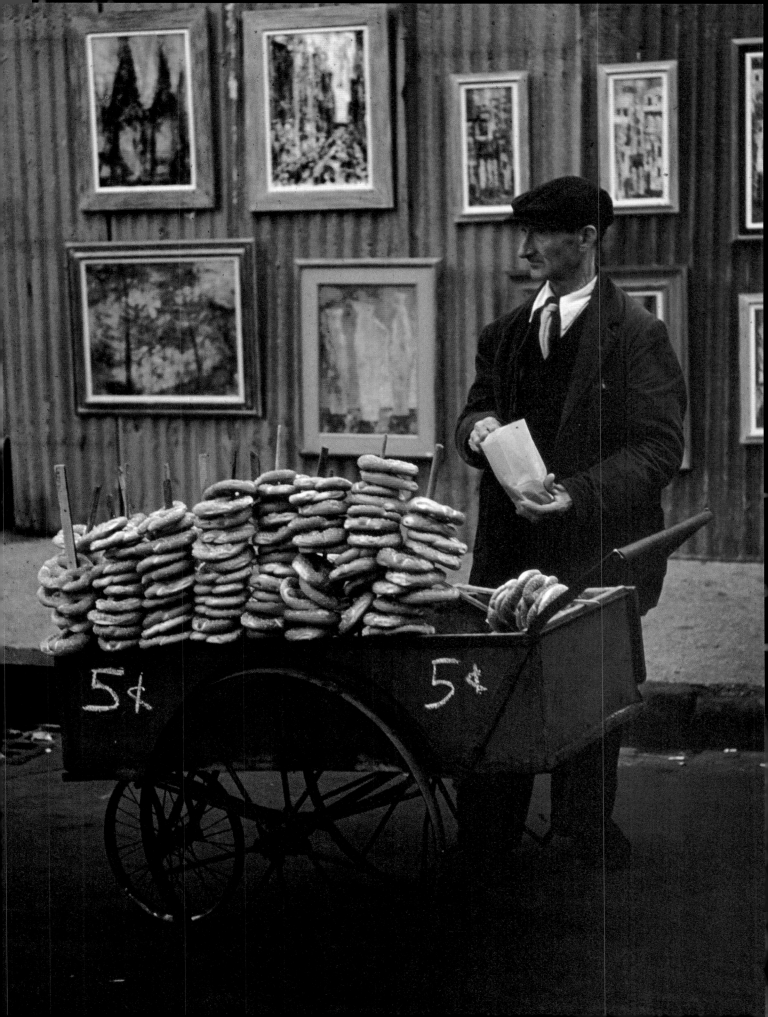

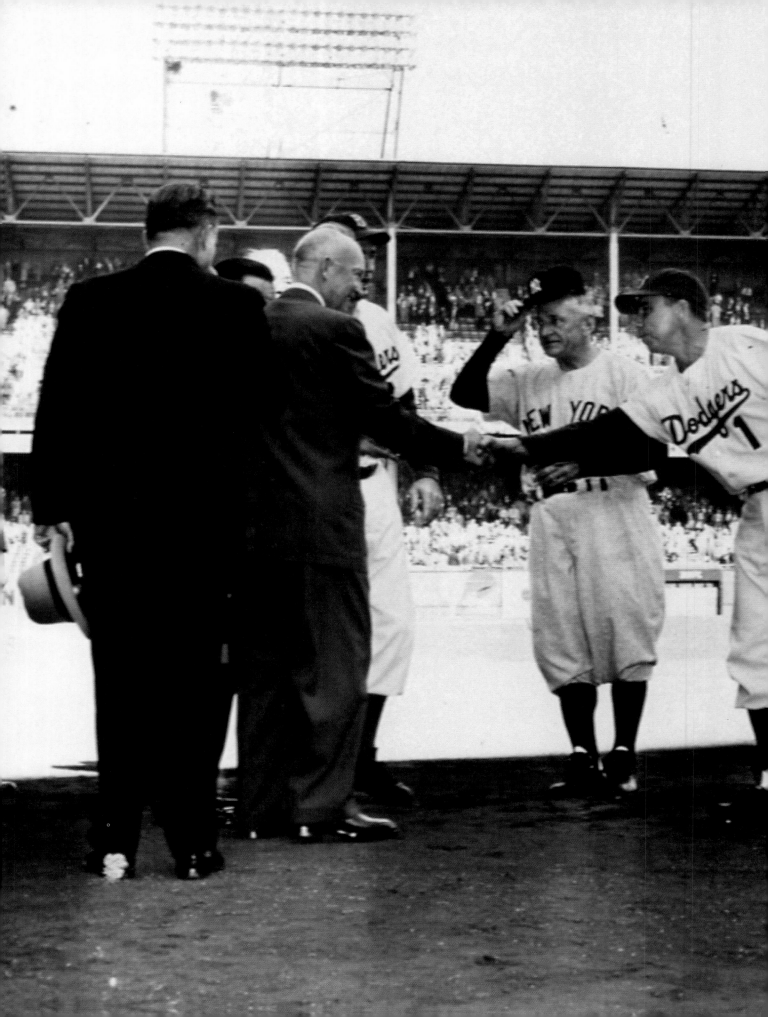

1956 Ever since William
Howard Taft opened the 1910
season by throwing out the first
ball, baseball and American
presidents have been linked.
Here, President Dwight D.
Eisenhower shakes hands
with members of the New
York Yankees and Brooklyn
Dodgers after having tossed
the ceremonial pitch that
opened the 1956 World Series.

c. 1955 It was a decade of big business, the explosion of the suburbs – and commuting. Here, in a scene repeated throughout America, gray-suited, felt-hatted suburban husbands board the morning train that will take them to their downtown offices.

1952 Millions of American women were employed in the nation's burgeoning business offices in the 1950s. The presence of a significant number of female executives was still a way off, but a start had been made.

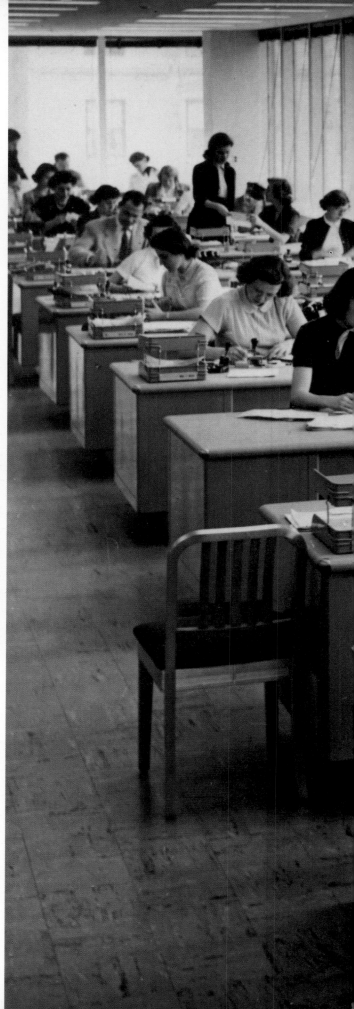

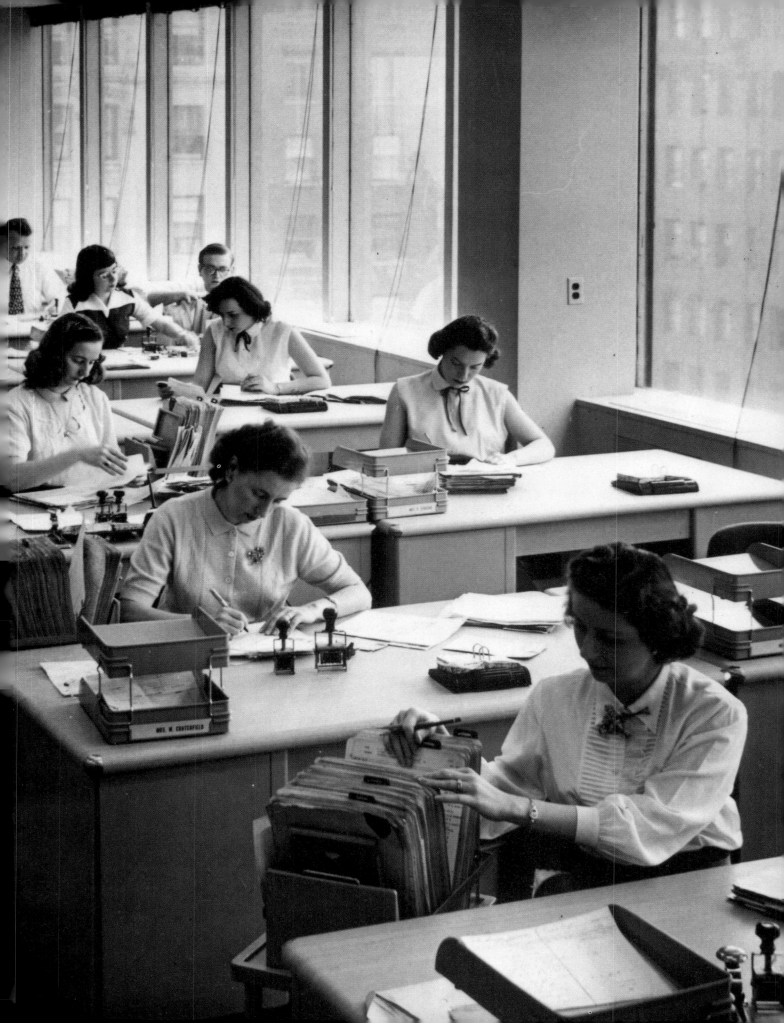

c. 1950 Many things began to change in the 1950s but the presence of an organ grinder was still common on city streets. Here a young girl dances to the music (*above*).

1953 In the hands of a talented photographer even the most simple occurrences can become the occasion for an arresting image. Harry Lapow captured this scene of a couple dancing at an informal wedding on the beach at New York's Coney Island (*right*).

1950 By the 1950s, scores of large photographic houses such as Worldwide Photos were taking and sending tens of thousands of images to newspapers and magazines throughout the nation. Human-interest pictures such as this one were "sure-fire" hits (*left*).

c. 1955 Sunday has always afforded city dwellers the opportunity to enjoy a variety of simple, relaxing pleasures. Here (*above*), people in Washington Square in New York's Greenwich Village listen to a folk singer.

c. 1956 A group of tourists pauses to watch a game of chess being played in a small park in New York City (*left*). Outdoor chess remains a common fair-weather New York pastime.

c. 1952 New York's Bronx Zoo, founded in 1899, has long been one of the most well-attended attractions of its kind, providing photographers with any number of intriguing images (*right*).

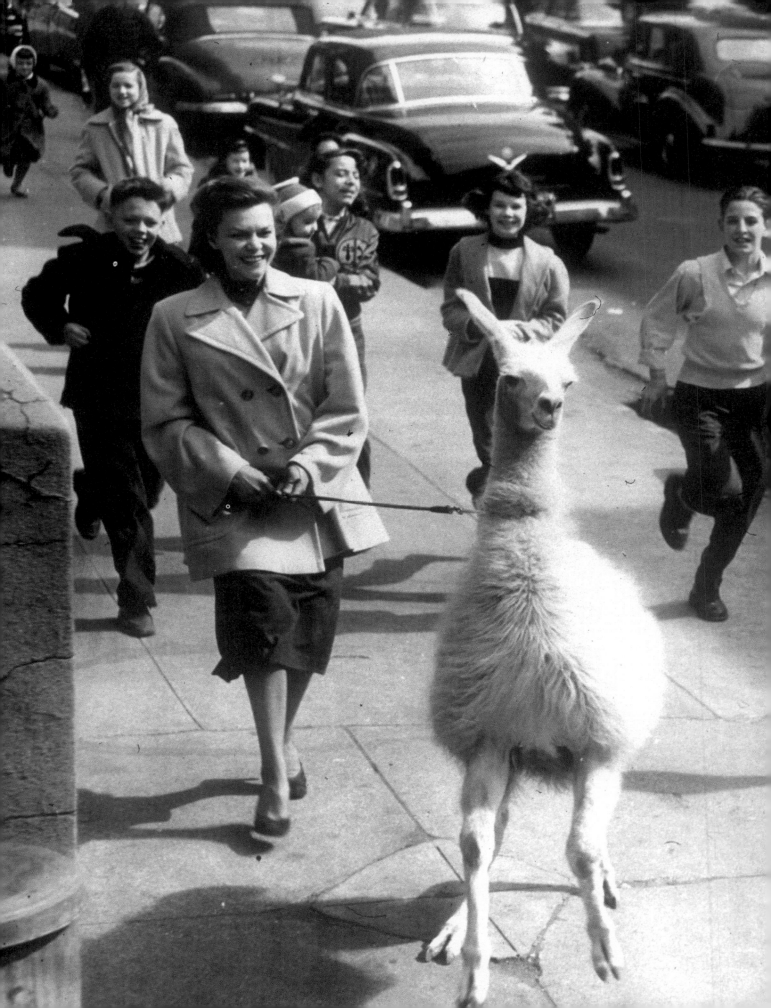

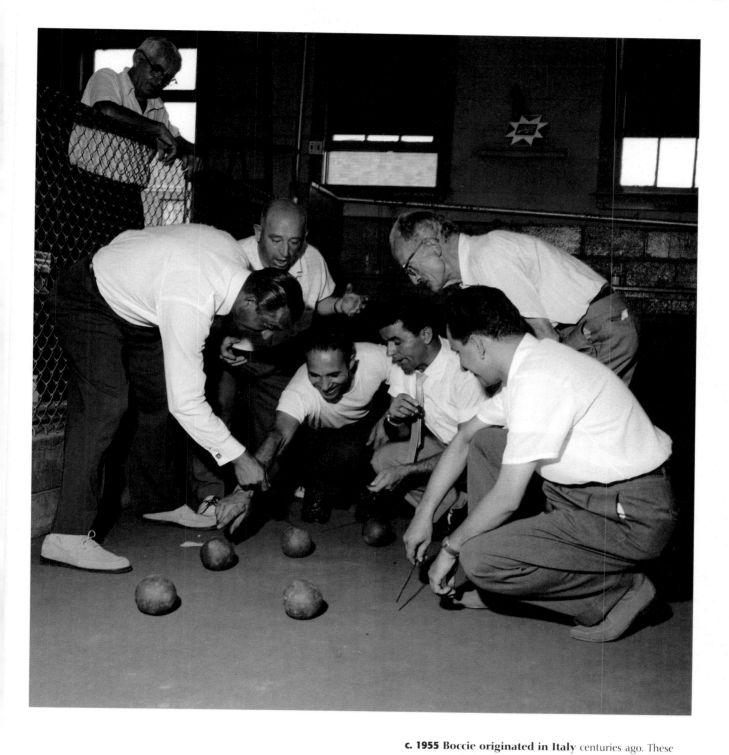

c. 1955 Boccie originated in Italy centuries ago. These men were playing the game at Brooklyn's North Italian Recreation Center.

c. 1952 It was a conservative decade, but it still had its goofy moments. Here a group of delighted New York City youngsters follows a woman as she walks her pet llama through the city's streets.

c. 1950 Weegee was known for his dramatic black–and–white pictures of New York City crime victims and fires, but he was master of color photography as well. This is his image of New York's Little Italy district at night.

c. 1955 The photographs of Ernst Haas inspired scores
of future masters of color, including Joel Meyerowitz and Jay
Maisel. In this picture, Haas transformed a common New
York street scene into an image of great beauty.

1952 A solitary subway rider, lost in thought or reflection, has been a favorite subject of both artists and photographers. This woman was riding the subway in New York City.

c. 1955 Americans have never lost their love of the automobile or their penchant for showing off prized cars. This was a rally of enthusiasts, all owners of 1950s' Chevrolet Corvette Stingrays.

1957 Gregory Peck (1916–) relaxing between scenes for William Wyler's movie *The Big Country* (*above*). Through his rugged good looks, resonant voice, and the often heroic roles he played, Peck became the epitome of the Hollywood leading man. His films include *Duel in the Sun* (1946), *Gentleman's Agreement* (1947), and *To Kill a Mockingbird* (1962), for which he won an Academy Award.

c. 1957 Gene Kelly (1912–1996) was one of the most beloved of all film stars (*left*). A singer, actor, director, choreographer, and dancer, he appeared in a number of MGM musicals. His dance numbers in such movies as *On the Town* (1949), *An American in Paris* (1951), and *Singin' in the Rain* (1952) have become classics.

c. 1955 Film star Esther Williams poses for photographer Slim Aarons in her swimming pool (*right*). A former aquatic champion, Williams gracefully swam her way through numerous movie musicals.

c. 1955 Photographers could never get enough pictures of Marilyn Monroe. Simple activities like a frolic on the beach near her Hollywood home quickly became photo opportunities (*above*).

1956 After a brief marriage to baseball great Joe DiMaggio, Marilyn Monroe (1926–1962) married famed playwright Arthur Miller. The couple is seen here (*left*) after their wedding.

1959 Marilyn Monroe was far more than the leading sex symbol of the 1950s (*right*). Through movies like *The Seven Year Itch* (1955) and *Some Like it Hot* (1959), she established herself as an accomplished comic actress. Her legacy has been kept alive through the writings of such well-known authors as Norman Mailer and Gloria Steinem.

557

BL13-129

1951 By the 1950s, some African–American performers had managed to obtain meaningful roles in Hollywood films. Here a young Sidney Poitier (1924–) consoles Canada Lee (1907–1952) in the movie *Cry, the Beloved Country*, based on the best-selling novel by Alan Paton.

c. 1950 Crooner Bing Crosby was the star of many movies including *White Christmas* (1942) and *Going My Way* (1944), for which he won an Academy Award. One of the earliest stars of television, he is shown here checking over a musical arrangement for his television show with his son Gary, who was also a singer.

1954 Fans have always been interested in married movie couples. Here film star Tony Curtis dances with his wife Janet Leigh (*previous pages*) at a Beverly Hills party.

1958 Author Truman Capote (1924–1984) had a style
singularly his own. His two most famous works were
Breakfast at Tiffany's (1958) and *In Cold Blood* (1966), a book
which he labeled a "non-fiction novel."

c. 1955 Critic Rex Reed once said of Audrey Hepburn (1924–1993) that "she was living proof that God could still create perfection." An elfin figure, she charmed audiences in such movies as *Funny Face* (1957) and *My Fair Lady* (1964). After her retirement from the screen Hepburn, seen second from the right in this photograph, became an effective roving ambassador for UNICEF.

1950s

c. 1955 In the 1950s, Palm Beach, Florida, solidified itself as one of the nation's favorite warm-weather habitats of the wealthy. Here Mrs. Winston (C. Z.) Guest, seen at the right, poses poolside with an equally elegantly dressed friend.

1958 For the wealthy, the 1950s was a decade
of the formal presentation of young women to
society. This was a debutante ball at Boston's
Copley Square Hotel.

1958 Famed American operatic soprano Maria
Callas (1923–1977) arrives in New York to appear on
the popular television program "Person to Person."
Callas was known both for the wide range of her
voice and for her tempestuous personality.

c. 1950 By the 1950s, major American circuses had moved to indoor arenas as well as outdoor fair grounds. Here, in a photograph by Weegee, a trainer puts his stallions through their paces (*above*).

c. 1956 Americans have always been attracted to the unusual and the bizarre. John Thorp, manager, owner, and trainer of a flea circus (*left*), carries his star performers home from work in a bag.

c. 1950 Every circus has its clowns. This is a portrait of Emmett Kelly (1898–1979) by Weegee (*right*). Kelly's sad face and comic antics made him the most famous clown in American history.

c. 1957 The decade of the 1950s is still regarded by many as the "golden age of television." Much of this reputation is based upon the several live dramatic anthology series that were aired regularly. Here, actress Joanne Woodward (1930–) is "made-up" for an appearance on "Playhouse 90," which presented a 90-minute weekly drama from 1956 to 1959.

c. 1957 Edward R. Murrow (1908–1965) was the most respected broadcast journalist of the 1950s. His current affairs programs "See it Now" and "Person to Person" won five Emmy Awards. He is perhaps best known for the courage he displayed in bringing to light the unsubstantiated accusations of powerful Senator Joseph McCarthy, a key factor in McCarthy's downfall.

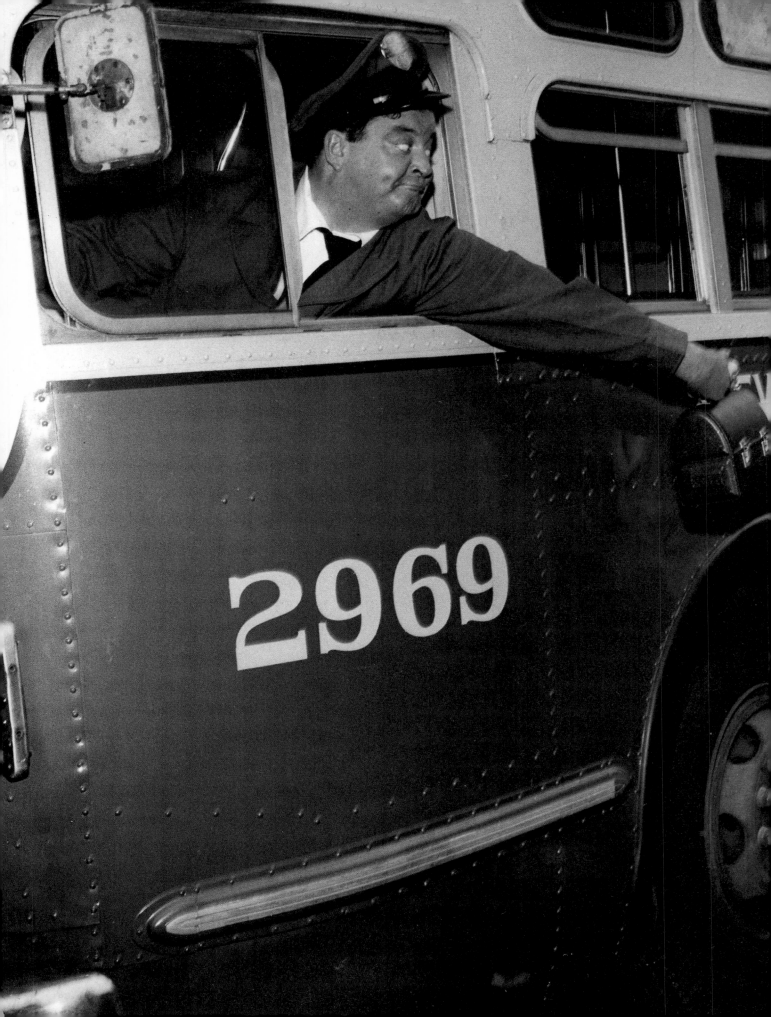

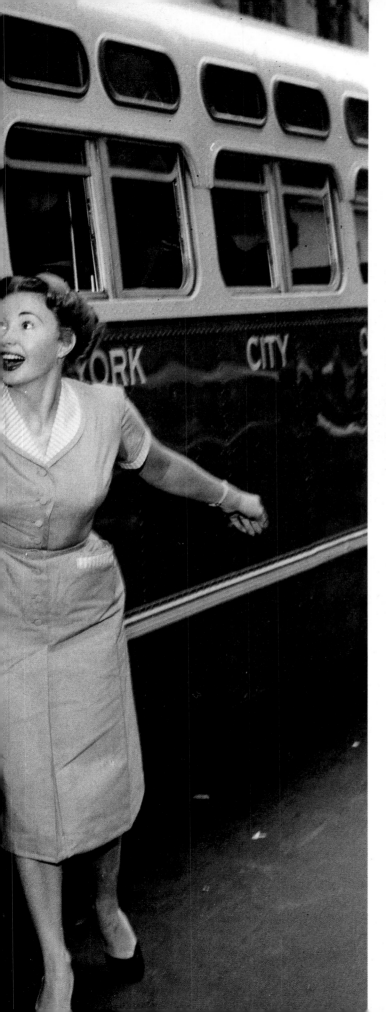

c. 1955 Lucille Ball (1910–1989) and her husband Desi Arnez (1917–1986) costarred in 179 episodes of the situation comedy "I Love Lucy." Through reruns, the series is still enjoyed by a worldwide audience.

c. 1957 In the 1950s, television burst upon the scene and has grown more important in the lives of tens of millions of Americans ever since. This is a scene from one of the most popular of all the early TV shows, "The Honeymooners," starring Jackie Gleason (1916–1987) and Audrey Meadows (1926–1996).

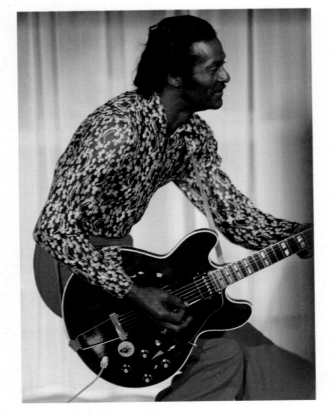

c. 1957 It was the decade of "rock–and–roll" and its undisputed maestro was Dick Clark (1930–), the host of an afternoon television show called "American Bandstand." Clark (*above*), who could make or break a performer by either including or excluding him or her on the program, received over 50,00 fan letters a week. He is shown here with rock star Bobby Rydell.

c. 1955 Chuck Berry (1926–) was one of the fathers of rock–and–roll (*left*). His first recording "Maybelline" became a classic, and Berry's music has remained popular ever since.

c. 1954 The man seated in the center of this picture is Steve Allen (1921–), one of early television's most popular figures (*right*). Host of both a forerunner to the "Tonight Show" and his own prime time program, Allen is seen here with conductor Skitch Henderson rehearsing a ballet scene for the premiere of "The Steve Allen Show."

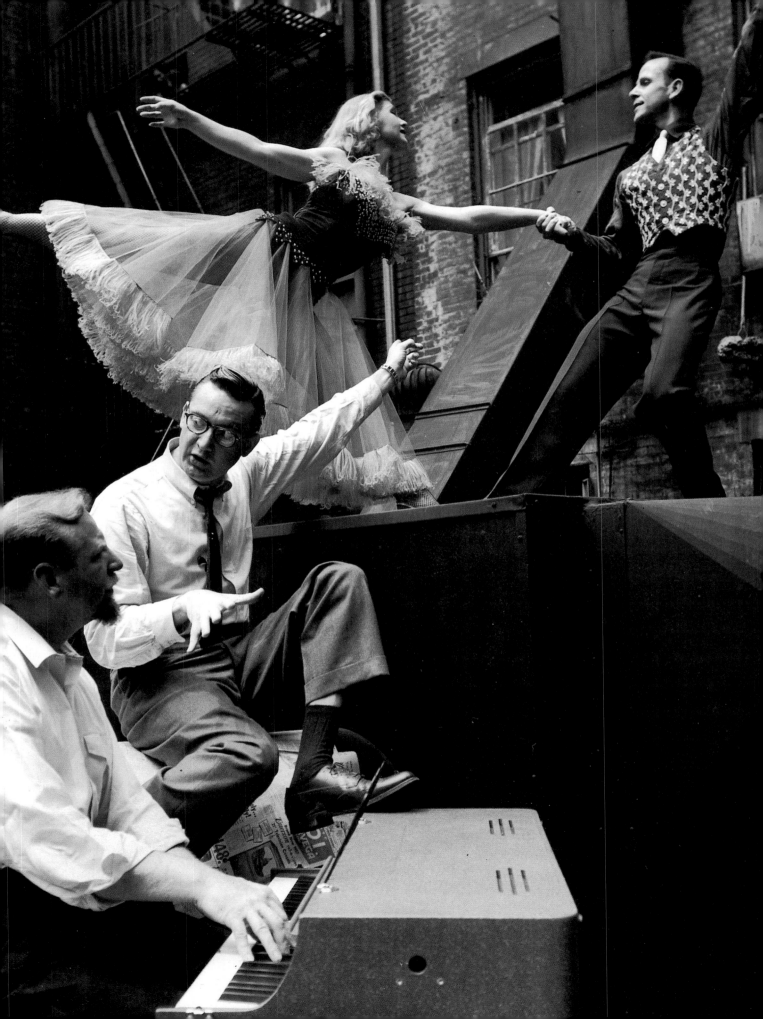

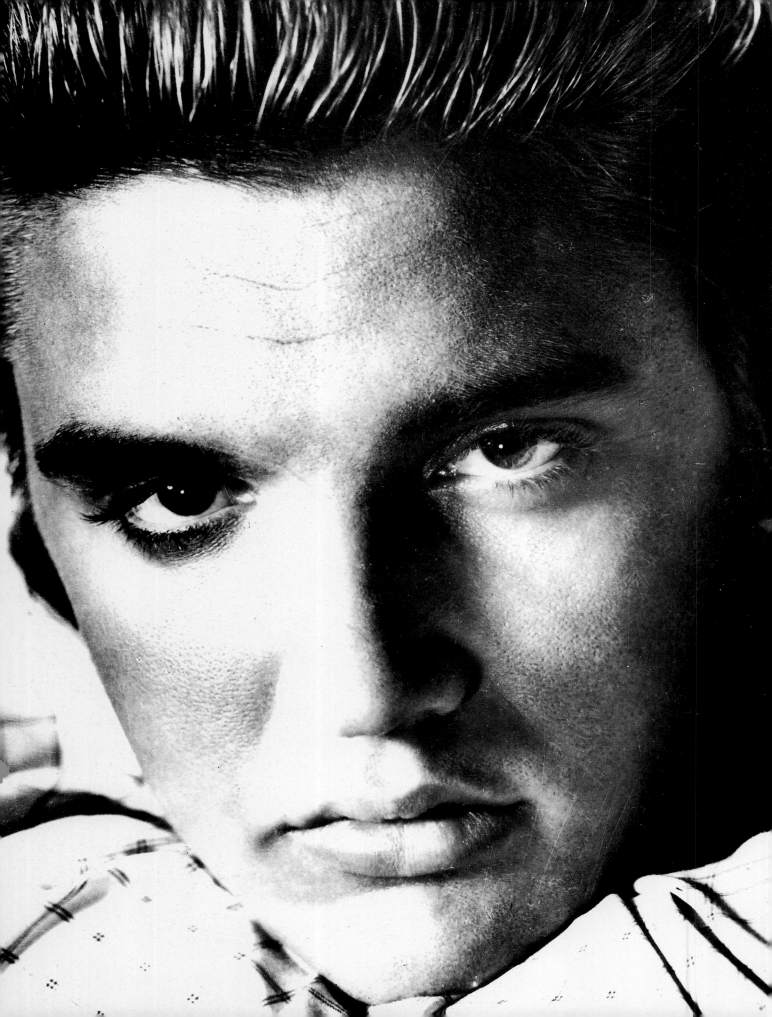

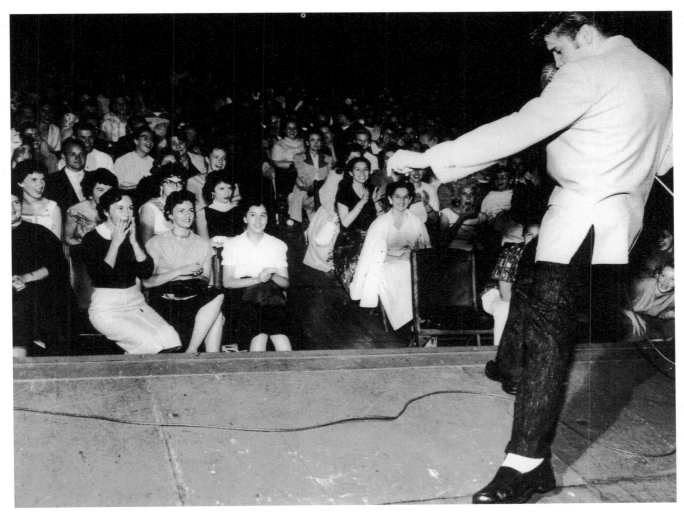

1956 In the 1950s, Ed Sullivan's "Toast of the Town"
became a Sunday night viewing "must." Because of the bumps
and grinds that were part of Elvis Presley's performances
(*above*), Sullivan at first refused to have him on his show.
When Sullivan finally relented on the condition that Presley
be televised only from the waist up, Presley's appearance
challenged all existing TV viewing records.

1955 Musical giants of the 1950s (*right*). Gathered
together from left to right are: Johnny Cash (1932–), Elvis
Presley, Carl Perkins (1932–1998), and Jerry Lee Lewis (1935–).

c. 1955 The King. Elvis Presley (1935–1977) turned
rock-and-roll into a teenage religion. His recordings
"Heartbreak Hotel," "Don't Be Cruel," and "Love Me Tender"
each sold over a million copies. Before the 1950s were over,
Presley had sold more than $120 million worth of records,
movie tickets, and merchandise and had become a major
Hollywood movie star (*left*).

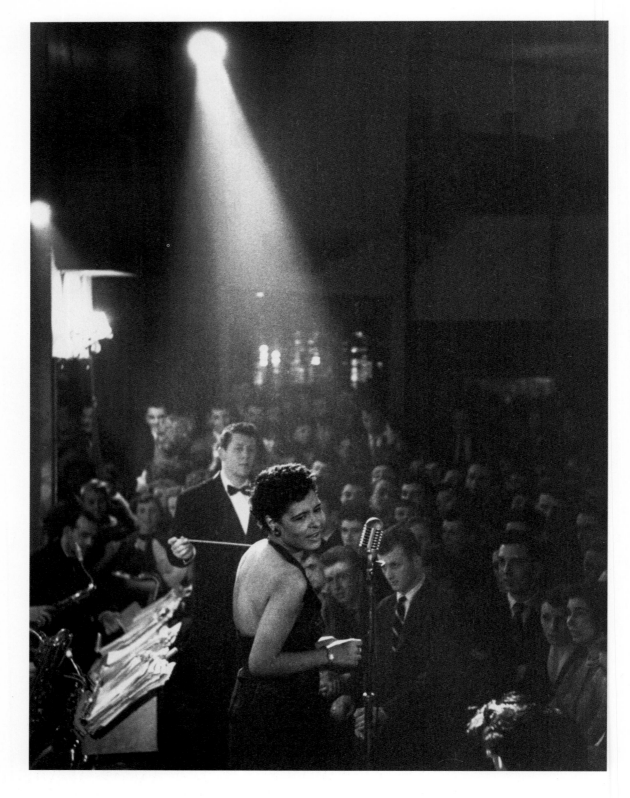

1954 The singer in the spotlight is Billie Holiday (1915–1959). Known affectionately as "Lady Day," Holiday inspired generations of future jazz and blues singers through her unique renditions of such songs as "Stormy Weather" and "I Cover the Waterfront."

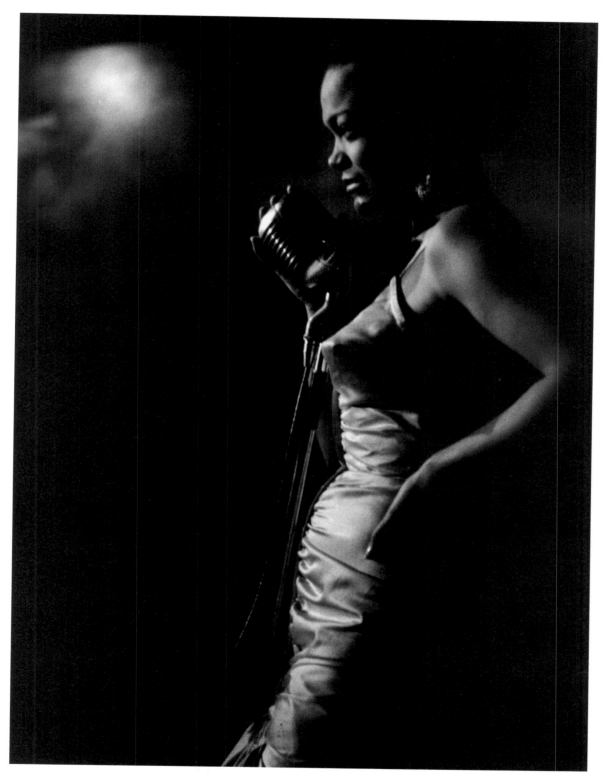

1952 With her distinctive voice and sultry manner,
Eartha Kitt (1928–) was a singing sensation. This photograph
was taken by Ernst Haas, a master of contrasting light and
shadow in his images.

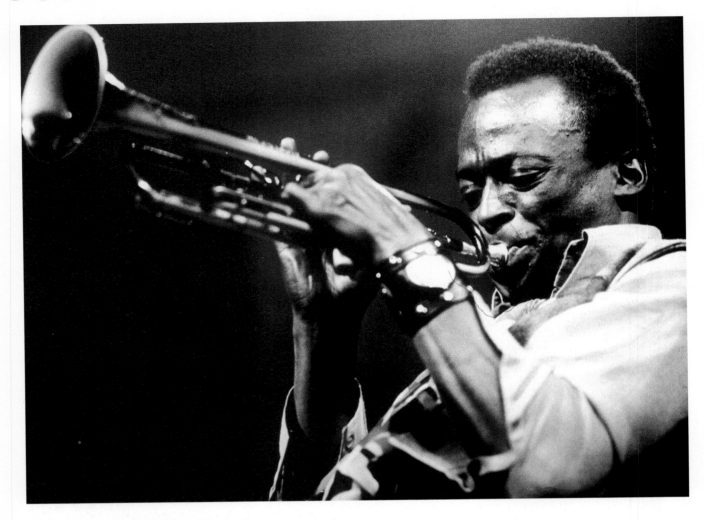

c. 1955 Trumpeter, bandleader, and composer Miles Davis (1926–1991) was among the most innovative of all musicians (*above*). He helped invent bebop and cool jazz and pioneered jazz–rock fusion.

1956 In the 1950s, jazz and rock festivals became increasingly popular. Here (*left*) we see Dizzie Gillespie (1917–1993), a giant of the jazz trumpet, performing at a festival at the Berkshire Music Barn in Lenox, Massachusetts.

1953 Jazz musician Thelonius Monk (1917–1959) playing at the Open Door (*right*). Monk, one of the co-creators of bebop, was one of the nation's leading jazz composers. Certain of his compositions such as "Round Midnight" and "Blue Monk" have become classics.

c. 1955 In the post–World War II decade of the 1950s, American museums grew in stature and attendance and often in size. This is the Solomon R. Guggenheim Museum in New York, which opened in 1959. The celebrated structure was designed by Frank Lloyd Wright.

c. 1953 Architect Frank Lloyd Wright works on a rendering of a sports pavilion. Wright (1867–1959) is regarded as one of the world's greatest figures in 20th-century architecture.

1953 Jackson Pollock (1912–1956) and his wife Lee Krasner (1908–1984) with friends in their Long Island studio (*above*). Pollock, one of the earliest practitioners of Abstract Expressionism, became known for his technique of splattering canvasses with paint.

1957 Stuart Davis (1894–1964) was another pioneer of abstract expressionism as well as a vanguard of pop art. This picture, by photographer Slim Aarons, was taken in New York's Museum of Modern Art at Davis's exhibition (*left*).

c. 1955 Sculptor Alexander Calder (1898–1976) gained his greatest fame by inventing mobiles, suspended shapes that move in the slightest breeze. He is shown (*left*) working on one of his mobiles in his Connecticut studio.

c. 1957 Mississippian Tennessee Williams (1911–1983) became one of the nation's leading playwrights (*above*) through his penetrating portrayals of Southern characters. His plays include *A Streetcar Named Desire* (1947) and *Cat on a Hot Tin Roof* (1955), both of which were awarded the Pulitzer Prize.

c. 1959 In the 1950s, the three giants of American literature – William Faulkner, Ernest Hemingway, and John Steinbeck (*below*) – were at the height of their powers. Steinbeck's novels include *Of Mice and Men* (1937) and *East of Eden* (1952); *The Grapes of Wrath* (1939) was awarded the Pulitzer Prize. In 1962 he received the Nobel Prize for Literature.

1957 Poet and playwright T(homas) S(tearns) Eliot (1888–1965) introduced a whole new form of verse and rhythm to the world of poetry. His most famous collections of poems were *The Wasteland* (1922) and *The Hollow Men* (1925). In 1948 Eliot was awarded the Nobel Prize for Literature.

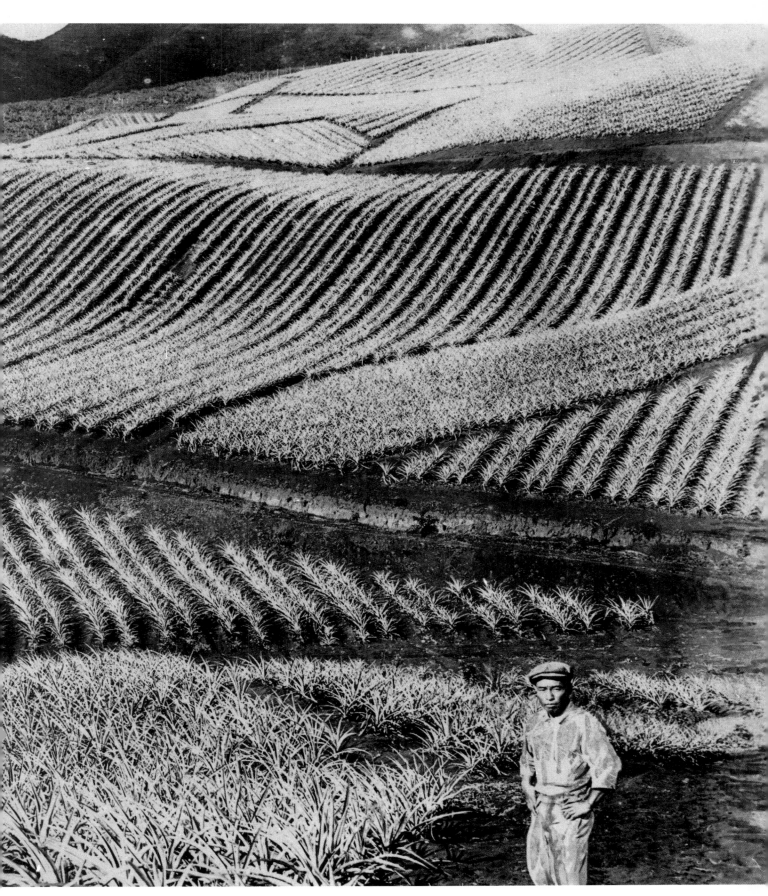

c. 1955 Hawaiian women at an outdoor party, or luau. The picture was taken by Fenno Jacobs, who, as a member of Edward Steichen's naval photographic corps, took some of the most dramatic of all the World War II photographs.

c. 1959 From the sixth century until 1893 when it became a republic, Hawaii was a Polynesian Kingdom. In 1900 it became a United States Territory and in 1959 it became the nation's 50th State. Here we see a field of pineapples (*previous pages*), long one of Hawaii's most important crops.

c. 1953 Hawaii has long been a tourist's haven. Here a group of hula dancers on Honolulu's Waikiki Beach extol their island in letters before beginning a performance.

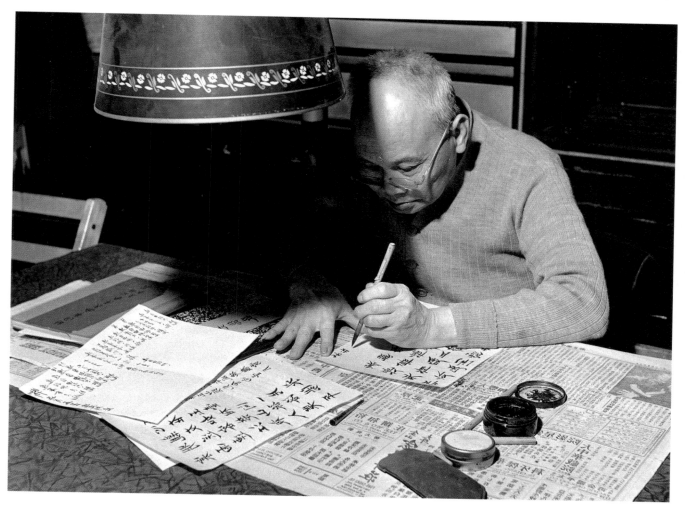

c. 1955 Many of those who lived in New York's Chinatown carried on traditions and skills that were centuries old. This man was writing Chinese script (*above*) at New York's Golden Age Center.

1951 In California, the Chinese influence could be seen even in areas outside San Francisco's Chinatown. This is the famous Graumann's Chinese Theatre in Hollywood (*right*).

c. 1955 By the 1950s, San Francisco's Chinatown was well established as a vital part of that city. Here a young girl sits with her classmates in the Commodore Stockton School, Chinatown's largest public school (*left*).

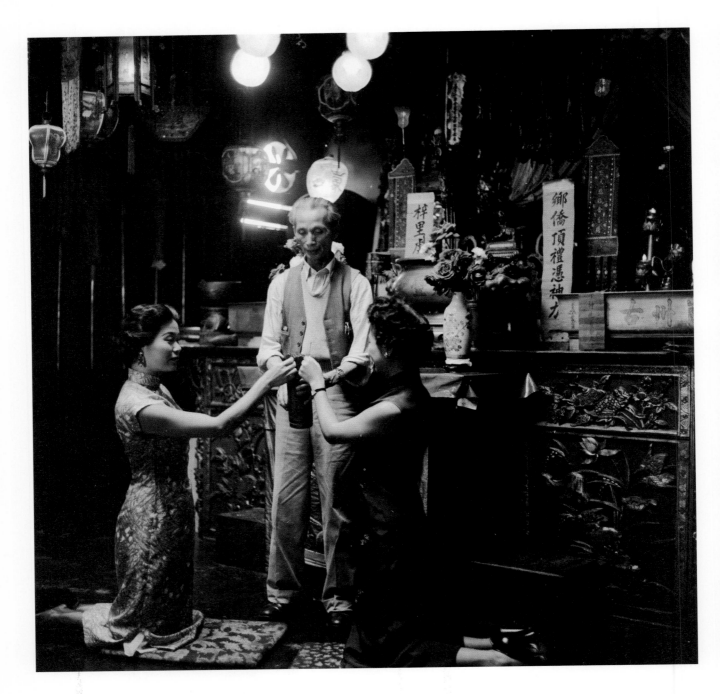

c. 1955 Two Chinese–American women have their fortunes told at a temple in San Francisco's Chinatown. The joss house, as it was called, was frequented by followers of Buddhism, Confucianism, and Taoism.

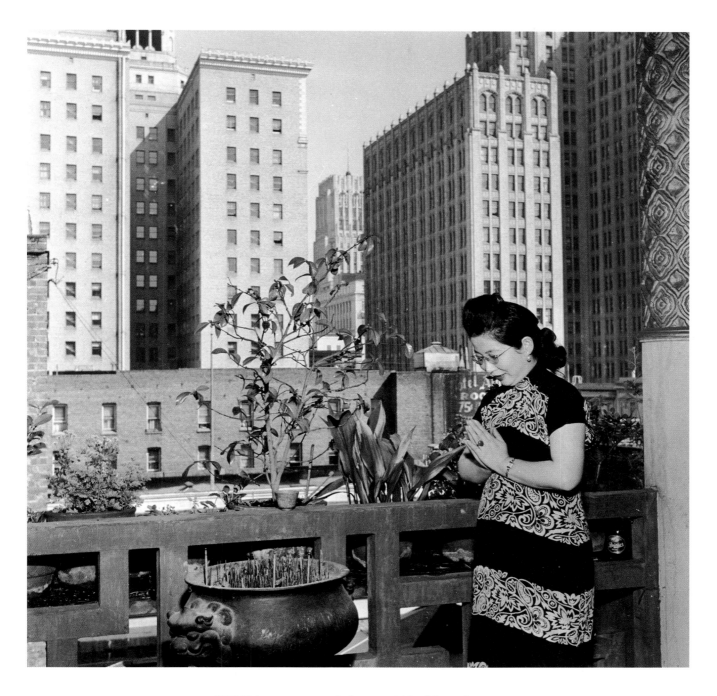

1950 This woman on a balcony outside of the main
room in a temple in San Francisco's Chinatown was praying
in the manner of her ancestors. The large ornate pot in front
of her is an incense burner.

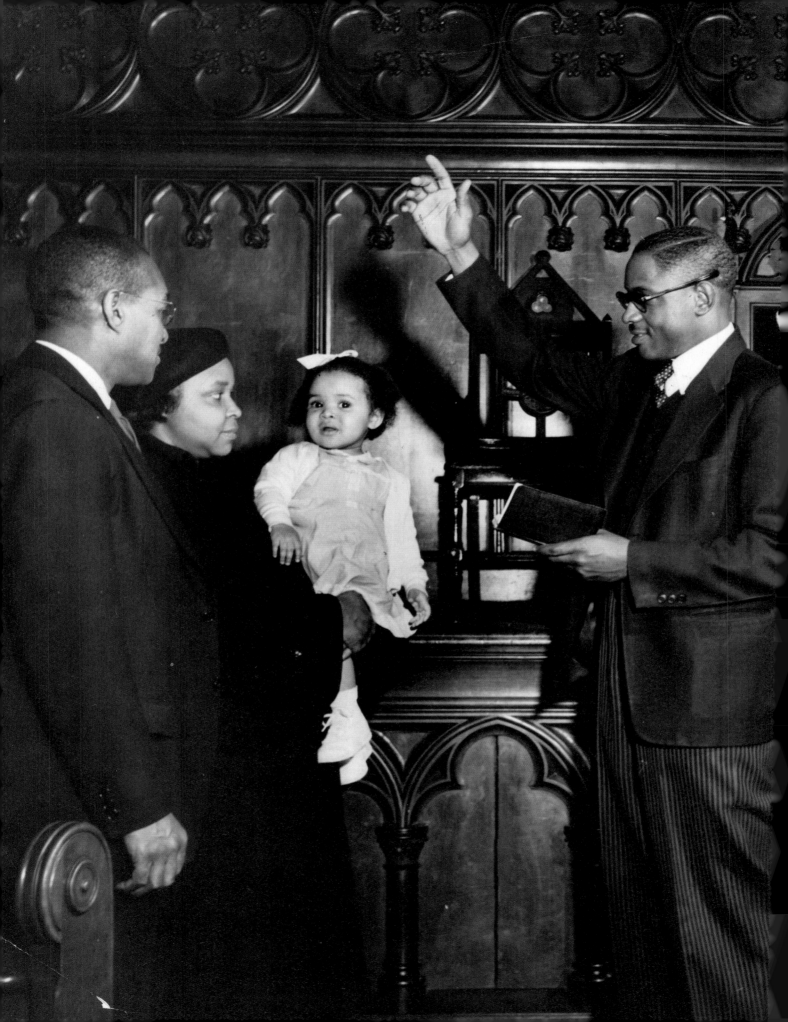

c. 1955 A minister's duties extend far beyond formal church services. Here a chaplain of the New York Protestant Episcopal Mission Society lends a welcome ear (*above*) to a constituent on a New York street corner.

c. 1954 The diversity of America is reflected in the rich variety of its houses of worship. The Philippus Kirche church, pictured here (*right*), has served Cincinnati's German Protestant community since 1890.

c. 1955 Almost all religions have a ceremony in which youngsters officially become members of that particular faith. Here, a Baptist minister (*left*) welcomes a small child into his congregation.

c. 1950 Rosh Hashanah is a two-day religious holiday that marks the beginning of the Jewish New Year. As part of the Rosh Hashanah ceremony, this man was holding a prayer shawl over his head (*above*).

c. 1950 This is the interior of the Touro Synagogue in Newport, Rhode Island (*left*). Consecrated in 1763, it is the oldest synagogue in America.

c. 1955 Training the young in the tenets of the faith is at the core of almost every religion. These were young students at a Jewish seminary (*right*).

c. 1950 The Jewish festival of Purim honors Queen Esther who, during the 473 B.C. Persian occupation saved the Jews from destruction. Here (*previous pages*), Jewish youngsters celebrate the holiday.

c. 1950 The people in this picture are carrying on an old tradition. They are attending a Catholic service at the immigration depot at New York's Ellis Island, in remembrance of that facility's role in ushering newcomers into America (*above*).

c. 1955 It is estimated that there are more than one billion followers of Islam worldwide. The practice of Islam in America dates back to the 1600s, and there are over five million Muslims in the United States today. These Muslim women (*right*), dressed in their traditional attire, were attending a convention in Chicago.

c. 1955 In the 1950s, some 585 million people worldwide were part of the Roman Catholic faith. Here (*left*), three Harlem, New York, youngsters chat with their parish priest.

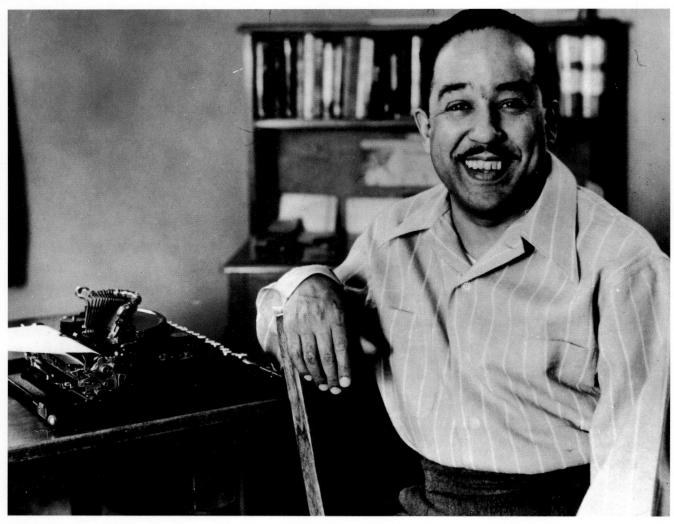

1952 Langston Hughes (1902–1967) was one of the most accomplished African–American poets and novelists. Acclaimed as the "Poet Laureate of Harlem," Hughes is shown here (*above*) shortly after his first collection of poetry, *The First Book of Negroes*, was published.

c. 1955 Rosa Parks (1913–) was a genuine American heroine (*left*). On December 1, 1955, she politely refused to give up her seat to a white man on a Montgomery, Alabama, bus. The incident touched off the 381-day Montgomery bus boycott, which ended when the Supreme Court ruled that assigning African–Americans to the rear of buses was unconstitutional. "I had no idea history was being made," said Parks. " I was just tired of giving in."

1955 Grandson of a slave, Ralph Bunche (1904–1971) taught at Harvard and Howard Universities, and acted as both United Nations undersecretary and special United States foreign representative in the Congo. In 1950 Bunche (*right*) became the first African–American to be awarded the Nobel Peace Prize.

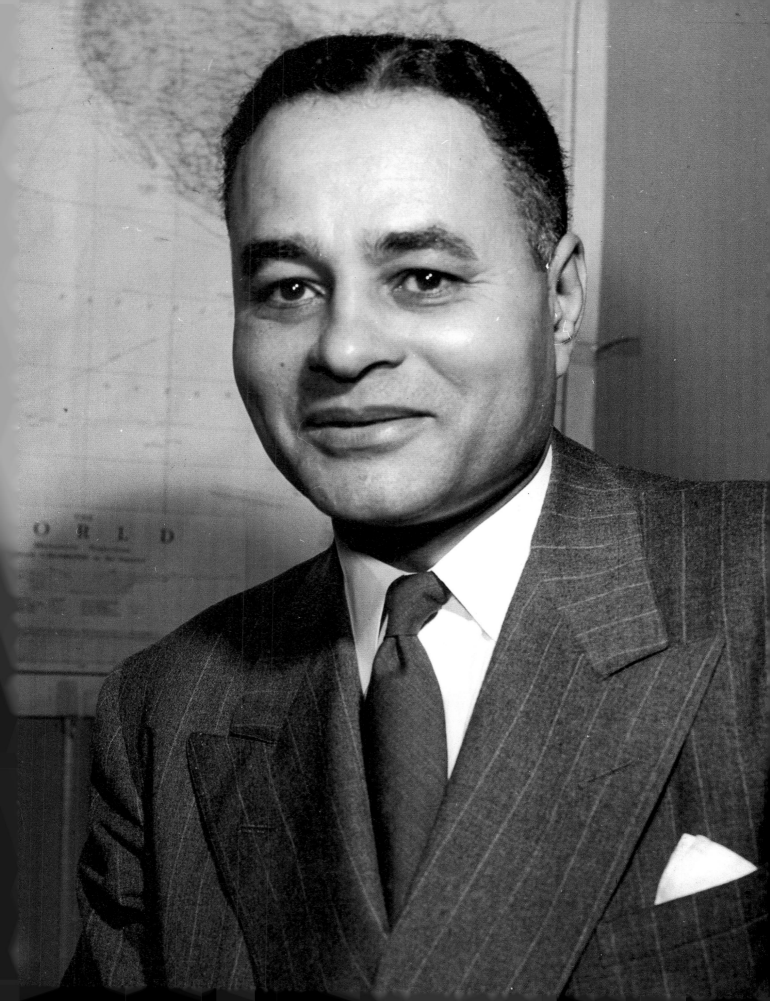

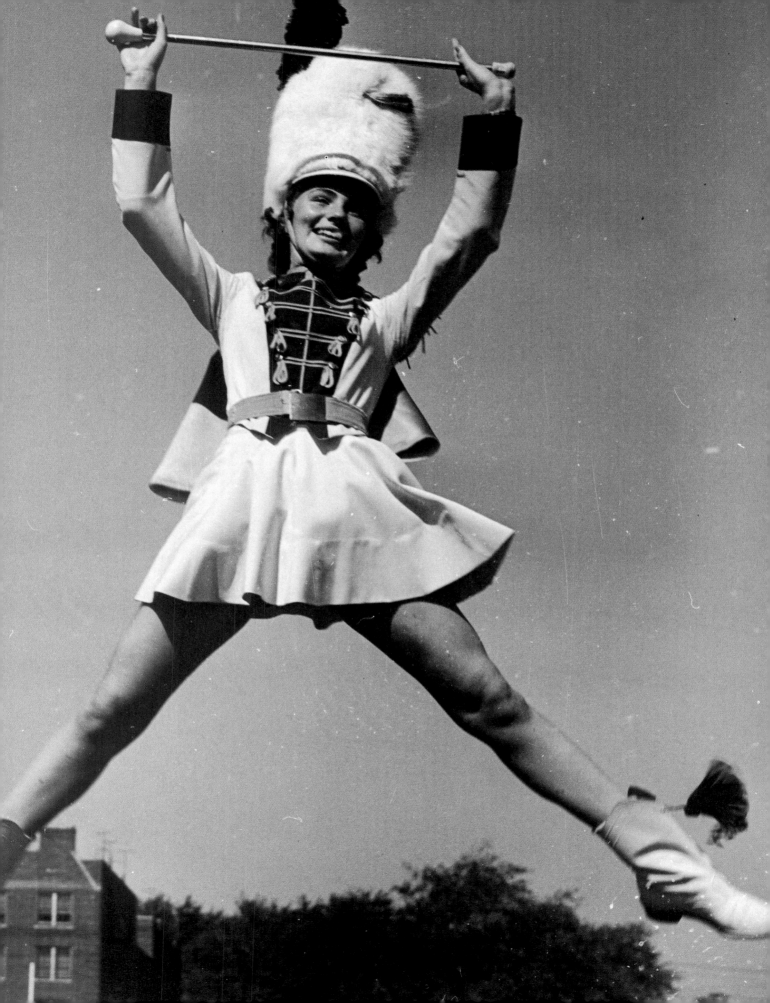

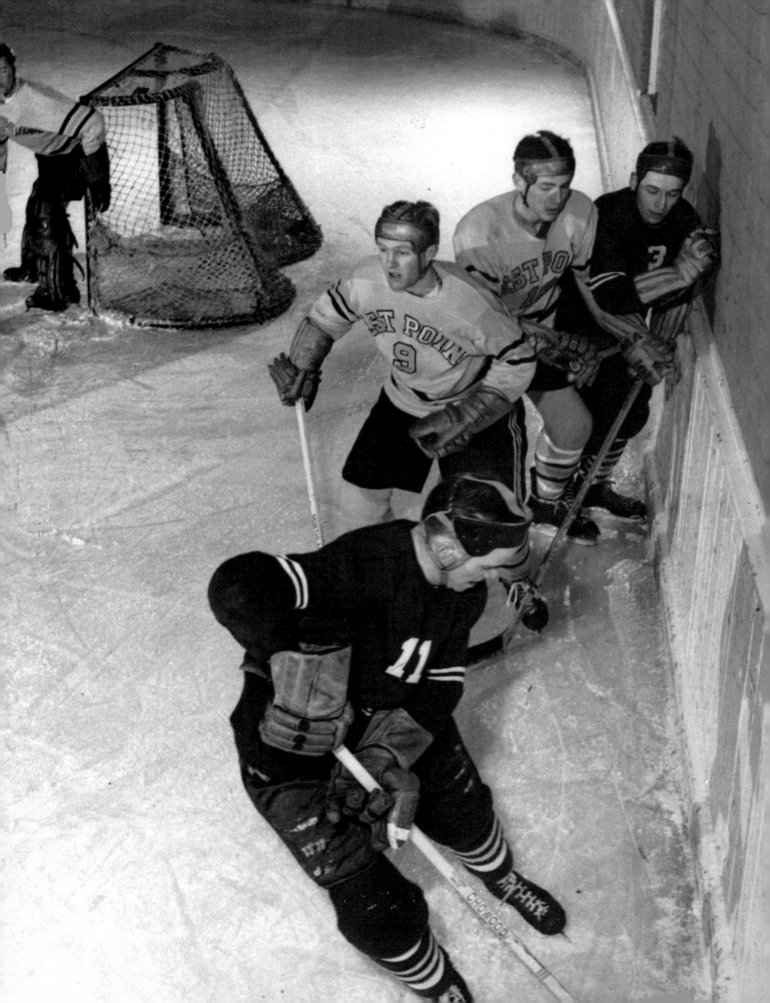

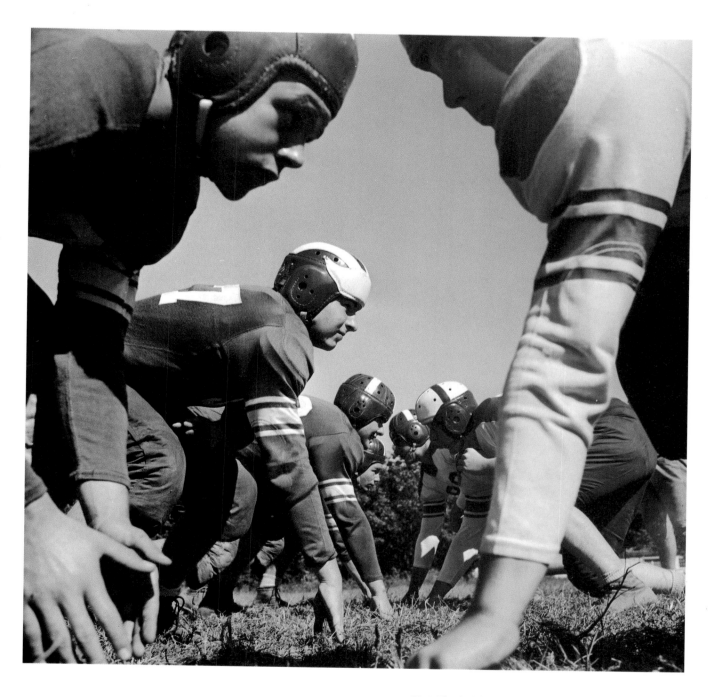

c. 1955 By the 1950s, ice hockey, Canada's national sport, was become increasingly popular in the United States. Here members of the West Point and Dartmouth College teams battle for the puck.

c. 1950 The helmets were still primitive and baseball was still by far the country's favorite spectator sport, but football was on its way to challenging baseball for national attention.

c. 1954 Drum majorettes have long been a part of the pageant that is American high school and college football. These young women (*previous pages*) were caught in mid-air during one of their many practices.

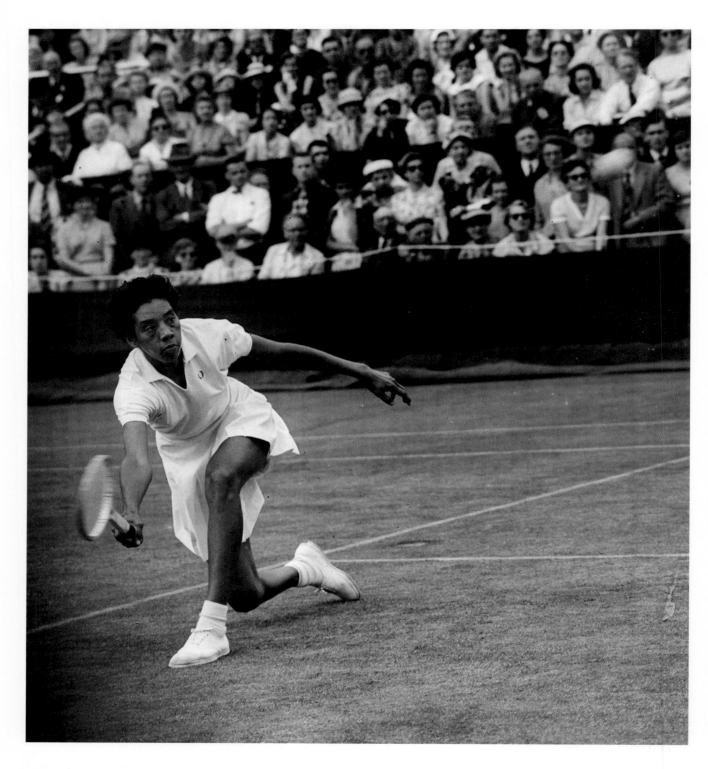

1956 Althea Gibson (1927–) was the first African–American woman tennis player to play for the U.S. champion-ship and to compete at Wimbledon. In 1957 she won the women's singles title at the U.S. Open and both the singles and doubles championships at Wimbledon. In 1958 she successfully defended all three titles.

1951 Babe Didrikson Zaharias (1911–1956) is widely considered the greatest woman athlete in history. She earned her greatest fame in golf and track and field, but she also excelled in basketball, baseball, tennis, diving, and swimming. In 1946 and 1947 she won 17 golf tournaments in a row and in 1948 was the winner of the U.S. Women's Open.

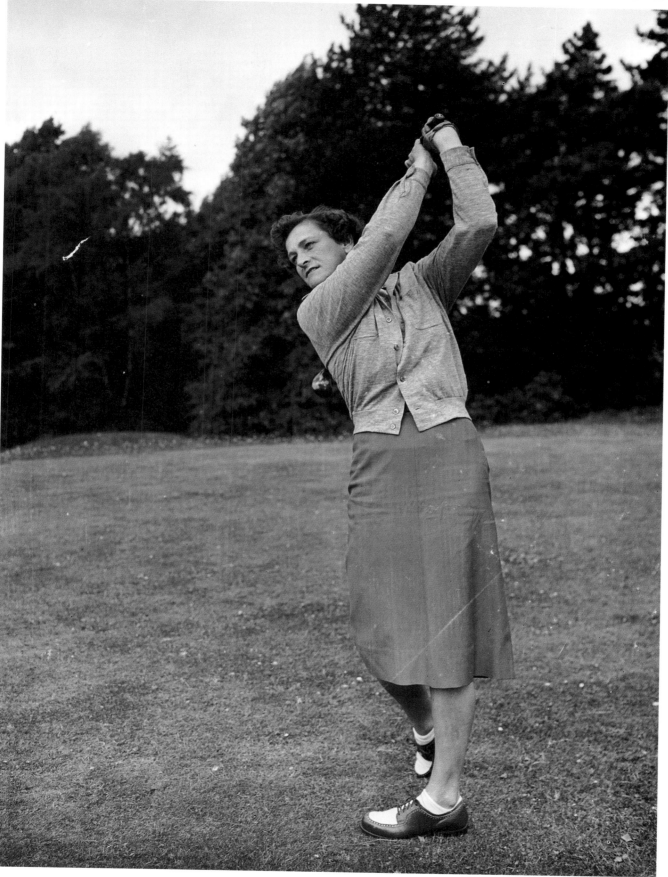

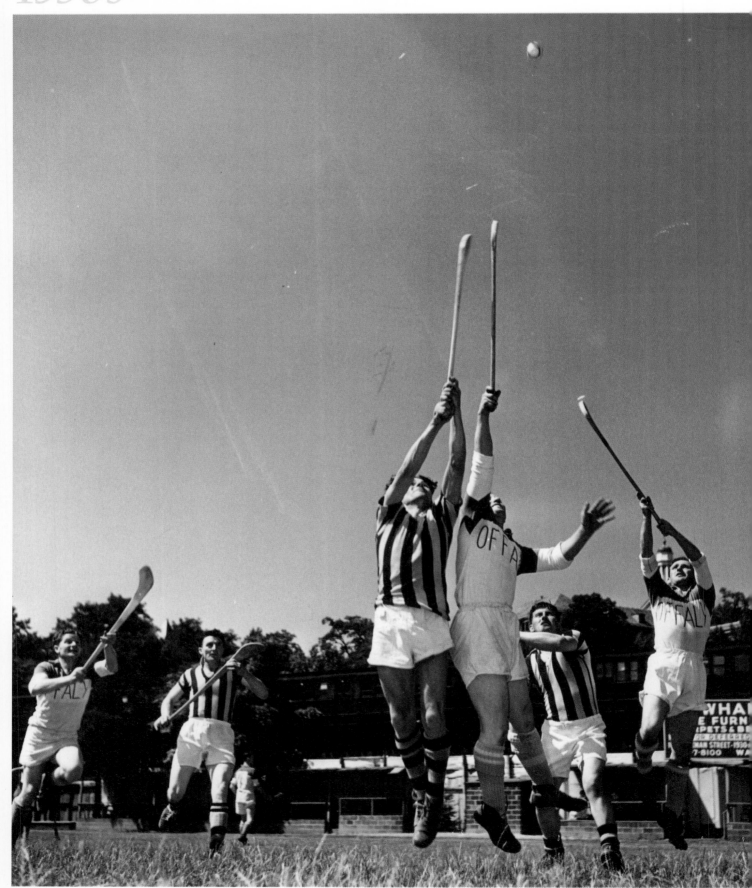

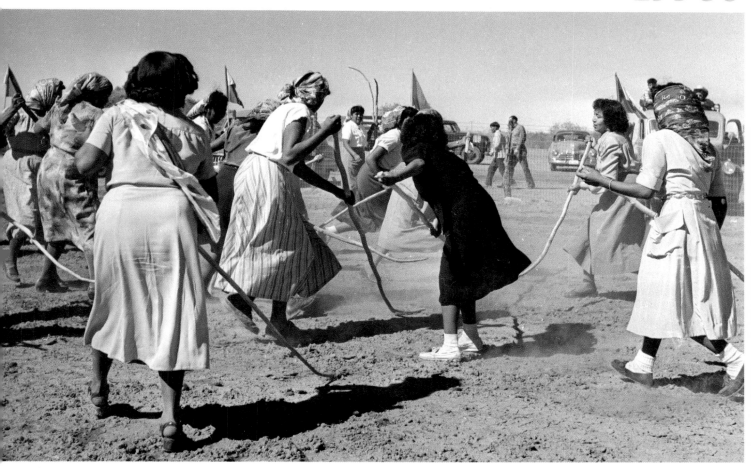

1950 As best they can, Native Americans have tried to carry on the traditions established by their ancestors long before white civilization encroached upon their way of life. Here Papago women (*above*) on a tribal reservation in Sells, Arizona play a ball game similar to field hockey.

c. 1955 With its "quickie" divorces and legalized gambling, Reno, Nevada, became a bustling community. Here a woman tries her luck at a slot machine housed in a Reno gift shop (*right*).

c. 1955 The immigrants who poured into America in the late 19th century and early 20th centuries brought many of their native games with them. Here players from the Offaly and Kilkenny teams jump high to intercept a pass during an Irish version of lacrosse called hurley (*left*).

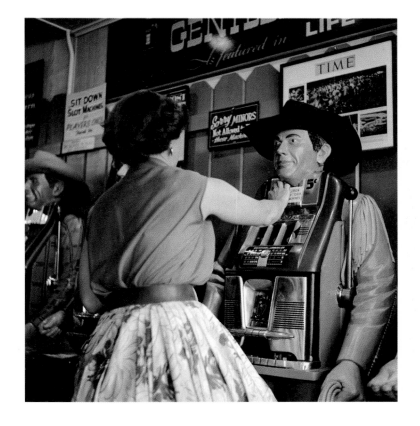

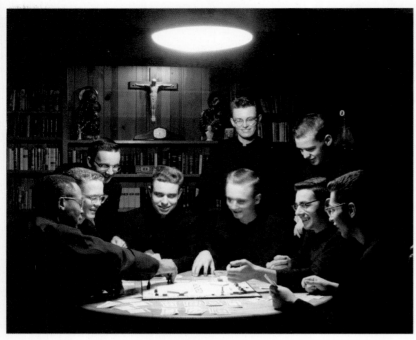

c. 1955 Monopoly was invented by Charles Darrow in the midst of the Great Depression. The game, which gave people the chance to play at becoming rich, caught on almost immediately. By 2000, more than 92 million sets had been sold. A group of monks (*above*) try their hand at the game.

c. 1955 For many young people, the 1950s was a time of conservative dress and simple pleasures. Teenagers at a party in Norwalk, Connecticut (*right*), enjoy a game of table tennis.

c. 1955 In America, each decade seems to be marked by its own fads. In the 1950s one of the simplest of all – the hula hoop craze – swept the nation (*below*).

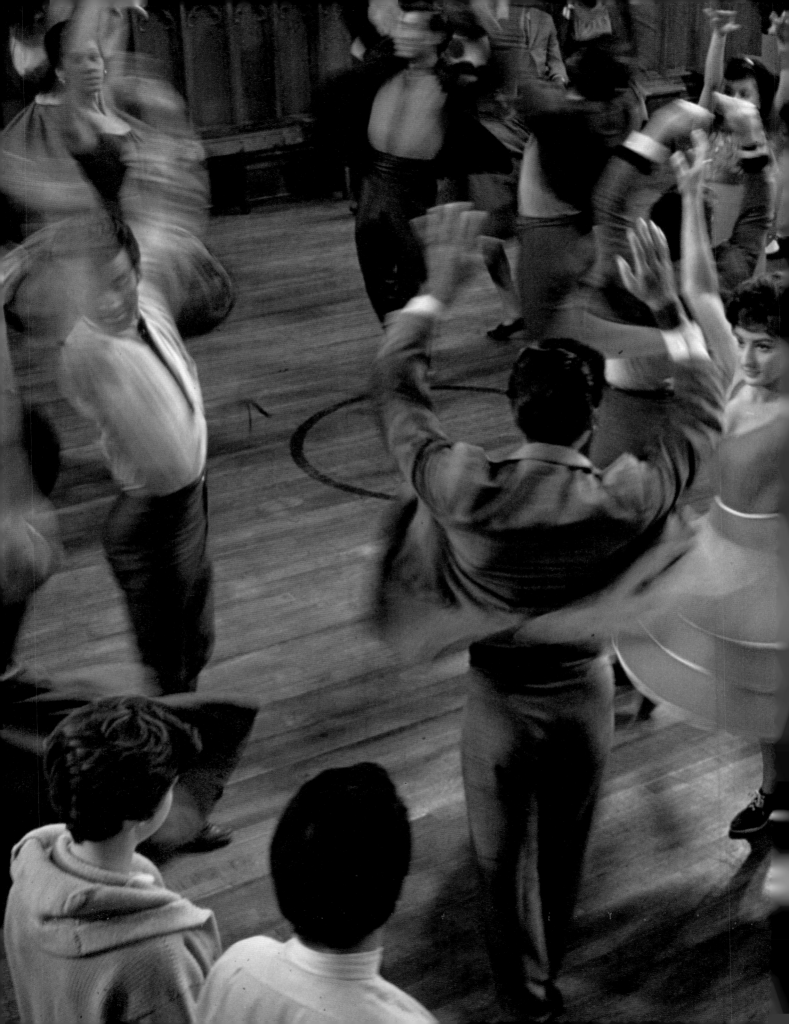

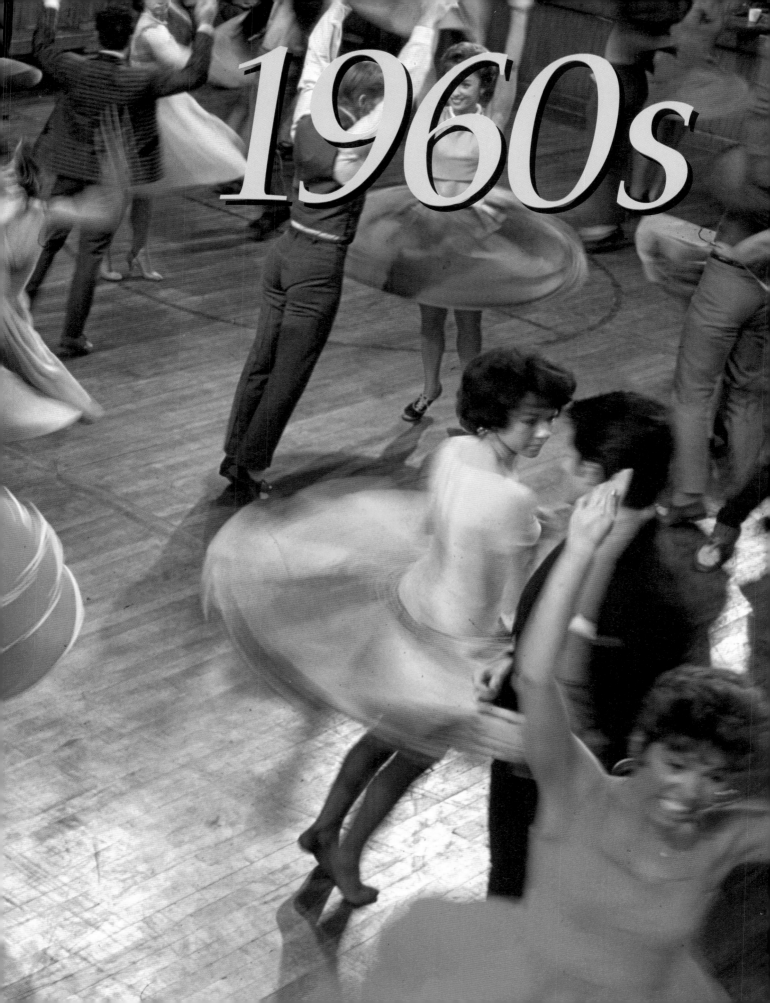

1960s

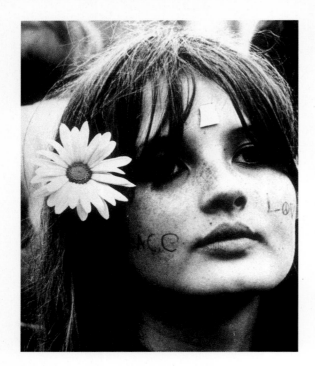

c. 1965 A child of the 1960s. Some of their parents had been called Bohemians. Many of them became known as "hippies." In a decade of youthful rebellion, "love" and "peace" became rallying cries.

1960s

It was a decade of triumph in space. Alan Shepard completed a suborbital flight. A year later John Glenn orbited the earth. And by decade's end, America had placed men on the moon. The 1960s was a decade of turmoil as well, marked by a counterculture revolution in which many of the nation's young acted out against the prevailing values, attitudes, and power of what they referred to as the "Establishment."

The Beatles, the twist, the Beach Boys, Bob Dylan, and Woodstock defined a generation. In sports, Roger Maris broke Babe Ruth's single season home run record and Muhammad Ali became one of the world's most recognizable figures. Dr. Martin Luther King, Jr. spoke for all of his fellow African-Americans when he delivered a speech titled "I Have a Dream."

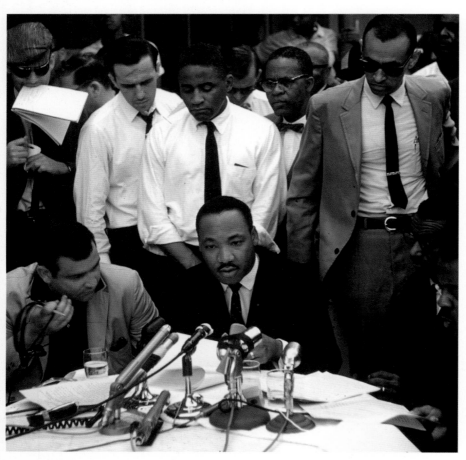

1962 Dr. Martin Luther King, Jr. (1929–1968), was the charismatic leader of the civil rights movement that came to full flower in the 1960s (*above*).

1960 With its music created by famed composer Leonard Bernstein (1918–1990), *West Side Story*, a modern–day adaptation of Shakespeare's *Romeo and Juliet*, was a Broadway sensation. Here (*previous pages*) are dancers in a scene from the movie version.

1968 In a decade of extraordinary achievements none were more heralded than America's accomplishments in space. In the first flight test of an unmanned lunar module, a rocket launches *Apollo 5* (*right*) from Cape Kennedy (Canaveral), Florida.

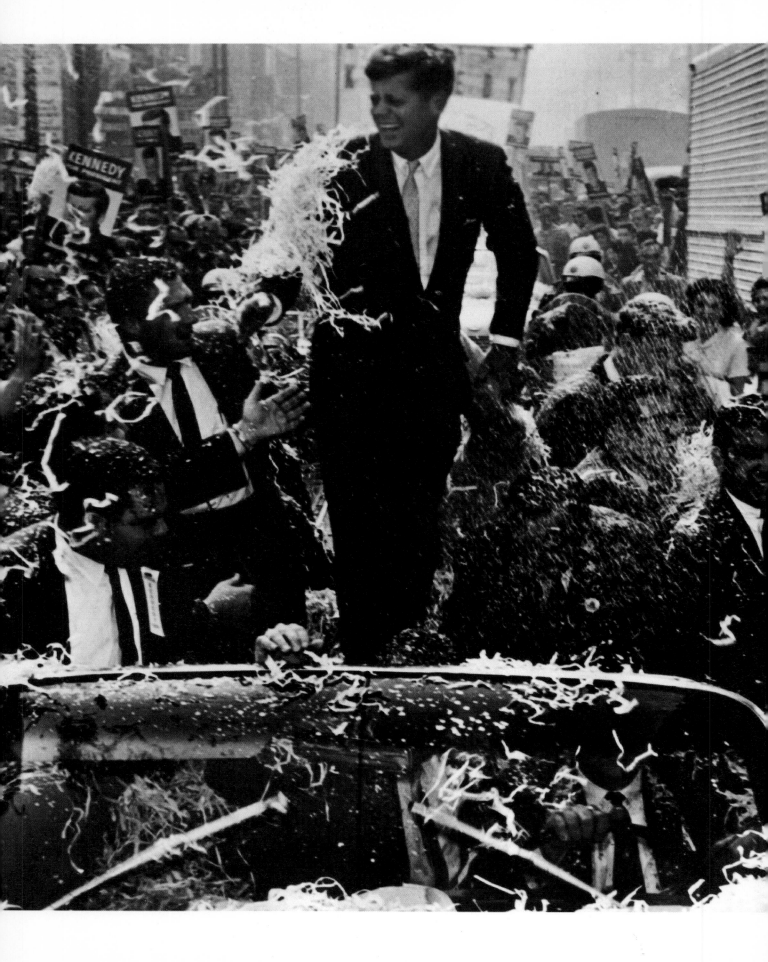

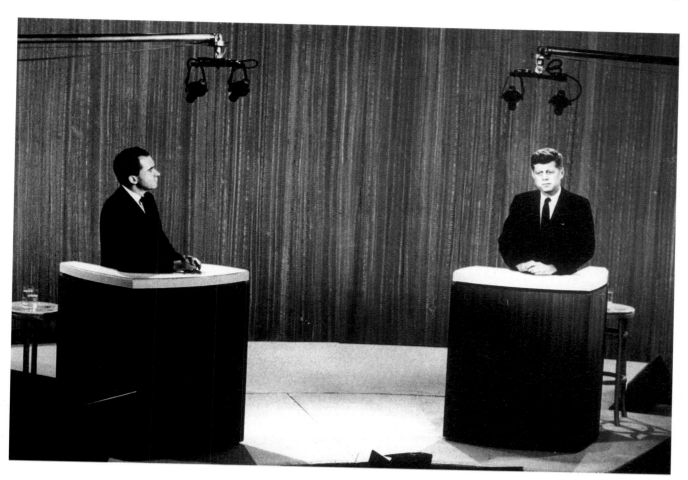

1960 The election of 1960 introduced an element into presidential politics that has become even more important than "pressing the flesh" or whistle stops. Here (*above*), Vice President Richard Milhous Nixon (1913–1994) and John Fitzgerald Kennedy (1917–1963) engage in the first–ever national television debate.

1960 John F. Kennedy was the first American president born in the 20ᵗʰ century (*right*). He was also the first Roman Catholic to be elected Chief Executive and is the only president to have been awarded the Pulitzer prize (for his book *Profiles in Courage*).

1960 He was young, he was handsome, and he promised to make government service a noble calling. In this scene taken during the 1960 campaign, candidate John F. Kennedy receives a rousing welcome (*left*).

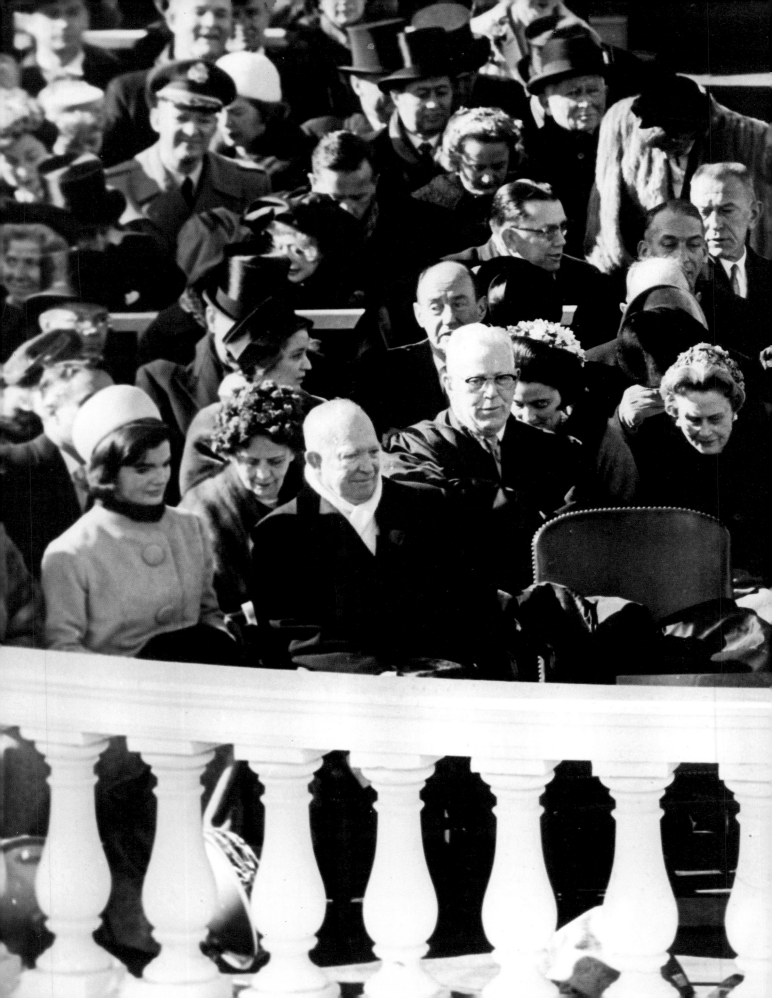

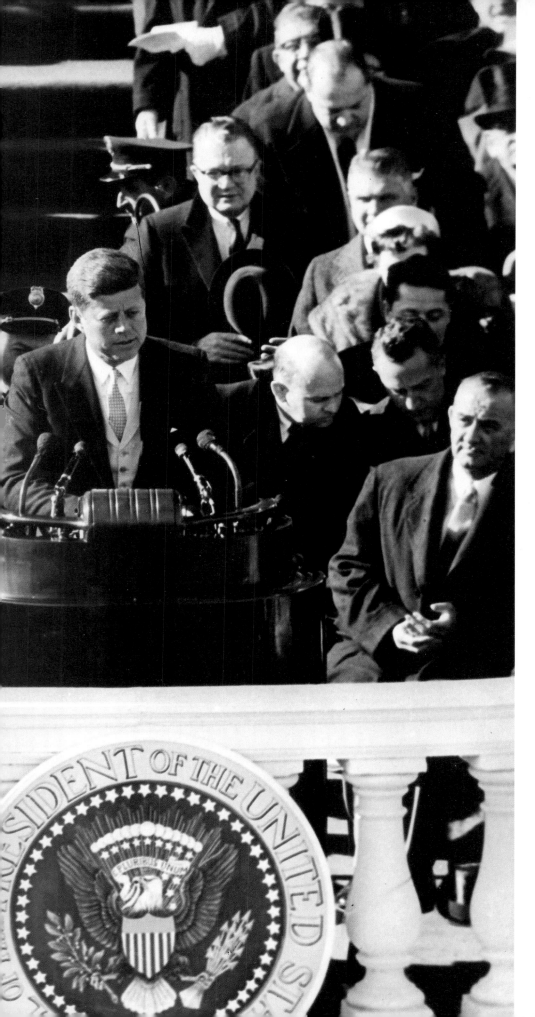

1961 President John F. Kennedy gives his inaugural address. His wife, Jacqueline, President Dwight Eisenhower, and Vice President Lyndon Baines Johnson are seen behind him.

c. 1962 During her time as First Lady, Jacqueline Kennedy transformed the White House. She restored historical treasures and made the White House the scene of great cultural events. Here she poses for photographer Slim Aarons alongside President Kennedy and Governor and Mrs. Muñoz Marín of Puerto Rico (*above*).

1962 The young, vibrant Kennedys brought vigor to the White House. Their children, Caroline and John Jr., became objects of national attention. Here Mrs. Kennedy introduces her son to the Empress of Persia (*right*).

c. 1965 Jacqueline Kennedy (1929–1994), the 35th First Lady of the United States. A photographer, painter, art collector, and linguist, Mrs. Kennedy – through her style and sense of fashion – became one of the most admired women in the world (*left*).

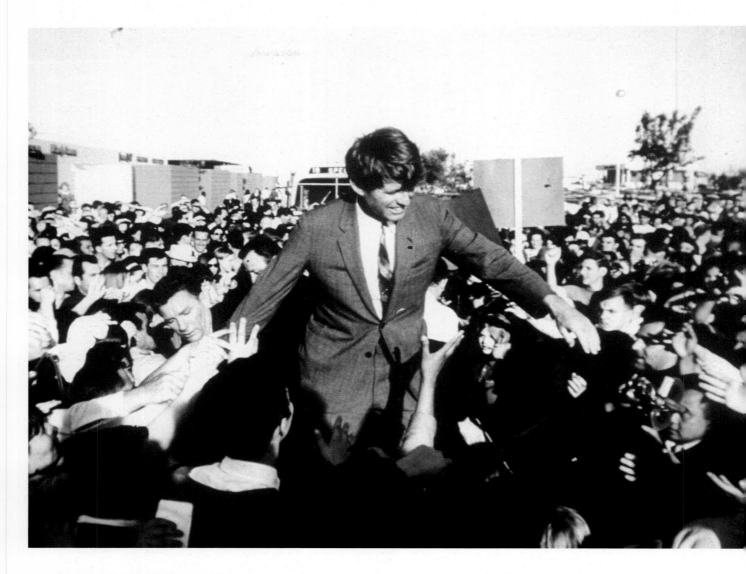

1968 Robert Kennedy (1925–1968), served as campaign manager during his brother's successful 1960 run for the presidency. In 1964 he was elected U.S. Senator from New York. Four years later (*above*) he made a spirited run for the presidency himself, a campaign which ended tragically when he was assassinated after a California campaign appearance.

1968 Richard M. Nixon (1913–1884), gives the victory signal (*above right*) after receiving the presidential nomination at the Republican National Convention in Miami. Elected in 1968 and reelected in 1972, Nixon's presidency ended abruptly in 1977 when, as a result of the Watergate scandal, he was forced to resign.

1968 Eugene McCarthy, (1916–) accomplished a major political upset when he defeated incumbent Democratic president Lyndon B. Johnson in the New Hampshire primary, forcing Johnson out of the race. A favorite of the young, McCarthy was defeated for his party's nomination by Hubert Horatio Humphrey (*right*).

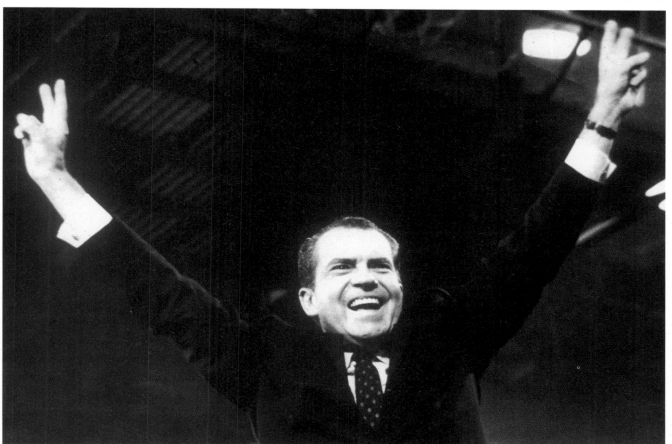

1961 In 1961 astronaut Alan Shepard (1923–1998) gained international fame when he accomplished the first manned U.S. space flight. In 1971 Shepard commanded the *Apollo 14* lunar landing mission.

1962 On February 20, 1962, astronaut John Glenn, in a three-orbit flight that lasted four hours and 55 minutes, became the first American to orbit the earth. He is shown here on his way to board his space capsule *Friendship*-7.

1969 Planet Earth. The world of photography has been one of the many beneficiaries of American accomplishments in space. This image of an earthrise captured by an *Apollo 11* astronaut from the moon has become one of the world's most famous photographs (*above*).

1969 "That's one step for a man, one giant leap for mankind." With these words, spoken as he became the first to set foot on the moon, astronaut Neil Armstrong earned a lasting place in history. Armstrong is shown here in his lunar module (*left*), *Apollo 11*, as it rested on the moon's surface.

1969 Where were you on July 20, 1969? If you were old enough you were probably glued to your television set as pictures of astronaut Edwin "Buzz" Aldrin (1930–) standing next to the American flag on the moon were transmitted back to earth (*right*).

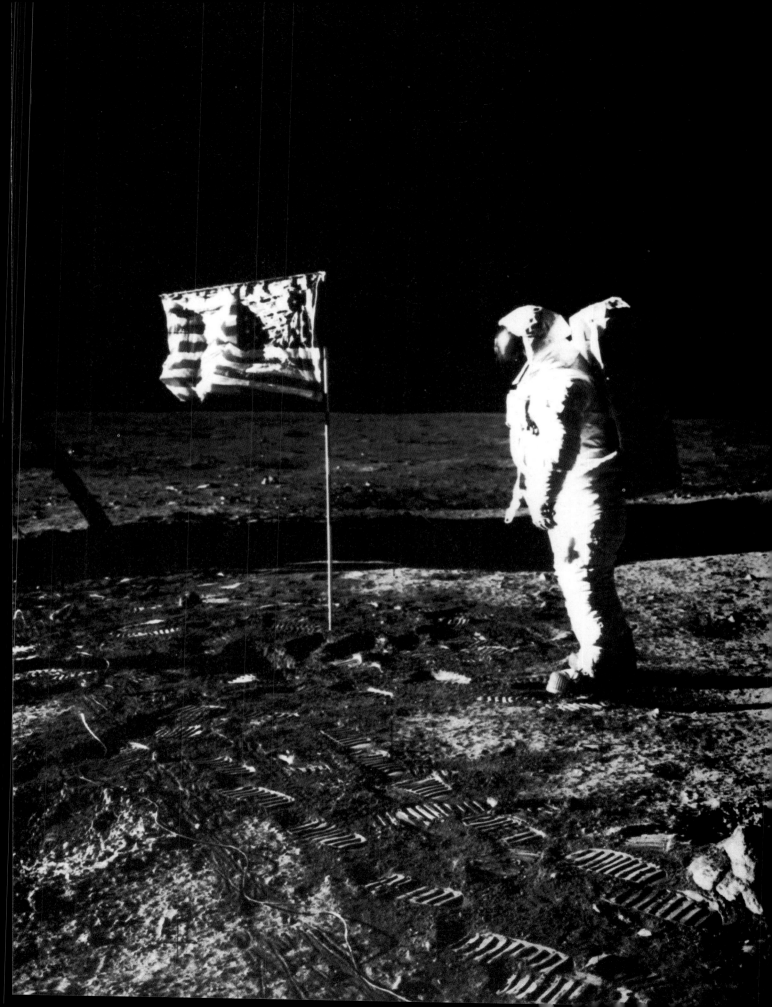

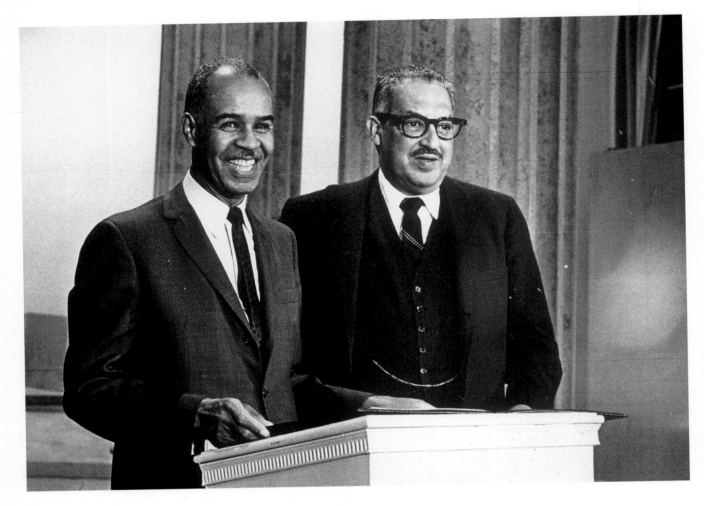

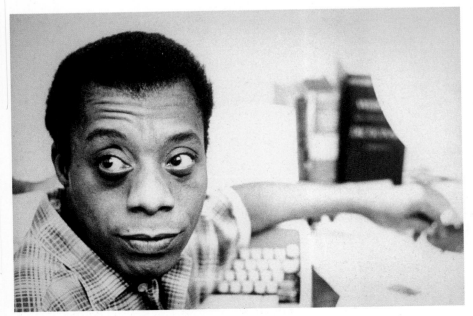

c. 1961 Thurgood Marshall (1908–1993) was one of the greatest of all civil rights advocates. In 1967 he became the first African–American member of the U.S. Supreme Court, where he often presided over landmark civil rights cases. He is shown here on the right of the picture receiving an award from NAACP executive secretary Roy Wilkins, another key civil rights activist.

c. 1965 By the 1960s, James Baldwin (1924–1987) had established himself as one of the nation's premier writers and a powerful depictor of the challenges faced by African–Americans in modern society. Baldwin's works include *Go Tell It on the Mountain* (1953), *Another Country* (1962), and *The Fire Next Time* (1963).

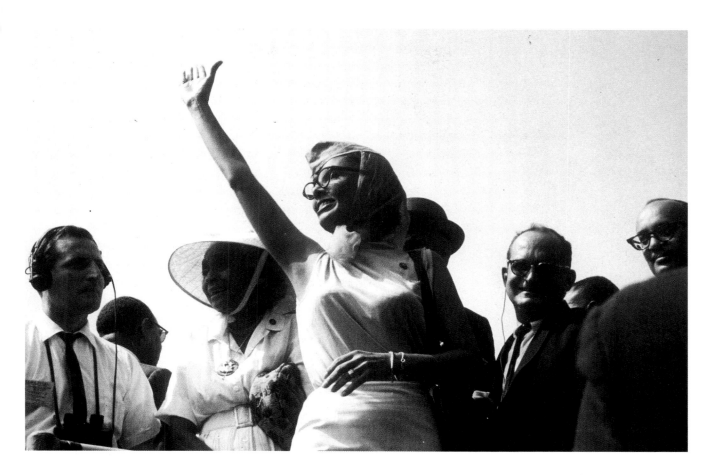

c. 1962 Many African-American celebrities became actively involved in the civil rights movement. Here singer Lena Horne waves to the crowd after speaking at a demonstration in the nation's capital.

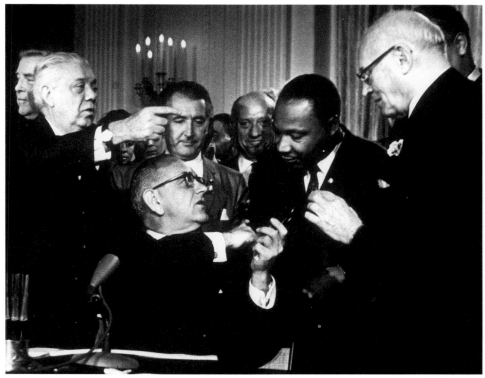

1964 The Civil Rights Act of 1964 guaranteed full and equal enjoyment of goods, services, and accommodations in places of "public accommodation." President Lyndon B. Johnson is shown shaking the hand of Dr. Martin Luther King, Jr. before signing the historic document.

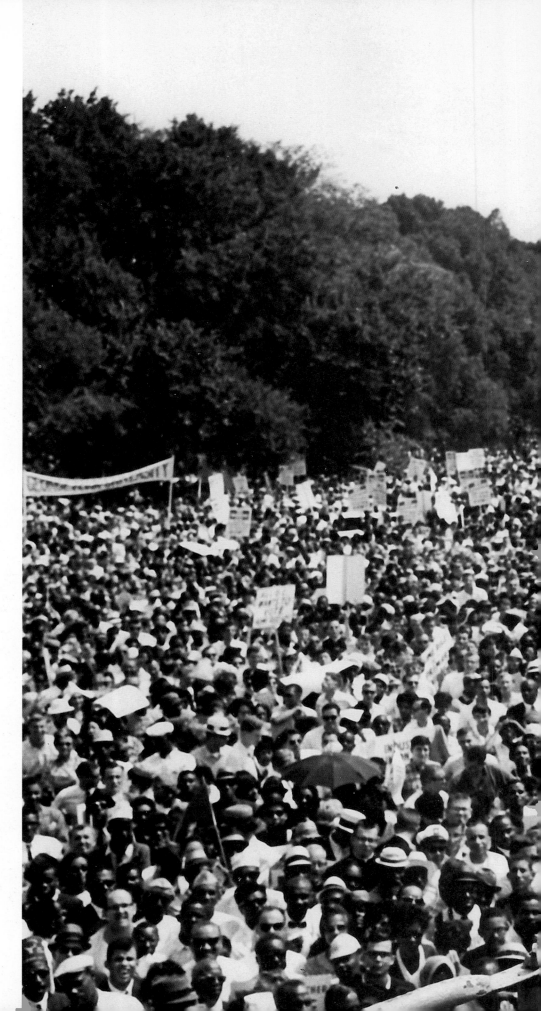

1963 Dr. Martin Luther King, Jr. waves to the crowd in Washington, D.C, during the March 28, 1965 demonstration to protest racial inequality. It was here that King delivered his now-famous "I Have a Dream" speech. A Baptist minister, King first came to national attention during the Montgomery, Alabama bus boycott of 1955. A passionate advocate of non-violence, King was awarded the Nobel Peace Prize in 1964.

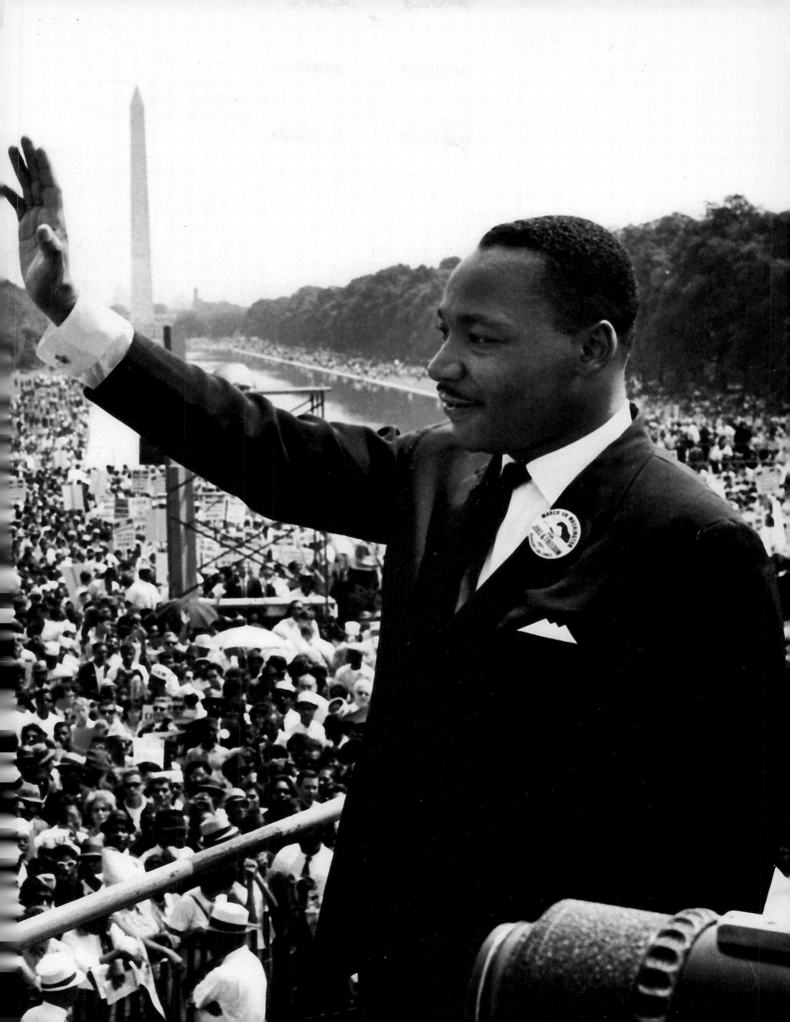

1966 Lawyer and consumer activist Ralph Nader (1934–) shocked the public with his *Unsafe at Any Speed*, a book which led to the passage of improved car safety regulations. He is shown testifying at a U.S. Senate hearing.

1961 Ernst Haas continued his photographic celebration of the diversity of the American landscape through the 1960s. Haas captured this image (*previous pages*) in California's Joshua Tree National Monument, which was made a National Park in 1994.

1965 During the 1960s, thanks in great measure to the
efforts of César Chávez (1927–1993), Americans were made
aware of the low wages and poor working conditions
endured by migrant workers. Chávez, the leader of the
United Farm Workers, it shown speaking at a rally in
support of a grape boycott.

1960s

1969 It was a decade of turmoil, but it was also a decade
in which consciousness was raised concerning the plight of
various minorities. These Native Americans were participating
in a parade in Gallup, New Mexico.

c. 1965 The majestic Grand Canyon has always been a
favorite subject of both artists and photographers. Ernst
Haas captured this image at dawn.

1966 Among his many photographic talents, Ernst Haas
had a marvelous ability to frame his images with natural
objects. Here a buffalo seeks shelter during a snowstorm in
Yellowstone National Park.

1962 Haas's photographic journey took him to all corners
of the nation. This scene was captured in the Great Smoky
Mountains in eastern Tennessee.

1967 Mickey Mantle (1931–1995) was one of the most prodigious sluggers in baseball history (*above*). Known for his gigantic home runs, one of Mantle's "round-trippers" was measured at a record 565 feet. A member of the Baseball Hall of Fame, the Yankee's star is one of the few to have won the Triple Crown (batting, home runs, runs–batted–in). Here is shown hitting his 500th home run at Yankee Stadium.

c. 1969 Roger Maris (1934–1985) began his major league baseball career with the Cleveland Indians. Traded first to Kansas City and then to New York, in 1961 he won lasting fame with the Yankees when he hit 61 home runs, a record held for 34 years by the immortal Babe Ruth. He never came close to repeating the feat and was eventually traded to the St. Louis Cardinals (*left*).

c. 1962 During the 1961–62 season, Wilt Chamberlain (1936–) (*right*) accomplished the astounding feat of scoring 100 points in a National Basketball Association game. In that same season he also set a record by averaging 50.4 points a game.

1963 **Muhammad Ali** (born Cassius Clay in 1942) won the world heavyweight championship in 1964 by defeating Sonny Liston. A charismatic figure, Ali, through his antics and many successful title defenses, became one of the most recognizable individuals in the world. Here he playfully poses with his mother.

1965 **"Float like a butterfly**, sting like a bee." That is how Muhammad Ali characterized his boxing style. Ali is shown successfully defending his heavyweight title against challenger Floyd Patterson.

1964 From their first hit single "Please, Please Me" to their
final album seven years later, the young singing group known
as "The Beatles" not only dominated the music charts with
their 38 gold albums, but dictated the fashions, haircuts, and
lifestyles of young people throughout the globe. Here Beatle
Ringo Starr (1940–), George Harrison (1943–), John Lennon
(1940–1980), and Paul McCartney (1942–) pose with TV host
Ed Sullivan during their historic appearance.

1965 Many of the songs that enabled the Beatles to dominate
rock music and pop culture in the 1960s were written by Paul
McCartney and John Lennon. Here McCartney and Lennon
enter an American stadium before a concert.

1960s

1969 The Woodstock Festival held in Bethel, New York, has been termed "the greatest event in counterculture history." Although its organizers expected a large turnout, no one anticipated that attendance would swell to some 400,000. These fans climbed a tower to get a better view.

1969 Despite the enormous crowd and the torrential rains that turned the field upon which the Woodstock Festival was held into a quagmire, the event was remarkably peaceful. This man arrived in his slogan-covered car.

1969 The three-day Woodstock Festival featured performance by such rock stars as Jimi Hendrix, Janis Joplin, and Jefferson Airplane. Here singer Joe Cocker performs for the vast audience.

c. 1968 Janis Joplin (1943–1970) became known for her husky voice, her outlandish costumes, and her on-the-edge lifestyle. A passionate performer (*above*), her smash hits included "Me and Bobby McGee" and "Piece of My Heart."

1967 Jerry Garcia (1942–1995), leader of the band the Grateful Dead (*left*), jamming at a "be-in." The band – an avatar of the San Francisco music scene – attracted legions of loyal followers who proudly termed themselves "Deadheads." The Dead toured constantly from their inception until Garcia's death in 1995.

1968 The outfits worn by many rock performers were often as funky as their music. The stylish Sly Sylvester (*right*), better known as Sly Stone, was the leader of the funk rock group Sly and the Family Stone.

1960s

c. 1965 In the 1960s folk music became almost as popular as rock. Joan Baez (1941–), like many folk singers, became deeply involved in the peace and anti-nuclear movements. Baez's rendition of "We Shall Overcome" became an anthem of the civil rights movement, and in 1965 she founded the Institute for the Study of Non-Violence.

c. 1964 Regarded as "the poet laureate of the folk revival," Bob Dylan (1941–) was, for millions of young people, the very symbol of the 1960s. Here Dylan accompanies himself with both a guitar and a harmonica. His phenomenal hits included "Blowin' in the Wind," "Masters of War," and "A Hard Rain's A–Gonna Fall."

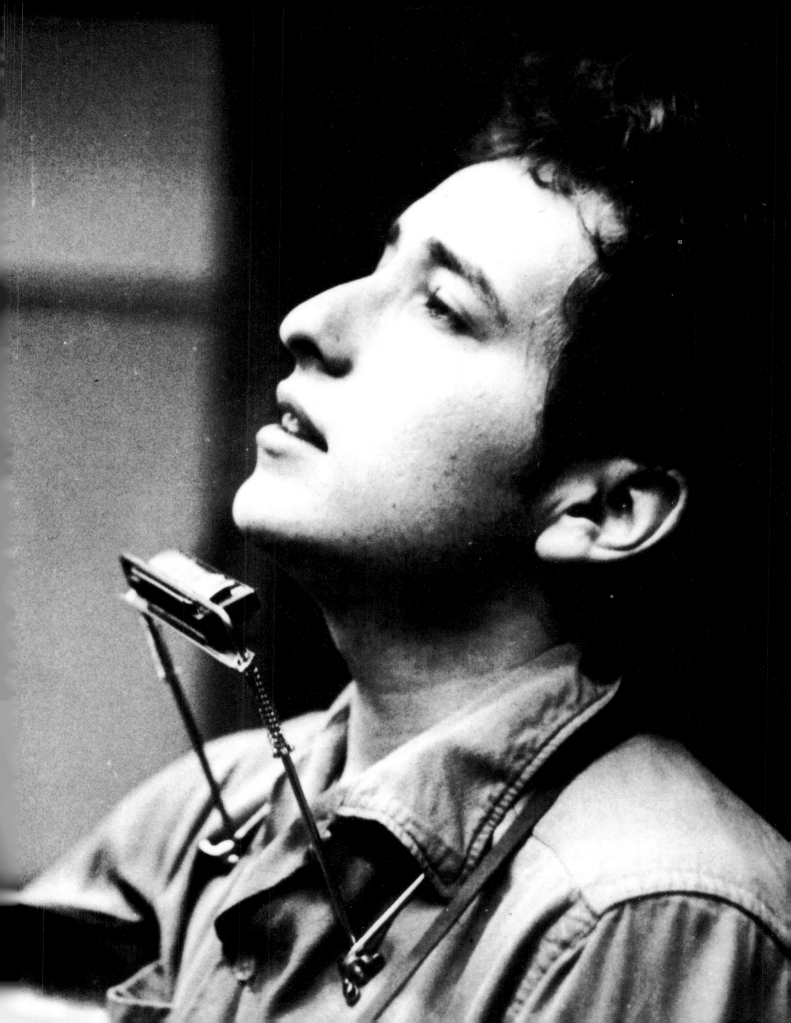

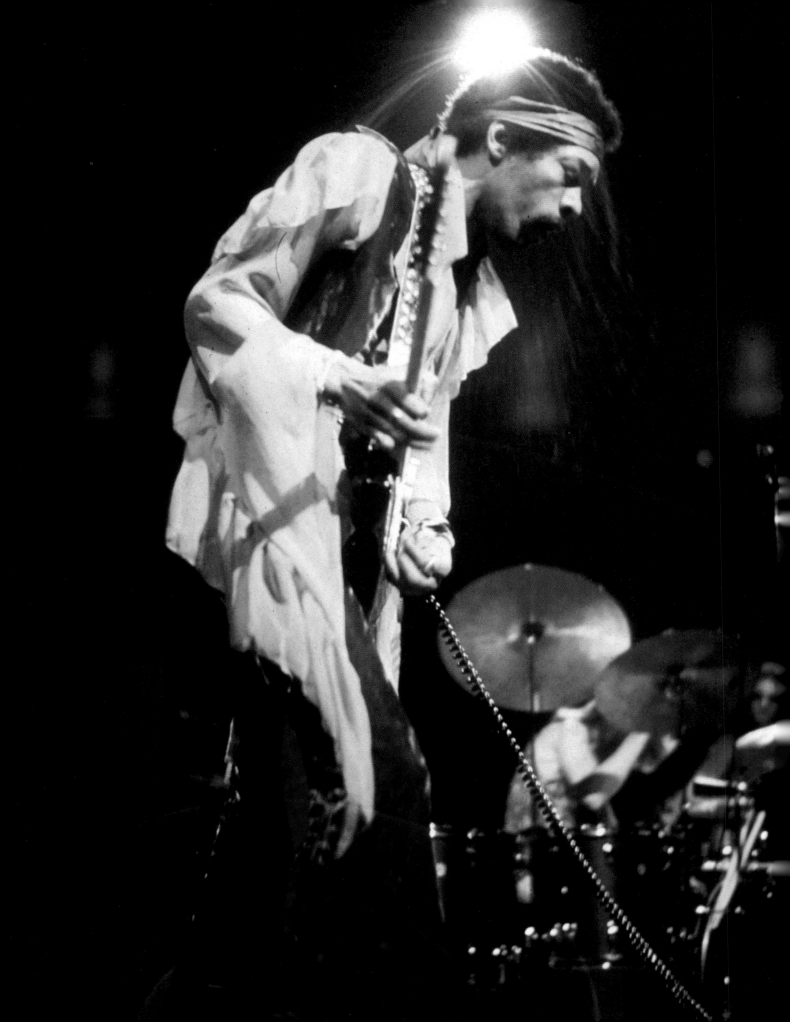

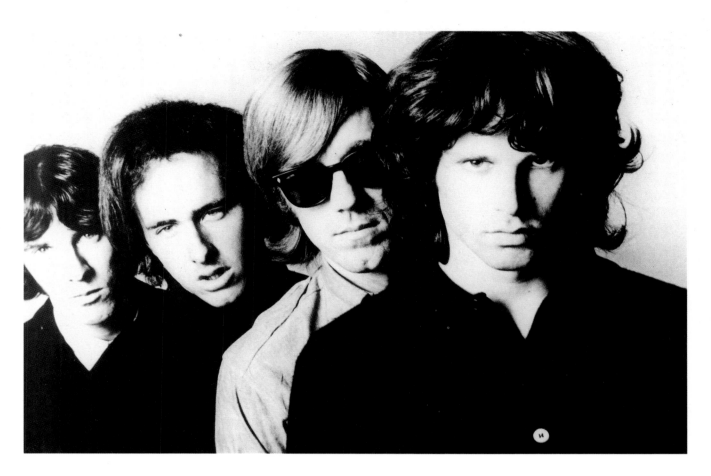

c. 1968 The Los Angeles rock group the Doors (*above*) topped the charts in the 1960s with such hits as "Light My Fire" and "Riders on the Storm." Lead singer and founder Jim Morrison (1943–1971) was one of the most popular and controversial figures in rock – a poet, sex symbol, and raw performer who called himself the "Lizard King." Left to right are: John Densmore, drums, Tobbie Krieger, guitar, Ray Mazarek, keyboards, and Morrison.

1968 Grace Barnett Wing (1939–), known as Grace Slick (*right*), the lead singer of Jefferson Airplane. Along with the Grateful Dead, Jefferson Airplane was one of the most influential groups to come out of San Francisco. "White Rabbit" and "Somebody to Love," from the acclaimed *Surrealistic Pillow* album, both rose to the top of the charts in the 1960s.

69 Jimi Hendrix (1942–1970), considered by many to be the most gifted guitarist in rock music, became known both for his explosive performances and for the innovations he brought to the electric guitar. Here he performs at a concert at New York's Madison Square Garden (*left*).

1966 The Beach Boys (*above*) explained that they adopted their name because they realized that although not everyone could live near a beach, almost everyone wanted to. America's top pop group, each of its concerts – featuring songs like "Surfin ' USA," "Shut Down," and "Be True to Your School" – sold out as soon as it was scheduled. Left to right are Carl Wilson, Bruce Johnston, Mike Love, Al Jardine, and Brian Wilson.

c. 1965 The duo of pop and folk singers Art Garfunkel (1942–) left, and Paul Simon (1942–) (*left*), dominated the charts with hits like "Mrs. Robinson," "Bridge Over Troubled Water," and "Cecelia." Most of their songs were written by Simon, whose solo work today is typified by his acclaimed album *Graceland*.

1968 The married duo (*right*) of Salvatore "Sonny" Bono (1935–1998) and Charilyn "Cher" LaPierre (1946–) brought both music and comedy to their own prime time television program. After they were divorced, Bono would go on to become a U.S. Congressman while Cher would become a major motion picture star and pop diva.

1968 Andy Warhol (1928–1987) shown here drawing a flower on actress Leigh Taylor-Young, was a highly successful pop artist and filmmaker. His silk-screened paintings of Campbell's Soup cans, Coca-Cola bottles, and movie stars are among the most iconic images of the latter 20th century. Warhol's films include *Chelsea Girls* (1966) and *Trash* (1970).

1967 Former Harvard professor Timothy Leary (1920–1996) was a self-appointed guru of the counterculture. He coined the slogan "Turn on, tune in, drop out."

c. 1965 Writer **William Seward Burroughs** (1914–1997) was one of the "Beat Generation's" favorite authors. His novels included *Naked Lunch* (1959), *The Soft Machine* (1961), and *Fingers Talk* (1963).

1965 Poet **Allen Ginsberg** (1925–) was regarded by many as the voice of the Beat Generation. A harsh critic of American materialism, Ginsberg's most influential poem was titled "Howl." He is shown here (wearing glasses) with fellow poet and publisher Lawrence Ferlinghetti. Ferlinghetti published "Howl" in 1956; the prose was so controversial that copies were impounded as obscene and he was arrested. The court ruled in the poets' favor.

1969 Blues singer, songwriter, and guitarist B. B. King (1925–) became an international star in the 1960s (*above*). Still a top performer today, King's albums include *Blues Is King* (1967) and *Blues 'n Jazz* (1983).

1968 Aretha Franklin (1942–) began her career as a Gospel singer. Known both as "Lady Soul" and the "Queen of Soul" (*right*), Franklin's hit singles include "Baby I Love You" and "Respect." Among her best–selling albums are *Lady Soul*, *Amazing Grace*, and *Aretha*.

1965 Stevie Wonder (1951–) was a child musical prodigy (*left*). Signed by Motown Records when he was only ten, Wonder's first record, *The 12-Year-Old Genius*, was a huge success. His other best–selling albums include *Songs in the Key of Life*, *Talking Book*, and *Hotter Than July*.

1968 In the 1960s, female singing groups such as the Shirelles, Martha and the Vandellas, and the Ronettes scored one recording hit after another on Detroit's Motown label. The most successful was the group known as the Supremes, comprised of, from left to right, lead singer Diana Ross, Mary Wilson, and Cindy Birdsong.

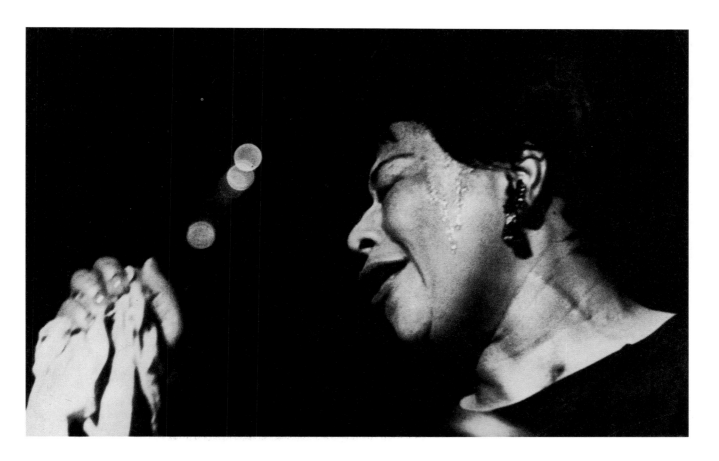

1963 Ella Fitzgerald (1917–1996) became recognized as the greatest of all jazz singers. Along with her jazz renditions, Fitzgerald also brought her own lyrical style to the songs of George and Ira Gershwin and Cole Porter.

c. 1962 America's most honored songwriter Irving Berlin was still going strong in the 1960s. Here (*above*) he shares a backstage laugh with Anita Gillette, one of the stars of Berlin's musical *Mr. President*.

1965 Famed singer and movie star Judy Garland (1925–1969) shares a hug (*left*) with her daughter Liza Minelli (1946–). When this picture was taken Minelli was well on her way to establishing her own highly successful music and film career.

c. 1968 The "Age of Aquarius" was epitomized in the groundbreaking Broadway musical *Hair* (*right*), which told the story of a midwestern army enlistee who joins a nomadic tribe of hippies in New York's Central Park. This picture shows a young Diane Keaton (front and center), whose career as an accomplished movie actress lay ahead of her.

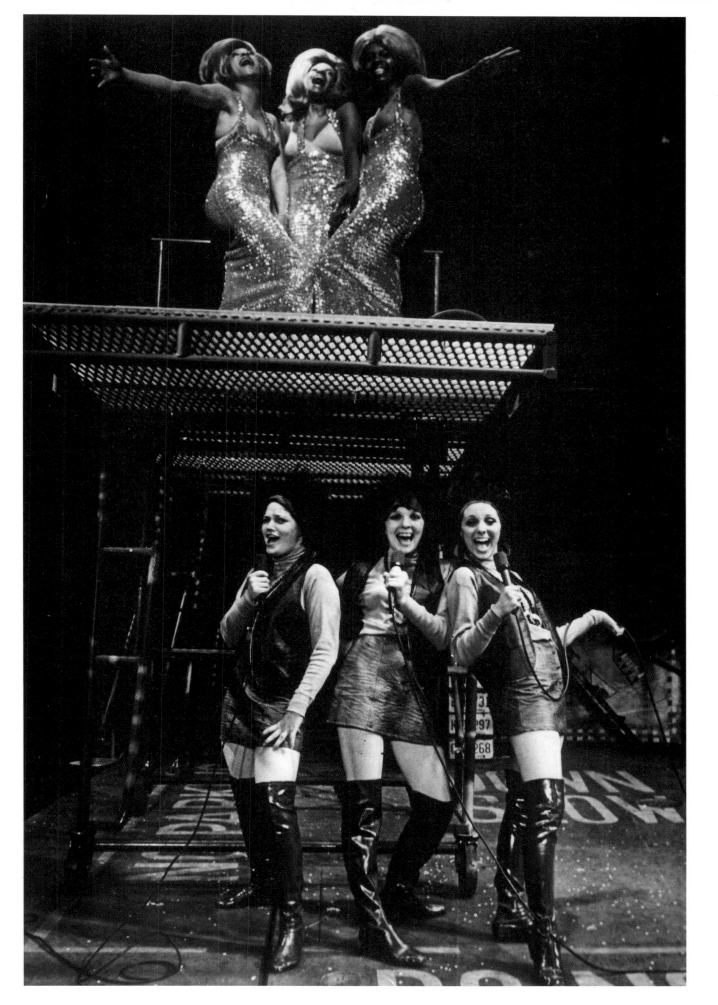

1962 George Balanchine (1904–1983), founder of the
New York City Ballet, was America's most influential ballet
choreographer. Here he takes dancers through the steps of
a scene for a television production.

1969 Abstract expressionist artist Helen Frankenthaler
employs an artistic technique she invented. By pouring
paint onto an unprimed and absorbent canvas she created
paintings with unique translucent effects.

1960s

1969 Entrepreneurship has always come in many guises. In the 1960s, Hugh Hefner created a lucrative empire through his *Playboy* magazine and Playboy Clubs.

675

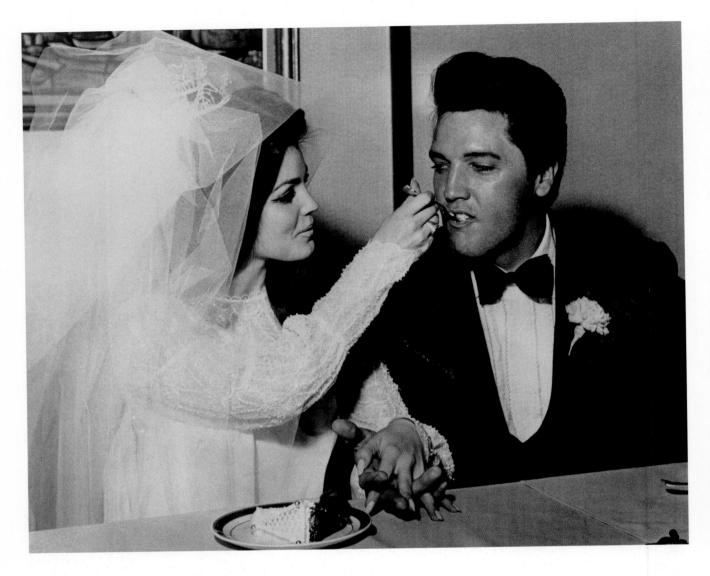

1967 May 4, 1967 was a dark day in the lives of millions of American young women. On that date Elvis Presley, the world's most eligible bachelor, tied the knot with Priscilla Beaulieu at the Aladdin Hotel in Las Vegas.

c. 1965 They were known as the "Rat Pack" and they packed them in at the Las Vegas casinos where they performed. Seen here from left to right are Frank Sinatra (the leader of the "Pack"), Dean Martin, Sammy Davis Jr., Peter Lawford, and Joey Bishop.

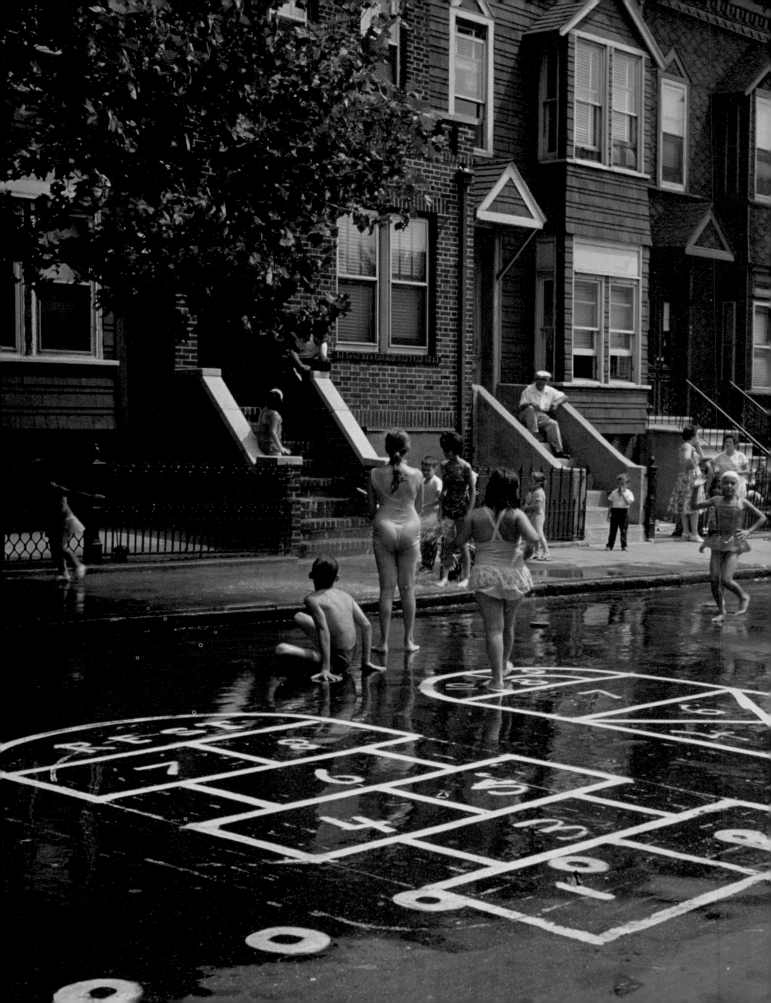

1961 In 1960 the Boy Scouts of America celebrated its 50th anniversary. These scouts were constructing a climbing frame.

1962 The sun glistens off the hot pavement as city children carry on a longtime tradition – turning a street into a makeshift playground.

1960 One of America's wealthiest and most charitable families, the Rockefellers pose in their Radio City, New York, office for photographer Slim Aarons. Left to right are Lawrence, Winthrop, John Davison 3rd, David, and Nelson.

1966 Continued improvements in the helicopter enabled it to become a particularly efficient way of moving in and out of the city. Here a "chopper" lands on the roof of New York's Pan Am Building, renamed the Met Life Building in 1981.

c. 1964 The 1964–65 New York World's Fair celebrated the city's 300th anniversary. The centerpiece of the fair was this spectacular "Unisphere."

1966 In a scene from the popular "Batman" television series, actors Adam West as Batman and Burt Ward as Robin climb a building as the show's guest, Sammy Davis, Jr., looks on.

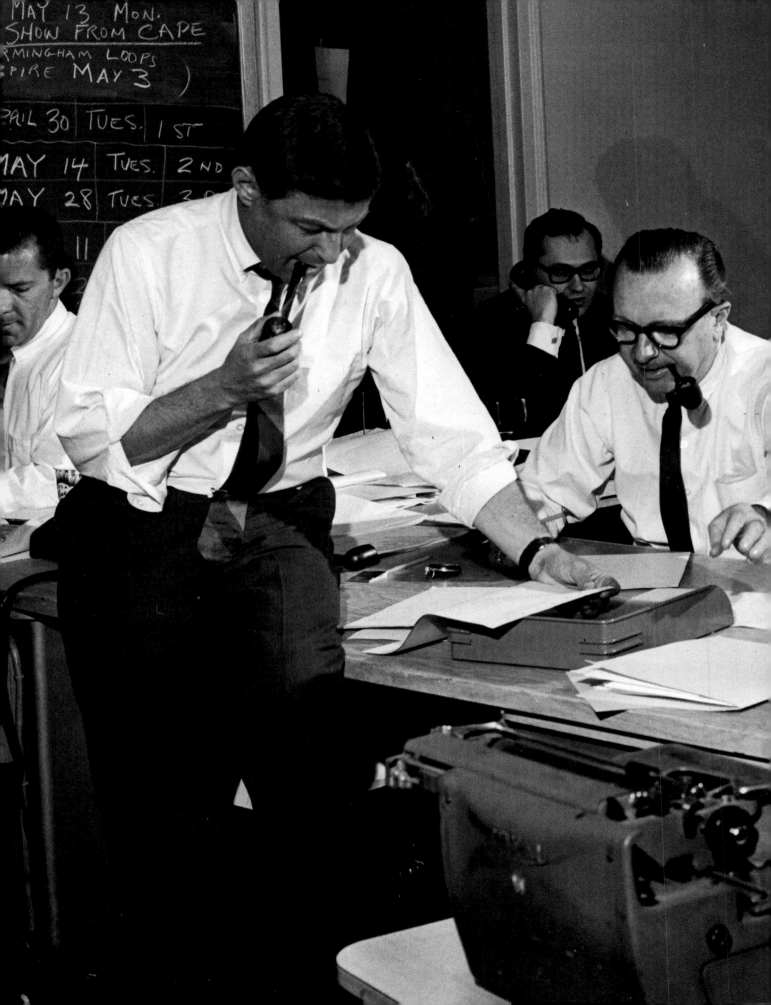

1962 From 1962 to 1981 the "CBS Evening News With Walter Cronkite" was America's highest-rated news program; its anchor, Walter Cronkite (1916–), is still considered the most respected and influential newscaster in television's history. As a young journalist, Cronkite (center) was one of the first accredited correspondents in World War II, and from 1952 to 1980 he covered all but one presidential election. Cronkite was the recipient of many awards, including five Emmys and the George Polk Journalism Award (1971). Standing next to Cronkite is Don Hewitt, future producer of the CBS newsmagazine "60 Minutes."

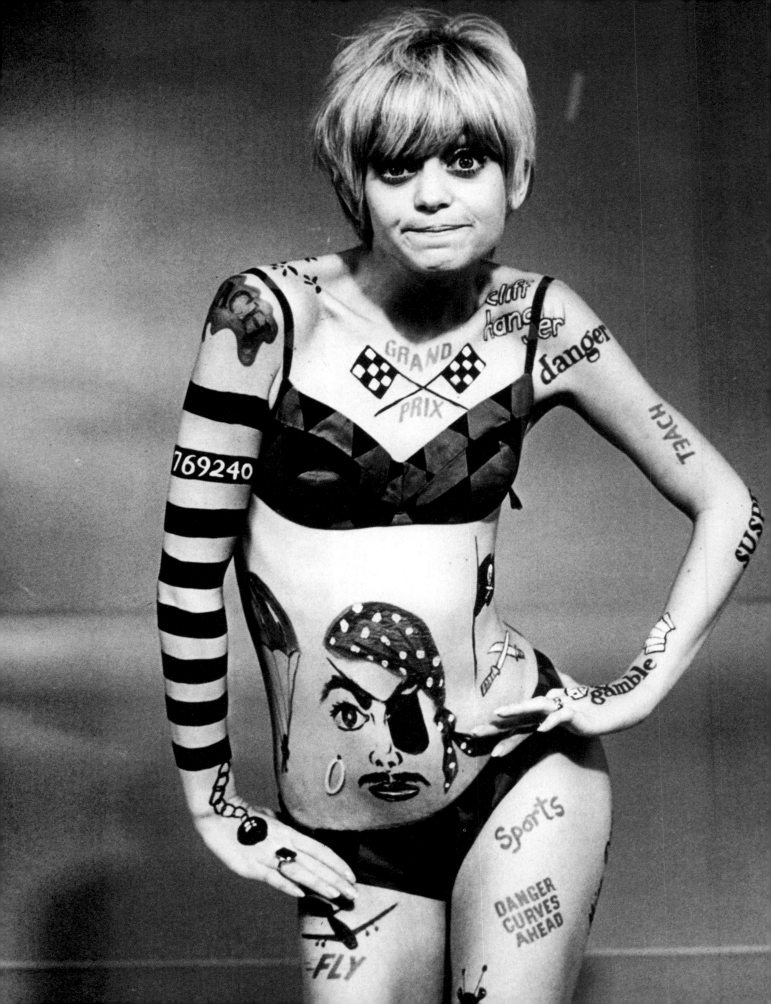

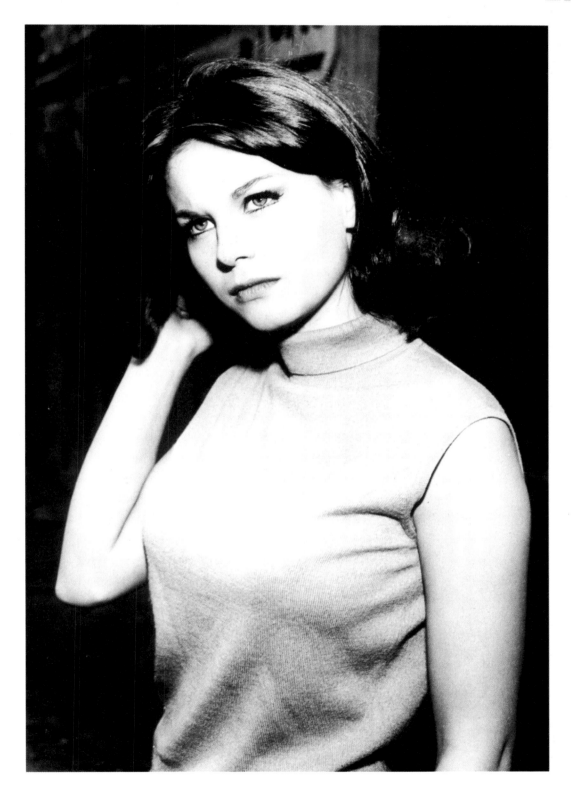

1968 Actress Goldie Hawn poses for a promotional portrait for the smash television hit "Laugh-In." In 1969 Hawn won an Oscar for best supporting actress in *Cactus Flower*, and went on to star in such films as *Shampoo* and *Private Benjamin*.

1967 From the mid- to late 1960s millions of Americans tuned in regularly to the steamy television series "Peyton Place" to uncover the secrets of a small New England town. Lana Wood, shown here, was one of the stars of the series, along with such notable actors as Mia Farrow, Gena Rowlands, and Lee Grant.

c. 1965 The horse in this picture was perhaps the best known animal in 1960s' America. He was Mister Ed the talking horse (*above*), the star of his own television series. Next to him is actor Alan Young, Mister Ed's human sidekick.

c. 1962 Comedian, actor, and director Jerry Lewis (1926–) moves a camera into position on the set of a movie he was directing (*left*). From 1946 to 1956 Lewis and his partner Dean Martin starred in both television programs and movies. When the partnership dissolved, Lewis, who is particularly revered by French audiences, carried on a highly successful solo career.

c. 1968 Leonard Nimoy as Mr. Spock and Jane Wyatt as Spock's mother (*right*) pose for a promotional picture for the cult science-fiction television series "Star Trek." When the original "Star Trek" series ended it spawned several new series and a succession of highly successful movies. In the process, "Star Trek" phrases like "Beam me up Scottie" became part of the American lexicon.

c. 1965 The see-saw is one of the world's oldest recreational devices and a common fixture in school playgrounds across the nation. Here a youngster shows off her own acrobatic technique.

c. 1965 young members of a dance class, having made their own fashion statements by adorning their leotards with brightly colored sashes, wait for their lesson to begin.

1964 Singer Frankie Avalon works out the steps of a new California dance called the "Malibu Beat." With him are members of the cast of the movie musical *Muscle Beach Party*, in which the dance was featured (*above*).

c. 1965 Actress Raquel Welch (1940–) poses for a publicity shot (*right*). After wowing audiences in *Fantastic Voyage* and *One Million Years, B.C.*, this 1960s sex symbol went on to appear in over 35 films.

c. 1965 This was the decade of "Surfin' USA," and California solidified its place as America's mainland surfing capital. Here (*left*) a young man carries his prized possession.

c. 1965 Actress Ali MacGraw smiles for the camera. MacGraw
gained her greatest fame from playing opposite actor Ryan O'Neal
in the movie *Love Story*. Her other movies included *Goodbye, Columbus*
and *Natural Causes*.

1966 Actor Steve McQueen (1930–1980) relaxes on the set of
Nevada Smith, in which he played the title role. McQueen's rugged
good looks and his often volatile personality made him a favorite
of Hollywood fan magazines. His movies included *The Great Escape*,
Junior Bonner, *The Thomas Crown Affair*, and *The Towering Inferno*.

1966 Sidney Poitier was Hollywood's first African–American movie star. His 1960s' films included *Lilies of the Field* and *In the Heat of the Night*. Here (*above*) he is photographed by Ernst Haas on the set of *Duel at Diablo*.

1962 Throughout the 1960s, Paul Newman (1925–) starred in a succession of movies that established him as a star of the greatest magnitude (*right*). These movies included *The Hustler, Sweet Bird of Youth, Hud, Cool Hand Luke,* and the now cult-classic *Butch Cassidy and the Sundance Kid.* In 1986 Newman, one of Hollywood's most enduring stars, won the Academy Award for his performance in *The Color of Money*.

1960 Film director Alfred Hitchcock (1899–1980) became as famous as many of his renowned stars (*left*). The master of the suspense thriller, his films included *Rebecca, Notorious, Rear Window, Psycho,* and *The Birds*. In the 1960s, Hitchcock hosted two television mystery series, "Alfred Hitchcock Presents" and "The Alfred Hitchcock Hour."

1968 By the 1960s, Hollywood had long discovered the box office magic to be found in converting hit Broadway musicals into major motion pictures. Here (*previous pages*) Gene Kelly directs Barbra Streisand (1942–) in the movie version of *Hello Dolly*.

1969 The "road" film *Easy Rider* follows two anti-heroes on a fateful motorcycle trip through the Southwest. *Easy Rider*, which premiered at the 1969 Cannes Film Festival and won for best film by a new director, has become a lasting symbol of the counterculture movement. Directed by Dennis Hopper (1936–), shown here in a scene with Karen Black (*above*), the film also starred Peter Fonda and Jack Nicholson.

c. 1965 In the 1960s, Sophia Loren (1934–) and Rock Hudson (1925–1985) epitomized the Hollywood leading lady and leading man. They are shown here (*right*) dancing at one of the film capital's many galas.

1964 Two of Hollywood's greatest stars, Elizabeth Taylor and Richard Burton, act out a scene from the movie *Becket* (*left*). The film was both an artistic and box office triumph.

1968 Charlton Heston (1924–) became known for his starring roles in such epic movies as *The Ten Commandments* and *Ben Hur*. He is shown here (*previous pages*) in a scene from the prophetic film *The Planet of the Apes*.

1970s

c. 1977 Author Alex Haley (1921–1992) scored one of the decade's greatest literary triumphs with his book *Roots: The Saga of an American Family* (1976). He is shown here on the set of the television adaptation of the book, one of the most-watched of all TV series.

In the 1970s, the long and divisive Vietnam War finally came to an end. The word Watergate came to mean more than the name of a luxury Washington hotel/apartment complex, and for the first time an American President was forced to resign.

The number of women lawyers, doctors, professors, managers, and administrators rose dramatically. In sports, African-American Arthur Ashe won both the Australian and Wimbledon tennis titles. It was also the decade of "All in the Family," "M.A.S.H.," streakers, Michael Jackson, the Supremes, *Rocky* and *The Godfather*. Topping it all off was the observance of Americas 200th birthday - a coast-to-coast bicentennial celebration.

1974 Carroll O'Connor and Jean Stapleton (*above*) in a scene from the highly rated television series "All in the Family." With his continual stereotypical comments and jibes, O'Connors' character, Archie Bunker, was himself a stereotype.

1977 In the late 1970s, the notorious New York nightclub Studio 54 was the celebrity "in" spot. The woman dressed in a tuxedo is Bianca Jagger (*previous pages*), wife of rock star Mick Jagger. To her right are pop artist Andy Warhol and singer/actress Liza Minnelli.

1976 A highlight of the decade was America's exuberant bicentennial celebration. Here "Uncle Sam" (*right*) cavorts in a Philadelphia parade.

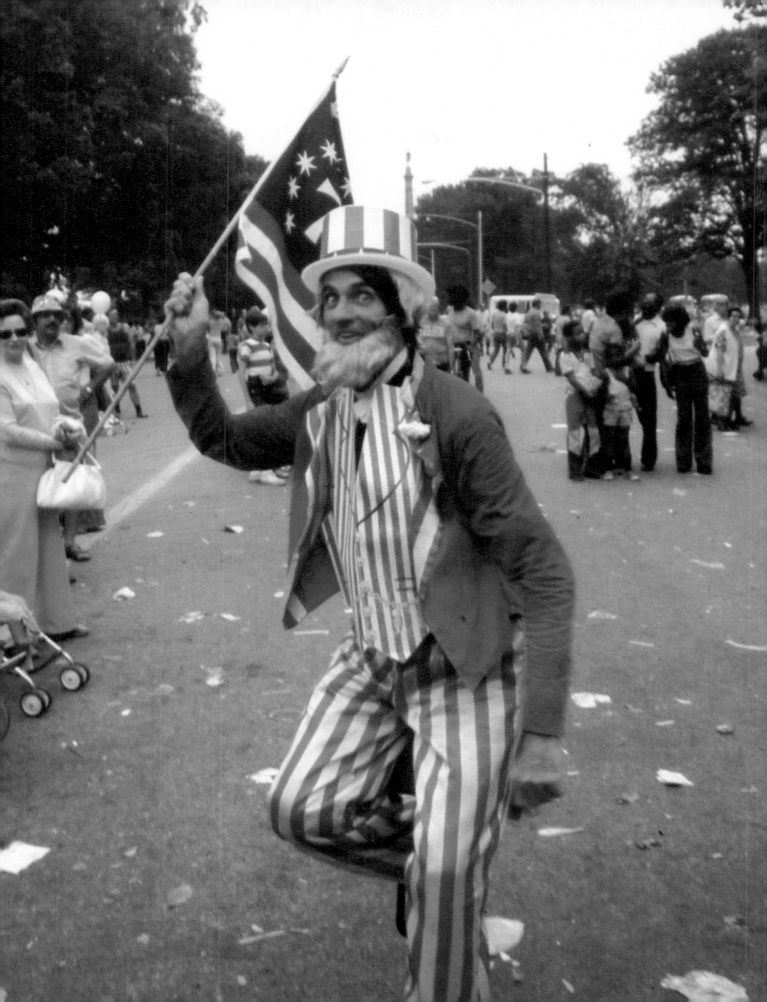

1969 Mary Tyler Moore (1936–) established herself as a television star through her role as Laura Petrie on the "Dick Van Dyke Show." She won her greatest fame as the star of the long–running sitcom "Mary Tyler Moore," in which she played an associate producer of an evening news program.

c. 1975 Flip Wilson was one of the decade's most popular television comedians, regularly appearing in a number of different shows. Here he is seen portraying "Geraldine," one of his best–known comedic characters.

1977 Farrah Fawcett (1946–) began her career in TV commercials and as a fashion model. In 1976 she became an overnight sensation through her costarring role in the TV series "Charlie's Angels." Although she appeared in the show for only one season, her popularity spawned an enormous sale of Farrah Fawcett dolls, wigs, and millions of "Farrah" hairdos.

c. 1975 Television in the 1970s was marked by the number of wholesome family series that drew large audiences. One of the most loved and enduring was "The Brady Bunch." This is a scene from an episode titled "A Very Brady Christmas."

c. 1973 Jimmie "J. J." Walker (1947–) was born in New York's South Bronx, and realized he had a talent for making people laugh when his first gig in Harlem floored the crowd. In 1972 Walker was cast in Norman Lear's new comedy series, "Good Times." "Dyn–o–mite!" was the slogan of the 1970s and *Time* Magazine named him Comedian of the Decade.

1975 From its inception, the raucous late–night comedy show "Saturday Night Live" was one of television's most innovative and popular television programs. Here, John Belushi (1949–1982) as the "Samurai" acts in a skit with writer/actor/director Buck Henry (*above*).

1975 "Saturday Night Live," which remains popular today, not only blazed new trails in television programming but launched the careers of dozens of future television and movie stars. In this scene (*above right*) on the SNL set are, left to right: Al Franken, John Belushi, Gilda Radner, and Lorraine Newman.

c. 1973 In the 1970s, the major TV networks became enamoured of the morning news program. In this picture (*right*) we see Jack Lescoulie, Hugh Downs, Barbara Walters, and Frank Blair, stars of NBC's "Today."

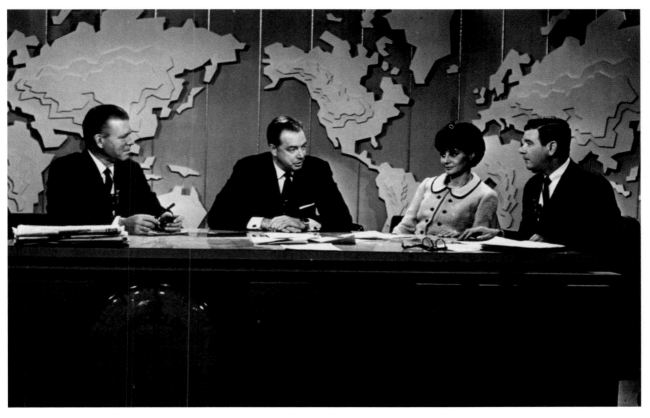

1972 Bill Cosby (1937–) changed the way African-Americans were portrayed on television. He accomplished this first with his starring role in the series "I Spy" and then with his top-rated program "The Cosby Show," which provided young blacks with positive role models. He is shown here with the famed musician Ray Charles.

c. 1978 Actor David Carradine (1936–), the son of actor John Carradine, has appeared in many movies. His greatest fame has come, however, from his starring role in the 1970s internationally popular television series "Kung Fu" (*left*).

c. 1976 The long-running television series "M.A.S.H.," still watched in reruns by millions of viewers, went beyond its laugh-filled scripts to present a powerful anti-war statement. Here (*right*) are cast members Loretta Swit, Wayne Rogers, MacLean Stevenson, and Alan Alda (at the steering wheel), who played the endearingly roguish surgeon "Hawkeye."

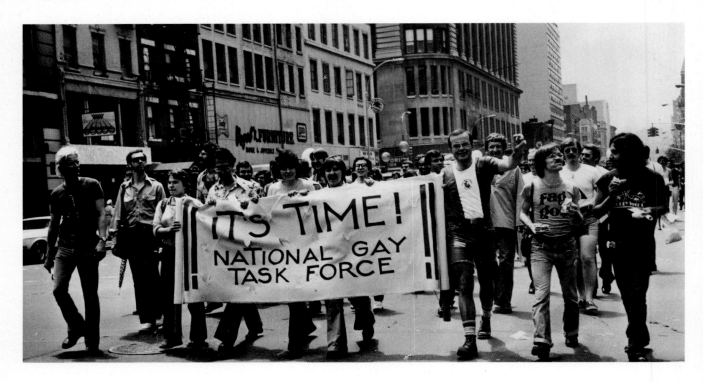

1975 During the 1970s, American minority groups continued their crusade for equal rights. This group (*above*) was marching to demonstrate its support for an amendment to the 1964 Civil Rights Act, which would include gay rights provisions.

1979 The man in clerical garb is the Reverend John Kuiper (*below*), marching to celebrate the fact that the New York state legislature had made him the first gay man to win the right to adopt a child.

1975 By 1975, gay rights parades had become annual events in many American cities. These men and women (*right*) were marching down New York's 4th Avenue.

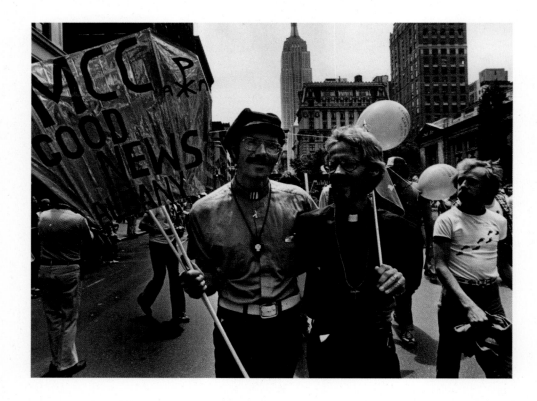

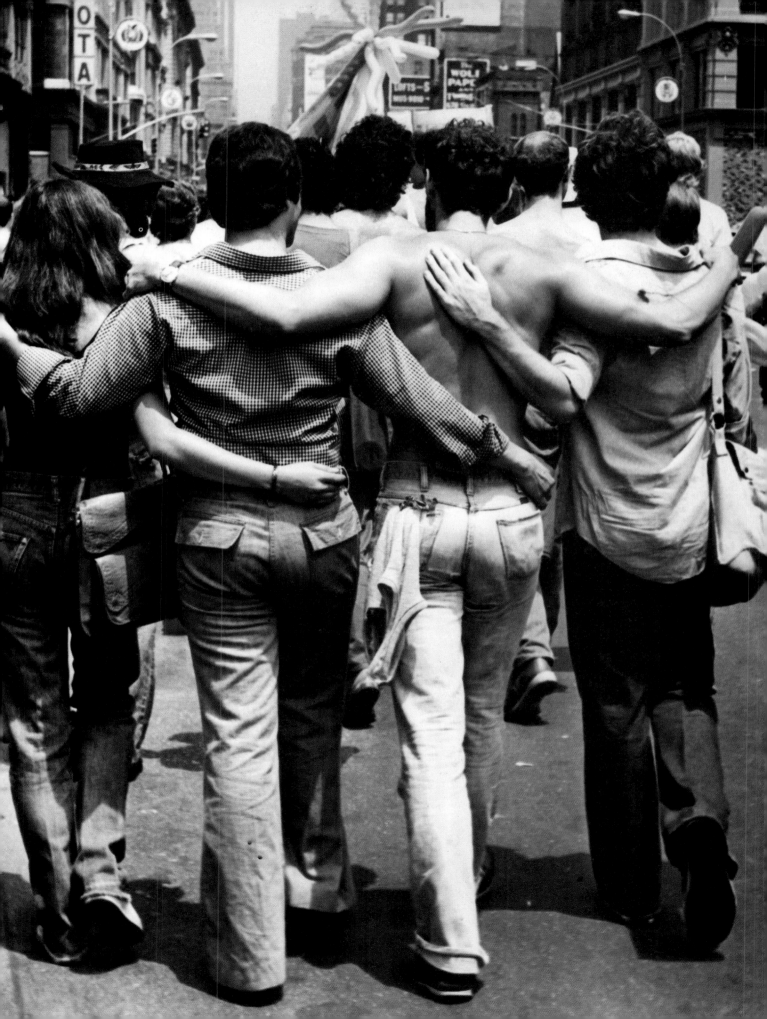

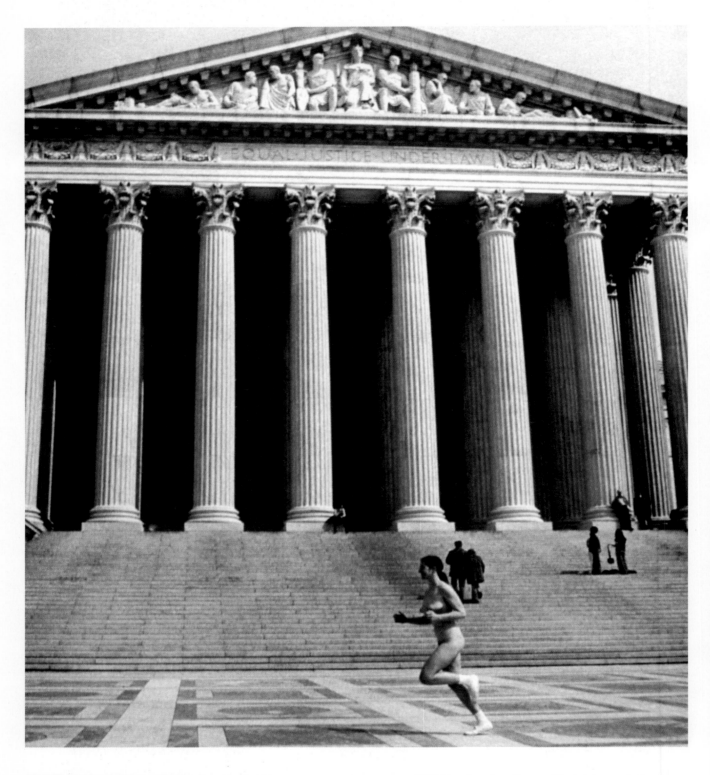

1974 The 1970s introduced Americans to that bizarre phenomenon known as the streaker. Here, on April Fool's Day, a young woman streaks past the Supreme Court Building in Washington, D.C.

1971 The decade witnessed many demonstrations on behalf of women's rights. This woman chose a space suit as her attire for marching in a women's liberation parade.

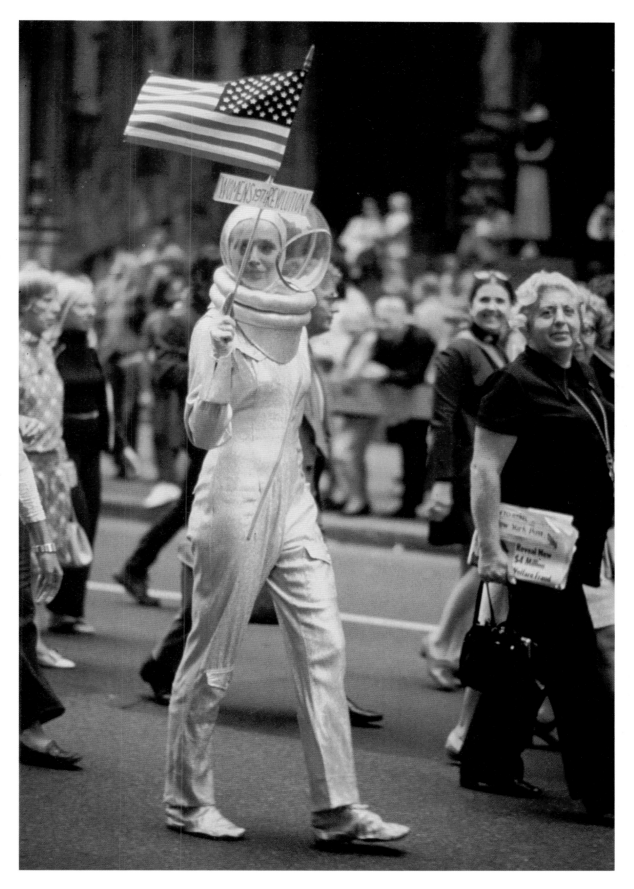

c. 1972 Feminist leader and writer Betty Friedan (1921–) rose into prominence with her book *The Feminine Mystique* (1963). The founder of the National Association of Women (NOW) in 1966 and its first president, she stressed new female societal roles and campaigned tirelessly for the passing of the Equal Rights Amendment.

WOMEN AGAINST PORNOGRAPHY

1979 Feminist Gloria Steinem (1934–) has been a leading figure in the women's movement (left). A co-founder of *Ms.* magazine, she led many protest against both the Vietnam War and racial discrimination.

1970 New York congresswoman Bella Abzug (1920–) speaks at a rally on Women's Strike for Equality Day (*right*). Nicknamed "Battling Bella," she founded both Women Strike for Peace and the National Women's Political Caucus.

1978 Ernst Haas used strong highlights in his color images to achieve the effects he sought. In this photograph of a Mardi Gras celebrant, he dramatically contrasted the woman's bright red lipstick and pink collar with the texture of her black skin.

1974 In a scene that might well be titled "Freedom from Convention," two long-haired young men play handball against a graffiti-covered wall in New York's Central Park.

1979 Ernst Haas's brilliant use of color in many of his photographs can be seen in this picture of children (*previous pages*) enjoying iced treats at a Fourth of July Maine fair.

c. 1974 As fashion editor of *Harper's Bazaar* and longtime editor–in–chief of *Vogue* magazine, "high priestess of style" Diana Vreeland (1901–1989) influenced clothing styles both in the United States and abroad.

1978 The jet–setting American designer Roy Halston Frowick (*above*), known simply as Halston (1930–1990), set many trends in easy–to–wear clothing. His understated designs won him many industry prizes including four coveted Coty Awards.

1970s

c. 1970 New York City pulses with energy and this is never more evident than at night, when literally millions of lights dazzle the sky. This purposely blurred photograph by Ernst Haas intensifies the brilliant effect.

1970s

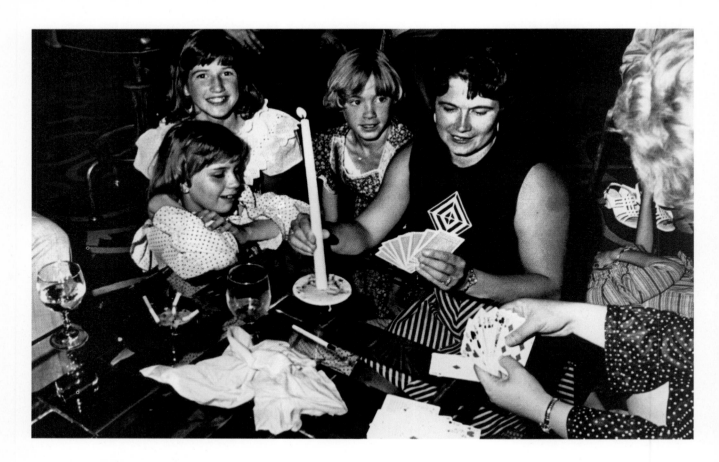

1977 On July 13, 1977 the extraordinary demand for electricity in New York City – caused by an extreme heat wave – occasioned a power overload that plunged almost the entire city into darkness. Here New Yorkers play cards by candlelight during the blackout.

c. 1975 By the mid–1970s, bathing fashions had changed dramatically. This young woman was strolling along the beach at New York's Coney Island.

1970 With almost no place to expand horizontally, New York City continued to grow vertically. These were the 110–story twin towers of the World Trade Center during their construction.

c. 1970 Georgia O'Keeffe (1879–1986), known for her spare paintings of flowers and the New Mexican landscape, was a pioneer of abstract art. O'Keeffe's striking features were the subject of many famous photographers, including her husband, Alfred Stieglitz.

c. 1973 In the 1970s Andy Warhol focused on painting portraits of celebrities from Elizabeth Taylor to Mao Tse-tung. From 1969 until his death, he published *Interview*, a monthly magazine on the latest fashions, films, music, art, and stars – Warhol's world.

1978 Harold Robbins (1916–1997), a high school dropout, made himself famous and enormously wealthy through the string of spicy best-selling novels he wrote about high finance, Hollywood, and life on the streets. One of his books, *The Carpetbaggers* (1961) sold more than six million copies.

c. 1975 Kurt Vonnegut (1922–) won worldwide acclaim with his book *Slaughterhouse Five* (1969), a work based on his experiences as a prisoner-of-war during World War II. Vonnegut's novels, most of which are satirical fantasies, include *Player Piano* (1952), *Cat's Cradle* (1963), *Deadeye Dick* (1982), and *Hocus Pocus* (1990).

1974 In the 1970s, America's gigantic strides in space continued. Here *Skylab*, the nation's first space station, orbits the earth with its panels deployed.

1972 In this photograph, a NASA photographer captured the exact moment of the launch of the *Pioneer 19* spacecraft as it started on its journey to Jupiter. After passing Jupiter *Pioneer 19* continued on out of the solar system, becoming the first terrestrial craft to venture into interstellar space.

1973 The long and bitter Vietnam War was among the most divisive conflicts in the country's history. This was the scene in Paris on January 23, 1973 (*above*) as at long last, the Vietnam Peace Agreement was about to be signed.

1970 Henry Kissinger (1923–) became President Richard Nixon's adviser on national security matters in 1969 and was the primary negotiator in the talks that eventually ended the Vietnam War. Kissinger (*below*) served as Secretary of State under Presidents Nixon and Gerald Ford.

1975 The official end of the Vietnam War brought with it to America a huge, collective sigh of relief. Here (*right*) a large crowd in New York's Central Park celebrates the end of the conflict.

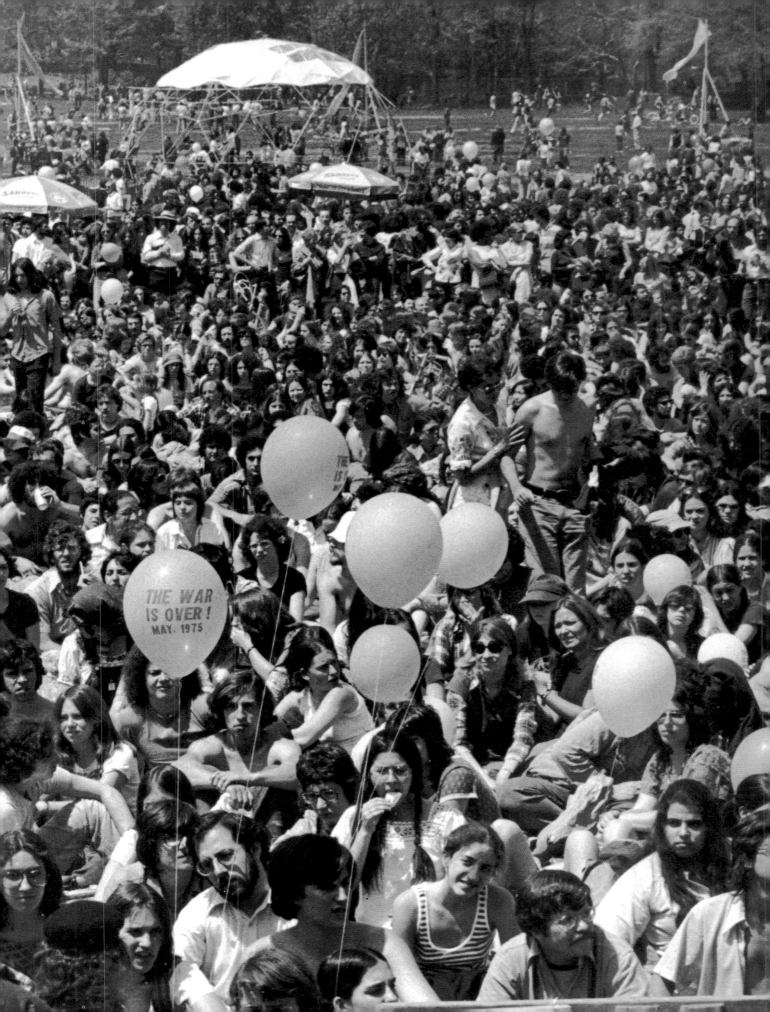

THE WAR
IS OVER !
MAY. 1975

1976 In 1976 **Jimmy Carter** (1924–) became the 39th President in the United States when he defeated Gerald Ford in an extremely close election. Defeated for reelection 1980 by Ronald Reagan, Carter has spent his post–presidency years working vigorously for human rights and on relief projects.

1978 President Jimmy Carter, Egyptian President Anwar al–Sadat, and Israeli Prime Minister Menachem Begin meet at the U.S. presidential retreat at Camp David, Maryland. The result of the meetings was the Camp David Agreement for peace in the Middle East, a high point of the Carter administration.

c. 1970 A young John F. Kennedy, Jr. walks with his nanny and his dog in New York City.

c. 1975 In the 1970s, America's heavy dependency on Middle Eastern oil took its toll. As fuel exports to the United States were reduced dramatically, service stations were forced to limit customers' purchases or resort to the tactic indicated by the sign.

c. 1975 When President Richard Nixon was forced to resign as a result of the Watergate scandals, Vice President Gerald R. Ford (1913–) became the 38th President of the United States. Ford won the nation's appreciation through the way he set the country back on course after the long period of turmoil caused by the scandals.

c. 1979 Industrial photographs have long been a favorite subject of magazine photographers. In this picture, two workers toil at an oil refinery in Texas.

1972 American labor union leader George Meany (1894–1980) addresses a labor rally (*above left*). Meany was elected president of the American Federation of Labor in 1962. In 1955 he became president of the combined AFL–CIO, a post he held for 25 years.

c. 1972 Shirley Chisholm (1924–) was the first African-American woman to be elected to the U.S. House of Representatives (*above right*). Holder of master's degrees from Columbia University, in 1972 she became the first black woman to run for president.

1972 In the 1970s, Americans were made more conscious than ever of the plight of the first Americans. This teepee (*right*) was set up outside the Bureau of Indian Affairs in Washington, D.C., in protest of the government's treatment of Native Americans.

1970 Political activist Abbie Hoffman (1936–1989) speaks at a flag-themed art show at New York City's Hudson Memorial Church (*left*). Hoffman co-founded the radical Youth Party International (Yippies) with Jerry Rubin in 1968.

1978 Known as "Colorado Gold," the aspens that grow on the sides of Colorado's Rocky Mountains provide a breathtaking sight.

c. 1970 Ernst Haas was able to portray beauty in even the most common objects. This is his photograph (*previous pages*) of telephone poles running along the desert between Los Angeles and Las Vegas.

1976 A flood-lit cross and a crescent moon provide the
dramatic effects in Ernst Haas's photograph, taken in the
darkness of Palm Springs, California.

1978 Among the most spectacular of Ernst Haas's
color images is this photograph of high rolling dunes
taken in Great Sand Dunes National Monument (*following
pages*) at the foot of the Sangre de Cristo Mountains.

c. 1974 By the 1970s, vacations in the great outdoors had become a favorite form of recreation for millions of Americans. These vacationers were enjoying a group meal in one of the nation's many trailer parks.

1970 In order to fully portray its beauty, Ernst Haas took his camera deep into the environs of the Grand Canyon, where he was able to capture this unique ground-level image.

c. 1975 Producer/composer Jacques Morali conceived the campy, wildly costumed group the Village People – international sensations in the days of disco. "Macho Man," "Y.M.C.A.," and "In the Navy" all reached the top of the charts, and by the end of the decade the Village People had sold over 65 million albums.

1976 America's bicentennial celebration provided the nation's photographers with intriguing opportunities. These sousaphone players and members of the U.S. Army band (*previous pages*) were marching along Washington's Constitution Avenue.

1977 The man in the tuxedo relaxing at Studio 54 is famed dancer Mikhail Baryshnikov (1948–). Next to him are actresses Shirley MacLaine (1934–) and Farrah Fawcett.

1979 Donna Summer (1949–) defined the 1970s pop music generation. Known as the Queen of Disco, her hits such as "Last Dance," "MacArthur Park" and "Dim All the Lights" kepts the crowds "Hustling" the night away.

1978 New York's Studio 54 was more than a music-filled nightclub. It was a happening where those lucky enough to gain admission were never sure what they might encounter – one night it was Lady Godiva (*left*).

c. 1970 The hard-rocking Joan Jett (1958–) became an inspiration for generations of female rock singers. Jett first gained popularity with the Runaways, and later scored top 40 hits with her own band called the Black Hearts. The song "I Love Rock–n–Roll" has become a classic, and helped propel her into an international success, with over 22 million albums sold.

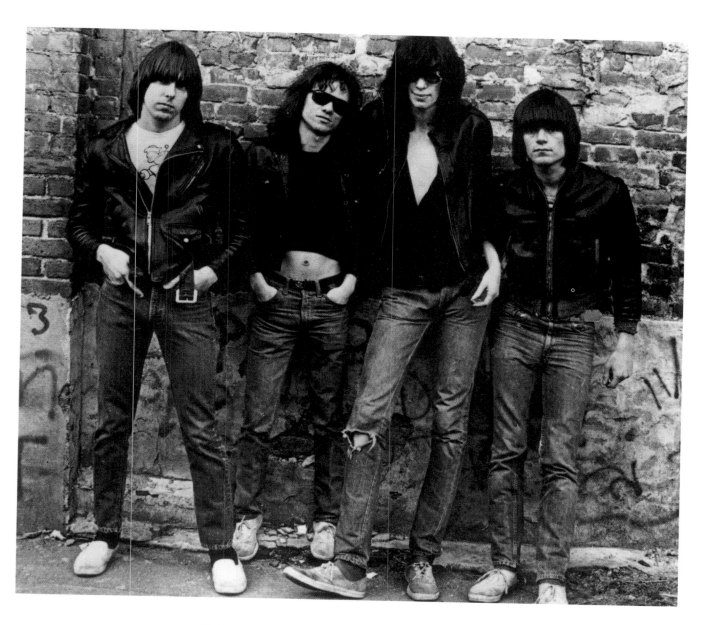

1976 In 1974 four musicians from Queens, New York –
Joey (Jeffrey Hyman, 1952–), Johnny (John Cummings, 1951–),
Dee Dee (Douglas Colvin, Sept. 18, 1952), and Tommy (Tom
Erdelyi, 1952–) – all took the last name Ramone. The
Ramones pared down rock-and-roll, sped up the tempo,
and upped the volume to become the uncontested leaders
of the emerging New York punk rock scene, earning a cult
following at the East Village nightclub CBGB.

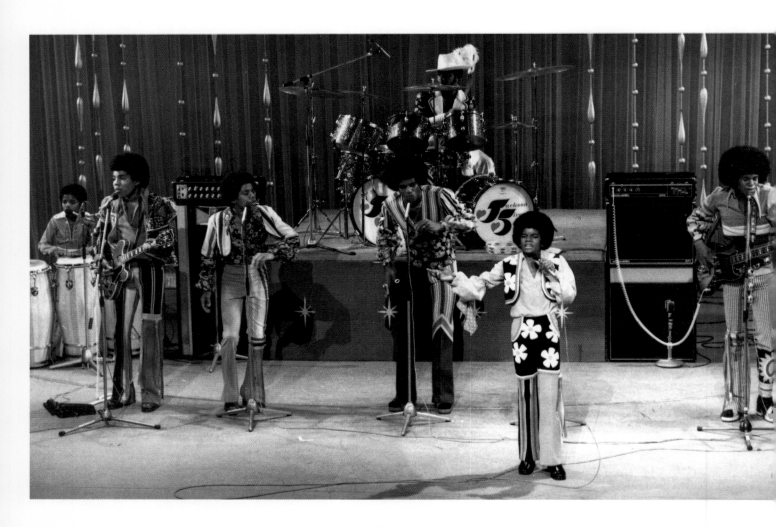

1972 The young performer at the front of this pop group known as the Jackson Five is Michael Jackson (1958–). Before the decade was over he would become an international star, known for his unique style of dancing and the imaginative choreography of all his performances.

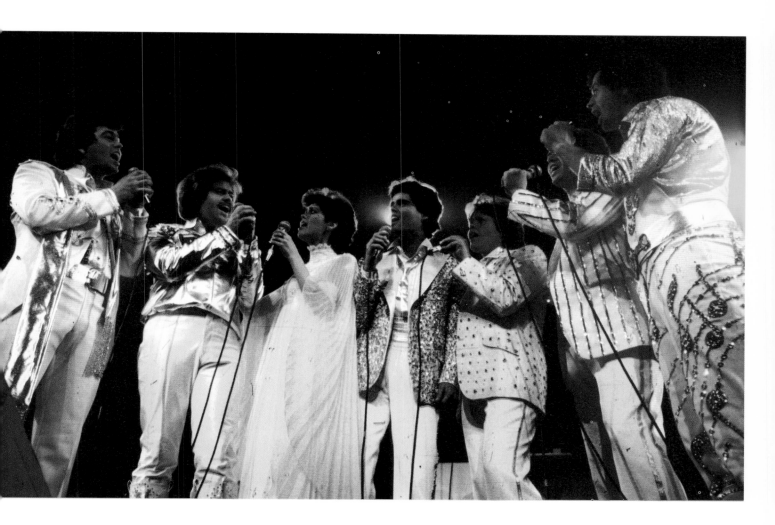

1979 In the 1970s, the Osmonds became known as the "first family of pop." They are shown here at a royal charity performance in London's famed Albert Hall.

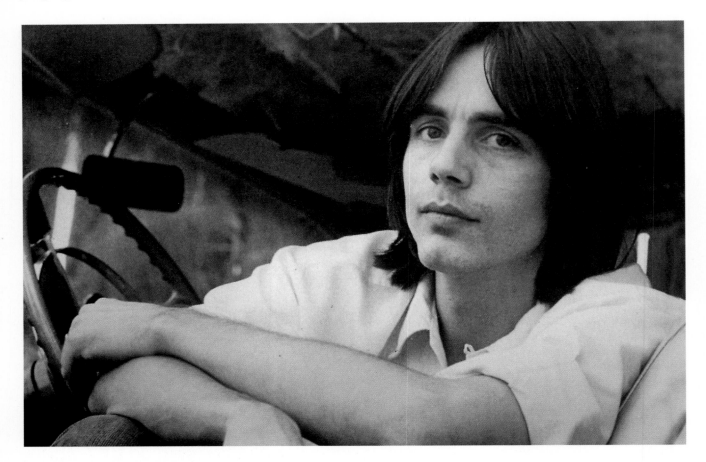

c. 1975 Jackson Browne's (1948–) reflective, literate lyrics and easy folk–rock style resonated with the 1970s' generation (*above left*). His 1976 album *The Pretender* and its 1977 follow–up, *Running on Empty*, both went platinum.

c. 1975 The singing duo of Karen Carpenter (1950–1973) and her brother Richard (1946–) were popular with both adults and young people (*above right*). In 1970 their album *Close to You* reached number one on the charts.

c. 1972 James Taylor and Carole King (*right*) were two of the 1970s most accomplished singers and songwriters. Taylor's *Sweet Baby James* and King's *Tapestry* were among the best-selling albums of the decade.

c. 1979 Singer, songwriter Neil Diamond (1941–) began his career by writing hit songs such as "I'm a Believer" and "A Little Bit Me and a Little Bit You" for the group the Monkees (*left*). In 1970 he had his own hit with "Cracklin' Rosie." Along with his many other hit songs and a successful singing career, Diamond starred in the remake of the movie *The Jazz Singer*.

c. 1972 He was older, he was heavier, and some of his performances were uneven, but despite all the newcomers, Elvis was still the King.

c. 1975 Yoko Ono (1933–) gained national attention in 1969 when she married famed Beatle John Lennon. An artist and singer in her own right, Ono worked closely with her husband in the peace movement.

c. 1979 For many rock fans, the louder the music, the more outlandish the costumes, the more outrageous the performance, the better it was. Here (*above*) we see singer/ bass guitarist Gene Simmons and lead/rhythm guitarist Paul Stanley of the highly popular rock group Kiss.

1970 Frank Zappa (1940–1993) was an avant-garde rock musician and composer who led the "underground" band the Mothers of Invention. Zappa (*right*) was also a filmmaker who created and wrote the music for the film *200 Motels*. A classical musician as well, many of Zappa's compositions have been performed by leading classical conductors.

c. 1979 In the 1970s, soul music gained new prominence. Barry White (1944–), with his unmistakable gravelly velvet voice, still seduces lovers everywhere with platinum hits such as "You're the First, the Last, My Everything," "Never, Never, Gonna Give Ya Up" and "Can't Get Enough of Your Love, Babe" (*left*).

769

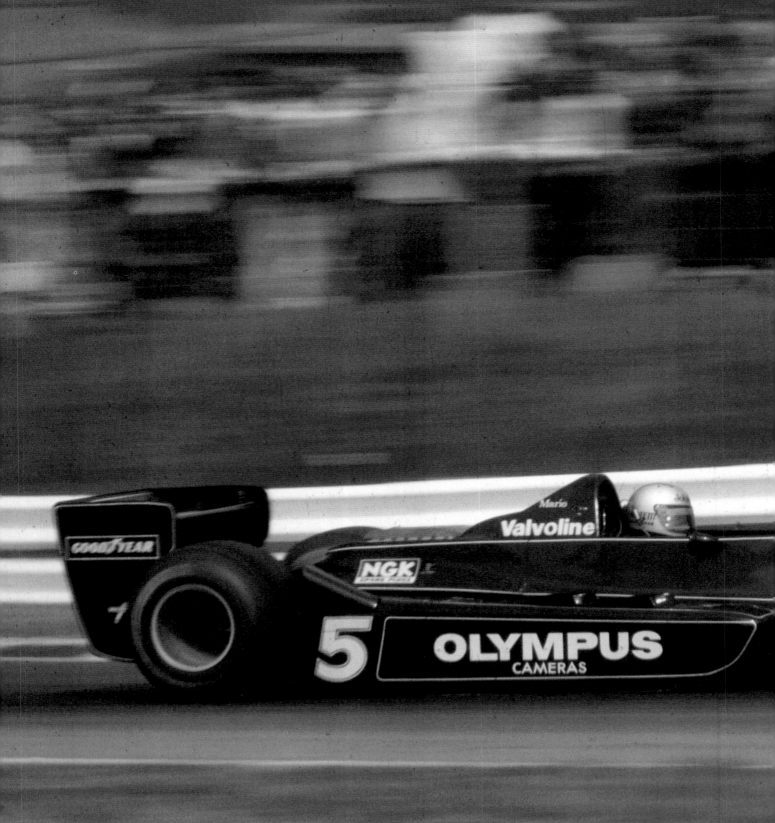

1978 In the 1970s, car racing continued to thrill millions of spectators. Here legendary driver Mario Andretti (1940–) pours on the speed during the British Grand Prix.

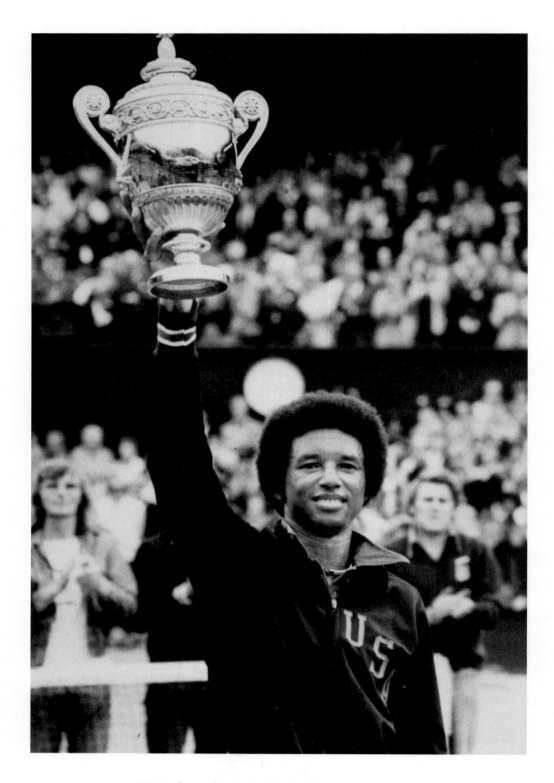

1975 Arthur Ashe (1943–1993) displays the coveted trophy after winning the men's singles Wimbledon title. Also a winner of the U.S. Open and Australian championships, Ashe, through his demeanor and charitable work, was a role model for millions of young African-Americans.

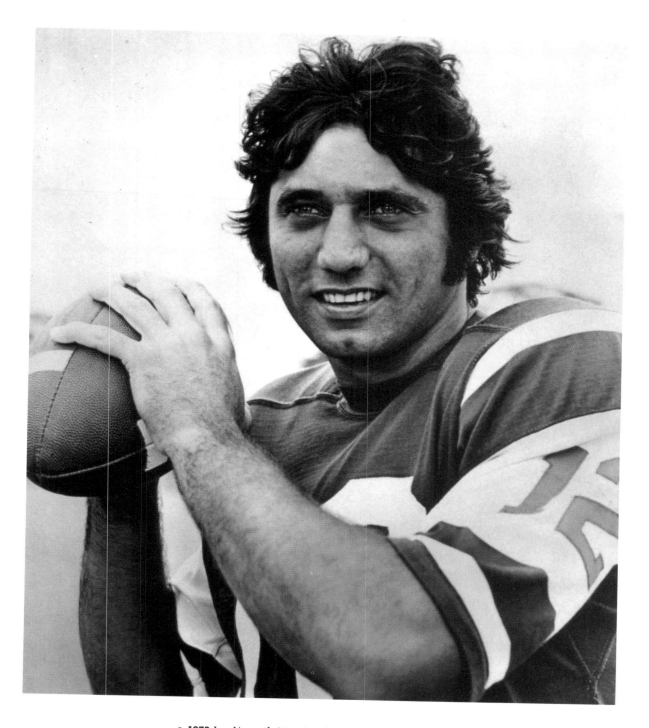

c. 1970 Joe Namath (1943–) ranked among the most popular athletes of the 1970s. The star of his unbeaten University of Alabama football team, Namath went on to even greater fame as the quarterback of the New York Jets. His greatest sports moment came in 1969 when he led the Jets to an improbable Super Bowl victory over the highly favored Baltimore Colts.

1970s

1979 As professional football
began to rival the popularity of
major league baseball, football
stadiums became even bigger
and more luxurious. This is the
Superdome in New Orleans.

c. 1972 Nolan Ryan (1947–) pitched more non-hitters (seven) than any other pitcher in baseball history. Regarded as one of the fastest hurlers ever, he is seen here tipping his hat to the crowd after just missing yet another no-hit game.

c. 1970 Known as Terrific Tom, Tom Seaver (1944–) enjoyed a brilliant 20-year pitching career, mainly with the New York Mets and Cincinnati Reds. He won 311 games and three Cy Young Awards. In 1992 Seaver was elected to the Baseball Hall of Fame.

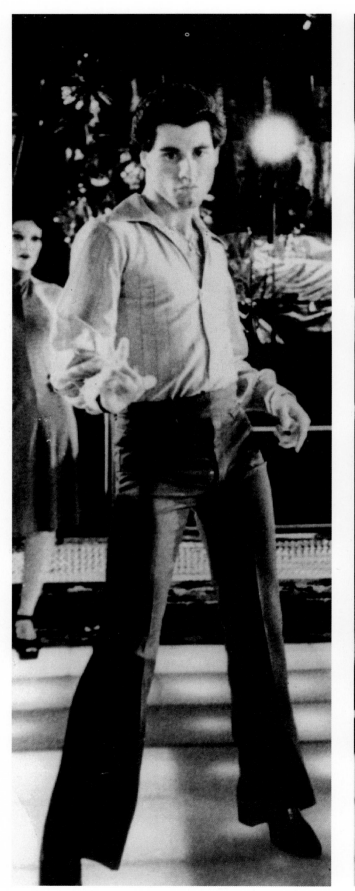
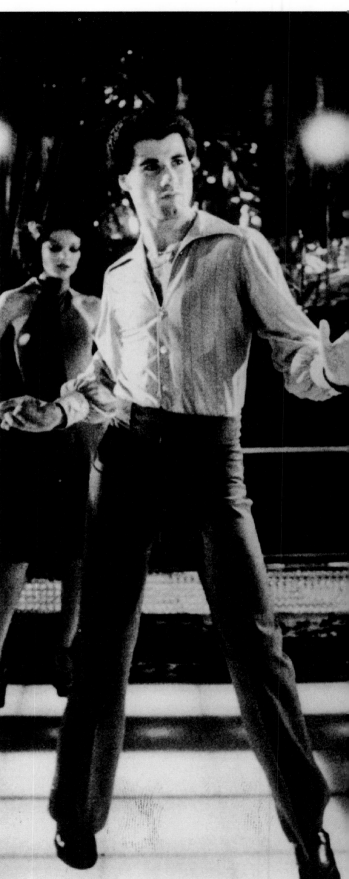

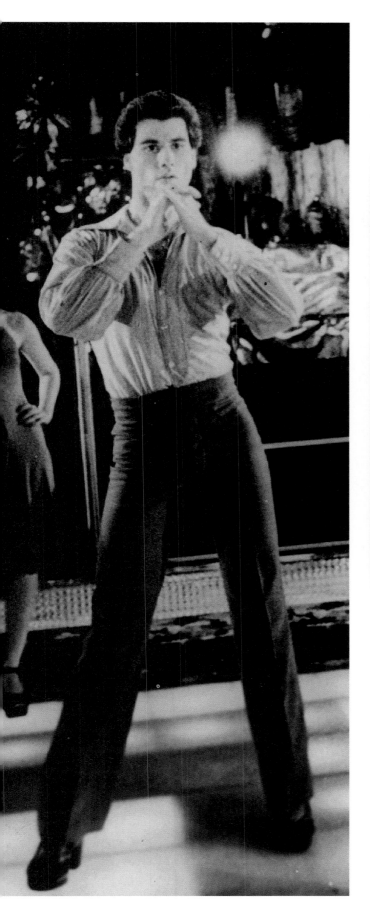

1977 John Travolta (1954–) and Olivia Newton-John (1941–) celebrate during the filming of the movie *Grease*. One of Hollywood's most sought-after actors, Travolta's films include *Urban Cowboy* (1980) and *Pulp Fiction* (1994). Newton-John was an internationally acclaimed pop singer before entering the movies.

1977 One of the top movies of the 1970s was the film *Saturday Night Fever*, in which John Travolta gave a dynamic performance in the role of Tony Manero, king of the Brooklyn disco scene.

c. 1978 Henry Mancini (1924–1994) began his musical career as an arranger and pianist for the Glenn Miller Orchestra. He won his greatest fame for the music and theme songs he wrote for both movies and television. His Academy Award–winning songs include "Moon River," and "Days of Wine and Roses." He also won Oscars for the entire scores of *Breakfast at Tiffany's* and *Victor/Victoria*.

c. 1972 Dancer and choreographer Jerome Robbins (1918–) was director of the New York City Ballet when he teamed with Leonard Bernstein in creating the musical *West Side Story*. Robbins's other Broadway musicals include *Gypsy* and *Fiddler on the Roof*.

1976 Sylvester Stallone (1946–) attained superstar status with his performances in the movie *Rocky* and the four sequels that followed it. He is shown here in a scene from *Rocky* along with costar Talia Shire, sister of director Francis Ford Coppola.

1978 Accomplished actor Christopher Reeve (1952–)
became known to millions as the title character in *Superman*.
In 1995 Reeve was paralyzed in a riding acident; unwilling
to let his disability affect his career, he directed the 1997
HBO TV movie *In the Gloaming*, and produced and starred
in the 1998 TV movie remake of *Rear Window*.

1974 Film director and screenwriter Francis Ford
Coppola (1939–) (*above*) is best known for his three block–
buster *Godfather* movies. His other films include *Apocalypse
Now*, *The Cotton Club*, and *Bram Stoker's Dracula*.

1976 Actor Al Pacino (1940–) strolls down New York's
Madison Avenue (*right*). Respected as one of Hollywood's
most sensitive actors, Pacino's films include *The Godfather* and
its sequels, *Serpico*, *Dog Day Afternoon*, and *Dick Tracy*. In 1992
Pacino won the Academy Award for his role as a blind
Lieutenant Colonel in *Scent of a Woman*.

1974 Acclaimed actor Robert De Niro (1943–), in vest (*left*),
has won Academy Awards for his roles in *Godfather II* and
Raging Bull. His numerous movies include *Taxi Driver*, *The Deer
Hunter*, *Awakenings*, *Casino*, and *Sleepers*. Now owner of his own
production company, De Niro began his directing career in
1992 with the film *A Bronx Tale*, in which he played the leading
role. He is shown with director Francis Ford Coppola in a
scene from *The Godfather II*.

1974 **Moviegoers had never seen** anything quite like the terrifying and visceral film *The Exorcist*, directed by William Friedkin (1939–). Millions sat on the edge of their seats as a young priest attempted to exorcise a 12–year–old girl from demon possession. Friedkin is shown here directing the movie's young star Linda Blair.

c. 1978 **The film *Midnight Cowboy*** was a box office smash and won the Academy Award for best film. Here the stars of the movie John Voight (1938–) and Dustin Hoffman (1937–) embrace at one of the film's receptions.

1979 **Actor/director Robert Redford** (1937–) has long been one of Hollywood's most popular leading men. His films include *Butch Cassidy and the Sundance Kid, The Sting, The Way We Were, All the President's Men*, and *Out of Africa*. In 1992 Redford established the Sundance Institute, dedicated to the development of theatrical talent and sponsor of the annual Sundance Film Festival in Park City, Utah.

c. 1975 Actor/director Clint Eastwood's (1930–) movie career was launched in the mid–1960s with Italian–made westerns. His movies include the *Dirty Harry* films, *Play Misty for Me*, *Bridges Of Madison County*, and *Absolute Power*. In 1992 he won oscars for best director and actor and of the film *Unforgiven*.

1979 Actress Sigourney Weaver (1949–) peers out from her space helmet in Ridley Scott's ultimate monster movie *Aliens*. The star of three *Aliens* sequels, Weaver's movies also include *The Year of Living Dangerously*, *Gorillas in the Mist*, and *The Ice Storm*.

1977 *George Lucas's* (1944–) archetypal masterpiece *Star Wars* changed filmmaking forever – the epic space opera transformed the classic story of good–versus–evil into a blockbuster with never–seen–before special effects that trancended the genre. One of the top–grossing movies in history, *Star Wars* is part four in a six–part series that includes *The Empire Strikes Back* (part five) and *Return of the Jedi* (part six). In this scene members of the "Force" prepare for battle against the "Dark Side." From left to right: Peter Mayhew (Chewbacca), Mark Hamill (Luke Skywalker), Alec Guinness (Ben [Obi–Wan] Kenobi), and Harrison Ford (Han Solo).

1974 Woody Allen (1935–) has been one of Hollywood's most prolific directors and comedic stars. His many films include *Bananas, Annie Hall, Hannah and Her Sisters, Husbands and Wives,* and *Bullets over Broadway.* He is shown here with actress Diane Keaton in the film *Love and Death,* which Allen wrote and directed.

1974 Known to the world simply as "Jack," Jack Nicholson (1937–) has long been one of Hollywood's greatest stars. His diverse films include *Chinatown, The Shining, Prizzi's Honor, Batman,* and *A Few Good Men.* Nominated many times for the Academy Award, he won Oscars for his roles in *One Flew over the Cuckoo's Nest, Terms of Endearment,* and *As Good As It Gets.*

1976 Actress Jodie Foster (1962–) as a 12-year-old prostitute in the film *Taxi Driver.* She was only 14 when she starred in both this film and *Bugsy Malone.* Foster won Academy Awards for her roles in *The Silence of the Lambs* and *The Accused.*

c. 1979 Mary Cathleen Collins, known as Bo Derek (1956–)
scored a "perfect ten" in the Blake Edwards hit comedy *10*. Derek
played the romantic obsession of the frustrated Dudley Moore,
and went on to become a sex symbol for the next decade.

1975 *The Rocky Horror Picture Show*, directed by Jim Sharman, is
still shown regularly around the world. An outrageously decadent
rock–and–roll musical that spoofed science fiction, suburbia, and
gender, the movie became an instant cult classic. Midnight movie-
goers throughout the 1970s dressed as characters from the movie
and acted it out in front of the screen, complete with props such as
rice, water pistols, and confetti – a practice still going strong today.

1980s

1988 American track star Carl Lewis (1961–) soars through the air during the long jump event at the Olympic Games in Seoul, Korea. Lewis went on to win the gold medal in the event.

In the 1980s a Hollywood movie star became President of the United States, the Supreme Court welcomed its first female justice, and, for the first time, a woman became a vice-presidential candidate of a major party. The nation celebrated the 100th birthday of the Statue of Liberty and the computer became an essential part of American life.

In sports, Jack Nicklaus ruled the fairways, Jimmy Connors and John McEnroe were kings of the court, and a young man named Michael Jordan soared high above the hoop. Rap music was introduced, Bruce Springsteen and Madonna thrilled concertgoers, the Vietnam Memorial was dedicated, and millions of Americans tuned in weekly to discover what a television character named J. R. Ewing would do next.

1985 President Ronald Reagan (1911–) meets with Soviet leader Mikhail Gorbachev in the White House (*above*). A former Hollywood actor and governor of California, Reagan became the nation's 40th president when he was elected in 1980.

1986 Thousands cheer and fireworks fill the sky (*previous pages*) as the nation celebrates the 100th anniversary of the installation of the Statue of Liberty in New York Harbor.

c. 1980 The television series "Dallas" was a runaway hit in the United States and in the many other nations in which it was shown. Among the show's trademarks were its unsavory lead character J. R. Ewing, played by Larry Hagman (*right*) and the cliffhanger final episode of each season's run.

1980s

1985 In the early 1980s,
artist Keith Haring's (1958–1990)
distinctive graffiti – graphic,
symbolic paintings of dancing
figures, dogs, and babies –
began to appear in New York
City subways and street signs.
Haring went on to become an
internationally successful artist;
his large-scale works appeared
in many museums and public
spaces. Here he works on a
giant painting for the Palladium
nightclub in New York.

1980 Sculptor and printmaker Louise Nevelson (1899–1988) began her career as an assistant to famed Mexican mural-painter Diego Rivera. She is best known for her abstract vertical wood sculptures.

c. 1985 Jean–Michel Basquiat (1960–1988) had no formal art training, but the talented former graffiti artist became a vibrant member of the downtown New York City gallery scene in the 1980s. His colorful, primitive paintings combined imagery from diverse sources, including ancient Egyptian, African, and popular art.

c. 1980 Geraldine Ferraro (1935–) was a successful lawyer and an assistant district attorney before being elected to the U.S. House of Representatives in 1981. In 1984 Ferraro earned a place in history when she was selected by Walter Mondale to be the first woman vice–presidential candidate of a major political party.

1980 Ronald Reagan tried unsuccessfully for the Republican Party's presidential nomination in both 1968 and 1976. In 1980, however, he won the nomination and the final election, defeating incumbent Jimmy Carter. Reagan, the nation's 40th president, is shown with his wife Nancy during the 1980 campaign.

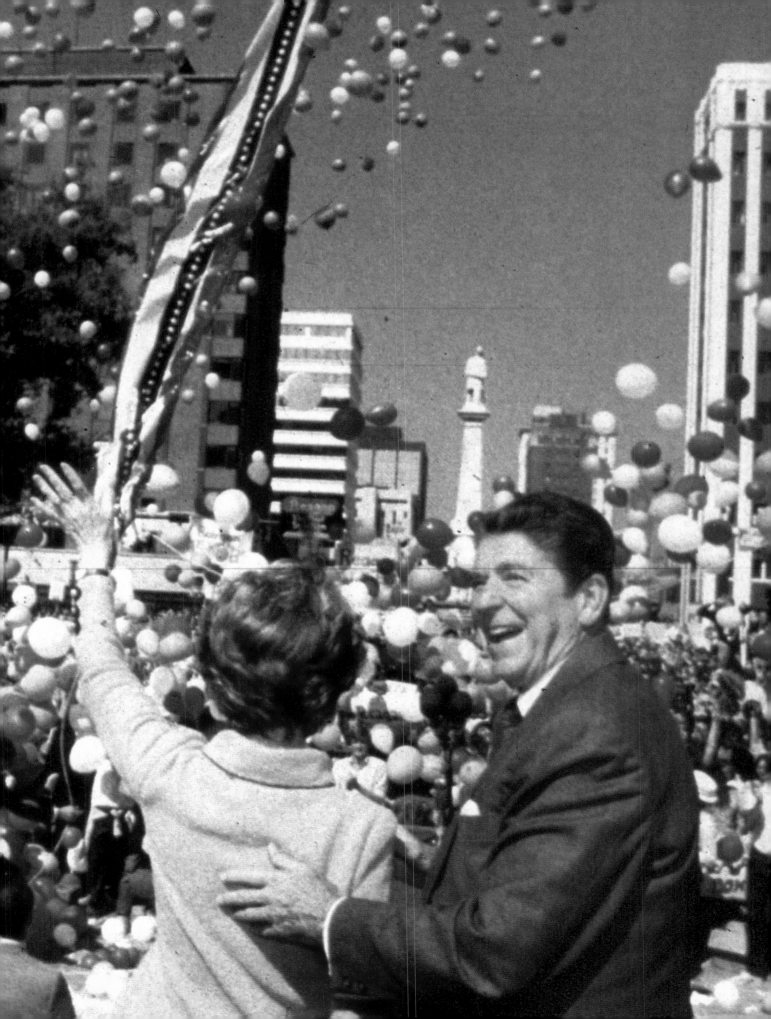

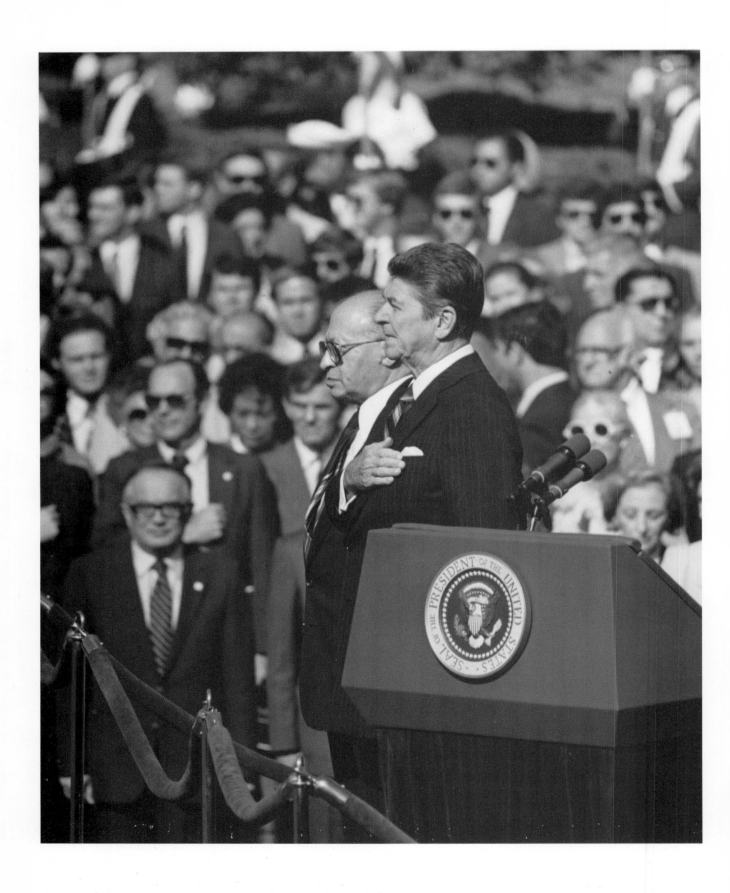

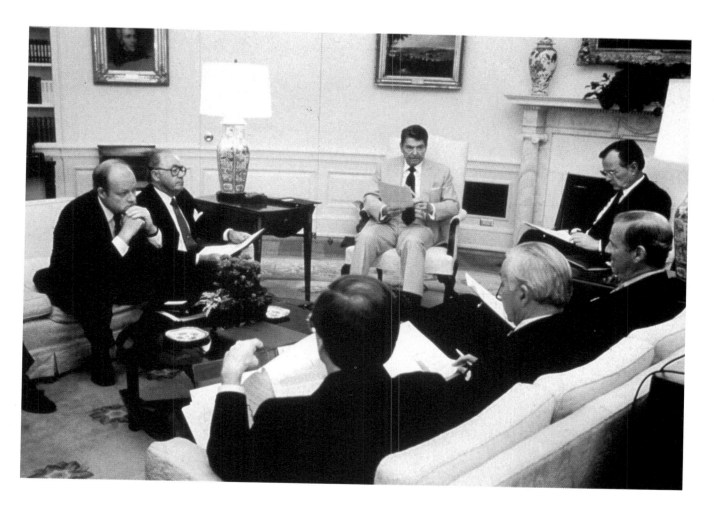

c. 1985 President Ronald Reagan meets with his council of economic advisors. Seated in the chair next to Reagan is his vice president, George Bush.

1981 During Ronald Reagan's eight years as president, events in the Middle East often captured the nation's attention. Here Reagan and Israeli Prime Minister Menachem Begin listen to the U.S. national anthem before meeting to discuss Middle East problems.

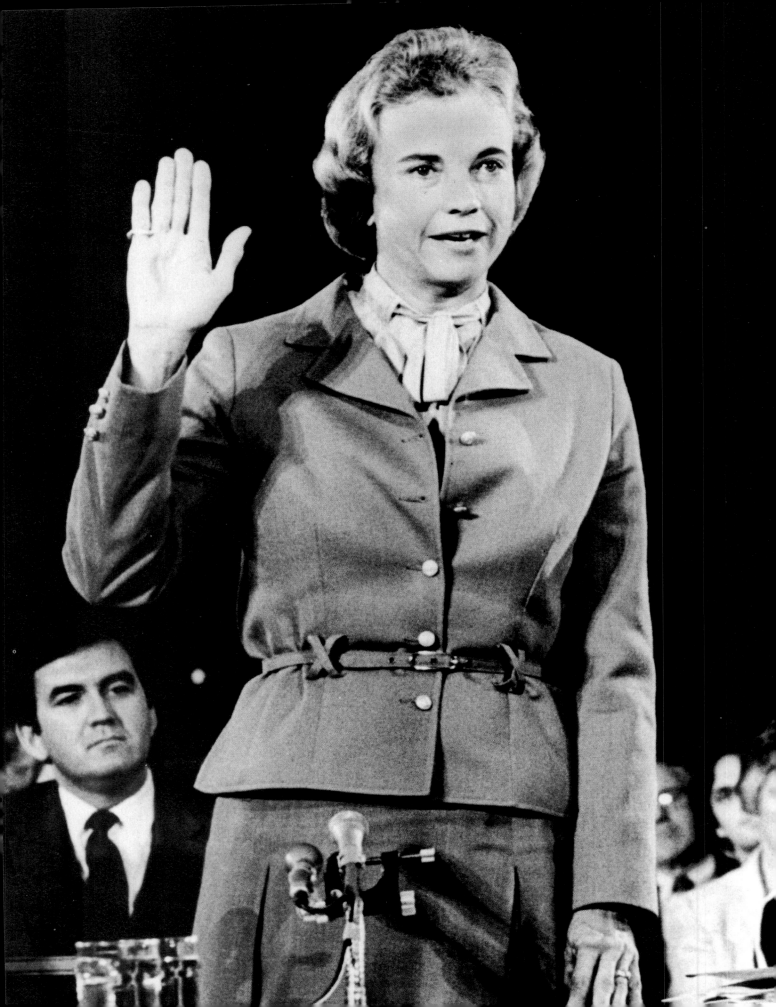

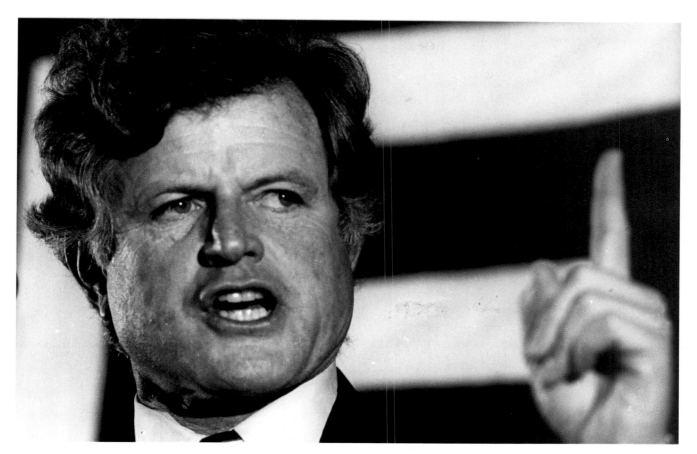

1980 The younger brother of John and Robert Kennedy, Edward Kennedy (1932) was elected to the U.S. Senate from Massachusetts in 1962 and has continued to serve effectively in that post ever since. Kennedy has been the sponsor of many bills aimed at bringing relief to the disadvantaged.

1988 Reverend Jesse Jackson (1941–) was a key activist in the Civil Rights Movement of the 1960s and has remained an articulate spokesman for African–American rights. Jackson ran for the presidency in both 1984 and 1988, becoming the first African–American to campaign seriously for the office.

1981 Sandra Day O'Connor (1930–) became the first female justice of the U.S. Supreme Court. Prior to this position, O'Connor was the assistant attorney general of Arizona and a judge of the Arizona Court of Appeals. She is shown here during her U.S. Senate confirmation hearings.

c. 1985 The four men in this picture shared a common experience: they were all the mayor of New York City. Left to right are Robert Ferdinand Wagner, Jr. (1910–1991), Edward Irving Koch (1924–), Abraham David Beame (1906–), and John Vliet Lindsay (1921–).

c. 1985 Affectionately known as "Tip," Thomas Philip O'Neill, Jr. (1912–1994) was the youngest speaker of the Massachusetts House of Representatives before being elected to Congress in 1953, where he served until 1987. Speaker of the U.S. House of Representatives from 1877 to 1987, O'Neill was one of the most influential political leaders ever to hold the post.

1989 George Bush (1924–) was a World War II hero, chairman of the Republican National Committee, director of the CIA, and vice president of the United States before being elected the 41st president in 1988. Here he holds hands with his wife Barbara (1925–) during his inaugural parade.

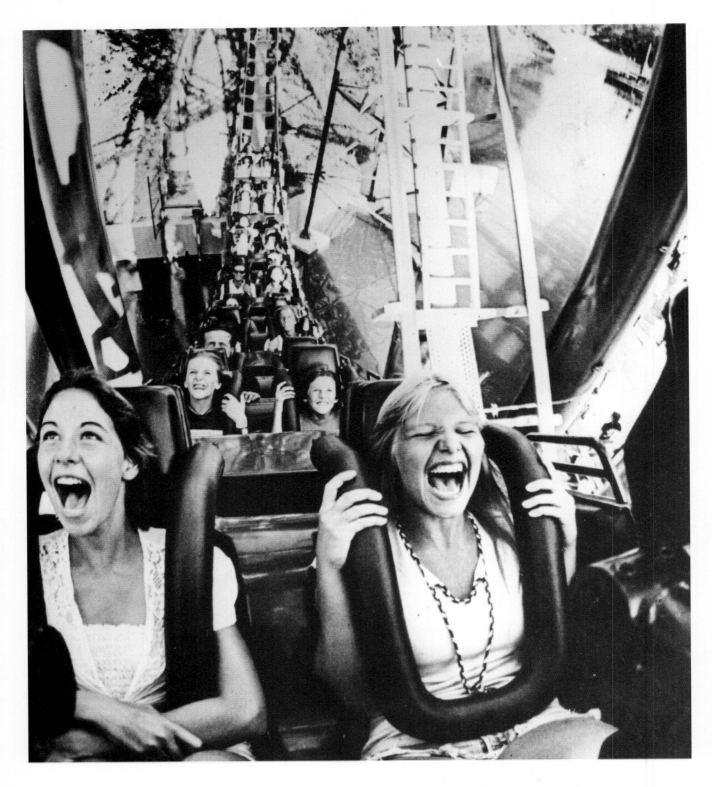

1981 Teenagers scream in delight as they ride the roller coaster known as the "Loch Ness Monster" at Virginia's Busch Gardens. The ride reached speeds of 70 miles per hour.

1981 In the 1980s, Ernst Haas continued to portray America in glorious color. Here (*previous pages*) he captured the various patterns and hues presented by clothing hanging out to dry.

1980 Pets come in all sizes, shapes, and forms. Here
a roller skater in Santa Barbara, California takes his boa
constrictor for an outing.

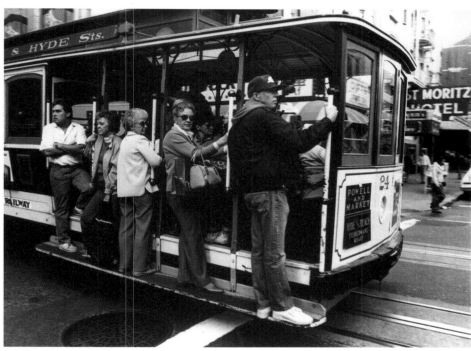

c. 1987 Every major city has its own featured landmarks and attractions. For more than 100 years, San Francisco's cable cars have been a favorite of tourists and residents alike.

c. 1980 New commercial airlines featuring few frills but lower fares began to challenge the supremacy of the larger passenger carriers. These stewardesses worked for Southwest Airlines.

1980s

1980 By the 1980s, computers had entered almost every facet of American life. This computerized system at a nuclear power plant in Wilmington, North Carolina, was designed to monitor inventory control measurements made at the facility.

1979 From the dropping of the first atomic bomb, people around the world have expressed anxiety and often displeasure with the development of nuclear energy. Here anti-nuclear advocates demonstrate on Washington's Capitol Hill.

1981 Photographers have always been intrigued with the patterns formed by snow on landscape. Ernst Haas captured this winter scene (*previous pages*) on a New York City street.

1982 The Vietnam Veterans
Memorial in Washington, D.C.,
has, from its inception, been
one of the nation's most well-
attended and emotion-inspiring
monuments. Dedicated in 1982,
the 493-foot long monument
was designed by 21-year-old
architecture student, Maya Lin.
This photograph was taken at
the Memorial's dedication.

c. 1985 At 20,300 feet,
Alaska's Mount McKinley,
named after U.S. President
William McKinley, is the highest
peak in North America. Native
Americans call this great peak
Denali (the High One). Snow–
covered throughout the year,
it presents a majestic view.

c. 1980 Arizona's Monument Valley has, for hundreds of years, been the home of Native Americans of the Navajo nation. This portrait of a Navajo woman was taken by Ernst Haas.

c. 1985 Photographer Tom Bean captured this striking scene of giant saguaro cacti lit up with Christmas lights outside Phoenix, Arizona.

c. 1985 In the 1980s, like "Dallas," the television series "Dynasty" drew millions of viewers and focused on a super-rich family. Shown here are two stars from the series: Joan Collins (1933–) played the scheming Alexis Colby, and John Forsythe (1918–) was her ex-husband and the family patriarch, Blake Carrington (*above*).

1980 Actors Robert Wagner (1930–) and Stefanie Powers (c. 1944–) on the set (*left*) of their hit TV series "Hart to Hart." They a played a wealthy married couple who spent their spare time as amateur detectives.

1985 Don Johnson and Phillip Michael Thomas share a laugh on the set of "Miami Vice" (*right*). Regarded by TV critics as the series that best captured the look and musical sounds of the 1980s, the action series was perhaps best described by NBC President Brandon Tartikoff, who characterized it as "MTV cops."

c. 1982 First aired in 1954, NBC's "Tonight Show" has been one of television's longest running and most profitable hits. Hosted from 1954 to 1957 by Steve Allen (1921–) and from 1957 to 1962 by Jack Paar, the torch was passed to Johnny Carson (1925–) in 1962 who for 30 years took the show to new heights. Carson (on the right) is shown here with the program's sidekick Ed McMahon (*above*).

1987 Johnny Carson brought a quick wit and a unique ability to set his guests at ease as the host of the "Tonight Show." Here (*right*), with his wife, Alexis, he arrives for his induction into the Television Academy Hall of Fame.

c. 1985 In the 1980s, CBS finally came up with a late-night program that topped NBC's Tonight show. "The Late Show with David Letterman" (1947–) swept the TV ratings and established Letterman as an international celebrity. Here (*left*) he takes to the street outside the studio to return a ball hit by tennis star Andre Agassi.

1981 Steve Rubell (1944–1989), owner of New York's Studio 54, parties with fashion designer Calvin Klein (1940–) and actress/supermodel Brooke Shields (1965–) (*above*). Klein, left, who started his own sportswear business in 1968, emerged as a top designer who had his finger on the pulse of American style. His racy 1980 TV ads featured the young Shields in just a pair of jeans, proclaiming that nothing came between her and her Calvins.

c. 1985 Actor Burt Reynolds (1936–) began his career as a Hollywood stunt man. The 1980s heartthrob starred in dozens of movies, and in the 1980s played a variety of macho, charming lead men in such films as *Smokey and the Bandit* and *Cannonball Run.* He is shown with his former wife, actress Loni Anderson (1946–), famous for her star role in the TV sitcom "WKRP in Cincinnati."

1980 In the early 1980s, disco music continued to take the nation by storm. Here, top fashion model Beverly Johnson celebrates the release of her new disco album *Don't Lose the Feeling.*

1982 The young man in this photograph was destined to become one of the most successful and highly regarded motion picture director/producers of all time. Among Steven Spielberg's (1947–) many blockbuster hits are *Jaws*, *Raiders of the Lost Ark*, *E.T. the Extra-Terrestrial* (scene from set, *above*), *The Color Purple*, and *Jurassic Park*. *Schindler's List* (1993) won 7 Academy Awards, including for best film and best director.

c. 1984 Drew Barrymore (1975–) at age nine (*left*). The daughter of actor John Barrymore, Jr., she appeared in her first TV commercial when she was only nine months old. Barrymore's movie career took off with her costarring role in Steven Spielberg's *E.T. the Extra-Terrestrial*.

1985 Eddie Murphy (1961–) has enjoyed a highly successful career as a stand-up comedian, "Saturday Night Live" regular, and movie star (*right*). His films, most of which have been huge box office hits, include *Trading Places*, *Beverly Hills Cops*, and *The Nutty Professor*.

1984 Ernst Haas created a striking contrast of blue and white with this photograph of pelicans (*previous pages*) lined up on a jetty in southern Florida.

1980s

1981 Three of the nation's top performers pose on the set of their hit movie *Nine to Five*. From left to right are singer/actress Dolly Parton (1946–), actress Jane Fonda (1937–), and television and movie comedienne Lily Tomlin (1939–).

1981 In her distinguished film career, Meryl Streep (1951–) has been continually nominated for the Academy Award and has won the Oscar for her role in *Sophie's Choice*. Streep has also won an Emmy Award for the TV mini–series *Holocaust*. Her movies include *The Deer Hunter*, *The French Lieutenant's Woman*, *Kramer vs. Kramer*, and *The Bridges of Madison County*.

1981 From 1976 to 1981 "The Muppet Show," created by
Jim Henson (1936–1990) was a prime-time showcase for his
Muppets, beloved characters from the morning children's
program "Sesame Street." In the 1980s, "The Muppet Show"
became the most popular syndicated rerun series in
TV history, seen by hundreds of millions in countries
throughout the world. Here (*above*), two of the most
popular Muppets, the Great Gonzo and Kermit, appear
in the movie *The Great Muppet Caper.*

1981 The glamorous Muppet, Miss Piggy (*right*), languishes
in jail in a scene from *The Great Muppet Caper.*

1980 The two men dressed as chickens in this publicity
shot for the movie *Stir Crazy* were among the top performers
of the 1980s (*left*). On the left is actor Gene Wilder (1935–)
whose films include *The Producers, Blazing Saddles,* and *The
Woman in Red.* On the right is comedian Richard Pryor (1940–),
star of *Lady Sings the Blues, Superman II,* and *Harlem Nights.*

c. 1982 Composer, songwriter, conductor, arranger,
Burt Bacharach (1928–) wrote the musical *Promises, Promises*
for Broadway and has written scores of songs for the
movies, including "Do You Know the Way to San Jose"
and "Alfie." He has won Academy Awards for his score
for *Butch Cassidy and the Sundance Kid* and his song
"Raindrops Keep Falling on My Head." Here he performs
with his future wife, singer/songwriter Carol Bayer–Sager.

1982 Dionne Warwick (1941–) began her singing career as part of a Gospel trio before becoming one of America's most popular solo singers and recording artists. Her hits include "Walk on By" and "You've Lost that Lovin' Feeling."

1986 Singer Marvin Lee Aday (known as Meat Loaf) and
composer Jim Steinman collaborated on the best-selling
1977 album *Bat of Hell*, a teen rock opera that featured three
top 40 singles including "Paradise by the Dashboard Light"
– a favorite of teenagers and radio stations nationwide. Their
1993 follow-up *Bat Out of Hell: II* was almost as successful,
selling over five million copies.

1983 Known for her mastery of range and tone, soprano Jessye Norman (1945–) has drawn the acclaim of tens of millions of music lovers both through her concerts and as the star of the New York Metropolitan Opera. She is shown here performing *Trojans*.

1981 Singer, songwriter, and producer James Brown (1928–), nicknamed "Soul Brother Number One" and the "Grandfather of Soul" (*above*), first won international acclaim with his song "Out of Sight." His "Say It Loud, I'm Black and I'm Proud" became an anthem for African–Americans.

1983 Soul singer Marvin Gaye (1939–1984) began his career performing with the group the Rainbows when he was only 15 (*left*). One of the 1980s most popular performers, his hits included "I Heard It through the Grapevine" and "Midnight Love."

1981 Singer Tina Turner (1939–) first achieved success with the rhythm-and-blues duo the Ike and Tina Turner Revue. With Tina's gyrating moves and gutsy voice, the band rose to the top of the charts with hits like "River Deep, Mountain High" and "Proud Mary." In the 1980s Tina was back on top (*right*) with the multi–platinum *Private Dancer* (1984). *I, Tina*, her best-selling autobiography, became the basis of the 1993 movie *What's Love Got to Do with It?*

c. 1985 The emerging form of music called hip–hop went from underground to pop-culture phenomenon when the rap group Run–D.M.C. (*above*) hit the airwaves. Along with their tight sound, the group introduced an edgy urban style to America: hats, gold chains, baggy jeans, and untied sneakers influenced youth across the nation and even showed up on haute couture runways.

c. 1986 The Pennsylvania group Poison (*right*) was one of the most popular "glam" metal bands of the late 1980s. Combining a pop heavy-metal sound with leather-and-lace outfits, long hair, and makeup, the band sold millions of albums, had legions of female fans, and dominated MTV.

1985 With their bluesy hard-rock sound and "bad-boy" persona, the 1970s' hard-rock band Aerosmith (*left*) launched one of the most incredible comebacks in rock history, returning to the top of the charts in the late 1980s and early 1990s with smash albums *Pump* and *Get a Grip*.

c. 1980 Before becoming a performer, Deborah (Debbie) Harry was a top model. In the 1970s, she and her boyfriend Chris Stein formed the new-wave band Blondie, one of the most inventive groups to come out of the New York scene. Their punk-meets-disco songs, "Heart of Glass," "Call Me," and "Rapture," introduced Americans to an entirely new sound.

1985 Madonna Louise Veronica Ciccone (1958–), known globally as Madonna, is perhaps the most media-savvy pop star in history. Her hit songs – including "Like a Virgin" and "Material Girl" – and provocative videos inspired millions of girls to bedeck themselves with beads and lingerie. As the decade went on, she continued to challenge social boundaries.

1983 The Talking Heads (*above*) drew on funk, classical music, and Afro–American rhythms to create some of the most exciting, and danceable new–wave music of the 1980s. Their 1983 album *Speaking in Tongues* was a top seller, and in 1984 they collaborated with director Jonathan Demme on the film *Stop Making Sense*. From left to right are: lead singer David Byrne, Jerry Harrison, Tina Weymouth, and Chris Frantz.

1981 Prince Rogers Nelson (1960–), known to the world as Prince, is one of the most influential figures in rock history. His unparalleled ability to fuse pop, funk, and rock helped redefine the boundaries of musical genres. Prince composed, arranged, and produced his own recordings and often played all the instruments on his arrangements as well. A dynamic live performer, he also starred in the autobiographical film *Purple Rain*, which won an Oscar for best original score.

c. 1985 In the 1980s, the Motown child–prodigy Michael Jackson metamorphosed into the self-titled but widely acknowledged "King of Pop" (*left*). With his albums *Thriller* (one of the most popular records of all time) and *Bad*, and spectacularly choreographed videos and live performances, he became one of the world's best known and wealthiest performers.

c. 1985 In the 80s, Bruce "the Boss" Springsteen (1949–) became the world's most popular rock star. One of the few rock performers to be featured on covers of both *Time* and *Newsweek*, Springsteen's 1980s hit albums included *The River*, *Born in the USA*, and *Tunnel of Love*.

c. 1980 In the 1980s Cher turned to acting, landing leading roles
in films such as *Silkwood, Mask, The Witches of Eastwick,* and *Moonstruck,*
for which she won an Oscar for best actress. In 1987 Cher returned
to recording: *Cher* went gold and the 1989 *Heart of Stone* went
double platinum.

1980 When writer/poet Erica Jong's (1942) influential first novel *Fear of Flying* appeared in 1973, Henry Miller cheered it as "a female *Tropic of Cancer*." Millions of women identified with the character Isadora Wing as she shared her innermost sexual fantasies; the revolutionary book opened the door for women to "find their own voices and give us great sagas of sex, life, joy, and adventure." In her novels, poetry, and many articles, Jong continues to celebrate women.

1985 Author and academician Elie Wiesel (1928–) is a survivor of the World War II Buchenwald concentration camp. In his determination to point out the dangers of both racism and violence, Wiesel (*left*) has devoted himself to documenting Nazi atrocities against the Jews. In 1986, Wiesel was awarded the Nobel Peace Prize.

1986 Paleontologist and author Stephen Jay Gould (1941–) relaxes at home (*right*). Gould gained attention through his highly documented theory that the evolution of the species was not a steady progression but rather one which occurred in various spurts. Gould has written numerous books and essays, including the best-selling *Wonderful Life: The Burgess Shale and the Nature of Things.*

1987 Author Toni Morrison (1931–) has been one of the most articulate and highly acclaimed African–American voices of modern times (*left*). Her novels include *Song of Solomon* (1977), *Tar Baby* (1981) and *Beloved* (1988), for which she received the Pulitzer Prize. In 1993 Morrison was awarded the Nobel Prize for Literature.

1984 Stephen King (1946–) poses for a gag photo with his son (*below*). King's phenomenally selling horror novels include *Carrie* (1974), *The Shining* (1978), *Christine* (1983) and *Dolores Claiborne* (1992). Several of King's books have been turned into hit movies.

1980 Norman Mailer's (1923–) first novel *The Naked and The Dead* (1948) established him as a novelist of prodigious skill (*above*). His books, *Armies of the Night* (1968) and *The Executioner's Song* (1980) were each awarded the Pulitzer Prize. Mailer's other books include *Ancient Evenings* (1983) and *Tough Guys Don't Dance* (1984).

1984 The computer revolution has been characterized by the inventive genius of brilliant young men who have forever changed the world of information, business, and communication. Here (*above*) Steven Jobs (1955–), chairman of Apple Computer (in bow tie) and John Sculley, the company's president, show off their new Macintosh personal computer.

c. 1985 By the mid–1980s, the creation and manufacture of computer software had grown into one of the world's largest industries. This was an assembly line at one of Microsoft's factories (*right*).

1985 Who could have known it then, but the young man in this photograph (*left*) was destined to become, by the age of 35, one of the richest men in the world. Bill Gates (1955–) was only 15 when he invented a device to control traffic patterns in Seattle. In 1977 he cofounded Microsoft and when, in 1981, IBM adopted DOS, Gates's basic operating system for computers, both Gates and Microsoft were on their way to fame and fortune.

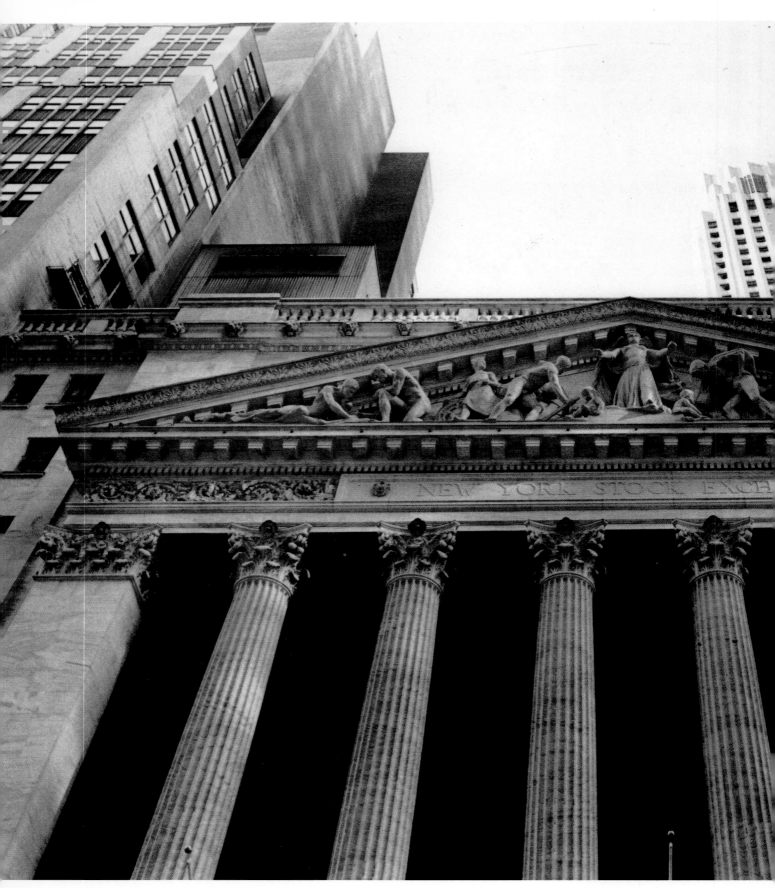

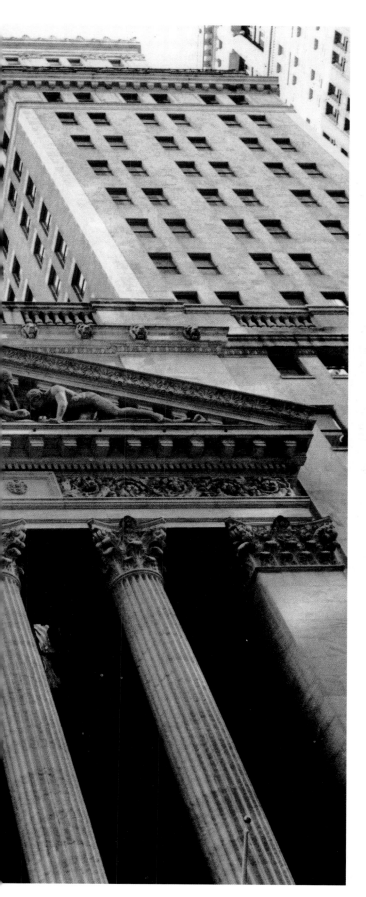

1985 Real estate developer Donald Trump's (1946–) many spectacular holdings – including the Trump Tower in New York and casinos in Atlantic City – along with his ability at self-promotion, made him a national celebrity. Here he considers yet another billion-dollar development project.

1985 The nation 's marketplace. More than 51 million individual investors and more than 10,000 institutional investors buy and sell securities issued by some 3,000 companies listed on the New York Stock Exchange.

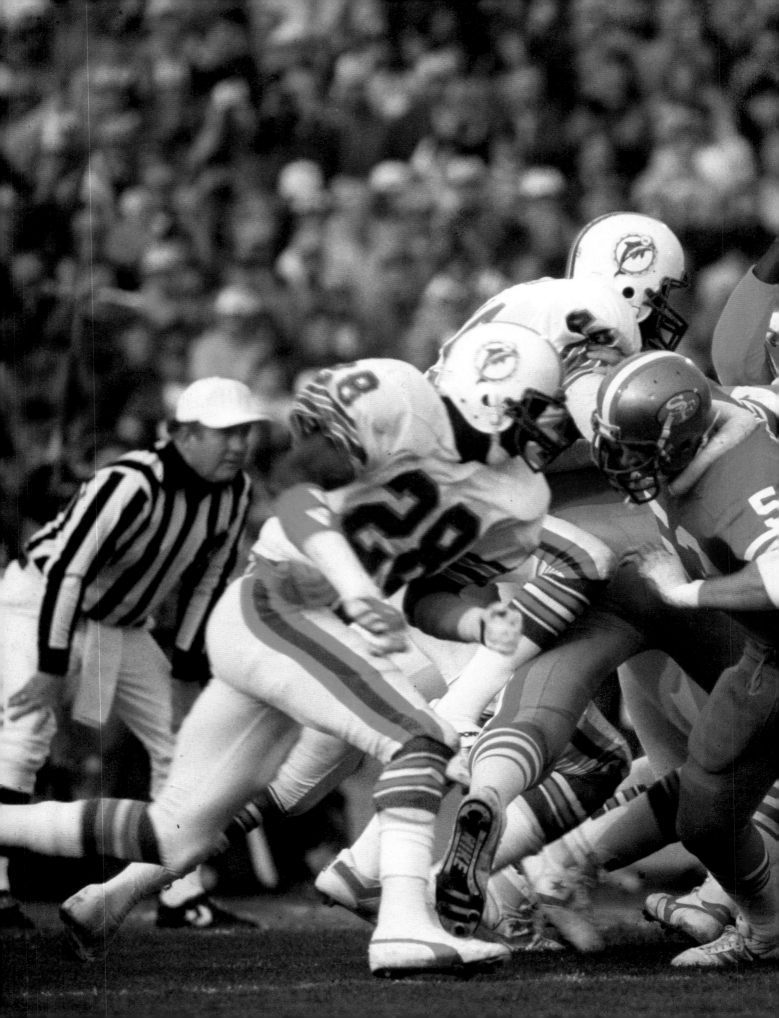

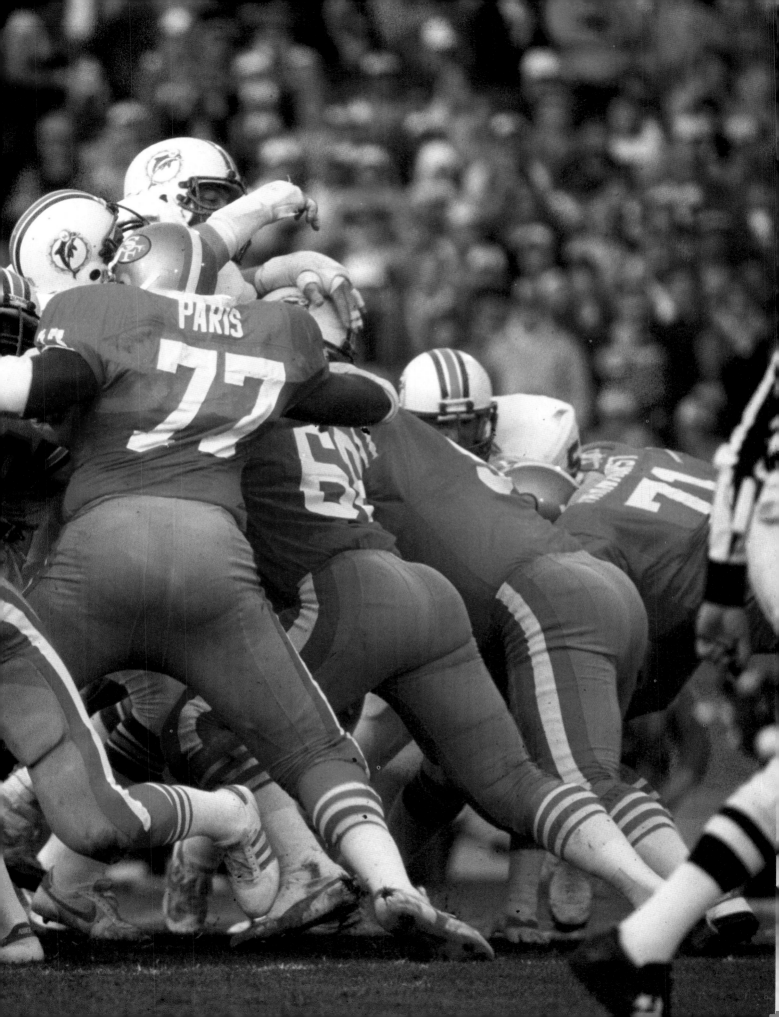

1988 Baseball and children have always gone hand-in-hand. These youngsters (*above*) were seeking autographs during spring training in Winter Haven, Florida.

1986 Golfer Jack Nicklaus (1940–) won the U.S. Amateur Title in 1959 and 1961 before turning professional. Nicklaus (*right*) went on to win six U.S. Masters, four U.S. Opens, three British Opens, and dozens of other titles. Here he acknowledges the cheers of the crowd en route to his 1986 Masters title, which, at the age of 46, made him the oldest winner of the prestigious event.

1986 Mike Ditka (1939–) was named head coach of the Chicago Bears in 1982 (left). He proceeded to lead the Bears to an overall record of 107-57, the only Bear coach to lead the team to five straight post-season appearances. In both 1985 and 1988, Ditka was named Coach of the Year by the *Sporting News* and the Associated Press; he was inducted into the Pro Football Hall of Fame in 1988. Ditka now coaches the New Orleans Saints.

1986 Members of the New York Mets celebrate after the final out in the Team's 8–5 win over the Boston Red Sox, in the last game of the World Series.

c. 1983 Reggie Jackson (1946–) was one of baseball's most powerful hitters. During his career Jackson played for several teams but he gained his greatest fame with the New York Yankees where his World Series home run feats earned him the name "Mr. October."

1985 With each passing year, pro football's Super Bowl seems to grow in stature and national attention. Here (*previous pages*), the Miami Dolphins and the San Francisco 49ers battle for the title.

1989 Olympic gold–medalist Florence "Flojo" Griffith–Joyner and comedian Bill Cosby await the start of a race. The duo was participating in the McDonald's Celebrity Relay on the campus of University of California, Los Angeles.

c. 1982 Michael Jordan (1963–) was a star at the University of North Carolina before joining the Chicago Bulls. Nicknamed "Air Jordan," he scored more than 50 points in a game on 34 occasions. His 63 points against Boston in 1986 is still an NBA play-off game record.

1988 Gymnast Mary Lou Retton won both the attention
and the heart of America with her accomplishments at the
Olympic games. Here she performs on the balance beam
en route to winning the overall gymnastics gold medal.

1988 Brian Boitano performs his routine during the
men's figure skating competition at the Winter Olympics
held in Canada. Boitano, who would go on to become a
top professional skater, won the gold medal.

1980 Ernst Haas brought
his photographic artistry to
the Winter Olympics held
at Lake Placid. In this image
he captured a participant
in the ski-jumping event
in full flight.

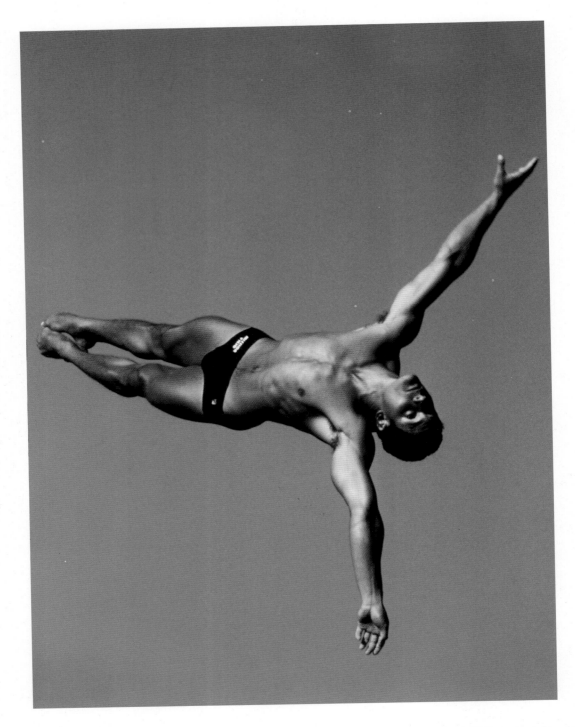

1981 Greg Louganis (1960 –) won the world platform diving championship in 1978, 1982, and 1986, and the world spring-board championship in 1982 and 1986. Louganis was the Olympic diving champion in both 1984 and 1988.

1984 American track and field star Carl Lewis (1961–) is carried on the shoulders of his teammates after anchoring the U.S. victory in the 4 x 100 meter relay, in the Olympic Games at Los Angeles. During the games, Lewis equaled Jesse Owens's record by winning four gold medals.

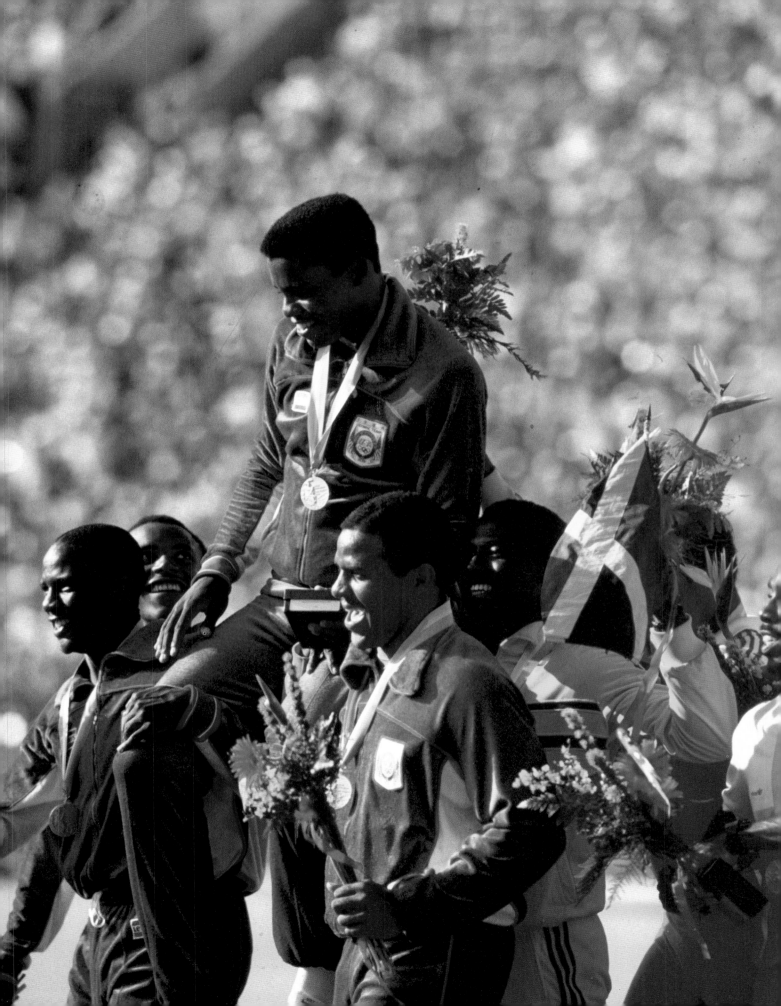

1980 Dubbed the "Miracle on Ice," the United States hockey team's improbable 4–3 victory over the Russian team made up of professional players in the semi–finals of the 1980 Olympic Games is regarded as one of the greatest feats in American sports history. The United States went on to win the gold medal.

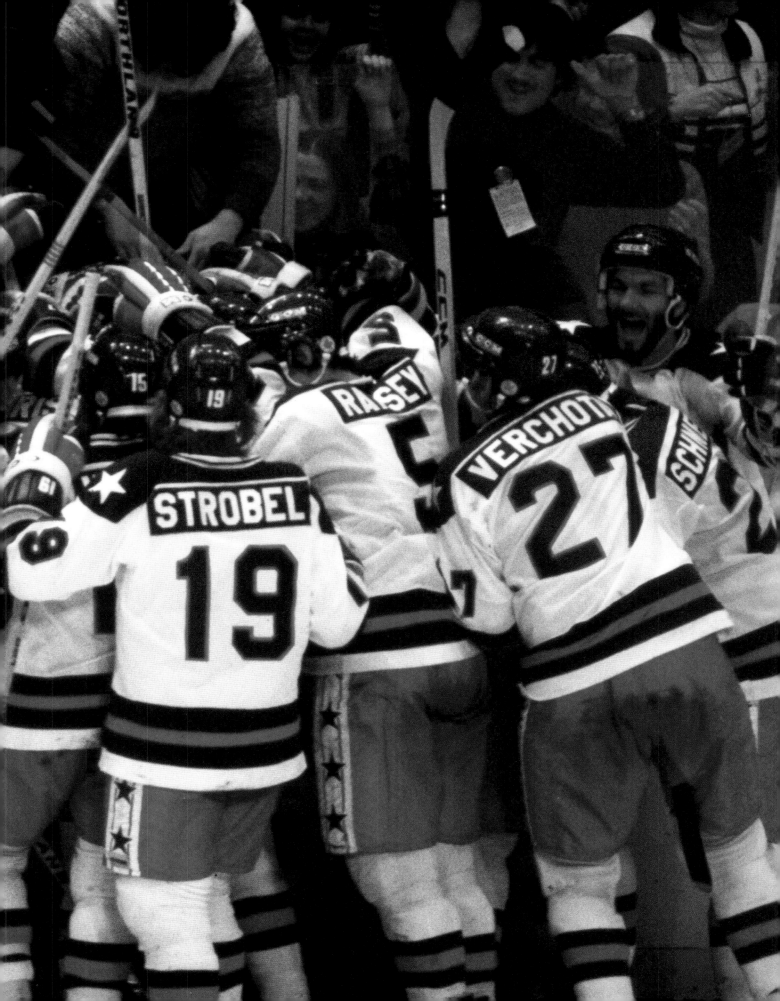

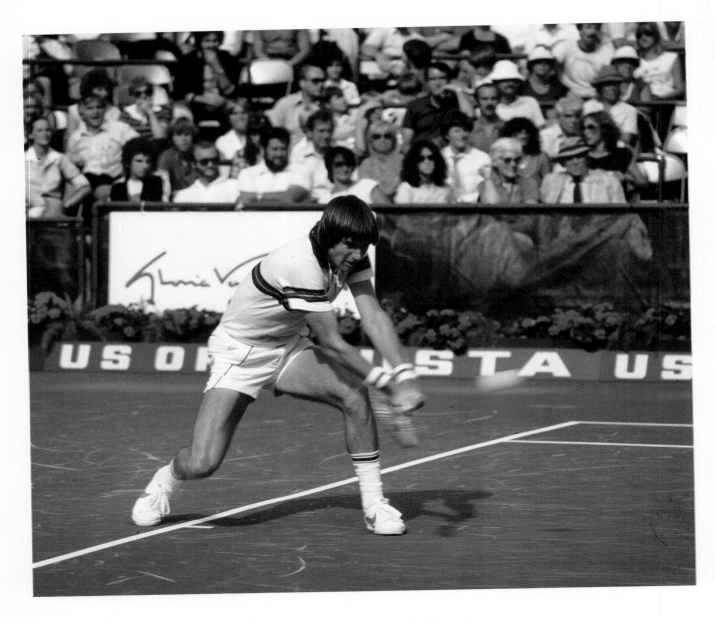

1981 He was brash and he was cocky but Jimmy Connors (1952–) was one of tennis' all–time greats. Winner of four U.S. Opens and a Wimbledon title, Connors was one of the first tennis players to employ a two–handed backhand.

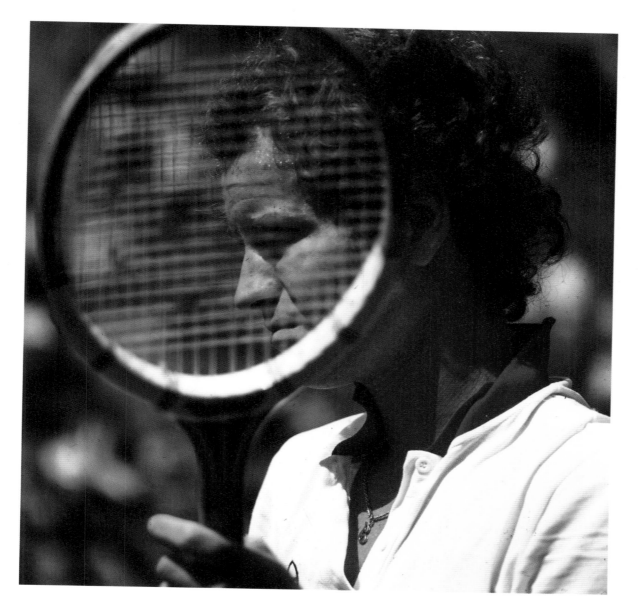

1981 Known for his fiery temper, John McEnroe (1959–)
was the predominant tennis player of the early 1980s. He
won the U.S. Open in 1980, 1981, and 1984. He captured the
Wimbledon title in 1981, 1983, and 1984. Regarded also as
the greatest doubles player ever, McEnroe won ten Grand
Slam doubles championships.

1988 NASA's space shuttle
Discovery is launched at the
Kennedy Space Center at Cape
Canaveral, Florida. The shuttle
carried a tracking and data
relay satellite, which its five-
man crew successfully placed
into orbit.

882

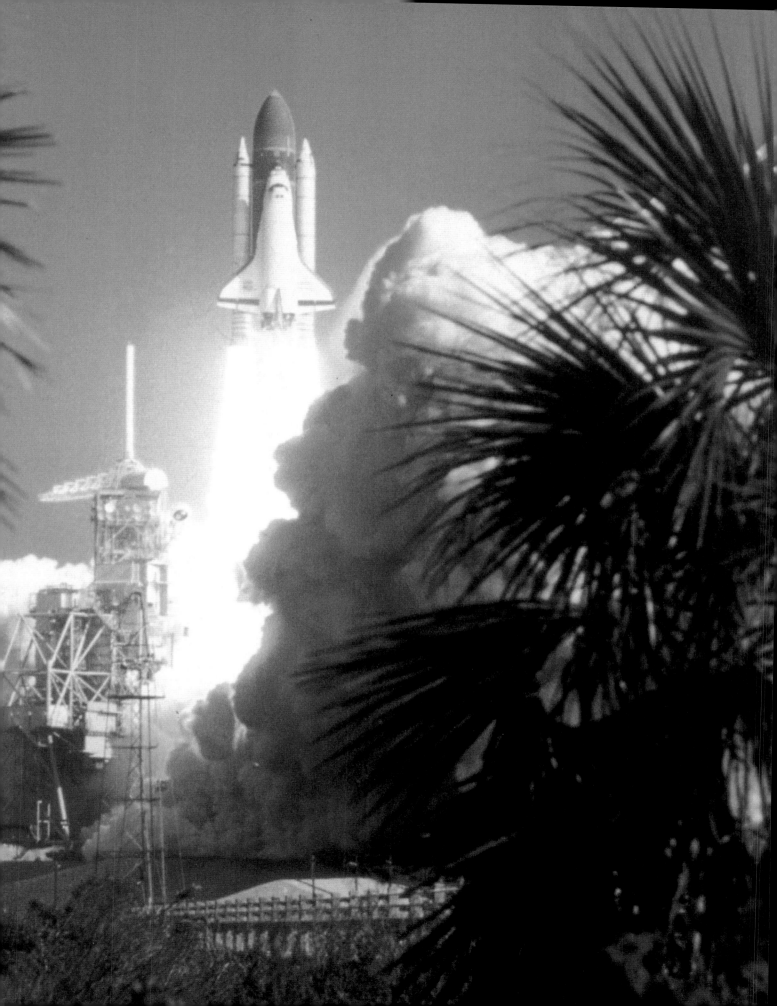

1989 Technicians work on the Hubble Space Telescope. Placed into orbit in 1990 by the crew of the space shuttle *Discovery*, the sophisticated device, far more effective than any earth telescope, has a main mirror that is more than 94 inches wide.

1981 The runway seems to stretch on into infinity as one of NASA's manned space shuttles returns after a test run.

1990s

1998 New York City Mayor Rudolph Giuliani hands a key to the city to astronaut/United States Senator John Glenn after his successful nine-day mission on the *Discovery*.

1990s

The nation was in the midst of an unprecedented period of economic growth. Names like AOL and Yahoo! became part of the American vocabulary. For the first time a woman commanded a space shuttle mission, and, more than 30 years after his first triumph beyond the earth, John Glenn returned to space.

A former basketball star made a run for the presidency and millions of television viewers watched contestants attempting to become millionaires. Mark McGuire hit an astounding number of home runs while the "Great Gretzky" retired. As the decade and the century ended, lavish plans were being made for millennium celebrations while millions wondered whether something called the "Y2K bug" would spoil the party.

1991 When Iraq invaded Kuwait, the United States and other nations sent in troops to drive the Iraqis out of the oil-rich country. The brief war, known as Operation Desert Storm, ended in February 1991 with the defeat of the Iraqi army. Here President George Bush (*above*) visits American troops.

c. 1995 Caesar's Palace has long ranked as one of the most plush gambling casinos in Las Vegas (*previous pages*). Photographer Grant Taylor captured this evening scene.

1999 American Lance Armstrong takes a victory ride after winning Stage 20 of the world's most prestigious cycling race (*right*), the Tour de France. Armstrong fought back from massive testicular cancer to be only the second American cyclist to win the grueling competition.

c. 1995 The fascinating shapes and forms provided by amusement park rides often make for arresting photographs, particularly when the rides are illuminated at night. Photographer Cosmo Condina captured this scene.

1996 Photographer Milan Chuckovich used the contrasting
vertical and horizontal shapes of a huge roller coaster in Valencia,
California, as the focus of this photograph.

c. 1995 The Japanese photographer Hiroyuki Matsumoto has successfully captured the flavor of night life in various American locales. This photograph was taken on Beale Street in Memphis, Tennessee – known as the "Home of the Blues."

c. 1995 Hiroyuki Matsumoto focused on the stark contrast created by the dark background and the subtle shades of light to create this image of a street saxophone player outside of New York's famous Carnegie Hall.

c. 1995 Although most masters of color photography use color as judicious accents and highlights, photographs featuring brilliant flashes of bright color can also be highly effective. This picture of Las Vegas showgirls (*previous pages*) was taken by Bruce Ayres.

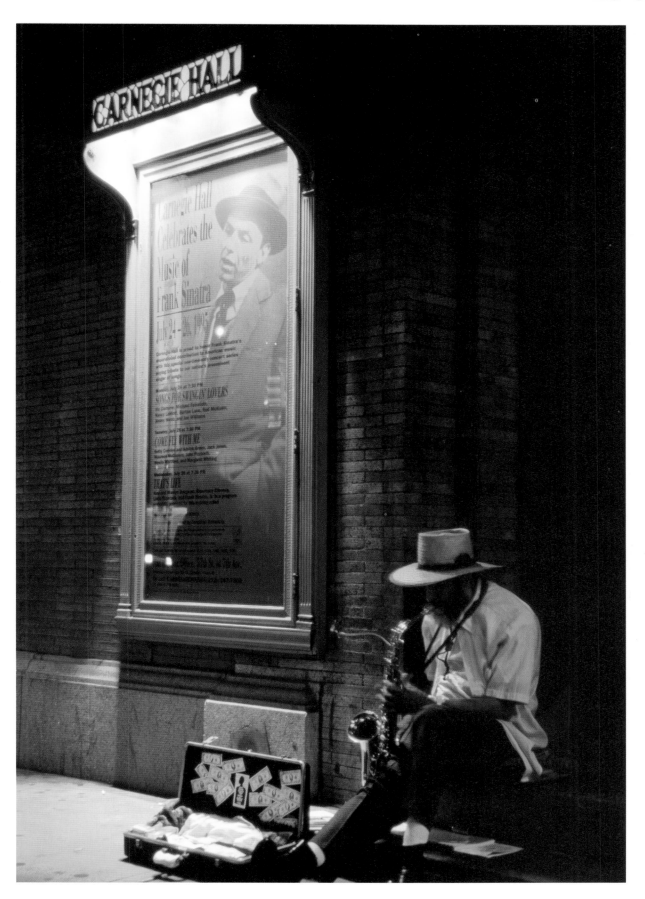

c. 1990 By the 1990s the American moviegoing experience – defined by multiplex theaters with digital sound – had evolved into a multi-billion dollar industry. Here is Chad Slattery's photograph of a California cinema complex.

c. 1997 The annual Bluegrass Festival held at Telluride, Colorado always draws enormous crowds. Photographer Robert Daemmrich captured this image of the throng enjoying the festivities.

1990s

c. 1995 Attending an evening bandstand concert has long been a favorite summertime activity, particularly in small-town America. Photographer Paul Souders traveled to Maryland to capture this peaceful scene.

898

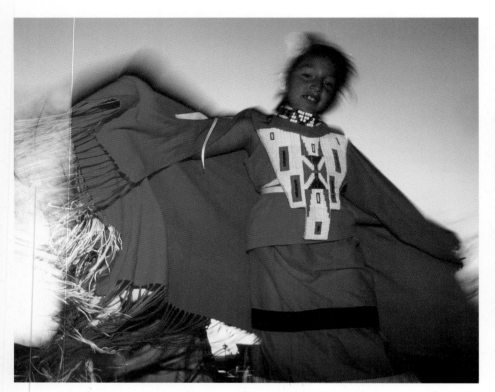

1996 A Native American dancer performs at the
Plains Indian Powwow in Cody, Wyoming. Powwows
give Native Americans the opportunity to celebrate
culture and traditions that have been handed down
from generation to generation.

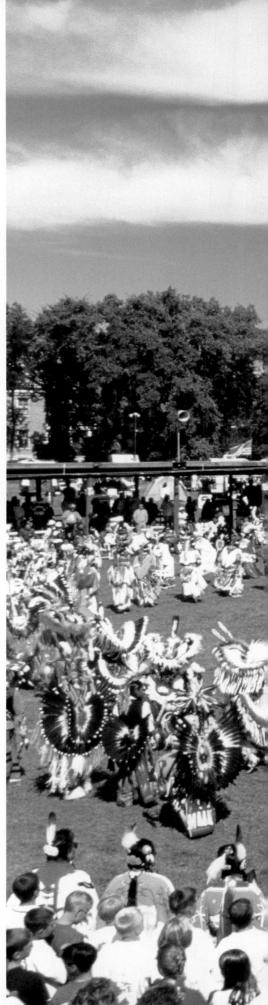

1995 A wide–angle view of the Native American
International Powwow in Bismarck, North Dakota. People
from around the world come to the powwow to view skills
introduced by the first Americans hundreds of years ago.

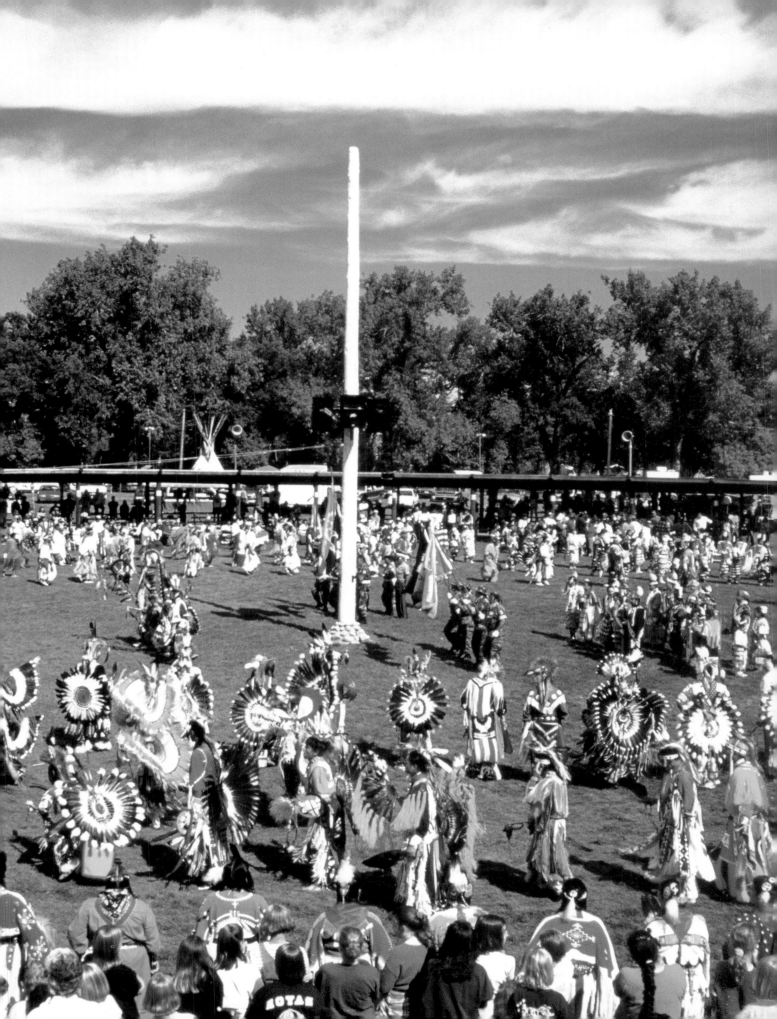

c. 1994 As the nation celebrates its birthday, marchers carry a huge American flag during Atlanta's Fourth of July parade.

c. 1995 Fireworks have been part of American Fourth of July celebrations since the birth of the nation. Photographer Vito Palmisano captured this scene in Detroit.

c. 1990 Bright foliage, charming houses and barns, cornstalks, and piles of pumpkins all combine to present a quintessential portrayal of fall in New England.

c. 1990 Two clowns capture a moment's rest before joining the line of march in a Fourth of July parade.

c. 1996 Women in spectacular pastel-colored attire create a stunning abstract design as they make their way down Peach Street (*previous pages*) in Atlanta's Fourth of July parade.

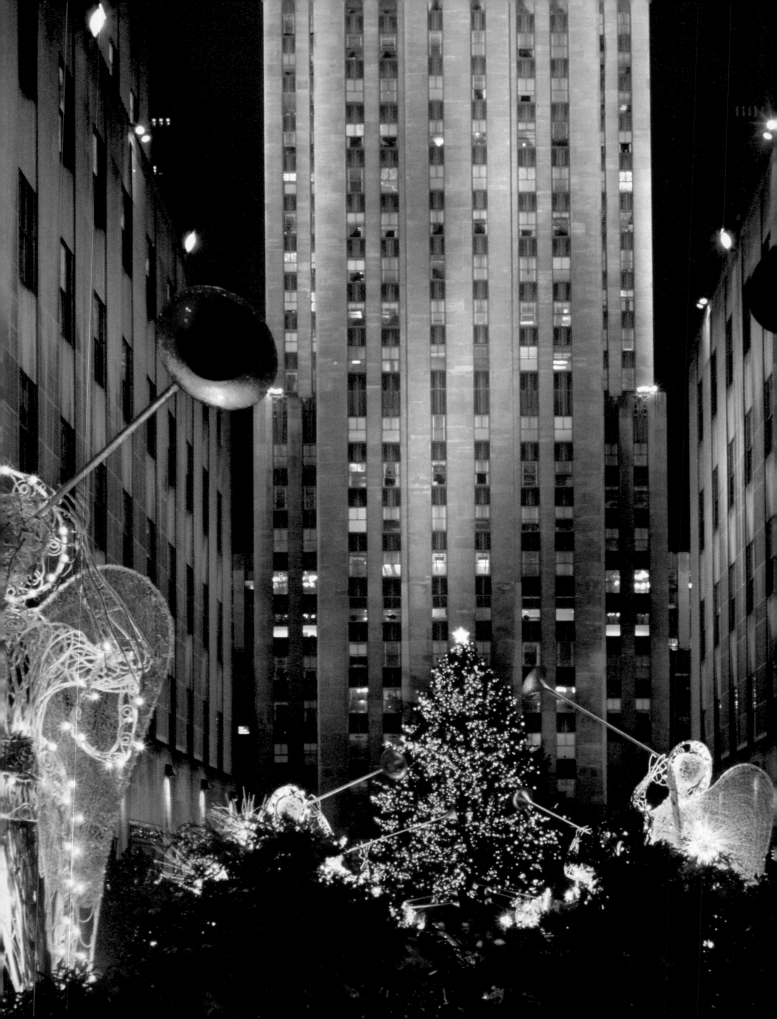

1994 John Cardinal O'Connor (1920 –2000) greets members of the crowd at New York's St. Patrick's Day parade. One of the country's most celebrated and popular religious leaders, O'Connor had a 16–year tenure as the head of the New York Archdiocese, which has a flock of 2.4 million. Cardinal O'Connor passed away on May 3, 2000.

1993 The annual Rockefeller Center Christmas–tree lighting always gathers hordes of onlookers. Bedecked with over 26,000 lights, the trees – usually weighing in at over 7 tons – are viewed by millions of New Yorkers and tourists over the holiday season.

1999 In a living symbol of the age of high tech, workmen make adjustments to a cellular telephone tower in Clackamas, Oregon. Cell phones are now ubiquitous all over the country, and the world.

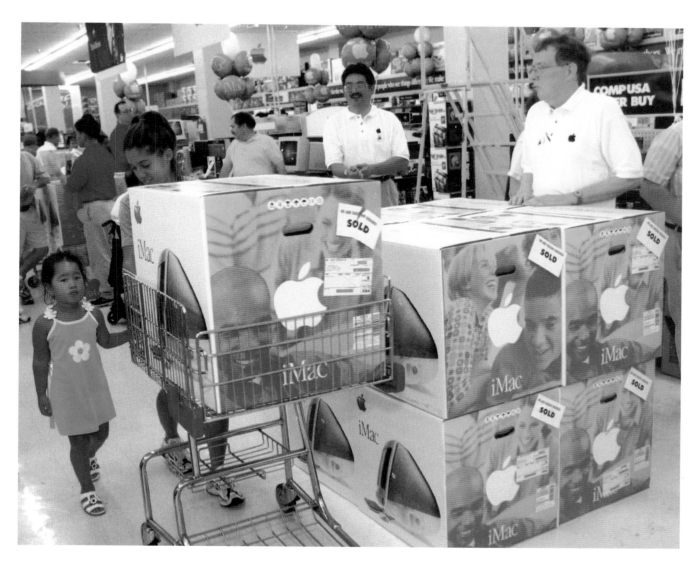

c. 1996 In the 1990s, with sales reaching all-time highs and competition increasingly fierce, computer companies worked feverishly to introduce "hot" new models. Here a young mother purchases an Apple iMac (*above*) on the day the new computer first went on sale.

c. 1999 In the 1990s, tens of millions of Americans linked themselves into the miracle of communication known as the Internet. Jerry Yang (*left*), founded one of the Net's most successful search engine companies, Yahoo!

1997 The Internet revolution has been fueled by the imagination and know–how of young American entrepreneurs. Steve Case (*right*), is founder and CEO of America Online (AOL), a leading Internet service provider that was a pioneer in bringing online computing to the masses.

1990s

1998 Technicians adjust Senator John Glenn's space suit as he prepares for a pre-launch exercise. Glenn, America's first man to obit the earth, went back onto space in October 1998 and conducted experiments designed to further man's knowledge of the aging process.

1999 Space shuttle commander Eileen Collins waves as she prepares to board the space shuttle Columbia at Cape Kennedy, Florida. Collins became the first woman to command a space shuttle mission.

1998 Actor William Baldwin (1963–) – a board member of the youth project "Rock the Vote," which promotes young voter participation – discusses the newly inaugurated voter registration website during a demonstration of the innovation at Washington, D.C.'s Hard Rock Cafe (*above*).

1998 U.S. Secretary of State Madeline Albright (1937–) discusses a Middle Eastern peace agreement on the CBS news show "Face the Nation." Albright (*below*) was the nation's representative at the United Nations before becoming the country's first female Secretary of State.

c. 1998 In the 1990s, efforts to improve America's voting participation intensified. This youngster (*right*) was obviously too young to vote, but he proudly displayed one of his parents' "I Voted" stickers.

**1999 From the moment of
his birth,** John F. Kennedy, Jr.
(1960–1999) was a celebrity. His
looks and charisma, along with
the Kennedy family aura, made
him one of the nation's most
eligible bachelors, and he was
named "sexiest man alive" by
People magazine in 1988.
Kennedy worked briefly as
a prosecutor for Manhattan
District Attorney Robert
Morganthau, and in 1995,
launched the political magazine
George. In 1996, millions of
women sighed when Kennedy
married Carolyn Bessette (1966–
1999), a former publicist for
Calvin Klein. Less than three
years later the couple was
killed in an airplane crash off
Martha's Vineyard, Massachusetts,
and the entire nation mourned.

1990 In the 1990s, AIDS continued to take a tragic toll around the world. Here, actress and AIDS activist Elizabeth Taylor speaks at a press conference held to urge U.S. Congressmen to initiate stronger legislation to seek a cure for the dreaded virus. In 1993 Taylor won the Jean Hersholt Humanitarian Award for her work in AIDS research.

1998 General Colin Powell (1957–) was the Chairman of
the U.S. Joint Chiefs of Staff from 1989 to 1993. Extremely
popular, Powell has been frequently mentioned as a possible
presidential or vice presidential candidate. In 1997, General
Powell served as chairman of the President's Summit for
America's Future, and has been a tireless advocate for
America' Promise, an alliance of over 500 national
organizations that promote the safety, health, and
education of children.

1996 New York's Mayor Rudi Giuliani at the Columbus Day
Parade. The outspoken Giuliani – only the second Republican mayor
to be reelected since Fiorello La Guardia – has helped reinvent New
York as a popular tourist destination. In 1999 Giuliani announced
his candidacy for the U.S. Senate but decided to abandon his
campaign in May, 2000 to fight back from cancer.

1999 Willie "Da Mayor" Brown, mayor of San Francisco,
lends his voice in support of labor. Brown was urging the
owners of local radio station KPFA (the oldest non–profit
radio station in the country) to allow locked–out employees
to return to work. The popular mayor is known for his
fedoras, dapper style, and old–fashioned charm.

1993 In 1962 Ross Perot (1930–) founded the Electronic
Data Systems Corporation, which grew into one of the
nation's most successful businesses. Turning to politics, Perot
ran as an independent candidate in both the 1992 and 1996
presidential elections. Here he speaks before the Joint
Committee to Reorganize Congress.

1990 President George Bush gestures during a speech he delivered midway through his presidency. In 1992 Bush was defeated for reelection by Bill Clinton.

1993 Despite scandals and the threat of an impeachment, Bill Clinton's popularity remained high throughout his eight years in the White House. Here the saxophone–playing new president (*above*) helps entertain the crowd at one of several balls held on his inauguration day.

1993 U.S. President Bill Clinton looks on (*right*) as Israeli Prime Minister Yitzhak Rabin (1922–1995) shakes hands with Palestinian leader Yasser Arafat (1929–) following the signing of the historic agreement which transferred much of the West Bank to Palestinian control.

1993 William Jefferson Clinton (1946–) served two terms as governor of Arkansas before being elected the 42nd President of the United States in 1992 and reelected in 1996. Clinton appointed more women and minorities as cabinet members than had any previous president. This was the scene (*left*) as Clinton delivered his first inaugural address.

1999 Democratic presidential hopeful Bill Bradley (*left*) shows off some of his old-time skills while campaigning in El Paso, Texas. A former NBA great and U.S. Senator, Bradley was forced to abandon his campaign after suffering key losses in the primaries to Vice President Al Gore.

1998 George W. Bush, Jr., son of President George Bush and the 2000 Republican presidential candidate (*below*), participates in a debate prior to his reelection as governor of Texas. Standing beside him is his wife Laura.

1998 As the United States approached a new millennium, millions of citizens became concerned that computer software would be unable to recognize the year 2000, throwing government, industry, and the lives of ordinary citizens into chaos. Here Vice President Al Gore (1948–) addresses the problem, known as "Y2K" at a meeting of the National Academy of Science. Gore was the 2000 Democratic presidential candidate.

c. 1998 Photographer Jules Frazier captured the action as a cowboy participating in an Idaho rodeo proudly carried the American flag around the arena.

929

1998 In the late 1990s, Chicago Cub's outfielder Sammy Sosa emerged as one of the game's greatest sluggers. Here Sosa gives the victory sign after winning the 1998 National League Most Valuable Player Award.

1998 In what has become an historic photograph, St. Louis Cardinal slugger Mark McGwire pumps his first while circling the bases after becoming the first major leaguer ever to hit 70 home runs in a season.

1999 Hockey star Wayne Gretzky (*above*) waves to the crowd after having played his final game. Known as the "Great One," Gretzky is the National Hockey League's all-time leading scorer and was voted the league's most valuable player nine times.

1999 Denver quarterback John Elway (*left*), known for leading his team to last-minute, come-from-behind victories, celebrates after running for a touchdown against the Atlanta Falcons in Super Bowl XXXIII. Elway was named the most valuable player of the game.

1999 Women's sports reached an all time high in participation and popularity in the 1990s. Here Brandi Chastain (*right*) of the American Women's Soccer Team celebrates the U.S. victory over team China in the Women's World Cup Final by throwing her shirt in the air.

1999 In the late 1990s, the Williams sisters, Venus and Serena, established themselves as among the best in women's professional tennis. Here they show off their trophy after winning the French Open doubles championship. Serena made history when she became the first black woman to win the Grand Slam championship since Althea Gibson in 1958.

1999 Nominated as one of *People* magazine's "50 Most Beautiful People in the World," Michelle Kwan (1980–) is one of the most graceful skaters in history. She is a four-time national champion, a three-time world champion, and a silver medalist at the 1998 Olympics in Nagano, Japan.

1998 Basketball, long a male–dominated sport, continued to change in the 1990s as, both on the college and professional levels, interest in women's teams soared. Here Sheryl Swoops (number 22), one of the stars of the Houston Comets, goes up for a rebound (*above*) during a game in the Women's National Basketball Association finals.

1999 Los Angeles Lakers center Shaquille "Shaq" O'Neal (left) began his professional career with the Orlando Magic. A perennial leader in field goal percentage, he has scored more than 10,000 NBA points. A highly popular figure, O'Neal starred in the movies *Blue Chips* and *Kazaam*.

1998 Michael Jordan (*right*) retired from basketball in 1992 in an attempt to become a major league baseball player. He returned to the Chicago Bulls in 1995 and once again became the predominant player in the game. Jordan was the first player ever to win the named regular–season and championship series MVP five four times, and has become a media star and one of the most-recognized individuals in the world.

1999 After a brilliant amateur career, Tiger Woods (1976–)
became internationally famous after winning the U.S. Masters with
a record margin at the age of 21. Here Woods, now recognized as
the world's greatest golfer, kisses his trophy after capturing the 1999
PGA championship.

1999 Andre Agassi (1970–) celebrates his victory over Todd Martin, which gave him the U.S. Open Men's Singles Championship. One of the few tennis players to have won the U.S. Open, Wimbledon, the Australian Open and the French Open, Agassi finished 1999 by ranking first in the world.

1999 Members of the New York Yankees celebrate
after watching teammate Jim Leyritz hit a home run to
give the "Bronx Bombers" a commanding 4–1 lead in
game four of the World Series. The Yankees went on to
win the championship.

c. 1995 Although supporters of professional football
might argue the point, for millions of fans baseball is still
the national pastime. Here spectators from far out in the
bleachers cheer on their team.

1999 In 1999, ABC introduced a television program destined to become one of the most widely watched of all time. Hosted by Regis Philbin (seen here signing a $1,000,000 check), "Who Wants to Be a Millionaire" (*above*) became so popular that the network began airing new programs in the series twice or even three times a week.

1999 Martha Stewart (*right*) became a national phenomenon in the 1990s. Home furnishing and clothing designer, interior decorator, chef, television personality, and author of dozens of best-selling books, Stewart reached new heights when stock in her company went public and she personally reaped over one billion dollars.

c. 1994 In the 1990s, particularly on syndicated reruns, "Bay Watch" (*left*) became one of the most watched television programs of all time. Widely distributed overseas, the series, in 1994 alone, was seen by some one billion viewers. Stars of the show seen here are, from left to right, Alexandra Paul, Pamela Anderson, and Yasmine Bleeth.

1999 Rosie O'Donnell's (1962–) career took off when she scored a triumph in the movie *A League of Their Own*. After appearing in other movies such as *The Flintstones* and *Harriet the Spy* and on Broadway in the revival of *Grease*, O'Donnell (*above*) became the host of a highly successful syndicated talk show. In 2000 she won her fourth consecutive Emmy for best talk show host.

1999 Oprah Winfrey (1954–) became internationally known through her performance in the movie *The Color Purple*. In 1986, she became the first black woman to host a successful national daytime talk show, a program that has had extraordinary success. Through her book club and her own film and television production company, Winfrey (*right*) has become one of the most influential individuals in the entertainment world.

1993 A pioneer in talk radio for almost 20 years, Howard Stern (1954–) has drawn an enormous listening audience through his often shocking on-air antics and statements. Host of the leading daily syndicated radio show in the world, Stern (*left*) was also the star of the movie *Private Parts*.

c. 1995 Americans in the 1990s revitalized their interest in spirituality, as is evidenced in the popularity of "Touched by an Angel," one of the highest-rated programs on television. The drama follows three angels as they bring faith and hope to people faced with adversity. From left to right are the stars of the show: John Dye, Roma Downey, and Della Reese.

1999 Victory at last! Susan Lucci, star of the television soap opera "All My Children," was nominated for the Daytime Emmy Award for best actress on a daytime drama 18 times before finally winning in 1999.

1997 Millions around the world tune in to the science fiction television series "The X-Files" to follow FBI Agents Scully and Mulder on their paranormal and alien investigations. Tapping into people's curiosity about the supernatural and the possibility of alien contact with Earth, the show has spawned a cult following, hundreds of websites, and a feature movie. Seen here is David Duchovy, who plays Agent Mulder in the series.

1997 Gillian Anderson, who plays the forensic doctor Agent Scully in "The X-Files" series, acts as a doubting foil to Duchovy's haunted character.

1999 Located near a secret U.S. military base, Rachel, Nevada, has earned a reputation for the number of residents who have claimed sightings of UFOs. In recognition of this reputation, state officials have given the name Extraterrestrial Highway to one of the major roads in the area.

1998 "Seinfeld," the critically acclaimed comedy series about the daily travails of a stand-up comedian (*above*), Jerry Seinfeld (1954–), and his three single friends, was a 1990s TV phenomenon discussed around water coolers every Friday. The series not only consistently topped TV ratings, but won a prestigious Peabody Award and many Emmy Awards. On the set are (left to right): Jason Alexander, Julia Louis-Dreyfus, Michael Richards, and Seinfeld.

1998 Nephew of singer/actress Rosemary Clooney, George Clooney (*left*) became the heartthrob of millions of female viewers through his role on top-rated television series "ER" In the mid-1990s, Clooney left the show to pursue a movie career and has appeared in such films as *One Fine Day*, *Batman and Robin*, and *Three Kings*.

1998 The all-American beauty Cindy Crawford (1966–) has parlayed her talents into a career as a supermodel, commercial spokesperson, TV personality, fitness-video producer, author, and attempted movie star. By 1995, *Forbes* calculated that she was the world's highest-paid model, with annual earnings of more than six million dollars. Here she attends *Vogue* magazines 100th anniversary party.

1993 Nirvana, the innovative band who brought the sound and spirit of Seattle "grunge" rock to a mainstream pop audience, soared to number one on the charts with their sarcastic youth anthem "Smells Like Teen Spirit." The tempestuous lead singer Kurt Cobain (1967–1994) became an icon for teenage angst. He is pictured here with his wife, Courtney Love, lead singer of the rock group Hole, and their daughter Frances Bean, at the MTV Video Music Awards.

1999 Named for lead singer Eddie Vedder's (1964–) grandmother Pearl and her homemade jam, Pearl Jam is considered the founder of the Seattle "grunge" sound. With their heavy guitar licks and Vedder's impassioned vocals, the group sold over ten million copies of their first two records.

1999 Los Angeles funk–rock group the Red Hot Chili
Peppers emerged as one of the early 1990s premier bands
with albums such as *BloodSugarSexMagik* and *Under the Bridge*.
Here lead singer Anthony Kiedis jumps into the air in one
of the Chili Peppers's trademark over-the-top performances.

1999 Rap artist Will Smith (1970–) holds his trophy at the MTV Video Music Awards (*above*). An actor and comedian as well as a musician, Smith has become a major box office star, appearing in such movies as *Six Degrees of Separation, Bad Boys, Independence Day,* and *Men in Black.*

1999 Rap impresario Sean "Puff Daddy" Combs (1970–) in performance (*right*). In 1993 Combs formed his own label, Bad Boy Entertainment, which sold over 12 million albums by 1994. Combs has won many awards for his songwriting, contributing material to performers such as Boyz II Men, TLC, and Aretha Franklin.

1999 The Latin blues–rock band Santana was formed in 1966 by singer and guitarist Carlos Santana (1947–) (*left*), and has continued to play to sold–out audiences wherever it performs. 2000 was an incredible comeback year for Santana, as his album *Supernatural* swept the airwaves and the Grammys.

1999 The chameleonic provocateur Madonna continued to soar in the 1990s with successes such as the 1990 Blonde Ambition tour; the book *Sex*; the albums *Erotica* and *Ray of Light*; the films *Truth or Dare* and *Evita*; and a $60–million deal with Time Warner to form her own label, Maverick. Her most important production, however, was daughter Lourdes, born in 1996.

1999 Country and Western legend Garth Brooks (*left*) performs during the televised "VH1 Concert of the Century." In the 1990s, the versatile Brooks also made headlines by trying out for the Los Angeles Dodgers.

1991 Whitney Houston (1963–) live in concert (*right*). An internationally popular singer, Houston is one of the top-selling vocalists of all time. She is also a major film star having appeared in such movies as *The Bodyguard*, *Waiting to Exhale*, and *The Preacher's Wife*.

1999 All–male pop "boygroups" had a resurgence in the 1980s and 1990s with bands such as New Kids on the Block and Back Street Boys. 'N Sync (*above*), made their U.S. debut in 1998 with *'N Sync*. In 2000, the group's second album, *No Strings Attached*, smashed sales records by selling an amazing 2.4 million copies during the first week of its release.

1999 In the late 1990s, pop singer Britney Spears (*below*) burst upon the scene with her smash hit "Baby One More Time." A teenage idol, posters depicting her have sold in the millions.

1999 The Puerto Rican–American sensation Ricky
Martin (1971–) is one of today fastest rising stars. Winner
of Billboard's Best New Latin Artist Award and multiple
Grammys, Martin has also appeared on the TV soap opera
"General Hospital" and has starred on Broadway in the hit
musical *Les Miserables*.

1995 The heartthrob of teenagers around the world, actor Leonardo DiCaprio (1974–) reached stardom at an early age with his portrayal of a mentally–challenged boy in *What's Eating Gilbert Grape*. He attained international fame as a result of his starring role in the blockbuster film *Titanic*. DiCaprio is shown here (*above*) with actor/musician Mark Wahlberg.

1998 Actress Julia Roberts (1967–), filmdom's most sought–after and highest paid female star (*right*), first captivated audiences in the 1988 film *Mystic Pizza*. The following two years she received Oscar nominations for her performances in *Steel Magnolias*, and *Pretty Woman*. Her other films include *The Pelican Brief*, *My Best Friend's Wedding*, *Notting Hill*, and *Erin Brockovitch*.

1999 Hollywood's hottest couple, Tom Cruise (1962–) and Nicole Kidman (1967–) pose at the premiere of the controversial Stanley Kubrik movie *Eyes Wide Shut* in which they both starred (*left*). Cruise's blockbuster films include *Risky Business*, *All the Right Moves*, *Top Gun*, *The Color of Money*, *Rainman*, and *A Few Good Men*. Kidman's movies include *To Die For*, and *The Portrait of a Lady*.

1999 Heather Donahue turns a camera on herself in the low–budget thriller, *The Blair Witch Project*. A surprise box–office smash by film students Daniel Myrick and Eduardo Sanchez, the movie follows three teenagers who disappear in Maryland's Black Hills while filming a "documentary" about a local legend known as the "Blair Witch."

1990 Denzel Washington (1954–), regarded as one of Hollywood's most accomplished actors (*left*), won an Academy Award for his brilliant performance in the film *Glory*. His other movies include *A Soldier's Story*, *Cry Freedom*, *The Pelican Brief*, and *Devil in a Blue Dress*.

1997 Actress Sharon Stone (1958–) made her film debut in Woody Allen's *Stardust Memories* (*right*). Her performance in *Basic Instinct* earned her a reputation as one of Hollywood's sultriest stars, and her role in *Casino*, for which she received an Academy Award nomination, led to her being regarded as a serious actress as well.

1998 The Dalai Lama presents Oscar–winning film director Martin Scorsese (1942–) with the International Campaign for Tibet's "Light of Truth" award for his achievements in bringing the film *Kundun* to the screen. Looking on at the left is "free Tibet" champion and actor Richard Gere.

1998 Director, producer, screenwriter, actor, and New York Knickerbocker fan Spike Lee (1957–). Lee's first block–buster, the sexy comedy *She's Gotta Have It*, was filmed on a shoestring budget but went on to rake in $8.5 million at the box office. His continued quest to paint realistic portraits of African–Americans resulted in such films as *Jungle Fever*, *Do the Right Thing*, and *Malcolm X*.

1997 The quintessential 1990s director and actor Quentin Tarantino (1963–) hold hands with his girlfriend, actress Mia Sorvino. Tarantino made his film debut in 1992 as director and screenwriter of the comically violent *Reservoir Dogs*, a movie in which he also starred. His other films include *Pulp Fiction* and *Jackie Brown*.

1999 Tom Hanks (1956–) seen here with director Steven Spielberg, soared to stardom in the film *Splash* and then scored an even bigger hit in the movie *Big*. In 1993 and 1994 Hanks won back-to-back Academy Awards for his performances in *Philadelphia* and *Forrest Gump*. His other movies include *Sleepless in Seattle*, *The Green Mile*, and the highly acclaimed D-day film *Saving Private Ryan*, for which Spielberg won a best director Oscar.

1999 Arnold Schwarzenegger (1947–), a five-time Mr. Universe and a seven-time Mr. Olympia (*right*), has won international fame through the action and science fiction thrillers in which he has starred, such as *Conan the Barbarian*, *The Terminator*, and *True Lies*. He served as chairman of the President's Council on Physical Fitness and Sports from 1990 to 1994.

c. 1995 Although drive-in movies in most locales are a thing of the past, there are still places where they not only exist but thrive. This drive-in (*left*) caters to Minneapolis movie buffs.

969

1996 Five American astronauts aboard the space shuttle *Atlantis* gaze out the shuttle's windows at Russian cosmonauts aboard the *Mir* Space Station. The *Mir*, having made 81,350 orbits around the earth in 14 years, will likely stay in orbit for another 5 years and may be purchased by a private venture.

1999 George Lucas's *Star Wars* "prequel" *Episode I: The Phantom Menace* took audiences on a journey to the beginnings of the intergalactic saga, with dazzling special effects. Here (*previous pages*), Qui–Gon Jim (Liam Neeson) and the young Obi–Wan Kenobi (Ewan McGregor) match wits and light sabers with the evil Darth Maul (Ray Park).

1999 As the 20th century moved towards an end, people around the world began making plans to celebrate the new millennium. Here, in preparation for the festivities, Walt Disney World's Epcot Center shows off its year 2000 logo.

2000

2000 New York's Times Square, long the center of New Year's Eve celebrations, teems with more than a million people from all over the world caught up in the biggest New Year's celebration of all.

It was a new year, a new century, a new millennium. The economy continued to boom and the "Y2K bug" failed to cause the computer disaster that so many had feared. Americans could breathe easy – and celebrate. And celebrate they did. From coast to coast, in communities large and small, the old century was rung out and the new millennium was ushered in with an exuberance that has characterized us as a nation.

The photographs that follow offer a sampling of ways in which Americans marked the historic passage and celebrated what they hoped would be the brightest millennium of all.

2000 Even Times Square, where legions have watched the "ball drop" since 1906, outdid itself in ringing in the new year (*right*).

2000 Zaida Zunida traveled all the way from Costa Rica (*above*) to take part in the New Year's party Times Square.

1999 On the last day of the 20th century, an enormous representation of Father Time (*previous pages*) is paraded through New York's Times Square.

2000 The Potts family of Philadelphia, Pennsylvania displays their own unique way of letting it be known that a new century has begun (*following pages*).

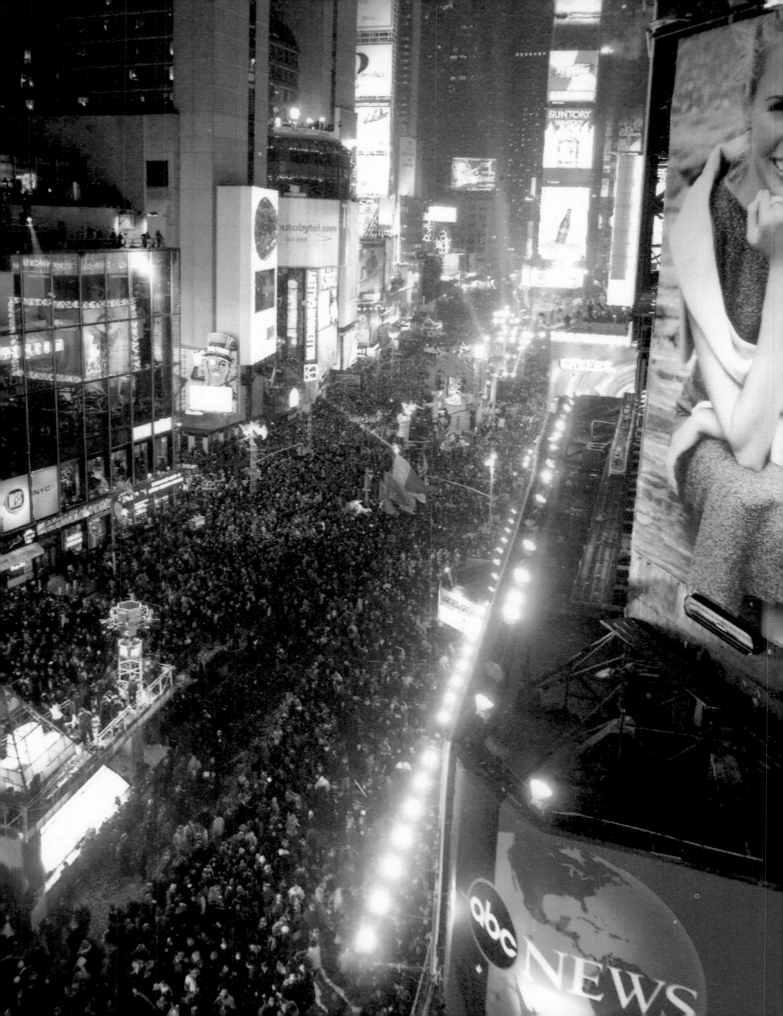

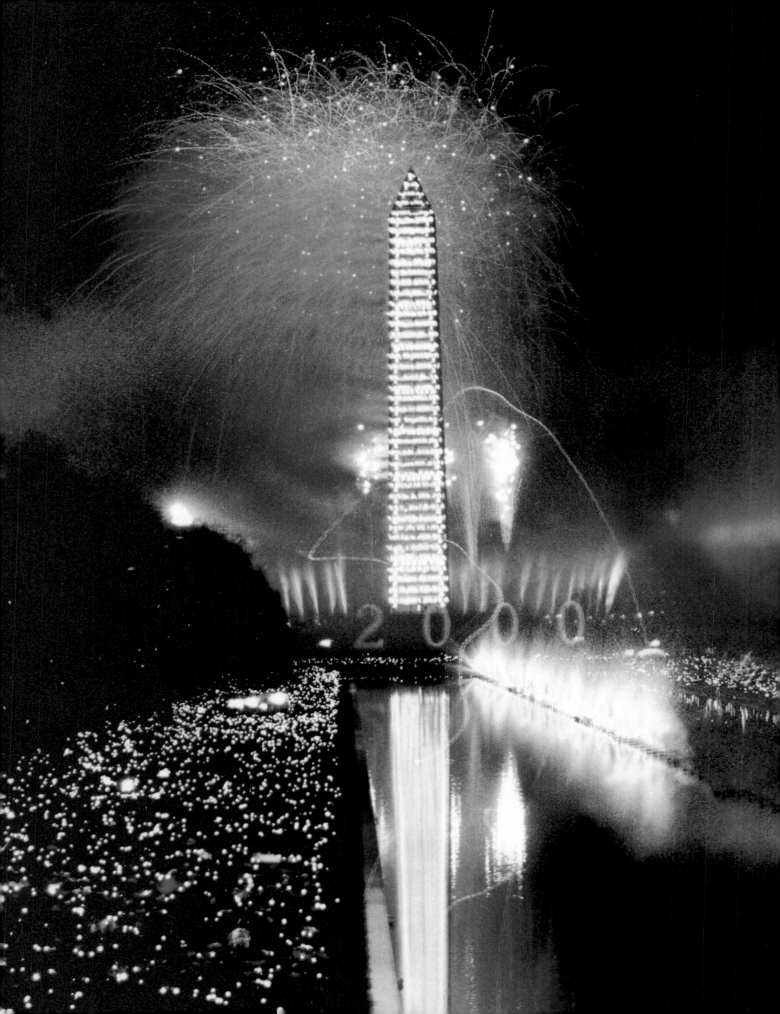

2000 Millennium celebrants wade in the reflecting pool (*above*) in front of the Lincoln Memorial in Washington D.C.

2000 Hundreds of thousands of spectators, including President and Mrs. Clinton, were on hand to view this spectacular sight (*left*) as the nation's capitol welcomed the new millenium.

1999 Dressed in tuxedos and gowns, 650 couples (*previous pages*) celebrate the end of a century by tying the knot at Philadelphia's Convention Center.

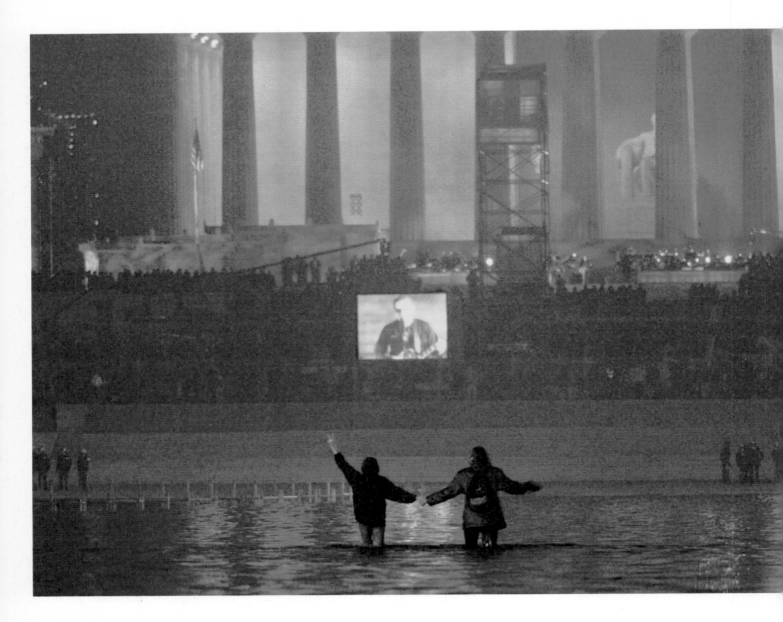

2000 This couple had a unique vantage point from
which to view the millennium celebration at Washington,
D.C.'s Lincoln Memorial.

2000 Photographer Jamal Wilson captured this scene of
police officers at the Lincoln Memorial.

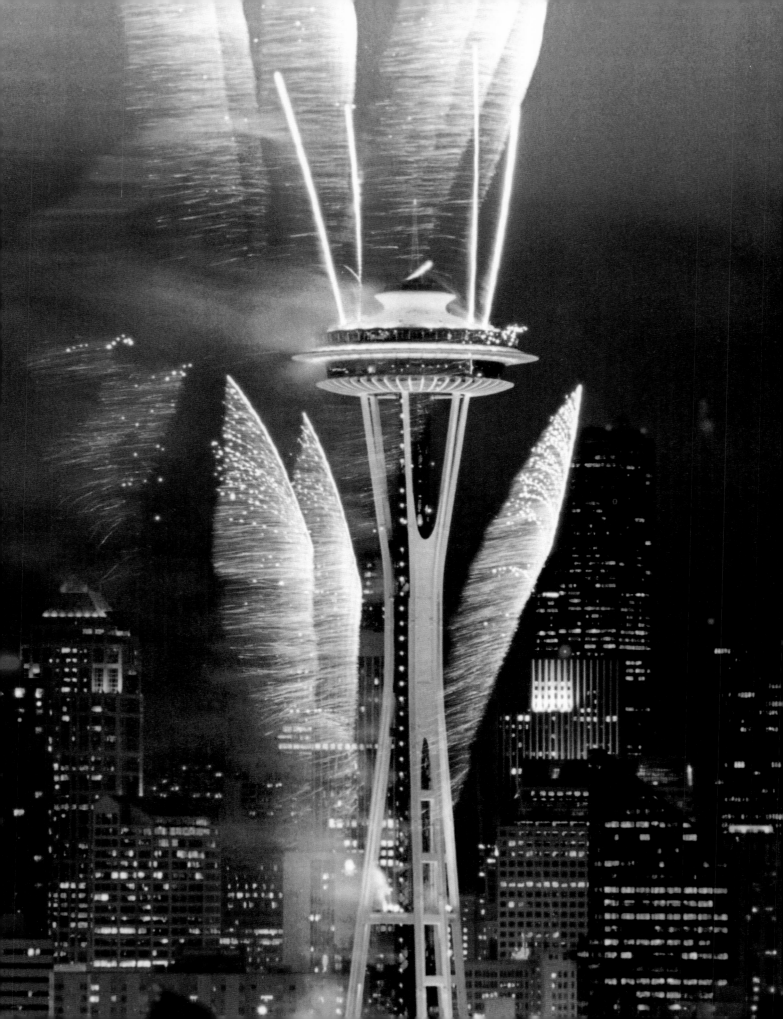

2000 The famed Hollywood sign (*above*) is illuminated in special colors as part of the millennium celebration in Los Angeles.

2000 Seattle's millennium party began with a gigantic fireworks display (*left*) set off near the city's renowned Space Needle.

2000 The sky above Lake Michigan (*previous pages*) is illuminated as Chicago ushers in a new year and a new century.

2000

2000 A couple dances–in the year 2000 during San Francisco's New Year's eve celebration.

2000 Fireworks light the Ferry Building on San Francisco's Embarcadero as thousands of revelers look on.

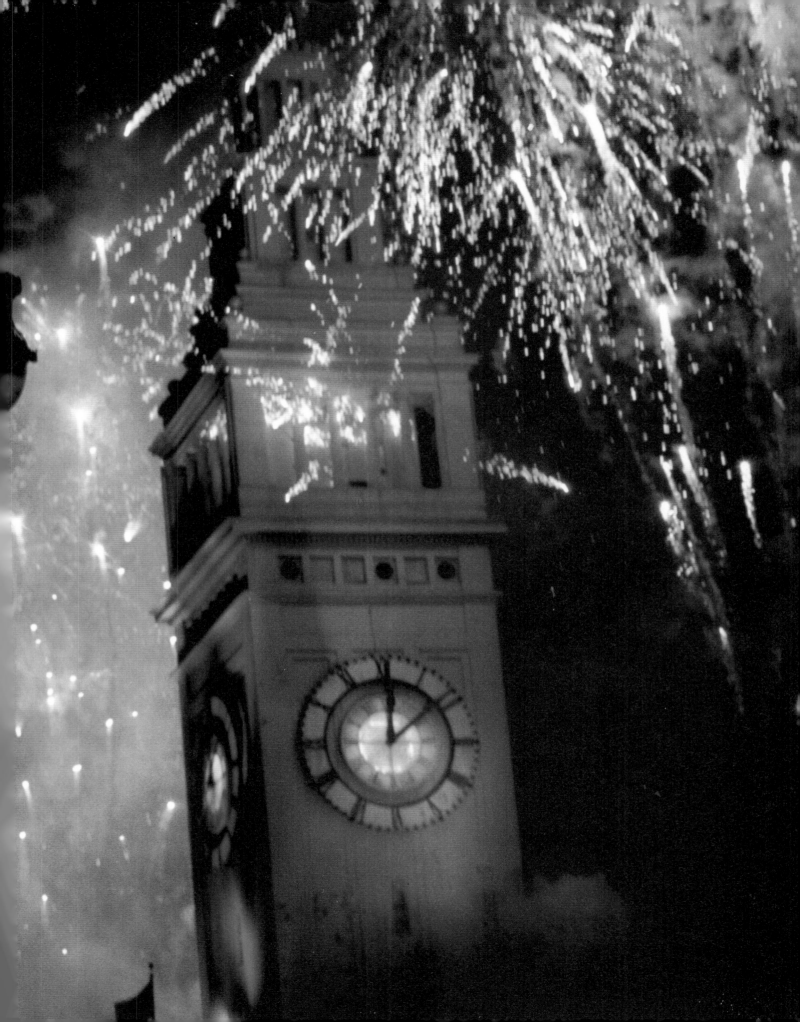

2000 A man surveys the
aftermath of New York's
gigantic New Year's party.

**2000 As the furthest point
east** in the United States,
Lubec, Maine (*following pages*)
provided spectators with the
distinction of being the first
to view the dawning of a
new millennium.

photography credits

photography credits

404–405 Walker Evans/Hulton Getty
406–407 Dorothy Lange/Hulton Getty
408 Fox Photos/Hulton Getty
409 (*top*) Hulton Getty, (*bottom*) General
Photographic Agency/Hulton Getty
410–411 Margaret Chute/Hulton Getty
412 (*both*) Hulton Getty
413 H.F. Davis/Hulton Getty
414 Fox Photos/Hulton Getty
415 (*top*) Ray Jones/Hulton Getty,
(*bottom*) Hulton Getty
416 (*top*) Archive Photos, (*bottom*) Hulton Getty
417 Hulton Getty
418 Hulton Getty
419 (*top*) Keystone/Hulton Getty,
(*bottom*) Archive Photos
420 FPG International
421 Hulton Getty
422–423 Hulton Getty
424–425 Keystone/Hulton Getty
426 Keystone/Hulton Getty
427 Archive Photos
428 (*top*) Keystone/Hulton Getty, (*bottom*) Fox Photos
429 Robert Yarnall Richie
430–431 Underwood & Underwood (AG)/Hulton Getty
432 Dorothy Lange/Hulton Getty
433 (*top*) General Photographic Agency/Hulton Getty,
(*bottom*) Fox Photos/Hulton Getty
434 Hulton Getty
435 Hulton Getty
436–437 Fox Photos/Hulton Getty
438 General Photographic Agency
439 Keystone/Hulton Getty
440 Sasha/Hulton Getty
441 (*both*) MPI/Hulton Getty
442 Fox Photos/Hulton Getty
443 Fox Photos/Hulton Getty

1940s

444–445 Keystone/Hulton Getty
446 (*top*) Keystone/Hulton Getty,
(*bottom*) American Stock/Archive Photos
447 Archive Photos
448 Keystone/Hulton Getty
449 Breitenbach/Archive Photos
450 Jack Delano/Hulton Getty
451 Russell Lee/Hulton Getty
452–453 Jack Delano/Hulton Getty
454 John Vachon/Hulton Getty
455 Marjory Collins/Hulton Getty
456 (*top*) Russell Lee/Hulton Getty,
(*bottom*) Gordon Parks/Hulton Getty
457 John Vachon/Hulton Getty
458 Fox Photos/Hulton Getty
459 MPI/Hulton Getty
460 MPI/Hulton Getty
461 Gordon Parks/Hulton Getty
462 ACME/Hulton Getty
463 Fox Photos/Hulton Getty
464 Nat Fein/Archive Photos
465 Anthony Potter Collection/Archive Photos
466 Gene Lester/Archive Photos
467 Keystone/Hulton Getty
468 MPI/Hulton Getty

469 Keystone/Hulton Getty
470–471 Keystone/Hulton Getty
472 Hulton Getty
473 MPI/Hulton Getty
474 Archive Photos
475 Keystone/Hulton Getty
476 (*top*) Weegee (Arthur Fellig)/Hulton Getty,
(*bottom*) MPI/Hulton Getty
477 MPI/Hulton Getty
478 Slim Aarons/Hulton Getty
479 Weegee (Arthur Fellig)/Hulton Getty
480 Charles "Teenie" Harris/Archive Photos
481 Keystone/Hulton Getty
482 Charles "Teenie" Harris/Archive Photos
483 Metronome/Archive Photos
484–485 Archive Photos
486 Slim Aarons/Hulton Getty
487 Hulton Getty
488–489 Three Lions/Hulton Getty
499 Marion Post Walcott/Hulton Getty
491 (*top*) Russell Lee/Hulton Getty,
(*bottom*) Archive Photos
492–493 Kurt Hutton/Hulton Getty
494 Keystone/Hulton Getty
495 (*top*) John Collier/Hulton Getty,
(*bottom*) Keystone/Hulton Getty
496 Keystone/Hulton Getty
497 Neil Boenzi, New York Times Co./Archive Photos
498–499 Nat Fein/Archive Photos
500 Douglas Grundy/Hulton Getty
501 (*top*) Orkin/Archive Photos,
(*bottom*) Archive Photos
502 (*top*) Ted & Shirley Bank/Hulton Getty,
(*bottom*) Marion Post Walcott/Hulton Getty
503 Charles "Teenie" Harris/Archive Photos
504 Fox Photos/Hulton Getty
505 Arthur Siegel/Hulton Getty
506 Jack Delano/Hulton Getty
507 (*top*) John Vachon/Hulton Getty,
(*bottom*) John Collier/Hulton Getty
508–509 Russell Lee/Hulton Getty
510 (*top*) John Vachon/Hulton Getty,
(*bottom*) Russell Lee/Hulton Getty
511 Arthur Siegel/Archive Photos
512 (*top*) Slim Aarons/Hulton Getty,
(*bottom*) NBC/Archive Photos
513 Keystone/Hulton Getty
514–515 Gene Lester/Archive Photos
516 (*top*) Lloyd Arnold/Archive Photos,
(*bottom*) Archive Photos
517 Gene Lester/Archive Photos
518 Archive Photos
519 Gene Lester/Archive Photos
520–521 Picture Post/Hulton Getty
522 Archive Photos
523 (*top*) Keystone/Hulton Getty,
(*bottom*) Keystone/Hulton Getty
524 Museum of the City of New York/Archive Photos
525 Hulton Getty
526 Archive Photos
527 Archive Photos
528 Ehis/Hulton Getty
529 (*both*) Weegee (Arthur Fellig)/Hulton Getty

photography credits

646 Archive Photos
647 Pittsburgh Courier Archives/Archive Photos
648 Bernard Godfryd/Archive Photos
649 Hulton Getty
650–651 Three Lions/Hulton Getty
652 Fotos International/Archive Photos
653 Three Lions/Hulton Getty
654 (*top*) Keystone/Hulton Getty,
(*bottom*) Archive Photos
655 Central Press/Hulton Getty
656 Sally Soames/Hulton Getty
657 Frank Driggs/Archive Photos
658 Terry Thompson/Archive Photos
659 (*top*) Archive Photos, (*bottom*) Hulton Getty
660 (*both*) Hulton Getty
661 Hulton Getty
662 Santi Visalli Inc./Archive Photos
663 Santi Visalli Inc./Archive Photos
664 Evening Standard/Hulton Getty
665 M.J. Stroud/Hulton Getty
666 Evening Standard/Hulton Getty
667 (*both*) Hulton Getty
668 Peter King/Hulton Getty
669 Keystone/Hulton Getty
670 (*top*) Express/Hulton Getty,
(*bottom*) Regan/Hulton Getty
671 Keystone/Hulton Getty
672 Ernst Haas
673 Ernst Haas/Hulton Getty
674–675 Michael Webb/Hulton Getty
676 F. Gillon/Hulton Getty
677 Archive Photos
678 Schafer/Hulton Getty
679 Ernst Haas/Hulton Getty
680 Slim Aarons/Hulton Getty
681 F. Roy Kemp/Hulton Getty
682 Weegee (Arthur Fellig)/Hulton Getty
683 Keystone/Hulton Getty
684–685 Archive Photos
686 Archive Photos
687 ABC TV/Archive Photos
688 (*both*) Archive Photos
689 Archive Photos
690 Ernst Haas/Hulton Getty
691 Ernst Haas/Hulton Getty
692 Tom Kelley/Archive Photos
693 (*top*) Keystone/Hulton Getty,
(*bottom*) Archive Photos
694 Evening Standard/Hulton Getty
695 Keystone/Hulton Getty
696–697 Ernst Haas/Hulton Getty
698 Archive Photos
699 (*top*) Ernst Haas/Hulton Getty,
(*bottom*) William Lovelace/Hulton Getty
700–701 Archive Photos
702 (*top*) Archive Photos, (*bottom*) Archive Photos
703 Archive Photos

1970s

704–705 Russell Turiak/Liaison Agency
706 (*top*) Fotos International/Archive Photos,
(*bottom*) CBS Television/Archive Photos
707 Matthew Naythons/Liaison Agency
708 Frank Edward/Fotos International/Archive Photos

709 (*top*) Milson/Hulton Getty,
(*bottom*) Peter Bosari/Archive Photos
710 Archive Photos
711 Archive Photos
712 Joseph Sia/Archive Photos
713 (*top*) Joseph Sia/Archive Photos,
(*bottom*) Archive Photos
714 (*top*) CBS Photo Archive/Archive Photos,
(*bottom*) Archive Photos
715 Hulton Getty
716 (*top*) Peter Keegan/Hulton Getty,
(*bottom*) Brian F. Alpert/Hulton Getty
717 Peter Keegan/Hulton Getty
718 Archive Photos
719 Ernst Haas/Hulton Getty
720 (*top*) Tim Boxer/Archive Photos,
(*bottom*) Sara Krulwich/New York Times Co./
Archive Photos
721 Russell Reif/Archive Photos
722–723 Ernst Haas/Hulton Getty
724 Ernst Haas/Hulton Getty
725 Ernst Haas/Hulton Getty
726 Santi Visalli Inc./Archive Photos
727 Tyrone Dukes/New York Times Co./Archive Photos

728–729 Ernst Haas/Hulton Getty
730 (*top*) Bryan Alpert/Hulton Getty,
(*bottom*) Harry Lapow/Hulton Getty
731 Peter Keegan/Hulton Getty
732 MPI/Hulton Getty
733 Bernard Gotfryd/Archive Photos
734 Slim Aarons/Hulton Getty
735 Bernard Gotfryd/Archive Photos
736 MPI/Hulton Getty
737 MPI/Hulton Getty
738 (*top*) Hulton Getty, (*bottom*) Archive Photos
739 Peter I. Gould/Hulton Getty
740 (*top*) Bernard Gotfryd/Archive Photos,
(*bottom*) MPI/Hulton Getty
741 Santi Visalli Inc./Archive Photos
742 (*top*) Ed Carlin/Archive Photos,
(*bottom*) MPI/Hulton Getty
743 Ernst Haas/Hulton Getty
744 Ty Dukes/New York Times Co./Archive Photos
745 (*top, left*) MPI/Hulton Getty,
(*top, right*) Archive Photos,
(*bottom*) Keystone/Hulton Getty
746–747 Ernst Haas/Hulton Getty
748 Ernst Haas/Hulton Getty
749 Ernst Haas/Hulton Getty
750–751 Ernst Haas/Hulton Getty
752 Reigler/Archive Photos
753 Ernst Haas/Hulton Getty
754–755 Archive Photos
756–757 Archive Photos
758 Keystone/Hulton Getty
759 (*top*) Russell Turiak/Liaison Agency,
(*bottom*) Robin Platzer/Hulton Getty
760 Hulton Getty
761 Evening Standard/Hulton Getty
762 Doug McKenzie/Hulton Getty
763 Keystone/Hulton Getty
764 (*top*) Platt Collection/Archive Photos,
(*bottom*) Keystone/Hulton Getty
765 (*top*) Archive Photos,

photography credits

1990s

886–887 Grant Taylor/Stone Images
888 (top) Jonathon Elderfield/Liaison Agency/
Newsmakers, (bottom) MPI/Hulton Getty
889 Tom Able–Green/Allsport
890 Cosmo Cordina/Stone Images
891 Milan Chuckovich/Stone Images
892–893 Bruce Ayres/Stone Images
894 Hiroyuki Matsumoto/Stone Images
895 Hiroyuki Matsumoto/Stone Images
896 Robert E. Daemmrich/Stone Images
897 Chad Slattery/Stone Images
898–899 Paul Souders/Stone Images
900 Paul Chesley/Stone Images
901 Philip Coblentz/Stone Images
902 Ron Sherman/Stone Images
903 Vito Palmisano/Stone Images
904–905 Ron Sherman/Stone Images
906 Donovan Reese/Stone Images
907 Steven Weinberg/Stone Images
908 John Lawrence/Stone Images
909 Renato Rotolo/Liaison Agency/Newsmakers
910 John Gress/Newsmakers
911 (top) Sean Gallup/Newsmakers,
(bottom, left) Alex Wong/Newsmakers,
(bottom, right) Chuck Kennedy/Newsmakers
912 NASA/Newsmakers
913 Brian Cleary/Newsmakers
914 (top) David Tracy/Newsmakers,
(bottom) Karin Cooper/Newsmakers
915 Keith Brofsky/Stone Images
916–917 Tyler Mallory/Newsmakers
918 Howard Sachs/CNP/Archive Photos
919 Richard Ellis/Newsmakers
920 Frances M. Roberts/Newsmakers
921 Kerry Richardson/Newsmakers
922 Ron Sachs/CNP/Archive Photos
923 Ron Sachs/CNP/Archive Photos
924 Hulton Getty
925 (top) Keystone/Hulton Getty,
(bottom) MPI/Hulton Getty
926 (both) Joe Raedle/Newsmakers
927 Richard Ellis/Newsmakers
928–929 Jules Frazier/Stone Images
930 Mike Theiler/Newsmakers
931 Tim Boyle/Newsmakers
932 (top) Ray Stubblebine/Newsmaker,
(bottom) Patrick D. Witty/Newsmakers
933 Jed Jacobson/Allsport
934 Phil Cole/Allsport
935 Clive Brunskill/Allsport
936 (top) Todd Warshaw/Allsport,
(bottom) Mike Fialla/Newsmakers
937 John Todd/Newsmakers
938 Craig Jones/Allsport
939 Jon Gordon/Newsmakers
940 Jamie Squire/Allsport/Newsmakers
941 Mark Green/Stone Images
942 Darlene Hammond/Archive Photos
943 (top) Maria Melin/ABC/Newsmakers,
(bottom) Rex Banner/Newsmakers
944 Bill Swersey/Newsmakers
945 (top) Karl Feile/Archive Photos,
(bottom) Robin Platzer/Online USA/Newsmakers

946 Courtesy CBS/Newsmakers
947 Diana Freed/Newsmakers
948 (left) Victor Malafronte/Archive Photos,
(right) Archive Photos
949 Dan Callister/Online USA/Newsmakers
950 (top) Darius Anthony/Castle Rock Entertainment,
(bottom) Kostas Alexander/Archive Photos
951 Victor Malafronte/Archive Photos
952–953 Miranda Shen/Fotos International/Archive
Photos
954 Diane Freed/Newsmakers
955 Vaughn Youtz/Newsmakers
956 Scott Harrison/Archive Photos
957 (top) Karl Feile/Archive Photos,
(bottom) Jeff Christensen/Newsmakers
958 (left) Courtesy White House Pool/Marshell/
Newsmakers, (right) RAC/Newsmakers
959 Tim Chapman/Newsmakers
960 (top) Scott Harrison/Archive Photos,
(bottom) Vaughn Youtz/Newsmakers
961 Frances M. Roberts/Newsmakers
962 Darlene Hammond/Archive Photos
963 (top) Sonia Moskowitz/Archive Photos,
(bottom) Adrian Rogers/Focus/Newsmakers
964 (top) Artisan Entertainment/Newsmakers,
(bottom) Archive Photos
965 Brian Hamill/Archive Photos
966 Darlene Hammond/Archive Photos
967 (top) Matt Campbell/Newsmakers,
(bottom) Max Trujillo/Newsmakers
968 Charles Mason/Stone Images
969 (top) Glenn E. Sircy/U.S. Navy/Newsmakers,
(bottom) RAC/Newsmakers
970–971 Courtesy Lucas Films
972 Courtesy NASA/Newsmakers
973 Brian Cleary/Newsmakers

2000

974–975 Chris Hondros/Newsmakers
976 (both) Chris Hondros/Newsmakers
977 Liaison Agency/Newsmakers
978–979 H. Rumph, Jr./Newsmakers
980–981 William Thomas Cain/Newsmakers
982 Robert Giroux/Liason Agency/Newsmakers
983 Jamal A. Wilso/Newsmakers
984 Jamal A. Wilson/Newsmakers
985 Jamal A. Wilson/Newsmakers
986–987 Tim Boyle/Newsmakers
988 Clarissa Bolante/Newsmakers
989 Pamela J. Cury/Newsmakers
990 Neil Jacobs/Newsmakers
991 Neil Jacobs/Newsmakers
992–993 Chris Hondros/Newsmakers
994–995 Lara Jo Regan/Newsmakers

index

index

index

index

index

index

index

Rockefeller, Laurence, 680
Rockefeller, Nelson, 680
Rockefeller, Winthrop, 680
Rockefeller Center, New York City, 372
Rockport, Mass., 456
"Rock the Vote," 914
Rockwell, Norman, 317
"Rocky" film series, 782
Rocky Horror Picture Show, The, 795
Rocky Mountains, 241, 748
Roebling, John and Augustus, 70
Rogers, Ginger, 421
Rogers, Roy, 527
Rogers, Wayne, 714
Rogers, Will, 434
Roman Catholicism, 603, 621
Rome, Baths of Caracalla, 300
Romeo and Juliet, 618
Ronettes, 668
Roosevelt, Col. James, 462
Roosevelt, Eleanor, 210, 401
Roosevelt, Franklin Delano
 career, 188
 death, 476
 family, 210
 presidency, 210, 369, 401, 402, 462
 World War II, 470
Roosevelt, Theodore, 102, 156, 211
Roots: The Saga of an American Family, 706
Rose, Billy, 442
Rosh Hashanah, 600
Ross, Diana, 668
Ross, Shirley, 419
Rough Riders, 102
"'Round Midnight," 580
Rowlands, Gena, 687
Rubell, Steve, 833
Rubin, Jerry, 745
Runaways, 760
Run–D.M.C., 849
Running on Empty, 765
Russell, Jane, 467
Russia, 972
Ruth, George Herman "Babe," 349, 427, 499, 644
Ryan, Nolan, 776
Rydell, Bobby, 574

S

al-Sadat, Anwar, 740
Sagamore Hill, N.Y., 211
St. Denis, Ruth, 169
Saint Esteban del Rey mission, 19
St. Johnsbury, Vt., 82
St. Louis, Mo., 138, 507
St. Louis Cardinals, 644, 931
St. Patrick's Cathedral, 131
St. Patrick's Day parade, 909
Salk, Jonas, 535
Salt Lake City, Utah, 23, 43, 181
Salvation Army, 371
"Samurai." *See* Belushi, John
Sanchez, Eduardo, 964
San Francisco, Calif.
 cable car, 95, 817

Chinatown, 95, 181, 593–595
earthquake, 225
Golden Gate Bridge, 435
gold rush, 95
Hotel Del Monte, 96
Market Street, O'Farrell Street, and Great Avenue, 337
mayor, 920
millennium celebration, 990
music, 654, 659
Salvation Army in, 371
San Francisco 49ers, 867
Sanger, Margaret, 311
Sangre de Cristo Mountains, 749
San Jacinto, Tex., 56
Santa Barbara, Calif., 815
Santa Cruz Grove of Big Trees, 96
Santana, Carlos, 957
Sarandon, Susan, 795
Saratoga, 412
Saturday Evening Post, The, 317
Saturday Night Fever, 779
"Saturday Night Live," 712, 836
Saving Private Ryan, 969
"Scarecrow." *See* Bolger, Ray
Scent of a Woman, 785
Schindler's List, 836
Schwarzenegger, Arnold, 969
Scopes, John, 309
Scorsese, Martin, 967
Scott, Ridley, 788
Sculley, John, 861
Seattle, Wash., 861, 953–954, 989
Seaver, Tom, 776
"See It Now," 571
Seinfeld, 950
Seinfeld, Jerry, 950
Sells, Ariz., 612
Seneca Falls Convention, 188
Sennett, Mack, 258, 324
Seoul, Korea, 798
Serpico, 785
"Sesame Street," 841
Seven Year Itch, The, 557
Sex, 958
Shakespeare, William, 618
Shampoo, 687
Sharman, Jim, 795
Shawn, Ted, 169
Sheik, The, 324
Shepard, Alan, 629
Shields, Brooke, 833
Shining, The, 793, 859
Shire, Talia, 782
Shirelles, The, 668
Showboat, 412
Shrine Auditorium, 958
"Shut Down," 660
Silence of the Lambs, The, 793
Silk Stockings, 441
Silkwood, 855
Silly Symphony, 327
Simmons, Gene, 769
Simon, Paul, 660
Sinatra, Frank, 481, 516, 523, 676
Singin' in the Rain, 554

Acknowledgments

Author

I wish to express a very special note of appreciation
to Barbara Berger, without whom this book would
not have been possible. Her skill in shaping and
editing this volume shines through on every page.

— Martin W. Sandler

Publisher

DK Publishing, Inc., would like to thank the following
people and organizations for their invaluable help:
Charles Merullo of Hulton Getty Publishing Projects
for making this book a possibility; Timothy Shaner of
Night & Day Design for his dedication and beautiful,
thoughtful design; Martin W. Sandler for his
enthusiasm and brilliantly insightful text; Carol
Weiss Sandler for her impeccable transcription of
the manuscript; and Walter Cronkite for his gracious
support. For their unflagging assistance in supplying
photographic material we would like to thank Liz
Ihre at Hulton Getty; Arlete Santos and Eric Rachlis
at Archive Photos; Nancy Glowinski at Liaison
Agency; Eric Smalkin at Newsmakers; Suzi Schatz
and David Blake at Stone Images; Paul Oliver at FPG
International; and Robert Ritter at Allsport. Special
thanks go to Nanette Cardon at Iris for her indexing
wizardry, and Marlene Adler and Julie Suckman in
Mr. Cronkite's Office at CBS for their kindness and
support. And we are grateful to Iain Morris at Lucas
Licensing; Ian Metrose at Castle Rock Entertainment;
Laarnie Ragaza; Christopher Measom; Rose Lynn
Marra at Kelly & Salerno Communications; Beth
Adelman; Ray Rogers; Mandy Earey; Michelle Baxter;
Jill Bunyan; Fiona Macmillan; and Darren Frankland.